MIXED BLESSINGS

New Art in a Multicultural America

Lucy R. Lippard

 THE NEW PRESS, NEW YORK

First published in the United States of America by Pantheon Books, a division
of Random House, Inc., 1990

Published in the United States by The New Press, New York, 2000
Distributed by W. W. Norton & Company, Inc., New York

Unless otherwise noted, all art is copyrighted in the name of the artist.
Permissions acknowledgments can be found on page 279.

Cover painting: Kay Miller, *The Seer*, 1987,
oil on canvas, 49″ × 60″. Although the fiery,
full-spectrum eye dominates the painting,
Miller says the feather is the truly important
element. The eye represents illusion, the
feather liberation and reality. Miller's source
for the eye is a detail of a drawing by Emile
Pierre in Ralph Metzner's 1971 book *Maps of
Consciousness* (Collier Books, New York).

THE LIBRARY OF CONGRESS HAS CATALOGUED THE HARDCOVER AS FOLLOWS:
Lippard, Lucy R.
 Mixed blessings: new art in a multicultural America / by Lucy Lippard.
 p. cm.
 Includes bibliographical references.
 ISBN 0-394-57759-0 (hc.)
 ISBN 1-56584-573-0 (pbk.)
 1—Minorities as artists—United States. 2. Intercultural communication—
United States. 3. Ethnic art—United States.
 I. Title.
 N6537.5.L5 1990
 704'.0693'0973—dc20

Artwork on back cover: Alfredo Jaar, *A Logo
for America*, 1987, Times Square Spectacolor
Board, New York. These are two of several
frames redefining the word "America" in a
hemispheric context.

The New Press was established in 1990 as a not-for-profit alternative to the large,
commercial publishing houses currently dominating the book publishing industry.
The New Press operates in the public interest rather than for private gain, and is
committed to publishing, in innovative ways, works of educational, cultural, and
community value that are often deemed insufficiently profitable.

The New Press, 450 West 41st Street, 6th floor, New York, NY 10036
www.thenewpress.com

Book design by Fearn Cutler and Anne Scatto
Printed in the United States of America

9 8 7 6 5 4 3 2

Contents

For TropicAna

Preface to the New Press Edition

In the decade between the writing of *Mixed Blessings* and publication of this new edition, a lot has changed and a lot has remained the same. In the late 1980s there was a certain excitement about and openness to the notion of "multiculturalism"—a term that has since, inevitably, gone through some vicissitudes. Hope springs eternal, at least on the Left, for a global explosion of hithero-marginalized art. We are always looking for breakthroughs. They rarely arrive, and when they do, they are often fleeting. Enthusiastic acceptance is too often followed by skepticism and then by indifference, and the search begins again. It's a necessary process, not as bad as it sounds.

Today, although intellectual and scholarly strides have been taken, the United States in general is shackled by a harsh and hard-hearted racism that often seems taken for granted as a fact of life. The abyss between rich and poor has widened. The number of incarcerated Latino, African American, and Native males and youth has grown disproportionately. Utter resignation is a real danger. Despite economic prosperity for the upper middle class, hopelessness often seems endemic among the disenfranchised, even as flashes of resistance show on the horizon, just enough to inspire the dreamers.

In the arts, thanks to the multicultural boom of the late '80s and early '90s (the "next wave" after that of the late '60s and early '70s), things are easier because there is less resistance to the success of artists of color. Things are perhaps harder because art-world success exacerbates individualism and diminishes communal energy. The number of recognized artists of color has certainly increased. A few have reached the upper echelons of international stardom. Many have hit the glass ceiling well known to women artists. Others have found themselves relegated to "community arts" status—a place of honor not generally honored in this society. (Radicals and most activists remain ghettoized by timid esthetes and eclipsed by cultural amnesia.) Still others find themselves caught between the once-dominant "identity politics" and the postmodern distrust of any such cultural identification. Most of these artists—balancing precariously on the fence between home and an unfamiliar esthetic neighborhood beyond—know how mixed the blessings can be. And they are working with this knowledge to produce an art that can both catalyze and cauterize.

Given the ravages of global nationalism in the 1990s, ethnic exclusivity must be viewed with suspicion. At the same time, bland and thoughtless assimilation into an equally suspect dominant culture is no better. Artists today continue to explore ways of being who they proudly are. Some of the clichés about diversity, nauseating as they have become when heard from those who use them only for personal and political gain, remain true. A richly woven fabric of cultures *is* better than a thin veneer of ethnic disdain or faked accord. This is as clear in the arts as anywhere else. As Tricia Rose

vi Preface to the New Press Edition

wrote recently about rap music in *The Nation*, "The creation, and then tenacious holding on, of cultural forms that go against certain grains in society is an important part of subversion." And of organizing, and of ongoing dialogue.

I'm glad I took a chance and wrote this book. Its use as a college text means that I frequently hear from those who are startled or stimulated by it. Ten years later it is, of course, being read in a different context. Yet apparently it still fills a need because there are so many younger artists coming up in isolation from the art centers (though not from their propaganda) who have not been exposed to cross-cultural esthetics in any depth. As I pondered this new preface, I had a long phone conversation with a young Chicano studying (on a "minority" undergraduate fellowship) at a prestigious eastern college. He was struggling with many of the issues and dilemmas discussed in *Mixed Blessings*. He had begun as a history major and was now making art, in homage to some of the Chicano and African American artists he had discovered in his research. He was also having trouble finding new material on many of them.

Mixed Blessings was never intended to be a survey, but ten years down the line, my major regret is the omission of any number of artists whose work I didn't know at the time or who have emerged since I chose the illustrations in 1988. My files are full of art I'd include if I were writing the book all over again, art that has informed my own books since. I also wish I'd gotten into theories of whiteness, which would have made the best open ending. Ideally, *Mixed Blessings* would have been joined now by other similarly mixed-up and inclusive volumes, emerging from tastes differing from mine and bringing the many newer artists and ideas to light.

If I were to write one of those volumes today, it too would be different. For most of the decade since this book was written, I have been living in New Mexico, which has provided a whole new set of experiences and brings its own peculiar insights to any such endeavor. Editing the community newsletter in a Hispano/Anglo rural village, seeing local attempts at harmonious "triculturalism" founder on economic and historic shoals, learning the politics of land and water in the poorest state in the union, watching a large and vital Native American population struggling with post–1992 backturning and the effects of tourism on its arts—I find myself farther and farther afield from the milieus that informed this book, and more immersed in the lives that are untouched by the international art mainstream.

The new time, the "third space" predicted below by Kumkum Sangari, has not yet emerged. However, history has caught the imagination of artists in the 1990s far more than it did in the 1970s and 1980s. This pre-millennial preoccupation suggests yet another entrance to that post-liminal era. The doors aren't locked yet. The margins are ever livelier and more crowded. *Mixed Blessings* remains with me personally as an unfinished journey.

LRL, July 1999

Acknowledgments

My first debt is to the artists in the book, and to the people who read the manuscript at various stages and saved me from innumerable (though not all) idiocies: Susana Torruella Leval, Margo Machida, Amalia Mesa-Bains, Moira Roth, Jaune Quick-To-See Smith, Anne Twitty, and Judith Wilson. David Sternbach was a sympathetic and knowledgeable editor and Sue Heinemann's copyediting was excellent, as usual.

I owe much that is buried in this book to the U.S. Solidarity movement with Central America, to the cultural vitality of the Nicaraguan Revolution and the FMLN in El Salvador, and to the vital young artists of Cuba.

Many people were helpful, among them: Randall Morris and Shari Cavin Morris, Robert Farris Thompson, Guy Brett, Philip Brookman, Deward Walker, Sam Gill, Cordelia Candelaria, the Consejo of Tierra Amarilla, Inverna Lockpez and the staff of INTAR, Margaret Archuleta of the Heard Museum, the Philbrook Art Center (which commissioned the essay that finally got me started), the Glenbow Museum, the Studio Museum in Harlem, the Alternative Museum, the Asian-American Arts Centre, and the Museum of Contemporary Hispanic Art. The Penny McCall Foundation gave me an unexpected award that provided for additional color plates. The University of Colorado at Boulder funded my annual symposium called "Mixing It Up," from which I learned a great deal. Over the last decade, conversations with Juan Sánchez, Faith Ringgold, Jimmie Durham, Howardena Pindell, Papo Colo and Jeannette Ingberman, Rasheed Araeen, Jolene Rickard, Jerry Kearns, Daniel Flores, Charles Frederick, Kathy Vargas, Kay Miller, Carmen Atilano, Chris Takagi, Judy Baca, Lorraine O'Grady, Houston Conwill, Cecilia Vicuña, César Paternosto, Luis Camnitzer, Suzanne Lacy, Peter Jemison, Josely Carvalho, Gerardo Mosquera, May Stevens and Rudolph Baranik, and many others have offered insights into the subject at hand. Andre Schiffrin's ongoing encouragement has been important. For research and clerical help, thanks to Marguerite Kahrl, Lanie Lee, Evelyn Leong, and Camille Ibbotson. And finally, thanks to my mother, Margaret Isham Lippard, and my son, Ethan

Isham Ryman, for living through much of the process with me.

Full citations are not given in sidebars for references included in the bibliography.

MIXED BLESSINGS

Fig. 1: **Alfredo Jaar**, *A Logo for America*, 1987, Times Square Spectacolor Board, New York. These are two of several frames redefining the word "America" in a hemispheric context.

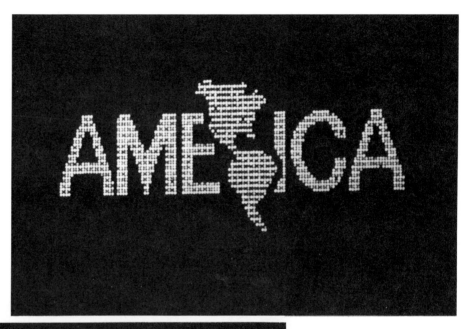

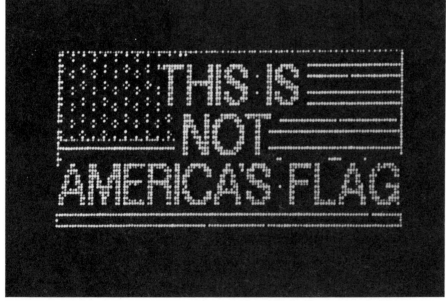

MAPPING

▼▼

The cross-cultural process is a recalcitrant, elusive subject, and I have tried to respect its urgency without succumbing entirely to its contradictions. This book's title, *Mixed Blessings*, is an ambivalent play on the possibilities of an intercultural world that reflects not doubt about its value, but a certain anxiety about the forms it could take. Although the book concentrates on art made in the United States, the "America " of the subtitle refers to the entire hemisphere.

The divergent trails of the artists I have followed defy conventional mapping methods, and the book itself, appropriately, has refused to stand still. For seven years it has veered from one end of the hemisphere to the other, beginning in Central America, spreading to the Caribbean and all of Latin America, finally coming more reasonably to rest at home in North America. Like its nomadic subject matter, the final product weaves in and out of unfamiliar territory. The disappearance of boundaries has been exhilarating and sometimes terrifying.

Each chapter is defined by a gerund because the gerund (from the Latin "to carry on") is the grammatical form of process. The first chapter is "Naming." It is about self-naming and being labeled, about coming to terms with self-representation, despite the shape-shifting identities most of us are forced to assume. The next chapter is "Telling," about history, family, religion, and storytelling. It looks back to where the intercultural process began and weighs the burdens of the past on the present. "Landing" is about roots and points of departure, about taking place and being displaced. The fourth chapter, "Mixing," is about *mestizaje*, or miscegenation—the double-edged past of rape and colonization, the double-edged future of a new and freely mixed world. The last chapter is "Turning Around," about subversion and trickery, the uses of humor and irony by which subjugated people survive. The brief postface is "Dreaming," proof that this subject has no conclusion.

▼▼▼

I want to make it clear from the outset that this book is not a survey of art from the Native, African, Asian, and Latino American communities. It is not a book "about" artists of color in the United States. (I have included a few Native Canadians because imposed national borders are irrelevant in their case.) The art reproduced here demonstrates the ways in which cultures see themselves and others; it represents the acts of claiming turf and crossing boundaries *now*, in 1990, two years before the five-hundredth anniversary of Columbus's accidental invasion of the Americas. More specifically, it deals with the ways cross-cultural activity is reflected in the visual arts, what traces are left by movements into and out of the so-called centers and margins. (Raymond Williams's concept of residual, dominant, and emergent cultures provides a useful armature.) The book is above all a record of my own still-incomplete learning process, and I hope it will encourage its readers to pursue a similar process.

Selecting a limited number of reproductions was the hardest part. Photography and performance have been given short shrift, and I have had to abandon film and video almost completely. There are many living artists who are not included here whose work is of equal importance. After much agonizing, I opted for fewer well-known names and more younger and/or lesser-known artists. Concentrating on images that share some of my own concerns as indicated by the chapter headings, I have, perhaps presumptuously, seen the art as a kind of collaboration with the text. The images actively operate in the gaps between "known" cultures and contribute in sometimes indirect ways to expose the barriers between them. Awkward as it often is, I identify the artists' and writers' ethnic backgrounds—not to confine them to stereotypes nor to exclude them from any dubious centers—but to demonstrate the tremendous range possible in an intercultural art that combines a pride in roots with an explorer's view of the world as it is shared with others. Though I am interested in cultural dissimilarities and the light they shed on the fundamental human similarities, I have tried to avoid dependence on the false histories: the master narratives and cultural myths we have all learned, and some have learned to resist.

I wanted to make a syncretic book that simultaneously reflected the enormity and the instability of its subject, to lay out a patchwork of images, not just a dialogue between myself (as a reluctant representative of my own firmly Anglo culture) and those from other landscapes. This is a time of tantalizing openness to (and sometimes untrustworthy enthusiasms about) "multiculturalism." The context does not exist for a nice, seamless narrative and probably never will. I can't force a coherence that I don't experience, and I write with the relational, unfixed feminist models of art always in the back of my mind. As the East Indian scholar Kumkum Sangari has observed, we are now "poised in a liminal space and an in-between time, which, having broken out of the

binary opposition between circular and linear, gives a third space and a different time the chance to emerge."[1] I write in what white ethnographer James Clifford has called "that moment in which the possibility of comparison exists in unmediated tension with sheer incongruity . . . a permanent ironic play of similarity and difference, the familiar and the strange, the here and the elsewhere"; and I have tried, as he suggests, not to "explain away those elements in the foreign culture that render the investigator's own culture newly incomprehensible."[2]

I have followed the lead of Henry Louis Gates, Jr., and others in putting the term "race" in actual or implied quotation marks, with the understanding that this is a historical rather than a scientific construct. Race is still commonly used when culture is meant, to connote, as Gates observes, some unspecific essence or feeling, the "ultimate, irreducible difference between cultures, linguistic groups, or adherents of specific belief systems which—more often than not—also have fundamentally opposed economic interests." Although arbitrary and biologically unsupportable, it is carelessly used "in such a way as to *will* this sense of *natural* difference into our formulations. To do so is to engage in a pernicious act of difference, one which exacerbates the complex problem of cultural or ethnic difference, rather than to assuage or redress it."[3] The word "racism," alas, describes a social phenomenon that is less questionable.

The fact that almost all of the artists whose work is discussed here are people of color, or "mixed race," is, however, no coincidence. Without minimizing the economic and psychological toll of racism in this country, and without exaggerating the strengths that have resulted in survival, it is still possible to recognize the depth of African, Native American, Asian, and Latino cultural contributions to an increasingly confused, shallow, and homogenized Euro-American society. The exclusion of those cultures from the social centers of this country is another mixed blessing. Drawn to the illusory warmth of the melting pot, and then rejected from it, they have frequently developed or offered sanctuary to ideas, images, and values that otherwise would have been swept away in the mainstream.

It is only recently that the ways different cultures cross and fail to cross in the United States have come under scrutiny. More or less taken for granted for two hundred years, the concept of the monotone meltdown pot, which assumed that everyone would end up white, is giving way to a salad, or an *ajiaco*—the flavorful mix of a Latin American soup in which the ingredients retain their own forms and flavors.[4] This model is fresher and healthier; the colors are varied; the taste is often unfamiliar. The recipe calls for an undetermined simmering period of social acclimation.

Demographics alone demand that a society change as its cultural makeup changes. But the contemporary artworld, a somewhat rebellious satellite of the dominant culture, is better equipped to swallow cross-cultural influences than to savor them. Its presumed inventiveness occurs mainly within given formal and contextual parameters determined by those who control the markets

and institutions. It is not known for awareness of or flexibility in relation to the world outside its white-walled rooms. African American and Latino American artists have been waiting in the wings since the '60s, when political movements nurtured a new cultural consciousness. Only in the '80s have they been invited again, provisionally, to say their pieces on a national stage. In the early '80s the presence of Asian Americans as artists was acknowledged, although they too had been organizing since the early '70s. Ironically, the last to receive commercial and institutional attention in the urban artworlds have been the "first Americans," whose land and art have both been colonized and excluded from the realms of "high art," despite their cultures' profound contributions to it.

The boundaries being tested today by dialogue are not just "racial" and national. They are also those of gender and class, of value and belief systems, of religion and politics. The borderlands are porous, restless, often incoherent territory, virtual minefields of unknowns for both practitioners and theoreticians. Cross-cultural, cross-class, cross-gender relations are strained, to say the least, in a country that sometimes acknowledges its overt racism and sexism, but cannot confront the underlying xenophobia—fear of the other—that causes them. Participation in the cross-cultural process, from all sides, can be painful and exhilarating. I get impatient. A friend says: remember, change is a process, not an event.

Affirmation of diversity does not automatically bring happy endings. Many of the artists in this book, like their colleagues in the fields of literature, music, theater, and cinema, make art that is profoundly critical of the host society. They often refuse not only the images and the values imposed on them, but also the limitations of a "high art" that disallows communication among certain mediums and contexts. The fusion of myth, history, religion, politics, and popular culture that fuels much Latin American art, for instance, has been neglected in the North where, after all, we have our own proud and sordid versions of history—rare as it may be to see them expressed in visual art. Mexican writer Carlos Fuentes has said that the role of Latin America is "to restore some kind of tragic consciousness . . . to make the United States understand that memory counts—that there is history, and that it does not renew itself every 24 hours when Dan Rather appears on the set."[5]

This is not intended as a book about "the Other," but a book about our common "anotherness." Thinking about crossing cultures makes us look more closely at our own environments. Most of us cross cultural borders every day, usually unconsciously. Assuming a dynamic rather than a passive role for the arts in society, one of my goals is to raise these daily encounters—at least in the realm of language and imagery—to a conscious level. I wrote this during the process of a personal "decentering," as I began to live outside New York, outside urban centers for more than half of each year, and began to experience firsthand the relationship of the provincial New York artworld to the so-called "regions."

The subject of the relationship between perceived center and margins in the United States is both unavoidable and curiously unapproachable, veiled as it is by the rhetoric of democracy and liberal "multiculturalism." Within the artworld, few cases of overt censorship due to racism are recorded or reported because personal taste and individual selection (called curating) rule for the most part unchallenged. The people doing the "caring" for art are overwhelmingly white, middle-class, and—in the upper echelons—usually male.

Ethnocentrism in the arts is balanced on a notion of Quality that "transcends boundaries"—and is identifiable only by those in power. According to this lofty view, racism has nothing to do with art; Quality will prevail; so-called minorities just haven't got it yet. The notion of Quality has been the most effective bludgeon on the side of homogeneity in the modernist and postmodernist periods, despite twenty-five years of attempted revisionism. The conventional notion of good taste with which many of us were raised and educated was based on an illusion of social order that is no longer possible (or desirable) to believe in. We now look at art within the context of disorder—a far more difficult task than following institutionalized regulations. Time and again, artists of color and women determined to revise the notion of Quality into something more open, with more integrity, have been fended off from the mainstream strongholds by this garlic-and-cross strategy. Time and again I have been asked, after lecturing about this material, "But you can't really think this is Quality?" Such sheeplike fidelity to a single criterion for good art—and such ignorant resistance to the fact that criteria can differ hugely among classes, cultures, even genders—remains firmly embedded in educational and artistic circles, producing audiences who are afraid to think for themselves. As African American artist Adrian Piper explains:

> Cultural racism is damaging and virulent because it hits its victims in particularly vulnerable and private places: their preferences, tastes, modes of self-expression, and self-image. . . . When cultural racism succeeds in making its victims suppress, denigrate, or reject these means of cultural self-affirmation [the solace people find in entertainment, self-expression, intimacy, mutual support, and cultural solidarity], it makes its victims hate themselves.[6]

One's own lived experience, respectfully related to that of others, remains for me the best foundation for social vision, of which art is a significant part. Personal associations, education, political and environmental contexts, class and ethnic backgrounds, value systems and market values, all exert their pressures on the interaction between eye, mind, and image. In fact, cross-cultural perception demands the repudiation of many unquestioned, socially received criteria and the exhumation of truly "personal" tastes. It is not easy to get people to think for themselves when it comes to art because the field has become mystified to the point where many people doubt and are even embarrassed by their own responses; artists themselves have become separated

from their audiences and controlled by the values of those who buy their work. Art in this country belongs to and is controlled by a specific group of people. This is not to say that there isn't art being made and loved by other people, but it has not been consecrated by a touch of the Quality wand; many of those whose tastes or work differ from mainstream criteria are either unaware of their difference or don't dare argue with the "experts"; others, who devote themselves to dissent, remain largely unheard due to official and self censorship.

One of the major obstacles to equal exposure is the liberal and conservative taboo against any and all "political" statements in art, often exacerbated by ignorance of and indifference to any other cultural background or context. Sometimes there is a condescending amazement that powerful work can actually come from "foreign" sources. Good or competent mainstream art by people of color is often greeted either with silence or with cries of exaggerated pleasure: "Well, what do you know, here's art by an Asian (or African or Latino or Native) American that doesn't fit our stereotypes!" (or the low expectations held for it). The dominant culture responds like condescending parents whose children have surprised them, affording a glimpse of the darker facets of future separation and competition.

Artists often act in the interstices between old and new, in the possibility of spaces that are as yet socially unrealizable. There they create images of a hopeful or horrible future that may or may not come to be. But artists are also often distanced from the world and from the people they hope to be envisioning for and with. The challenge to represent oneself and one's community is sometimes ignored in favor of denial of difference. Confronted by the overwhelming responsibility of self-representation, yet often deprived of the tools with which to achieve it, some deracinated artists of color escape into the obfuscatory "personal" and political apathy, distancing themselves from the "ghettos" of ethnic identity seen by the mainstream as parochial and derivative. Brainwashed by the notion that "art speaks for itself," artists of all races have often been silenced, abdicating responsibility, doing little to resist the decontextualization of their works (and thus themselves). Others, in an attempt to preserve their identity, fall into the trap of wishful, idealized stereotyping of self and community, or into a rage that is disarmed by borrowed rhetoric.

Recent cracks in the bastions of high culture now allow a certain seepage, the trickle-up presence of a different kind of authenticity that is for the moment fundamentally unfamiliar and therefore genuinely disturbing. Advocates of cultural democracy, of respect for differences and a wider definition of art, are often taunted with the specter of "the lowest common denominator." But art does not become "worse" as it spreads out and becomes accessible to more people. In fact, the real low ground lies in the falsely beneficent notion of a "universal" art that smoothes over all rough edges, all differences, but remains detached from the lives of most people. The surprises lie along the bumpy, curving side roads, bypassing highways so straight and so fast that we can't see where we are or where we are going. Bruce Chatwin tells the story of an

Australian aboriginal man trying desperately to "sing" or pay homage to the individual features of the land he is driven through by truck at such a speed that both sight and song are blurred beyond recognition.[7]

Modernism opened art up to a broad variety of materials and techniques as well as cultures. Nevertheless, knowledge of one's sources, respect for the symbols, acts, or materials sacred to others cannot be separated from the artistic process, which is—or should be—a process of *consciousness*. Well-meaning white artists and writers who think we are ultra-sensitive often idealize and romanticize indigenous cultures on one hand, or force them into a Western hegemonic analysis on the other hand. And while it is difficult *not* to be moved by the antimaterialism, spirituality, formal successes, and principled communal values of much traditional art, there is no "proper" or "politically correct" response by white artists that does not leave something out. But there is a difference between homage and robbery, between mutual exchange and rape. I am not suggesting that every European and Euro-American artist influenced by the power of cultures other than their own should be overwhelmed with guilt at every touch. But a certain humility, an awareness of other cultures' boundaries and contexts, wouldn't hurt. Not to mention a certain tolerance of those with different concerns. As white Australians Tony Fry and Anne-Marie Willis note:

> The so-called cultural relativism of the First-World art world that encourages difference is in reality a type of ethnocentrism, for while the value system of the other is acknowledged as different, it is never allowed to function in a way that would challenge the dominant culture's values. . . . difference is constructed almost exclusively on a binary model and is therefore bound up with the West's internal dialogues and is a manifestation of its crises and anxieties.[8]

Among the pitfalls of writing about art made by those with different cultural backgrounds is the temptation to fix our gaze solely on the familiarities and the unfamiliarities, on the neutral and the exotic, rather than on the area in between—that fertile, liminal ground where new meanings germinate and where common experiences in different contexts can provoke new bonds. The location of meaning too specifically on solider ground risks the loss of those elements most likely to carry us across borders. The uneasy situation of First World critics acting within or on the dominant culture is sharpened and enlivened by the artists' strategies to disabuse us of our static, long-held, and sometimes treasured illusions concerning the nature of Third World art. Caren Kaplan, challenging feminist critics to work cross-culturally, warns against "theoretical tourism . . . where the margin becomes a linguistic or critical vacation, a new poetics of the exotic" and suggests that we examine our own "location in the dynamic of centers and margins. Any other strategy merely consolidates the illusion of marginality while glossing over or refusing to acknowledge centralities."[9]

Emily Hicks, a member of the Border Art Workshop in San Diego, offers

the role of "postmodern penitente" for Anglos who want to redefine their careers to articulate "the pain of living between two cultures, to describe in detail the experiences of that wound." Learn Spanish, she suggests, "collaborate with bilingual artists/writers/teachers/critics; define yourselves in relationship to the South instead of the East; scrutinize the cultural barriers that divide us."[10] Latina professor Maria Lugones, in an article written with her Anglo colleague Elizabeth Spelman, asks in regard to the articulation and interpretation of the experiences of women of color, "Why would any white/Anglo woman engage in this task?" She suggests that "the only motive that makes sense to me for your joining us in this investigation is the motive of friendship."[11]

White critics are criticized when we complain about being criticized by people of color no matter what we do and no matter how good we think our intentions are. If we talk too much, we are seen as taking over; if we shut up, we are seen as condescending onlookers. Sometimes our compliments are mistrusted as fearful flattery; our critiques are fended off as attacks. "Damned if we do, damned if we don't," we mutter to ourselves. This is all part of the process, edifying if not enjoyable. Everyone is ethnocentric to some degree. All white people, no matter how well-meaning, are racist to some degree by virtue of living in a racist society. This is not merely a matter of socially concocted middle-class guilt, but of responsibility. It's not always easy to reach across cultures. One discovers racist tensions in one's own heart and in those of people of color, sometimes focused on other communities in the same boat.

There have been times during the writing of this book when I despaired of even the smallest success. As the material—more of it every day until we went to press—swirled around in my mind, I often wondered if I should have taken it on. Sometimes I am saying things I cannot really know. Despite the best intentions to make *Mixed Blessings* an egalitarian collage, I still find myself, paradoxically, speaking for others whose voices I am hoping to make heard. Yet another contradiction, since I am all too aware of the history of such co-optations.

So why am I trespassing? I know why I am drawn to "minority discourse." Friendship has certainly played a part. The need for a multivocal art has also emerged from my own life and from painful but crucial work with culturally mixed feminist and leftist collectives. But this book was written because artists and writers of color are making some of the most substantial art being made today. Many of those whose work appears here are politically active and/or spiritually intelligent artworkers. Sometimes they achieve a rare fusion of these two usually polarized motives. For various psychological and sociological reasons, many of these artists seem inspired (and sometimes enabled) to combine theory and practice in ways that open common ground for those of us seeking deeper meaning and broader participation for cultural work. They are unashamed to acknowledge the roles played by the world and by the unworldly in their art. And at best they distinguish, in the words of Barbara Christian,

a professor of African American Studies, "the desire for power from the need to become empowered."[12]

In addition, even as I have become increasingly skeptical of the motives and contexts fueling contemporary art (and even though most of my own intellectual and critical pleasures in the past twenty years have come from such third-stream mediums as photo-texts, performance, site-specific art, video, community, street and demonstration art), in the course of writing this book, I have been forced to rethink the "art is dead" syndrome. I have been drawn back to handmade images, to painting and sculpture, just as I was around 1970, when feminist artists reinvigorated conventional mediums with new meanings. For many artists of color, often the first generation to perceive art as a professional option, painting and sculpture, drawing and printmaking, are effective vehicles of content, and they have renewed the importance of "visualization." Nevertheless, art with spiritual depth and social meaning is homeless in this society, trapped in an artworld dedicated to very different goals. The presence of more women and artists of color has changed some things about art, but it has not changed the artworld much.

The arts are often pleasurable and entertaining, apparently unthreatening (if intimidating in certain contexts), but they can also be redemptive and restorative, critical and empowering. When cultural continuity and identity are suppressed through colonization and cultural imperialism, the artist loses more than a superficial vocabulary. C. G. Jung pointed out that the power of meaning is inherently curative. But meaning exists only when it is shared, and in our society, meaning tends to rest in the domains of politics and the spirit. They are both fundamentally moving forces, acts of faith, and their innovations are often doubly nourished by tradition and personal experience. If we are not moved, if we stand still, the status quo is our reward. Without at least some conviction that change can be positive, the only place to go is around in circles. Intelligent people are often reduced to academic foreplay and an obsession with tracking meaninglessness into its lair. Postmodern analysis has raised important questions about power, desire, and meaning that are applicable to cross-cultural exchange (although there are times when it seems to analyze everything to shreds, wallowing in textual paranoia). The most crucial of these insights is the necessity to avoid thinking of other cultures as existing passively in the past, while the present is the property of an active "Western civilization."

Both women and artists of color are struggling to be perceived as subject rather than object, independent participants rather than socially constructed pawns. Since the late '60s, the feminist movement's rehabilitation of subjectivity in the face of the dominant and loftily "objective" stance has been one model in the ongoing search for identity within so-called minority groups. It is precisely the false identities to which deconstructionism calls attention that have led women and people of color to an obsession with self-definition, to a re-creation of identity from the inside out. On the other hand, overemphasis

on static or originary identity and notions of "authenticity" imposed from the outside can lead to stereotypes and false representations that freeze non-Western cultures in an anthropological present or an archeological past that denies their heirs a modern identity or political reality on an equal basis with Euro-Americans.

Acknowledgment of existing fragmentation is basically unavoidable, even as the prospect of permanent fragmentation may prove unbearable. The blanket denial of "totality" and a metaphorical "essence" encouraged by some deconstructionist theoreticians can be seen as another form of deracination, destabilizing potentially comforting communal identities, pulling the floor (hearth) out from under those who may have just found a home, and threatening the permanent atomization of hard-earned self-respect. "Such skepticism," says Kumkum Sangari, "does not take into account either the fact that the postmodern preoccupation with the crisis of meaning is not everyone's crisis (even in the West) or that there are different modes of de-essentialization which are socially and politically grounded and mediated by separate perspectives, goals, and strategies for change in other countries."[13] A number of artists of color are creating from the basis of their own lives and experiences despite their understanding of the poststructuralist distrust of the resubjectification of art. "Without 'totality', our politics become emaciated, our politics become dispersed, our politics become nothing but existential rebellion," says African American theologian Cornel West. "Watch out for the colonization of 'decentering'!" At the same time, he calls for

> a new historiography, a structural analysis beyond the postmodernist base. . . . There are still homogenous representations of our communities, and we must go beyond that to their diversity and heterogeneity. But we also need to get beyond *that*—beyond mainstream and malestream, even beyond the "positive images"—to undermine binary oppositions of positive and negative: male/female, Black/white, straight/gay, etc. . . . Maybe the next step is to see how the dominant notions of whiteness are *parasitic* of blackness. . . . I'm as much concerned with how we understand modernity and the dominant culture as with the African-American experience.[14]

White scholar Nancy Hartsock, remarking on the most recent manifestations of self-determination observes:

> Somehow it seems highly suspicious that it is at this moment in history, when so many groups are engaged in "nationalisms" which involve redefinitions of the marginalized Others, that doubt arises in the academy about the nature of the "subject." . . . Why is it, exactly at the moment when so many of us who have been silenced begin to demand the right to name ourselves, to act as subjects rather than objects of history, that just then the concept of subjecthood becomes "problematic"?[15]

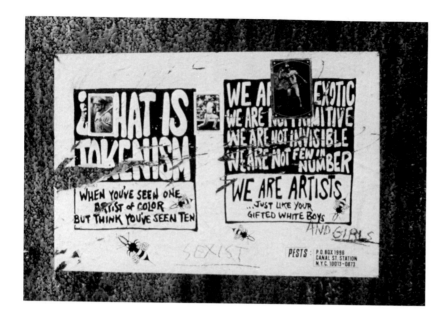

Fig. 2: PESTS, posters in New York, 1987. PESTS is the artists-of-color counterpart of the Guerrilla Girls. The makers are anonymous, but since 1986 the Black Hornet logo has been found on a variety of posters and an occasional newsletter/calendar of events. Some posters, like these, criticize; others celebrate or inform. These are among the early texts: "What is Tokenism? When You've Seen One Artist of Color But Think You've Seen Ten." "We Are Not Exotic. We Are Not Primitive. We Are Not Invisible. We Are Not Few in Number. We Are Artists . . . just like your gifted white boys."

The question of difference and separation is not only being played out on the level of personal subjectivity, but is also paramount in discussions of the relationship between "First" and "Third" World cultures, especially in the context of a newly aware anthropology, which has been particularly useful in its auto-critical models. This debate is extremely complex, given the multi-leveled tensions within the conservative and the radical discourses, the on-going, if eroding, hegemony of Western culture, and its current soul-searchings about the appropriate degrees of neocolonialism with which to approach different cultures. Once the crucial permeability of such encounters is recognized, contradictions are exposed by the very presence of the "Other," and we see the ways in which the Third World can disrupt the esthetic complacency of the First World as it rides precariously on the Western crisis of cultural superiority.

In the course of writing this book I have often been told, sternly, "You can't understand other cultures until you understand your own." I have tried to honor that admonition. Claude Lévi-Strauss's warning to his colleagues is well taken for the contemporary art critic as well; he advised the anthropologist to remember that the values attached to foreign societies are "a function of

his disdain for and occasionally hostility toward, the customs prevailing in his native setting."[16] I am well aware of my own "hostilities" and their role in this book; they provide both positive energy for social and attitudinal change and negative imperviousness to contributions from distrusted quarters.

My subject, of course, is not anthropological. The artists included here are peers, who work in more or less the same context I do. There is even less of an excuse for ignorance and paternalism or maternalism when it comes to the artists of color with whom we share a society than there is in regard to those who do not live on the same block or in the same country. In the artworld there remains a divisive either/or attitude toward people of color, women, gays and lesbians, working people, the poor. This is often as obvious in the Marxist and social-democratic rhetoric of some "deconstructionists" as it is in the less rigorous rhetoric of conventionally liberal art historians.[17]

Yet I'm inclined to welcome any approach that destabilizes, sometimes dismantles, and looks to the reconstruction or invention of an identity that is both new and ancient, that elbows its way into the future while remaining conscious and caring of its past. Third World intellectuals, wherever they live, are showing the way toward the polyphonous "oppositional consciousness," or the ability to read and write culture on multiple levels, as Chela Sandoval puts it,[18] or to "look from the outside in and from the inside out," in the words of Bell Hooks.[19] Maxine Hong Kingston says in *The Woman Warrior*, "I learned to make my mind large, as the universe is large, so that there is room for paradoxes."[20]

At the vortex of the political and the spiritual lies a renewed sense of function, even a mission, for art. The new fuels the avant-garde, where "risk" has been a byword. But new need not mean unfamiliar, or another twist of the picture plane. It can mean a fresh way of looking at shared experience. The real risk is to venture outside of the imposed art contexts, both as a viewer and as an artist, to live the connections with people like and unlike oneself. When culture is perceived as the entire fabric of life—including the arts with dress, speech, social customs, decoration, food—one begins to see art itself differently. In the process of doing so, I have become much more sensitive to, and angered by, the absence of meaning in many of the most beautifully made or cleverly stylized art objects. When it is fashionable for artworld insiders to celebrate meaninglessness and the parodists operate on the same level as the parodied, perhaps only those who have been forced outside can make a larger, newly meaningful contribution.

The negation of a single ideal in favor of a multiple viewpoint and the establishment of a flexible approach to both theory and practice in the arts are not the tasks of any single group. Stylistically the artists in this book share little. But they have in common an intensity and a generosity associated with belief, with hope, and even with healing. Whether they are mapping, naming, telling, landing, mixing, turning around, or dreaming, they are challenging the current definitions of art and the foundations of an ethnocentric culture.

▼▼▼▼▼▼▼▼▼▼▼

The terminology in which an issue is expressed is indicative of the quality of the discourse, and the fact that there are no euphonious ways to describe today's cross-cultural exchange reflects the deep social and historical awkwardness underlying that exchange. Much has been tried and found wanting. Writing about intercultural art, looking for satisfying ways to describe the groups involved, many of whom are living between cultures, I find myself caught in a web of ungainly, pompous, condescending, even ugly language.

A vital, sensible, and imaginative vocabulary can only be self-generated during the process of self-naming. Even then, consensus is unlikely. Inevitably, there is division in the ranks because frustration, contradiction, and growth are the gears by which the continuing cross-cultural education grinds ahead. From the inside, artists get restless, begin to feel imprisoned or ghettoized by the simplistic aspects even of self-imposed categories. ("Black Art" is so far the most examined example.) From the outside, after an initial period of surprise and dislike, the same categories begin to seem convenient places to keep the image of women, or black people, or Asian Americans. Yet the naming process must continue, if it is to mean anything deeper than internal or external name calling.

I say, for instance, that this book is based in art by people of color, because I can hardly say, ludicrously, that it concerns "art of color." I use the term "people of color" because it is, at this writing, the nomenclature of choice among the self-named. Yet we are all aware that it too is somewhat absurd, when the range of pinks and browns take in virtually everybody across racial borders. Liberals talk a lot about "blue or green or purple people"[21] ("We're all alike under the skin"), hoping for a humanist filter that will rid them of uncomfortable semantics and guilt. But society itself—censuses, segregation, racism, as well as local and family history and memory, affirmative action, and self-representation—acknowledges differences, sometimes for good reasons. And marginalized groups can still be intimidated into veiling themselves and their images in order to be acceptable in the dominant culture.

At the moment, artists "of color" has replaced "Third World" artists, which was more or less acceptable to all concerned in the '70s. Although still used to describe artists living in Third World countries, it has proved confusing when applied to people of color born in, or citizens of, the United States. As Vietnamese American filmmaker Trinh T. Minh-ha has insisted, "There is a Third World in every First World and vice-versa."[22] Like "the West," the term "Third World" has now most often a geographical and economic connotation. Artist Paul Kagawa offers a new and radical definition of Third World art:

Artists who create works which support the values of the ruling class culture are ruling class artists, no matter what their color. The "Third World Artist" (hereafter T.W.A.) is one who produces in conscious opposition to the art of the ruling class, not just to cause trouble or to be "different," but because the artist is sympathetic with "Third World" people in other sectors of society and the world. Not all "Third World" people are aware of their oppression (or its cause), but all T.W.A.s must be because they are, by our definition, a voice of the oppressed.[23]

Fig. 3: Mario Torero, *We Are Not a Minority*, 1978, acrylic, 30′ × 40′, Estrada Courts Housing Project, East Los Angeles. This mural with a didactic Che Guevara has an embattled history. In the three times it has been painted, it has been censored and vandalized three times by those to whom Che is anathema. It was painted on August 8, the anniversary of his death, by the Congreso de Artistas Cosmicos de las Americas—seven artists under Torero's direction, including Zopilote, Leonel Heredia, and Charles Felix. Torero was a founding member of the Chicano Cultural Movement of San Diego and remains committed to "The Master Plan of Aztlan," to the "total spiritual liberation of the earth" (letter to the author, 1990).

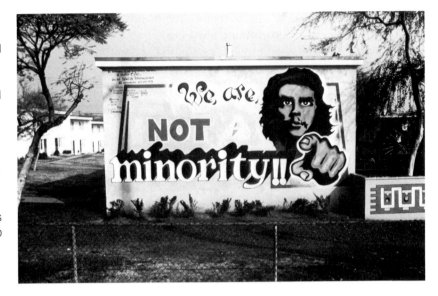

Kumkum Sangari objects to "Third World" on the grounds that it "both signifies and blurs the functioning of an economic, political, and imaginary geography able to unite vast and vastly differentiated areas of the world into a single 'underdeveloped' terrain."[24]

Is Japan a Third World country? Is Korea? When the question of definitions came up at a panel discussion in 1988, Korean American artist Yong Soon Min pointed out that even within economically developed countries, Third World remained politically valid because it indicated resistance to Western imperialism and referred to the experience of colonialism.

Similarly, "American," hemispherically, does not mean from the United States, but from the entire Western hemisphere. "Anglo America" might once have been a justifiable counterpart to "Latin America," but now it is becoming demographically outdated, and we have yet to find the phrase that expresses José Martí's bicontinental concept of *Nuestra America* (Our America) with its equal emphasis on indigenous populations. Logically, only Native peoples should be called Americans, and everyone else should be a "hyphenated" American. (To complicate matters, the hyphen—in "African-American," for example—is sometimes construed as a divisive insult, as another imposed separation.)

"Minority" artists is another outdated phrase; I use it now and then in antirepetitive desperation (at least it's one word instead of three). In this hemisphere, of course, people of color are the minority only in the United States and Canada. Globally, Caucasians are distinctly in the minority. This fact has been a source of empowerment for people of color in the United States. However, the force of our shared vocabulary is such that, as Sylvia Wynters observes, "we all know what we mean when we use the category *minority* to apply to an empirical *majority*":

Bill Strickland was the first scholar to note, in a talk given at Stanford in 1980, the strategic use of the term *minority* to *contain* and defuse the *Black* challenge of the sixties. . . . The term *minority*, however, is an *authentic*

term for hitherto repressed Euro-American ethnic groups who, since the sixties, have made a bid to displace Anglo-American cultural dominance with a more inclusive Euro-American mode of hegemony.[25]

Then there is the increasingly popular "multicultural," which many of us have used for years in grass-roots and academic organizing, although it has already been co-opted in institutional and decidedly nonactivist rhetoric. It is confusing because it can be used interchangeably with "multiracial" (voluntary and conscious, or involuntary mixing); or it can be used to denote biculturalism, as in "Asian American."[26] I use it to describe mixed or cross-cultural groups or as a general term for all of the various communities when they are working together, including white.

Finally, the word "ethnic," which is ambiguous in its application to any group of people anywhere (though it is, significantly, rarely applied to WASPs) who maintain a certain habitual, religious, or intellectual bond to their originary cultures. It sometimes serves as a euphemism for people of color or "the Other," and has also been condemned as a vehicle for exclusion.

The vocabulary continues to evolve. "Cross-cultural," "transcultural," and "intercultural," for instance, have not been sorted out and remain interchangeable. While they should apply to culture rather than race (itself a cultural construct), they have all been used euphemistically for cross-racial. I prefer cross-cultural to transcultural, although they mean the same thing, because "trans" to me implies "beyond," "over and above," as in "transcend," and the last thing we need is another "universalist" concept that refuses once again to come to grips with difference. Intercultural, suggesting a back-and-forth motion, might be an improvement on cross-cultural, which implies a certain finality—a cross-over or one-way trip from margins to center, from lower to middle class, rather than a flexible interchange.

Fig. 1: Linda Nishio, *Kikoemasu Ka (Can You Hear Me?)*, photo-text, 1980. An Asian woman (the artist) gestures and shouts, her face pressed against the picture plane as though against a soundproof window. In a similar series—a photocopied book called "Pinups"—the woman's face and body are fragmented, rarely visible in their entirety, and the gestures or facial expressions are distorted and tormented. In both works, Nishio, a Japanese American conceptual and performance artist from Los Angeles, calls out not only to be seen and heard, but to be considered whole. In 1989 she made a piece called *Competitor* on the computer Spectacolor billboard in Times Square, which phonetically spelled out the names of familiar Japanese corporations ("meet-sue-BEE'-she") and her own name ("KNEE'-she-oh"), similarly calling attention to alienation and assimilation through uses of language.

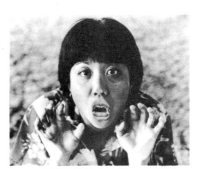

My name is Linda Nishio. I am 28 years old. I am a third generation (sansei) Japanese/American. I grew up in L.A. in a household where very little Japanese

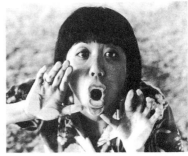

was spoken, except of course by my grandmother, who spoke very little English. during those early years I picked up some Japanese phrases, a few of which

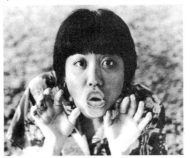

I still remember today. Then I went to Art School on the East coast. I attended classes in an environment where very little art was taught but where iconoclastic

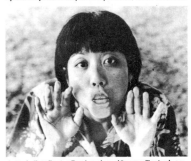

rhetoric (intellectualism) replaced "normal" art education. Before long I realized I, too, was communicating more and more in this fashion. Ho hum. Upon return-

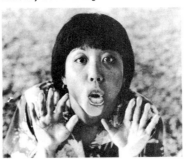

ing to L.A. I found myself misunderstood by family and friends. So this is the story: A young artist of Japanese descent from Los Angeles who doesn't talk normal.

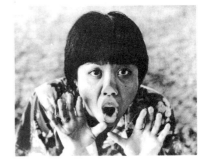

KI·KO·E·MA·SU KA
(Can you hear me?)

NAMING

▼▼

So where we are now is that a whole country of people believe I'm a "nigger," and I *don't*, and the battle's on! Because if I am not what I've been told I am, then it means that *you're* not what you thought *you* were *either*! And that is the crisis.
—James Baldwin[1]

For better or worse, social existence is predicated on names. Names and labels are at once the most private and most public words in the life of an individual or a group. For all their apparent permanence, they are susceptible to the winds of both personal and political change. Naming is the active tense of identity, the outward aspect of the self-representation process, acknowledging all the circumstances through which it must elbow its way. A person of a certain age can say wryly, "I was born colored, raised a Negro, became a Black or an Afro-American, and now I'm an African American or a person of color,"[2] or, "I was born a redskin, raised an Indian, and now I'm a Native American, an indigenous person, a 'skin,' or the citizen of an Indian nation."[3] Each one of these names had and has historical significance; each is applied from outside or inside according to paternalistic, parental, or personal experience. Each has had its absurd moments: "I'm Black, but yellow," said one young woman wryly. And none of these changes in nomenclature, as art historian Judith Wilson has wearily observed, have ever

> stopped a racist from calling me "nigger"! I doubt that switching to "African American" will change members of the dominant culture's attitudes or give Blacks greater control over material or cultural production. The term certainly didn't help its 19th-century advocates speed the end of slavery.[4]

Three kinds of naming operate culturally through both word and image. The first is self-naming, the definition one gives oneself and one's community,

▼▼▼▼▼▼▼▼

Question: How do we know who we are?

Answer 1: Society tells us. "Society," first in the form of family and other care-takers. Later, we learn our "place" increasingly via messages from institutional mechanisms—municipal governments that replace some street lamps far more readily than others, schools that teach us Columbus "discovered" America, media wizards who assign non-Western features to creatures from outer space. . . .

Answer 2: If society tells us lies, how can we know who we are?

Answer 3: Maybe the only thing to know is that we need to keep on searching. . . . "Searching" can sound tedious to people with too little time of their own, too much work, too many kids, never enough money. It can sound like a convenient cop-out if you see a city crumbling before your eyes, frozen corpses on sidewalk steam vents. "The hell with an identity I've got to search for," you scream. "I need one for immediate use!"

—Judith Wilson, *Autobiograhy: In Her Own Image* (p. 10)

Fig. 2: Vivian E. Browne, *Enraged Rage Outrage,* 1982, mixed media, 27″ × 37″. (Photo: Nick Levine.) Browne, an African American New Yorker who usually paints lyrical abstractions and images based in nature, has over the years occasionally expressed her anger in more political forms. She made this piece for an ''Angry Art'' show in 1982, but it harks back to her ''Little Men Series'' of the '60s, when she ''expressionistically depicted some contradictions in men as power symbols.'' The collage ''was inspired by a visit I made with my mother to her bank. She was treated like a very dull child by a young bank officer and was subjected to ageism and racism while trying to conduct her financial affairs. I was incensed and, despite my mother's pride, had to intervene'' (letter to the author, 1990).

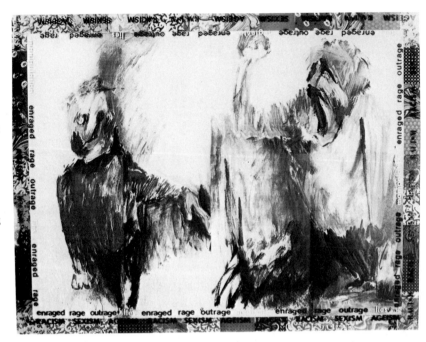

▼▼▼▼▼▼▼

Black, black, get back
If you're brown, stick around
If you're white, it's all right.
—Jump-rope rhyme (New York City)

People keep asking where I come from
says my son
Trouble is I'm American on the inside
 and oriental on the outside

No Doug
Turn that outside in
THIS is what American looks like.
—Mitsuye Yamada, *Camp Notes and Other Poems* (1976)

▼▼▼▼▼▼▼

We have reached a point where to name things is to denounce them: but, to whom and for whom? . . . *We are what we do, especially what we do to change what we are:* our identity resides in action and struggle. Therefore, the revelation of what we are implies the denunciation of those who stop us from being what we can become. In defining ourselves our point of departure is challenge, and struggle against obstacles.
—Eduardo Galeano, in *The Graywolf Annual Five: Multicultural Literacy,* edited by Rick Simonson and Scott Walker (pp. 119, 121)

reflected in the arts by autobiography and statements of racial pride. The second is the supposedly neutral label imposed from outside, which may include implicitly negative stereotyping and is often inseparable from the third— explicit racist namecalling.

Cultural pride is a precious commodity when it has survived generations of social undermining. Yet it also opens rifts no one wants to consider long enough to change. It is easier to think of all Americans moving toward whiteness and the ultimate shelter of the Judeo-Christian umbrella than to acknowledge the true diversity of this society. Too often, self-naming must battle the self-loathing created by the larger society, not to mention suspicion and prejudice between cultural groups.[5] Such internal struggles may be buried deep in a work of art, invisible except when inferred through style and approach. We have been given some insight into these conflicts by the feminist art movement, which in its early days was particularly concerned with the construction and destruction of masks, costumes, "made-up" identities—subjects that engendered the postmodern concern with an analytical autobiographical art a decade later.

I write this at a moment in the late '80s when solidarity and coalition-building among the various ethnic groups is a priority. As cross-cultural activity becomes a reality within ethnic categories that appear homogenized only from the outside, it is occurring in both the political *and* the esthetic realms. The project of understanding the intercultural process is perhaps evenly divided between understanding differences and samenesses. Every ethnic group insists, usually to deaf ears, on the diversity within their own ethnicity, stressing the

impossibility of any one individual or group speaking for all the others.

We have not yet developed a theory of multiplicity that is neither assimilative nor separative—one that is, above all, relational. In the '70s cultural identity in "high art" was largely suffocated in the downy pillow of a "pluralism" in which the SoHo galleries resembled network television—lots of channels, all showing more or less the same thing and controlled by the same people. The intercultural enterprise is riddled with sociological complexities that must be dealt with before esthetic issues are even broached. There are classes and cultures within cultures, not to mention the infinite individual diversities that disprove both external stereotypes and group self-naming alike. At the same time, the alienation that rides on individualism in this country is unenviable, and an individual "identity" forged without relation to anyone or anything else hardly deserves the name. I have to agree with Elaine Kim when she insists, "Without the reconciliation of the self to the community, we cannot

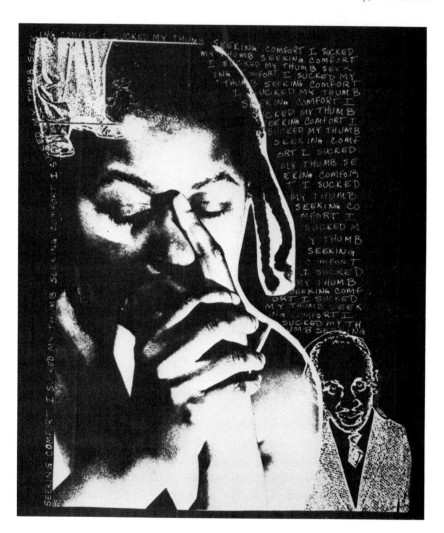

Fig. 3: Clarissa Sligh, *Seeking Comfort, I Sucked My Thumb*, 1989, cyanotype, 30" x 23". Sligh is an African American narrative photographer who also makes artist's books. Her subject is usually childhood, home, family, memory, and sexism—her own disturbing early years when she was abused by a relative and was also the lead plaintiff in a high school desegregation case in Virginia in 1955. (Her first solo show in 1984 was ironically titled "The Pleasures of Childhood.") Sligh's work always includes words, usually written on and around family photographs, as an attempt to correct what is written about black people as "criminals and on welfare." In childhood she was keeper of the family albums; as an adult she "reframes" them. Her images are a curious mixture of comforting familiarity and uneasiness. She recommends to her students a process that clearly resembles her own: "To go back and try to be who they were when they were growing up, and to look at the construction of a family album and all the things that are not shown and not said. It gives them an opportunity to gain some clarity about their lives, to think about what they want to do, or to grieve for a loss they have been unable to acknowledge. . . . Whenever you make a statement that challenges the boundaries of the private versus the public, it becomes political," she says. "The act of speaking out when I am scared is the greater political act" (interview with Laura U. Marks, *Afterimage*, December 1989). Recently Sligh began to reenact events of which she has no conscious memory. *Seeking Comfort* is part of a "birth reenactment series." Sligh writes: "My stomach sinks. I suck my thumb. The act is a symbol of the experience. . . . What does it have to do with my current investigation into relationships between women and men? . . . It is the climactic moment in the life drama"— simultaneously a marriage, a birth, and a death.

Fig. 4: Edna Jackson (Tlingit), *Kaaswoot*, 1982, handmade cast cedar paper, prisma-color pencil on a black silk, beaded box, 14½″ x 8½″ x 2″. Kaaswoot is Jackson's Indian name, so this is a self-portrait, reflecting her dual heritage. "My father was a Tlingit native from Southeast Alaska and my mother was [from] Dutch/German/Jewish (and I don't know what-all) farm people in the Midwest." The mouths on both figures are veiled because Jackson feels she is "better at communicating with my hands and what they make, rather than with my mouth and words." Before this piece, her cast-paper pieces were attempts at duplicating the old carved wooden masks from the Northwest cultures. "This piece was a 'break-through' in that I let the cedar paper's inherent qualities show me what to do, rather than trying to make it look like something else." Now she makes portraits of her Alaska community or works from local legends, often intertwining the eagle and the raven (her own and her husband's clans and the symbol for their village, Kake). She paints, stitches, collages, and draws on her masks: "My artworks could be compared to our traditional totem poles in that they exist to record stories or events in our lives." Cedar bark is a traditional material used for many different functions in the Northwest. Jackson gathers hers in the springtime in the same forests her grandmother used, splits and cooks it to break it down into pulp, and then makes her paper. (Quotations from letter to the author, 1989.)

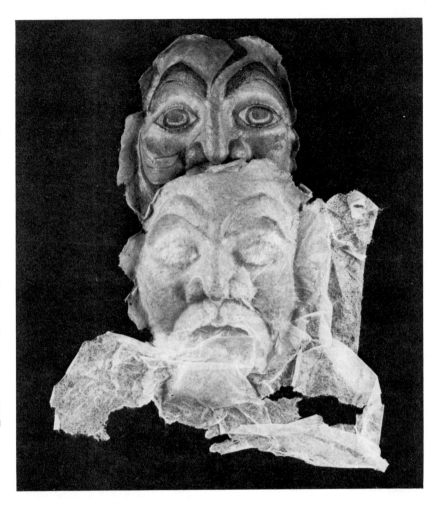

▼▼▼▼▼▼▼
The storyteller Pohd-lohk gave me the name Tasnai-talee. He believed that a man's life proceeds from his name, in the way that a river proceeds from its source.
—N. Scott Momaday, *The Names* (n.p.)

I protect my Klallam tribe and the Coast/Salish path because my good name is a measure of its language and its arts. Ever since my great-aunt gave me her father's Indian name, "Niatum," in the spring

invent ourselves."[6] Art speaks for itself only when the artist is able to speak for her or himself, but the support of a sensed or concrete community is not easy to come by. Much of the art reproduced in this book exposes the vulnerable point where an inner vision of self collides with stereotypes and other socially constructed representations.

In order to confirm identity in the face of ignorance or bigotry, a name may have to be changed, or even *be changing*. In some cultures a person has a secret name, a nickname, a public name, and/or a name given or earned later in life or on coming of age. In the United States, Native Americans may have an Anglo name and an Indian name in addition to their own inherited and given names; the Indian name may be translated into English and acquired in different ways, according to different tribes and different individual experiences. A name may be received in a vision, conferred by an elder, or taken from an ancestor. (Vine Deloria, Jr., has pointed out that there is nothing "personal" about a name like George Washington, which primarily refers to

a genetic line.)[7] Latino and Asian immigrants may anglicize their given names as a gesture toward their new identities as North Americans; African Americans may rename themselves not into but out of the dominant culture by taking a new African or Islamic name, attempting to bypass the history of slavery, just as some women, by renaming themselves after places or within a female line, have attempted to bypass the history of the patriarchy.

On the bloodless battlefield of culture, optimists envision the Americas harboring many languages, many images, as changing demographics make the abolition of Eurocentrism necessary to everyone's survival. Because words and images form the walls within which we dream, major skirmishes are taking place in the educational institutions where artists, like everyone else, are taught who they are. Charges that the standard university requirements are biased against non-Western cultures have led to bitterly contested course revisions at several large North American institutions. The academic conflict has been bitter and at times absurd. Chants of "Hey hey! Ho ho! Western culture's got to go!" have been met by warnings about the dangers of "'60s populism" and the decline of traditional values. According to William King, president of the Black Student Union at Stanford University in 1988, the Western Civilization course is "the one requirement that really says to us, we're different. We want a sense that America, where we are now, is not just the progress that came from England and France, that it wasn't only Thomas Jefferson and the Founding Fathers." The other side is represented by novelist Saul Bellow, a member of the right-wing organization U.S. English, who said disdainfully that he did not know (and by implication did not care to know) "the Tolstoy of the Zulus, the Proust of the Papuans."[8]

The goal of the new, more globally inclusive curricula being forged amid heated debate is the perception of Western civilization as one of many worth studying in a multicultural nation, where white students will be encouraged to see themselves as simply another Other. Things move more slowly in the art field. Prehistoric art and rapid overviews of thousands of years of Asian, African, and Pre-Columbian art are now included in some introductory art history courses, though as far as I know, museums and graduate schools rarely offer any programs that acknowledge the immensity of the Third World's contribution to Western culture or treat the many civilizations as equals. When the subject is raised, it tends to take a romantic and paternalistic tone. As white artist Susan Hiller said of the 1977 exhibition "Sacred Circles: 2,000 Years of North American Indian Art": "It would have been educational, as well as providing badly needed 'context,' if the exhibition had attempted to make us aware of the interactions between the objects displayed and our own history; but instead, there has been an effort to empathize with the Native American world view."[9]

What the canon is to education, the museum is to the visual arts. The widespread relegation of indigenous arts to ethnographic museums (equating the art of people of color with "natural history") parallels Cambridge Uni-

of 1971, I have published under that name. And in 1973 I went through the courts and made it legally my last name. Because I feel this as a sacred trust, I have reason to suspect that if I live long enough, this name will turn out to be what ultimately changed my character and life.
—Duane Niatum, in *I Tell You Now*, edited by Brian Swann and Arnold Krupat (p. 129)

Some tribal names are given as nicknames, some are borrowed and dreamed, and some are stolen, but descriptive names in translation are too far from sacred to hold power. Traditional skins, or tribal people, seldom revealed their secrets or told their sacred dream names to white missionaries for translation. Now, we live in new worlds and new words, assuming animal and bird names to be different from white people, which is superficial and political, not a vision, and to suit the tribal image as a public invention.

When some of us mixedblood skins took on bird and animal names in middle school on the reservation, two generations after nicknames and tribal sacred names were forbidden, the white teachers made us write all three names—the first, the descriptive, and the last name—a hundred times. Those teachers must have thought that tribal names were diseases. In college when we were expected to be walking and talking puppets from the traditional tribal past, we dropped our first and last names and became known in the white academic world by our descriptive names. We pretended that these names were sacred names in translation.

So, here we are now, translated and invented skins, separated and severed like dandelions from the sacred and caught alive in words in the cities. We are aliens in our own traditions; the white man has settled with his estranged words right in the middle of our sacred past.
—Gerald Vizenor (Anishinabe), *Earthdivers* (pp. 106–7)

Fig. 5: Jane Ash Poitras (Cree), *Family Blackboard*, 1989, mixed media collage, 23″ x 23″. Poitras was raised in Edmonton in a foster home after her mother died when she was six. After receiving a degree in microbiology, she found her mother's death certificate and began to search out her past, which led her to an MFA in art. Her "Indian Blackboard" series deals with Native education. Here she includes a page from a Cree dictionary defining the word "orphan." She uses traditional Cree iconography along with Egyptian hieroglyphs, Chinese characters, torn phonebook pages, airplane tickets explaining passengers' rights, invalid credit card numbers, and an altered Canadian dollar bill in which Queen Elizabeth wears a feather.

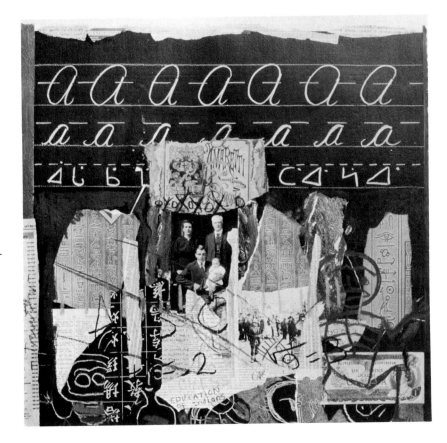

▼▼▼▼▼▼▼

Like Orpheus, who by looking at her, killed the woman he loved, western culture seems doomed to destroy any other form of expression by the mere fact of taking esthetic notice of it. . . . The transition from the former stage of outright destruction to one of pillage and then of anthropological and esthetic interest has the advantage of saving and preserving the objects concerned. But while cultural colonization has taken to milder methods, the end result is much the same. The method is now one of ingestion, assimilation, and homogenization. Having passed through this digestive process, the object ends up in a museum, that insatiable maw into which goes everything that can be described as art.
—Michel Thévoz, *Art Brut* (p. 14)

versity's relegation, as recently as the '70s, of Wole Soyinka's African literature lectures to the department of anthropology. Even now that much Third World art has arrived at the art museums, the "they-got-rhythm" approach to "ethnic" and "primitive" art as entertainment and spectacle, presented either formally or didactically, still dominates museum display. These "canons" are being questioned by some "new anthropologists." Their assumptions are in turn being questioned by Native peoples themselves, newly welcome in some rare institutional settings.[10]

The most pervasive and arguably most insidious term artists of color must challenge is "primitivism." It has been used historically to separate the supposedly sophisticated civilized "high" art of the West from the equally sophisticated civilized art it has pillaged from other cultures. The term locates the latter in the past—usually the distant past—and in an early stage of "development," implying simplicity on the positive side and crudity or barbarism on the negative. As James Clifford has written, the notion of the primitive in Western culture is "an incoherent cluster of qualities that at different times have been used to construct a source, origin, or alter ego confirming some new 'discovery' within the territory of the Western self," assuming "a primitive world in need of preservation, redemption and representation."[11]

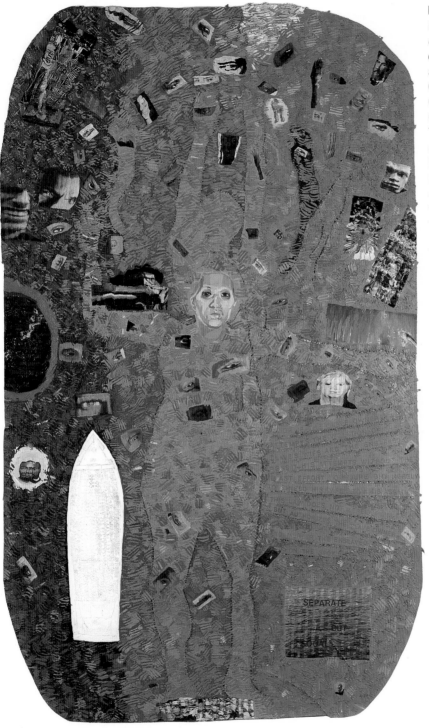

Plate 1: Howardena Pindell, *Autobiography: Water/Ancestors, Middle Passage/Family Ghosts*, 1988, acrylic, tempera, cattle markers, oil stick, paper, polymer photo-transfer, and vinyl type on sewn canvas, 118″ × 71″. Collection Wadsworth Atheneum, Hartford, Connecticut, Ella Gallup Sumner and Mary Catlin Sumner Collection. (Photo: James Dee.) This water image from the ''Autobiography'' series centers on a sewn insertion of the artist's body template, with a whitened self-portrait indirectly influenced by Michael Jackson's ''Thriller'' makeup. It includes the blank white shape of a slave ship and references to Pindell's own African ancestors and to the abuse of slave women in the United States. There are also allusions to twins (significant in African folklore), because of the frequency of twins on both sides of the artist's family, and perhaps as a metaphor for biculturalism.

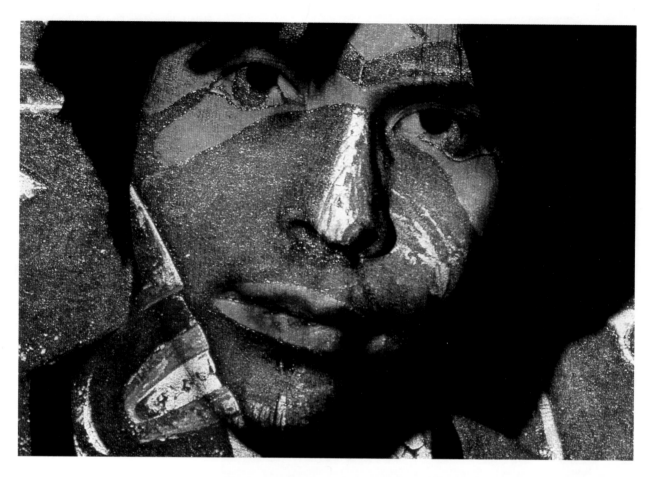

Plate 2: Jesse Cooday, *Self Portrait*, 1984, color photograph, 11" × 14". Cooday is a Tlingit, born and raised in Alaska, who now lives in New York. In this series, he overlays on living faces, often his own, the patterns of traditional masks. "Art is a way of transcending cultural boundaries," he says. "The Pacific Northwest Mask Series" are montages; a black and white self-portrait is overlaid with the color mask photograph in the dark room. The influences are European, Native American, and contemporary art. "It's always a challenge," says Cooday, "to take personal concepts to another level, beyond labels." (*The Fourth Biennial Native American Fine Arts Invitational*, Heard Museum, Phoenix, 1989.)

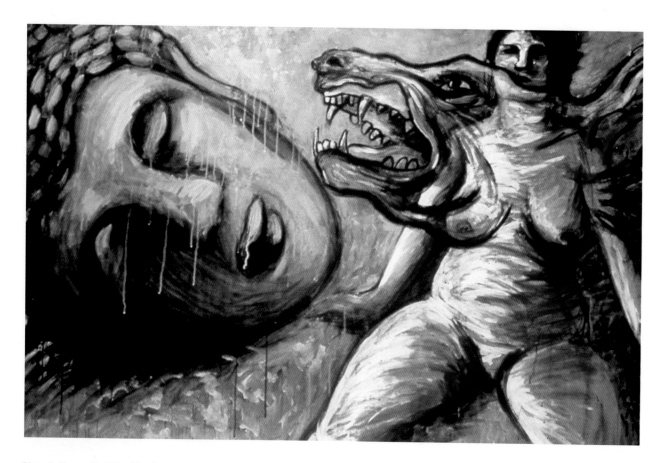

Plate 3: Margo Machida, *The Buddha's Asleep*, 1985, acrylic on canvas, 50″ × 78″. This is one of Machida's autobiographical series of self-images based on posed Polaroid photographs. The subject, she says, "is my sense of divided identity, torn between a desire to find centeredness and repose in a distant, idealized Asian heritage (Buddha) and the pained, angry and defensive present reality (the snarling dog). The dog is a recurrent image in my paintings as a guardian figure and alter ego, representing strength, survival, and aggression. The Buddha's head, severed from its body, is a cultural artifact incapable of offering any help. The nude image of my upper body is vulnerable and literally unable to move (cut off at the legs), caught between these conflicting desires" (letter to the author, November 19, 1989).

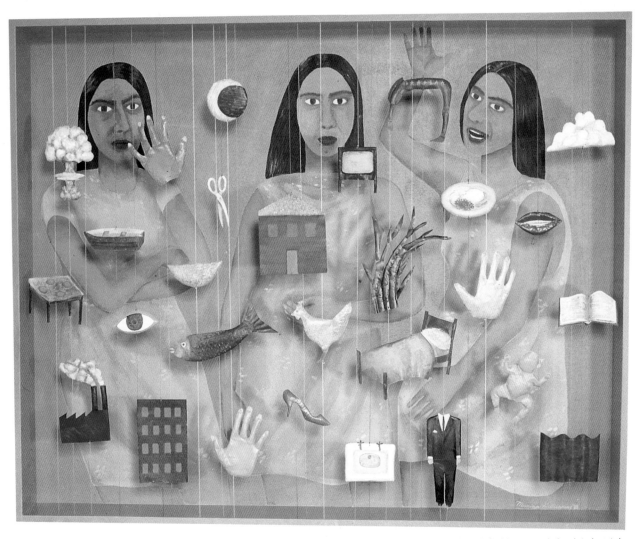

Plate 4: Marina Gutiérrez, *Biography*, 1988, acrylic on Masonite with suspended painted metal reliefs, 48″ × 60″ × 6″. Gutiérrez is a NuYorican artist whose works are inspired by Puerto Rican folk arts. She plays with scale, usually to symbolize power relations. She often fragments body parts and uses small cut-out images, which are hung delicately before larger forms, reminiscent of the *milagros* in Latin Catholicism. This triple self-portrait is a coded rebus. The subject might be creation of and by the self, with another self as mediator. Two of the Marinas stare directly at the viewer, regal and confrontational, while the third, hand raised in incantation, seems to invoke the promised miracles, to put the pieces together. The added shapes, each of which has a private meaning for the artist, include a blue eye (a reference to Toni Morrison's book *The Bluest Eye*), which stands for racism, and a business suit—"the embodiment of evil, the real Evil Empire." "I think of myself as being very literal," says Gutiérrez. "My subjects are those of the world which move me . . . life versus death, oppression and hope, political struggle, stories of the simple beauty of life, of earth and humanity. There is always a story, a narrative to be read in the placement and interaction" (quotations from unpublished 1984 statement and unpublished 1989 interview with Moira Roth).

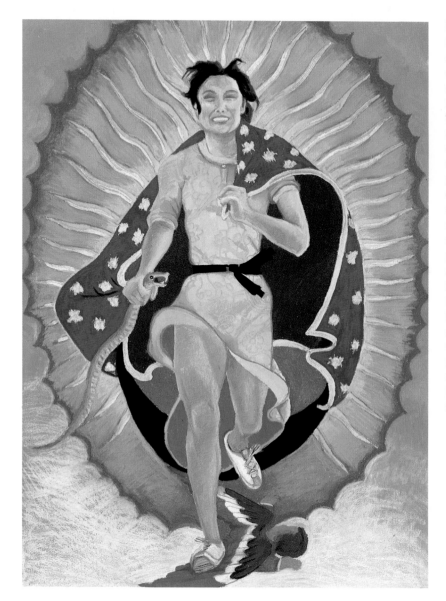

Plate 5: Yolanda López, *The Guadalupe Triptych: Victoria F. Franco, Our Lady of Guadalupe; Margaret F. Stewart, Our Lady of Guadalupe; Portrait of the Artist as the Virgin of Guadalupe*, 1978, (detail) oil pastel on paper, 30" x 24". A triptych of portraits show the artist, her mother, and her grandmother as the Virgin of Guadalupe with the great cloak of stars and the sun-ray body halo that are her attributes. Each figure is accompanied by a snake, which stands for knowledge, wisdom, respect, and sex. (These casual deployments of the Freudian phallus make a double point; the snake also represents consciousness and regeneration.) López's grandmother, who is an Indian ("an Aztec," as she puts it) is skinning the snake, knife in hand: "It's under control, and she has survived the Garden of Eden with serenity and dignity." López's mother is shown as a seamstress, "a valentine to working women," using the domesticated snake as a pincushion. In her own portrait, the youthful Guadalupe, in running shoes, comes bounding out of the frame like Superwoman, and the snake has become an accomplice.

Plate 6: Carlos Villa, *Third Coat*, 1982, outside: feathers and acrylic on canvas, 80″ × 52″. Villa is a Pinoy (Filipino) painter from San Francisco well known for his color abstractions, some of which, like his occasional ritual performance works, were inspired by religion and traditional cultures. In the last few years he has concentrated increasingly on his bicultural background and his strong ties to the Filipino American community he was raised in; he has also organized a number of "multicultural events." Villa made his first cloak in 1969. "I used a lot of materials," he recalls, "that were at the time identified as 'ethnic' or 'fetish.'" Painted on canvas with feathers and lined with painted satin, the cloaks (and then coats) were inspired by Matisse's vestments for the Vence chapel and by Hawaiian feather cloaks. Villa learned that Plains Indian shamans had buffalo robes with histories painted inside of them. Thus the lining of one coat has a sewn pouch with hair, teeth, spit, sperm, and blood in it, and this one has bone dolls sewn inside. The taffeta lining rustles when worn; feather quills outline the shape of his body, suggesting a personal sense of release. Villa always has the cloaks and coats fabricated (in this case by Beverly Berrish) and then does the painting and ornamentation himself. "I liked the idea that someone could wear a painting, the idea of transformation. But although these pieces were my size, I hardly wore them. Hung on walls or from ceilings, they were mostly *reminders* that ceremonies can't exist any more in the same way that old traditions existed before" (letter to the author, 1989).

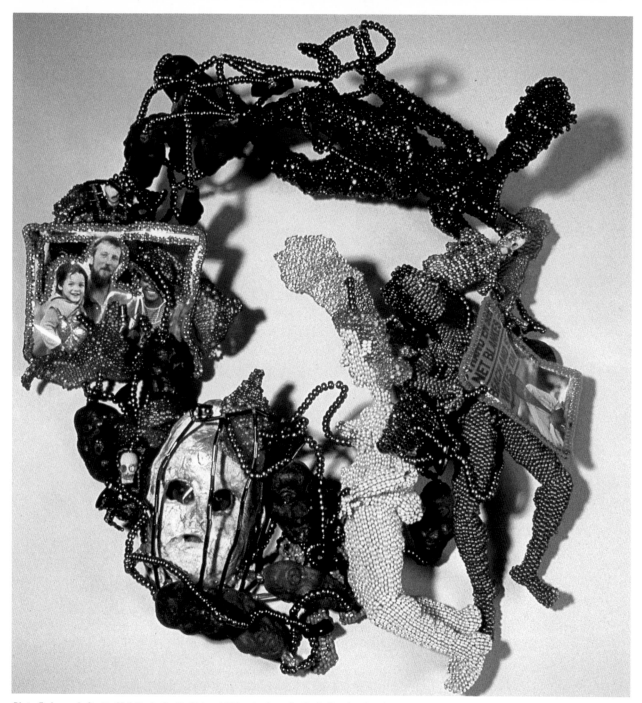

Plate 7: Joyce J. Scott, *Mulatto in South Africa*, 1986, mixed media (including beads, photographs, doll heads), 12″ × 12″ × 12″. As though out to prove that there is no boundary between art and craft, Scott has made a chaotically rhythmic "necklace" that incorporates one of the great international issues—race in South Africa. Black, white, and in-between figures and faces are entangled in the net that is apartheid, identified by the sign "Net Blankes" (Whites Only). An almost white face behind beaded bars is accompanied by a tiny skull; a mixed family portrait is partly hidden, as it must be in a racist society.

Plate 8: Helen Oji, *Mt. St. Helens*, 1980, 60″ × 72″, acrylic, Rhoplex, glitter on paper. Collection Home Insurance Co., New York. (Photo: Alan Kikuchi.) Oji grew up in California, aware that her parents had been interned during World War II. She gained attention in New York for her striking series of kimono-shaped paintings, which relate to the *mon*—the Japanese family crest—and thus to "discretion and propriety." One kimono painting was invaded by the image of Mount Saint Helens and it then exploded into a whole series, symbolizing, perhaps, both sides of the Pacific and the eruption of female power. (One is titled *A Woman at Her Volcano*.) Next came a related series called "Spirit Lake" in which a steaming red-earth volcano with a shell-like crater rises against an orange and yellow sky in a simmering landscape that appears both primeval and dangerous, the beginning or the end of the world.

I should not even have to touch upon this anthropological problem in a book devoted to the contemporary art of my peers, but the Western concept of primitivism denigrates traditions with which many contemporary artists identify and fortify themselves. The term "primitive" is also used to separate by class, as in "minor," "low," "folk," or "amateur" art—distinguished from the "fine," "high," or "professional" art that may in fact be imitating it. There is an inference that such work is "crude" or "uncooked," the product of "outsiders."[12] "Primitives" are those who "naively" disregard the dictates of the market and make art for the pure joy of doing so. In fact, much "primitive" art is either religious or political, whether it is from Africa or from today's rural or urban ghettos. It is not always the quaint and harmless genre, the ideological captive, pictured in the artworld.

And yet, as Jerome Rothenberg has pointed out, "primitive means complex."[13] The West has historically turned to the Third World for transfusions of energy and belief. In less than a century, the avant-garde has run through some five centuries of Western art history and millennia of other cultures with such a strip-mining approach that it has begun to look as though there were no "new" veins to tap. Where the Cubists appropriated the *forms* of traditional cultures and the Surrealists used their dreamlike *images* to fantasize from, many artists in the '70s became educated about and fascinated with the *meanings* of unfamiliar religions and cultures. The very existence of the international mini-movement called "primitivism" constituted an admission that Western modernism once again needed "new blood." In the '80s the overt rampage through other cultures was replaced by postmodernist "appropriation" (reemploying and rearranging borrowed or stolen "readymade" images from art and media sources)—a strategy warmed over from '60s Conceptual Art and often provocatively retheorized. Some of this work is intended to expose as well as to revise the social mechanisms of image cannibalism. The "appropriation" of anything from anywhere is condoned as a "critical" strategy. Yet as Lowery Stokes Sims has pointed out, such "visual plagiarism" has its limits, especially when it reaches out into other cultures "in which this intellectual preciosity has no frame of reference. . . . Appropriation may be, when all is said and done, voyeurism at its most blatant."[14]

There are more constructive ways of seeing the "primitive." Cuban art critic Gerardo Mosquera has pointed out that "for Latin Americans, the 'primitive' is as much *ours* as the 'contemporary,' since *our* 'primitivism' . . . is not archeological material, but an active presence capable of contributing to *our* contemporary world."[15] Judith McWillie, a white scholar of black Atlantic art, has pointed out that the art of self-educated black artists closely paralleled the works of early modernists; that

even before Derain, Matisse, and Picasso began to unfix the classical boundaries of Western imagination and form, blacks in the Americas were synthesizing African, European, and Native American idioms to create non-objective as-

Fig. 6: Daniel Rosenberg, *Hopi Woman in Museum*, 1986, silver print taken in the Field Museum of Natural History, Chicago, 9½" x 9½". Collection Civia and Irwin Rosenberg, Boston. Rosenberg, a young white photographer who died at twenty-three, before he could further develop his interesting work, was making a study of culture and display. He wrote: "My museum pictures never have live people in them. This is significant in that the constructs of a society are shown without relation to the members of society." This Hopi mannequin, backed by a shadowy group of *tablitas*, decontextualized into alien surroundings, looks as though she were reluctantly posing for a picture by an intruding tourist or anthropologist. As Tom Drysdale has written, "There is an unsettling mystery in these photographs of institutional representations of historical or biological 'facts.' . . . Rosenberg reveals the irony implicit in even the most earnest attempt to recreate nature or history." (Quotations from unpublished statements.)

▼▼▼▼▼▼▼▼

Something strange is going on here. Why is "ethnic" art in major institutions portrayed only as ancient relics of past civilizations? Why do I (an Asian-American artist) feel as though I am intruding in some rich man's trophy room when I tiptoe through the cool, dark labyrinth of the Asian Art Museum? How is it possible that I feel out of place among the well-crafted artifacts of my ancestors? Why does the museum make me feel even more cut off from my cultural heritage than when I stroll through the Modern?
—Paul Kagawa, in *Other Sources*, edited by Carlos Villa (p. 13)

semblages and narrative improvisations that prefigured the aesthetic revolutions to come; and that African consciousness, in spite of history's most profound shocks and disassociations, is able to sustain itself independently, flavoring and transforming, without exception, every culture that comes into contact with it.[16]

African American writer Michele Wallace identifies another contemporary response as "a process of imitation and critical reversal":

For instance, my mother, Faith Ringgold, saw in Picasso a place where she, as a black artist produced by the West, could think about her African heritage. I mean you could sort of run it backward: black artists looking at white Europeans appropriating African artifacts for modernism and Cubism. If you came as, say, a black person in the '50s studying art, the way to translate the tradition that exists in African sculpture was to look at a painter who had already traveled that route of appropriation, and then reinterpret his appropriation.[17]

When other cultures appropriate from Western modernism they are called derivative. When new information is brought into the isolated art world through new images and interests, its welcome is qualified. The dominant culture prefers to make over its sources into its own image, filtering them through the sieve of recent local art history, seeing only that which is familiar or currently marketable and rejecting that which cannot be squeezed into "our" framework. Art from ethnic groups is still seen as though it were made for export to the "real" U.S.A. It wasn't until the mid-'80s that exhibitions organized *by subjects* rather than *of objects* began to attract attention.

Ironically, and sadly, access to information about global art is more available to the educated and well-traveled Western artist than to most of the heirs of those dehistoricized cultures. This constitutes a dilemma for the nonwhite or non-Western artist whose work may even be called derivative just because its authentic sources have already been skimmed off by white artists. The artworld's assumption of its centrality, and its massive absorption of Native imagery through "neo-primitivist" art, made Flathead/Shoshone painter Jaune Quick-To-See Smith

feel sad, because it's material we could be using. White artists can be "objective" about it, where Indians are "subjective" and not exactly sure how to draw on their backgrounds, because they are so much closer. When Native Americans refer to Indian art, it is automatically assumed to be "traditional" by white critics, even when it transcends tradition and is mixed with Euro-American styles.[18]

There are two sides to the boundary-crossing between the Third and First Worlds: the one-way trip in which TV, Donald Duck, Coca-Cola, Nestlé's baby formula, pesticides, and drugs outlawed in the United States replace

traditional products and customs, contributing to the complex and not necessarily negative "creolization" of the Third World; and the return trip where remnants of ancient customs are abducted and carried triumphantly home to the West, to rest in splendor in elaborate museum installations—or to be buried in museum basements inaccessible to the public.[19] (This too is not as simple as I'm making it sound here; these objects, however deracinated, do constitute the base for cultural identifications that might otherwise have no material focus.) An enlightened attitude on the part of the West would convey a heightened awareness of the *contemporary* arts being made within those cultures whose pasts now appear to be common property, an acceptance not only of a culture's artifacts, but of its living creators as well.

In the United States, Native America is the place to start learning these lessons. The loss of the original communal name as well as individual names inevitably threatens the loss of culture and identity itself. (Most original names for Native peoples mean "the people," or "ourselves": the Navajo are Dineh; the Cheyenne, as artist Edgar Heap of Birds often points out in his work, are Tsistsista; the Salish are Sle'ligu, "We the Human Beings.") Modernist Indian artists are often caught between cultures, attacked by their own traditionalists for not being Indian enough and attacked by the white mainstream for being "derivative," as though white artists hadn't helped themselves to things Indian for centuries and as though Indians did not live (for better and worse) in the dominant culture along with the rest of us. Seneca artist Peter Jemison has demanded: "What about all of the white people who have taken things from Indians and reflected off us as though they were their own ideas, i.e. Jackson Pollock, Max Ernst. . . . You know, it's ok for Picasso to take African masks, so it's ok for us too."[20]

A classic example of one-sided "universalism" was the Museum of Modern Art's controversial 1984 exhibition " 'Primitivism' in Twentieth-Century Art: Affinity of the Tribal and the Modern." Curator William Rubin, hiding behind quotation marks, declared that the term "primitivism" is simply part of modern art, owned by those who name its components, and was not meant to reflect on the original cultures from which the West borrows. His exhibition included no current art by "high artists" from Africa, Melanesia, or Native America, who were presumably not "primitive" enough. A single African American modernist—Martin Puryear—appeared in the contemporary section. Romare Bearden, the dean of African American modernists and then at the height of his career, was in the show but excluded from the "contemporary" section. (There were no Latinos or Asians represented at all, since Pre-Columbian art was designated "court" rather than "tribal" art and omitted entirely, as was Asian art.) But with classic ethnocentrism, the curators did include in another section such utter irrelevancies as a Kenneth Noland target painting of 1961, absurdly juxtaposed against a New Guinea sculpture that incidentally bears concentric circles. Cross-cultural or "transitional" objects bearing witness to the effects (often powerfully integrated) of "contact" with the invaders were

▼▼▼▼▼▼▼▼

One day Polingaysi came home [from school] with a cardboard hung around her neck on a string. Lettered on it was her new name: Bessie. Her sister Duvangyamsi's new name was Anna. The change of name was merely one more evidence to the girls' mother and grandmothers that the white man was unfeeling.

"You had your beginning as a true Hopi," Polingaysi's mother told her, fingering the cardboard. "You were named in the Hopi way. Your true name is Polingaysi. That will always be your true name."

"I took you, newly born," Polingaysi's paternal grandmother chimed in. "I held your warm body against my bared legs. I presented you with your first Mother Corn. I pierced your little ears. For twenty days I cared for you, observing the traditional manner of caring for a newborn child. Your true home is the house in which you were born. Your navel cord was tied to a stirring stick and thrust into the wattled ceiling of that room where you emerged from the darkness of your mother's womb into the warm dark of your first outer home. That is where your roots are. Your beginning. It was I who named you Polingaysi. It is a beautiful name. It fits you well. You are a daughter of the Kachinas, as any Hopi will know by your name. This silly name the white man has given you means nothing."

Solemn in the face of this passionate outburst, Polingaysi looked fondly into the grandmother's wrinkled face. "I am Polingaysi," she declared. "I will always be Polingaysi. But when the *Bahana* calls me Bessie, I will pretend I have forgotten my own name."
—Polingaysi Qoyawayma (Elizabeth Q. White), *No Turning Back* (pp. 28–29)

Fig. 7: Peter Jemison (Seneca),
Aotearoa / Ganondagan, 1986, color pencil and
grease crayon on paper bag, 8¼″ × 16″ × 5″.
(Photo: courtesy S. Gambaro, private collection.)
Jemison grew up on the Cattaraugus Reser-
vation and studied in Buffalo and Siena,
Italy, directed the American Indian Community
House Gallery in New York and is now the
site manager of a seventeenth-century Seneca
town at Ganondagan, near Victor, N.Y. Influ-
enced by Seneca beaded bags, Lakota par-
fleches, Cree birchbark containers, and
Mimbres pottery, Jemison chose the paper bag
as the contemporary counterpart, celebrating
its ordinariness with strong pastel drawings
that often reflect on the abuse of the envi-
ronment in Third World countries. In 1984 he
met a group of Maoris who came to New York
for their exhibition at the Metropolitan Mu-
seum, and he was invited to New Zealand to
speak to the Maori Society of Artists and Writers.
He traveled on a Haudenosaunee (Iroquois)
passport, reaffirming Native sovereignty. This
bag commemorates the visit by a self-portrait
paired with a traditional Maori mask and
scenes of New Zealand and Ganondagan.

almost entirely absent from the Museum of Modern Art's show; they were
considered "impure." Jaune Quick-To-See Smith adamantly denies the notion,
found in parts of the Indian community as well, that Native peoples who
incorporate modernism into their art become, in the process, "inauthentic."
She says they are simply acknowledging the reality that they live in two cultures:
"Dying cultures do not make art. Cultures that do not change with the times
will die."[21]

The very different exhibition "Magiciens de la terre," an extravaganza of
current "global" art held at the Centre Pompidou in Paris in 1989, displayed
its biases from another angle. Although focused on the present, and on one
level far less elitist and arrogantly ethnocentric than the MoMA show, it
featured shamans, popular artists, sign painters, ritual ground painters, and
what-have-you from all over the Third World, while all but one of the U.S.
participants were white. Of the one hundred artists in the show, only ten were
women and only five of them came from the Third World.[22] No credit what-
soever was given to a preceding global exhibition, the Second Bienal of Habana
in 1986—a motley, yet amazing conglomeration of art from the Third World
chosen not by the Cubans, but by people from the countries where it was
made.[23] The French curators, sometimes accompanied by Western artists, made
"field trips" all over the Third World, but seem to have visited only the "high
art" centers of the West.

One of the functions of "Magiciens de la terre" was to "extract" or "bring
out" Third World art and artists from the mostly non-art contexts they inhabit.
The act of decontexualization transformed them into exotica, as Pakistani/
British artist Rasheed Araeen has pointed out, raising broader political
questions:

> If the relationship between the "center" and the "periphery" is one of in-
> equality, is it possible for an equal exchange to take place within a framework
> which does not challenge this relationship? [Marginality in these postcolonial
> conditions] has little to do with the nature of their cultures but with the
> extremity of their exploitation and derivation resulting from Western impe-
> rialism. . . . If other peoples are now aspiring to [the West's] material achieve-
> ments and want to claim their own share, why are they constantly reminded
> of its harmful effects on their own traditional cultures? If aspiration to mod-
> ernity and modernism is detrimental to the creativity of other cultures, why
> is this concern confined only to the production of art? . . . Modernism for the
> "other" remains a basic issue. . . . But it seems that the Emperor does not
> want to be reminded of his nakedness, not when he is actually wearing so
> many colorful clothes imported from all over the world.[24]

The Pompidou show drew some perceptive criticism from Western pro-
gressives of the way the work was presented and even of the fact that it was
presented at all. But little attention was paid to (or information given about)
the reasons the non-Western artists chose to participate and how it affected

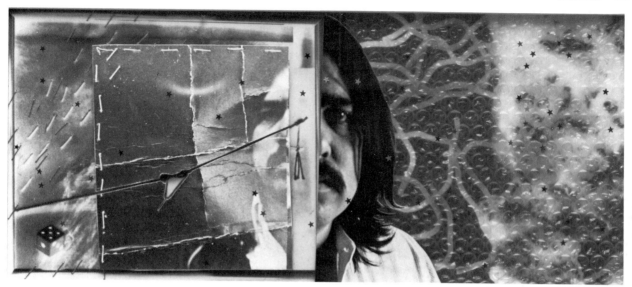

their art. Did the abrupt displacement of rooted images and actions damage their functional effectiveness? Did it fulfill agendas "we" are not aware of? How did it fit, or not fit, into the "strategy of self-concealment"[25] that has been one of Native peoples' best defenses against colonial oppression? Curator Jean-Hubert Martin, refusing to take the blame for exploitation, cited a countermotive: the Australian aboriginal artists, he said, acknowledge "the problem of their decontextualization. . . . But they go on to argue that they commit their 'treason' for a particular purpose: to prove to the white world that their society is still alive and functioning."[26]

A name less obviously irritating than "primitive" for the creations of people of color and "foreign" whites is "ethnic art." Although it was originally coined with good intentions and some internal impetus, it has since been more coldly scrutinized as a form of social control that limits people's creative abilities to their culture's traditional accomplishments; both Left and Right have been accused of harboring this "separate but equal" agenda of "ethnic determinism."[27] There are categories and contexts where "ethnic" artists are supposed to go and stay, such as folk art and agitprop, community arts centers, ghetto galleries and alternative spaces. The Los Angeles artist Gronk, whose zany expressionist paintings and performances fit no Chicano stereotypes, says, "If [well-known white artist] Jon Borofsky makes a wall painting, it's called an installation. If I do one, it's called a mural, because I'm *supposed to be* making murals in an economically deprived neighborhood."[28]

The National Endowment for the Arts has a program called "Expansion Arts," which uses its "community-oriented" mandate to fund art that can't get past the mainstream-oriented panels in other granting categories. (The "Art in Public Places" program also sometimes tries to integrate such projects.)

Fig. 8: Joe Feddersen (Colville/Okanogan), *Self Portrait*, c. 1984, photograph/collage, 9″ × 18″. (Photo: Ken Wagner.) Feddersen was born, raised, and now teaches in the Northwest (at Evergreen State College). His concern has long been the relationship of the human to the environment, or "the delicate balance between self and an external force." Mixing photography and computer graphics, he has often used himself—in the form of a straightforward self-portrait or a mysterious silhouette—as a stand-in for humanity. The environment is also abstracted into ambiguous space. Sometimes the artist's head and shoulders become a mountain form, and sometimes figure and ground merge entirely into a web of patterned color; culture and nature become one. The shell and fragile string, thread, and the dice often appear in these self-portraits, in which the artist's face is halved, like the pictures, as though straddling fantasy and reality, or two worlds.

▼▼▼▼▼▼▼

We Indians have always hidden our identity and kept our secrets to ourselves. That is why we are discriminated against. We often find it hard to talk about ourselves because we know we must hide so much in order to preserve our Indian culture and prevent it being taken away from us. . . . I'm still keeping secret what I think no-one should know. Not even anthropologists or intellectuals, no matter how many books they have, can find out all our secrets.
—Rigoberta Menchú (Quiché Mayan), *I . . . Rigoberta Menchú: An Indian Woman in Guatemala*, edited by Elisabeth Burgos-Debray (London: Verso, 1984, pp. 20, 247)

▼▼▼▼▼▼▼▼

I could tell you how hard it is
to hide right in the midst of
White people. It is an Art
learned early because Life depends
on dissimulation and harmlessness.
To turn into a stone in the midst of snakes
one pays a price . . .
—Jack Forbes (Powhatan/Delaware/Saponi), in *I Tell You Now*, edited by Brian Swann and Arnold Krupat (pp. 120–121)

▼▼▼▼▼▼▼

We say *nosotros los mexicanos* (by *mexicanos* we do not mean citizens of Mexico; we do not mean a national identity, but a racial one). We distinguish between *mexicanos del otro lado* and *mexicanos de este lado*. . . . Being Mexican is a state of soul—not one of mind, not one of citizenship. Neither eagle nor serpent, but both.
—Gloria Anzaldúa, *Borderlands/La Frontera* (p. 62)

In the United Kingdom and Australia, community arts is a respected domain into which "high" artists can cross while still showing their studio art in the artworld. In the United States, however, there are few such "crossovers" and most of them are white. The short-lived rages for graffiti art in the '70s and again in the '80s demonstrated clearly that the time had come for only a handful of black and Latino artists to move—temporarily—from subways and streets into galleries and museums (see chapter 4).

Observing that while "it would be foolish not to recognize the differences between European and non-European cultures," Rasheed Araeen contends that nevertheless:

> it has been the function of Modernism since early in this century to 'eliminate' the importance of these differences in its march toward an equal global society. Why are these differences so important now? Instead of seeing the presence of various cultures within our modern society as our common asset, why are they being used to fulfill the specific needs of specific people? Does this not somehow echo the philosophy of Apartheid?[29]

On the other hand, African American scholar Barbara Christian defends Black Studies and Women's Studies departments against attacks as "separatist ghettos" precisely because they provide a realm within which to work out these contradictions:

> It is in this context that many others of us are discovering the extent of our complexity, the interrelationships of different areas of knowledge in relation to a distinctly Afro-American or female experience. Rather than having to view our world as if we were hybrids, we can pursue ourselves as subjects.[30]

At the very least the "ethnic arts" have often provided a base for self-naming among artists who prefer not to leave their own communities or have, for ideological reasons, turned their backs on the "centers." At their best ethnic arts programs and "specialized" museums like San Francisco's or Chicago's Mexican Museums or New York's Studio Museum in Harlem open channels to new audiences, to an exchange between artists and their communities; they offer parallels to the shelter afforded (mostly) white artists by the national network of "alternative spaces," but with a far lesser degree of economic independence. Yet despite, or because of, their success, they are accused of "ghettoizing" the artists they exhibit. There is, however, no question that culturally targeted funding encourages self-determination and has on occasion provided arenas where truly "multicultural" interaction can take place. The interfaces within even a single racial community may be intricate, providing a linguistic and cultural microcosm of the larger society. African Americans, for instance—involuntary early settlers of the United States and for two centuries more homogeneous than other "minorities"—now find their ranks

swelled with African peoples from Brazil, Colombia, Central America, Cuba, Haiti and other Caribbean islands, who speak Portuguese, French, Spanish, patois, or West Indian English.

For young artists yearning to have their art freed from labels and seen extraculturally (especially those working in abstract modes), contradictions within ethnicity can be baffling on two levels. First, they will encounter people who insist, and may even believe, that color makes no difference, even as artists of color are systematically excluded from galleries and exhibitions. Then they will encounter others, like me, who have sadly observed that within a racist society you will be called on your race no matter how much you try to avoid it, so you might as well stand up and be counted. The question remains whether there is a conflict between recognition of one's full potential as a human being and entrance into the mainstream where that potential may be swept away in the general flow.

Names are not necessarily communally agreed upon. No group is immune to internal conflict as it is buffeted by the complexities of late capitalist gains and losses. For example, in the mid-'80s, noting the surge of the Latino population, the arts establishment (along with hardly altruistic right-wing corporations—usually cigarette and alcohol producers such as Philip Morris and Coors[31]—that support the arts as a classy advertising device) began to tolerate, then approve, then control the organization of exhibitions of "Hispanic Art." This occurred just at the moment when the term Hispanic was giving way in the community to the term Latino, in recognition of the increasing national diversity of "Hispanics" in the United States.

Both Latino and Hispanic—despite the internal delineation between grassroots/progressive and upscale *assimilado*—melt down the vast racial and economic diversity of the U.S. Spanish-speaking population, now around 8.4 percent. Collapsed into one name are the educated (and, significantly, often European-educated) Latin Americans in transit or exile, the campesino and working-class refugees from political and economic repression in Central America and Mexico, sixth-generation Chicanos, undocumented workers, first-generation Dominicans and Puerto Ricans, fourth-generation NuYoricans, mestizos and Afro-Indians of innumerable different origins. In addition, not all Mexican Americans like to be called Chicano, preferring to emphasize their status in an "occupied land" by calling themselves *Mexicano* (from which Chicano was derived to denote biculturalism), while others find Hispanic preferably upscale.

Latino artists' sense of marginality is compounded by North American ignorance of their histories and of the diversity of classes, races, and cultures lumped together as "South America" or "our backyard." (When President Reagan returned from Latin America to announce his discovery of difference— "You'd be surprised. They're all individual countries!"—he was ahead of many North Americans.)[32] Another factor is the obdurate refusal of most North

Fig. 9: Michele Godwin, *Unmasked*, 1986, mixed media, monoprint, 14″ × 7″ (Photo: Sabra Moore.) Godwin is a young African American artist from New York. In this print, which is presumably about assimilation, a stolid, middle-class couple pose for a formal snapshot, the black face of the woman tilted to one side to reveal the white skin beneath. There is an ominous quality to the space they stand in, which reflects their predicament.

▼▼▼▼▼▼▼

[My teachers kept] my attention from straying in class by calling out *Rich-heard*—their English voices slowly prying loose my ties to my other name, its three notes, *Ri-car-do*. . . . I no longer knew what words to use in addressing my parents. The old Spanish words (those tender accents of sound) I had used earlier—*mama* and *papa*—I couldn't use any more. They would have been too painful reminders of how much had changed in my life. . . . Only when I was able to think of myself as an American, no longer an alien in *gringo* society, could I seek the rights and opportunities necessary for full public individuality. The social and political advantage I enjoy as a man result from the day that I came to believe that my name, indeed, is *Rich-heard Road-ree-guess*.
—Richard Rodriguez, *Hunger of Memory* (pp. 21, 30)

▼▼▼▼▼▼▼

The term *Latino* is preferred to *Hispanic* [which] excludes racial and cultural differences. *Latino* (from Latin America) is a more inclusive term accounting for those who come or descend from a specific geographical area where the Spanish and Portuguese legacy is dominant but not exclusive. It recognizes the presence and importance of nonwhite populations and cultures (Amerindian and African) in the group.
—Xavier F. Totti (quoted by Enrique Fernandez, *Village Voice*, June 21, 1988)

Americans, even those living in the Southwest, to learn Spanish. Judging from the priorities of even educated artworld whites, the majority of people in this and most other countries are still incapable of making distinctions other than the simplest physical ones. ("They all look/talk alike.") Along with the North American habit of seeing exclusively through North American eyes, this lack of distinctions exacerbates relations between the United States and the rest of the world. Gabriel García Márquez called attention in his Nobel Prize acceptance speech to the ways Europeans and North Americans insist on interpreting Latin America within the referential frameworks of their own cultures, which renders Latin Americans still more isolated, constricted, and incomprehensible to the rest of the world.

Asian immigrants are even more difficult for the average American to distinguish, since they are not only different nationalities and classes but are further categorized by regions and religions within each nation of origin, and fewer North Americans have set foot, or flag, in their homelands. The name Asian American in itself represents an internal effort to overcome intra-Asian historical barriers. (Koreans and Chinese have good historical reason to forgo identification with the Japanese; some Vietnamese with the Chinese, and so on.) Many Asians no longer like to be called "Orientals" (if they ever did) and the blatant inanity of the equivalent term "Occidentals" should make both obsolete. This outdated polarity splits the world into an East-West axis, ignoring Africa, Oceania, Latin America, and everywhere else in between. The "Orient," as Palestinian American scholar Edward Said has made abundantly clear, is an idea rather than a location.[33]

Current political reality and immigration trends affect the naming process, and new labels for Third World people have evolved since World War II. The formerly dependent "child/barbarian" becomes the independent (out-of-control) communist dupe and political/religious terrorist/fanatic, or an economic threat from two directions: the immigrant intruder who works too hard and the welfare intruder who doesn't work hard enough. Since the Exclusion Acts began in the nineteenth century, anti-Asian prejudice has accumulated: from the shameful internment of Japanese Americans during World War II, the destruction of Hiroshima and Nagasaki, the callous division of Korea, the dehumanization of Japanese (then Koreans and then Vietnamese) as "gooks," the use of Agent Orange on all growing things in Vietnam, to recent trade wars. The atom bomb has been used only in Asia—it would have been inconceivable in Europe—and recently declassified papers show that the U.S. government also considered its use in Korea and in Vietnam, thus giving Asians an undesirable edge as this country's favorite targets of aggressive military racism. At the same time, a gathering storm of resentment stemming from the U.S. loss of the war in Vietnam has led to more recent incidents like the 1982 murder of Chinese American Vincent Chin, who suffered a stereotypically all-American death, beaten to death in Detroit with a Louisville Slugger by Euro-American workers enraged at the success of the Japanese

Fig. 10: **Cristina Emmanuel**, *Madre Dolorosa*, 1985, drawing, photocopy, frottage, cut metal on paper, 45″ × 33″. (Photo: Wolfgang Dietze.) Emmanuel is a Puerto Rican artist living in California, and her work is informed by two poles of Latin culture—*chuchería* (kitsch) and African-Catholic religions. *Madre Dolorosa* is a multicoded composite image of Our Lady of Sorrows and Erzulie, the Daho-mean goddess of love and abundance. It is one of a series of six collages that were shown together as "Altars and Secrets" in San Juan in 1986. Puerto Ricans, says Em-manuel, tend to be secretive about their African-based beliefs ("the more white and middle-class one appears, the less it is men-tioned"), but all over the Caribbean, Erzulie is associated with Ochún, the Yoruba river goddess. There are incarnations as Ochún Yumú (who is old and deaf and makes ce-ramic pots) or Ochún Awé (who is associated with affliction and dirty clothes). "When I use saints, I use them in an archetypal sense," says Emmanuel. "I don't use them as 'Cath-olic' or 'religious' images, but as images of human experience and potential." The Virgin "seemed to be to me so much *more* than the 'official' church teaches. I perceived her to be an expression of the ecstatic experience and mystery of the opening of the heart cen-ter—transformational ecstasy—and I associ-ated her with the experience of being in love (or 'being' love)" (letter to the author, 1990).

▼▼▼▼▼▼▼

The term Hispanic, coined by techno-marketing experts and by the designers of political campaigns, homogenizes our cul-tural diversity (Chicanos, Cubans, and Puerto Ricans become indistinguishable), avoids our indigenous cultural heritage and links us directly with Spain. Worse yet, it possesses connotations of upward mobility and political obedience.
—**Guillermo Gómez-Peña**, in *The Graywolf Annual Five: Multicultural Literacy*, edited by **Rick Simonson and Scott Walker** (p. 132)

automobile industry.[34] As Palestinian writer Fawaz Turki contends, "Grammars of human perception do not emerge in a vacuum; they grow in response to the needs of a culture's objective reality."[35]

Generational differences, where cultural polarities are sited, are paramount in the Asian American community. The sense of identity that by the post–

Fig. 11: Mo Bahc, *Untitled*, 1985, mixed media, 77″ × 98″ × 15″. Bahc is a Korean artist living in New York, and this piece is one of a series on language. By juxtaposing/superimposing abstract art and Korean calligraphy, he is making the point that to the culture he now lives in, his language of origin is an abstraction. The black characters say "Let's rather become Me-ju"—an idiom meaning stupid, ugly, dumb, applied to Koreans (and to the rest of us) who are stupid enough to let terrible political chaos and human rights disasters happen. On the left is a petition with a pen and on the right an excerpt from the torture diary of a Korean dissident. The white map of Korea is shedding blood. At the top is a plastic remake of a rice pot, suggesting weighty traditions, hunger and injustice in distribution of wealth. Generally, says Bahc, this is "self-criticism, anger, guilt at being a spectator and a powerless artist." Yet he is in New York to explore the experience of "marginal alienation." Unacceptable in Korea because of his politics and in New York because of his color, Bahc hopes that "maybe I am privileged with more freedom to do something unexpected, in a place where I cannot belong forever" (letter to the author, 1989).

▼▼▼▼▼▼▼

[A Chicano is] a Mexican-American involved in socio-political struggle to create a relevant, contemporary and revolutionary consciousness as a means of accelerating social change and actualizing an autonomous cultural reality among other Americans of Mexican descent. To call oneself a Chicano is an overt political act.
—Santo Martinez, Jr., in *Raices Antiguas / Visiones Nuevas* (p. 4)

World War II period was conventionally based on being/becoming American changed in the mid-'60s when, with the liberalization of Asian immigration laws, there was an influx of new immigrants who still identified with their country of origin. (The Chinese community is the most complicated because it has so many chronological and geographical layers. It is the elder among Asian American groups, drawing its members from the Mainland, Taiwan, and Hong Kong.) Heightened awareness of the historical continuity of racism awakened many to activism in the '60s. The Asian American urban community arts movement of the early '70s, for instance, was an outgrowth of the civil rights and antiwar movements in the United States, and a new set of political problems were broached with the arrival of Koreans and Southeast Asians fleeing communism.[36]

Fig. 12: **Arlan Huang**, *Chamber of Sterilization*, from "Ellis Island Series", 1986, acrylic and oil, 72" x 90". Collection Lillian Ling. (Photo: Gene Moy.) Huang is a Chinese American painter born and raised in San Francisco, working in New York, where he has been active in the Asian American community. The "Ellis Island Series," painted in muted grays, yellows, browns, and blacks, resulted from a visit by the Chinatown History Project to investigate Chinese graffiti at Ellis Island—unusual since most Chinese entered through Angel Island on the West Coast. Huang recalls: "The dilapidated corridors, rooms, and porches contained the remnants and ghosts of immigrants." The Great Hall, with its lofty tiled barrel vaults, built to impress, "translates: 'Welcome to America, get clean, get re-educated, sterilize your past and you can get rich or become a ballerina.' . . . Coming upon a padlocked chamber, our ranger unlocked it and said 'You're not going to believe what this room was for.' Entering, we were confronted by what appeared to be rusted cast iron ovens about 8' x 10' x 10' deep. With iron-spoked-wheel-walk-in door, there was a flash of the death camps. I could feel everyone blacking out for an instant. The ranger, knowing our feelings, brought us back by explaining the ovens as high-pressure steam cookers for sterilizing mattresses. It made me dizzy to think of my grandparents sleeping on steaming mattresses" (letter to the author, 1990).

Artists who do not name themselves are promptly baptized by those who control the art distribution systems. Just as Native American children were renamed when they were forced into government schools, and just as the very land they stood on was renamed overnight; just as the immigration officials at Ellis Island simplified their jobs by truncating, respelling, or reinventing

▼▼▼▼▼▼▼

[Asian Americans are placed] visually, wherever United States policy *lies*. In grade school, I was called "Jap," or "Chinese Chinese"; now people wonder if I'm Korean ("Excuse me, how much are these oranges?").
—Kimiko Hahn, in *Yesterday* (p. 3)

I was Japanese before it was L.A. cool
. . . I was Asian before Suzie Wong cat-fought over Mr. America wearing tight China dress imitated by import stores
. . . I was Japanese before California went sushi bar
. . . before blacks found out Asians also had to pay dues
before sansei re-discovered their cultural identity
before rednecks learned to wield chopsticks
. . . I was Japanese when it was painful and un-American . . .
—Velina Hasu Houston, in *Pacific Citizen* (Dec. 20–27, 1985)

▼▼▼▼▼▼▼

The Kearny Street Workshop on the West Coast and Basement Workshop on the East were the beginnings of the Asian American cultural movement. Fay Chiang, who was to become the hard-working director of Basement Workshop for several years, recalls: "In the Fall of 1971, I got a call to come to a meeting at a place called Basement Workshop of artists and writers working on a project called 'Yellow Pearl.' . . . I was shown an orange crate and a four drawer filing cabinet and informed that this was The Asian American Resource Center, 'the only collection of its kind on the east coast' " (*Basement Workshop Yearbook*, 1986, p. 3).

Fig. 13: **Bing Lee**, *Under the Black Flag: China Star 6/4* and *Pants on Fire*, 1989, acrylic on plexiglass, 8″ × 11″ each. (Photo: Laura Lee.) Lee was born in China and raised in Macao and Hong Kong, coming to the United States in 1974 to study. He lives in New York and is an experimental filmmaker as well as a member of the collaborative Epoxy Art Group. His expressively graphic painting style hovers between East and West, as do his themes of "Man, God, Demon and Beast," whose iconic forms overlap, merge, and separate, sometimes forming "sentences" and symbolic narratives. Lee's witty use of archetypes brings humor but not forgetfulness to the grim history and current events he schematically depicts. This series is called "M.O.R.A.L. (Museum of Rejects and Leftovers)." The white character in *China Star* stands for June 4, 1989, the day of the massacre of dissident students in Beijing's Tiananmen Square; the accompanying black images resemble the character for "blood."

the unfamiliar names of new citizens, so the high-art world renames the art of the "Other" when it arrives at the gallery's loading platform.

At the same time that artistic self-determination is working its way under the surfaces of social construction, the white noise of the dominant 79 percent of the population with its stereotypes and ethnocentrism continues to loom in everyday life and in the mass media, drowning out other, more shadowy images. Renegotiation continues. Labeling is the social mire from which individuals and groups must extricate themselves in the process of self-naming. The co-optation of comforting internal images through reductive and restrictive stereotypes follows the loss of language. Some names are acceptable within a community but entirely unacceptable when used by an outsider. Artists' images can be misidentified, misused, or ideologically compartmented in such a way that the original liberating intentions are lost, resubmerged, or maliciously manipulated. "Indian people," for example, can be a proud designation despite its colonialist origins; "skin," like "nigger," is entirely reserved for internal use.

In 1979 a young white artist showed his innocuous, if competent, abstract charcoal drawings at a New York alternative space under the title "The Nigger Drawings." He admitted he had chosen the title to be "sensational," and then compounded the problem by publicly linking it first to the charcoal on his hands that made him emerge in blackface and then to his feeling that he had been "niggerized" by having to show in an alternative space instead of a commercial gallery or museum. Subsequent protests by the black and progressive communities and the ensuing publicity forced the artworld to deal directly with the ramifications of racism in regard to free expression.

Some whites had trouble understanding what was wrong, since avant-garde art is by definition "risky" and "controversial." They insisted that artists (unlike anyone else in the world) were free from any social restraints: in art, the argument went, anything goes, so any attempt to remind artists that they too have a social responsibility is censorship. Others, shaken by the pain and anger expressed by the black community, sensed that anything unspeakable in a school or on a subway (for different reasons) should not be said in an art gallery either. Lines were drawn, consciousness was raised, friendships were broken, and avant-garde art in some ways came of age.[37]

If "names can never hurt me"—that defiant cry of the obviously hurt— what about the abuse images can inflict? Racist incidents on college campuses in the last few years have demonstrated that while fraternities (consistently the worst offenders) have learned a modicum of sensitivity about verbal name-calling, they still seem to feel that labeling images are fair game. (I base this assumption on the number of flyers with pictures of "cannibals," "Fijis," sexy "Black Mommas," or blackface parties I have seen in the four semesters I have spent near a western university campus.) One subtle but telling example of unconscious racism in the arts is a story told by a black art professor: A black

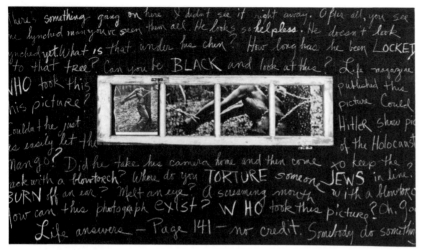

here's something going on here & didn't see it right away. After all, you see me lynched many you've seen them all. He looks so helpless. He doesn't look lynched yet. What is that under his chin? How long has he been LOCKED to that tree? Can you be BLACK and look at this? Life magazine published this picture. Could Hitler show pic of the Holocaust WHO took this his picture? couldn't he just as easily let the man go? Did he take his camera home and then come back with a blowtorch? Where do you TORTURE someone JEWS in line. BURN off an ear? Melt an eye? A screaming mouth with a blowtorch How can this photograph exist? WHO took this picture? Oh, god Life answers — Page 141 — no credit. Somebody do something

Fig. 14: Pat Ward Williams, *Accused / Blowtorch / Padlock*, 1987, magazine page, silver prints, film positive, window frame, paint, text, 60″ × 100″. Williams is an African American photographer who studied in Philadelphia and Baltimore and now teaches at Cal Arts. The window frame (which she has used in other works) functions as a distancing device at the same time that it forces us to look through it and enter the picture's reality; the scrawled text also insists on participation by its initial illegibility. Although this piece appears to be about race alone, the anguished series of questions to the viewer demands a response as critical as it is sensational, and raises the issue of "responsibility in the print media, the idea of holding mental 'turf.'" Williams examines not only the act of lynching but the act of photographing that act: "*Life* Magazine published this picture. Who took this picture? Couldn't he just as easily let the man go? Did he take his camera home and then come back with a blowtorch? . . . *Life* answers—page 141—no credit. Somebody do something."

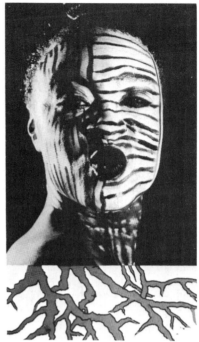

Fig. 15: Judith Jackson, postcard designed by Maria Fang for her performances *Bags and Mother Tree Foot* and *Pygmies in the Rain Forest*, 1989, Home Theater, New York. (Photo: John Pinderhughes.) Jackson is a highly original performer who studied mime with Marcel Marceau and works with children as well as in film and the legitimate theater. Her one-woman shows draw from a range of cultural influences, especially African, while aiming lethal blows at contemporary racism. The *Pygmies* piece was about deforestation in the African rain forest and "the eventual eviction of the Baccae (Pygmies) and the impending homelessness of us all." Her performances explore racism, sexism, and the roles of the mulatto, the pickaninny, the Mammy, and other stereotypical and archetypical depictions of the black woman, taking off on the minstrel show, Southern plantation melodrama, Hollywood Civil War epics, TV sitcoms, and stand-up comedy. The confusion of styles echoes the confusion of identity facing contemporary black women. (Quotations from letter to the author, 1990.)

student came to him puzzled because he had been asked to be in a political art show and his paintings weren't political at all, just portraits of his friends. The teacher broke it to him that the mere presence of a black face was perceived as a political statement.

Visual stereotypes are psychologically damaging and socially distancing, yet children are exposed to them from early on, via television, comic books,[38] schoolbooks, and general socialization in and out of the family. We are taught not to believe our own eyes and we learn to look at our environments, families, and selves through the eyes of the dominant culture, which is usually ignorant of our realities and prefers the flattened, monophonic, portable versions. Advertisements either ignore or project fantasies onto people of color, often barging into the Third World for "local color" or photo opportunism (as in a recent series of gloriously colored magazine spreads of western landscapes occupied by high-fashion models imitating Native Americans).

Sometimes "subtler" modernized versions of the sheer brutalization and sadism of earlier stereotypes—ashtrays or golf tees with helpless grinning black

Fig. 16: Carrie Mae Weems, *Mirror, Mirror*, 1986–87, black-and-white photograph, 15½" x 15½". Weems was raised on the West Coast and went to Cal Arts and the University of California at San Diego. She teaches film and photography at Hampshire College in Amherst, Massachusetts. In 1989 she wrote, "I'm feeling extremely colored now days, and I'm happy about my 'conditions.' For much too long, I've placed great emphasis on being European and Western . . . often at the expense of overlooking the value of Afro-American culture" (*Nueva Luz*, v. 2, no. 4, 1989, p. 22). In the last few years Weems has made photographs of insulting black-stereotyped bric-a-brac in domestic settings ("American Icons"), narrative still lifes, portraits and self-portraits exploring the stereotypes of black people, especially women—wittily and angrily employing such weapons as watermelons, fried chicken, jump-rope rhymes, folklore, and proverbs.

▼▼▼▼▼▼▼

Nigger. A word used as a psychological weapon by everyone . . . except the people it's most often aimed at. In fact, the only people who use that word in jest! . . . are black people. "See that N*gg*r run. Hear that N*gg*r sing. Wear that hair N*gg*r." This confuses white folks. Hell, this confuses me. They're saying, "Why do they get to say N*gg*r all out loud. Not fair. We can only say it at home, in private, in the dark."
—Judith Jackson, *N*gg*r Cafe* (1988 performance)

▼▼▼▼▼▼▼

Right after the "Nigger Drawings" show, white artist Steve Gianakos exhibited his blatantly racist painting *Which Person Can't Read?* It depicted five "alert" male faces paired with letters of the alphabet while one black face, drawn like a cartoon stereotype of stupid surprise, was paired with a question mark. The artist told *The Village Voice*, apropos of the "Nigger Drawings" show: " 'a bunch of blacks tried to take advantage of a situation so that they could

LOOKING INTO THE MIRROR, THE BLACK WOMAN ASKED, "MIRROR, MIRROR ON THE WALL, WHO'S THE FINEST OF THEM ALL?" THE MIRROR SAYS, "SNOW WHITE, YOU BLACK BITCH, AND DON'T YOU FORGET IT!!!"

faces ("golliwogs"), a terrified black baby labeled "a dainty morsel" about to be eaten by a crocodile—appear in the form of slapstick and sit-com idiocies.[39] High art, too, carelessly reduces people to abstractions even as it decries the "simplistic propaganda" of political content, because, as David Goldberg has remarked, "the 'terms' of art tend to the universal."[40] It is in this area between the popular expectations of art as a bellwether and modernist art's inability to confront the specific, the everyday, the personal/political, that a new naming process is taking place.

The instigator of the protests against the "esthetically motivated racism" of "The Nigger Drawings" was Howardena Pindell, an African American artist who was at the time associate curator in the Department of Prints and Illustrated

Books at the Museum of Modern Art. She was already well aware that "as a black artist, the first effect when you walk into a gallery still has to do with the color of your skin. You are not seen as an artist first, but as a political entity." But she cites "The Nigger Drawings" as the event that forced her to "come of age politically."[41] Since 1979 Pindell has been an antiracist activist within the artworld, writing, speaking, and organizing with a ferociously elegant candor. She points out that the mainstream artworld is cleverer than Bob Jones University (which lost its tax exemption for barring blacks from admission) because its racism is not stated, but merely practiced. "Then," says Pindell, "they roll out the word 'quality.' "

In 1988 Pindell compiled an appalling file of documented statistics about the representation of artists of color in major New York galleries and museums. In the commentary, she included, without naming names, a series of damning quotations from artworld luminaries. One "major New York art critic" told a student interviewer that he was not interested in "minority structures, that non-white artists had their own institutions that were set up to 'take care of them,' " adding that he himself was "only interested in quality."[42] When the anonymous artists' group PESTS began to poster SoHo in 1986 demanding "Why don't you see us?" on behalf of the 11,000 artists of color in New York, someone scribbled the reply: "Because you do poor work." Things haven't changed much since 1979.

Pindell's heritage is a grand mixture of African, Seminole, French, English, German, Christian, and Jewish; she has traveled in Africa, Asia, Europe, the Soviet Union, Latin America, and the Caribbean, and has lived in Japan and India. Her own paintings were for years primarily abstract, metaphors for self-definition, the rearrangement of fractured realities, balancing precariously between compulsive order and chaos. However, buried in their intricate surfaces—often made with compulsive meticulousness from tiny fragments of paper or postcards layered and inlaid to form kaleidoscopic new images of the world—were chains of autobiographical and political references to racism. In the '80s these references gradually expanded and took front stage.

The 1980 abstract painting *The Feast Day of Iemanja*, named after a black Brazilian goddess whose history was explained on a wall label, was sprayed with perfume to enhance its function as an offering to the deity. In the 1982 *Hiroshima Disguised*, Pindell hid military images and mutilated body parts in surfaces boiling with glitter and ash. By 1986 she had begun her "Autobiography" series, about historical and personal abuse and trauma (plate 1). The first painting was *African Buddha*, triggered by a text she had written in 1984 on "The Aesthetics of Texture in African Adornment." But the series' underlying content was the exorcism of the effects of an automobile accident she had suffered in 1979, which caused loss of memory and long-term physical damage. The resulting disequilibrium excoriated Pindell's cultural unease, confirming her sense of danger in everyday life. Four nonrectangular canvases in the series call upon the four elements; the one on fire is called *Sati*, after the

start to show at Artists Space. . . . I don't think people won't show blacks because they're black, but because they don't do interesting work. It has nothing to do with color. It's like women. Women happen to be inferior artists to men, and it's the same with blacks. They happen to be better at peddling dope. Maybe that's their talent. I mean why should blacks be good at art?' " (quoted by Richard Goldstein, "Art Beat, Darky Chic," *Village Voice*, March 31, 1980, p. 34).

I'll teach you differences.
—William Shakespeare, *King Lear*

▼▼▼▼▼▼▼
These caricatures and stereotypes were really intended as . . . prisons of image. Inside each desperately grinning "sambo" and each placid three hundred pound "mammy" lamp there is imprisoned a real person, someone we know. If you look hard at the collection and don't panic . . . you will begin to really see the eyes and then the hearts of these despised relatives of ours, who have been forced to lock their spirits away from themselves and away from us . . . I see our brothers and sisters, mothers and fathers, captured and forced into images they did not devise, doing hard time for all of us. We can liberate them by understanding this. And free ourselves.
—Alice Walker (commenting in 1981 on the Janette Faulkner Collection of Stereotypes and Caricatures of Afro-Americans; quoted in *Prisoners of Image*, p. 5)

Fig. 17: Coreen Simpson, *Brother from Another Plantation*, 1984, hand-painted color C print, 40″ × 60″. Simpson is a freelance photographer, filmmaker, jewelry designer, and former curator of photography at the Studio Museum in Harlem. Fond of "flamboyance and excessiveness," and perceiving style as power, she is best known for her ongoing "B-Boys" series. "I am fascinated with how people put themselves together at night," she says. "They seem to me as beautiful birds or peacocks." Painting and altering her prints is a way of denying the purity of photography. In this image, disguise is also her focus, taking off from black stereotypes with a punning reference to John Sayles's film *Brother from Another Planet*. A black man in added blackface is seen against a bright blue sky, TV antenna on his head, holding a fake chunk of watermelon, hand and eyes raised in pious blessing: he is part humorous, part sad, part portentous. The photo was originally done on assignment for a black business magazine about how blacks were represented on TV; it was too strong for them. (Quotations from *American Arts*, September 1982, p. 13.)

▼▼▼▼▼▼▼

When the occasional non-white or non-Anglo person is represented on the [TV] screen, it is usually as a stereotyped ethnic extreme: the noble Savage, the Geisha girl or Sumo wrestler, the Jewish mother, the athletic or bopping musically adept Black, the mariachi-playing Mexican, the carrying-ears-of-corn Indian maiden, the Karate expert or the de's dem's and dose Mafioso. The Anglo dream is as much an unrealistic view of our society as the ethnic stereotype. Is it possible that all Anglos have whiter teeth, sweeter breath, cleaner shirts and a better more valuable life?
—Terry Berkowitz, *In(di)visible* (1989 video installation)

still-lingering Hindu custom of burning the widow on her husband's funeral pyre. *Earth: Eyes/Injuries* refers directly to the accident, and *AIR/CS 560*, which contains Pindell's own blood, refers to the poisoning of the atmosphere by chemicals and by racism.

The "Autobiography" series evokes displacement, dismemberment and amnesia (dis-memory-ment), crumbling structures, false histories. As an involuntary wanderer, Pindell is always "finding her way," even as she is perceived by many as "out of place." She is charting a vital but painful search, an absence that, in her art, becomes a strong presence.

Visual artists are conscious, and unconscious, agents of mass dreams, allowing forbidden or forgotten images to surface, reinforcing aspects of identity that provide pride and self-esteem, countering the malignant imprint of socially imposed inferiority. As namers, artists participate in an ongoing process of call and response, acting in the space between the self- or individual portrait and the cluster of characteristics that supposedly define a community. In the expansion from one to many, from the mirror to its frame, visual images play an increasingly important role. Just as dreams may precede or parallel reality, images often precede texts, and elusive self-images can precede new names, though they are rarely understood at the time they appear. Visual images can also offer positive vision to those whose mirrors are clouded by social disenfranchisement or personal disempowerment. The naming process involves not only the invention of a new self, but of the language that creates the context for that self—a new world.

Yolanda López, a Chicana artist from San Francisco who is education

Fig. 18: Ernie Pepion (Blackfeet), *The Sun Dancer*, 1989, oil on canvas 60″ × 60″. A Vietnam vet living in Bozeman, Montana, Pepion survived the war only to be paralyzed as the result of a car accident in the early '70s. He was inspired to become an artist at the veterans hospital and in college, and he now paints with the aid of an electric brace on his hand. "I've experienced various degrees of discrimination as an Indian growing up near a reservation border-town and attending a predominantly non-Indian school. I have had similar experiences since becoming a quadriplegic," he writes. "Painting is the language I use to express my feelings about the degradations we all experience at different times. . . . My happy-go-lucky facade is slowly dissolving as I become more open in my work. . . . *The Sun Dancer* came about after I dreamed that I was dancing at a Powwow. Since I am a firm believer in dreams, I believe that one of these days I'll dance right out of this chair, maybe not in this lifetime, but maybe at the end when I go to the Sand Hills. I am trying to show that even though we handicapped people may have physical limitations we can conquer anything mentally, if not physically" (statement and letter to the author, 1990). With a similarly wry humor in the face of adversity, Pepion's painting *Buffalo Jump* shows him riding a hobby horse/wheelchair over a cliff, wearing a trucker's cap that reads "oops."

▼▼▼▼▼▼▼

The possibilities of meaning in "I" are endless, vast, and varied because self-definition is a variable with at least five billion different forms . . . the I is one of the most particular, most unitary symbols, and yet it is one of the most general, most universal as well.
—Cordelia Candelaria, *Chicano Poetry: A Critical Introduction* (Westport, Conn.: Greenwood Press, 1986)

director for the Mission Cultural Center, has concentrated for more than a decade on the positive and negative aspects of images of Mexicans on both sides of the border (plate 5). She deconstructs some of the most familiar stereotypes in a half-hour videotape called *When You Think of Mexico*. Two narrators, male and female, comment with humor and indignation on the Mexicans in advertising, the media, and Hollywood films. The images range from Frito Banditos (which imply that Mexicans—and revolutionaries in general—are, among other things, out to rob "us"), to the "picturesque and nonthreatening" lazy Mexican asleep under an oversized sombrero and a cactus, to religious symbols borrowed to sell food ("one bite and you'll be speaking Spanish"), to skewed versions of Mexican masculinity (a rooster) and femininity ("the hot little Latin"). The narrator says of "the new Mexican Aunt Jemima" on a corn flakes box that there are some Chicanas who wear their hair parted in the middle or hoop earrings or peasant blouses—"but *all at once?*"

In another section, analysis is focused on the 1956 *Giant*, a self-consciously pioneering movie that offered unprecedented if paternalistic respect to Mexican

Fig. 19: Yolanda López, cover for *Fem* maga-
zine, June–July, 1984. *Fem* is a Mexican fem-
inist magazine and when this cover
appeared, with the Virgin in the dress of a
contemporary working-class Mexican woman,
its office received a bomb threat.

Americans and looked relatively calmly on interracial marriage. At the film's
end a shot of the two grandchildren—one white, one brown—is superseded
by a shot of a white lamb and a black kid (goat), demonstrating, says López,
that "we are still seen as different species."

Intent on teaching Chicanos to look critically at the way they are repre-
sented and controlled, López declares "We have to be visually literate. It's a
survival skill." Her prime subject has been the ubiquitous "Brown Virgin" of
Guadalupe. López deconstructs her idealization in the Mexican community,
scrapes off the Christian veneer, and transforms "La Lupita" into a modern in-
digenous image echoing pre-Conquest culture. (When she did a cover for the
Mexican feminist magazine *Fem* showing the Guadalupe in short skirt and high
heels, its office received bomb threats.) "Why," she asks, "is the Guadalupe
always so young, like media heroines? Why doesn't she look like an Indian in-
stead of a Mediterranean, a nice Jewish girl from the sixteenth century?"[43]

At the same time, López perceives the Guadalupe as an instrument of social
control and oppression of women and Indians. She points out that the Church
first tried to suppress the "Indian Virgin" and only accepted her when her
effectiveness as a Christianizing agent became clear. The Virgin of Guadalupe
was the Americas' first syncretic figure, a compromise that worked. She became
the pan-Mexican icon of motherhood and *mestizaje*, a transitional figure who
emerged only fifteen years after the Conquest as the Christianized incarnation
of the Aztec earth and fertility goddess Tonantzin and heiress to Coatlicue,
the "Lady of the Snaky Skirt," in her role as blender of dualities. The Guad-
alupe is a unifying symbol of Mexican "mystical nationalism" equally important
to Indians, mestizos, and *criollos* (American-born Spaniards), fusing indigenous
spiritual concepts of the earth as mother with "criollo notions of liberty,
fraternity, and equality, some of which were borrowed from the atheistical
French thinkers of the revolutionary period," and a symbol of the "power of
the weak."[44] More recently, La Lupita has become a Chicana heroine, rep-
resenting, with Mexican artist Frida Kahlo, the female force paralleling male
heroes like Emiliano Zapata and Diego Rivera.

Discovering one's own difference from the so-called norm—on TV, in
schoolbooks, movies, and all the other social mirrors—can be a wrenching
but illuminating experience. The African American art historian Judith Wilson
tells a story about the power of the relationship of self to communal imagery:
"As a child, I only drew women's faces, and, though I was frequently praised
for my skill, I was never satisfied with my own products." By the time Wilson
was a senior in high school she had studied art and visited European museums;
she had read widely about black history and culture, but she hadn't learned
"how to put black women's features down on paper."

**One day, an old white woman who told me she'd grown up somewhere in
Africa and who ran a dusty little bookshop where I frequently browsed, handed**

me a slim paperback on art in Nigeria. . . . I stared and stared at photographs of crowds following bearers of Gelede masks. I stared at the masks, I stared at the people, then back again at the masks—astonished at the correspondence between the masks' supposedly stylized features and the specific planes and angles of Yoruba people's faces. Soon I was drawing those faces. Because I was finally able to see them for the first time![45]

Self-portraiture has not been a wildly interesting genre in recent decades. In most modern self-portraits one is given objects rather than subjects; faces staring out rather than being stared into—the artist's face simply replacing that of the absent model. Culturally conscious self-portraits often double as communal self-portraits. They are interfaces between outside pressures to conform to stereotypes and the inner desire to become in a hopeful but ill-defined future. Sometimes such conscious self-portraits are double images, turning the mirror around, mocking physical and political reality, making believe, making the mirror the mediator between being seen and seeing oneself.

Adrian Piper is a black woman who often involuntarily passes for white. A daring performance artist and a Harvard-educated philosophy professor, Piper addresses her multiple identities directly, charging her art with a unique intensity. In fifth grade Piper's poise was such that a hostile teacher asked her mother, "Does she know she's colored?" In the '60s, when she was in art school, a professor asked a friend of Piper's, "Is she black? She's so aggressive." In recent years, because she not only acknowledges but flaunts and insists upon her racial heritage, Piper has been accused of masochism, of purveying bourgeois guilt by "passing for black" when she could pass for white. She considers unthinkable the alternative: to deny the sufferings of her family and of African Americans in general. Finding herself in the curious position of being able to "misrepresent herself," Piper writes:

Blacks like me are unwilling observers of the forms racism takes when racists believe there are no blacks present. Sometimes what we observe hurts so much we want to disappear, disembody, disinherit ourselves from our blackness. Our experiences in this society manifest themselves in neuroses, demoralization, anger, and in art.[46]

As an artist, Piper has concocted a number of complex devices to let people know that she knows who she is. Her use of masks or disguises is as complex as her analysis of her situation. In her "Catalysis" pieces, performed in the streets and public places in the early '70s, Piper "mutilated" and "barbarized" her image as an attractive young woman (by wearing vile-smelling clothes and performing bizarre, nonviolent but antisocial acts) to mirror in repulsive exaggeration how the Other is perceived. By simultaneously emphasizing her difference and dissolving the usual means of communication between herself and a viewer of her art, she discovered a destabilizing strategy, a way of subverting social behavior to make it reflect upon itself.

▼▼▼▼▼▼▼▼

Still popularly revered, the Guadalupe remains immune to such retroactive historical analysis. In 1987 the Centro Cultural de Arte Contemporaneo in Mexico City mounted an exhibition, "Four Centuries of the Image of the Virgin of Guadalupe" including traditional ex-votos, recent ones commissioned especially for the show, and avant-garde art. Rolando de la Rosa's contribution was a montage of Marilyn Monroe's face and bare breasts over the Virgin. It detonated protests against "satanic blasphemy" by thousands who were ready to lynch the artist, despite the fact that "La Guadalupana" is daily desecrated in advertisements throughout Mexico. The artist's stated aim was in fact to point out precisely "how our consumer society uses religious and sacred symbols for commercial ends." A right-wing protester confirmed the fusion of religion and nationalism represented by the Guadalupe: "It was only when this brown-skinned virgin appeared that Mexican nationality was born. Before that, there were only Spaniards and Indians here" (quoted in *New York Times*, April 2, 1988).

Fig. 20: Adrian Piper, *Some Reflective Surfaces* #2, 1975, mixed media performance (film, video, audio, dance), Whitney Museum, New York. (Photo: Warren Silverman.) The narrative concerned Piper's experiences as a disco dancer. As she "danced with herself" (in slides captioned by cartoon balloons), she appeared as an update of the Mythic Being, dressed in black, wearing silver reflective sunglasses, long black hair flowing, her face whitened and incongruously penciled with a mustache.

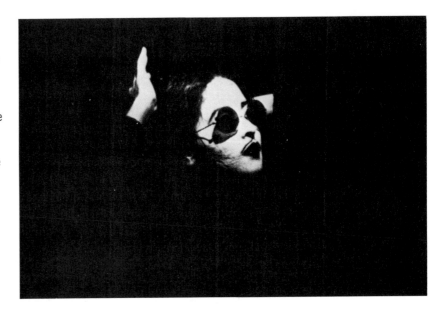

For several years in the mid-'70s, Piper assumed an alter ego, the "Mythic Being," who also appeared in public and in poster pieces. A slight young man in shades, Afro, and a pencil mustache, he permitted Piper to experience a cross-sexual, androgynous identity, as well as to become the black or Latino street kid she could never fully transform into as a teenager. The Mythic Being was often hostile or threatening. He offered his creator a way of being both self and other, of escaping or exorcising her past and permitting her to re-form herself.

In the Mythic Being pieces Piper emerged in "blackface." In her concurrent performance pieces, however, she was made up in whiteface, as well as in a curious kind of drag, with long flowing hair and sensuously female dance movements unbalanced by a pencil mustache, a vestige of the Mythic Being's street persona. Piper's work since the early '70s may have provided the model for Cindy Sherman's shifting personae, which, detached from the anger about racism that fuels Piper's art, became a fashionable (and perceptive) individual exploration with full theoretical potential for both feminism and the mainstream.

In the autobiographical *Three Political Self-Portraits* of the late '70s, Piper made mass-produceable posters with long narrative overlays in which she detailed her experiences of conflicts in the categories of gender, race, and class. She recalls being called "paleface" by her neighbors in Harlem and "colored" at the private school she attended on scholarship. In the 1980 *Self-Portrait Exaggerating My Negroid Features*, Piper tried to embody "the racist's nightmare, the obscenity of miscegenation, the reminder that segregation has never been a fully functional concept, that sexual desire penetrates the social and racial

barriers, and reproduces itself."[47] In all of her work, Piper enacts, as Homi Bhabha has said of Frantz Fanon's achievement in his classic *Black Skin, White Masks:* "the intricate irony of turning the European existentialist and psychoanalytic traditions to face the history of the Negro that they had never contemplated."[48]

As the internal search intensifies for names to counter anachronistic impositions, names that will reflect and reinforce the difficult coalitions being forged among Asian, African, Latino, Native, and European Americans, it becomes clear that ethnicity itself, as Michael M. J. Fischer has pointed out, is

> something reinvented and reinterpreted in each generation by each individual and it's often something quite puzzling to the individual, something over which he or she lacks control. . . . It can be potent even when not consciously taught; it is something that emerges in full, often liberating flower, only through struggle.[49]

He goes on to say that today, as we reinvent ethnicity, it's also something new: "To be Chinese-American is not the same thing as being Chinese in America. . . . The search or struggle for a sense of ethnic identity is a (re)invention and discovery of a vision, both ethical and future-oriented."

Thus a "hyphenated" American is not "just an American" but a particular kind of American. All double identifications, awkward as they sound, make clear that the user acknowledges and is proud of her or his biculturalism. Nevertheless, the choices for artists of color in the United States, as well as for exiles and expatriates from the Third World living in North America, can seem irreconcilably polarized. There is a good deal of internal ambivalence and conflict about the degree to which they want to, or are able to, assimilate in their art. "We don't go around saying white art," art historian David C. Driskell once said, "but I think it's important for us to keep saying Black art until it becomes recognized as American art."[50] The venerable African American painter Lois Mailou Jones had her first prize at the Philadelphia Academy withdrawn in the '30s because she was "colored"; by 1985, with a number of honors and museum solo shows under her belt, she said, "I'm sick of being called Black. I'm an American artist in the Mainstream."[51] Asians too point out that physically they can hardly pass as "natives" no matter how many generations they can trace in America and despite the possibility that they were "the first Americans."

Although for artists of color looking back to suppressed traditions, self-portraiture and autobiography might be expected to be seen as anachronisms—the unwanted or unfamiliar products of a self-conscious Western experience—in fact, personal narratives continue to be revitalized and clearly play a significant role in the naming process. Robert Lee, director of the Asian American Arts Centre in New York, has suggested that "the Asian art of calligraphy is the nearest traditional equivalent to self portraiture."[52] Margo Machida has

▼▼▼▼▼▼▼▼

. . . the *act* of representing (and hence reducing) others almost always involves violence of some sort to the *subject* of the representation. . . . Whether you call it a spectacular image, or an exotic image, or a scholarly representation, there is always this paradoxical contrast between the surface, which seems to be in control, and the process which produces it, which inevitably involves some degree of violence, decontextualization, miniaturization, etc.
—Edward Said, "In the Shadow of the West," *Wedge* (no. 7–8, Winter–Spring 1985, p. 4)

For the image—as point of identification—marks the site of ambivalence. Its representation is always spatially split—it makes *present* something that is *absent*—and temporarily deferred—it is the representation of a time that is always elsewhere, a repetition.
—Homi K. Bhabha, in *Remaking History* edited by Barbara Kruger and Phil Mariani (p. 140)

▼▼▼▼▼▼▼

Sticks and stones can break my bones, but names can never hurt me.
—Anglo-Saxon folk saying

Oh yeah?
. . . gringo, honky, anglo, coyote, whitefolks, The Man, ghost, gauje, wop, dago, wog, frog, limey, slope, squaw, kike, peasouper, goy, redneck, hillbilly, cracker, hebe, canuck, polack, nigger, greaser, meskin, beaner, yellowbelly, redskin, spic, mick, bohunk, slant, coon, wetback, pigtail, WASP, yellow peril . . . (LRL).

Fig. 21: Emma Amos, *Thurgood and Thelonius—Some Names to Name Your Children*, 1989, acrylic with woven borders and collage of African strip weaving, 84" × 82", with shaped figure on floor, 37" × 19". (Photo: Robert Levine.) Amos, who went to Antioch, studied art in London, and was an original member of the Spiral group in the '60s, thinks of herself as a "writer in paint." Once a weaver, Amos borders her paintings with her own fabrics or with kente cloth to salute African artists. Much of her work deals with African American history—for example, *Odyssey*, a ten-part series of paintings about her family and the past of Atlanta, her hometown. Sometimes she juxtaposes black people and jungle animals: "I want to make clear the relationships between artists, athletes, entertainers, and thinkers and the prowess, ferocity, steadfastness, and dynamism of animals." Often, as in this painting, her figures are falling through space, "flying but not landing in any cushy place," a metaphor for dislocation and anxiety. Firm ground in this case is represented by the names of admired black people such as Thurgood Marshall and Thelonius Monk, or Bessie Smith, FloJo, Faith Ringgold, Rosa Parks, Josephine Baker, Alice Walker, Langston Hughes, Fannie Lou Hamer. One figure has fallen off the canvas, "like she's going through the floor." The figures are "black" but painted in white against a somber black ground bordered with funereal black velvet, so that "the only color [is] in the names; everything else [is] disaster." "Every time I make a color it's a political statement," Amos explains. "It would be a luxury, to be white and never have to think about it. I don't have that luxury" (quotations from interview with the author, June 1989, and from *The Afro-American Artist in the Age of Pluralism*, p. 9).

pointed out that for an Asian American, self-exposure and autobiography constitute "a crossing of a code of silence, transgression of the tradition of keeping problems within the family."[53] Her own use of "psychological self-portraiture" (from Polaroids of her own body) as a means of "self interrogation," is therefore "a radical step in affirming my experiences and presence in the society."[54]

Machida is a Japanese American artist raised in Hilo, Hawaii, who has lived for twenty years in New York, where she has been active in the Asian American political and cultural communities. Her self-images are introspective but also unexpectedly harsh and critical, incorporating a level of psychic violence repressed in most Asian American art. She studied psychology and art, and, deeply affected by the '60s vision of a counterculture based on

humanist values, worked for ten years as a counselor and art therapist in mental institutions, halfway houses, and schools for the emotionally disturbed and developmentally disabled. Her contact with the struggles of clients living on the edge of society led to a series of disturbing narrative paintings in 1984.

Machida's work (plate 3) is based in her own "paralyzing feelings of culture shock, isolation, disorientation, and marginalization in New York," having come from "a small, conservative Asian community with close ties to traditional Oriental culture." As in all Pacific Island cultures, she recalls, there was a deep appreciation of natural forces, personified in a pantheon of goddesses, gods, and spirits manifested in volcanic eruptions, typhoons, and earthquakes:

> I was exposed early to Japanese esthetics through brush painting, bonsai, tea ceremony, and Buddhist religious rituals. An equally compelling influence on my visual development came from Japanese language television programs, comic books, and samurai movies which are available in the islands. These popular forms of media were filled with mythic images of ghosts, demons, and talk of the supernatural with characters which continuously changed states from human to animal to spirit. Such concepts of transformation are integral to my current work, in which I reflect shifting and contradictory self-concepts of male/female, human/animal, child/woman, Asian/other. My works, which are metaphors for my feelings of detachment, pain, and displacement, describe my ongoing process of self-definition as an Asian-American woman. . . . Painting has become the vehicle for an animate, self-empowering process that, by giving form to painful inchoate conflicts, allows for recognition of feelings I can thereby come to "own."

The waves, typhoons, and volcanoes of Hawaii are both metaphors and realities that continue to haunt the artist's nightmares. In *Tidal Wave* (1986) a child holds tightly to a red ball, in an attempt to ward off her fear of impending doom. This image has been read as representing the Asian awash in a dangerous sea of Occidental extroversion, employing introversion as a defense.[55] In many of her self-portraits since 1985, Machida calls upon animals as guardians and alter egos as well as images of personal power. In *Charmed* she is a snake handler, a metaphor for "confronting the dangers of self-discovery." In *First Bird* she represents herself as a ghostly geisha (the Asian female stereotype) and a skeletal Jurassic archaeopteryx (the transitional creature who straddled reptilian and avian worlds). She cites the influences of Francis Bacon, underground comics, and Frida Kahlo, "whose arrestingly frank, graphic and bizarre imagery of her body, sexuality, cultural and political identity showed how much more was possible to express." Like Kahlo, whose work and life have become models for women of all cultures, Machida uses skeletal references as images of illness, vulnerability, and mortality.

Among Machida's most complex works are two multipartite paintings in which she identifies with the tormented Japanese novelist Yukio Mishima, who exposed a "private obsession with inventing a position of psychological strength for himself" in his sexuality and politics, in his paranoid, voyeuristic

▼▼▼▼▼▼▼▼

There is no doubt in my mind that the Asian American is on the doorstep of extinction. There's so much out-marriage now that all that is going to survive are the stereotypes. White culture has not acknowledged Asian American art. Either you're foreign in this country, or you're an honorary white.
—Frank Chin (quoted in Nikki Bridges, *Conversations and Convergences,* Asian American Women Writers' Panel, Occidental College, Los Angeles, January 1978, p. 16)

Sometimes
 I want to forget it all
 this curse called identity
 I want to be far out
 paint dreams in strange colors
 write crazy poetry
 only the chosen can understand

But it's not so simple
 I still drink tea
 with both hands.
—Nancy Hom, in *Conditions* (no. 6, Summer 1980, p. 208)

▼▼▼▼▼

[Indian people are] outside representation, unrepresentable, except as a phantasm masquerading under the misnomer "Indian"—a term that homogenizes what was in fact a heterogeneous population, as diverse in language and customs as Europe and Africa.
—Jean Fisher, *Artforum* (Summer, 1989, p. 101)

I feel fairly sure that I could address the entire world if only I had a place to stand. You (white Americans) have made everything your turf. In every field, on every issue, the ground has already been covered. . . . Inquiry and discourse itself are confined to the "experts" of whatever field . . . confined, for control by a system of power not necessarily organic to human society.
—Jimmie Durham, Broadside, Orchard Gallery, Derry, 1988, and *Artforum* (Summer 1988, p. 101)

By the time they reach second grade, every child in the country knows what an Indian is. They wear lots of feathers, ride spotted ponies and shoot arrows. Indians who don't fit the type are invisible; they simply can't be imagined by the majority of white children or adults.
—Rayna Green (quoted by Edward Chappell, *The Nation*, Nov. 27, 1989, p. 657)

Other groups have difficulties, predicaments, quandaries, problems, or troubles. Traditionally we Indians have had a "plight." Our foremost plight is our transparency. People can tell just by looking at us what we want, what should be done to help us, how we feel, and what a "real" Indian is really like.
—Vine Deloria, Jr., *Custer Died for Your Sins* (p. 9)

fantasies, his books, and the formation of his own paramilitary cadre. In two crucifix-like paintings, Machida takes upon herself Mishima's "erotic fascination with the image of the Christian martyr Saint Sebastian."

It is no accident that Machida and others have chosen literary models for their visual analyses or transformations. The literary field is where the discussions of "the nature and context of minority discourse" (to borrow the title of a Berkeley conference) have been most intricately developed. Ethnographers are also citing literary models from past and present, and younger, more-and-less feminist and postmodernist art theorists are applying them to the visual arts, although usually to an unfortunately narrow range of North American work.

The co-optation of images through reductive and restrictive stereotypes coexists with the loss of language, the loss of the original name, which inevitably includes the loss of culture and identity itself. In Hawaii, Machida's dilemmas about bicultural identity are reflected in the threat to the islands' lingua franca. Pidgin is a creole language that sounds strange to the English ear, "a spare, direct, and often delightfully irreverent patois" that is for many Hawaiians "a crucial link to a rich past that is quickly being bulldozed for tourist and commercial development."[56] It is a full language, "the mother song" for non-Anglo Hawaiians, the communicative link that blends Japanese, Chinese, Filipino, South Pacific, Portuguese, Puerto Rican, and other components into a unique culture that can stand up against the growing influx of mainlanders.

"Indian people still speak English as a second language, *even if we no longer speak our own languages*," says Cherokee artist, Jimmie Durham:

That is the true meaning of illiteracy in a class society; one is not in control of the language one speaks. Our own Indian languages are extremely subtle and extremely exact, as language *must* be in a preliterate society in which the community relies on the spoken word. While our languages no longer predominate in our own communities, and we no longer live in preliterate societies, saying the right thing in the right way is still very important to us.[57]

Native Americans and Mexican Americans are still punished for using their own languages in schools, a practice that did not end in the early twentieth century; there are Chicano students in college today who recall being made to stand next to the blackboard on tiptoes for extended periods, placing their noses in a circle of chalk, for the crime of speaking their own language. The "English Only" movement—now law in several states—is attempting a total eradication of bilingual education and day-to-day commerce that might even be applied to Puerto Rico if it "achieves" statehood. "Official English" is a vestige of the discredited melting pot concept, lamented only by those who are threatened by diversity.

Sentence structure, accents, and body language can be retained for as long as three generations after a language is lost. Jaune Quick-To-See Smith feels

On the left edge of the image, vertical text reads: W H E N P A R A D I S E

On the right edge of the image, vertical text reads: A R R I V E D

Fig. 22: Enrique Chagoya, *When Paradise Arrived*, 1989, charcoal and pastel on paper, 80″ × 80″. Collection Di Rosa Foundation. (Photo: Wolfgang Dietze.) Chagoya was raised in Mexico City, where he studied art and political economics at the University of Mexico. He is now the artistic director of the Galeria de la Raza in San Francisco. This huge cartoonlike drawing is charcoal with a touch of red pastel, one of a series in which unexpected scale and juxtaposition provide ironic political commentaries in almost cinematic form. (With their theme of colonialism on both sides of the border, they recall the much-quoted statement, "Poor Mexico. So far from God, and so close to the United States.") Icons of pop culture and ancient religions coexist. In *When Paradise Arrived*, the inflated Mickey Mouse hand (inscribed in tiny letters "English Only") is poised to carelessly dispose of the barefoot little girl holding a heart, but the beauty of her features and the intensity of her stare seem to be holding off destruction. "I wanted to make her eyes like some of the Pre-Columbian sculptures where the eyes look off into the distance. They express a deep concentration, a different state of mind. I've seen eyes like that in religious paintings made by the Indians in Mexico. A lot of the cherubs in the churches have eyes like that—they look as if they took peyote or something, and they are looking at the horizon in ecstasy." Each drawing has an object that is displayed near it, or an image that is painted on the wall, as an afterthought or echo. In this case it was a Mexican lottery card of a heart crossed by an arrow. (Quotations from interview with Moira Roth in catalog for Chagoya's one-man show at the Alternative Museum, New York, 1989, p. 9.)

that her "right-brain" thought process, with its dependence on imaging, relates to the sign language, glyphs, and pictograms developed in such complexity by pre-contact Native peoples, and she finds many in her community who agree. With this in mind, Indian educators across the country are developing textbooks, courses, and computer programs to meet these needs. All twenty-six tribal colleges now teach their own languages.

White scholar Roy Wagner has contended that educated Westerners use "language as control," while poorer, less educated people, especially those from rural backgrounds, "control language through expressive formulations."[58] Kiowa writer N. Scott Momaday says that Native Americans "do not take language for granted." In the oral traditions, "words are intrinsically powerful as well as beautiful."[59] The stereotypes of Native Americans are reflected not only in the racist overuse of such terms as Brave, Squaw, and Chief, and in the visual counterparts cited by Rayna Green (see sidebar), but also by colloquialisms absorbed into the language, such as "Indian-giver," "honest-injun," "the only good Indian is a dead Indian" (hideously updated by a slogan perpetrated by racists in Wisconsin opposing Native people's fishing rights: "Save

Fig. 23: Lance Belanger (Maliseet), *The Good Doctor's Bedside Manner*, 1983, oil on canvas, 36″ x 48″. This cruel joke was actually played on a Native woman in a Canadian hospital, whose white doctor sewed her up with beaded stitches after an operation. Belanger is a founder of the Om niiak Native Arts Group in Ottawa. He is working to bring Indian art into the Canadian mainstream while maintaining its internal integrity. His own varied art includes abstractions, installations, and sophisticated satires. For instance, he has framed seal, mink, and lynx pelts in ornate antique gold frames as a witty reference to cultural colonialism and the exploitation of nature.

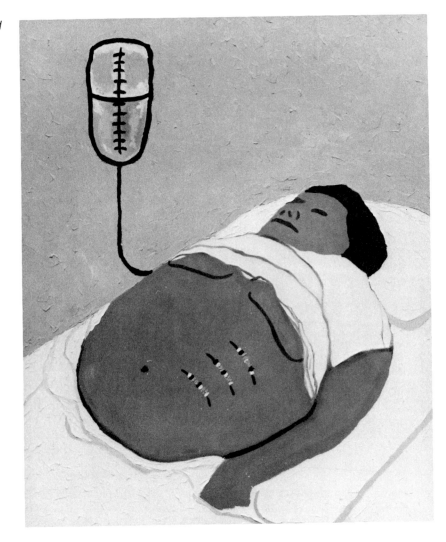

a walleye / Spear a pregnant squaw"). A full-blown racist comic strip called "Redeye" featuring fat, feathered, stereotypically stupid Indians is still nationally syndicated. Stereotypes promoted by photographs of Indians, associated by Native peoples with government surveyors, priests, anthropologists, and tourists "yearning for the 'noble savage' posed and dressed in full regalia," are at the heart of the lack of interest, until recently, in photography as an Indian art;[60] this explanation replaces the old saw about tribal people being afraid that photographs will "steal their souls."

The visual arts might be able to make a contribution to the intercultural process far greater than that of literature, due to language barriers and the gaps between written and oral traditions. Yet that has not been the case so far, in part because art is the prisoner of its status as object and commodity—its bulk

and expense, and the perceived elitism that results. It is therefore necessary to broaden our definition of naming to include the processes and vehicles by which these names are transmitted and received.

North American critics and intellectuals have begun only recently to look with respect rather than rapacity at Third World cultures. The progressive postmodern sensibility (including the rejection of *all* "sensibility" as crippled by culture or ideology) has focused first on "decentering" and then on the relationship between center and margins. Yet it has been the discourse *about* rather than *by* Third World artists and writers that has risen to the surface via feminist and French theories about difference and the Other in the last decade. Most of the debate, like this book, has been within white control. In addition, it has been inaccessible to many working artists because scholars tend to prefer the illusory coherence of theory to the imperfections of practice. This bias against artists' attempts to expand or experiment with theoretical premises curtails the development and effectiveness of the art itself and permits theory to sail off into the ozone, unanchored by the difficulties of execution and direct communication with audiences.

African American literary critic Henry Louis Gates, Jr., says that rather than shying away from "white power—that is, literary theory" (and its hegemonic style), African Americans must translate it "into the black idiom, *renaming* principles of criticism where appropriate, but especially *naming* indigenous black principles of criticism and applying them to explicate our own texts." However, by questioning the ownership of the language itself, he seems to imply that renaming is not enough:

> In whose voices do we speak? Have we merely renamed terms received from the White Other? Just as we must urge that our writers meet this challenge, we as critics must turn to our peculiarly black structures of thought and feeling to develop our own language of criticism. We must do so by turning to the black vernacular, the language we use to speak to each other when no white people are around. My central argument is this: black people theorize about their art and their lives in the black vernacular.[61]

In his book *The Signifying Monkey*, which elaborates on this theory, Gates uses the figure of the Yoruba trickster deity, Eshu-Elegbara, god of the crossroads, as a bridge—a precarious, teasing suspension bridge. However, while recommending a new vernacular, Gates is also aware that his medium is an analytical language incomprehensible to the black community he writes about and for. He runs the risk of alienating not only the white critical establishment, but also the black audience, which is not monolithic in the first place and is often unwilling or unequipped to deal with "the principles of criticism" in any case. Black visual artists find themselves in a similar position.

Taking a distinctly feminist position, Barbara Christian also warns against monolithic theory and jargon, against "authoritative discourse" from anyone,

▼▼▼▼▼▼▼

When asked why black art is so much less known, and apparently less powerful than black music or literature, Cornel West replied: "The strong, puritanical Protestantism of black religion has not been conducive to the production of pictures. For the same reason, there is a great belief in the *power of the word*, in literary acumen. Painters, consequently, have no status in the black community and writers do. . . . The access to the kinds of education and subcultural circles is much less available to potential black artists. It is not so much that the avant-garde [art] world is racist but that it is too far removed from what black artists would be exposed or even open to. You are talking about extreme marginality for the few blacks involved" (quoted in *Flash Art*, April 1987, p. 55).

▼▼▼▼▼▼▼

"I read somewhere that Black critics don't respect your work 'cause it ain't militant enough and white critics don't dare say anything about your books 'cause they might offend the Black critics. How do you feel about this?" All Mason's answers were as awkward as the sound of a bugle suddenly blown in a quiet reading library. Answering was like trying to launder dirty money.
—Clarence Major, *My Amputations: A Novel* (New York/Boulder: Fiction Collective, 1986, p. 65 [Mason is the novel's main character, a trickster-writer figure in his own right.])

The South African poet of liberation Mongane Serote drives himself into bilingual near-gibberish in his effort to escape the prison of Western words: "You've trapped me whitey! Memm/wanna ge aot Fuc / Pschwee e ep booboodubooboodu blllll / Black books, / Flesh blood words shitrr Haai, / Amen" (quoted in *Village Voice Literary Supplement*, June 1989, p. 7). This desperate song answers playwright Suzan-Lori Parks's description of "Black English/Ethnospeake": "verbicide onslaughted toward language-myth dissolution" (BACA playbill for Parks's play *Imperceptible Mutabilities in the Third Kingdom*, 1988).

insisting "There is no one way to be Black. . . . [Black people] have always been a race for theory—though more in the form of the hieroglyph, a written figure which is both sensual and abstract, both beautiful and communicative." "My fear," she continues, "is that when theory is not rooted in practice, it becomes prescriptive, exclusive, elitist." She senses that the "new" doctrine of textualism, for instance, could preempt the "literature of Blacks, women of South America and Africa, etc. as overtly 'political' literature" because reality does not exist, everything is relative, and "every text is silent about something—which indeed it necessarily must be."[62] African American theologian and Princeton professor Cornel West, who writes within the postmodernist framework, seems nevertheless to share her apprehensions:

> Ironically, First World reflections on "postmodernism" remain rather parochial and provincial—that is, narrowly Eurocentric. . . . My own hunch is that oppositional black intellectuals must be conversant with and, to a degree, participants in the debate. Yet until the complex relations between race, class, and gender are more adequately theorized, more fully delineated in specific historiographical studies, and more fused in our concrete ideological and political practices, the postmodernism debate, though at times illuminating, will remain rather blind to the plight and predicament of black America.[63]

The most satisfactory strategy for displaced African peoples confronting these problems is Paul Gilroy's admittedly "preliminary" option: " 'Populist Modernism,' a deliberately contradictory term which suggests that black artists are not only both 'defenders and critics of modernism' but mindful of their historic obligation to interrogate the dubious legacies of occidental modernity premised on the exclusion of blacks."[64]

The young African American artist Lorna Simpson has fused current theory with her practice, which consists of life-size color photographs of female figures and cryptic texts that serve as both captions and speech. Raised by parents politicized in the '60s, she is one of the generation that includes filmmakers Spike Lee and Julie Dash, actress Alva Rogers, performance artist Lisa Jones, artist Carrie Mae Weems, and writers Trey Ellis, Michele Wallace, Greg Tate, and Kellie Jones. Originally a documentary street photographer, Simpson moved into more ambiguous territory when she went to graduate school at the University of California at San Diego, partly because she had become uncomfortable with invasions of privacy endemic to documentary work. She remained interested in both the gestural and the linguistic aspects of "body language," and in the stereotypes they incorporate: "We need to shave off even the fictions that we've created for ourselves in terms of who we think we are as blacks."[65]

Appearance and disappearance, the invisibility of the "I witness" who because of race or gender is disbelieved by society, is another one of Simpson's themes. She prefers not to limit her subjects to specific issues (such as South Africa) because she wants "an echo that I'm also talking about America . . . so that the viewer realizes I'm also talking about your life. . . . I leave the

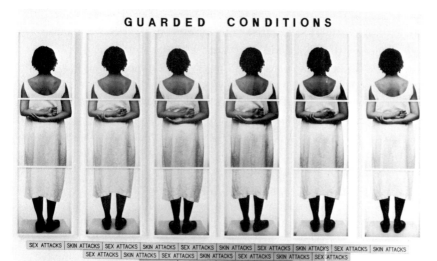

GUARDED CONDITIONS

SEX ATTACKS | SKIN ATTACKS | SEX ATTACKS | SKIN ATTACKS | SEX ATTACKS | SKIN ATTACKS | SEX ATTACKS | SKIN ATTACKS | SEX ATTACKS | SKIN ATTACKS
SEX ATTACKS | SKIN ATTACKS | SEX ATTACKS | SKIN ATTACKS | SEX ATTACKS | SKIN ATTACKS | SEX ATTACKS
SKIN ATTACKS | SEX ATTACKS | SKIN ATTACKS | SEX ATTACKS

Fig. 24: Lorna Simpson, *Guarded Conditions*, 1989, 18 color Polaroid photographs with 21 plastic plaques, 91″ x 131″. (Photo: Ellen Page-Wilson.) Simpson is interested in language and body language. She sees the viewer "as a kind of mirror," but the subject—a woman who is trying to "play the game"—is always partly concealed: headless, faceless, masked, or veiled. This concealment is physical, but also by implication metaphorical, calling attention to the way language itself—with its double meanings and the stereotypes or clichés that define gender and race and determine "proper" behavior—can distort, fragment, and ultimately "disappear" a person. *Guarded Conditions* repeats itself: the rear view of a standing woman six times, the accusatory label "Sex Attacks, Skin Attacks" some ten times, running on. The figure, in her anonymous shift that suggests a slip, a hospital gown, or a slave's garb, is both vulnerable and defended. Her back is to us, but her arms are clasped behind her back and one hand makes a fist. She could even be seen as defending us, the viewers, who are in a sense lined up behind her as she faces the unseen. The multiple imagery and the multiple words imply a transindividual situation, something that happens often, something against which we must all be "on guard."

reconstruction to the viewer. . . . I'm not so interested in morally defining what should be, [as in] exposing clichés that seem quite harmless."[66] Simpson is questioning roles and how they are "played." She looks back at the history of role-playing by using as sources game books from the '50s, remarking at the same time how "fade-cream" (skin lightener) ads have reappeared in the '80s. Given the apparent conservatism of the upwardly mobile black community and some of the student generation, Simpson is critical of a political ignorance abetted by national historical amnesia. Her images are of day-to-day experience, the mundane as entrance to common ground, and she connects this to a trend (paralleling the early women's movement) "where everyone works from their personal experience or from incidents in their own lives." Kellie Jones sees in Simpson's allegories of "the archetypal Black woman" a "suave innuendo of the Blues and the duality of use and meaning in the Black community (e.g. bad = good)."[67]

Black women share much of their experience with white women (and black men), yet their own stories are just beginning to be told, and a Black Women's Studies anthology is acutely titled *All the Women Are White, All the Blacks Are Men, But Some of Us Are Brave*.[68] Although interracial, intercultural work has been a priority for some white feminists since the beginning of the Women's Liberation Movement and the experience of feminism itself has been a catalyst for white women's involvement in antiracist work, the story of black and white women's relations is still a painful and an unfinished one.[69] Black women artists, along with other women of color, have been monitoring the feminist movement since its beginning, resisting, among other things, white women artists' assumptions that black art had no choice but to be political. The reviews have been mixed and most women of color have kept their distance from the feminist mainstream, but their vigilance has been rewarded by a somewhat more conscious sisterhood.

▼▼▼▼▼▼▼

We and you do not talk the same language. When we talk to you we use your language: the language of your experience and of your theories. We try to use it to communicate our world of experience. But since your language and your theories are inadequate in expressing our experience, we only succeed in communicating our experience of exclusion. . . . Complaining about exclusion is a way of remaining silent.
—the "Hispana Voice" (in Maria Lugones and Elizabeth Spelman, "Have We Got a Theory for You!" p. 575)

Fig. 25: Patricia Rodriguez, *Self-Portrait*, 1980, mixed media, 16″ x 25″ x 9″. Rodriguez is a *Tejana*, raised in the town of Marfa, Texas, near the Mexican border. She studied and now lives in San Francisco. She satisfies large-scale impulses in murals (with Mujeres Muralistas, in Balmy Alley, and elsewhere) and the small-scale ones in her assemblages. The reliquary, box, or *nicho* form is her true home, as she indicates in this self-portrait. (The other side of the mirrored bureau is a strikingly ornamented mask of herself.) A variety of little objects (bones, nail-bristling hearts, a skeleton, a comb, leg *milagros*) decorate the miniature piece of furniture, but the drawers hide other secrets.

Although the Women's Liberation Movement's early model was the Civil Rights Movement (just as nineteenth-century feminists had a complex relationship with the abolitionist movement), white women have consistently referred to themselves as generic Women, distinguished from a subgenre—women of color. Thus when a Latina speaks, she is seen as speaking only for her subspecies, not, as white women do, for women in general. "It is the dominant race that reserves for itself the luxury of dismissing racial identity while the oppressed race is made daily aware of their racial identity," writes Bell Hooks. "It is the dominant race that can make it seem that their experience is representative."[70]

As Maria Lugones and Elizabeth Spelman demonstrated in a groundbreaking 1983 paper on feminist theory and cultural imperialism called "Have We Got a Theory for You!" there is a general presumption that "those who do the theory know more about those who are theorized than vice versa." Citing the difficulties of "translating" theory from one group to another and locating the concrete place from which theory is spoken, they reject the notion that white women writing about all other women "must know more about all other women than other women know about them. But in fact, just in order to survive, brown and Black women have to know a lot more about white/Anglo women—not through the sustained contemplation theory requires, but through the sharp observation stark exigency demands."[71]

The role of feminist art within the Women's Liberation Movement has yet to be scrutinized in any depth. From such an analysis might come a theoretical bridge between white feminists and the art made by people of color that is directly connected to lived, local, political experience, as well as to the often overgeneralized international experiences of neocolonialism and postcolonialism. Gender experience, however, has a different structure in different ethnocultural communities and, as Judith Wilson points out, "Frantz Fanon provides a better theoretical basis for analysis of the socio-political role of art by women of color than, say, Simone de Beauvoir."[72]

Distinctions among the experiences of women from different races and classes were long omitted from most Marxist and most feminist discourses, yet they provide precisely that gap between the taken-for-granted and the inconceivable where new ideas can take root. An example is the writing of filmmaker, musician, and writer Trinh T. Minh-ha, whose recent book, *Woman, Native, Other: Writing Postcoloniality and Feminism*, questions the language of cultural representation, identity, and difference by using memory and storytelling as ways to deny "white men's lies." She has called for distinctions between "an alienating notion of Otherness" (the Other of Man, the Other of the West) and "an empowering notion of difference," identifying with "this Inappropriate/d Other who moves about with always at least two/four gestures: that of affirming 'I am like you' while pointing insistently to the difference; and that of reminding 'I am different' while unsettling every definition of otherness arrived at."[73]

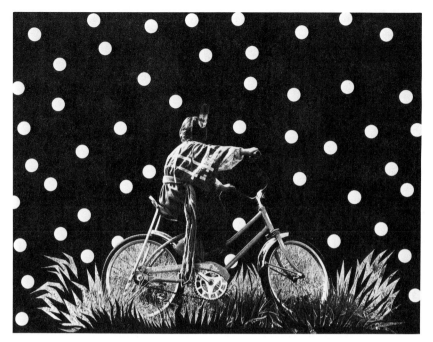

Fig. 26: Hulleah Tsinhahjinnie (Navajo/Creek/Seminole), *Mattie Rides a Bit Too Far*, photo-collage, 22″ × 24″. Collection Benny Alba. (Photo: Roger Gass.) Tsinhahjinnie is a photographer, curator, and lecturer in Ethnic Studies at the California College of Arts and Crafts. Since 1988 she has been working on a series called "Mattie Goes Traveling." Mattie, always dressed in traditional style, "is an enrolled member of the Yakima tribe, which means that she is recognized by the federal government as a 'real' North American Indian," writes Tsinhahjinnie. "Mattie symbolizes the child that has an unbroken spirit, no boundaries, and is moved by the slightest emotions. Mattie also represents Native people past and present." In this photo Mattie rides determinedly into the polka-dotted starry space of the unknown. It reminds the artist "that I need to teeter on the edge, and that at times we must go where we have been told not to go" (letter to the author, 1990).

Trinh's unique style of poetic analysis operates on the threshold between disciplines and transcends the last decade's intrafeminist debates over "essentialism" and poststructuralist "deconstructionism." Having become fluent in several languages, having studied in Vietnam and France and taught in Senegal and the United States, she is well equipped to "expand the language of the colonizer and use it in totally disrespectful ways."[74]

Self-naming is a project in which such relational factors—balancing one's own assumptions with an understanding of others—are all-important. When names and labels prove insubstantial or damaging, they can of course be exposed as falsely engendered and socially constructed by those who experience them; they can be discarded and discredited. But they can also be chosen anew, even if only temporarily, to play a part in the "polyphonous recuperation" that Gerardo Mosquera looks to from the Caribbean.[75] James Clifford seems to suggest the possibility of a changeable, relational identity when he says, "There can be no essence except as a political, cultural invention, a local tactic."[76] This seems a healthy compromise that allows historical and cultural commonality a role—and a political role at that—without freezing it into another instrument of control. As names and labels change, the questions change too. And as consciousness rises and dialogues take place, any single, unified resolution becomes more unlikely.

▼▼▼▼▼▼▼

It seems obvious to some of us that the disenfranchised *female* in decolonizing space, being doubly displaced by it, is the proper carrier of a critique of pure class analysis. Separated from the mainstream of feminism, this figure, the figure of the gendered subaltern, is singular and alone.
—Gayatri Chakravorty Spivak, in *Remaking History*, edited by Barbara Kruger and Phil Mariani (p. 273)

Fig. 1: Fred Holland and **Ishmael Houston-Jones**, *Cowboys, Dreams, and Ladders*, February 1984, performance at the Kitchen, New York. (Photo: © Dona Ann McAdams.) When two inventive black postmodern performers, each with an extremely individual style, took on the history of black cowboys, sparks flew. The poetic, action-packed piece was dedicated to Carlos Foster, a Cuban cowboy from the Bronx who started the "Urban Western Rideing Program" for inner-city youth. (He made his appearance in the piece via tape and a Super-8 film by Holland in which he rides his horse through the crumbling South Bronx.) Combining kids' and adults' cowboy fantasies (B movies acted out in pools of red light), dancing explosively to cowboy records played on a child's victrola, blasting stereotypes to excavate the history of black cowboys in the Wild West (including the Boley, Oklahoma, annual black rodeo), telling ironic stories about cowboys and Indians with toys as props, and other ironic stories about researching their piece, Holland and Houston-Jones roped politics, gender, and race into their eccentrically paced talking-dance performance.

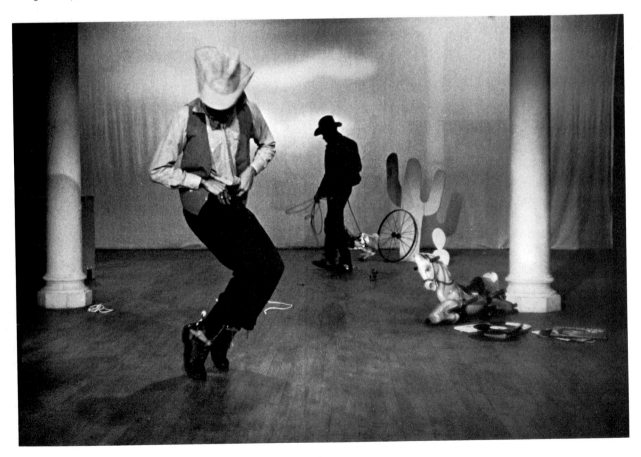

TELLING

▼▼▼

The story never stops beginning or ending. It appears headless and bottomless for it is built on differences. . . . The story circulates like a gift; an empty gift which anybody can lay claim to by filling it to taste, yet can never truly possess. A gift built on multiplicity. One that stays inexhaustible within its own limits. Its departures and arrivals. Its quietness.—Trinh T. Minh-ha[1]

. . . if the condemned of the earth do not understand their pasts and know the responsibilities that lie upon them in the future, all on earth will be condemned. That is the kind of world we live in.—C. L. R. James[2]

The role of tradition and belief, of memory, family, and history in art is a touchy subject today for a variety of valid political and theoretical reasons (as described in the last chapter). Yet origins—some dimly recalled and still meaningful, and some more recently invented and manipulated—constantly surface in even the most sophisticated and experimental art forms; they are often manifested in "traditional" elements as diverse as storytelling, pattern, references to belief and value systems, and family histories. But they are emotionally and analytically complex, hybrid narratives derived from both tradition and experience. These new/old stories challenge the pervasive "master narratives" that would contain them. Through them, and the arts by which they travel, it has become clear that the hybrid is one of the most "authentic" creative expressions in the United States—"in a local present-becoming-future."[3]

The deeper ground of "Telling"—the process of understanding and drawing strength from one's past, one's cultural history, beliefs, and values—is distinguished here from the socialized topsoil of "Naming," although the two are in fact inextricably connected, since they are the ways in which communal identity is forged and history is recomprehended.

▼▼▼▼▼▼▼▼

Stories come through you and through your culture. When I lived in Georgia, in my family there were "storytellings" around the breakfast table. The stories would start back in slavery time. They were funny stories with a twist—with one of us winning—and often made up right at the moment. The real and false Br'er Rabbit tradition, or even Amos and Andy—two white guys imitating two working-class Black men to bring up the issues of the working class. That's the kind of strange mixture we make our stories out of. Liberals from the NAACP come around and tell us we have to throw all of that away; it's demeaning. But they are survival stories. That's what I form my theater out of—those spontaneous storytellings creating characters right at the moment, but it goes back to the oldest oral tradition in Africa—the telling over and over.
—Robbie McCauley, "Mixing It Up II" (on radio station KGNU, Boulder, Colorado, April 1989)

In the African American community, for instance, artistic references to African cultures can be bitterly symbolic of lost freedom on one hand; on the other, they can be hopefully symbolic of the reclamation of culture—a freedom to reconnect and remember and perhaps to be freed from the overwhelming tragedy of the past. This kind of telling is neither nostalgia nor an imposed and falsified memory existing in a vacuum. Connected to the present, it becomes a survival mechanism—what Chicana artist Amalia Mesa-Bains has called an "art for the sake of life . . . remembering what [we] had chosen to forget."[4] Pilgrimages to Africa are sometimes undertaken not in the illusion of merging into a now-foreign culture, or of shedding Americanness, harsh as it may be. On the contrary, black American artists often turn to Africa to establish historically and emotionally their dual African American identities. Reacquaintance with distant African roots has proved both comforting and challenging, a point at which African American artists, intellectuals, and their communities can meet. The passionate welcome afforded Alex Haley's *Roots* in the '70s indicated the significance and necessity of such reborn memories. Painter Rosalind Jeffries wrote in 1971: "Sometimes there is an African cast to my images not merely because I lived more than two years in Africa and now see the world at large as my environment, but because I am Africa reincarnated in America."[5]

While most white critics and art historians would say they were familiar with the sentiments expressed by Jeffries, they/we have rarely taken them into consideration in regard to art that is not overtly Africanizing. Take, for example, the following exchange: in 1985 black artist Claude Ardrey wrote to *Arts Magazine* to protest reviewer Gerrit Henry's description of Sam Gilliam, a black artist from Washington, D.C., who then painted abstractly on loosely hanging or arranged fabric and has long been well-known and respected in the mainstream artworld. Ardrey said Henry had characterized Gilliam as "a kind of living monument to his own persistence and tenacity, a latterday representative of Sartre's 'existential man' who, having no traditions, no high-art past to grow on, must create his own past, his own present, and his own art-historical future." Ardrey indignantly replied to this statement:

Whether you may know it or not, Black or African people have a very "high-art" past to draw from and many creative traditions. Sam Gilliam draws from his heritage of African art . . . from the carved stone churches of Ethiopia to the masterpieces in wood carvings, weaving and bronze sculpture. Maybe your "no high-art past" remark means that you believe that functional and utilitarian art doesn't qualify? But be assured that just because Western civilization has decided on a certain set of rules to judge art, it doesn't mean that those rules or ideas are universally true. . . . The hypocrisy comes out strongly in light of the fact that the Western "world" is constantly borrowing or co-opting ideas, styles, and creativity from non-Western people and countries, and giving little or no credit where credit is overdue.[6]

The resurgence of overt African influence has ebbed and flowed since at least 1914, when Meta Warrick Fuller published her *Ethiopian Awakening*, but it remains as deeply rooted in black American art as it is in Cubist-derived Euro-American art. The literature of the Harlem Renaissance, which later inspired the concept of "Negritude" in the Caribbean via the writings of Aimé Césaire, provided a model for nonpolemic, esthetic Africanism in the arts. The militant (and sometimes oversimplified) Africanism that was a revolutionary inspiration in the '60s—most visible in "natural" hair, dashikis, kente cloth, and the invention of Kwanza celebrations at Christmas time—has been augmented in the late '80s by a more critical and complex view of the rela-

Fig. 2: *John Outterbridge, Captive Image 2,* from "Ethnic Heritage Group," 1978–82, wood, leather, cloth, and metal, 31" x 13" x 9". Outterbridge is an African American artist from Pasadena who works at the Watts Towers Community Art Center. His series of bound slaves—mutilated, blindfolded, but dressed in the remains of tribal finery, sometimes riding to their fates in a cart decorated with bright colors and symbols, sometimes (as here) apparently crucified on the wheel of a slave ship—suggests the power of the heritage to endure: "Along the way: deep within the spirit and flesh of my being, the fretting breath of ancestors guides the burning faith. Sacred are the visions ingrained like gleaming sermons preached far beyond the face of my night. Give me the courage to know the things of life that I may be worthy of my place. Above all teach me to share the gift" (John Outterbridge, *Other Gods*, p. 25).

▼▼▼▼▼▼▼

We must search for our own processes and symbols, if we can't find them in our individual selves then we must find them in our families and friends, in our cities (Harlem or Watts or South Sides or Fifth Wards), in our rural Texas, Mississippi, Alabama, Georgia, Carolina, Ohio, Nebraska, Arizona, California, Utah. We must take ideas from Guyana, Brazil, Jamaica, Cuba, Puerto Rico, Trinidad. From the Philippines, New Guinea, India, Ghana, Nigeria, Algeria, Egypt, Congo, Zimbabwe, Zambia, Tanzania, etc. They are all ours.
—Mel Edwards, *Mel Edwards* (New York: The Studio Museum in Harlem, 1978)

tionship between ancient and modern Africa and their historical effects on African-American culture.

To begin with, as Ardrey points out, there are many cultures from which to draw. The results are as diverse as Adrian Piper's didactic-conceptual performances, "Funk Lessons" (see page 70), and Martin Puryear's graceful forms indirectly monumentalizing the elegant objects from Africa's past and present. Abstract sculptors have been particularly attracted to African culture because of the power of its ritual and functional designs. For instance, Mel Edwards's monumental iron and chain sculptures pay homage to Shango, Yoruba god of thunder, and Ogun, god of iron, as well as to the great African metalworking traditions. (There are stories of mutinies aboard slave ships where African blacksmiths managed with found objects to form hammers and anvils, and to break the shackles of their countrymen.) Edwards's large, abstract "Rockers" of the '70s, with their arched steel and chains, were based on the chair in which his elderly, and politicized, grandmother spent much time.

The majority of slaves were abducted to the United States from West Africa but had cultural roots in the Central African Kongo and what is now Angola. However, the intricacy and brilliance of West African Dogon cosmology as reflected in architectural and other material culture has been a significant inspiration for contemporary artists, along with the Yoruba. Dogon complexity has also appealed to a number of white scholars and is probably the best-known African culture within the arts world. George Smith's massive wooden architectural structures based on Dogon habitats in the Bandiagara Cliffs, for instance, are part of the mainstream of massive geometric sculptures, but they are also homages to and "an exploration of ancestral origins and cultural identity as well as African art's emphasis on binding a community together with the dignity of appropriate symbols."[7] Sculptor Tyrone Mitchell has visited Dogon peoples in Mali and found among them the *hogon*—the blacksmith/mask-maker/shaman/healer/historian of the community, who offers an impressive model for the social role of the artist.[8]

Another high-energy point of contact between European and immigrant Third World cultures in the United States lies in the misty and controversial domain between art and religion where artworld "primitivism" meets mass and popular culture, "kitsch," and the "folkloric." The richly material religion called Santería, one of the fusions of Catholicism and African beliefs that emerged in Brazil and the Caribbean, claims 100 million followers in Latin America and an estimated 5 million in the United States. During the eighteenth and nineteenth centuries, the outlawed and suppressed African religions offered spiritual solace to slaves ripped from their homelands. Although legal for a century now, they remain suspect and repellent to xenophobes, who equate animal sacrifice with Satan worship and animism with barbarism.

In recent years the syncretic religions have emerged from vernacular and nationalist academic art and surfaced within avant-garde art, first in the Caribbean, where the practice of Santería and other Afro-Catholic religions has

▼▼▼▼▼▼▼

It was, after all, in the name of Spirit, not ingenuity, that artist/devotees of *Candomblé* in Brazil, *Santería* in Cuba, and *Voudoun* in Haiti syncretized Yoruba *orisa* and Kongo *minkisi* with images of Roman Catholic saints to constellate new images designed to bypass Western distinctions between the *sacred* and the *secular*.
—Judith McWillie, in *Another Face of the Diamond* (p. 9)

Fig. 3: Mel Edwards, *Cup Of?* and *Alterations* from "Lynch Fragments," 1988–89, steel, c. 12" high each. Edwards, born in Texas and raised in California, has been a resident of New York since 1967. Although he has art in museum collections, received a Guggenheim, major commissions, and a professorship at Rutgers University, he has not had a one-man show in New York and is only now being belatedly recognized as a major mainstream sculptor. Edwards is a well-traveled pan-Africanist who also spends time in the Caribbean. *Cup Of?* was made during a three-month stay in Zimbabwe, after meeting with Mozambican refugees; *Alterations* was made on his return. Edwards has said of the "Lynch Fragments"—an ongoing series begun during the Civil Rights Movement in 1963, now numbering over one hundred pieces—that although they deal with "bad luck, or bad fate" for African Americans, they are positive images: "They are powerful and they are ours, and they are mine, and they are not made by our oppressor. . . . What I'm doing is taking fragments of the intensity of a lynching, turning it around, changing it into an object. . . . So the thing itself is not to look like it's been lynched, but to have that scale of intensity, and that kind of power." Related to but never imitating African masks from different cultures, when seen together, these small endlessly varied steel pieces, made from objects found and invented, take their weight from an implied history of work and brutality, constituting a chain of form and meaning. (Quotations from Mel Edwards, "Lynch Fragments," *Free Spirits I*, pp. 94–96.)

flourished and continues to develop, and later in the United States as a result of migration. Distance and lack of institutionalization have allowed a flexibility and constant flux in practice and iconography that resemble (from the outside) nothing so much as art. Even closer to the cultural roots, the lines between ritual and art are blurred. The boundaries are defined by context: sacred space, or profane art space.

Santería faithful and adepts can be both respected practitioners and "real artists" working inside or on the margins of the established art context.[9] Among

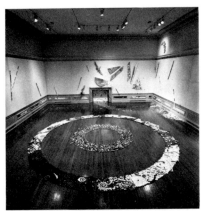

Fig. 4: Martha Jackson-Jarvis, *The Gathering*, 1988, installation with ceramic shards. c. 40' in diameter. Jackson-Jarvis is an African American sculptor raised in Lynchburg, Va., and living in Washington, D.C. She teaches at the Corcoran School of Art and the University of the District of Columbia. Here Jackson-Jarvis brings together the cultural fragments among which she lives: broken crockery, architectural tile, and rejects from her clay studio, re-investing these discards with new meaning and life. "Embedded in the body of the work, the shard re-establishes its place in the universal order and represents recovery of lost identity," Belena Chapp has written (*Martha Jackson-Jarvis*, University Gallery, U. of Delaware, Newark, 1988, n.p.). The rich colors and textures and syncopated rhythms seem to have exploded onto the walls, where shield and spearlike pieces call back to the central rings. "For me, art is the documentation of the human spirit," says the artist.

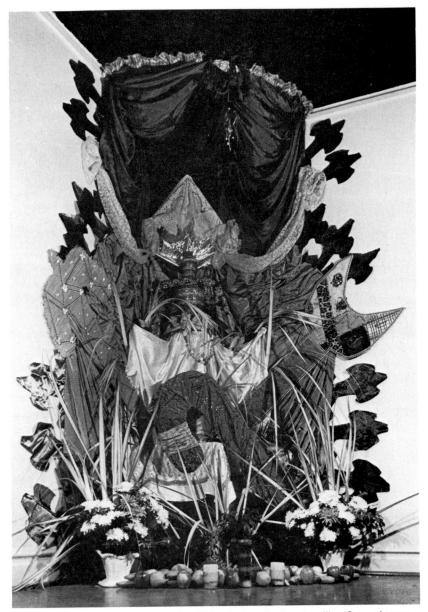

Fig. 5: Juan Boza, *The Greater Ceremonies*, 1988, mixed media, floor to ceiling. Boza, who was raised in Cuba, is an American painter and printmaker whose art departs from a childhood that revolved around "animals, trees, rocks, ritual objects from nature, the energies and mysteries of Yoruba Lucumi. . . . The states of the soul are sometimes violent, always mysterious and invisible." He often works from *nsibidi* signs used by the secret, all-male Abákua, or Leopard Society, in Cuba. Installations like this one, in which the central figure is Shango's father, Aganju, might be actual altars, with their anarchic combination of flowers, candles, Shango's axes, dimestore figures, satin costumes, mysterious objects collected apparently at random, each with its own occult meaning. Boza's art altars are in fact religious composites. His first show in New York (at INTAR) was called "Black Mysticism," countering the notion of "black magic."

Fig. 6: Trena Banks, *Untitled*, 1986, acrylic on paper, 4' × 5'. Banks is a young African American artist from Scottdale, Georgia, who attended the University of Georgia at a time when it was recruiting black students, though the campuses were not ready to accept a "fly in the buttermilk." Finding herself the only black in many classes, she "attempted to share the African part of my African-European culture," but was "forced to refrain from using many of my forms of expression in order to be accepted." Her influences are local rather than those taught in the university. Apparently abstract, her paintings all have specific references. Banks begins her explanation of this work by saying, "First, I give honor to God who is my friend and comforter, who is responsible for my creativity." The names on the left of the painting are of men whom the artist admired as a child; "I respected these men because they respected me and provided me with a secure and loving environment. They are the members of my family, the leaders of churches I attended, and the fathers of my childhood friends." A second list is the names of white men she saw on television, including Jesus Christ. "The figures across the top show whites and blacks holding hands. It is a symbol of unity." The lower part depicts her youth, her "struggles with assimilation." Committed to a world united in desiring peace and justice, Banks insists on the necessity to "accept the fact that everyone is different. We must seek to destroy our fears of things which appear foreign . . . and become more submissive to change" (letter to the author, 1990).

the *santeros*, or priests, who are also exhibiting artists are Cuban American Juan Boza and the late African American Charles Abramson (plate 9). Many others have borrowed the compelling motifs of the various African-based religions. Secularization does not seem to amount to blasphemy, as it does in the Catholic church, due in part to the traditional African lack of separation between life and art, life and religion. But artists raised within the religion say that there are certain aspects they would never expose in a secular context.

The North American scholar who has done the most to illuminate the vitality of specific African cultures in today's Americas is Robert Farris Thompson, a Yale professor of art history and Africanist who concentrates on and, for a white man, is uniquely attuned to contemporary African American popular and mass culture. He speaks Yoruba and often travels to Africa. His writings on black art and philosophy in this hemisphere simmer with insights for a still mostly oblivious mainstream. (When he lectures, he walks "up and down the aisles like an old-time Southern evangelist, dancing and drumming the top of the lectern."[10])

Thompson has identified a new web of rhythms and patterns, playing off African textiles, jazz, myths and rituals, quilting, break dancing, contemporary art, syncretic religion, and even sports. His concept of "body architecture," determined by an asymmetrical, polyrhythmic visual tradition, clarifies much recent Latino and African American art, as well as some white art.

Maverick sculptor David Hammons is one artist who confirms Thompson's ideas (plate 10). Best known for his architectural bricolages, his public sculp-

▼▼▼▼▼▼▼

In Black art, you actually create life in a visual image. Western and European philosophy is based on "I think therefore I am." Black African philosophy is, simply, "I am."
—William O. Thomas (quoted in Elsa Honig Fine, *The Afro-American Artist*, p. 192)

tures and actions, Hammons has worked for years with materials found in Harlem and other black communities, especially hair, bottles, and bottlecaps:

> I do my street art mainly to keep rooted in that "who I am." If an artist doesn't have his own rules then he's playing with those of the artworld, and you know those are stacked against you. . . . Working the way I do, collecting stuff and letting it build up around me, feels very good. I can't do any wrong. The objects find each other. It all flows together and that feels very fine. I like the energy of used things. I like my objects to have spirit already in them.[11]

Hammons's "garden" of *Bottle Trees* in Harlem closely resembles African-influenced grave offerings in the South and their protective offshoots, the Kongo-derived "bottle trees" intended to ward off spirits. (In fact, Hammons cited Thompson's book *Flash of the Spirit* as inspiration for a sculpture of a vodun doll in a bottle.)[12] Hammons commented to Guy Trebay:

> One artist accused me of "showing a bad image of Harlem." And I said, "I'm not showing anything, I'm just putting stuff that's on the ground onto a tree. I'm not responsible for that wine bottle getting there. All I'm doing is playing with it, activating it in some form. . . . My big inspiration is Simon Rodia's Watts Towers. They're magical. . . . Stand next to [them] and it's like a beautiful rocket ship shooting up to heaven.[13]

As a determined iconoclast, Hammons deliberately plays the "holy fool," a figure of great importance in communal purification in many ancient societies:

> Sometimes I carry a whole arch of wine bottles around in the neighborhood. I walk from 125th up to 145th Street and people follow me, ask me questions, give me answers, tell me what I can do. . . . I do this every once in a while to cleanse myself. It's putting myself out there on the street to be made fun of. I think it's important to be laughed at. Black people, we have more problems with being made fun of than any people I've ever met. That's why it's so important for us to be cool, cool, cool. If you're not cool then you're something else and no one wants to be that other thing. But that other thing is what I'm interested in, because you have to really work at getting to that other space. Black artists, we are so conservative. We've come up under this Christian, puritanical, European form of thinking and it's there, deep-rooted. It can be worked at, loosened up some, but it's very difficult.[14]

Belief and ritual as they are integrated into everyday life and a certain nostalgia for the historical African unification of work, religion, and art are a frequent subject of contemporary black art. Yet the syncretism at its core is often misunderstood by white critics, as epitomized by Benjamin Buchloh's question to the organizer of the "Magiciens de la terre" show: "Don't you think that the search for the (re-)discovery of spirituality originates in a disavowal of the politics of everyday life?"[15] Such a view misses the crucial point at which spirituality and politics meet and reinforce each other.

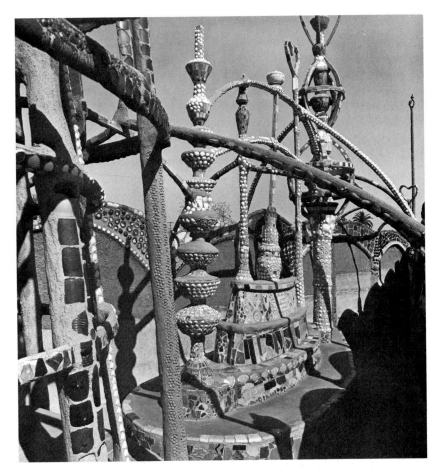

Fig. 7: Simon Rodia, *The Watts Towers*, 1921–54, 99½′ high (Photo: © Seymour Rosen.) Among the materials: 70,000 sea shells, broken china, cement, dismantled pipes, steel bed frames. Rodia was an Italian immigrant who left Watts (a suburb of Los Angeles) when he had singlehandedly completed this monumental lifework. "You have to be good good or bad bad to be remembered. I had in mind to do something big, and I did," he said (quoted in *Art Issues*, no. 2, Feb. 1989, p. 15). The towers look delicate but are structurally strong. Their glorious colors and patterns have influenced countless contemporary artists, especially artists of color, since Watts became a black neighborhood. The state of California has approved one million dollars for the preservation of Watts Towers.

Alison Saar (plate 13) has long been inspired by African, Latin American, and Caribbean (especially Haitian) art and religion, as well as Haitian art and vodun in the United States. Her approach to materials—often carved and painted wood and patterned tin—is as inventive and unselfconscious as that of many untrained artists, though her sense of scale, breadth of mediums, and layered meanings reveal her sophistication. Saar incorporates into her sculpture old wooden or ornate metal frames, votive candles, plastic flowers, and bric-a-brac. Tin angels in business suits and whimsical contemporary *santos* ride bicycles or ascend gleefully into the clouds. An impassive black male (with a punk-Afro cut, sly green eyes, and two earrings in his left ear) holds in his mouth a horizontal green snake—a collaborative balancing act that can be read as a commentary on nature and culture, on fear and faith. Saar's 1986 *Soul Service Station* in Roswell, New Mexico—an outdoor cement and mosaic sculpture in which a gas pump, a friendly attendant, and a waiting dog offer "Petrol for the Soul, Spirit Tuneups, Blues Flushout and Ol' Tickers Charged"—was inspired by "the vastness of the land and the sky, how it

Fig. 8: Noah Jemison, *The Ritual House*, 1984, wood chips and string, personal ritual materials, 4′ × 6′ × 8′. (Photo: John McKie.) Jemison is an African American painter, sculptor, and curator in New York. The house and a similarly executed bed are outlined in delicately strung wood strips, which were laboriously carved from a tree trunk, then gracefully knotted into long lines. The house has been shown in several different versions and contexts, indoors at Kenkeleba House, in collaboration with Lorenzo Pace, and outdoors on Staten Island, where it was placed on tilled ground that was planted with morning glories and running beans so that it changed through the seasonal cycles (Jemison documented the process in photos, drawings, and watercolors). His string sculptures relate to his paintings, in which overlapping images are woven from a looping, tangible line of encaustic. In all of his work the African ritual influence is indirect, but deeply felt, "cosmic and primitive (as in the first, earliest, or original)." "Tactileness is an Afro-American esthetic concern," he writes, "an expression of empathy with materials and with one another. . . . I like to think of *The Ritual House* as a piece of organic sculpture created to

induced one to reflect on things great and small."[16] It also paid homage to Latino roadside shrines and *descansos* (invitations "to passersby to honor dead ancestors"). This and many of Saar's works recall childhood influences—especially that of Italian-American Simon Rodia's spectacular Watts Towers, built over the years from discarded pottery, glass, tiles, mirrors, and other neighborhood detritus, as well as "Grandma" Tressa Prisbrey's "Bottle Village" (also in southern California).

These works of the early '80s were followed by large vertical black-and-white drawing scrolls—iconic, full-length portraits of "Shamans, Saints and Sinners" framed by mosaics of shardlike images—pictorial fragments from old encyclopedias doubling as broken mirror/broken knowledge. Figures like *Juju Eugene*, *Python Lady*, *Tattooed Lady*, and *El Bato Loco* rise like genies through blank white space, just as their spiritual powers emerge within their own communities, where they transcend their daily disguises as anonymous workers in the general public. As such, these works are complex and nonrhetorical symbols of a Black Power unrecognized in the outside world. Saar describes the portraits as "modern fetishes of the magic and mystery of the urban underground." Like many self-taught black artists, such as Bessie Harvey, Saar also uses the root-figure form, but in a scale hugely magnified from that of the traditional charm.

Harvey, who is from rural Tennessee, describes her process:

> I see this vision of one of these dolls or somethin', and I can't sleep. . . . It's somethin' like a torment. . . . When I was a child I had these strange things I'd see and feel and now I'm puttin' them in wood . . . and just about everything I touch is Africa. . . . I must claim some of that spirit and soul. . . . To me Voodoo is just like Methodist and Baptist. . . .
>
> You go to the wood pile and all at once you see a face, in any piece of wood, and it looks like it's just askin' for help, for help to come out. . . . Take Horace. Well, when I first found him he was just a big limb but I knew he was a beautiful man, I knew that when I pulled him out. . . . I said to him, "Ain't you pretty." He said "Granny, I ain't nobody." But I saw him and I just couldn't wait to get him home to get started bringing him out.[17]

Harvey's wooden figures (plate 12), many made from the found root and branch forms that constitute an important genre of black art, are provoked by dreams and visions. Married at age fourteen, she had eleven children. "I didn't become truly human until my youngest was half-grown. I was a little better than an animal trying to scrape together food and shelter for them," she recalls. As her religious and spiritual life deepened, Harvey began to envision the "dolls," as she calls her sculptures. She views her art "as a collaboration with God and Nature," says her white agent/dealer Shari Cavin Morris. They are the children of trees, or "soul people," a "family" or "tribe" that goes back to a legendary "Old Africa." There is a passion or wildness (not savagery) in

Harvey's art that testifies to its "roots" deep in both psyche and history. Bessie Harvey is not imprisoned in her cultural sources, but freed by them.

Nowhere are the intercultural and the spiritual shaken up more impressively than in the work of Houston Conwill. His relief paintings, sculptures, installations, performances, and public works combine African religions and mythologies with his Catholic upbringing, an abandoned vocation for the priesthood, and ecstatic black Protestant rituals that turn the circle back toward Africa. He is concerned with generosity, with *ashe*—the Yoruba spiritual command, the power to make things happen. He plays the role of the *griot*—"keeper of history, doctor, musician and blues singer, not in moaning self-pity but as the voice of a people"—and of the messengers Eshu and Hermes, both associated with crossroads, an appropriate symbol of this intercultural moment in history.

Conwill's fusions of Catholicism and African religion share the syncretic impetus of Santería, Vodun, Candomblé, Macumba, and Abákua, and the other African-based Christian sects, but his art is primarily metaphysical. He sees singing and drawing as the points of contact between the African and Western worlds, and he has layered and inflected his art far past ordinary viewers' immediate comprehension, whatever their race.

> **Black culture is the fusion of spiritual and physical; the blues are spirituals physically expressed. . . . Religion is a pain because you can't deal with it without being affected by it. The church isn't hip, but it provides leadership and a structure in which we can communicate with the unfathomable.**[18]

Conwill has adopted the ideographic *nsibidi* or "cruel language" of the Cameroons and Nigeria, and the cosmograms and ground drawings, or *vévé*, of Haitian vodun. He uses "goofer" or grave dust and the reflective powers of mirror or light to suggest the power of death to invert and set in upward motion. He maps out places for the African American psyche to rest, but never without reminders of the preconditional sacrifices and dismemberment—taking yourself apart and putting it back together. In his "Passion of Saint Matthew" exhibition in 1986 (dedicated to the memory of Ana Mendieta), Conwill surrounded the classic Christian myth of death and resurrection with auras from other pasts, including the prehistoric labyrinth, the reconstitution of Osiris, and the suppressed version of Orpheus and Eurydice in which they escape from Hades. Circle sculptures and a glorious rainbow arc commemorated "times spent in the 'circles of hell' " as well as "love of self, mate, culture . . . a willingness to descend to the depths of hell for love."

Descent, death, and burial and their implied correlations—ascent, rebirth, and the morally purifying firelight—have been the themes of Conwill's "time capsule" pieces. The ongoing series began with a 1979 earthwork in Atlanta, where forty-eight scrolls were interred in niches deep in a rectangular pit of

catch the wind." The extra whiff of spirit, the breeze that blows the hanging walls, comes perhaps from Birmingham, Alabama, where the artist was raised, and whose brutal recent history he shared. (Quotations from unpublished statement, c. 1986, and letter to the author, 1989.)

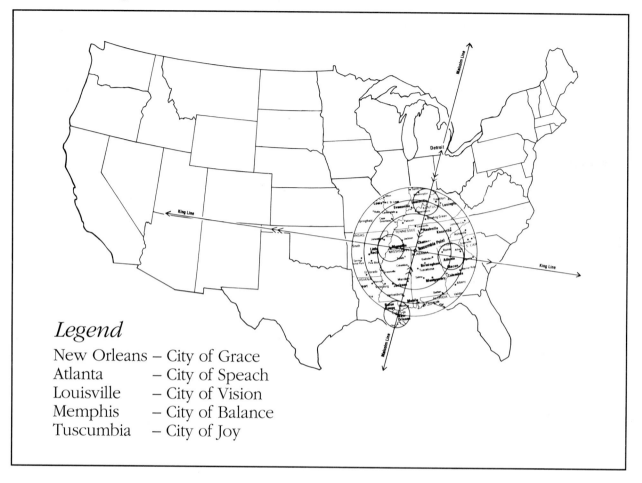

Legend

New Orleans – City of Grace
Atlanta – City of Speach
Louisville – City of Vision
Memphis – City of Balance
Tuscumbia – City of Joy

Fig. 9: Houston Conwill, (a) *The Cakewalk Humanifesto*, as shown at the Museum of Modern Art, New York, 1989, etched glass (8′ × 9′), glass table with glass bowls containing earth from New Orleans, Atlanta, Memphis, and Louisville, and *Libations*, a book by the artist's sister Estella Marie Conwill Majozo, read from by volunteers during the exhibition (Photo: Mali Adelaja Olatunji); (b) diagram of *The New Cakewalk*. For most of the '80s Conwill worked on pieces related to this grand design. The "initiatory topography" unfolds within three concentric circles. The first is quartered—an ancient image of the cosmos symbolizing power drawn to a center from the four cardinal directions, and

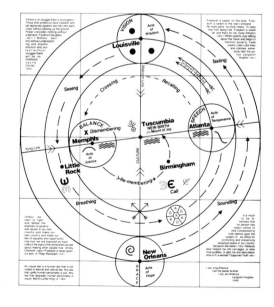

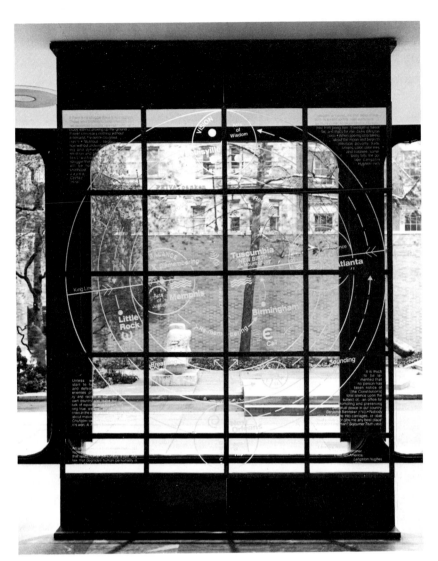

the crossroads where blues musicians traditionally gather. The second is a rearrangement of the ancient ritual hopscotch game, numbers one through ten guiding the player from heaven to hell. The third is the maze at the Cathedral of Chartres, an ancient dance diagram overlaying Christianity on paganism. Four cities represent the four senses: Louisville, Kentucky, where the artist was born, is the City of Vision, the eye (art); Atlanta, home of Martin Luther King and Conwill's wife, Kinshasha Holman, director of the Studio Museum in Harlem, is the City of Speech, the mouth (leadership); Memphis, where King died, is the City of Balance, the nose (justice); and New Orleans is the City of Grace, the ear (music). At the center of the cosmogram—the mirror in the belly to draw the light and also site of the maypole or earth axis around which the transcendent dance takes place at the end of the journey—is the City of Joy, the Alabama town of Tuscumbia (Choctaw/Chickasaw for "walking to power," originally called "cold water"), where Helen Keller, symbol of communication against odds, was born (water was her first word): "I was blind and now I see."

The pattern is set by directional lines, reminiscent of ancient "ley lines," often incorporating ancient Native American sacred sites. The cakewalk dance is the activator. The "King Line" goes from Atlanta to Memphis, birth to assassination, representing the zone of dismemberment or symbolic death, the chaos that must be passed through to form a new self; the "Malcolm Line" runs through New Orleans, Louisville, and Detroit. This ideogram is "a matrix on which to put your ideas—not answers, so much as a way to find the right questions"; around it Conwill has developed a complex iconography, almost an independent theological system. (For details, see Susan Krane, *Art at the Edge: Houston Conwill, The New Cakewalk* [Atlanta: High Museum of Art, 1989] and brochure by Lynn Zelevansky for MoMA show.)

Georgia red clay, a gift of art back to the earth. "The blues are about digging and burying—you dig? As a Catholic I didn't hear those songs, the hollers and shouts, in church, but my grandmother hummed the blues under her breath."

The time capsules were "juju bags" in tubular form, decorated in bas-relief with African symbols. They were the focal point of *Joyful Mysteries*, a public ritual performance in Harlem for which Conwill solicited statements about the future of Afro-America from a series of well-known figures (including Eleanor Holmes Norton, Leontyne Price, and Romare Bearden). These were then wrapped, encased, and ceremoniously buried by a group of Harlem children who were asked to return in fifty years, retrieve the capsules, and share their elders' messages. ("I pledge to return and give life to the seeds we plant here," said fourteen-year-old Garikai Campbell.) This was part of Conwill's "communal quest for a blues vision—a critical vision that can lead to the transformation of society."

Conwill's "Festival Uniting Newday Kingdom" (F.U.N.K.) is "Funktional," designed for the year 2000 as a pilgrimage from hell to heaven ("You've got to get down to get up; you got to dance hot to get cool"). By following the path of communal survival in the spirit of self-healing, by drawing the energy of one's ancestors toward the crossroads, the "mythic boundaries of potentiality" are established for future generations. Conwill poses "re-memberment" against "dis-memberment" in a hopeful reembodiment of a whole humankind. The installations Conwill has constructed since 1987 around the F.U.N.K. "Humanifesto" are ambitious, expansive mappings of a rite of passage toward spiritual maturity, when "funk rises." He delineates the spiritual journeys or "cultural pilgrimage" of African Americans within a psychological geography superimposed on that of the United States, citing Victor Turner on the pilgrimage as "a paradigm for ethical and political behavior."

In very different forms, Adrian Piper shares Conwill's role as messenger and teacher. In 1983 she began to travel with a series of performances called "Funk Lessons." Piper spoke professorially about the origins of Funk and then gave dancing lessons. This curious but effective mixture was billed as "a collaborative experiment in Cross-Cultural Transfusion; Music Appreciation; Social Dancing." The glitzy poster featured a regal Bootsy Collins in velvet and ermine, crown, and rhinestone-studded star-shaped shades.

As she studied this music from the heart of the black working class, with its obviously African roots, Piper realized her own whole-hearted identification with it. She had been listening to Funk and dancing to it for years before she discovered the aversion many white people felt to its multilayered polyrhythms: "I was not, in fact, as assimilated into white society as I had always thought." Funk became more than an esthetic vehicle for revelations about her own social/racial situation. As the possibilities for political confrontation became more vivid, she began to use the music and dance as a communicative vehicle

across the barriers of difference, as a wedge into the consciousness of those who could, at least, move to music. Watching Piper at work at the Los Angeles Woman's Building, Irene Borger called her "a healer in the African tradition" and observed that "learning the ethos of a culture on a body level means being able to cross borders without getting stepped on by the guards."[19]

Because Funk was a gift from the "disadvantaged community," it reversed the engrained puritanical/liberal notion that the talented and privileged are the only ones with gifts to give. As the straight, "almost-white" professor, Piper was also the conductor of an implicitly sexual, "down and dirty" electricity. She perceived that Funk's overt and nonchalant acceptance of sexuality as part of daily human relations repelled or terrified many whites. "Let your body talk," say the funky lyrics (which white feminists have frowned upon because of their sexism).

Piper found, not surprisingly, that dancing plays a different role in white and black cultures. Funk is the work-stained counterpart of Soul, igniting a kinesiological ecstasy implied by the spiritual implications of the original Kikongo word.[20] As a musician friend of mine put it, Soul invites you to dance; Funk demands that you dance. Its "heteroglossia" or "polyphony" is paralleled by the dance itself, which demands the ability to move different body parts to different tempos, a metaphor for the balancing act demanded of black people in a white culture. Here the hybrid represents the ideal. Piper's own "Notes on Funk" are provocative. She writes that the reluctance of some whites to partake in black dance comes less from puritanism than from a sense of intrusion and impotence: to participate in black cultures is "to pretend to be what one is not"—hipper and sexier than one really feels. Piper also connects this rarely acknowledged feeling of inferiority to African Americans with the Euro-American's feelings of inferiority to "real Europeans." Given such complexities, white writer Dave Matheny felt that the basic premise of "Funk Lessons"— "Let's get down and party, together"—worked: people "seemed to shimmer back and forth between black and white in their movement."[21]

Marcel Griaule pointed out in 1948, as have many others since, that among the Dogon the symbolism of loom and cloth is interwoven with the origins and activity of speech. This suggests parallels to the Navajo Spider Woman and Pueblo Thought Woman stories. "The interrelation of woman, water, and word pervades African cosmogonies," writes Trinh T. Minh-ha, who has lived and taught in Senegal. "Making material: spinning and weaving is a euphonious heritage of wo/mankind handed on from generation to generation of weavers within the clapping of the shuttle and the creaking of the block—which the Dogon call 'the creaking of the Word.'"[22] African American women (like Indian, Latina, and Asian women) have also been the keepers of stories, the holders of history. Yet when they translate these elements into their art, they are sometimes accused of being simplistic, rhetorical, anachronistic, or over-

Fig. 10: Martin Puryear, *Seer*, 1984, painted wood and wire, 78″ × 52½″ × 45″. Collection Solomon R. Guggenheim Museum, New York. (Photo: © Douglas M. Parker.) Puryear has for years worked between African sources and modernist art and craft sources, including the domestic architecture of many cultures. He worked in Sierra Leone with the Peace Corps, studied woodworking techniques in Sweden, and has an MFA from Yale. He was attracted to Scandinavian furniture because it had "evolved out of a craft tradition into modern production without losing the vitality of the original" and to African arts because they too were "part of a continuous tradition, not a revival" (interview in Hugh Davies and Helaine Posner, *Martin Puryear* [Amherst: University of Massachusetts at Amherst, 1984], p. 31). Puryear's unexpected objects are dignified, graceful, obdurately private. They are unexpected in part because they suggest forgotten or unfamiliar functions, not only because of their shapes but because of the loving care with which they have been created. The continuously inventive and elegant wooden forms are often contrasted with incongruous materials such as tar, dried earth, rope, or patched wire mesh. The curving "horn" of *Seer*, for instance, is painted blue. It could be a trap, a cage, an implement, or a ritual object.

optimistic, despite the fact that in the real world of art practice, contradictory theories can meet and overlap within one body of work.

When the British–West Indian artist Sonia Boyce was asked in an interview about "the unidirectionality of the positive black image . . . being just as oppressive as the negative stereotype," and the possibility that her own elaborate figurative drawings and paintings about black women were "playing with and against the black stereotype at the same time," she replied:

> In one sense I am celebrating the strength of black women; however I try not to glorify that strength because I'm constantly reminded of why black women have to be strong. As we know there is a barrage of institutionalized representations of black people. There are enough negative and insulting images. The question becomes then, how does one confront these distortions and initiate change. . . . When you start to discuss the issues that affect a community, transposing positives for negatives is insufficient in dealing with the complexities of human experiences and given structures. . . . Is negativity the privilege solely of white people? You become a caricature if you're always positive.[23]

Boyce sees herself as "an oral translator through pictures," paying homage to the strong oral tradition of African culture. She also attributes her use of pattern to her mother's house, where "your eyes can't stop blinking for all the patterns in the house." Faith Ringgold, born and bred in Harlem's Sugar Hill, might cite similar influences. She often worked with her mother, Willi Posey, a dress designer who had learned sewing and quilting from her mother and her grandmother, who had learned in turn from her slave mother.[24] For two decades, Ringgold's tankas (cloth frames), masks, stuffed sculptures, performances, and story quilts have told Harlem's stories (plate 14). Ringgold's family constitutes an impressive matriarchal line; her daughters are the linguist and teacher Barbara Wallace and writer Michele Wallace, author of *Black Macho and the Myth of the Superwoman*, who wrote recently that she was raised within "a deliberate and self-conscious black counterculture"—counter, that is, to "The Great American Whitewash." Wallace recalls following her activist mother through the galleries of the Museum of Modern Art in the late '60s as Ringgold, in her role as self-appointed docent, "lectured on the influence of African art and the art of the African diaspora on the so-called modern art displayed there."[25]

Ringgold, now a full professor at the University of California at San Diego, began showing in the '60s as a radical figure painter, best known at first for her altered flags in which messages like "Die Nigger" were secreted among the stars and stripes, and for her courageous pioneering role among black feminist artists. She is also an abstract painter, influenced by Kuba designs (geometric African textiles) and Tibetan tankas, playing with the concept of "black light" and its references to the physical and spiritual luminosity of black skin and paint as the skin of a canvas. And she has also been a performance artist, working sometimes in collaboration with her daughters, who have occasionally

helped script her soft sculptures and "Witch Masks" into stories about life and death in the black communities.

In 1980 Ringgold made her first quilt, on commission from "The Artist and the Quilt" project.[26] In 1983 she made the first of the painted story quilts that constitute her major mature works. The quilts combine the gridded ranks of frontal, hieratic portraits of fictional Harlem residents that have recurred in Ringgold's painting since the '60s, and the narrative threads and African influences of her fabric pieces and portrait masks. With flair and ebullience, Ringgold performs the griotte's function in the domestic materials of story and cloth, telling dramatic tales of foreign wars and city street life, slavery and resistance, passion and greed, jazz and the Harlem Renaissance, murdered children in Atlanta, family intrigue and tragedy, all painted with compassion, humor, and often anger in a proud vernacular tradition.

Ringgold's quilts fuse, as Amiri Baraka has put it, the field and the drawing room. Alternating rhythms of intensity and relaxation mark all of Ringgold's work. The repeated ovals of her protagonists' multishaded brown faces stare straight out at the viewer like African carvings, Ethiopian saints, or Fayum mummy cases—a formal and double-coded political device that addresses black viewers with complicity and stares back with a certain haughtiness at those white viewers who may never have looked a person of color in the eye. And then there are the flamboyant juxtapositions of pattern and texture, sedate florals nudging jungle swirls, velvets, brocades, and other finery, providing royal garb for a communal dignity. For all her references to Africa, and despite occasional coyness, Ringgold's art never archaizes. Her interest is decidedly in the present; her stories and her images are firmly ensconced in today's Harlem, and when they leave home, they bring Harlem into other drawing rooms.

Cee Cee, the determinedly original heroine of Ringgold's *Bitter Nest* quilt story, is the female connection between African roots and the twentieth-century intellectuals, irritating the latter by reminding them of the former. Cee Cee's method, as described by Ringgold, is precisely that of "rhythmized" Mande narrow-strip weaving and its creole, African American offshoots discussed by Robert Farris Thompson. He calls Mande cloth "a world of metrically sparkling textiles" designed "in visual resonance with the famed off-beat phrasing of melodic accents in African and Afro-American music." Even without access to the West African narrow loom, artists in the New World could cut down imported cloth to "cultural size, to frequency modulation, as it were, of the narrowstrip, multistrip style," enabling African Americans to continue the long-standing visual tradition.[27]

The polyrhythmic tradition of African art continued to surface in textiles, blankets, and quilts made in the Americas, and there is a strong possibility that New World quilting was itself of African rather than European origins. Thompson has written about the "thunder" and the "metric witticisms" found in African American quilts, the way the artists talk about "building a quilt" and "playing the fabric," denying separations between mediums and cultures.

He finds the "hidden cross-rhythms" of African music, quilters "shading the count" like jazz dancers. "The whole phenomenon," he writes,

> reminds me of what one Kongo aesthetician calls "blood time" (*kumu mu menga*, lit. holding and developing the beat in the blood). To have *kumu mu menga* means that a sense of time and patterning emerge, like a spirit, in the fingers to be resolved in finished textiles, or in the tongue, to be resolved as song or chant.[28]

The terraced shifts of conventional quilting were often broken up into new rhythms by black women, paralleling the Bakongo belief that such breaks "symbolize passing through two worlds, the quest for superior insights and power of the ancestors" (plate 15). A Kongo traditionalist told Thompson in 1986, "every time there is a break in pattern that is the rebirth of [ancestral] power in you."[29] Just as African American quiltmakers would intentionally include a mistake welcomed as a path to new insight, the Navajo weaver, accepting but subverting the borders around her rug designs encouraged by traders in the early 1900s, wove into enclosed forms an opening (seen by whites as an "imperfection") that came to be called (by whites) a "spirit trail," but was in fact a path for imperfection, flexibility, and freedom of movement.[30] Pueblo potters include a "line break" below the rim, made, according to some, in order to avert physical misfortune. The Zuni call the line that separates the pot's neck from its body "the road," and it is identified with the potter's life and safety.[31] Accident and spontaneity are also prime factors in Zen Buddhist art and in Islam, where only God is perfect and even the most intricate patterns must contain an imperfection.

Joyce Jane Scott (plate 7) is an African American artist from Baltimore. Like many of her generation, she is a transitional figure between tradition and the avant-garde. Her mother, Elizabeth Scott, and her grandmother are African-influenced quilters. Scott herself makes eccentric sewn and beaded assemblages as well as performances. "Generations tearing through stitching and hitching their dreams to untamed stars have coalesced in me. I accepted that challenge," she says.[32] Scott's small figures—a "yellow" woman giving birth to a "brown" baby in *Birthing Chair*, or *Upside Down*, a lynching reversal— parallel her weaving, her fiber art, and her sculpture/jewelry, which is unlike any other "wearable art" in its fusion of a wry and nasty political humor with opulent materials. Scott insists on taking on the biggest issues in the smallest scale and most intimate materials. She says of her "Race Break" series that it

> speaks to inflexibility. To the unyielding state of affairs for a person of color in the world generally and the U.S.A. specifically. To the unjustness, how it hurts. In fact, all the work, whether written, performed, or visual, addresses the constant fight to be balanced in an existence where your skin tone, weight, or ethnicity, validates your impact. Not your kindness, your need to love and give love in return.[33]

▼▼▼▼▼▼▼

In the British West Indies, patchwork dress keeps the *jumbie*, a spirit, away from a resting place. . . . In Senegambia it was important to randomize the flow of paths, since "evil travels in straight lines." And the Mande themselves coded, in discretionary irregularities of design, visual analogues to danger, matters too serious to impart directly.
—Robert Farris Thompson, *Flash of the Spirit* (pp. 221–22)

Fig. 11: Carol Ann Carter, *Support System*, 1986, mixed media, 60″ × 72″ × 2″. Collection Robert E. and Pam Beam. (Photo: Rick Lucas.) Carter was raised in Indiana and now teaches at the University of Michigan. After art school she made intaglio prints of overlapping patterned cloths, and in 1984 she went to Nigeria to study Hausa men's traditional weaving and embroidery. "The energy and exaggeration of life there made it imperative to me, and subsequently to my work, to respond with like energy," she recalls. "Nigeria was the catalyst for the shift in my art's direction" (*Thom Bohnert, Carol Ann Carter* [Detroit: Detroit Institute of Arts, 1990], p. 10). Since then Carter has made ragged and opulent wall pieces of cloth strips, paint, buttons, rhinestones, horsehair, embroidery, sequins, and other found objects. They are generated, she says by "notions of accumulation, reclamation, and regeneration of lost or forgotten cultural information." In *Support System*, which is shades of black with brilliant dots of color, the influence of African ceremonial costumes merges with the inheritance of her mother's twenty-year-old button collection. Like all her works, it is also a psychological portrait, revealing a process of "ripping, channel stitching, dyeing, painting . . . [that] results in paradox as the positions of elegance/ugliness, male/female, insider high art and outsider low art are cross-referenced. The conflict is central to the work" (artist's statement 1989). Recently, Carter has begun to create performances in which the costumes are wearable versions of her wall art, a natural progression, she feels, since her work "is about human encounters."

Scott has studied craft traditions in Mexico, Central America, and Africa, and cites the silkscreened fabrics of West Africa with their portraits of political leaders and pop stars as the basis for her opinionated adornments. The "Jonestown" series of beaded brooches with stones, pig bone, plastic, razor blades, hair, hide, and photographs was made "to exorcise the rage and despair" Scott felt on reading about the Guyana massacre. These pieces are informed by her Pentecostal upbringing as well as containing references to African American religions: "Razor blades are important in macumba ceremonies to separate the soul from its ties to earth."[34]

Scott and Ringgold, along with Carol Ann Carter, are heirs to the African American quiltmakers' interest in being different, a motivation shared with the modernist avant-garde. Conventional patterns are seen as "other people's ideas."[35] Paradoxically, such an approach is widely considered characteristic of "high" or "fine" art, not of "folk art" or "crafts." Yet untrained artists and their trained offspring and heirs have offered a solidly innovative foundation for and bridge to African American modernism; visual and narrative parallels abound in this book alone. It is not only in quiltmaking that the inner sense of "cross-rhythms," the improvisational "ability to hear two different kinds of beat at once" surfaces, or in respected gallery and public art like that of Faith Ringgold and David Hammons, but also in the work of extraordinary self-taught contemporary artists like Bessie Harvey, Lonnie Holley, Thornton Dial, Mary T. Smith, and the late Nellie Mae Rowe—the list could go on and on.[36]

Fig. 12: James (Son Ford) Thomas, *Man's Head*, **and Thomas at work.** (Photos courtesy the W. R. Ferris Collection, University of Mississippi Archives.) Thomas's unfired clay heads and skulls are often equipped with real hair and teeth. Many resemble death masks. Thomas, who is also a blues singer and storyteller, lives in Leland, Mississippi, where he has worked as a farmer, tractor driver, and gravedigger. He was given the nickname "Son Ford" because of the clay Ford tractors he made when he was in school. He works with local "gumbo" clay and values the ugliness of his heads: "a skull has got to be ugly cause it's nothing but bones and teeth. People are more likely to be interested in something like that. . . .

In the 1940s French artist Jean Dubuffet coined the term *art brut* ("raw art") for those "works of every kind—drawings, paintings, embroideries, carved or modeled figures, etc." made by "children, madmen and primitives," emphasizing the direct unmediated flow of power between hand and object, to which he opposed the *"arts culturels."* He suggested (like others before and after him) that art "likes to preserve its incognito. Its best moments are when it forgets its very name."[37]

The expressive depth and directness of work by many untrained artists has long been a source of fascination to and a thorn in the flesh of professional artists. While it seems rather unfair that education and exposure to high art should make direct access to creativity more, rather than less, difficult, it often appears that training in art shutters the windows that might encourage an audience to look in. Picasso is supposed to have said, "When I was a child I drew like Michelangelo. It took me years to learn to draw like a child."

Folk art has had a huge influence on modernism in general and on the white avant-garde of the '70s and '80s, from Claes Oldenburg to Red Grooms and David Bates (both of whom were raised in the South). But for artists like Joyce Scott (and probably for many white rural and rurally raised artists), it is a direct source of empowerment. Now that folk art has been welcomed into the vestibule of high art—validated to some extent in art schools and museums through the avant-garde's appropriations—it has provided a field of respectability in which even the lowly hobby arts can be seen with fresh eyes.[38] Although the important African American artists William H. Johnson and Jacob Lawrence drew inspiration from folk art in the '30s, today there are few black, Latino, Asian, or Native American artists with the high visibility of, say, Robert Rauschenberg or Lucas Samaras. Cross-cultural impact in the mainstream still is assumed to come either from the past or from "below"— from the less respected world of crafts and so-called outsider art.

Folk art has been defined as art that reflects its surroundings (though certainly that applies, if more narrowly, to conventional gallery art); those surroundings are understood to be "outside" everyday modern urban life, and therefore the objects are valued as artificial bonds to an idealized past. Yet in fact, with modest or traditional technical means, these artists provide intricate maps of reality, of daily and spiritual life. The real "outsider" art is that confined to the intimidatingly clean or luxurious art gallery or the grandly institutionalized museum—outside the flow of life. To justify the segregation of vernacular art, conventional (and defensive) wisdom within the art profession has it that the untrained can randomly hit veins of beauty and meaning, but that they can never be fully mined because of the artists' intellectual and technical limitations. The history of modern art insists that the best art is the most innovative. Yet when the pressure for constant novelty is forced on creativity, competition and commercialism tend to win out over originality. Innovation for innovation's sake has taken its toll on meaning and effectiveness in the second half of the twentieth century.

There remains a great reluctance in the artworld to seriously acknowledge solutions other than those dictated by upper-class Western convention (and, of course, its tradition of ripoffs from the "Other"). In a classic admission of the mainstream's limitations, Donald Kuspit once praised folk artists for their willingness "to take the risk of depicting the familiar."[39] The concept of folk art was in fact initiated as a class distinction in Europe and India in the nineteenth century. Eugene W. Metcalf, Jr., has pointed out the importance of North American folk art as part of a national belief system including social and historical meanings lost and/or dehumanized. The artworks become relics of a mythical search for a utopian democracy, and their consumption as a commodity by the middle class becomes a system of communication within the market place.[40] Susan Havens Caldwell has said, "the folk artist is not art-conscious; [s]he is image-conscious."[41] Yet the same can be said of many artists of color who are conscious of their alienation from the dominant culture

They say, '[When I die] will I be in the same shape that skull there is in ?' . . . When I do my sculpturing work things just roll across my mind. . . . I lay down and dream about the sculpture. . . . I make a face first, then make me a skull. First I shape it up like a regular man's head. *Then* I cut it down to a skeleton head. That's the onliest way you can get a shape." (Oral history by William Ferris in *Afro-American Folk Art and Crafts*, p. 112, and *Local Color: A Sense of Place in Folk Art*, pp. 134–156.)

▼▼▼▼▼▼▼▼
Because terms like Folk, Outsider, Naive, and Untrained are really attempts to label the artist rather than the art, it is important to remember that it was the aesthetics of the art that attracted people in the first place. In the end, the formal and psychological issues that apply to any piece of art define art that is considered "Folk" as well.
—Anonymous text (in brochure for "'. . . seeds of the future,'" CompassRose and Dart galleries, Chicago, Feb. 1989)

I wanted to show another level of American taste. When you look up at the art work, there is a positive feeling, an up feeling. You don't see downtrodden, negative, I-can't-do-I-won't-do. You see people with heads up. That's the symbolism. That's the strength.
—Bill Cosby, on collecting black folk art (quoted in *New York Times*, Jan. 29, 1987)

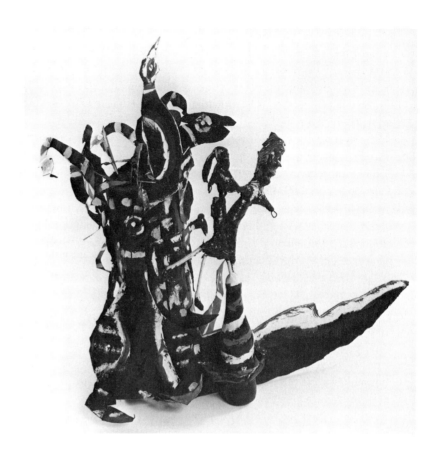

Fig. 13: Thornton Dial, *Two people went fishing on the river, but started eating what they had caught, covering it with catsup. Before they had gone home, while they were still out there, they looked around and saw that things were rising up against them, and they got real scared, so they tried to jump in the catsup bottle they brought*, 1988, tin, wooden stump, wood, wire, plastic tape, glass bottle, enamel paint, 30½″ x 12″ x 33″. Collection William Arnett, Atlanta. (Photo: Kathryn Kolb.) Dial is a self-taught artist who lives in Bessemer, Alabama, where he has been making art in woods and backyards for more than forty years, using ideas and techniques discovered while working as a farmer, cement mixer, house painter, carpenter, and metal worker. One of his major themes is that of friction between humans and nature. According to Robert Farris Thompson, Dial is "signifying" in this red, white, and black sculpture against those who "fish in a river when they aren't even hungry," thus criticizing waste within the African and African American bottle tree tradition, "the coaxing of all evil into a container." The people, the artist notes, are made of different materials from the snakes, but the two can coexist, given mutual respect. The crime of the fishermen (one is a woman) is not only bragging about their catch but gilding nature's lily with catsup, and the bottle becomes the only place they have to hide. Thus it contains rather than fends off evil. (Quotations from *Another Face of the Diamond*, pp. 39, 62, and letter from Paul Arnett.)

even as they have begun successfully to participate in its artworld. In the process of maintaining "homes" on both sides of the bridges they build, these artists open up the mainstream to aspects of everyday, political, and spiritual life long denied fine art.

The struggle over representation is taking place among untrained artists as well as in the artworld. The term "Outsider art," for example, is determinedly exclusive (classist, divisive, discriminatory), used loosely to span art by all untrained artists, usually of the working class, and more tightly to describe art by visionaries inspired by religion or by mental illness—in short, art by anyone who is not "like us." I prefer the term "vernacular," which implies "made at home." Vernacular art gives people a way to speak for themselves across the moat that protects the high-art world from knowing what "the people" really think and see. These artists too are taking part in the struggle against the flattened stereotypes promoted by mass culture. Dot Kibbs, a self-taught white Vermont artist, said of the artist-run program in which she learned to paint, "Without G.R.A.C.E., I might be more interested in TV."

The impetus to artmaking is shared on both sides of the fence or tracks. "Why do I draw?" asked a mental patient in Maine. "It's like a dog wetting

up a tree so that the other dogs will know he was there."[42] "Don't put my name in the paper as an artist," said ninety-seven-year-old Roland Rochette in Vermont, also a G.R.A.C.E. participant. "Just say it's an old man trying to help himself. This might get some people to go and help themselves. In this life, you need the will to help yourself. If you have that, you're all right. And you need to be a nut."[43]

In his important book *Through Our Own Eyes: Popular Art and Modern History*, the British critic Guy Brett, who is white, calls attention to the new criteria that must be brought to bear on international vernacular art, which despite the wide range of its various sources, has certain things in common wherever it is made, emerging

> as part of the act of standing up for oneself against domination; and either explicitly or implicitly asserting a world of different human values . . . making visible aspects of the world previously hidden by the barriers of class . . . [through] displacement from the traditional cultural contest.[44]

For Betye Saar, the work of art is not only an object, but an object of power. As a child in the early '30s in Los Angeles, Saar was clairvoyant and psychic; when she visited her grandmother in Watts, she watched Simon Rodia's towers grow. As an adult, combining mystery and honesty, her art is informed by dreams, the occult, and the process of bricolage (plate 11). She has studied tarot, phrenology, palmistry, vodun, and shamanism. She haunts yard sales, thrift shops, flea markets, swap meets, and botanicas. Mediating between her spiritual knowledge and the art that emerges from it are the used objects she finds and incorporates into her imagery. Each one has specific implications—mythical, autobiographical, historical, sometimes political— that support the visual impact.

Saar makes shrinelike assemblages, altars, hanging fetishes, or "mojos." Some refer directly to syncretic religions, such as Haitian vodun. Other works are still more intricately cross-cultural, inspired by the artist's extensive travels and by her own mixed African, Irish, and Native American heritage. She combines symbols and objects found in the markets of Africa, Mexico, India, Europe, and the Caribbean with those discovered at home. For Saar, materials are just that—mothers and matrixes. "There's power in changing uses of a material," she explains, "another kind of energy that is released. I am attracted to things because they have multiple meanings. Dreams are like that, full of puns, double meanings."[45]

Her creative process is ritual in itself, a "prescribed series or set of acts," which she has broken down into the following components:

> **The imprint—ideas, thoughts, memories, dreams, from the past, present and future.**

> **The search—the selective eyes and intuition.**

▼▼▼▼▼▼▼
Folk art is a lesson in what the have-nots have. . . . Folk art, indigenous and strange, is not concerned with issues in art—rather its concerns are with the human condition. . . . In fact, it is the folk artists who are the most tuned into popular culture, translating and expanding it.
—Susan Hankla, *Retrieval—Art in the South* (Richmond, Virginia: 1708 East Main Gallery, 1983)

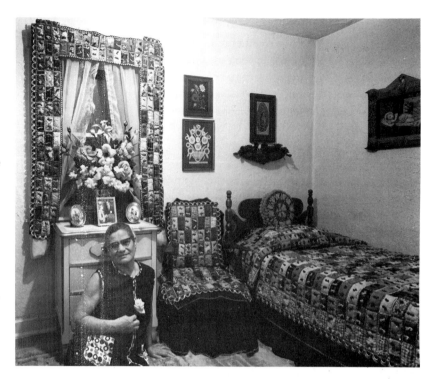

Fig. 14: María Enríquez de Allen, 1982, with her *Quilt Ensemble*, (1972–73); quilt, 494 double blocks, crocheted, stuffed, and tie-quilted, 58″ x 94″; chair cover, 83 blocks; curtain valence and side panels, 106 blocks. (Photo: Harold Allen.) Enríquez de Allen is a Mexican-born artist who moved to Texas in 1955, and to Chicago in 1962. She began to draw and model clay at the age of seven, and since then has always made art—quilts, dolls, artificial flowers, clay animals, santos, and crucifixions. She has had one-woman shows at the School of the Art Institute of Chicago and at the Fondo del Sol, in Washington, D.C. These quilts were made from discarded factory samples (all the same size but all differently patterned) that one of her sons, a truck driver, found while making a delivery. "María's art often expresses, in current materials, attitudes and skills both exotic and passé. The amalgam, hybrid but fascinating because of María's personal vision, with its eagerness and sense of humor, is neither pure Mexican nor all-American, but something in between, appealingly odd and new" (Harold Allen, *The World of María Enríquez de Allen*, Fondo del Sol, 1981, n.p.).

The collecting, gathering, and accumulating of objects and materials, each bringing a presence, an energy (old, new, ethnic, organic).

The recycling and transformation—the materials and objects are manipulated and combined with various media. . . . The energy is integrated and expanded.

The release—the work is shared (exhibited), experienced, and relinquished. The "ritual" completed.[46]

Saar's work epitomizes the "collage esthetic" by which women so often transfer to their art the sense of patched time by which they lead their lives. (When asked how she managed to have three daughters and make art, she replied, "What's the difference?") She has literally "picked up the pieces" of her family's lives, developing an iconography that incorporates psychic symbolism, the historical private and family lives of black people, and the spirit (if not the letter) of world religions.

Death has been one of Saar's central themes, but it is always paired with rebirth, bearing historical connotations as well as personal ones. She has said that she finds herself "on the other side of the past." She sees herself as the medium through which the energies of all these weary objects are revivified, the seer who perceives the hidden properties of discarded lives. Her use of objects, and the way she taps the life and energies they themselves have

accumulated, is evocative in the most profound sense of the word, giving voice. She rescues and restores, unifying parts of personal pasts into a more powerful whole, releasing them into the world as new energies for the communal good. But Saar deals in absence as well as presence. While unveiling unexpected connections, she also veils her meanings, layers them, offers specters and shadows like those that inhabit dreams and visions rather than daylight life.

Like other modernist black artists, Saar has been criticized for making things "the community" can't understand. But she makes a distinction between things people can't understand and things they "haven't seen"—ideas and images that will open up new experiences departing from the familiar. "I use Egyptian and Oceanic and American Indian and African, any kind of culture that is related more to the earth or to nature . . . it all works together as a tribal thing. But then, it's a secret tribe."[47]

Saar's cumulative process can be seen in historical terms, but also as a way of hoarding psychic nourishment. Although she was deeply impressed by her first glimpse of Joseph Cornell's magical boxes, as Mary Schmidt Campbell has pointed out, the ethos and esthetic behind the Western avant-garde definition of assemblage—"ironic, perverse, anti-rational, even destructive"—differs from the view that informs African fetishes and accumulation, which "emphasizes consensus and consolidation, and the affirmation and reinforcement of social values and cultural continuity."[48] There is also a subtle social message in Saar's reclamation of African American history and her enshrinement of the humble objects through which it has so precariously survived. Folk art has influenced her more than the dominant culture. "I never had the stroke for 'mainstream,'" she has written, "it went against my flow."[49]

Home altars were already being made by women in Europe 10,000 years ago. In the United States today, the altar form is most firmly rooted in Latino art, especially within the tradition of the Dia de los Muertos, the Day of the Dead, or All Souls' Day, celebrated on November 1–2 by Mexicans on both sides of the border as a welcome to souls who visit from another "other side" and as a bridge between their ancient and modern religious traditions. Graveyard decorations include flower arches, special wax and foil crowns, *pan de muerto* (bread sculptures), and shredded *zempasuchitl* flowers (marigolds), many of which can be traced to Pre-Columbian sources.[50] The most popular symbol of the celebration is the *calavera*—the cavorting skeleton or laughing skull in fancy dress. Westerners are fascinated by the relaxed assumption of a connection between the worlds of the living and the dead, by the candy skulls, the altars and feasts (including liquor and cigarettes) laid out for the departed, and by the concept of consolation through festivity, which is so engrained in the Mexican psyche and so foreign to the Western Protestant.

Home altars, more elaborately designed than grave offerings, and not limited to the Dia de los Muertos, also combine *santos* (wooden saints), *milagros* (metal body parts and figures to encourage or express thanks for "miracles"),

▼▼▼▼▼▼▼

I sit here before my computer, *Amiguita*, my altar on top of the monitor with the *Virgen de Coatlalopeuh* candle and copal incense burning. My companion, a wooden serpent staff with feathers, is to my right while I ponder the ways metaphor and symbol concretize the spirit and etherealize the body. . . . Only through the body, through the pulling of flesh, can the human soul be transformed. And for images, words, stories, to have this transformative power, they must arise from the human body—flesh and bone—and from the Earth's body—stone, sky, liquid, soil. This work, these images, piercing tongue or ear lobes with cactus needle, are my offerings, are my Aztecan blood sacrifices.
—Gloria Anzaldúa, in *The Graywolf Annual Five: Multicultural Literacy*, edited by Rick Simonson and Scott Walker (p. 40)

requerdos (painted prayers), lacy *papeles picados* (cut-paper designs), tragicomic *calaveras*, breads, toys, food, liquor, cigarettes, flowers, photographs, foil-wrapped talismans and fetishes in a roughly pyramidal form that is endlessly variable and powerfully decorative. This site of "accumulated power," "abundance and display" is "a threshold, a point of departure" to the past of *la raza*, the culture, the family, as well as a "performance space" in the present, and the site of prayer and desire for future fertility, protection, good fortune.[51] "An altar, by definition," writes white folk-historian Kay Turner,

> can never merely represent; there is no altar made for art's sake alone. The personal altar always invites communicative exchange: it engages the viewer who, moving beyond the simple seeing of altar images, begins to use them, to encounter them, to speak to them.[52]

The Bay Area Chicana artist, writer, and educator Amalia Mesa-Bains (who also has a doctorate in psychology and serves on San Francisco's Art Commission) is among those responsible for the modernist and theoretical evolution of the altar, or *ofrenda*, form and for its documentation as an art and a source for art (plate 16). She observes that:

> in an increasingly technological society the division between experience and ritual grows more vast. When rockets reach the moon, the mysteries of the lunar religion lose their power. Where death can be delayed by injections . . . the liturgy of mourning declines. . . . The everyday life experiences upon which rituals are built finally diminish as a shared observance. . . . Yet within this failing of popular ritual we have seen the growth of offeratory expressions in the institutions of the art community. . . . If we look further we discern that the practitioners of such "ritual art" are most often women.[53]

Mesa-Bains traces two strands of women artists' involvement in ritual: that which has been "part of a continuous tradition of domestic folk-ritual" within minority art communities and the "reclamationist" phase instigated by the latest wave of feminism, which has "pursued the secret history of women." They share roots in "a decorative tradition and the restricted mode of women's relegation to production in the home." Thus altars "became the most political of statements. They were the outgrowth of the individualized oppression in the most private places of the domestic chamber, the bedroom and the kitchen."[54]

The altar form (and its portable counterpart, the box/reliquary) has become very popular with Latino artists in the last decade, but few have expanded and developed it like Mesa-Bains and her East Coast counterpart, Juan Boza. Mesa-Bains's altars have become innovative full-scale installations, sometimes incorporating music and sound, reflecting her scholarship and her personal concerns, but never abandoning the initial cultural impetus. She began by making homages to the home altars and yard shrines (*nichos* and *capillas*) she had grown

up with. As her art became more sophisticated, she began to heighten her esthetic as well as didactic cultural statements. She experimented with the traditional forms, honoring women who had broken social barriers such as Sor Juana de la Cruz, Frida Kahlo, Dolores del Rio, and her own beautiful, Indian-featured grandmother—a domestic worker who had never received the social respect she deserved and whom Mesa-Bains wittily celebrated in a confessional booth, where visitors had to kneel before her to receive art's absolution.

A piece dedicated to Frida Kahlo, with whom Mesa-Bains, like so many Latina (and so many feminist) artists, identifies strongly, placed a little ruined stone room in a landscape of dead leaves; it is filled with mementos and references to the Mexican popular arts that meant so much to Kahlo. Mesa-Bains made this piece when she was forced to have a hysterectomy, and it acknowledges her personal empathy with Kahlo, who suffered constantly from a terrible accident and also could not have children, yet triumphed as an extraordinary artist and independent woman.

Tomás Ybarra-Frausto has devided Mesa-Bains's altar-making into three stages: "Cultural Reclamation" (1975–80), which coincided with the "con-

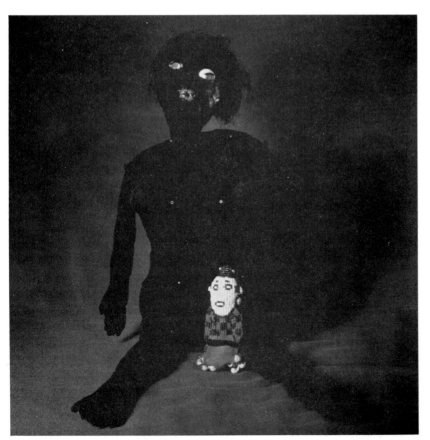

Fig. 15: Geno Rodriguez, *Other God Series: Madonna and Child*, c. 1980, Cibachrome, 40" × 40". Rodriguez is a Puerto Rican artist who lives in New York, where he directs the Alternative Museum, which he founded in 1975. After serving with the U.S. Navy in North Africa, he received his art degree from the Hammersmith College of Art in London. This photo is very "plain" compared to most of Rodriguez's work, which usually consists of highly manipulated and erotic mythological tableaux. The black Madonna doll is a pathetic and fearsome shadow behind the unformed white-faced beaded "child." White is often the African color for death. The subject here might be the "mammy" who nurtured wealthy white Southern children, or it might be Mother Africa, whose sustaining spiritual values have nourished both the white and black populations of this country.

certed effort by Chicano scholars, intellectuals, and community artists to destroy configurations of Chicano experience that stressed cultural determinism while at the same time presenting fluid, dynamic and historically derived versions of Chicano identity and culture"; "Shrines of Reconciliation" (1980–85), focused inward, exploring the artist's female psyche, "generating an ancestry or lineage of women significant in her own life" and beginning to make "cross-cultural investigations of arcane spiritual traditions among women in traditional cultures"; and finally, the current "Ceremonies of Memory."[55]

These are the works of a mature artist confident in her own culture and in its importance to the larger culture. They are increasingly ephemeral and dispersed, evoking consideration of the passage of time, of individual and historical duration. Mesa-Bains fuses material and religious opulence while forgetting neither their erotic implications nor the tragic history and economic poverty that produced such riches. Her attention to detail as she bridges ancient and modern belief systems and her respect not only for originary meanings, but for their contemporary spiritual and political ramifications, have opened new passages between Latinos and the mainstream. Splintered mirrors are reconstituted as they are placed in new contexts and new patterns, offering metaphors for pride and self-images shattered and reintegrated into society.

A good deal of Latino art in the United States emerges from an ambivalence toward traditional belief systems, an ambivalence fueled by both the seductive life of postindustrial capitalism and by the alienation it ultimately produces, felt most strongly among those who have little share in the spoils. It is ironic that as Third World countries adopt modernization policies, First World countries begin to feel that we have lost something in that process—ecological health and spiritual depth. Pockets of belief have survived the determined ethnocentrism that has substituted for religious persecution in this country, though these cultural survivals are often viewed by the dominant culture as "sects" or "cults" rather than as institutions taken for granted like Catholicism and Protestantism. For the artists raised in these pockets of belief and for those to whom belief itself represents something new, the visual accoutrements of religion are both disturbing and attractive.

Kathy Vargas, a Chicana photographer who is director of the Visual Arts Program at the Guadalupe Cultural Arts Center in San Antonio, conveys her religious/spiritual subject matter through near-abstraction. Working with the Pre-Columbian and Catholic mix ubiquitous in the Southwest, she is especially knowledgeable about Mayan art. Her layered, lyrical imagery focuses on themes of death and mourning, loss and consolation, the replacement of the older, fiercer deities with a gentler Christ figure. Her photographs are predominantly black, white, and gray with soft touches of warm color, always multifaceted in imagery and meaning.

A series called "Discard This Image" emerged from Vargas's conviction that non-Western images are discarded in the dominant culture, along with women's work, which is seen as nonintellectual; but it also refers to "leaving

▼▼▼▼▼▼▼

Life extended into death, and vice versa. Death was not the natural end of life, but one phase of an infinite cycle. Life, death and resurrection were stages of a cosmic process which repeated itself continuously. Life had no higher function than to flow into death, its opposite and complement; and death, in turn, was not an end in itself: man fed the insatiable hunger of life with his death.
—Octavio Paz, *The Labyrinth of Solitude: Life and Thought in Mexico*, translated by Lysander Kemp (New York: Grove Press, 1961, p. 313)

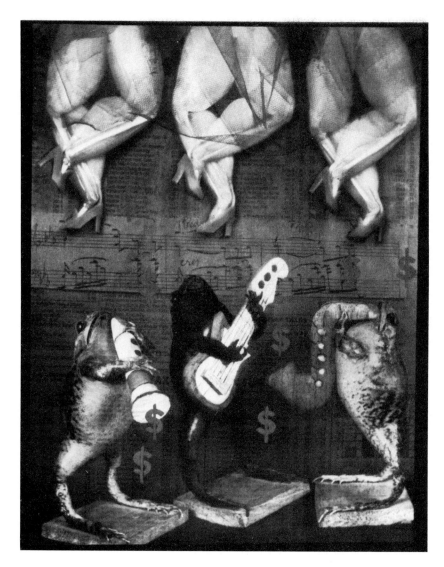

Fig. 16: Kathy Vargas, *I Was Playing Out My Fantasies When Reality Reared Its Ugly Leg*, 1989, hand-colored photograph, 30" x 24". Recalling the frog musicians she saw in Mexico as a child, and struck at a restaurant by how human frogs' legs look, Vargas made this "tableau" piece about the way humans "consume each other's countries and each other." The musicians' hands are nailed to their instruments and the notes coming out are dollar signs—"the music we all seem to love." The sheet music in the background is joined with stock reports from the *Wall Street Journal*, "indicating where our priorities are and what tunes we dance to. . . . So the photograph is semi-humorous, hoping that people will see the darkness too." Vargas intends her "little dead things" to seduce viewers into remembering what people do to people in Guatemala and South Africa. "They are visual counterparts of the Day of the Dead," she says, "a cultural comforter . . . a way of continuing love even after death. We all play out our fantasies without a second thought until someone or something reminds us what it 'costs.' " Vargas quotes Barthes, who called the photograph "flat death." "The edge is very thin," she says, "from one plane to the next, and life is sometimes so tentative that we need to be reminded we are in it: extreme pain, intense longing, stifling confusion. I make pictures to remember that" (letters to the author, 1988–89).

the shell of life behind, stepping into another dream." Her "Priest" series of palely visible altarpieces moves from dark to light, creating a complex iconography with references to martyrdom and mysteries, the exorcism of personal pain. The relics of birds that are the central images symbolize spirit, dream, hope—anything free; but they are lured into nets and thorns of pain, which are also the womb, related to the womblike body halo that traditionally surrounds the Virgin of Guadalupe. Vargas's photographic models are "little dead things"—flowers, birds, and frog skeletons—ghosts that she has found are offensive to a mainstream culture which likes to have death distanced or on TV, while Third World cultures are far more comfortable with death. "I'm not morbid," she says. "I love life, but we really have to see the end to love the middle."[56]

Ana Mendieta was also obsessed with life, death, and rebirth. A Cuban sent to an Iowa orphanage at age twelve and raised in alienating circumstances, she adopted the earth itself as a personal and a spiritual mother. Her "Silueta" (Silhouette) series (plate 21), begun in the early '70s, consisted of schematic female figures cut or drawn into the earth, mounded or impressed upon it, in a variety of natural mediums—fire, ashes, leaves, gunpowder, grass, flowers, blood, water, wood, clay, stones, mud, and sometimes her own flesh. She also frequently worked with trees, again merging her body or its image—and by extension the female body—with nature, and eventually with the Latin American culture she had lost as a child. Mendieta's references were consistently feminist and religious. During her Cuban childhood she had "played priest" in the family chapel. Just before her death she visited the Neolithic "sleeping goddesses" in Malta; entering the temple, she said she felt as though she were "in a big womb. . . . That's what art is about . . . it binds us historically. . . . I think I am the shaman of pre-Iberian-Afro-Caribbean goddesses," she wrote.[57]

Two early performance works referred to Santería rituals: in one Mendieta held a beheaded chicken that spattered blood over her naked body and in another she rubbed herself in blood and rolled in a bed of white feathers, transforming herself into the white cock that is crucial to certain rites. In other works, she lay down nude in an Aztec grave and was photographed covered in tiny white flowers; she curled herself up, swaddled in white grave clothes, to become a primitive burial bundle lying on the red earth; she lay on a skeleton, giving it life, and painted her own skeleton on her nude body as a living *vanitas*. A "Fetish Series" in the late '70s dealt with the cruelty of, or to, an abandoning or abandoned mother earth and coincided with her mother's cancer (which she survived); moundlike figures were marked with red paint or stabbed with sharp sticks. In 1981 Mendieta revealed the image of a female figure in the knots and bark of a tree in Miami that was a local Santería shrine; later the worshippers added to the healing figure, so that her sculpture entered the public domain on several levels.

Mendieta's work was for years an expression of the need for roots, a desire to belong culturally. When, beginning in 1980, she finally returned to Cuba for several long visits, she carved her voluptuous female deities into the walls of caves in Jaruco, an ancient indigenous site. She said that when she worked on a site, she "claimed territory . . . somewhat like a dog pissing on the ground. Doing that charges the whole area for me."[58] In 1981 she made a small "valentine" to her lost and then found motherland—five hearts made of areca palm roots were sunk into a square of red earth. This accomplished, her work began in 1982–83 to separate itself somewhat from the outdoors, from the earth (and from Cuba), although the female outline remained its focus, burned, drawn, and carved on leaves, bark paper, and logs, or molded from mud, which then parched and cracked. In 1985 Mendieta met her death, and the earth, falling from a high window in an eerie echo of her art.

Calvinist mistrust of Catholic sensuousness and the WASP's still more drastic reaction to syncretic religions (despite Christianity's own indisputably syncretic origins) were neatly demonstrated in 1989 when fundamentalist groups, congresspeople, and museums attacked the National Endowment for the Arts for funding the work of two photographers.[59] One of them, Andres Serrano (plate 35), is an American-born artist of Honduran and Afro-Cuban descent. His large bizarre color photographs, despite their innate elegance, also convey a raw and eerie power that transports religious iconography into the realm of the extremely sensual and even barbaric. While flirting with the postmodernist obsession with slick commercial photography, he is at the same time protesting the commercialization of religious imagery and recalling the Spanish tradition of violence and sexuality in religious art. Serrano is almost ironically obsessed with the carnality, the literal flesh and bone of belief. In his early work, he reenacted an imaginary history in eerie tableaux of everyday and religious life, often centered on dead animals or chunks of raw meat—simultaneously representing living and dead, the body and the blood, voluntary and involuntary sacrifice, nurturance and torture. *Memory* (*Recuerdos de Honduras*) of 1984, for instance, with its masked "priest" offering a side of meat while a small boy looks away, suggests cruelty and innocence, the contradictions of organized religion reflected in a Central American church divided between corrupt support for U.S.-backed oligarchies and mercenaries and the healing empowerment of Liberation Theology. *Cabeza de Vaca* (1984) is just that—a cow's head—but it also refers to the fifteenth-century Spanish explorer of that name who preceded Coronado in northern Mexico and Brazil. The head of an invading conqueror on a platter is thereby fused with the sacrificial victims of the Conquest and sends multiple reverberations into the present.

In the mid-'80s Serrano began to simplify his imagery and to close in on various religious symbols, stripping away their usual connotations and revealing an underlying awe that is also somehow ironic. The iconic force of *Blood Cross*—a plexiglass form filled with animal blood—and the beneficent "purity" of its companion, *Milk Cross*, also recall the contradictory history of Catholicism. *Dread*—a head of Rastafarian dreadlocks seen from the back—is both humorous and ominous, a visual and verbal pun on fear of the "faceless" Other. Among Serrano's images are also three plucked chickens on gold crosses, crucifixes surrounded by chicken claws or placed on a glistening, jewel-like field of chicken hearts, and *Piss Christ*, a cheap crucifix floating in a golden aura revealed by the title to be urine—the image that brought the wrath of the godly down on the NEA. (Neither his *Piss Satan* nor his *Piss Elegance* drew such raving notices.)

Serrano has made it clear that his use of natural fluids (later works employ milk, menstrual blood, and sperm) is not only a formalist device to capitalize on their unique color and luminosity, but also a reference to the body fluids as part of the essence of life, and thereby clearly related to Catholic theory and practice. *Piss Christ* is a monumental, dramatic image, its earthy roots

▼▼▼▼▼▼▼
Violence is the heart and soul of the sacred.
—René Girard, *Le Violence et le sacré* (Paris: Bernard Grasset, 1972, p. 31)

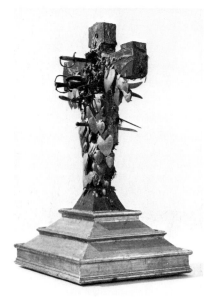

Fig. 17: Michael Tracy, *Cruz de la Paz Sagrada* (*Cross of the Sacred Peace*), 1980, mixed media, 69" × 43" × 31". The Menil Collection, Houston. (Photo: Hickey & Robert and Son, Houston.) Tracy's secular/political passions are informed by a religious angst, suggesting scenes of torture and assassination, of the bondage, violence, and grief that characterize the relationship between the First and Third Worlds. His sculptures are the compost heaps of Western imperialism and religion, seen at a moment of truth on the edge of independence. His crosses emerge as figures, dark, encrusted over seasons, buried in the paraphernalia of the artist's obsessions, shrouded, costumed, adorned with hair, food, blood, semen, animal horns, urine, ancient fabrics, tinwork, blades, bones, *milagros*, flowers, photographs. Brilliant pinks and purples and tarnished golds and silvers merge with murky, dried-blood reds, earthy browns, and glutinous blacks that testify to forbidden acts, substances, and emotions. One cross is a handsome, menacing monument to Archbishop Oscar Romero (assassinated by Salvadoran death squads condoned and virtually supported by the United States); the lyrically phallic *For Julio Cesar (Corn Icon)* is dedicated to a refugee friend murdered on his return to El Salvador.

revealed only by its title. Although Serrano's subjects are straightforward and concrete despite their theatricality, the imagery itself is so unexpected that the viewer is jolted into "another place"—or the place of the Other. ("I've always had trouble seeing things black or white," says Serrano. "I'm of mixed blood. I've always accepted that duality in myself.")[60]

The repressed sexuality and inverse emphasis on the body inherent in Catholicism is also the source of Michael Tracy's art. Because of his cross-cultural life on the Texas-Mexico border, I include Tracy here as a stand-in for the many white Catholics whose art has similarly ambivalent roots and imagery and whose appropriation of Latin imagery can be problematic. Tracy's "Sanctuarios"—towering sculptures in ecclesiastical drag, with their corroded, corrupted, flayed surfaces, lure the viewer into the artist's own quicksand of tensions between sexuality and grace, power and vulnerability, pain and pleasure, religious frenzy and spiritual peace. Hybrids inspired by the artist's adopted village of San Ygnacio, Texas, the "Sanctuarios" straddle the exotic and the familiar. They exude a morbidly original sexuality not quite liberated from religious repression.

Tracy's identification with the real and mythical Mexico is self-consciously acquired rather than inherited and is problematic for Latinos. He views Mexico like the body of an unattainable lover from across the Rio Bravo/Rio Grande, or River Styx. ("Mexico is the cross I want to be . . . am nailed upon.") For him, as for D. H. Lawrence, Mexico is a romanticized and barely civilized Other; the border is not merely national and cultural, between "North" and "Latin" America, but is perceived in the North as a line between the known and the unknown. In a microcosmic replay of centuries of colonialism, Tracy offers himself as sacrifice and at the same time devours "Mexico" through his art, which is in turn clarified by his ecstatic prose:

> **You are glorious Mexico. A sacred family. China in your eyes. Your Chicanos grind me like corn. I am a natural paste. Put me on your wounds. Smear my heart on the altar of your misdirected wants. Eat me as I have eaten your heart and your body. Rub the soles of my feet. Wash my loins. Slash my tongue so language cannot matter.[61]**

Many Latino artists work from a concern with the body that Victor Zamudio-Taylor identifies as "the somatic discourse," which characterizes the Pre-Columbian foundation, as well as the Christian superstructure, of Latino American culture:

> **The catalogue of body imagery and somatic concerns in the ceremony of memory draws from all the cultures that are constitutive of the Latino identity. From the pre-Hispanic and African to the new world baroque and popular culture, the body is a sign, a metaphor and allegory for the wounds inflicted on the corpus of our culture from the first encounter. Yet it is the battered body and the mutilated corpus of a shared tradition where difference and specificity as well as resistance and change has and is to be grounded. . . . In**

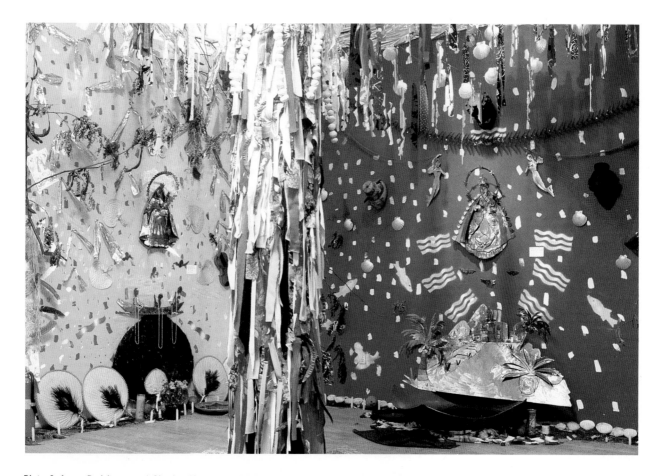

Plate 9: Jorge Rodriguez and **Charles Abramson**, *Orisha / Santos*, 1985, installation at the Museum of Contemporary Hispanic Art, New York. The installation was subtitled "An Artistic Interpretation of the Seven African Powers," which are Elegua, Ogun, Obatala, Orunla, Ochún, Yemaya, and Shango—gods of the crossroads, war, peace, divination, erotic love, maternal love, and fire. Rodriguez made his curling steel sheet sculptures in the tradition of the Puerto Rican wooden *santos*, the cherished household gods that are asked to intercede in everyday life. The late Charles Abramson, an African American *santero*, or priest of the Santería religion, made the altars. He and Rodriguez met in 1981, when both were artists in residence at the Studio Museum in Harlem, and later they often collaborated. Here they took off from the visual puns by which African slaves re-created their own lost gods (*orishas*) within the devotional figures of saints with similar attributes. Gender and cultural barriers were crossed with impunity. For example, the tower and zigzag patterns associated with Santa Barbara, patron of fire and lightning victims, became the crown and lightning of Shango the Thunder god. Abramson's altarpieces and surrounding environment continued the punning theme of double messages by adding a jungle of North and South American images and natural substances, including a tree, roots, stones, herbs, yams, and cotton balls—standing for the great natural context from which African religions can never be torn—as well as a rich and colorful compendium of found objects and human-made materials, including a daughter's doll collection, live goldfish in a pond, fans, and discarded textiles found in the neighborhood. (See the catalog *Orishas/Santos*, with valuable texts by Susana Torruella Leval, Cynthia Turner, and Robert Farris Thompson.)

Plate 10: David Hammons, *Delta Spirit*,
1985, mixed media, 288″ × 288″ × 192″.
Delta Spirit was constructed with architect
Jerry Barr in 1985 for "Art on the Beach," an
annual outdoor exhibition on a New York City
landfill. It was "about that kind of spirit
that's in the South . . . that Negritude archi-
tecture," says Hammons. "I really love to
watch the way Black people make things,
houses, or magazine stands in Harlem, for
instance. Just the way we use carpentry.
Nothing fits, but everything works." The
"spirit house" was made of piles of lumber
found in Harlem. A hexagon on six-foot poles,
it was studded with bottlecaps, feathers, and
tin, topped by a propeller, and open to the
views. *Delta Spirit* was an exuberant antidote
to the sterile new skyscrapers of downtown
Manhattan. Specifically inspired by memories
of the South and by Simon Rodia's Watts
Towers, Hammons recalls, "its significance
changed as it got more ornamented; as it got
more detailed, it went universal. People
started seeing it who were from places like
Tibet and Viet Nam, for instance, and told us
about houses they'd seen like that in all cor-
ners of the world. Getting this type of feed-
back also affected the piece" (interview with
Kellie Jones, *Real Life Magazine*, no. 16,
1986, p. 9).

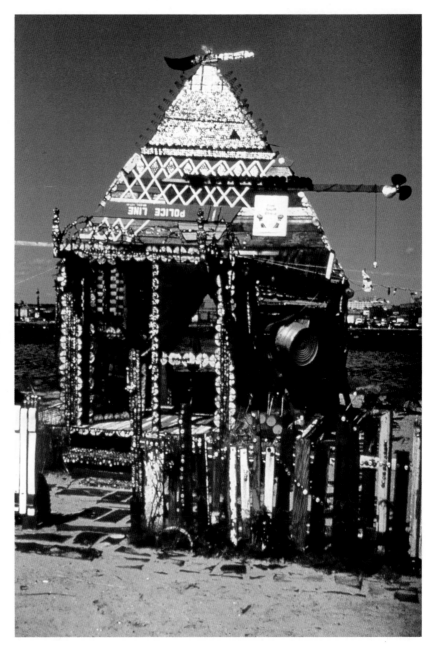

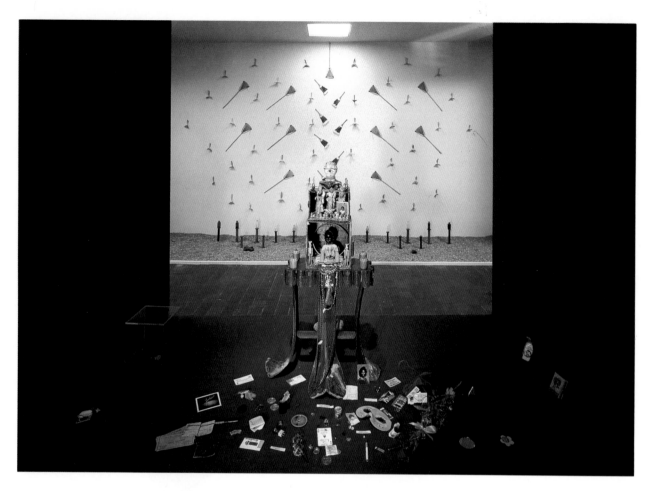

Plate 11: Betye Saar, *Mti*, 1973, mixed media, 42½″ x 23½″ x 17½″; shown in front of Saar's installation *Secrets and Revelations* at California State University, Fullerton, 1988. (Photo: William Nettles.) Saar made her first altarpiece—*Mti* (Swahili for "wood")—in 1973. When it was shown later, in 1977 and 1980, she expanded its function by inviting viewers to contribute something of their own to the installation; toward the end of an exhibition, the piece changed form again when people could reclaim or exchange their offerings. Thus outside energy was solicited in the process of creating new, syncretic myths, with Saar in the role of priestess and *griotte*. At the top of the altar is a godlike, featureless sphere with a single eye, capped by a grinning skull that faces upward; below are a brown cherubim with winged face, three two-legged human/animal figures with different colored faces, then a mass of smaller ones over the central figure—a black doll in a bowl-like recess, a large string of beads draped below her. The table legs are like big wooden fronds, and candle wax from the altar has dripped onto them. The offerings range from photographs of children to flowers, coins, letters, and a mask.

Plate 12: Bessie Harvey, *Snake Through Eye*, 1986, root wood and mixed media, 25" × 14" × 10". (Photo courtesy Cavin-Morris Inc., New York.) Once Harvey sees the images buried in her wood, she may add marble, beads, paint, glitter, even locks of her own hair. Sometimes, as here, her pieces are double-sided or Janus-faced, as in African Ejagham art, where one face looks into the future and the other into the past, symbolizing conscience informing the soul, or, according to Robert Farris Thompson, clairvoyance and presence in two worlds. *Snake Through Eye* can be construed as an original version of the Eve and serpent story, in which the serpent controls how Eve sees the world. (Some mornings "you just wake up feeling like you got snakes coming out of your eyes," Harvey told Shari Cavin Morris.)

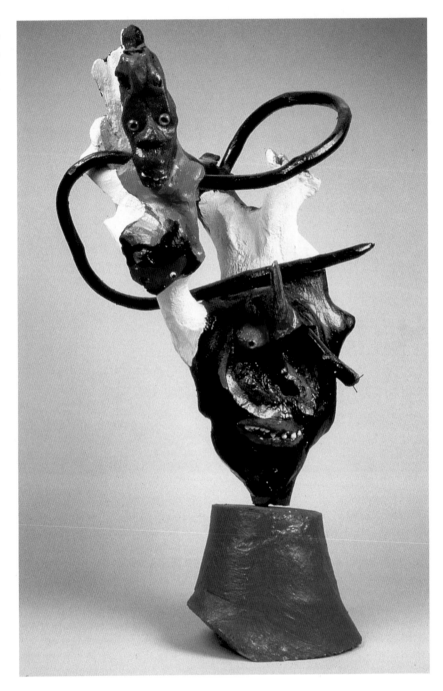

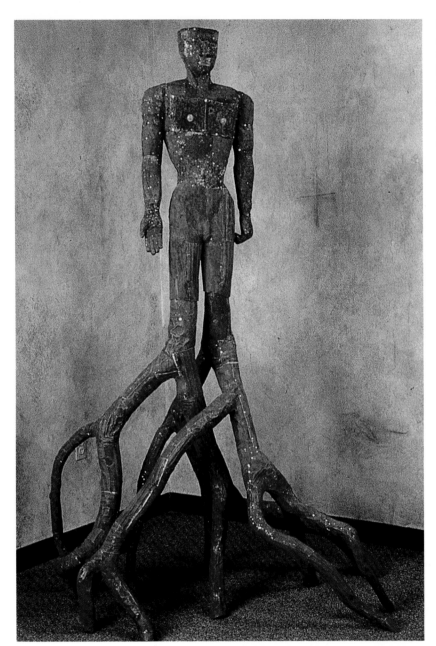

Plate 13: Alison Saar, *Love Potion #3: Conkerin' John*, 1988, wood, nails, tin, 6' x 5' x 4'. (Photo: Ellen Page-Wilson.) In 1988 Saar had a solo show called "Zombies, Totems, Rootmen, and Others," which included small carvings, jujus, totems, and an installation about the power of love dedicated to the vodun goddess Erzulie. It was dominated by the six-foot wooden figure of *Conkerin' John*, rising proudly from a massive tangle of roots—a monumental version of traditional magic charms and vernacular art. Saar is no doubt aware of the expanding body of knowledge on African religions in the American South, where "High John the Conqueror" or "Johnny the Conqueroo" is a gnarled root sold for love and gambling. "When you see a twisted root within a charm," Nigerian elder Fu-Kiau Bunseki told Robert Farris Thompson, "you know, like a tornado hidden in an egg, that this *nkisi* is very very strong" (*Flash of the Spirit*, p. 131). Saar has adapted this idea to a political image of Black power, a continuation of the concept of the extraordinary buried in the ordinary.

Plate 14: Faith Ringgold, *Bitter Nest Part II: Harlem Renaissance Party*, 1988, acrylic on canvas, printed, tie-dyed, and pieced fabrics, 94″ × 82″. (Photo: Gamma One, courtesy Bernice Steinbaum Gallery, New York.) *Bitter Nest* is a five-quilt story about a young black woman doctor, Celia Cleopatra Prince; her father, a socially prominent black dentist named Dr. Percel Trombone Prince; and her creative, eccentric, deaf mother Cee Cee, married out of the schoolyard at fourteen to the much older man. The tale is a convoluted one of family intrigue and unrequited love. The story's real heroine is the eccentric mother, who "made odd looking things and dressed up in strange costumes," as well as producing fabulous dinners for Harlem Renaissance stars such as Langston Hughes, Zora Neale Hurston, and Aaron Douglas.

"Dressed in her oddly pieced and quilted costumes, masks and headdresses of her making, she moved among the illustrious guests. . . . Was this art? [Cee Cee didn't care, and ignored those who called her a] tasteless, low class hussy to clutter up the dentist's fine house with all that 'Mammy-made' stuff."

Although Celia thinks her mother is "crazy like her quilts," and is disturbed by her odd patterns, Cee Cee's work is fabricated from African textiles sent to her by her mother, and the methods Ringgold describes are those of the traditional African American quiltmaker.

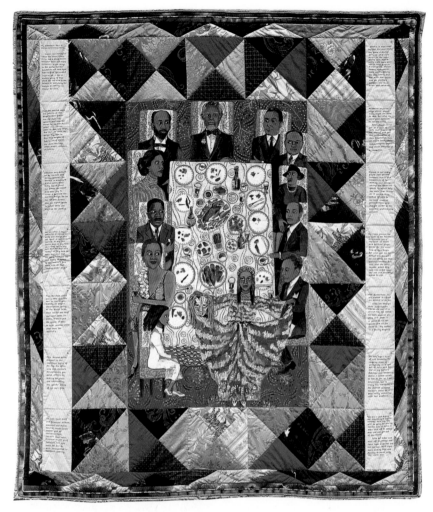

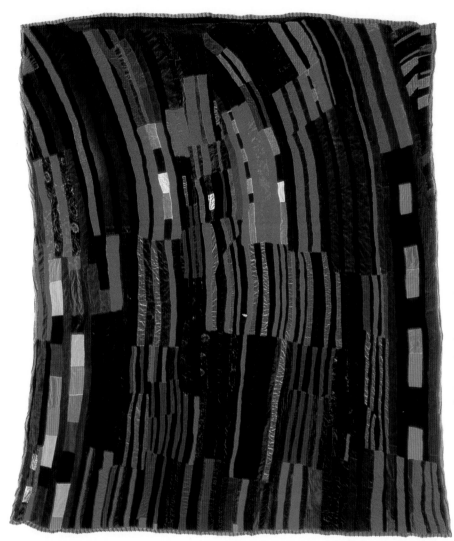

Plate 15: Rosie Lee Tompkins, *String*, 1985, fabric, 85½" x 100". Restructured and quilted by Willa Ette Graham, Oakland. Collection Eli Leon. (Photo: Geoffrey Johnson, © the San Francisco Craft and Folk Art Museum). "Tomkins" is the pseudonym of a quilter from Richmond, California, who chooses to remain anonymous. This is a stunning example of what Eli Leon calls the flexible, improvisatory "Afro-traditional" (as opposed to the "standard-traditional" American) quilt. Leon tells the story of showing his quilt collection to a group of black women quilters. While they were very appreciative of a handsome "standard" Double Wedding Ring example, when he brought out an Afro version of this pattern, he was "thunderstruck by the reaction. These five stately women, a moment before so sweet and serene, started to hoot and stomp until the house shook. The room became a stadium, the fans gone wild. It was an exhilarating experience and it gave me some information I had been unwittingly seeking about cultural differences in standard and Afro-traditional esthetic intention" (*Who'd a Thought It*, p.37).

Plate 16: Amalia Mesa-Bains, *Altar for Dolores del Rio*, 1988, mixed media, c. 8' high, installation at INTAR, New York. The glamorous satin-draped Dolores del Rio altar/dressing table refers in sacred and profane language to Hollywood Art Deco and to different cultural perceptions of women's age and beauty. Mirrors, perfume bottles, strings of pearls, and tissues bearing lipstick kisses accompany movie stills and information on the star's life. There are also clues to a fictional narrative in the photographs, letters, and objects laid out on this secular altar. As Tomás Ybarra-Frausto has pointed out, Mesa-Bains evokes del Rio's presence "via the process of association." Her underlying intention is to "shift perception of Dolores del Rio from being merely a fashionable commodity to her recognition as a woman of significant accomplishment; the first Mexican superstar breaking racial taboos of mainstream Hollywood" (*Amalia Mesa-Bains, Grotto of the Virgins*, p. 9). Del Rio was a friend of Frida Kahlo, a supporter of the socially committed arts in Mexico. Rejected by Hollywood because she supported the anti-fascist forces in the Spanish Civil War, she was allowed back in the '60s. Another Mexican American star, Rita Cansino Hayworth, was also the subject of a Mesa-Bains altar.

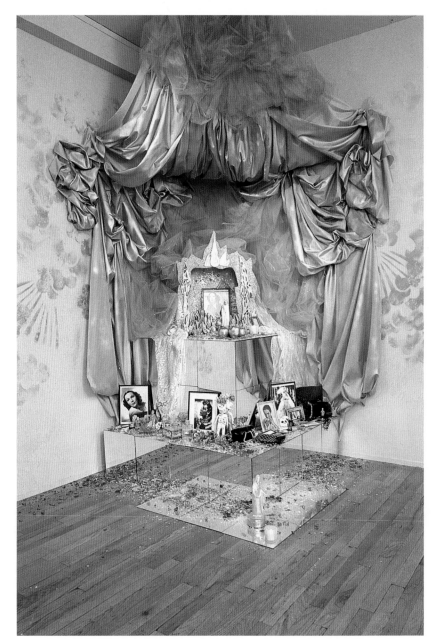

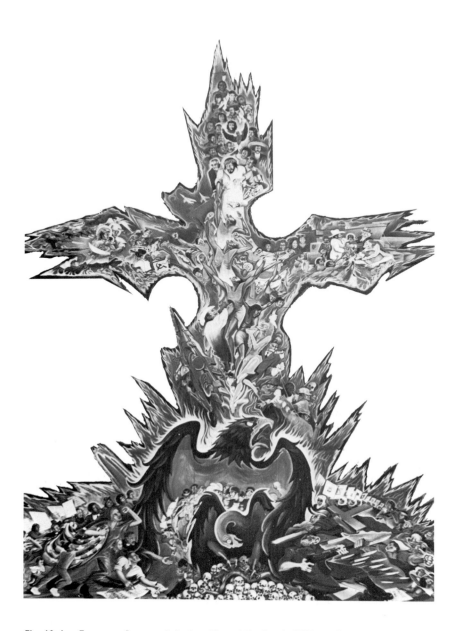

Fig. 18: Leo Tanguma, *Despues de la Cruz* (*Beyond the Cross*), 1986, acrylic on textured ply-wood, c. 33′ x 45′. (Photo: Jeanne Tanguma.) This portable mural, constructed and displayed in various places in Colorado, depicts the history and hopes of Central America. Tanguma, the son of Texas farmworkers, has been making Chicano community murals since 1973. He developed the portable "sculptural mural," influenced by David Alfaro Siqueiros, to avoid the short life of most street murals. The flaming cross, in brilliant colors, with its writhing masses of figures, is a metaphor for the travails of the Central American people, based in the gruesome eagles of the local oligarchies and U.S. foreign policy, and culminating in the revolutionary heroes who rise above the figure of Christ with Archbishop Oscar Romero at his side. Every detail and figure is carefully researched and rendered because Tanguma, who often works with city school students, sees his art as educationally and politically as well as esthetically illuminating.

the religiosity involved in venerating relics as pieces that belonged to the blessed whole there is fetishism. Just as there is promise in the offering of an ex-voto that which was the object of healing through divine aid or miracle. . . . the fragmented body is a sign that a cure is at work. . . . The ceremony of memory shatters the reified universe and breaks the monopoly of the established discourse to define what is real and true.[62]

Regina Vater, a Brazilian who has lived primarily in the United States for twenty years, also sees this "culture of the body" as constituting a cross-continental or hemispheric bond:

In terms of dealing with the body on a psychological but playful level, Latin America is 'hors concours'. Perhaps this is because of the strong absorption of Black and Indian culture, or perhaps because it is an equatorial climate. But in Brazil in particular, the body breathes and invents itself with a sensual spontaneity more intense than in any other place I know.[63]

African-Latino cultures—still condescendingly assumed to be "merely popular"—bring a celebratory ebullience into a still-inhibited white society. Music, especially, celebrates the resilience of the human spirit. Thanks to commerce, the late '80s in the U.S. witnessed a surge of interest in Latin and Caribbean music so that reggae, salsa, ranchero, meringue, and Brazilian samba have all become increasingly audible (and salable). The visual aspect of these public spectacles is the sacred or profane festival, carnival, pageant, or ritual procession with its costumes, floats, food, and general ambience of joy and release.[64]

The traditional function of such celebrations—to allow the populace their temporary bread and circus, even at times to reverse for a day the power structure—is hardly absent from contemporary manifestations like the ethnic-pride parades in cities across the United States. Lorraine O'Grady is one of the few artworld artists to have availed herself of such festive opportunities to escape "cultural confinement" in the ivory-walled towers. Her float for the Afro-American Day Parade through Harlem in 1985 consisted of a huge gold frame inscribed "ART IS . . ." White-garbed passengers on the float leapt off into the crowds to hold small gold frames up to the faces of onlookers, making the point that Harlem and black people were worthy subjects for the classiest art and suggesting more complex aspects of social representation and "framing."

Performance artist and actor Robbie McCauley suggests that music is the frame for African American culture:

Music is the art that has *functioned* for my culture. The music comes out of the pain of being chained to the ship. Amiri Baraka's play *Slave Ship* is the image of everything about our lives in the U.S. symbolized on that ship. Pain, being bound. The one thing that wasn't physically bound was the voice. The scream turned into music. Although I'm not trained as a musician, blues and jazz inform all of my work. The idea that one can hurt and turn it into something beautiful is the way I use the pain.[65]

Fig. 19: Lorraine O'Grady, *Art Is . . .* , 1985, float in Afro-American Parade, New York. The float had the title written on its side, and the people in white riding it would jump off and frame the onlookers with smaller gold frames.

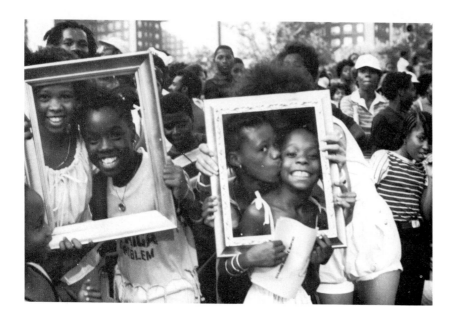

Music and carnivals are not the only cultural performance forms, only the most public ones. Identification with the land, place, family (and therefore history) begins with the body, so storytelling performance artists in particular have their senses tuned to the rhythms, gestures, accents, "local color," and climates where they came up or came out. While artists of color (primarily African Americans) were doing performance art and creating new forms of

Fig. 20: Robbie McCauley, *Indian Blood*, 1988 performance. (Photo: Vivian Selbo.) McCauley, trained as an actress, tells stories in a very untraditional performance art context, backed by slides, video, and often a live band. (She and her husband, jazz musician Ed Montgomery, worked for several years with the Sedition Ensemble, a band devoted to the opposition of racism, imperialism, and gentrification on the Lower East Side; she also works collaboratively with Jessica Hagedorn and Laurie Carlos as Thought Music, in an evolving saga called *Teenytown*.) McCauley's woven stories and songs are about her family's history, and consequently about American history. *Indian Blood* carried on where her previous work, *My Father and the Wars*, left off. Both emphasize contradictions. For instance, her grandfather, who was part Indian, killed Indians in the Spanish-American War and helped take San Juan Hill with arch-colonialist Teddy Roosevelt: "There never was a war we weren't in fighting for them. . . . They say I have Indian blood in my veins. I think I got it on my hands."

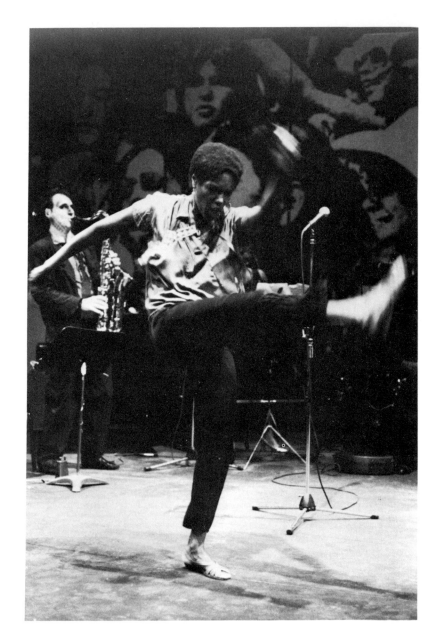

▼▼▼▼▼▼▼

Darlene Clark Hine, professor of African American history at Purdue University, was led to her "Black Women in the Middle West Project" by local women who were determined to have their histories told: "They believed that somehow you could change your present circumstances if only your history was told. Then they would finally be accorded recognition and legitimacy. It knocked me on my heels and taught me, the historian, what history can really teach" (quoted in Andrew Malcolm, "Black Women Find History in the Attic," *The New York Times*, Feb. 2, 1987).

Louise Anderson, North Carolina storyteller and healer, mourns a past when "people would sit out and talk about the

poetry-performance and music-performance on both coasts during the '70s,[66] until around 1980 there were relatively few performance artists of color visible even at the peripheries of the mainstream, despite the purported respect for their strong dance, music, theater, and storytelling traditions.

Black women, especially young women, became the exception. Performance art came into its own with the beginnings of the feminist movement

around 1970, and women have long led its ranks, but according to Lowery Stokes Sims:

"Acting Out" was the exclusive province of black American women long before it was accepted as a creative strategy for women as a whole. The image is a familiar one: given the appropriate provocation—be it anger, annoyance, defiance, or enjoyment—the body language of the black American woman shifts into gear. Hands go on hips . . . the head flings back, and the mouth opens to emit what is more often than not an eloquent and relentless stream of epithets or commentary befitting the situation.[67]

Another factor in the development of performance art has been those politicized artists concerned with outreach into their communities and the decommodification of art, some of whom were influenced by the guerrilla street theater of the '60s. As Sims observes:

Performance art, in conjunction with video, serves as a bridge between the seclusion of the studio and the gallery to the "real" world, the street. It also reclaims for these black Americans a connection with the traditional African nuances of his or her task, whereby the art object was created to be used as part of a grand performance piece—i.e. a ritual that addressed the needs of an entire community, rather than serving as some kind of trophy for a privileged, elite, art-consuming class.[68]

Yet once performance art did develop, it was often too esoteric for the targeted community audiences and was relegated to alternative spaces in the artworld. A number of black artists began performing at their exhibitions, as a way to expand the affect of paintings, sculptures, or installations. Among them were Faith Ringgold, Noah Jemison, Lorenzo Pace, and Houston Conwill. Others, like Kaylynn Sullivan, Danitra Vance, Jawole Willa Jo Zollar of Urban Bush Women, Robbie McCauley, and Judith Jackson came from the legitimate theater, while Ishmael Houston-Jones, Fred Holland, and Bill T. Jones came from dance. Laurie Carlos is a poet; Lorraine O'Grady moved into performance as a writer, former economist, and rock critic. Candace Hill-Montgomery and Joe Lewis III have always been free spirits in their language, medium, and intentions, never resting in any one form.

In the New York Puerto Rican community, Rafael Montañez Ortiz, artist, teacher, and first director of El Museo del Barrio, pioneered the performance art field. His art has always been obsessed with sacrifice. In the '60s, influenced by Dada, Fluxus, and the European "Destruction in Art Symposiums," he killed chickens and smashed pianos. In an anti–Vietnam War piece, he released mice with "dog tags" into a field of mousetraps. In the '70s, as his work became more ethnically connected, he turned to healing the wounds, creating a performance religion of his own influenced by animism, shamanism, and ancient ceremonial rituals that often pay homage to matriarchal sources.

things that hurt them, things that concerned them. At that time people knew how to heal each other by talking to each other. This is what the psychiatrist does today. I knew a girl who told me about her grandmother. It was a terrible story about how her grandmother had been treated as a slave. The girl said she hated to think about it, but I told her that is her story, and she needed to take it, bring it back and hold onto it."
(Quotation from Caroline Senter, "The Healing Art, An Interview with Louise Anderson," *Southern Exposure*, v. 14, no. 3–4, 1986, p. 22.)

The American English Black people speak has been ridiculed as a sign of stupidity, you know, like lower class, but to me it seems very powerful. It struck my mind even as a child. . . . I was always amazed at the language that people spoke, regardless of their education. The metaphors were fabulous: They used pictures that would make your mind jump. . . . When I began to write . . . I wanted to represent that African feeling. It was not possible to talk about a certain time, a historical time, without including that perception. Well-educated Black people will not accept that because it reminds them of their ignorant, barefooted past, but their grandmother's life was like that.

. . . [Literature or art] is always filtered through white sensibilities. . . . Even if it is something exotic, it has to be something that white people are interested in. Even slave narratives were not read by Black people; they were addressed to a white audience.
—Toni Morrison, interviewed by Angeles Carabi, *Belles Lettres* (July/August, pp. 8–9)

Fig. 21: Joe Lewis III, *Viva La Revolución*, January 1984, performance for Artists Call Against U.S. Intervention in Central America at Taller Latinoamericano, New York. (Photo: © Dona Ann McAdams.) When Lewis—a notoriously inventive artist in many mediums and co-founder of Fashion Moda in the South Bronx—cut off his dreadlocks in public in the context of a Central America event, he was performing an act of traditional mourning in many cultures, in homage to the dead of El Salvador. It was also a personal act, marking a time of philosophical change, of "subterfuge, because without that look I disappeared as an entity. People didn't recognize me. It was an intense experience." Lewis's work at that time consisted of putting himself into very exaggerated physical situations, after which he stopped making objects for several years and devoted himself to artist's books and facilitating important cultural work by others. Today, having received his MFA, he is making above-ground art again; c.f. *Artforum*, March 1990. (Quotations from conversation with the author, 1990.)

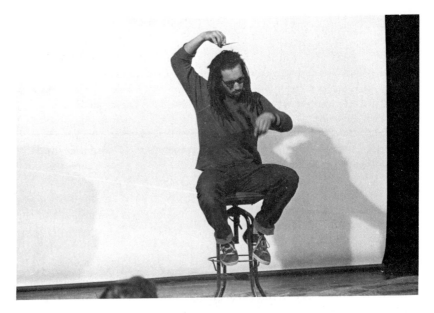

Fig. 22: Rafael Montañez Ortiz, *Communion with the Trees*, 1988, performance for Arte Sella, Italy. In the '60s Ortiz (harking back to the bloody rituals of his Aztec ancestors and a childhood job in a chicken slaughterhouse) smashed pianos and killed chickens in an international orgy of "sacrifices to violence" and deliberately infantile behavior, some of which protested social taboos while other actions were more politically oriented: "Destruction has no place in society—it belongs to our dreams; it belongs to art." After 1970 he became involved in the Human Potential Movement, studied healing, Sufi, and Tantrism. By the '80s—by then a Ph.D. from Columbia, first director of the Museo del Barrio, and something of a neo-shaman—Ortiz cofounded the "International Symposium of Art and the Invisible Reality" and developed a metaphysical theory of "Physio-Psycho-Alchemy." He sees art as "the dream of the awake state, as our dream is the art of our

Puerto Rican choreographer Merián Soto and visual artist and set designer Pepón Osorio have collaborated for several years on performances dealing with Caribbean popular culture and have been described as "the hottest Latin performers on the 'blanco' art circuit."[69] Their group, Pepatian, which has performed in New York and Puerto Rico alongside dancers like Patti Bradshaw and Viveca Vasquez, weaves folklore and the pop narratives of soap operas and *fotonovelas* (photographic comic-book romances) into tragicomic melo-

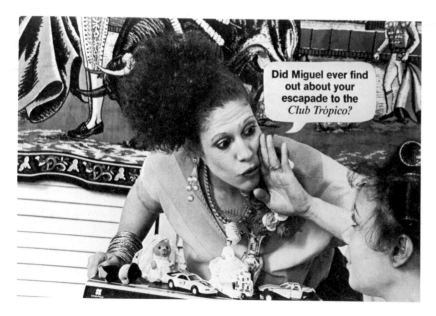

dramas that recall the *variedades* shows of the '50s. Osorio's sets are lavish, sensuous, garish, colorfully patterned within an inch of chaos, subverting and reversing the notion of Latin "extravagance" and "bad taste." In her *Memorias de la Revolución*, Carmelita Tropicana also uses melodrama for high-camp intrigues about prerevolutionary Cuba seen from an East Village perspective. The NuYorican poetry and theater movement, led by such figures as the late Miguel Piñero, Pedro Pietri, Ballet Hispanico of New York, and the group Pregones, also sometimes spills over into the performance art arena.

In "Califas," politically conscious Chicano performance from Asco and Gronk to Guillermo Gómez-Peña and the Border Art Workshop (see chapter 5) is countered by the kind of ritualistic work epitomized by Victor Mario Zamballa in his mythical *Mixcoatl, Serpiente de Nube*, based on "the origins of ancestor worship and cave painting in prehistoric Mexico."[70] In Phoenix, Arizona, Larry Yañez performs as *Fumamoto*, a Samurai Chicano fond of cross-cultural puns because there are words in Spanish that sound Japanese, and vice versa.

With the advent of "talking dance," and as the lines have blurred between performance and "legitimate" theater in the '80s, it has become increasingly difficult to say what branches of acting out belong in what "world." Asian performance, for instance, combines dance, video, music, and theater as a matter of course. Ping Chong has long been one of the most respected performers in the United States, his elegant, stylized choreography, often with masked performers, blending modernism with its own Asian influences. Jacki Apple has written of his work that he "consistently and consciously reverses the viewpoint so that we see our own strangeness, while also identifying with

sleep state." This piece was performed by Ortiz, channeling the voices of the trees, in Italy, and also on the property of the late Fluxus artist Robert Watts. (Quotations from Kristine Stiles's text in *Rafael Montañez Ortiz: Years of the Warrior 1960, Years of the Psyche, 1988* [New York: El Museo del Barrio, 1988].)

Fig. 23: Merián Soto and **Pepón Osorio**, *No Regrets* (with script by Lourdes Torres Camacho, photographs by Beatriz Schiller), 1988, performance at P.S. 122, New York. (Photo: © Beatriz Schiller). Here Lillian Morillo and Maria Aponte act out a *fotonovela* (photo-tragicomic book) that was presented in slide form within this experimental adaptation of the soap operas that appear on Spanish-speaking television. The heroine, Maria, is struggling to raise her children, get an education, and decide between two men. The story unfolds in video, music, dance, performance, and photography. Soto is a choreographer and performance artist and Osorio is a sculptor and installation designer, a master of Puerto Rican *rasquachismo*. They have been collaborating (sometimes as a group called Pepatian) since 1983. Their pieces examine urban reality, Puerto Rican popular culture, and cultural, geographic, and linguistic displacement. Vividly colorful in every aspect, full of life and energy, the pieces are often reminiscent of '50s *variedades* shows, but with contemporary style and social content.

Fig. 24: Muna Tseng, *Post-Revolutionary Girl*, 1988, performance/dance. (Photo: Nan Melville.) Tseng is a Chinese American dancer/choreographer working out of New York whose incandescent performances have dealt with cross-cultural issues for some time. *Post-Revolutionary Girl*—a solo accompanied by Phill Niblock's video and Chinese and Balinese folk music—is partially autobiographical, a meditation on memories from a Hong Kong childhood and studies at the Ying Wah Girls School ("very Chinese curriculum with an English schoolmistress"). Tseng describes her evolution from a "thickly bespectacled noiseless adolescent" to a striking performer: "Noiselessly, I discovered ephemeral sensory and kinesthetic possibilities, elusive symbolic threads from my psyche. . . . For the past decade and a half, my muse and I have inched circuitously like a snake (I was born that year), shedding old skins of selves and egos in the evolution of my outer form and inner voice" (program notes from *Post-Revolutionary Girl*, Mulberry Street Theater, 1988). In the performance, the evolution of Chinese women is an elusive parallel narrative, particularly poignant when the dancer lies on her back and binds her feet, held high in the air, "dancing" without standing.

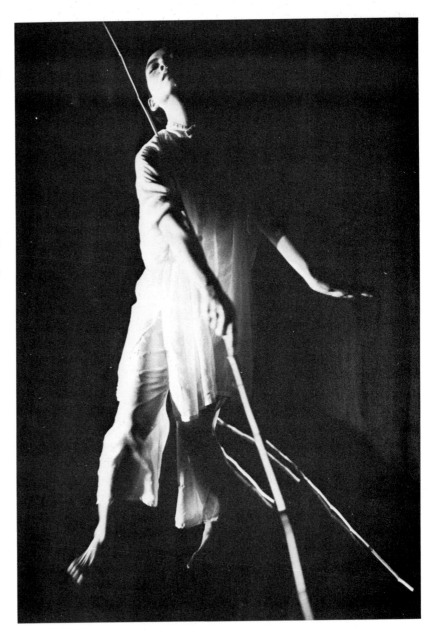

someone who is 'different,' be it a golem or a gorilla. . . . Which world is more 'alien'—the new one we imagine or the one we have created? Are they not one and the same? Chong leaves us to ponder such abstract questions."[71]

Jessica Hagedorn, who often works with other women of color, performs humorous and sometimes surreal music and poetry pieces about love, romance, and modern Filipina women and families. Barbara Chang's *Steel Magnolia*

(1988) traverses a thousand years in a love story between a classical Chinese moon goddess and a modern dancer. Yoshiko Chuma's School of Hard Knocks performs with cyclonic movement and topical humor about East and West. Jude Narita dramatizes the experiences of Asian women of various generations. Korean American Kumiko Kimoto's 1988 *Lost Map* radicalized the American musical, while Rumiko Tsuda uses natural materials to comment lyrically on the Japanese tea ceremony, flower arrangement, Kabuki, and Noh theater. Kei Okada's 1988 *Salt 40*, described as "an audiovisual madrigal," looked at forty years of conflict in Israel seen from Japan and Manhattan. On both coasts, Maria Cheng, Carlos Villa, Linda Nishio, May Sun, Ruby Shang, Daryl Chin, Muna Tseng, the late Theresa Hak Kyung Cha, and Roger Shimomura (in Kansas) have all worked out from their Asian heritages in wildly various and more or less direct manners.

For the Native American communities, powwows and traditional dances and ceremonies seem to fulfill many of the needs of performance art, and their theatrical offshoots are in the fields of drama and dance rather than the visual art context. When the American Indian Dance Theatre performs, for instance, they are forced to edit and choreograph, since the original dances may last for a day or more. The dancers, however, are veterans of the national powwow network. The word "powwow" meant "he dreams" in seventeenth-century Algonquin and colonials used it to denote a shaman or a healing process; it also meant an intertribal gathering, suppressed by the U.S. government from 1882 until 1934; it was revived, perhaps for the first time by the Shinnecocks in 1936, as a response to reforms that allowed Native peoples to meet again.[72] In its present form, the powwow burgeoned in the '50s and '60s, when automobiles became common on reservations and mobility increased. The powwow, as Jaune Quick-To-See Smith describes it,

> is not just a random gathering, but an orchestrated event, with eating and socializing a part of it too. It's so complex, that a large powwow could be likened to a parade, circus, street theater, dance, drama, comedy, and Billy Graham all rolled into one grand theater. It serves the Pan-Indian community as a place for preaching and politicking, a place to raise consciousness, trade, reidentify ourselves, listen to our elders, teach our children about giving back through the giveaways.[73]

Within the art context, Jimmie Durham performs occasionally, as does Luiseño/Digueño James Luna, whose drawn-out, "real-time" contemplative performances are about maintaining traditional values in contemporary culture as well as about his social work around alcoholism on the reservation. White Cloud (a Choctaw) performs a "Multi-Media Multiple-Shamanic Art-Piece," disavowing responsibility for his witty, irreverent, and sometimes obscene monologues delivered in a trance: "Everyone knows I will do anything in an effort to attain enlightenment, and have neither the intelligence, the imagination, nor the experience to conceive of such things. I am merely a pawn

▼▼▼▼▼▼▼

I will tell you something about stories,
They aren't just entertainment.
Don't be fooled.
They are all we have, you see,
all we have to fight off
illness and death.
You don't have anything
if you don't have the stories.
—Leslie Marmon Silko (Laguna/Pueblo),
Ceremony (New York: Viking Press, 1977
p. 2)

The women have always kept the stories, in clay or reeds, in wool or cotton, in grass or paint or words to songs. . . . Sometimes she thinks it's funny the way the stories change when she tells them. She doesn't know Indian country the way Grandma knew it, and no matter how much she might wish she looked like the old ladies out in the plaza sometimes, she knows she never will. It's bluejeans and sunglasses for her after all—save the fringed shawl for powwow. One of her cousins called her a Disco Indian last week. But still, she's not as hip as she looks sometimes. It's not that she could ever get away from the old stories, even if she wanted to.
—Rayna Green (Cherokee), *That's What She Said* (pp. 3, 5)

Fig. 25: Spiderwoman Theatre, *Sun, Moon and Feather*, 1989 performance. Muriel Miguel, Gloria Miguel, and Lisa Mayo are three Cuna/Rappahanock sisters who spent their childhood in Red Hook, Brooklyn, where their parents ran a touring (and touristic) "Medicine Show." In this performance (and a hilarious film made by Bob Rosen and Jane Zipp that includes thirty years of home movies) they vigorously and humorously chronicle their family life, bursting into bursts of "Indian Love Song," among other musical sidetracks. Spiderwoman Theatre blasts stereotypes on two levels, first by aiming directly at them and second, indirectly, by a presence and a sense of humor that may be more profoundly Indian than anything easily recognizable as "Indian."

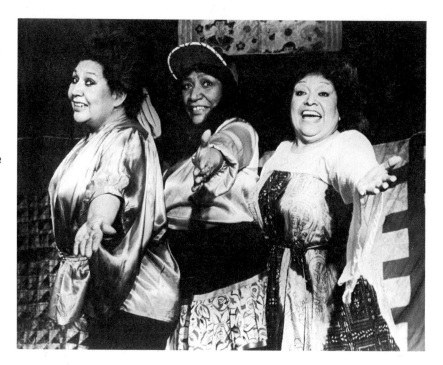

in the hands of cosmically merciless wit."[74] Alanis Obomsawin, a Canadian Abenaki, is a musician who performs haunting original and traditional syllable songs, a filmmaker, political spokeswoman, and unique storyteller of modern Indian life; she has been honored by tribal elders with the name Ko-li-la-wato, "the one who brings pleasure."

The New York–based Spiderwoman Theatre was founded by three extraordinary Cuna-Rappahanock sisters who performed as children in their Brooklyn-based family's "Indian Medicine Shows." Muriel Miguel was trained as a nurse, became an actress and then a drama professor at Bard College; Gloria Miguel is a mother and grandmother who studied drama at Oberlin College; Lisa Mayo is a classically trained mezzo-soprano. The three sisters, who have become increasingly popular through the '80s, have been described as "a daring, idiosyncratic, energetic and dauntless" collective that "challenges the concept that all women's theatre is the same." Sometimes they work with Vira and Hortensia Colorado, Chichimec sisters who are also Off-Broadway playwrights and work together as "Coatlicue: Los Colorado." Spiderwoman's pieces satirize everything in sight, Indian and white, including bogus "plastic Shaman" workshops and " 'Wannabees'—the largest 'tribe' in Indian country."[75]

Artists of color who had been innovating performance for years were finally noticed by white critics in the '80s. Their contributions have proliferated (I have given their breadth short shrift here) and are now more or less recognized as vivid avant-garde alternatives to the stagnant dogmas of a conventional ethnic art. At the same time, these artists often use unfamiliar strategies and

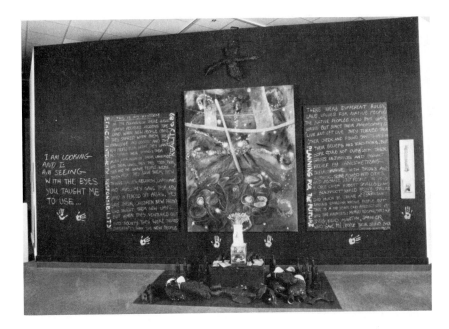

Fig. 26: Joane Cardinal-Schubert (Peigan), *Deconstructivists: Preservation of a Species*, 1988–89, mixed media installation at Glenbow Museum, Calgary, 1989, 30′ x 20′ x 30′. (Photo: John Dean.) Cardinal-Schubert was raised in Red Deer, Alberta, and graduated from the University of Calgary, where she now lives. While working as a curator, she visited ancient sites and began to research Native history. "I am looking and I am seeing, with the eyes you taught me to use," reads the text at the left of this installation. It could be read two ways—as an acknowledgment of what the artist has learned from Native elders, or as a subversive use of what she has learned from white theory. Her texts illuminate the tragedies of children in foster homes, the graveyards of Indian schools full of four- and five-year-olds, burial grounds plundered by university museums, and ecological damage. The matte black walls are inspired by the pages of photo albums. "My part in all this preservation of an invisible culture is of a receptor or translator," she says, "one who would point out what there once was, what there still is, and the importance of all this to us" (*Visual Arts Newsletter*, Calgary, 1985).

baffling modernisms that can appear hostile outside the artworld and remain problematic for conservative middle-class ethnic art circles as well as for inner-city communities. As working artists, they are also affected by the hard economic realities and prejudices that minimize interest in nonsalable work. Yet they are telling the stories that risk being forgotten, and as an increasing number of middle-class families come to terms with their histories, the arts that provide their vehicles for remembering become increasingly valued.

> Storytelling conjures up the image of some nice person telling sweet things to children. That's not how we understand it at all. The stories come to us when we need them. They come to our elders and to our young people. The stories

▼▼▼▼▼▼▼
My sense of this land can only ripple through my veins
like the chant of an epic corrido.
I come from a long line of eloquent illiterates whose history reveals what
words don't say.
—Lorna Dee Cervantes, "Visions of Mexico While at a Writing Symposium in Port Townsend, Washington," in Marge Piercy, ed., *Early Ripening* (New York/London: Pandora, 1987, p. 23)

Fig. 27: Celia Alvarez Muñoz, *Tolido*, 1986–87, mixed media including maple, photos, letterpress type, mirror, 7' × 6' × 4'. (Photo: Tracy Hicks.) Muñoz was raised in a bilingual, bicultural household in El Paso, and many of her "foto-fables"—narrative photographic boxes and books—stem from stories told in or about her childhood, always related with an ironic twist that is visual as well as verbal, including the parts "your mother never told you." She calls these works the "Enlightenment Series," because they have helped her synthesize her own history. Muñoz came from a "family of storytellers," a grandmother who "wove superstition and religion into a seamless reality" and a father who told "tall tales with a caustic bent" and made comic strips on the walls of their outside bathroom. When, after raising her children, she went to college, Muñoz discovered that instead of drawing on her new knowledge, she was making increased use of her own background in her art. She often introduces into this local milieu elements from European high culture, in this case El Greco's famous painting, here equated with the family privy. The text below the painting (which is lit by a red neon ring around the little house set within a picket fence) reads: "I used to hear the old ones say that the site of a buried treasure gave off an intense red glow. One such place was in grandmother's backyard. The event occurred every evening at about seven. That was also around the same hour that the ritual took place of burning the daily papers from the privy called 'Toledo,'" (or "toilido," from "toilet"). El Greco was himself a transplant from Greece who "managed well in Spain," says Muñoz. "*Tolido* deals with value systems, with material values as buried treasures that might literally or symbolically be trash. It is also very much about the adaptation of one culture from another. Linguistically, the border existence is one of survival. Giving birth to new languages is part of the strategy" (letter to the author, 1989).

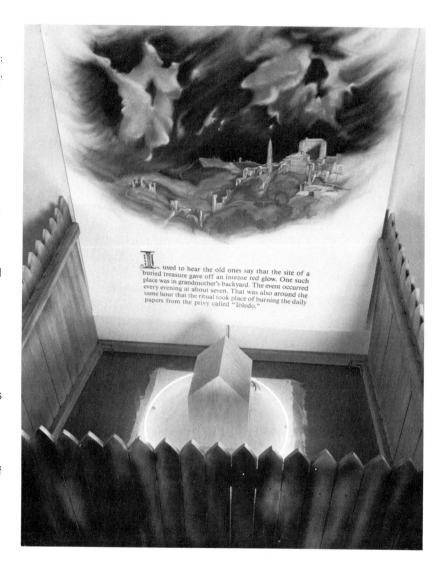

are there to help guide you and help you know what the connection to the land is. It doesn't need to be a weak unfocused spiritual flight. We don't get dressed up in our Indian clothes and smoke tobacco. . . . Storytelling is challenging the validity of people's memories today. You can't hear the truth from reading. And there's a big difference between reading and the truth.[76]

In Iroquois tradition, all stories came from a round stone in the middle of the forest; it was given to be told forever to all generations, as Tuscarora photographer Jolene Rickard points out above. Every culture has its traditional stories, no matter how diffused they may have become in families concerned primarily with survival or assimilation. Those in the dominant groups devalue stories for different reasons; inundated by texts, perceiving themselves as part

of "history," they are confident that their stories will be told for them, and they are less likely to understand the crucial significance of personal/communal memory.

Narrative is also prevalent in Latin American art—one reason, Susana Torruella Leval points out, that it is considered "retardataire" by the mainstream.[77] The oral tradition that nurtures the Native and African American cultures is not sharply separated from music and dance. Trinh T. Minh-ha describes the storyteller in all cultures as "an oracle and bringer of joy . . . the living memory of her time, her people."[78] In visual art, storytelling appears more hermetically as a narrative element, a pictorial emphasis, or as abstract pattern translating rhythm or language. In all cultures, women have been the strongest force for maintaining their history and heritage. Now that they are more likely to be educated, to become artists, they have translated the old stories, beliefs, and customs into their arts. They are the *griottes* or *fundis*—social healers, keepers of history, politics, stories, mysteries, and arts, passing them on from one generation to another. In Mexican culture on both sides of the border the musicians and poets who compose the *corridos* play this role. A storytelling song or oral broadside, often composed in the heat of current events and getting instant radio play, the *corrido* focuses on such subjects as Mexican heroes triumphing over Anglo oppressors, the tragic deaths of undocumented workers, or national dramas like the death of John F. Kennedy.

Art that tells stories is fascinating to modernists and postmodernists because of its openness to textual and linguistic analysis, and to social perceptions of the role of truth and lies, as well as their consequences. In a mistrustful (and mendacious) society like ours, based on the illusion of pragmatism, griots and artists are suspect because they might be "liars"—as though most of the "fact-tellers" were in fact any more truthful than the "storytellers." In other cultures

▼▼▼▼▼▼▼

The everpresent *corridos* narrated one hundred years of border history, bringing news of events as well as entertaining. These folk musicians and folk songs are our chief cultural mythmakers, and [like country-and-western music] they made our hard lives seem bearable.
—Gloria Anzaldúa, *Borderlands/La Frontera* (p. 61)

Fig. 28: Lanie Lee, *Stellular Storyboard*, 1985, mixed media, 17½″ x 43″ x 3″. Lee's art incorporates the tales her mother told and those she has read. Her mythical objects resurrect narratives and primal images "pulled out of a repository of symbols I have been collecting since childhood—memories and dreams and cross-cultural experiences. By collaging different materials and images, I am trying to connect the mixture of thoughts with intuition in order to resolve some of the identity conflicts [of growing up with] both Asian and American rituals and thoughts." The central, faceless "figure" in this painting is gold, giving it the distance of wealth and privilege, while the little girl's portrait and the "mosaic" at the left are framed in silver; the spheres, says Lee, are "frames that contain some of my emotional and psychological experiences layered into the larger scheme of things" (letter to the author, 1989).

Fig. 29: Kwok Mang-Ho, *Gods' Party*, 1986, found objects from nature and human garbage, 16' x 30' x 20', installation at the Everson Museum of Art, Syracuse. Kwok is a multimedia artist from China, now working in New York, who was called in 1980 "the most eccentric artist in Hong Kong." His favorite medium is plastic ("it originates from a natural earth element and can take on many shapes and forms"), especially plastic bags (a worthless container that "can become a vehicle for anyone's playfulness"). He often uses, as here, the image of the frog, "its ever-changing life cycle symbolizing perpetuity. Its double froggy eyes represent the cross cultural bridge between eastern and western traditions with wide eyes open . . . sharing happiness and awareness. *Gods' Party* is a place for people to have fun. It's a spiritual world comprised of froggy Gods, early ancestor images . . . a party in another time and space" (*Other Gods*, p. 50). Kwok remains close to his Chinese heritage, writing calligraphy, living in a Kung Fu club in Chinatown, incorporating village icons and ancient religious symbols (as well as political buttons and all kinds of kitsch) in his colorful, chaotic installations.

these blurred lines are celebrated. Zora Neale Hurston, African American novelist and pioneer anthropologist within her own southern communities, was told when she returned to her Florida town to collect stories: " 'Zora, you come to de right place if lies is what you want. Ah'm gointer lie up a nation. . . . Now, you gointer hear lies above suspicion.' "[79]

Maxine Hong Kingston recalls, "Night after night my mother would talk-story until we fell asleep. I couldn't tell where the stories left off and the dreams began."[80] At the same time, Trinh T. Minh-ha points out that while Kingston was " 'often mad at the Chinese for lying so much,' and blames her mother for lying with the stories, she happily *lets the lying go on* by retelling us her mother's 'lies.' "[81] Nevertheless, family portraits appear to stand for the storytelling tradition in Asian American art, as seen in the work of Tomie Arai, Hung Liu, Simon Leung, and the performances of Muna Tseng and May Sun, among others. The stories often lurk behind the solemn figures and impassive faces of old family photographs, waiting to be guessed at, or "lied about."

Margo Machida speculates on why there is so little of this narrative tradition in contemporary Asian American visual art: "Perhaps our history is not so culturally disrupted as that of African Americans and there is less need to construct a separate history."[82] Robert Lee surmises that references to the religious folk arts have disppeared from most modern Asian work because their original roles have been forgotten.[83] It also seems possible, however, that the Chinese folk religions, with their hungry ghosts and paper gods, remain so strong in recent immigrant communities that they are too close to be distanced into a foreign art tradition. Artists like Bing Lee and Kwok Mang Ho, who are part of the Epoxy group (see chapter 5), do employ the artifacts of popular

Fig. 30: Theresa Hak Kyung Cha, *Aveugle Voix (Blind Voice)*, 1975, performance, San Francisco. (Photo courtesy the Theresa Hak Kyung Cha Memorial Foundation, Orange, California.) Cha was born in Korea, came to the United States at twelve, went to the University of California at Berkeley, and lived in Paris, Amsterdam, and New York. Influenced by sources as diverse as Samuel Beckett, French film theory, and Korean traditional dance, she wrote, made videos, and performed her visually ethereal and intellectually original pieces until her death at the hand of a stranger when she was thirty-one. Cha was fascinated by language but maintained her visual focus. The title *Aveugle Voix* is a typical cross-reference between the senses. Images and language shifted and wove in and out of each other. "You write. You write you speak voices hidden masked you plant words to the moon you send word through the wind," she wrote in her book *Dictée* (New York: Tanam Press, 1982, p. 48). Cha's materials were simple, usually black and white, like print: paper, white cloth, candles, fire, and words. Her themes were time, memory, and loss. When she died she was working on a performance about the representation of hands in art as an esthetic and anthropological study of cultural differences.

Chinese culture, altered by caricature or chaos as they are reflected in American contact. Fred Wei-han Ho's (formerly Houn) 1989 experimental opera, *A Chinaman's Chance*—a bilingual chronicle of more than 140 years of Chinese American history—included jazz, folk songs, proverbs, ballads, chants, "orature," new music, modern dance, and Peking Opera. The title term, coined in the 1880s, meant "no chance at all," and Ho intended his work as "a recuperative, rejuvenating extension of what was once a popular form of entertainment and cultural expression in Chinatown communities throughout the U.S."[84]

The mythological references that pervade postmodern art and writing indicate how hard it is to let the stories go. Even as they are being deconstructed, the tenacious power of memory at their base—most often entrusted to women—refuses to be uprooted. In the words of Theresa Hak Kyung Cha:

> Let the one who is diseuse, one who is mother who waits nine days and nine nights be found. Restore memory. Let the one who is diseuse, one who is daughter restore spring with her each appearance from beneath the earth. The ink spills thickest before it runs dry before it stops writing at all.[85]

Fig. 1: Isabel John (Navajo), *Yeibichai Healing Ceremony*, 1984, handspun wool, natural and commercial dyes, 5'1½" x 8'3". Collection Jan and Frederick Mayer, Denver. John is an award-winning weaver living in Many Farms on the Navajo reservation. She has been weaving since she was eleven. This intricate pictorial tapestry depicts the last day of the nine-day Yeibichai ceremony, combined with a feast. The smoking hogan is the healing place. The dance takes place in the center as people arrive; others cook; cattle and sheep graze in the background while horses hold the foreground. The site is near Canyon de Chelly and John has located it by the red Round Rock buttes in the distance. The presence of a horizon is Western, but the spatial sense of the scene itself is closer to the multiple viewpoints of traditional sand paintings, combined with the horizontal bands of traditional Navajo weaving. The colors are rich, subtle, and soft, the earth a yellow brown made from vegetal dyes, the figures browns, turquoise, green, white, and black.

LANDING

▼▼

Any place can be the center of the World.—Black Elk[1]

The events of one's life take place, *take place*. . . . they have meaning in
relation to the things around them. And a part of my life happened to take
place at Jemez. I existed in that landscape, and then my existence was indivisible
with it. I placed my shadow there in the hills, my voice in the wind that ran
there, in those old mornings and afternoons and evenings.—N. Scott Momaday[2]

The cracks and canyons in this supposedly unfenced culture show nowhere so
clearly as in attitudes toward significant place—its presence and its absence.
Place can be perceived as static and cyclical, a coiled snake marking rootedness,
Mother Earth; or it can be seen as a traveling snake, its riverlike track marking
the rough and restlessly worn roads of modern life and the imagination, of
history, progress, and patrimony. There is land and there is *the* land—ancestral
soil or scenery, and nation. The landing process is not always a matter of
geographical turf, nor of coming to rest; it can be equally a process of change,
of being sent away or of "taking off" on a quest for home that may never be
satisfied. For those in internal or external exile, landing can become a psychic
image, even a vision.

The history of all North Americans has been one of diaspora, or dispersion.
Even the Native peoples who have been here for 25,000 years were probably
immigrants from Asia.[3] In the last five centuries they have been force-marched
away from their homes and/or confined to reservations that are a fraction of
their original territory. Since place is experienced through a filter of culture
and history, landing for Native Americans is now a concept fraught with
ambivalence. Individual motives for leaving the reservation, and returning,
can be influenced and constrained by a history of genocide, racism, political

▼▼▼▼▼▼▼

Gretel Ehrlich, an Anglo former journalist turned sheepherder and rancher in Wyoming, has become a spokeswoman for her adopted land. As a trained observer who knows and respects difference, she writes eloquently about lives lived in common but not alike:

"I have Indian neighbors all around me—Crow and Cheyenne to the North, Shoshone and Arapaho to the south—and though we often ranch, drink, and rodeo side by side, and dress in the same cowboy uniforms—wrangler jeans, tall boots, wide-brimmed, high-crowned hats—there is nothing in our psyches, styles or temperaments that is alike. . . .

"Because Christians shaped our New World culture we've had to swallow an artificial division between what's sacred and what's profane. Many westerners, like Native Americans, have made a life for themselves out in the raw wind, riding the ceremony of seasons with a fine-tuned eye and ear for where the elk herd is hidden or when in fall to bring the cattle down. They'll knock a sage hen in the head with a rock for dinner and keep their bearings in a ferocious storm as ably as any Sioux warrior, but they won't become visionaries, diviners, or healers in the process" (*The Solace of Open Spaces* [New York: Penguin Books, 1986, p. 102–5]).

and economic disenfranchisement. "Settling" and "homecoming" acquire double-edged meanings: comfort for some, eviction and loss of freedom for others. Kiowa writer and artist N. Scott Momaday, who spent his childhood in different Indian communities throughout the Southwest, including the Navajo reservation and Jemez Pueblo, wrote of his father, also an artist:

> There came about a great restlessness in my father, I don't know when. I believe that this restlessness is something in the blood. The old free life of the Kiowas on the plains, the deep impulse to run and rove upon the wild earth, cannot be given up easily; perhaps it cannot be given up at all. I have seen in the old men of the tribe, especially, a look of longing and—what is it?—dread. And if dread is the right word, it is a grave thing, graver than the fear of death; it is perhaps the dread of being, of having been in some dark predestination, held still, and in that profoundly shamed.[4]

The subject of a great deal of the art discussed here is internal exile. It haunts even those who have remained more or less in place, those who belong to the Fourth World, described by the Sioux writer Vine Deloria, Jr., as:

> all aboriginal and native peoples whose lands fall within the national boundaries and techno-bureaucratic administrations of the countries of the First, Second, and Third Worlds. As such they are peoples without countries of their own, people who are usually in the minority, and without the power to direct the course of their collective lives.[5]

Because Native American artists live today in two places at once, in a mysterious synchronicity or "extended present," their art is far more complex than is realized by a public that identifies it primarily with the annual Indian Market in Santa Fe and all the beige-and-turquoise-decorated galleries specializing in Southwest art (which is often neo-Indian art by whites). The Fourth World is not entirely defined by powerlessness, but its status of internal exile determines its strategies. In the process of asserting a new identity or reclaiming an old identity, Indian artists in particular are haunted by invisible boundaries and dangers. As they search for their lost lands, they often find that someone else has built there—actually and metaphorically—and they run the risk of reinventing themselves not on their own terms, but on those that history has inserted between their loss and their roots. However, deracinated Native people continue to identify themselves by their places of origin even if they are two generations removed from them. Many contemporary Indians go back and forth between their reservations and their current homes. There is even a reverse migration taking place, in which educated Indians are leaving the cities to go back and work for their tribes as artists, lawyers, or in economic development.

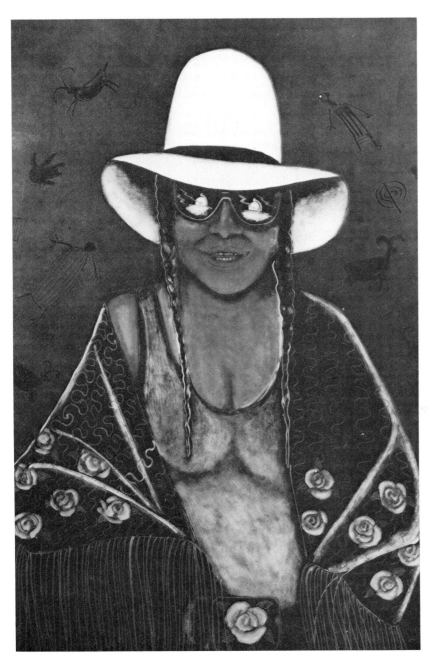

Fig. 2: Jean LaMarr (Paiute/Pit River), *They're Going to Dump It Where?!?*, 1984, monoprint, 24″ × 36″. LaMarr, who is from the reservation at Susanville, California, where she still lives, describes this portrait of a contemporary Indian woman as an image of resistance. Her rose-covered shawl refers to the fact that Paiute women are traditionally named after flowers, but her dress is modern and her dark glasses reflect the image of the much-disputed Diablo Canyon nuclear facility being struck by lightning. The background is dotted with ancient petroglyphs. The print refers to the destruction of Indian lands and sacred sites in favor of lucrative but ultimately destructive technology. LaMarr has taught on the reservation, in prisons, schools, and universities. On principle, she does not show in commercial contexts, and she is a printmaker (and muralist) because her primary concern is that her work be available and accessible to her community: "I use contrasts that reflect the passage of time, respect for the land juxtaposed with exploitation of the land, and the stereotype Indian contrasted with the contemporary Indian of today. . . . The warrior spirit continues today" (*Ni'Go Tlunh A Doh Ka*, p. 30).

If anxiety and alienation ensue in exile, so may an agonizing sense of freedom—at worst a directionless void, at best a creative catalyst. The art being made about dislocation today is a critique of modern society. It is often morally and ecologically as well as esthetically and politically critical. Immi-

Fig. 3: Peter J. Clair (Micmac), *Sing to the Four Directions—From the West Came Many a Death Song*, 1989, ash splint, 18″ x 18″ x 29″. Clair, a Canadian, calls his adaptation of the Micmac and Maliseet ash splint basket traditions "sculptural weaves." While they allude to cone-shaped baskets, they also suggest architectural forms and large scale. The four swaying cylinders, each a different height, become figures or entities singing over a drum or a sacred mound.

▼▼▼▼▼▼▼

It is the spatial image alone that, by reason of its stability, gives us an illusion of not having changed through time and of retrieving the past in the present. . . . Space alone is stable enough to endure without growing old or losing any of its parts.
—Maurice Halbwachs, quoted in Jonathan Z. Smith, *To Take Place: Toward Theory in Ritual* (Chicago: University of Chicago Press, 1987, p. 1)

grants, exiles, and refugees not only change the societies into which they move, but make visible aspects of that society that were previously hidden, that surface when illuminated from the perspective of a different culture.

When understood in the context of transformation as well as oppression, art about place and displacement may include an overt or covert religious or spiritual aspect. The relationship between religion and land is often forgotten in modern belief systems. Yet even those religions that have been carried across oceans and around the world bear the imprint of their original places—not necessarily in traceable iconography, but in the submerged rhythms and patterns that served the land itself and the spirits that inhabit it. This seems particularly true of indigenous and African religions in the Americas, which evoke the land and water where they were born through their rites and cultures. Since religion is integrated with daily life in many societies in ways unsuspected (and suspect) in the West, traces of earlier religious beliefs survived even after their institutional apparatus disappeared. In Mexico (and elsewhere), as Anita Brenner wrote in her 1929 book *Idols Behind Altars*, indigenous peoples worshipping at certain places could be revealed to be kneeling not only before the Catholic altars that the Church had knowingly superimposed on "pagan" sites, but worshipping that which lies beneath—sometimes buried idols, sometimes simply the land itself as the ultimate symbol.

"Landscape," in the sense of pictured "scenery," is not a favorite subject among artists of color working today, at least to judge by what can be found within the artworld. The land is a constant presence in Native American work, but it is rarely represented as a passive vista or as a commodity. "The distinction between designs that are representations of landscape features and the symbolic landscape has caused a great deal of confusion in the literature."[6] In symbolic form, the image may or may not look like "nature" to the uninitiated. There is even some question about what pictures of the land mean to a land-based population, although once people are uprooted, a painting over the urban mantelpiece can mean a lot. In rural settings, however, nature has a way of overpowering art. A window in the kitchen is more important than a picture of the mountain seen through it.

This is not to say that nature itself does not play a large part in much of the work reproduced here, but there is a difference between landscape painting and nature in art. Nature is an all-encompassing force. Its power is recognized in virtually all cultures, although Euro-Americans tend to reduce and contain that power by romanticism, anthropomorphism, or association with those threatening forces rendered powerless, like women, children, and "primitives." No matter how convincingly or realistically depicted landscape may be, as a Western genre it is usually a stage set for human activities, the object of the benevolent or wary human gaze. Some Indian artists' attempts to reconcile, or acknowledge, both of these views suggest new channels between the cultures that remained closed during the Western appropriation of indigenous motifs.

Fig. 4: Kay Walkingstick, (Cherokee) *The Scary Place*, from "Cascade" series, 1989, charcoal on paper, 30" × 60". (Photo: Jon Reis.) Walkingstick, who teaches at SUNY, Stony Brook, expands Longfish and Randall's definition of "landbase" by including the process of making art—a "ritualistic and emotive" element that is as much a part of her sophisticated modernist style as it is of the impressionistic landscapes she juxtaposes to it. Her surfaces have included dirt and metal shavings collected locally. "My method of working is highly physical, and also 'labored' in a sense. I redraw, and repaint, repeat, and layer. . . . The two portions of the work relate in a mythic way—the natural is made full, more concrete by the abstract . . . one is the extension of the other. . . . The two portions represent two kinds of memory . . . momentary and particular, permanent and non-specific. . . . I see my work as a dialogue with the spiritual, with that which transcends our bittersweet daily lives. And in this sense the work is not only Romantic but Tribal." The "scary place" of the title might be the river, cliffs, and rapids at the left, or the unknown so poignantly represented at the right. She has called her works from the "Cascade" series "a metaphor for the onrush of time and the unstoppable, ultimate destiny of our lives." (Quotations from unpublished statements, 1989–90.)

▼▼▼▼▼▼▼▼
The symbolism in American Indian ceremonial literature, then, is not symbolic in the usual sense, that is, the four mountains in the Mountain Change do not stand for something else. They are those exact mountains perceived psychically, as it were, or mystically. The color red, as used by the Lakota, doesn't stand for sacred or earth, but it is the quality of a being, the color of it, when perceived "in a sacred manner" or from the point of view of the earth itself. That is, red is a psychic quality, not a material one, though it has a material dimension, of course. But its material aspect is not its essential one . . . as Lame Deer the Lakota shaman suggests, the physical aspect of existence is only representative of what is real.
—Paula Gunn Allen, *The Sacred Hoop* (p. 69)

In accordance with the symbolic complexity of Native concepts of nature, abstraction is favored by many contemporary artists as a way to render loved terrain. The term "landbase," as defined by the Seneca/Tuscarora painter George Longfish, writing with Joan Randall, is broader than landscape, incorporating

> the interwoven aspects of place, history, culture, physiology, a people and their sense of themselves and their spirituality, and how the characteristics of the place are all part of the fabric. When rituals are integrated into the setting through the use of materials and specific places and when religion includes the earth upon which one walks—that is landbase.[7]

In art by modernist Native American artists, the cross-cultural process is visible not so much in style as in attitude. Within the concept of landbase, Native artists can choose freely which older and which newer elements they

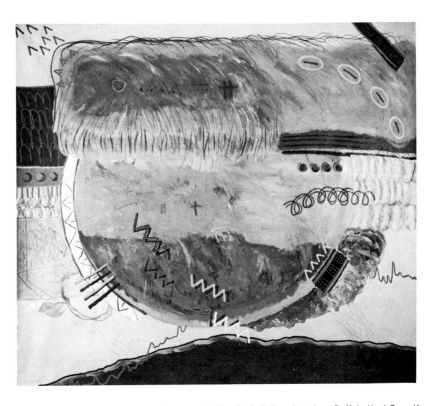

Fig. 5: George C. Longfish (Seneca/Tuscarora), *You Can't Roller-skate in a Buffalo Herd Even If You Have All the Medicine*, 1979, acrylic on canvas, 83" x 96". Longfish was educated in the Indian School near Gowanda, New York, and received his MFA from the Art Institute of Chicago. He teaches at the University of California at Davis. "I had just started working with the circle," he recalls, "because I was interested in the Native American philosophy of cycles." Many of the elements appear in sacred fours ("four directions, four sacred plants, the cross form, the morning star"). The zigzag forms are mountains. The cloud form above the circle "represents both the Oriental concept of the attainment of spiritual growth and the upward progression through the different levels of that growth." The horse's hoofprints are a Plains image of movement. The red, black, yellow, and white on the left (the four cultural groups) protect the spiritual information it contains. The title was added "to inject amusement into a serious painting" (letter to the author, 1989).

will utilize. The sense of space in some Navajo paintings, for instance, can be related to their curative sand paintings in that they have no top or bottom. Like the land, they extend horizontally, comprehensible from the multiple viewpoints they reflect. Sand as an artistic medium is a microcosm of the desert itself. Jackson Pollock understood and borrowed this worldview. In another tradition, nothing could be further from the bold, flat graphic motifs of the Tlingit tradition than Dorthea Romero's misty abstractions, inspired by the mapping of northwest weather patterns. Yet her decision to interpret familiar forces and places in an unfamiliar medium makes her art no less "authentic."

Fig. 6: Emmi Whitehorse (Navajo), *Mt. Taylor, Early Morning*, 1987, oil and chalk on paper, 37¾″ × 50″. (Photo courtesy Lewallen/Butler Fine Art, Santa Fe.) A lyrically abstract painting by Whitehorse might recall to the general art viewer Matta, Gorky, or early de Kooning, but the inspiration is her own life associated with that of her grandmother, who can also "juggle things foreign to her with her deeply rooted traditional values." "I am intrigued," Whitehorse has written, "by the casual equating of nature and geometry in her weaving. . . . By mixing atmospheric space, the colors of the land, and a sprinkling of geometric personal iconography from my grandmother, I am able to express the things that are important to me" (*Women of Sweetgrass, Cedar and Sage*, n.p.). Other forms found in her painting come from her father's branding iron, and the gouges in wooden gates that record her family's sheep herds. Whitehorse's earlier *Kin' Nah' Zin'* ("Standing Ruins") series was about the place where she grew up on the Navajo reservation. This series, although the style has evolved, is also about her native land.

▼▼▼▼▼▼▼

My ideas are constantly changing, even my concept of myself as a Shawnee, a singularly tribal person.
—Barney Bush, in *I Tell You Now*, edited by Brian Swann and Arnold Krupat (p. 218)

There is no direct concept for art in my culture. So what am I doing? People before made pots and jewelry; pre-contact, what we were dealing with was more involved than what we do today. As a people we were more advanced then. We've had to take a couple steps back. People say I should make beautiful things and there are people in my community making beautiful things; but I see photography as a form of functional activity, like pots and jewelry. My work tends to have more of an edge on it because it's about our life today, it's reality, how we have to deal with what the world has presented on our doorstep—or on our shores, literally. So a little manipulation of the next century is a way of not giving up.
—Jolene Rickard, "Mixing It Up II" (on radio station KGNU, Boulder, Colorado, April 7, 1989)

In 1987, while in her early thirties, Tuscarora photographer Jolene Rickard (plate 40) moved back to the reservation in northern New York where she grew up, interrupting a successful career as a television art director and graphic designer, reintegrating herself in an ongoing spiritual education, and becoming embroiled in the intricacies of reservation politics. Like the Cheyenne artist Edgar Heap of Birds, who also moved back to his (more or less) ancestral territory in Oklahoma, and like others who have spent less time away, Rickard acknowledges the contradictions and the satisfactions of such a return to a landbase where members of her family have long been tribal leaders.

▼▼▼▼▼▼▼

I have intruded into their [Pueblo peoples'] plazas during the long dance days and, not of their blood, have been one more voyeur upon their culture and have written about it and speculated about them. I can only say I meant no harm. In my European-American way I have been driven to know, because what they are and do seems to me full of meaning and importance. My respect for their mordant intelligence and wit is as great as my perhaps rather urbanized amazement at their knowledge of sun, moon, stars, plants, animals, and all natural and living things. I can only extend to them in return my gratitude and my hope that having resisted European imperialism so long they will not let it pull them down in its very death throes now.
—Vincent Scully, *Pueblo* (p. xiii)

For all the emotional and intellectual bonds to a real or imagined homeland, relatively few Native American artists have had a direct and continuous experience of the lands on which their parents and grandparents were raised. Yet landbase is such a crucial element in most Indian philosophies that however it is represented (and what appears abstract to outsiders may be very concrete to insiders), it remains a symbol of belonging and home. Even deracinated Native artists do not, in general, treat the land in their work the same way the average white artist does. Their historically respectful approach to nature—whether handed down through the generations or recently acquired as part of a search for identity—differs from the dominant culture's use-oriented and touristic approaches to nature, which, it must be said, are also opposed by many other groups, not just by the romanticizing "wannabes" who would totally reject their own culture.[8]

Jaune Quick-To-See Smith (plate 19) is a member of the Flathead tribe, born on the Confederated Salish and Kootenai Reservation in Montana, to which she is still deeply connected through her art and her Pan-Indian organizing. Her middle name, taken from a grandmother, means "insight, perception." Her need to transcend differences among Native peoples originates in childhood work with her horse-trader father. (She observes, with some awe, that her life has "spanned 500 years—from a nomadic childhood to an educated woman with a master's degree.")[9]

Quick-To-See Smith became a professional artist late, returning to school as a mother of two in her thirties after having spent years working, among other things, as a waitress, factory worker, domestic, Headstart teacher, librarian, veterinary assistant, janitor, and secretary. She began to show her work in the Southwest and New York, and was making a living from her painting before she finished her master's at the University of New Mexico in 1980. Since the mid-'70s, she has founded groups, curated shows, taught, lectured, and networked nationally among Native American artists, becoming a role model for Native artists, especially women.

Quick-To-See Smith lives (with her family and her animals, including her much-painted paint horse Cheyenne) on fallow colonized land in Corrales, New Mexico, where Indian peoples have lived for millennia, reseeding it with an indigenous approach to life. Her vivid abstractions emerge not only from her study of nature and its relation to Native cultures but also in a direct line from the "modern masters"—Klee, Gris, Picasso, Miró. She talks about her work both as a home and as a journey:

My feelings about my ethnicity and the land build metaphors . . . a language of my own for events which take place on the prairie. I place my markings onto a framework in homage to the ancient travois: in a sense, piling my dreams on for a journey across the land. Smears and stains of pigments with the crudeness of charcoal feel aboriginal and prehistoric to me.[10]

Quick-To-See Smith's paintings offer a rooted but kaleidoscopic view of the world, with a space sometimes reminiscent of the Plains Indians' ledger drawings (many of which were executed in Florida prisons, in the style of tepee paintings that commemorated significant events). She has worked in a variety of styles, all more or less abstract (and at the same time more or less figurative), none of which are accepted as "traditional" or "Indian," and all of which are characterized by a vision of the world in which change reigns and hierarchies are absent. In 1987 she did a series of paintings that while apparently abstract, were specifically political protests against the destruction by developers of Albuquerque's seventeen-mile Escarpment, filled with petroglyphs. Almost invisibly incorporating some of the ancient images, she chose with subtle irony to employ a style for these canvases derived from European Cubists, which had in turn been derived from tribal peoples. She combined synthetic Cubism, the geometricism of her own people, and a robust palette drawn from southwestern nature. Noting that the petroglyphs themselves were "universal ways of talking with people," she sent her paintings out into the world with similar tasks. Since then her work has become more topically involved with the environment.

The energy conveyed by Quick-To-See Smith's best work is charged by constant motion—and by the central stillness it contains. Her multiperspective landscapes are simultaneously structured and tumultuous, with a vast geometricized space inhabited by stylized horses, dogs, indigenous plants, wells, water jars, and petroglyphs—images collected as she roams her reservation and her adopted home. She calls them narrative landscapes; the stories hidden within them are visible only to those who know how to see the life in the arid "empty" landscape itself:

> When we talk we talk in the past, present and the future. When I paint I do the same. When you grow up in this environment, life is not romantic, and when it's low income as mine was it centers around survival for food and shelter. Thus language and living [are] not embellished but simple and direct. I feel that in my painting as well. . . . I paint in a stream of consciousness so that pictographs on the rocks up behind me muddle together with shapes of rocks I find in the yard, but all made over into my own expression. It's not copying what's there, it's writing about it.[11]

Language is an integral part of this equation of land and culture. A kind of desecration/dislocation occurs when place names are erased. Native American history has been buried in the Spanish and Anglo names that now define its topography. In the process of a "linguistic remapping" project on the White Mountain Apache reservation in Arizona, for instance, the land regained a different cultural character. The reclaimed names are ephemerally descriptive and narrative, such as a burial place called "a flat open place beneath bitter mescal" or a mountain called "butterflies flutter on top." Many of the places

▼▼▼▼▼▼▼▼

I learned about the process of making art and about aesthetics from my father. In an early memory, I watched him split shingles for our cabin and cover the walls in careful rows. This was so beautiful to me. . . . At another time we built corrals together. To this day they remain some of the most splendid sculpture I've ever seen. Watching my father run his hands over a horse to read its history; watching him braid lariats; sharing his collection of beadwork and pestering him to draw a sketch of an animal so I could carry it in my pocket—all this and more taught me to see and feel. This is my beginning in art.
—Jaune Quick-To-See Smith, in *Women of Sweetgrass, Cedar and Sage* (n.p.)

Fig. 7: Frank Bigbear, Jr. (Chippewa), *Red Boy*, 1989, prismacolor pencil on paper (diptych), 60″ × 44″. (Photo courtesy the Heard Museum, Phoenix.) Bigbear was raised on the White Earth Reservation in Minnesota. He came to Minneapolis at the age of fifteen and studied art primarily in high school. Largely self-taught, working in his family living room where he incorporates images from his children or from TV, he has developed a style that dips into Pop Art, psychedelic images, the Mexican muralists, Surrealism, Cubism, and traditional Native designs. Bigbear has been called a contemporary Hieronymous Bosch, and consumer culture is the hell he warns against. As Margaret Archuleta has written, "Bigbear's war is the everyday survival of the poor. The battles are poverty, alcoholism, diabetes, tuberculosis, discrimination, and loss of hope" on the reservations and in the urban ghettos (*American Indian Art*, Winter 1989, p. 61). In *Red Boy* figures and landscapes are barely discernible in the brightly colored chaos of melting body parts, traditional symbols and ceremonies, spaceships, bones, peyote waterbirds, and references to a genocidal history. Yet somehow compositional sense is made of this writhing furor of times and spaces and diverse energies. The mirror, held up to us by a sinewy arm, asks us to look and change, to remember the interconnectedness of people and the environment.

are sacred. "Every piece of ground here has its Apache name for a reason that is significant to the Apache people," says former tribal chairman Ronnie Lupe:

> When you want to know about your history you can go to an encyclopedia or dictionary to look it up. But this [said as he dipped his hand in a mountain spring that has curative powers] is the root and the future of our people. We are discussing what to do with the stories.[12]

When George Longfish and Joan Randall include in landbase the "environment"—"the weather, the land or soil, people, plants, and animals . . . sounds and smells, costumes and foods, different ranges of normalcy and deviance"—they might be defining "culture." Indeed, Robert Gay of the Oglala

Lakota tribal college on the Pine Ridge reservation declares, "Unless you can save the land, there's no way you can preserve the culture."[13] For this reason, land struggles such as that taking place at Big Mountain in Arizona (purportedly between the Hopi and the Navajo, but in fact between government, the multinational corporations, and the Indian nations who hold title to so many natural resources in the Southwest) are a key to much more than future economic distribution of wealth. How different this continent might be now, had we seen the earth as sacred rather than as a suspect and secular connection to the "pagan past."

The purple-prosed idealization and sleazy commercialization of Native American concepts of the earth and ecology in art and literature provide an ironic contrast with the physical damage being wrought—the commercial exploitation of Indian lands, from the destruction of the ozone layer to the destruction of Chaco civilization ruins by chemical pollution in the Four Corners. A generous past is being lost to greed through illegal archeology, art dealing, grave-robbing, and pot hunting. Indignities escalate. In 1988 the U.S. Supreme Court ruled 5–3 against the Native American community and made it legal to bulldoze, destroy, or build over sacred sites and burial grounds, continuing the "tradition" of stealing and displaying Indian corpses and grave goods that originated with the European invasion of the Americas. This ruling against the Yurok, Karok, and Tolowa peoples of northern California stripped them of their constitutional rights to practice their religions, stating cavalierly that "it seems less than certain that construction of the road will be so disruptive that it will doom their religion."[14]

Yet sacred sites are not, like churches, replaceable. Native religions will probably survive this latest blow, but each time they are deprived, they are weakened. The Supreme Court's decision is yet another insult to those whose "churches" are thus consigned to the rubbish heap of progress. This most recent in a series of cases makes it clear that religious freedom in the United States applies fully only to Euro-American religions; Catholic and Protestant churches, synagogues, and Mormon temples are far less likely to be destroyed in the name of a highway.

At the same time museums that present the accoutrements and holy objects of "primitive" religions as art would no doubt be reluctant to display their own recent ancestors lying in state in glass cases. As one Native person put it, "If an Indian dug up a white person's bones and put them on display, he would be jailed; if a white person digs up an Indian's bones and puts them on display they get a Ph.D."[15] Indian graves as recent as 1750 have been exhumed for research. In Union County, Kentucky, a ceremony was held recently to rebury thousands of Indian bones dug up by artifact hunters. The Stanford University Museum has just announced that it will return all human remains in its collections to their sources, and the Smithsonian has also made some gestures in that direction. Others have refused to consider any such retroactive decency, claiming that the present Indian nations are different people than those whose remains are held hostage.

The best estimate is that the remains and/or burial offerings of some 2 million Indians are now in the possession of museums, state historical societies, universities, the National Park Service offices and warehouses, and curio shops. These remains are, for the most part, classified as "resources" rather than as human remains. —Vine Deloria, Jr., "A Simple Question of Humanity: The Moral Dimensions of the Reburial Issue," *NARF Legal Review* (v. 14, no. 4, Fall 1989, p. 1)

Hopi Don Talayesva recalls in his autobiography the dire effects of the presence of missionary and amateur anthropologist-in-residence H. R. Voth. A drought was blamed on his theft of ceremonial secrets and intrusions into the kiva: "He wore shoes with solid heels, and when the Hopi tried to put him out of the kiva, he would kick them." When Talayesva was older, he went to Voth and told him, "You break the commandments of your own God. He ordered you never to steal or to have other gods before him. He has told you to avoid all graven images; but you have stolen ours and set them up in your museum. This makes you a thief and an idolator who can never go to heaven" (*Sun Chief*, edited by Leo W. Simmons [New Haven: Yale University Press, 1942, p. 252]).

▼▼▼▼▼▼▼▼▼▼▼

The attack on indigenous religious practices is taking place in the halls of academe as well as in the corporate boardrooms and the halls of justice. One skirmish involves the origins of an idea in Native religion cherished and overworked by Western scholarship—the image of Mother Earth. In Native American art this is not a literal concept. She is rarely pictured as a woman, but is symbolized with female attributes as a living force in her own right.[16] Russell Means comments:

> In order to view the earth as goddess, you would have to see it as an extension of human beings, which is a distinctly Christian sort of view. We Lakotas look at it in the exact opposite way, that humans are an extension of the earth's life-giving nature.[17]

Although the concept of Mother Earth has been fundamental to Native American religions as we know them, and each nation, each tribe, has its distinct way of expressing it, European scholarship has translated it awkwardly and inadequately. Sam Gill, an Anglo and professor of religious studies at the University of Colorado, has scrutinized the sources of the concept of Mother Earth and come up with some ideas about "the invented Indian" that have been angrily rejected by both Native Americans and non-Natives inspired by indigenous religious beliefs. Gill's 1987 book, *Mother Earth: An American Story*, is devoted to proving that scholars have shamelessly based their claims on only two nineteenth-century quotations and a few derived examples, all of which may have been invented by contemporary white recorders. The first text is Tecumseh's famous declaration: "The Earth is my mother—and on her bosom I will repose"; the second an equally famous statement by Smohalla:

> You ask me to plow the ground. Shall I take a knife and tear my mother's bosom? You ask me to dig for stone. Shall I dig under her skin for bones? You ask me to cut grass and make hay and sell it, and be rich like white men. But how dare I cut off my mother's hair?[18]

It seems absurd to assume that if an idea is repeated, it must derive from a single incident rather than from a long-standing body of shared belief expressed in similar words. Even as Gill "proves" convincingly that the *popular* (i.e., Europeanized) concept of earth as mother is yet another instance of white domination, he seems to be applying metaphor in a European rather than a Native manner; the concept of Mother Earth is not that of a fertility deity or "goddess," as Eurocentric scholarship assumes.

The Native response to Gill's book has been predictable outrage in the face of a proposal that appears to confirm the fears of cultural genocide expressed by Vine Deloria, Jr., in 1982:

The realities of Indian belief and existence have become so misunderstood at this point that when a real Indian stands up and speaks the truth at any given moment, he or she is not only unlikely to be believed, but will probably be publicly contradicted and "corrected" by the citation of some non-Indian and totally inaccurate "expert."[19]

Pam Colorado, an Oneida professor in Canada, adds:

In the end, non-Indians will have complete power to define what is and is not Indian, even for Indians. . . . When this happens, the last vestiges of real Indian society and Indian rights will disappear. Non-Indians will then "own" our heritage and ideas as thoroughly as they now claim to own our land and resources.[20]

Gill does, however, make another provocative point, which need not validate his first, less acceptable premise. He suggests that the extraction and foregrounding of one element in the web of symbols that formed the general theology of many tribes was a subversive strategy designed by them to intensify the moral imperative against ongoing theft of Indian lands—a diplomatic bulwark, counterpart to the spiritual weapon represented by the Ghost Dance. If, in this process of deliberate overemphasis, the earth-based belief systems themselves were altered (as indeed they have been constantly changed and changing throughout the post-contact period), the results are the concern of the Native communities for whom this belief is a keystone rather than of voyeuristic colonial scholarship.

In order to understand both voluntary and involuntary decentering and disjunction (the turf of postmodernism), we have to keep in mind the "parental" (or paternalistic) relation of the "centers" to the "peripheries." It is a temptation for all concerned, of course, to cure deracination with relocation, hoping for reracination—a process that can also assure assimilation of white values. It is often difficult for Euro-Americans to grasp that home for originally nomadic peoples is not just a single plot of land.[21] It can be a relatively vast territory used seasonally and changed according to marriages, dances, illness, flood, or drought. Boundaries tend to be lines of sight rather than fence lines. Sacred mountains in the distance mark the margins, but they too can move and change, replaced by other mountains as life itself changes.

When forced displacement disrupts communities and breaks traditions, it is a violation of human rights, which include the right to cultural and religious autonomy. Gentrification on the multicultural Lower East Side of New York City and all the other inner-city communities across the country is a cultural

Fig. 8: Santa Barraza, *Renacamiento (Rebirth)*, 1981, pastels and gold leaf on paper, 54" × 56". Collection of the Mexican Museum, San Francisco. Barraza was raised in Kingsville, Texas, and counts among her ancestors Karankawa and Caddo Indians, a Spanish settler, and nineteenth-century Mexican landowners who were cheated out of their properties when the United States failed to honor the Treaty of Guadalupe Hidalgo in 1848. Now teaching at Penn State, she retains the stories she was raised with, the mysticism, folklore, and real history of South Texas, which inspired her art. With Carmen Lomas Garza and César Martinez, among others, Barraza participated in the Chicano movement of the '70s and co-founded a statewide Chicana women artists group. In the late '70s she began to use the maguey (cactus) as a symbol of rebirth and resurrection, the role it plays in this painting. A young woman in shirt and jeans prays at the *angelito*'s grave, which is protected by an iron crib (often found in the Southwest) and by the Virgin of Guadalupe, who appears as a Nahuatl teenager—a symbol of resistance to assimilation. The baby's umbilical cord is the fertilizing root of an aloe-vera (a curative plant much used by folk healers) in an image of continuum—death, birth, life, the ideology of predestination. (Letter to the author, 1990.)

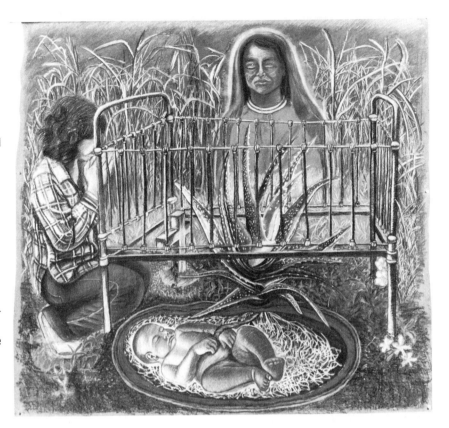

issue like the desecration of indigenous burial grounds and sacred sites and the theft of indigenous lands, including those of the mestizo Mexicans who preceded the Anglos in colonizing the Southwest.

The Mexicans, like the gringos, historically stole land from the Native North Americans and also enslaved them, although cultural attitudes were very different and intermarriage was more accepted. Many New Mexicans, for instance, have Pueblo, Ute, Apache, or Comanche grandparents, as well as indigenous roots in their own Mexican *mestizaje*. Where the wealthier "old families" still tend to deny Indian ancestry, progressive sectors claim the bonds of a powerful sense of identification with the land, although not all of the Indian nations share this perception of Mexicans as indigenous peoples (see chapter 4).

Southwestern Mexican Americans are nevertheless among the most profoundly landbased peoples in this country, their ancestors having received land grants from the Spanish king and/or Mexican government centuries ago. In a land grab second only to the mass eviction of Native Americans, these grants were appropriated by Anglo ranchers and lawyers soon after the unrespected Treaty of Guadalupe Hidalgo in 1848. Aside from sheer greed, one of the conflicts lay in culturally dissimilar attitudes toward the community land. The

Mexicanos shared the land, aside from individual house and garden plots, while Anglos were committed to private ownership of everything. Communal land was considered "unowned" and therefore up for grabs.[22]

Today, land-grant heirs and later landbased immigrants are appalled when developers buy land sight unseen, strictly for profit. For the Mexicanos, land is not something simply to walk and build on, a commodity that is bought and sold when convenient. The land is something you live amidst, something that gives life and is part of life, something worth dying for in order to live and raise children where one's grandparents were raised. The revolutionary cry *Tierra o Muerte* ("Land or Death") is still heard in northern New Mexico; underscoring the connections between a rural and an urban "homeland," a group of rent strikers in the Bronx have hung banners over their embattled tenement building that read *Casa o Muerte* ("Home or Death").

Land and community history are preserved most consciously by artists. One of these esthetic defenders is Carmen Lomas Garza, who grew up in Kingsville, Texas, went to San Francisco State University, and is now a much-exhibited artist in San Francisco (plate 17). The stories she tells in her paintings combine her ongoing research into the Chicano culture of the Southwest with freshly colored, sparkling memories of a *Tejano* (Spanish-speaking Texan) childhood. The word *querencia*, or love of place—a sense of belonging and bonding—is not only expressed, but created by her work. Lomas Garza draws out the history of an area that balances between two cultures, just as her own art does. However, she does not work from dislocation or alienation. It is clear from the luminous detail in her quotidian narrative paintings that her memories are good. She celebrates a reality that warms her compatriots with its familiarity and triggers a vicarious nostalgia in others.

Lomas Garza's meticulous quasi-naive style evolved from watching her mother paint the traditional illustrated lottery cards, which Carmen recognized as a genuine folk art. Having learned the seventy-five figures and numbers, the riddles and jokes that accompanied each card, she began to design a modern *lotería* deck, which led to a series of *monitos*—stylized images of animals, figures, and objects. These led in turn into the more expanded landscapes and domestic scenes, which are sometimes confused with the folk art that inspires them, despite the innate sophistication evident in hermetic detail.

Lomas Garza paints the GI Forums and Ladies Auxiliary cakewalks, the gathering of cactus fruits, communal tamale making, fairs, birthday parties complete with piñatas, the killing of a rabbit or a chicken for Sunday dinner at her grandparents' house (while the ice drips from her brother's snow cone). In many of her works there is a slightly sinister or erotic note that counters the outward sweetness of her imagery—a maimed person, knives cutting food in a metaphor for pleasure and pain.[23] Others are genuinely tender. In her 1985 *Camas para sueños* (*Beds for Dreams*), two little girls sit on the roof of a small house gazing at the moon while below, seen through a lighted window, their mother is making up their bed. Similarly, Lomas Garza often paints

In 1988–89 land activists in the northern New Mexico town of Tierra Amarilla established an armed occupation against encroaching developers of a last patch of land belonging to the original Tierra Amarilla Land Grant. The town of Tierra Amarilla has been the heart of hard-core land rights activism in the Mexicano community for almost a century. "TA," as it is called locally, is one of the many microscopic Third Worlds tucked away among the "blue highways" of the United States. Scenic and under siege, it will either become a "national recreational area" of ski resorts, guest ranches, and health or spirit farms; or it will become a base for the revival of Mexican culture in the Southwest, a project begun when the occupiers won a partial victory. A community cultural center is being built on two hundred acres of communal land legally reclaimed from the developers.

▼▼▼▼▼▼▼

Soy de aquí
y soy de allá
from here
and from there
born in L.A.
del otro lado
y de éste
crecí in L.A.
y en Ensenada
my mouth still
tastes of naranjas
con chile
soy del sur
y del norte
crecí zurda
y norteada
cruzando fron
teras crossing
San Andreas
tartamuda
y mareada
where you from?
soy de aquí
y soy de allá
I didn't build
this border
that halts me
the word fron
tera splits
on my tongue.

—Gina Valdés, "Where You From?" in *Made in Aztlán*, edited by Philip Brookman and Guillermo Gómez-Peña (p. 98)

curanderas, or local healers—usually women who have found in themselves the power to heal. Background details such as unfinished embroidery, a TV set, religious images, family portraits, all have allegorical significance as ordinary life and beneficent legend are merged.

Luis Jimenez (plate 20) was raised in "El Chuco" (as El Paso is called locally), grandson of a carpenter, son of a nationally known and very inventive neon sign maker, with whom he apprenticed in his teens. He works with colored fiberglass—glistening, bulbous surfaces that often convey a freshness that transcends their commercial source and the irony of much of his content. Jimenez makes art from deep within the Mexican culture that everyone in the Southwest is heir to, regardless of race or racism. It seems appropriate that he has been one of the few successful "crossover" artists of his generation. He has received a Prix de Rome and other major awards, and is currently a professor at the University of Arizona.

Jimenez's project has been to make a public art that both heroizes the ordinary and makes the heroic ordinary. "I am a traditional artist in the sense that I give form to my culture's icons," he has said. "I work with folk sources, the popular culture and mythology, using a popular material—fiberglass—shiny finishes, metal flake and at times illumination. In the past important icons were religious; now they are secular."[24]

Targeting the educational institutions and mass media that continue to oppress his people, Jimenez has "immortalized" various folk heroes from the Native, Latino, and Anglo cultures, beginning where the revolutionary Mexican muralists left off. *End of the Trail* (1971) literally highlights the commercialization of the Indian by taking off from the original academic sculpture, made by James E. Fraser in 1915, of an Indian warrior slumped in defeat on his equally dejected horse—now a pop icon in its own right. Jimenez's version suggests that victory and defeat are cyclical: beneath the horse's belly rises an electric sun. In the lush and terrible *Progress I* (1973), an Indian warrior and his horse are impaled on the horns of a demonic red-eyed buffalo. Jimenez's homage to the original cowboy—the Mexican *Vaquero* (1980)—stands in the heart of Houston's barrio as a reminder that "Americans" came late to the Southwest. His homage to farmwork—*The Sodbuster* (1983–84), which idealizes the bearded ploughman and straining muscles of the ox in a three-dimensional version of Thomas Hart Benton—is on permanent location in Fargo, North Dakota, but it could also stand for the people of San Ysidro Valley, New Mexico, where the artist lives (San Ysidro is the patron saint of farming).

Jimenez makes what his friend the writer Dave Hickey has called "High Popular Art" or "South Texas Sweet Funk"—an art with emotional and ethical rather than educational prerequisites, which appeals "to the highest common denominators in the popular imagination."[25] The melancholic up-and-down beat of country music provides the atmosphere in which people work, play, and love, often accompanied by cars and horses. On a more subtle level, Jimenez is a knowledgeable admirer of western flora and fauna. Eagles, wolves,

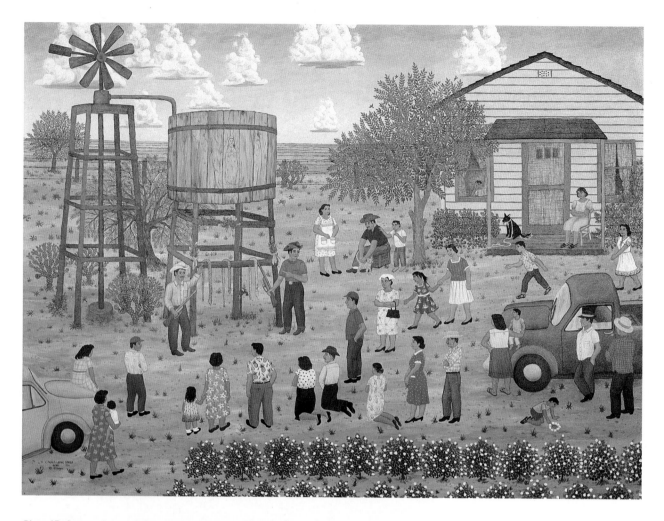

Plate 17: Carmen Lomas Garza, *El Milagro*, 1987, oil on canvas, 36″ × 48″. Collection Lorenzo R. and Mary Francis Hernandez, Pasadena. (Photo: Wolfgang Dietze.) The artist explains, "There was a rumor going around the colonia that the Virgin of Guadalupe had appeared on a water tank in a ranchito not too far from town. So when we all got home from school and work my parents took us in the truck on a search for the ranchito. Some of us could see the Virgin in the water stains, others did not believe. Many people had been there all day praying and trying to make out the image of the Virgin. Instead of bothering the family of the ranchito some people had gone out into the fields to relieve themselves, which alarmed the family. The rattlesnakes [hanging over the base of the water tank] were a warning to people to be very careful when walking in the fields." There are other levels beneath the simple beauty of this scene of worship at a local shrine. The convergence of the Virgin/earth goddess and the snake brings together two ancient female symbols in both the European and American traditions. This meticulously rendered memory of daily life also takes on a mythical dimension, a sinister touch that acknowledges both good and evil.

Plate 18: Luis Cruz Azaceta, *Aliens: Refugee Count II*, 1989, acrylic on canvas, 10′ × 8′. Private Collection, courtesy Frumkin Adams Gallery, New York. When Azaceta came to New York from Cuba at age eighteen, he spoke little English and his friends were other immigrants. "I think immigrants always feel a little territorial. This is wrong; it only leads to isolation." Fear was the prime emotion he recalled from his childhood during the Cuban revolution. "It was all totally surreal. All of this comes out in my work. . . . I deal with fears, phobias and taboos; also black magic in a way. I use a lot of large severed heads in my paintings . . . I use self portraits as a vehicle to convey these conditions. In my work, the heads are always screaming. . . . Fear motivates my work. . . . I paint to kill La Muerta, and also to kill Cruelty, Injustice, Violence, Ignorance, and Hypocrisy" (*Luis Cruz Azaceta* [Cologne and New York: Kunst-Station Sankt Peter and Frumkin/Adams Gallery, 1988], p. 34). This is one of Azaceta's numerous paintings on the theme of exile, about the dangerous journey of survival undertaken by people all over the world escaping repression. The interior of the boat, says Azaceta, is fiery orange because confinement in unknown waters is certainly hell. Sometimes his archetypal vessel holds only one figure, a self-portrait. Sometimes, as here, the repetitive waves are replaced by numbers, representing the global hordes of refugees and the way international politics reduces people to abstractions.

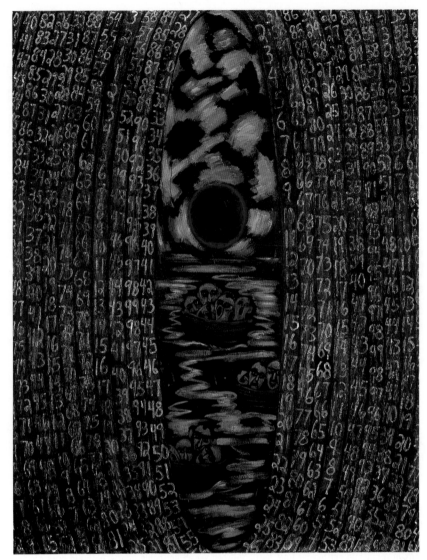

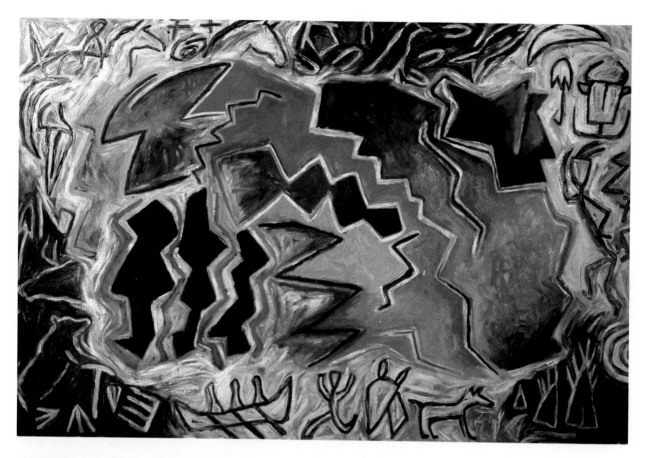

Plate 19: Jaune Quick-To-See Smith, *Osage Orange*, 1985, oil on canvas, 48" × 72". (Photo courtesy Bernice Steinbaum Gallery, New York.) The figures around the edge are drawn from nature, and from nature as drawn by Quick-To-See Smith's ancestors in the petroglyphs she studies. The brilliantly colored central forms are abstractions of natural forces. While the zigzag is associated with Native American design, Quick-To-See Smith has imbued it here with an extraordinary exuberance as it describes a kind of maze, the power of nature itself, the "landscape in motion" that is always her subject. Osage Orange is the name of a small woody scrub used by Osage Indians to make bows to hunt for food. It was also the precursor of barbed wire; when whites came, they used the scrub bushes to fence off land so neither animals nor Indians could move freely. "So this little shrub played two very different roles in two different cultures," says Quick-To-See Smith, who points out that the ideas behind her apparently apolitical works are always political (letter and conversation with the author, 1990).

Plate 20: Luis Jimenez, *Southwest Pietà*, 1987, fiberglass, 10′ × 10½′ × 6′, Martineztown/ Longfellow Park, Albuquerque (Photo: Bruce Berman.) *Southwest Pietà* has a typically cross-cultural saga. Although based in Pre-Columbian beliefs in dualities—light and dark, male and female, as exemplified by the Valley of Mexico's two reigning volcanoes, Popocatépetl and Ixtací-huatl—it illustrates a relatively recent and European-inspired Mexican legend about an Aztec warrior whose lover kills herself on the false news that he is dead; there is also a syncretic reference to the Catholic pietà, although here the male is alive, the female dead. The sculpture was commissioned for the Old Town Plaza in Albuquerque, but met unexpected opposition from the old Spanish or "Hispanic" community (those whose families go back to the earliest settlers) because it was too "foreign." The piece ended up in Martineztown, an Albuquerque barrio, where it was welcomed by more recent immigrants. As Chicano poet Rodolfo Anaya wrote for the sculpture's inauguration, the Albuquerque mountains behind it "incorporate our feelings as a community and reconcile earth and sky." The voluptuously supine Ixta is partially covered by a white cloth, which makes the woman/nature/snowcapped mountain reference. Popo is kneeling, but still phallically erect, accompanied by an eagle and a cactus, while Ixta's body is curled around a snake and flowers, and rose petals fall from her hand. In a detailed analysis of the work's iconography, William Petersen points out that this is an image of mourning "for the loss of the past and for the loss of the heroic dimension in contemporary life" (*Artspace*, 1988).

Plate 21: Ana Mendieta, *Silueta Series: Earth, Gunpowder*, 1979, color photograph of work exe-cuted in Iowa. (Courtesy Carlo Lamagna Gallery, New York.) This literally explosive image has several interpretations within the framework of the artist's ongoing dialogue between the land-scape and the female body. Gunpowder is used in Santería healing rituals. An earlier *Silueta* of 1977 in the "Tree of Life" series was photographed in flames, as though at the apocalyptic moment of birth. One of Mendieta's "*Serie Volcan*," this piece smolders, suggesting further po-tential for revolutionary eruptions, personal and political.

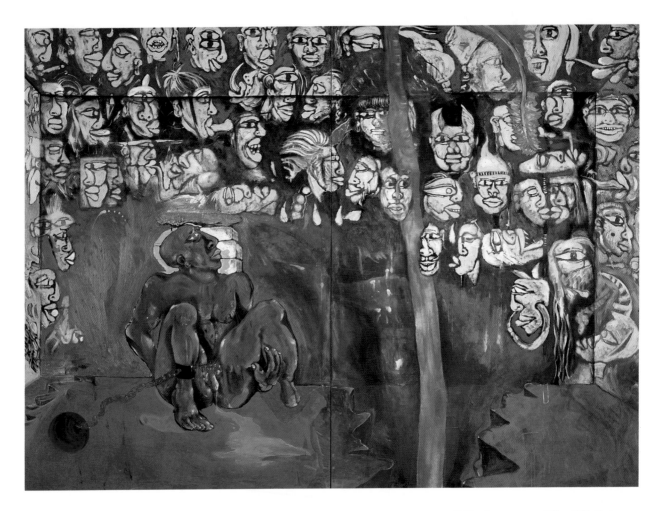

Plate 22: Jorge Tacla, *Descansando antes de saltar*, 1985, oil on canvas, 96″ × 132″. Tacla, a Chilean living in New York, has long been preoccupied with the African diaspora and its effect on Latin America, especially with the historical hypothesis that Africans coexisted with indigenous peoples before the Conquest. His paintings reflect a jungle of color, figures, nature, animism that seems profoundly primeval, as though he had truly been able to dream his way back to the past of the African and Latin American continents. With boundless imagination, Tacla juxtaposes grotesquerie and beauty; fables of good and evil lurk in the undergrowth of lush color and churning form. The title of this painting means "Resting before Taking the Leap." The shackled slave about to be removed to another continent (or about to kill himself) is haunted, or supported, by an eerie horde of ancestors.

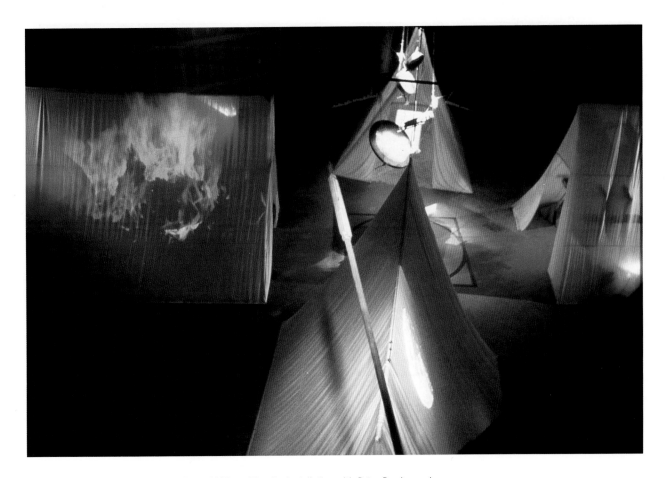

Plate 23: May Sun, *L.A./River/China/Town*, 1988, multimedia installation with Peter Brosius and Tom Recchion, Santa Monica Museum of Art. (Photo: David Familian.) Sun is a Chinese-born artist who has long worked with Asian references as a painter, sculptor, and performance artist. This monumental installation was the result of her ongoing research into the obscured history and untold stories of Los Angeles' Chinatown. Sun and Brosius describe the work as "an attempt to find the history that's present in a city that seems to have none . . . a series of images that are a meditation . . . a search for the dialectic between myth and history" (unpublished 1988 statement). Entering the museum, the viewer crossed a wooden bridge over a river of soil that surrounded four large white tents, like those inhabited by Chinese railroad workers in the 1870s. In each tent there was a fusion of visual elements, objects, sound, lighting, text, and audiotape. The first told the story of railroad work and the 1849 flood that sent Chinese workers to America, in part through the personal psychological narrative of one man. The second portrayed Homer Lea, an eccentric Caucasian from Santa Monica who became a military adviser to Sun Yat-sen and trained troops in Chinatown. The third commemorated the tragic 1871 massacre in Chinatown, using texts, dream interpretations, first-person and newspaper accounts. The fourth, about the power and fragility of the rivers and their symbolic context, juxtaposed the river in Chinese mythology with the L.A. River as a parallel to Sun's reflections about Chinatown and her own Chinese American culture. (See also Judith Hamera, "L.A./River/China/Town," *High Performance*, Summer 1989, pp. 22–27.)

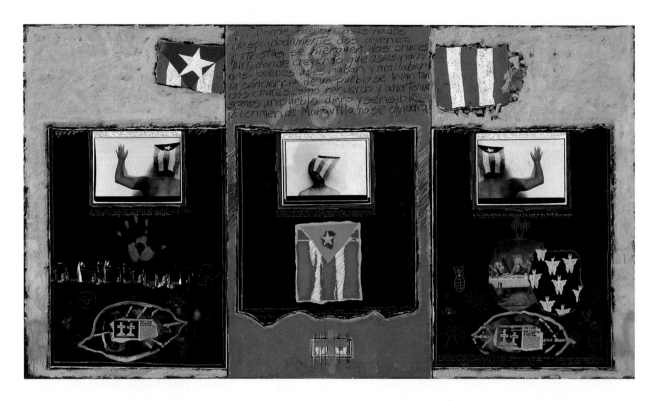

Plate 24: Juan Sánchez, *Mixed Statement*, 1984, oil, photographs, and mixed media on canvas, 54″ × 96″. (© Guariquén Inc.) This is a triptych about political prisoners, martyrdom, and the violence suffered in the United States by Puerto Rican nationalists. The handwritten text beneath the Taino Indian symbol at the top, flanked by a torn Puerto Rican flag, commemorates two *independentista* youths who were assassinated and describes the two crosses raised at the site of their deaths as symbols of communal consciousness. (Another text pays homage to Angel Rodriguez, a nationalist who died suspiciously in prison in Florida in 1979.) Below are three photographs of a man with his features obscured by the flag, which might be interpreted as the protective homeland or as a suffocating nationalism. Other elements are the threatening red handprint of the death squad, a religious image of the Last Supper, newspaper clippings, other Taino motifs, and a dollar bill overlaid by a cross. The triptych form itself is reminiscent of an altar, and it is typical of Sánchez's art in its fusion of the religious with the language of struggle.

and coyotes share the stage with his legendary figures and the ground from which most of them rise is teeming with plants, flowers, reptiles, and small animals, whose persistent fertility suggests the seeds of new legends. Sometimes a glimpse of the indigenous past is offered by a shard or broken pot emerging from the fiberglass earth.

Today, most of the Anglo artists in Texas have acknowledged and deployed (or exploited) their unique Tex-Mex mix, but when Jimenez lived in New York for several years in the '60s, his work attracted attention because it revived within unfamiliar cultural boundaries the raw exuberance of Pop Art. At the same time, he was reviving the notion of a nationally important regional art, dormant since the '40s. Combining an Anglo plainness and a Mexican elegance, the robust melodrama of Jimenez's sculptures epitomizes the Western myth for all the peoples that formed it. "The myth only starts when the reality ends,"[26] he says, but he does not deny the potential heroism of the daily present in his raunchy and rural renditions of lovers and low-riders, sturdily voluptuous rodeo queens and honky-tonk dancers. (He worked in New York as a community dance organizer and has clearly let some good times roll.) Jimenez wants to "make people aware of what it's like to be living now, at this time, in this place," and his work, as Annette DiMeo Carlozzi says, "is a startling social portrait of a nation where fantasy and reality are often confused."[27]

Jimenez, Lomas Garza, and others are able to make such rooted "regional art" because of the strength of Mexican culture in the Southwest (although they would insist on its ability to travel as well). In 1986 Kay Turner and Pat Jasper of Texas Folklife Resources organized an exhibition that strayed far beyond the museum walls. *Art Among Us / Arte entre Nosotros* (accompanied

Fig. 9: Joe Gómez with the wrought iron Volkswagen he made in 1975, San Antonio. (Photo courtesy of *San Antonio Express News*.) Gómez inherited his skills and pride in his work from his father, an iron worker who made gates, furniture, and architectural components. "If I was going to make something I want something to look nice and fancy," Gómez recalls. "So, I don't know if I was awake or daydreaming, or if I was asleep, but all of a sudden—it must have been about two o'clock in the morning—I just jumped out of bed. [My wife] said, 'What happened? Did you hear a noise or something?' And I said, 'I'm going to make a car.'" It took almost nine months. Although the form itself is not traditional, the scrolls, curlicues, and leaf work are. (Quotations from *Art Among Us*, p. 69.)

▼▼▼▼▼▼▼▼

A drive through the tightly enclosed neighborhoods on the Westside alerts the observer to a particular use of color, arrangement, and symbols. We might call this visual distinctiveness a kind of "aesthetic loyalty." . . . Mexican folk art in San Antonio exemplifies the very way in which art-making may constitute strategies for affirming and recreating anew loyalties in the family, the neighborhood, and the community at large. . . .

Mexicanismo is the expression of identity and belonging used by Mexicans whether in their native country or in the United States. . . . [Outside of Mexico, it] takes on a different flavor—it becomes a marker of allegiance to a cultural "homeland" that is distinct from the dominant culture in which Mexican Americans live. . . . What makes this Mexican aesthetic unique is the way in which "bits and pieces" are creatively put together to form a coherent and meaningful whole. . . . Once incorporated into the folk aesthetic of *barrio* life, these bits and pieces [cast off from the Anglo culture] are transformed into objects and expressions of beauty and meaning. A strong sense of *mexicanismo* is therefore able to survive in the San Antonio area through an artful and active process of transformation . . . it is the aesthetic code that most apparently and most appropriately defines Mexican American life.
—Suzanne Seriff and José Limón, in *Art Among Us* (pp. 40, 45).

by an exemplary catalog that combines scholarship and local history) offers a loving and intellectually provocative view of the local art of San Antonio, proposing, with Clifford Geertz, that "traditional art forms are inseparable from the cultural realities they join in creating."[28] As they examine the history and the contemporary manifestations of such varied arts as stone carving, automobile decoration, yard shrines, low-riders, wrought iron, saddle making, gardens, whirligigs, woodworking, murals, and park sculpture, the authors uncover a full-blown esthetic that probably exists in many cities, but is usually left undignified by documentation.

The expatriate is in some senses the postmodern hero, as the madman was the existentialist hero. The two have in common alienation, but not necessarily fatalism. The expatriate, and the expatriate artist in particular, is master of bricolage, of the collage life, keeper in the ongoing present of an album bearing the fragile leaves of the past. As Ricardo Pau-Llosa put it:

The expatriate never unpacks from his soul the razors of anxiety that have brought him here or there and that always threaten to overtake those other aspects of his soul that should define him. If the expatriate fails to master the art of being out of place, bitterness and loneliness overwhelm him. If he succeeds in this art he becomes the master of simultaneity, a conqueror of time and place, the maker of a new sense of history and space.[29]

This has not always been the case, as indicated by the experiences of all African Americans, internal exiles deprived of Africa as well as of first-class citizenship in the United States. Clifford Jackson, a black expatriate painter, now a Swedish citizen, has asked, "How can you be an expatriate if you've never been a patriot?"[30] And another black painter, Beauford Delaney, who moved to Paris in the '50s and stayed there, declared bitterly, "One must belong before one may then not belong. I belong here in Paris. I am able to realize myself here. I am no expatriate."[31]

Fig. 10: Tseng Kwong Chi, *Disneyland, California / Grand Canyon, Arizona*, 1979/1985, silver gelatin prints, 36" x 36". The image of a "Chinese" man standing proud and erect in his Mao jacket is incongruous anywhere in the United States. But Tseng Kwong Chi exacerbated his difference by making monumental self-portraits "out of place" in the American landscape, at such prototypical sites as Disneyland and the Grand Canyon. Exposing the absurdity of exile (and tourism) by juxtaposing himself against Mickey Mouse, he maintains a certain dignity when miniaturized by Nature in her grandest moments.

Fig. 11: Keith Morrison, *Banana Republic*, 1990, acrylic and oil on canvas, 66″ × 72″. (Photo: Jarvis Grant.) Morrison was born in Jamaica and is the chairman of the art department at the University of Maryland. This painting "is about the debris from the Industrial World which destroys the environment of Third World countries." The objects strewn across the ground include an unplugged Tyco Train power pack and the remains of a derailed electric train set, one car labeled "fruit company," matches, leaves, some cigars, and banana peels to slip on. "Comedy," says Morrison, "is a distinct part of my work. . . . In my world there is a lot of misery, but people laugh bitter-sweet at adversity. Perhaps this is because there are few larger-than-life heroes in my world, where people's destiny so often seems outside their control. Sometimes humor seems to be the best defense against outrage and one's own insanity." (Quotations from *Keith Morrison: Recent Painting*, Alternative Museum, New York, 1990, p. 13.)

The military strategies of "low-intensity conflict"—which substitute guerrilla combat, economic sabotage, and destruction of homelands for full-scale warfare—have resulted in economic and political upheavals in this hemisphere since the '60s. These in turn have produced a new population of expatriates and exiles whose priorities differ from those of their predecessors. Today in the United States there are internal and external exiles, voluntary and involuntary, conscious and unconscious. The complexity of their experiences has led to the notion of "deterritorialization," a term originally used by Gilles Deleuze and Félix Guattari in regard to literature that "travels, moves between centers and margins."[32] With its references to the slippage between what is said and what is meant, it is an idea particularly applicable to art that crosses cultures. Filtered through feminist theory, deterritorialization has also come to "stress difference and oscillation of margin and center in the construction of personal and political identities."[33] This applies not only to those who have been voluntarily or involuntarily uprooted, but also to those who remain in their geographical home, only to find the ground moving beneath their feet.

There are vast and intricate differences in the lives and the art of Latin American artists living in the United States, which often reflect the political situations in their homelands. Many middle-class Latin Americans, unlike

Fig. 12: Alfredo Ceibal, *Tonito's Wake*, 1984, acrylic on canvas, 24″ × 30″. Ceibal is a Guatemalan living in New York, whose charming paintings of an anachronistic village and hacienda life reflect none of Guatemala's recent murderous history. There is, however, a touch of imbalance in his cavernous rooms, with tiny figures (the rich) and his tilting, crowded landscapes (the poor). As the volcanos career on their sides, a family mourns their baby, while the wake proceeds gaily in the foreground. "Guatemala has the virtue of being born time after time . . . a mysterious land where everything is possible and unpredictable," writes Ceibal. "My paintings attempt to reveal my fascination for a series of multi-faceted worlds occurring somewhere in a time imprecise" (statement for 1989 exhibition at Baca Downtown, Brooklyn, N.Y.).

▼▼▼▼▼▼▼

Exile makes you re-examine your presuppositions, makes you look at things that once were stable in your world—as stable as your geography—and look at them again. The distance kills you, but it also fertilizes you. In exile you are forced to re-create culture. You are forced to surround yourself with it as a weapon and a defense.
—Ariel Dorfman (quoted in Pat Aufderheide, "Ariel Dorfman: Bereaved Exit," *In These Times*, June 29–July 12, 1983, p. 19)

As in all people who have come to this country, I have lost and gained a paradise.
—Papo Colo (statement on exhibition announcement, Exit Art, New York, 1982)

their poorer compatriots or Asian immigrants, intend to return to their countries someday—when repressive regimes are overthrown, when family members are freed from prison, when culture is opened up again, when the economy can once again support the arts. Many go back and forth, tempting new upheavals in their lives and arts and, in some cases, risking real physical danger.

The exiles' and immigrants' perspectives on their new and old countries obviously range across the emotional spectrum. Luis Cruz Azaceta (plate 18) came to New York from Cuba in 1960 at the age of eighteen. After living by factory and other manual labor for several years, he attended the School of Visual Arts. When he arrived in the United States, he was particularly struck by the silence of people in the subway, compared with Cuba, where everyone talks to each other on public transportation. His ambivalence about his adopted city and about the role of the artist in it is clear in *The City Painter of Hearts* (1981)—a big canvas of a city in flames, with scenes of lust, bestiality, and murderous violence to an extreme, while the tiny figure of the painter, nude, looks on from a corner, calmly painting a red heart on a blue ground. Azaceta often paints self-portraits—as in *Artist Cockroach* and *Tough Ride Around the City* of 1981—with the New York skyline as part of his head or body, crowned by the Empire State Building. "New York is in my blood," he says, and while

Fig. 13: Josely Carvalho, *Rebirth: She Is Visited by Birds and Turtles*, 1987, silkscreen on bark paper, raffia, burnt cheesecloth, ashes, and turtles, 84″ × 36″ × 20″. (Photo: © Sarah Wells.) Carvalho, a Brazilian artist and poet long resident in New York, is conscious of her divided cultural loyalties: "We are made of several pieces. It is like a large jigsaw puzzle. Women have been sewing for centuries . . . procreating . . . cooking . . . working outside of home . . . taking care of children . . . being wives . . . being lovers . . . being witches (men are visionaries!) . . . Are women more aware that human beings are made up of lots of pieces?" Carvalho's series "She Is Visited by Birds and Turtles" is about "carrying history in the shape of my own turtle shell. The turtle became a metaphor for my own hybrid state. Living on land and swimming in waters, the turtle combines two different habitats in the course of her life, carrying her own shell through waters and savannahs. My body is my country." At the same time the series is about the destruction of both nature and culture—"the destruction of cultures by other cultures" and the destruction of the environment and of turtles as a species. The turtle is also a reference to "the political reality of the tremendous debt in Latin America, which not even the turtle shell can bear" (letter to the author, 1989).

conceding that his style and themes are often Latin, he considers himself a New Yorker. Azaceta's paradoxically fond and apocalyptic allegorical views of New York and of himself—his two favorite subjects—are Kafkaesque, pervasively fearful and paranoid. He frequently paints himself as an insect or as a mutilated survivor. Susana Torruella Leval has described the inhabitants of Azaceta's nightmare metropolis as "a new urban race. Psychically and physically maimed creatures . . . this race, much like Buñuel's *Los Olvidados*, fits nowhere, has nowhere to go."[34]

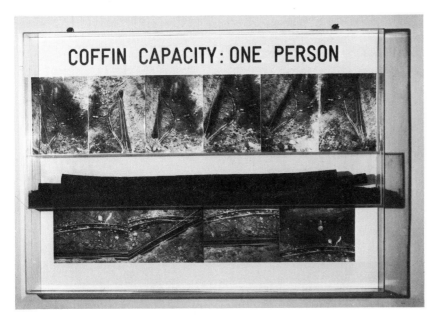

Fig. 15: **Cecilia Vicuña**, *Cemetery*, 1982, wood, bone, 7″ × 7′ × 5″. (Photo: César Paternosto.) Vicuña's concern is to bring from her native Andean Chile into her art the concepts of popular art and religion that have provided a resistance to colonialism for five hundred years. The guiding metaphor behind her *precarios* series, begun in 1966, is that of correspondences, or reciprocity, as reflected in the textile, or weaving, process. Latin America's great gifts are often treated by Europeans and North Americans as "garbage," which inspired her *basuritas* (little rubbish)—fragile fragments of discarded beauty that she constructs and leaves in landscapes and cityscapes, evidence of humanity no matter how scorned. Looking at her larger concept, she wonders, "what is it to throw a little boat into the Hudson River, to touch and encounter the real *basuritas*, the condom with AIDS, the plastic plate that will live for a million years? Is it a recognition, a form of saying: this is us, our legacy, our remains, our shadow?" (letters to the author, 1988–89).

Fig. 14: **Catalina Parra**, *Coffin Capacity: One Person*, 1972, black and white photographs, acrylic, soil, hose, c. 32″ × ½″ × 4″. (Photo: Pedro Sanchez.) Parra is a Chilean whose mature work began in 1968, after she had three children. Returning to Chile from Europe in 1972, she found "a country in chaos on the verge of military takeover." She began to compile a collection of newspaper clippings that made it clear that "a catastrophe was approaching." Working in the countryside, she used the headlines and materials at hand to begin a "journal" of the coup that brought General Pinochet to power. "As I worked with the materials I came to understand that they were loaded with meanings that went beyond the objects themselves; the gauze spoke of hospitals, wounds, the dead; the animal hides and plastic bags spoke of corpses and the stitching and thread" invoked an indigenous legend of the *imbunche*—black magic, curses, spells, or people transformed by witches who have had all their body orifices sewn shut. This and the torn maps and media images became Parra's allegory for censorship, violence, and repression in Chile. She was able to exhibit this work because the army did not understand "a language which is just as explicit as the other official language, but with different codes, which speaks by creating a certain climate, and in which the viewer plays an extremely important role since it is the viewer who closes the circle, who decides what is in the art." Parra, who came to New York in 1980 on a Guggenheim fellowship, feels that Latin American political art differs from that in the U.S. because it has learned to be direct through indirect means, in order to survive. (Quotations from *Catalina Parra* [New York: Terne Gallery, 1987].)

Josely Carvalho, a Brazilian artist who has lived in the United States for twenty years, often works with the inner-city Latino communities and returns frequently to Latin America. She uses the metaphors of birds and turtles to express her "flight" from Brazil and her dual emotional citizenship: "The turtle is a metaphor of my statehood. I carry my house with me. There is an absence from Brazil and a not quite presence in New York."[35] Cecilia Vicuña, a Chilean poet living in New York, makes very delicate, gentle, "throwaway" sculptures for the streets and indoors, often made of feathers, shells, stones, branches,

Fig. 16: Ismael Frigerio, *In Nomine D.H. Jesu Christi*, 1987, burlap, Dacron, feathers, gold leaf, 9′ × 42′ × 8′, installation at INTAR, New York. This was the first in a series of installations intended to culminate in 1992 with the 500th anniversary of Columbus's accidental invasion of the Americas. A giant serpent and a green-on-white cross partially swallowed by a curtain of feathers depict the confrontation between cultures that took place beginning in 1492 and the continued suffering exacted "in the name of God." Quetzalcoatl, the Aztec plumed serpent, represents cosmic fertility to one side and an evil, unholy dragon to the other. Frigerio, a Chilean living in New York since 1982, has been preoccupied for some time with the aftermath of the Spanish Conquest. His apocalyptic paintings of boats, water, serpents, fish, and figures are often readable as reflections on philosophical exile, their monumental forms caught in a frozen, oneiric moment of waiting for return to the origins of an indigenous world that was destroyed by the coming of the ships from across the sea.

and other found or discarded materials; her anger is betrayed in their title, *Basuritas* ("little rubbish")—a reference to the prevailing view of Latino immigrants in the United States. Her reigning metaphor is weaving, or the "metaphysics of textiles," through which she can, like Spiderwoman, travel precariously on the threads that connect her two lives.

In the work of three other Chilean exiles, frustration and coiled rage play virtually esthetic roles as the artists deal with loss and restoration of self-esteem, nostalgia, and newfound psychological distance. Catalina Parra literally rips up the U.S. mass (print) media and then, in a healing gesture, sews it back together in new configurations. Ismael Frigerio's monumental paintings and their indictment of colonialism are informed by his preoccupation with myth and history (the boat, the cross, the serpent, the rock, and the passive, almost corpselike human figure are his prime symbols). Jorge Tacla's darkly dramatic, primeval paintings about the African diaspora have recently taken a topological turn, adding a geometrical metaphor of the continuous surface to express the experience of three continents (plate 22).

Some artists remain "Latin American" rather than becoming Latino American, despite long terms of exile. Others choose to adapt and make the transitions more easily. Some begin anew, choosing citizenship over exile, international styles over anything reminiscent of Latin culture, while others continue to include an undercurrent of Latin American content no matter what style they evolve. All of this is reflected in their art, and in its reception within the North American mainstream. The experience of colonialism is as integral to the art of the bourgeois exile or emigrant from Latin America as it is to poorer economic and political refugees. The best way to deal with it has often seemed a critical or deconstructive technique that acknowledges and

Fig. 17: Luis Camnitzer, *They Found That Reality Had Intruded upon the Image*, 1986, color photograph of detail of mixed media installation, c. 3′ × 231′. Camnitzer was born in Germany on the eve of World War II, fled with his Jewish parents to Montevideo, Uruguay, and moved to New York in the mid-1960s, maintaining strong ties with Latin America. A conceptual and political artist, he works primarily with large series of tableau photographs in which he explores social brutality in refined, ambiguously beautiful images. Much of his work deals with cultural fragmentation and social injustice as well as the destruction of cross-cultural illusions. The vehicles are always words and objects, the human hand standing in for the figure. This piece is one of nineteen that made up his representation for Uruguay at the 1988 Venice Biennale. A broken plaster facsimile of a gold-framed, somewhat apocalyptic, perhaps nineteenth-century landscape painting in shades of golds and browns lies on a rough wooden floor with its title written in script on a fragment below. The installation as a whole guided the viewer through a sequence that had two possible readings: "through the mind of a prisoner who slowly tries to escape prison and torture through hallucination" or "through the mind of an artist who believes he can be free by making art, realizes he cannot, and tries to escape through hallucination." This work followed two other series about the individual perils of war: "Agent Orange," about the aftermath of the Vietnam War, and "Torture in Uruguay," about the military dictatorship in Camnitzer's native country.

confronts this part of history and the artists' position in it. Luis Camnitzer, a Uruguayan born in Germany and living in New York for twenty-five years, maintains strong ties with Latin America as both a conceptual artist and a critic. His photo-text work, including an excruciatingly understated series, "Uruguayan Torture," was ironically called "Post-Latin American" by the Uruguayan critic Angel Kalenberg.[36]

Many of these artists are double exiles, in the sense that their families fled Europe within the last one or two generations to settle in Latin America. Liliana Porter, born in Argentina, makes drawings and wallworks that "fool the eye," making illusion their home rather than any specific place; books and boats, as symbols of travel, figure prominently. Leandro Katz, also born and

Fig. 18: Liliana Porter, *Alice III* (detail), 1989, mixed media collage on paper, 40" × 30". Porter, born and raised in Argentina and living in New York since the mid-1960s, makes the visual counterparts of Jorge Luis Borges's fictions, seamless collages that are fragile and hallucinatory. She draws exquisite trompe l'oeil illusions, on and off the paper and the wall, introducing shifting signs and rebuslike images, bits of torn paper, painted and real books, mirrors, objects and cultural artifacts that seem to have been picked from other lives. Porter operates on both sides of the looking glass. She uses Alice in Wonderland as a protagonist for her own search for an expatriate's identity, the Alice of "Who in the world am I?" (or, Who am I in the world?). The mirror and the boat are metaphors for history and for her own cross-cultural journeys in and out of reality and illusion (or disillusion). In this detail there are texts in Spanish (the fragment of a poem that begins, in my translation, "to watch the river made of time and water") and English ("her life" . . . "of tears"). Porter says her recurrent themes are "the journey," "the traveler," and "reconstructions." This is a new poetic and intellectual version of the Latin fantasy worlds known for their more robust forms in the work of several male writers.

raised in Argentina, of European Jewish parents, is an installation artist and filmmaker, author of *The Milk of Amnesia*. He came to New York in the '60s and maintains close relations with Latin America. His *21 Columns of Language*—a conceptual piece begun in 1971 that is part of a larger project called "Dislocation and Relocation of Monuments"—places lists of linguistic fragments in relation to sites in North and South America. The artist plays the role of communicator between times and places. Fragmentation of language and culture stands for forgetfulness, as the columns of words are named after one site and placed in another. For instance, *Column I* conceptually exists "in relation to its surroundings" in the northwest corner of Inwood Hill Park in Manhattan and also

Fig. 19: Leandro Katz, *Tulum after Cather-wood*, from "The Catherwood Project," 1984–1988 silver print, 16″ × 20″. Frederick Catherwood was an Englishman (1799–1854) who rediscovered many major Mayan ruins and made extremely accurate drawings of them, published in his *Views of Ancient Monuments in Central America, Chiapas and Yucatan* in 1844. Katz, an Argentine artist and film-maker who lives in New York, photographed the same sites from the same vantage points, in black and white and color, completing the itineraries of two of Catherwood's expeditions. His intention was "not only to reappropriate these images from the colonial period, but also to visually verify the results of archeological restorations, the passage of time, and the changes in the environment. In this 'truth effect' process issues having to do with colonialist/neocolonialist representation became more central." The series (based on more than 5,000 photographs) juxtaposes three versions of "reality"; Katz, invisible except for his hand, holds up Catherwood's drawing before the present-day site, and we are asked to test the European version against the actual place. The overlay of photo technology on drawing technique on "reality" is a metaphor for different methods of remembering. "I have no roots in Mayan culture," says Katz, "but there's a connection between the Judaic and the Mayan searches for language . . . a sleepwalker's language." This series challenges the "ahistorical environment of the U.S." and fuses the guilt, desire, and aggression that Latin America provokes in its colonialists. Academic possession of Meso-American archeology is deconstructed through its own instruments of torture (text, photography, illustration) and replaced by the more flexible interpretation of an artist who is not "native" to anywhere. (Quotations from unpublished statements, n.d.)

in relation to its given name ANGUALASTO meaning "water from the heights," actual name of the site and terrain of a town by the Chilean frontier in the Western province of San Juan, Republic of Argentina, once occupied by communities of people tributary to the Inca Empire, and probably later occupied by Incas fleeing South at a certain period of bracketed time and gardens of meaning.[37]

Puerto Ricans occupy a unique place in the Latin life of New York because of their complex two-way acculturation. They are both North American (as members of a commonwealth) and Latino (speaking a different language and identifying with Latin America). The lines between Puerto Rican, NuYorican, and North American are blurred here. As the New York filmmaker Zydnia Navario wrote concerning her film *Linking Islands*:

> The constant migratory flow to and from Puerto Rico produced a community in which several generations with varying degrees of involvement with the island coexisted, a reality which still characterizes the Puerto Rican community today. As a result, the Puerto Rican cultural context in the U.S. is neither a static nor a coherent unity.[38]

Despite our intertwined histories, Puerto Rican art is barely known in New York, which is the hub of Island culture in the United States and at the same time very different from *La Isla*, where the term NuYorican can be used pejoratively. In 1969 artist Rafael Montañez Ortiz founded Spanish Harlem's El Museo del Barrio, which, with the almost simultaneous beginning of the Taller Alma Boricua (Puerto Rican Workshop), gave the barrio an artistic center and a voice, inaudible though it was for the mainstream artworld; twenty

Fig. 20: Marcos Dimas, *Opiyel Guaurioban*, 1975, ink on Hoshi paper, 35″ × 24″. Born in Puerto Rico, Dimas found Taino Indian artifacts in the fields where he played. His art deals with the mythic dimensions of that lost culture. Opiyel Guaurioban is a Taino dog deity. In this work, one of the first of a series of drawings and assemblages on Pre-Columbian symbols, the dog is counterbalanced by an ancient tool and a stone collar; stretched between the branches is a thorn-tortured skin in the shape of the island of Puerto Rico. Dimas is one of the founders of the Taller Boricua in New York's barrio. His concern in both his political and artistic work has been to "use art as a vehicle to contribute to our history and the social cultural revolution." He cites his influences as Pre-Columbian art, Duchamp, Rauschenberg, and Latino popular culture. He intends "to make visible through a pictorial vision an invisible culture, made invisible by the Spanish Conquistadors and their colonization in the first stage, and by the Euro-American cultural-political invasion in the second stage. To make an art that would incorporate-propagate-encourage and acknowledge New World Aesthetics" (letters to the author, 1982, 1990).

years later, museum and workshop are still flourishing. The young artists involved in the Taller Alma Boricua tended to move away from the first-generation Puerto Rican artists' emphasis on the naive and folkloric and to plunge into a distinctive modernism emphasizing myth and politics, merged in Caribbean indigenous imagery and abstraction. Marcos Dimas, Rafael Colón Morales, Jorge Soto, and Rafael Ferrer are among the participants whose work has achieved recognition outside the barrio. The Taller's radical cultural approach, however, has always focused on their own community. According to Ortiz, they chose their own

> ethno-centrism . . . to create a fine arts proper to the underclass, rooted in the artist's native culture, authenticating and revealing the community to itself . . . [because] only a self-conscious, deliberate liberation from European-American "isms" could heal their culture shock. . . . For the underclass, art must become a means of collective and personal survival and regeneration.[39]

For Puerto Ricans in New York, the landing process has been fragmented. One visible vernacular form is the *casita*—a small wooden garden house, or religious shrine, or social club, brightly painted and often decorated with national symbols—found in yards and lots in *el barrio*. Another unique folk form is Dennis Urrutia's dioramas, three-dimensional scale models of daily life in his Spanish Harlem neighborhood and of historical events in Puerto Rico or North Africa.

In Puerto Rico, as elsewhere in Latin America, the arts of the upper classes and the arts of "the people" are still separated by vast abysses of money, access to travel, education, and power equaling those between the First and Third Worlds. There are class divisions between those artists remaining in Puerto Rico (who tend to be university-educated if they are making "high art") and those born in New York, and those who travel back and forth.

Rafael Ferrer is the best-known Puerto Rican artist working in the United States, having made his mark as a "process" artist in the late '60s. During the '70s he exhibited colorful sculpture that appeared to be about water crossings and travel or exploration, incorporating boats, maps, drums, and indigenous detail. In the '80s Ferrer returned to painting in a curious, almost "naif" realist style, depicting local and rural life on the Island.

The most exciting work in Puerto Rico itself tends to be done by artists who have either remained deeply immersed in local culture (like Antonio Martorel's fusion of printmaking and political performance and Nick Quijano's neoprimitivist domestic interiors with their undertones of romance and intrigue), or those who have studied on the mainland and returned (like Mari Mater O'Neill's figures crackling with a curious punk/Picasso/García Márquez energy and Carlos Collazo's dreamlike paintings with their white-outlined, upside-down figures and darker shadows at the edges, suggestive of the voids left by the destruction of one culture and the suppression of another). Arnaldo

Fig. 21: Papo Colo, *Superman 51*, 1977, performance on the West Side Highway, New York. (Photo courtesy Exit Art, New York.) To express support for the Independence of Puerto Rico, Colo attached 51 sticks by ropes to his body and ran with them trailing after him until he collapsed from exhaustion. The number 51 referred to the possibility that Puerto Rico might become the fifty-first state: "Bound in ropes / premeditated act of defeat / a way Americans sometimes make sacrifices."

Colo was born Francisco Colon Quintero in Puerto Rico. He spent his youth as an adventurer, living with the Huichol and Cora Indians in Mexico and spending two years in the Merchant Marine. He calls himself a "transculturist" and disapproves of the "fetishistic" idiom of geographic identity that surfaces in much Latino art. In 1971, as a conceptual art piece, Colo forged his degree from the University of Puerto Rico, explaining that it was a "declaration of marginality of my own culture."

> Education, where the functions of colonial mentality are more sinister, creates a mirage about identity/culture/language/history, etc. By fabricating an exact copy of the document that symbolized that perversion . . . I fulfill the dream of so many underdeveloped people—to have an education. I do it with another mirage, with another lie, perhaps with more substance than the original.

(Quotations from letter to the author, 1986, and *Will, Power, & Desire: Papo Colo* [New York: Exit Art and Rosa Esman Gallery, 1986].)

Roche Rabell, who lives part-time in Chicago, evokes a poignant, brutal past that is fused with intense personal conflicts, conjuring ghosts of vanished indigenous peoples, and the history of the African Americans who replaced them, through an evocative rubbing technique.

The work of Juan Sánchez (plate 24) is an example of the kind of dialectical "interpresence of past and present" cited in the writings of Abdallah Laroui. Sánchez is an Afro–Puerto Rican firmly based in the NuYorican community, whose work moves across cultural frontiers without being a "crossover"— without giving anything up on the return trips. As subtitle for a series of prints,

Fig. 22: Rafael Ferrer, *El Billar de Noche,*
1987, oil on canvas, 60″ × 84″. (Photo: Zind-
man/Fremont, courtesy Nancy Hoffman Gal-
lery, New York.) Ferrer's earlier work fell into
"process" and then "neo-ritualist" cate-
gories, but recently he has rejected the mod-
ernist movements that he had adapted to the
needs of a Latino exile, and returned to
guileless scenes of Puerto Rican and Carib-
bean life such as this one.

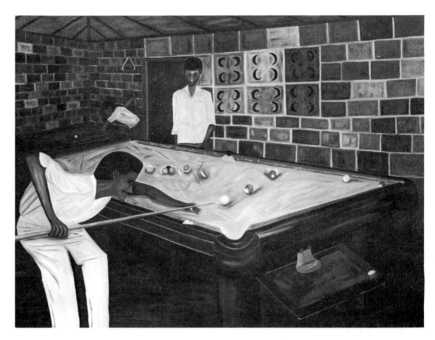

▼▼▼▼▼▼▼

Puerto Rico has a particularly schizo-
phrenic history, having been forceably re-
oriented in 1898 from Spanish to Yankee
language and domination. A strong nation-
alist expression emerged in the '40s with
the reformist government of Luis Muñoz
Marín (who later lost his nerve and did not
go as far as he had originally planned). The
establishment by several North American
New Dealers of the Division of Community
Education played a role in cultural aware-
ness. In 1952, when Puerto Rico officially
graduated from colony to commonwealth
status, a new optimistic burst of culture
ensued. But it was only in the late '60s that
international modernism seeped in, al-
though even then the local strength re-
mained a strong figurative and graphic
tradition. Only in the '70s did abstraction
belatedly display any force.

Such deliberate isolation from interna-
tional trends is a double-edged sword, a
delicate balance between an "esthetics of
resistance"—enlightened, politically aware
nationalism that maintains cultural iden-
tity—and a reactionary stance that fears
both the folkloric "low" roots of much Ca-
ribbean culture and the international "high"
avant-garde identified with dominant and
dominating U.S. art. The failure in the '60s
of Governor Luis Muñoz Marín's "Operation
Bootstrap," which was to provide prosperity
through "free" enterprise (i.e., U.S.-financed
industrialization and exploitation) brought in

he borrowed the phrase "Rican/struction" from the salsa percussionist Ray
Barretto, because what he does in his art is restructure a colonized reality by
photographing it, painting it, writing it, tearing it up, and rearranging it to
reflect a different reality. One of his paintings includes the inscription: "Tito,
born Puerto Rican, died New Yorican . . . please give respect to Tito because
even if he's americanized . . . there was some culture and conscience left to
at least keep the word Rican as a surname."

While some Latino artists boil bitterly, if justifiably, in isolation, or aspire
to cultural forgetfulness, and while some non-Latino artists either admiringly
or callously borrow from the energies of Latin culture, Sánchez has all along
been totally unselfconscious about where he comes from. Still living in Brook-
lyn, where he was born and raised, invigorated by his communal base in the
Latino and progressive art communities, and unafraid of politics, emotion, or
sentiment, he takes the "risk" of bringing them into his art, which is permeated
by the traditional values of family and religion. The rose, the cross, the Puerto
Rican flag, and street graffiti are frequent motifs, as is the artist's late mother,
a poor, often ill, working woman whom he much admired. In one painting
she is sheltered by a rainbow. In another she appears with a botanica doll like
those she once made. The titles of two other works by her son are: *Never saw
her as an oppressed Puerto Rican Woman . . . Only as Mommy* and *Lord, find
me a role where my love can live in struggle.* In *La Lucha Continua* a little girl's
first communion is joined with the ongoing political struggle; a collaged de-
votional card represents San Martin de Porre, a popular patron of the poor

usually pictured with a broom, a kind of spiritual janitor. At the other end of the spectrum, political art clichés like barbed wire and the Puerto Rican independence flag take on new resonance because of the many-layered context in which they are placed.

Confronting the fragmentation of his culture by imperialism and dispersion, Sánchez lovingly weaves his fragments into a new fabric that is both spiritually restorative and politically radical. The patches in his quiltlike paintings (or comforters) are words, photos he takes himself, quotations and images that recall homely, proud, and rebellious moments from the distant and recent pasts of Boriquén (the indigenous name for the Island). He mourns the sterilization of one third of the women living in Puerto Rico, the number of Puerto

a conservative pro-statehood government in 1968, and in Puerto Rico, as elsewhere in that period, art became political and explosive. The *independentista* movement and the disproportionate number of Puerto Ricans serving and dying in Vietnam were among the sparks.
—based on Mari Carmen Ramírez, *Puerto Rican Painting Between Past and Present* (Washington, D.C.: Museum of Modern Art of Latin America, 1987)

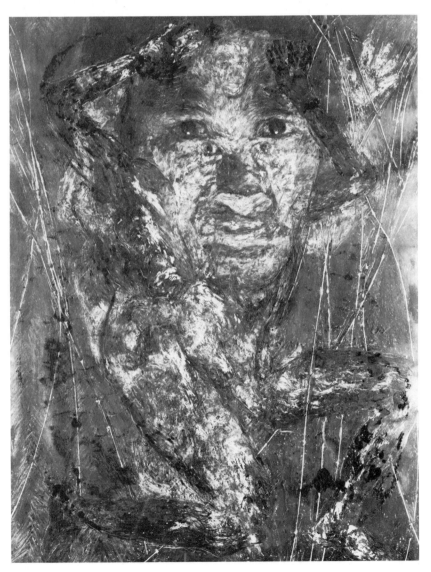

Fig. 23: Arnaldo Roche Rabell, *Now You Know How I Feel*, 1985, oil crayons on gesso paper, 66″ x 50″ (Photo courtesy Galeria Botello, Hato Rey, Puerto Rico.) At least two, perhaps three figures, painted black and white, but all with African features, are superimposed or merged in this poignant image of conflicting identities. The large head (a self-portrait) with two pairs of eyes seems to loom behind the kneeling figure, which has two pairs of arms. The larger eyes gaze at the viewer with an unavoidable stare. Tense, haunting, and confrontational, the drawing supports Mari Carmen Ramírez's contention that Roche's subjects are "usually violent dreams or visions that he has experienced intensely" and that he paints to exorcise these "monstrous events"—a metaphor implying Puerto Rico's social history. Roche lives part-time in Chicago, where he received an MFA from the School of the Art Institute.

Fig. 24: Willie Birch, *Reminiscing about Jackie Robinson*, 1987, gouache on paper with relief frame, 54″ × 42″. Birch is an African American painter and sculptor born in New Orleans, living in Brooklyn, and teaching at Hunter College. His "Personal View of Urban America" (the title of this series) calls on African roots, black history, and untrained southern artists. In his poetic sculptures, such as the large wooden site sculpture in Fort Greene Park titled *For Old Bones and Southern Memories*, Birch often uses earth, wood, and cemetery references, but his paintings are oriented to the urban present. They are lively, if often depressing, chronicles of street life in "the ghetto," with subjects ranging from high school graduation to break dancers, drug busts, the local barbershop, or "Playland" (kids playing ball and riding bikes before a wall graffitied with memorials to dead friends). "I want to force the viewer to see not only 'America the Beautiful' but also . . . the forgotten America that suffers from premeditated as well as unintentional neglect" (*Loaded*, n.p.)

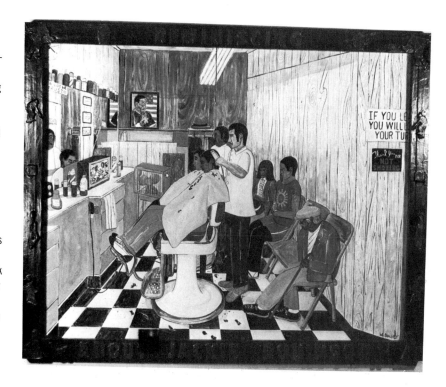

Rican political prisoners held in U.S. jails, brutality and intimidation on the U.S. military base at Vieques. His sources include the heroes and heroines of Puerto Rican history, the churches where solace from poverty and racism is sought, the community organizations where the seeds of a broader resistance are planted, the Afro-Latino botanicas where the medicines associated with religions like Santería are bought.

He also uses petroglyph images from the caves and stone steles of the Taino (a peaceful Arawak people who inhabited the Antilles and mostly disappeared under colonization; 300,000 were extinguished by Columbus). Paying homage to the beneficent Taino god Yu-cahu Bagua Maorocoti, he simultaneously makes the connection to urban graffiti and popular culture. He ironically juxtaposes ancient images with, say, the eternally youthful pop group Menudo (the concocted culture heroes of deculturated Puerto Rican teenagers adrift in the Northland), or he combines a Taino fertility goddess with an homage to Pedro Albizu Campos—the nationalist hero and longtime political prisoner in the United States—honoring an uprising in the town of Jayuya in 1950. In the process he is telling history.

The layering of Sánchez's work is reflected in his technique. Walter Benjamin said, "the painter maintains in his work a natural distance from reality, the cameraman penetrates deeply into its web."[40] Sánchez does both, embedding his own photographs in his paintings. He incorporates long texts, like a

conceptual artist. But the subtleties of his messages are more likely to be lost on supposedly sophisticated art audiences than on uneducated Latino audiences familiar with his cultural references. As much or more powerfully than most postmodernists, Sánchez takes on the issue of representation by replacing stereotypes of urban Latino people with images of people as they see themselves. The richness of his color, surfaces, and textures constitutes an homage to his subjects. It is not the opulence of wealth, but of popular culture.

African American Willie Birch and Chinese American Martin Wong also celebrate the diversity, vitality, and tragedies of New York's poor neighborhoods. Birch looks at Brooklyn's local culture—barbershop camaraderie, high school graduation, graffiti, and drug busts—with a loving but unflinching eye and a quasi-naive style. In his portraits of place, Wong (plate 32) unites an Asian-derived joy in the decorative with a gritty Western paint surface to depict his Lower East Side neighborhood—a multicultural world of lovingly detailed brick walls, vacant tenements, skateboarders, firemen, drug addicts, and poets. They live with a vehement and often joyful desperation beneath skies of mapped constellations and lyrical messages written by hands in deaf sign language, endowing everyday realities with a glimpse of the distant sublime. As John Yau writes, Wong has transformed his displacement "into an expressive choice," a deep desire "to both record an emerging cultural identity as well as invent one which is hybrid and relational."[41]

The contrasting threads of longing and loss, desire and displacement, are woven through the art of many Asian Americans, who are far from their ancestral lands and whose histories of dislocation are many and varied. At the same time that Latino and African Americans are resurrecting religious motifs in high art, and the visual richness of their heritage is attracting those unfamiliar with it, one hears frequent observations about how the white West is moving toward the East in the spiritual realm (often by way of New Age ripoffs of Native American traditions). In modernist art, this is nothing new, given the work of Morris Graves, Mark Tobey, and others in the '40s and '50s, and the influence of Asian art on Europeans from Impressionism to Abstract Expressionism. Today, however, it is Asian Americans themselves who are turning back to see what was left behind, not only in history, but in their childhoods or in the present lives of relatives in the homelands or the Chinatowns or Japantowns of this country. In doing so, they are producing art that bears only superficial stylistic resemblances either to their own traditional arts or to earlier Western borrowings from the East. As recent arrival Hung Liu puts it, "All in all, I am trying to invent a way of allowing myself to practice as a Chinese artist outside of Chinese culture. Perhaps the displaced meanings of that practice—reframed within this culture—are meaningful *because* they are displaced."[42]

It is inevitably controversial to try and pin down the elusive cultural characteristics in any artist's work. But since they are almost always assumed,

▼▼▼▼▼▼▼

For this Western-trained, third generation Asian American, curating an exhibition of Japanese-born sculptors raised unexpected issues. Initially, I believed that these artists were informed by Western formal ideas and used abstract or symbolic modes, reminiscent of well-established trends in contemporary American art, to similar ends. However, in preparatory interviews, they revealed distinctive sensibilities primarily derived from non-Western conceptual frameworks. Although Japan has a long history of acceptive foreign forms, critics and curators should not automatically assume that such appropriation transmits intercultural filters intact! In fact, any cross-cultural transmission assures that meaning and purpose will alter for those informed by distinctly different cultures.
—Margo Machida, *Crossed Cultures* (Brooklyn: The Rotunda Gallery, 1989, n.p.)

Fig. 25: Kazuko, installation at the A.I.R. Gallery, New York, 1980. (Photo: Tom Flynn.) Kazuko, who was raised in Japan, dedicated this 1980 exhibition to a great white swan protecting a pebble, twig, and stone nest full of huge blue eggs that she had seen around the time she conceived her son. She built many of the pieces during her pregnancy, when "my body was stored with energy. . . . I was more like a woman who worked in the fields, full of strength. . . . I kept making pieces, forming, shaping; they looked like baskets, chains, spirals." She collected branches and twigs in Central Park and made rope from brown paper bags. "I admire the beauty of braided things . . . and in Japan I often had the chance to see Kumi-Himo —braided or woven string." The central pieces were two huge nests on the floor and paper-rope bridges spanned the ceiling, suggesting the connections between generations, between countries. (Quotations from letter to the author, 1989.)

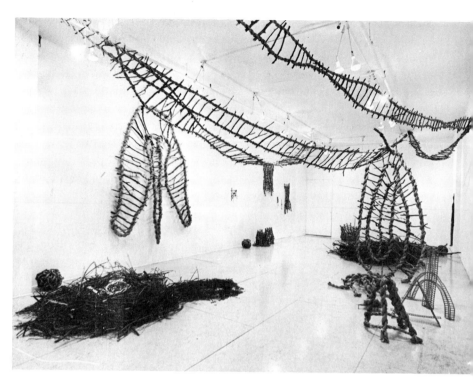

Fig. 26: Reiko Goto, *Nezumi*, 1989, 200 pieces of white cloth (12″ × 12″ each), corrugated cardboard, sawdust, a used chest of drawers, metal dishes of water and dry animal food, and recorded sound, 11½′ × 25½′ × 28½′, installation at the San Francisco Art Institute. (Photo: © Michael Selic.) Goto is Japanese, living in the Bay Area. Recent works were made in collaboration with living creatures, such as *Natsu and Haru*, in which swallow-tail pupae were placed on bunches of fennel and, when they became butterflies, left through an open window. *Nezumi* was inspired by her work as caretaker for laboratory animals. She gave the animals scraps of material for nesting and each one "signed" it with individual markings, which she then replicated in human scale on the white cloths. The piece might be an allegory for displacement, absence, and the exploitation of nature. *Nezumi* is intended to facilitate an understanding of the difference between "life-sizes, a sharing of perspectives" (*1989 Annual Exhibition*, San Francisco Art Institute).

even if subliminally, they constitute a basic building block in understanding the intercultural process and therefore must be a significant component of this book. Most Westerners and many Asians seem to take for granted that there is some distinctly "Asian" quality underlying much contemporary Asian American art, even when its presence is unintentional. Pinning it down is problematic. Given an Asian name, certain things get read into work that may not be there. Art-oriented Euro-Americans consider ourselves relatively familiar with Asian art history. We know just what we mean when we say admiringly, "It looks Oriental," despite the great range of Asian traditions with which few of us are familiar. The aura is contemplative and introspective, water and stone, expressed with simplicity and a certain elegance. The two most familiar poles are delicate, spacious monochromes, and intricate, brilliantly colored patterns. Since the influence of Indian, Cambodian, Indonesian, and other Southeast Asian arts on the arts of North America is minimal, the most obvious "characteristics" are the calligraphic stroke (easily adapted to Western art, and easily read as Asian), delicate collages of papers and fabrics, and an austere or ornamental geometry.

A number of contemporary Asian artists seem to favor abstract biomorphism—an elegant, certainly not stereotypically "Oriental" imagery, but one which apparently reflects some culturally shared elements that convey a sense of "landing." The most ubiquitous and felicitous element, in sculpture and installations as well as in painting, is a clean, airy space that simultaneously absorbs humanity into nature and conveys a sense of contemplative isolation from everyday life. It is a cliché perhaps to attribute this to the Buddhist assertion of the oneness of all things, just as it is trite to promulgate the elaborate, gaudy, crowded image of Latino art now resisted by some Latino artists and enthusiastically adopted by others. But like the raucous vitality of some Latino art, the metaphysical openness of some Asian art is based in cultural realities, and it is all too easily dismissed along with the more superficial elements of any cultural difference—whether or not it is adaptable to or absorbable into Western life and art. Even if an "Asian" respect for nature has been transformed by North American society into a visual style, rather than a spiritual base or way of perceiving the world, much can still be learned about intercultural experience through analysis of these styles or worldviews. (For instance, young Japanese avant-garde artists today have proclaimed themselves "Against Nature" in a show of that title, in order to escape national stereotypes.) Art offers a perhaps illusory way out of the confines of stereotype and a way into a truly bicultural view.

Looking beyond the surface, the austere and apparently tranquil elements associated with Asian art often appear to mask considerable anxiety, as shown by statements in the "Yesterday" catalog from the Asian American Arts Centre.[43] Amy Cheng represents her sense of displacement in "still life" paintings of giant fruits or vegetables incongruously set in landscapes or seascapes,

▼▼▼▼▼▼▼

Shards of memory fall through my fingers. . . . The past is as much about origin as it is about recollection, regardless of how a person may feel about that heritage. . . . The past encompasses the attempt to mix Eastern tradition (say, the tea ceremony) and American culture (say, rock n' roll). When the two "sides" contradict, they create a dialectic that can resolve itself in artistic expression. . . . If there is an "Asian American esthetic" perhaps it lodges here, in these conflicts and resolutions. . . . We are our own juxtapositions.
—Kimiko Hahn, in *Yesterday* (p. 3)

Fig. 27: Nina Kuo, *Politeness in Poverty*, 1988, photo mural installed in the Broadway-Lafayette subway station, New York. (Part of the Artmakers, Inc., and MTA "Creative Stations Project.") Kuo's grandmother had bound feet; her father is an abstract painter in the United States. She has traveled and photographed widely, focusing on cultural gestures and the aging process as it is lived out in different cultures. The photograph, taken in Burma, portrays "a female monk who in her daily act of begging represents the virtues of humility and meditation." This act, Kuo continues, "symbolizes the simplicity and sense of pride that the monk, homeless person, or subway rider may feel in their own journey on the trains. We are reminded that this act contains simple spiritual values and it helps us understand the plight of the homeless individual, our fellow citizens of New York City. For the growing Asian population in the SoHo and New York City area, this image may represent the ritual of 'seeking alms,' " recalling the need for mutual courtesy, compassion, and consideration notoriously lacking in the urban environment. (Unpublished statement, 1988.)

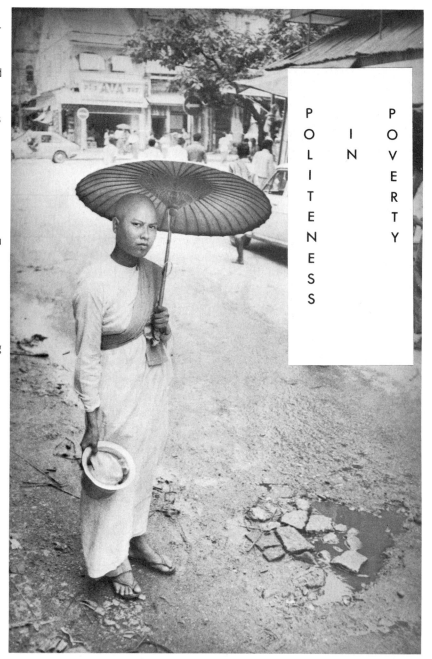

attempting "to reconcile the apparently irreconcilable," and reflecting her experience of moving "an average of once every two years, not only to a different house, neighborhood and school, but sometimes to a different country, continent, language, and culture." Anna Kuo includes the memories of past lives, "embodying events which occurred before the now"; her overlapping

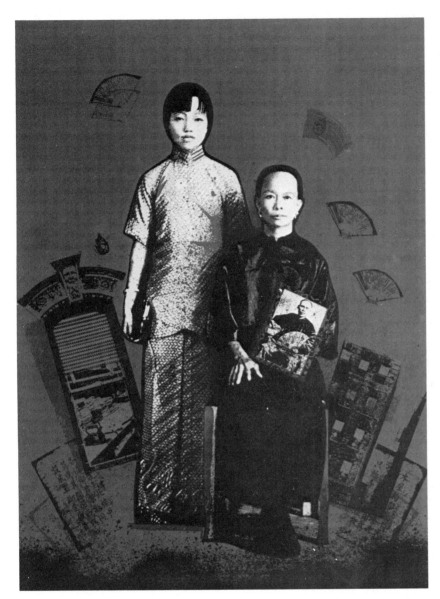

Fig. 28: Tomie Arai, *Laundryman's Daughter*, 1988, silkscreen on Rives BFK, 22″ × 30″, Avocet Editions. (Photo: Millie Burns.) This intense blue and red print is part of Arai's "Memory-in-Progress: A Mother/Daughter Project," based on interviews by Arai and Dorothy Rony and shown in 1989 at New York's Chinatown History Project. "My intent," said Arai in her statement for the show, "was to create a sense of place through positive images of Asian American women. It seemed important for others to know that Mrs. Chin lived on East Fifth Street for over thirty-five years; that the Hong family—a neighborhood fixture on the Upper West Side—opened a store on Broadway and 105th Street in the early 1950s." Behind the formally posed subjects an array of disparate images from their double context—fans, Chinese objects and writing, old ornamented tenements—spin in the air as though looking for a place to land. Arai says she is still defined by the immigrant experience. "The sojourner, forever foreign, uprooted and marginal, is a central character in Asian American art."

biomorphic forms are meditations on an Eastern heritage interfacing with Roman Catholicism, "the symbology of the Revelation and the microcosmic development of the human chakras." In Carol Sun's *The Inside*, her long braids, cut off, form a magic circle, the relic from a rite of passage, a "visceral allegory for accepting this transformation in my psyche."

Tomie Arai, who is sansei, or third-generation Japanese American, lives in the same apartment on Manhattan's Upper West Side she grew up in. Yet many of her images depict people falling or cultural artifacts floating above tenement roofs, as though time had not brought rest. She has been developing

a silkscreen series about Asian American history because her children are hungry for family stories,

> stories about the past as a way of making sense of the present. I find this is certainly a part of motherhood: to pass down memories and lessons for survival. It is also within our power to change the way our children look at ourselves. While we may be immigrants or the descendants of immigrants, our art and our words mark our place in the heart of this city and country.[44]

At times Asian American artists have seemed more immune to, or averse to, ethnic "placement" than other groups. Aside from the natural desire to be taken seriously within the mainstream, this may have to do with the fact that Americans are so ignorant of the diverse cultural cues that they become invisible from the outside. It is as if one's own land ceases to exist when others do not recognize it.

The prevailing image of Asian art in the United States is derived from the great classical—and aristocratic—traditions of brush paintings and gardens rather than the intricate ornament and teeming, sensual facades of the Buddhist temples of India or the vivid "floating garden" popular prints of Japan or the robust, often erotic, folk arts of China, Korea, and Japan, to list only a few of the neglected sources. Yet as musician Fred Wei-han Ho has pointed out, "we must be clear that even esthetics are class partisan, that society conditions our tastes, values and norms about what is beautiful and what we should love."[45]

The folk traditions are rarely recognized in Asian American art except in occasional Chinatown murals in New York, San Francisco, and elsewhere. Yet as Ho wrote in an article titled "Tradition and Change, Inheritance and Innovation, Not Imitation!": "The great body of the Asian American cultural tradition emanates from the working class Asian communities and is in the Asian languages and dialects."[46] He lists early Asian American folk-cultural forms such as the oral tradition of "talk stories," ballads, Cantonese opera, chants like the *muk-yu go* (wood-fish song), the forty-six-syllable Cantonese folk-song form called *seisapluk jigo*, and the bitter, lonely poems carved into the wooden barracks at Angel Island, the entry point for Pacific immigration. Ho calls for Asian American artists

> to study and grasp the traditional forms, not to be academic experts, but to create a living contemporary art. . . . It is my contention that Asian American art is not the loose collection of voices of artists who happen to be Asian American. Rather Asian American culture and art is a collective body of folk and art traditions to which our works will be judged. And I have tried to argue that within this continuum, there are different class tendencies. The strongest and most powerful works have been closely connected and rooted to the community . . . while those works representing the Asian American petty bourgeoisie are more watered-down and white-assimilated and are weaker examples, peripheral to the thrust of this continuum.[47]

The lives and work of first-generation Chinese American artists illuminate some of the dilemmas and choices made. Ming Fay, who was born in Shanghai, came to the United States on scholarship in 1961 at the age of eighteen, after studying with traditional Chinese teachers in English schools in Hong Kong, where he was raised. At first his heritage was a burden, and he made monumental geometric sculpture in an international style. By the late '70s he was ready to confront his past, or rather his bicultural present. He began to make a sculptural "Celestial Garden," where all the plants grew supernaturally large and each claimed mysterious powers based in traditional Chinese symbolism.

Fig. 29: Ming Fay, *Extinct Ancestors*, 1987, mixed media, 24″ × 14″ × 12″. Ming Fay works from his imagination, making "divination objects, totems, and magical things" by a fusion of Eastern and Western techniques—lacquer and airbrush. His refugees from the natural world are decontextualized and almost dreamlike, even when they are united in installations. Naturalistic but not "realistic" in the Western sense, they suggest the teachings of ancient Chinese painters who cautioned artists to wait until they perceived, or received, the spirit of the nature they depicted. (In fact Ming Fay once said that his fruit and vegetable forms "grew" slowly in the studio until they were ripe enough to be "picked.") The "Ancestor Series" was in part inspired by a trip he took around the world; he saw holy places where people traveled long distances to see a tooth or a piece of bone. He made his first wishbone sculpture on this trip, and wished for a child. When his son was expected, he recalls, "I started to do skulls. I guess these are ritualistic pieces for a 'life crisis.' This piece deals with the idea that the big being and the little being all face the same path at the end. No generation without corruption, no life without death" (letter to the author, 1989).

▼▼▼▼▼▼▼

When I came to America, I was (ironically) reluctant to work in ways that had political overtones because to do so in China, unlike here, involves serious risks. Having been forced to work in the fields for four years during the Cultural Revolution, I have experienced repression that few Americans know, and do not take lightly the roles public and sometimes political images play in my work. As an escape from propaganda art in China, I looked toward the ancient artists of my culture and traveled extensively among the ancient monuments. Here, however, the reproduction of traditional work is seen as academic and unimaginative—unless one selects iconography from the past and inserts it, collage-like, into the present. . . . Consequently, I have become interested in the peculiar ironies which result when ancient Chinese images are "reprocessed" within contemporary western materials, processes, and modes of display. . . . often, they refer to such traditional Chinese artmaking processes as repetition as a kind of prayer, copying as an act of homage, ancient myth, or production of folk art and kitsch.
—Hung Liu (unpublished statement, 1988)

(The peach, for example, is a magical fruit of longevity, cherries are love, and there are also "herbs of immortality, the elixir of life and aphrodisiac plants.") Fay also sees his swelling vegetables, fruits, and root figures in a more contemporary vein as metaphors for sexuality, humor, and irony.

The fruits led to a series called "Relics"—natural at first, then cultural. Ming Fay began with giant dried-up seedpods and broken seashells. He neither imitates nor idealizes Nature. These literally "marvelous" objects are layered composites of reality and memory, bearing no resemblance whatsoever to the cheerful elephantiasis of Pop Art. Barry Schwabsky has described Ming Fay's snail, its shell both mathematically perfect and physically battered, as a point of intersection, producing "a kind of spatial elision or syncopation, a playing off of silence against a steady beat. The result is an evocative reverie on duration."[48] The same could be said of the series of wishbones and ancestral skulls that followed. The skulls are sometimes fragmented, sometimes associated with an ancient artifact, as though spanning the whole history of the human race as a means of bonding backwards, with a land the artist barely knew.

Hung Liu (plate 37) arrived in the United States only in 1984—"Five-thousand-year-old culture on my back. Late-twentieth-century world in my face. . . . My Alien number is 28333359."[49] She is already a university professor at Mills College and has had one-woman shows in Texas, San Francisco, and New York. She had been a faculty member at the Central Academy of Fine Arts in Beijing, and her transition to graduate school at the University of California at San Diego was eased by the fact that her adviser, Allan Kaprow, knew and appreciated Asian art and philosophy. Hung Liu's first show in Texas, in 1985, paid homage to and simultaneously relegated to the past a major project from her Chinese life—drawings made from the hundreds of murals dating from the fourth to the fourteenth centuries at the isolated Dunhuang Buddhist caves in Gansu province. In her later work she has continued to juxtapose images of China and Chinese American life from past and present, recording the cultural changes experienced by other individuals and families as a way of understanding her own transformation, which is documented in her art.

Although the issue is clouded by hegemony, by the fact that we speak from within one system, in a language born of that system, I remain convinced by the evidence of contemporary art that the hybrid experience can be a significant esthetic factor, even when fragmented and demeaned by the dominant culture. A certain element of groundedness, or landing, a sense of history and belonging to a place or to a quaking middle ground can be retained or recuperated without sinking into the mires of obfuscatory stereotyping. Such groundedness can endow less trained artists with more force than those who are highly educated but suffer from a lack of meaning and substance endemic in cultural vacuity.

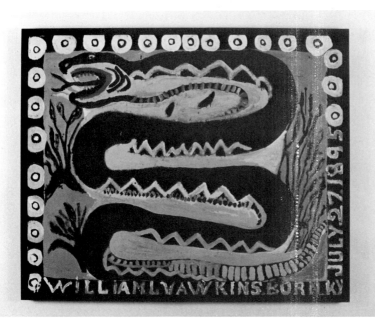

Fig. 30: William Hawkins, *Rattlesnake No. 3*, 1988, enameled paint and collage on Masonite, 50½" × 62½". (Photo courtesy Edward Thorp Gallery, New York.) This bold green, yellow, and black painting is partially framed by the words "William Hawkins Born KY July 27, 1895." An African American artist living in Columbus, Ohio, who taught himself to paint and has only been making art seriously since 1979 (when he was eighty-four), Hawkins stimulates his imagination with magazine photos, usually depicting animals and buildings (or the Rock of Gibraltar from a Prudential Insurance ad). He sometimes achieves a curious double-coding by collaging photographic details onto his paintings.

At the same time, cultural consciousness is always in danger of becoming yet another elusive and manipulable aspect of an already overmythologized activity.

Nevertheless, the effect of power relations on culture cannot be denied, and it is still necessary to question the concept of authenticity in each instance, whether or not it is appealingly expressed. The notion of cultural authenticity is suspect in its resemblance to cultural and biological determinism and even to "cultural apartheid." The minute the term is raised, we have to ask, "Authentic for whom? Who's to say?" Virginia Dominguez, an anthropology professor at Duke University who was raised in the Caribbean, has challenged the very existence of authenticity in today's world, citing "the implicitly hierarchal nature of otherness," since

> **the empowered group's ideology so penetrates into the underprivileged sections of a population that there is no guarantee that the representation of self produced by members of the minority population would necessarily differ from the empowered group's representation of their otherness.**[50]

Certainly there is no guarantee of cultural integrity within this porous and precarious process. Too often, however, regional art is implicitly defined as art that is simply behind-but-trying-to-keep-up with the urban centers and international trends. There is plenty of that around too. Yet however dismissed and even eclipsed it may be by those with all their eggs in the internationalist basket, regionalism continues to offer options unavailable in the more skep-

▼▼▼▼▼▼▼

Beginning from the premise that "artists can let us inside and show us tensions we're not even aware of," Ralph and Deborah Clifton Hils posed a series of hard-to-answer questions to the mostly white community and progressive artists in ACD:

"The professional arts community is primarily an urban phenomenon. How sensitive is that community to the aspirations of rural peoples? Can that community help bridge the widening gap between the urban and rural South? How would that be done?

"Is the professional arts community willing to help in opposing the merchandising of traditional cultures—the most recent blatant example being the franchising of Cajun culture?

"Is the professional arts community willing to face and explore the mythic dimensions of our current problems and so offer leadership in healing open wounds from the past? (We are thinking here about such matters as the desecration of burial grounds, the removal of the South's major Native American nations, the denigration of traditional cultures of all kinds, and the psychic wounds caused by destruction of the land, air, and water. . . .)

"Can professional artists move from a concept of art as individual expression to one of art as an expression of the spiritual and social values of one's community? Would this kind of move help bridge the gap between professional artists and traditional craftspeople? Would it help to make 'fine arts' more interesting and relevant to the lives of traditional people?"
—Ralph Hils and Deborah Clifton Hils, "Some Comments on the Arts and Rural Development" (unpublished, c. 1986)

tical, often cynical mainstream. By "regionalism" I mean art genuinely rooted in (though not immovable from) place, whatever style it may be, whether it is made by trained or untrained artists.

The concept of a local or native art was discredited when, after its great popularity (and idealization) in the '30s and '40s, anything populist came to be tainted as "Communist," since only the Left claimed any interest in "the People." Even during the '60s, although mitigated by radical movements based on local and racial pride, this taboo held; it had been so deeply absorbed in the artworld that regionalism had become synonymous with "bad painting." Unbeknownst to the mainstream, however, an often vital multicultural and grass-roots art survived the '60s. In the mid-'70s, regionalism had something of a renaissance, in part because the dominance of New York within the artworld had become not only intolerable but also somewhat absurd.

By the early '80s, tentative coalitions had formed between artists in the experimental avant-garde disaffected by the rigid institutionalization of the mainstream, artists in the urban political and community arts, and artists in smaller towns and rural areas, especially groups working with murals and alternative theater. This scattered movement engendered a cross-pollination of ideas brought together as "cultural democracy," described by its primary theorists, the activists Arlene Goldbard and Don Adams, as a national policy "whereby each person is guaranteed the right to culture, each voice contributes to building culture, and each of us takes a role in cultural debate and decision-making." Such a position, they write, combats the notion of "love it or leave it"—"the dominant culture's assumption that citizenship is earned by silence."[51]

Since the '70s, this epic concept has been centered, or decentered, in a national liaison organization called the Alliance for Cultural Democracy. One of ACD's interests has been to link the rural and urban arts communities, both of which were hard hit economically by the Reagan era. At a 1987 meeting in Atlanta the most cogent statements on the subject came in the collaborative talk by Ralph Hils and Deborah Clifton Hils, from the Highlander Research and Education Center in Tennessee. They are, respectively, a white farmer raised in the Southeast and a black Cajun craftswoman and artist originally from Louisiana. Pointing out that while southern traditional cultures are rural, only one in seven southerners now lives in the country, Deborah Hils stressed the depth of dislocation and the phenomenon of a "lost" mainstream that has run into the ground; "artificial irrigation"—nostalgia, exploitation of traditional cultures, turning to the traditions of different ethnic groups—doesn't work. People are torn between the lure of the unfamiliar and the lure of the familiar. Ralph Hils observed that the southern arts are characterized by tension, pointing out some regional ironies: the Georgia flag flies over Martin Luther King's tomb, and "we vie for toxic waste sites because they bring jobs."[52]

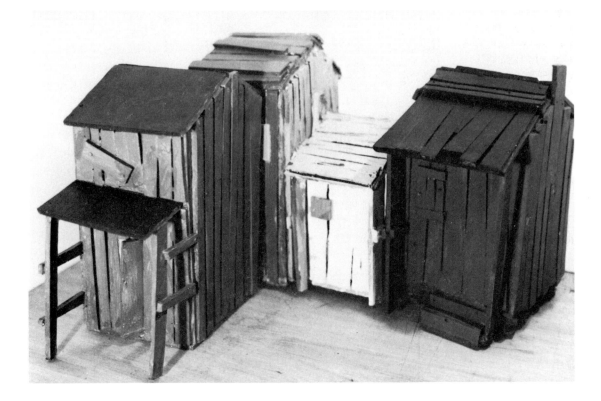

Fig. 31: Beverly Buchanan, *Family Shacks*, 1987, archival paper, 15" × 15" × 14". Buchanan
came to sculpture late, after acquiring two degrees in public health. Her first major site sculp-
tures were mysterious, irregular black blocks or apparently natural outcroppings that hovered
between the natural and the cultural. Her "Shacks" series began in the mid-1980s as small
black ceramic structures, which, although architectural in their planar components, collapsed or
unfolded like flowers. They were inspired by the "skeletons" of houses in the Georgia country-
side, and the life stories that lurk in the ruins. "The empty ones," she wrote, "are stark and
strong images but are very fragile structures. Not all black structures or people are as strong as
they appear. . . . In the shacks I wanted to capture the whole idea of vulnerability." The shacks
are now made of heavily painted cardboard or wood. Some are grouped in "towns," but most
stand alone as they do in the fields, forlorn but defiant, often painted gay carnival colors as
though to belie the historic sadness they shelter. Buchanan has always been interested in and
influenced by southern folk art, "being of and from the same place with the same influences,
food, dirt, sky, reclaimed land, development, violence, guns, ghosts." She had seen such shacks
all her childhood in South and North Carolina, but she was amazed when she discovered that
her father's thesis at Ohio State had been on a similar subject. In 1988 the artist visited the
schoolhouse on Indian land in North Carolina where her grandmother had taught Seminole chil-
dren. A weary, weather-beaten structure surrounded by large stones, it seemed to presage all of
Buchanan's sculptures, which are a "celebration of the spirit of the people I had known who
lived in 'shacks.'" (Quotations from a letter to the author, c. 1986; tapes of Mixing It Up sym-
posium, 1988; and *Influences from the Untaught: Contemporary Drawings* [New York: The Draw-
ing Center, 1988].)

Fig. 32: Kit-yin Snyder, *Cloister*, 1982, wire mesh, 30′ × 30′ × 9′. Snyder was born in Canton, lived for a while as a child in Macao, and is now based in New York. Her sculpture is made of handmade wire mesh "bricks," "mortared" by wire. Combining memories of the temples of her childhood and first-hand studies of Roman architecture, she points out that Chinese, like Pompeiian, architecture is built around an atrium. The floating forms and shifting plays of light and shadow in these ghostly, translucent ruins offer a metaphor for time and space. Recently Snyder has been working with performers and making theatrical pieces of her own in which the actors are invisible, their voices taped, another manipulation of distance and reality.

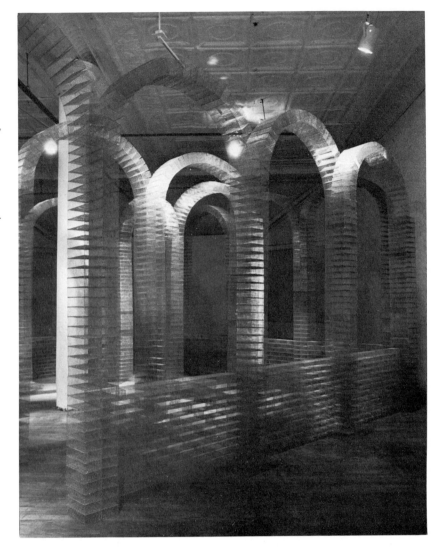

The decentering process that has provided a modus vivendi for much progressive theory in the last decade is an important antidote to the exaggerated centrality and power of urban art hubs with all their ethnocentric trappings. But taken to an extreme, it excludes entirely the need for community, for the centered world on which mythologies have been based for eons. It is playing with fire, or at least with coals, to deny the profound sense of landing that continues to be reflected in contemporary art, just as it would be ridiculous to deny the ambivalence and complexity of such feelings. Even for the displaced, the exiled, and the disoriented whose moorings have been cut loose, landing of some kind is necessary. Recuperation of the past is not merely nostalgic,

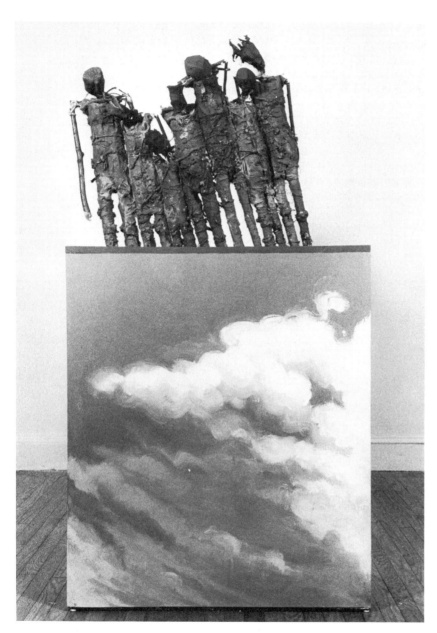

Fig. 33: Carole Byard, *The Gathering*, 1989, earth, branches, canvas, acrylic, bamboo, 60″ x 32″ x 16″. (Photo: Ellen Eisenman.) Byard is an African American painter, sculptor, muralist, illustrator, and earthworks-artist living in New York. In 1977 she exhibited her work in Africa, sponsored by the U.S. government. In *The Gathering* the figures of dead and long-buried ancestors are reunited above the clouds in a bright blue sky. Their earth colors and decaying garments turn the world upside down, Mother Earth over Father Sky, in a scene of affirmation and perhaps rebirth. ("Rent or torn cloth symbolizes internal and external forces we strive to overcome," she wrote about an earlier series.) Byard's subject in all of her media has long been "social madness and inner strength," survival and persistence, the transcendence of the human spirit over material obstacles.

not merely a surrender to "another's" view of "us." It is a filling-in of the parts needed to become a whole person, part of a culture. Wholeness need not be intrinsically static or dangerously generalizing, for all its distortions from New Age to fascism. The dialectic between place and change is the creative crossroads. Even when nationalism has dissolved, place persists, in the back of the mind, in the weight of the footstep.

Fig. 1: Manuel Macarrulla, *Goat Song #1: Struggle*, 1986, oil on canvas, 7′ 4″ × 8′ 9″. (Photo: Peter Jacobs.) This is one of a series of five "political pictures" about military repression supported by the American presence in Latin America. It is inspired by the drawings of atrocities and destruction witnessed by refugee children from El Salvador and by the fantastic elements in Caribbean carnivals. The "Goat Songs" are tragedies in the classical Greek sense. The "hero," whose arrogance brings down the wrath of the gods, is American foreign policy. The *calaveras*, or skeletons, are inspired by the great Mexican graphic artist José Guadalupe Posada. The series title is taken from the etymology of the word "tragedy," which, the artist points out, is used indiscriminately in the American media. Macarrulla, who now lives in Hoboken, New Jersey, has said that all his art is informed by his childhood in the Dominican Republic, by a "naturalism infused with the invisible spirits—demons and angels alike—which animate the world"(unpublished 1983 statement).

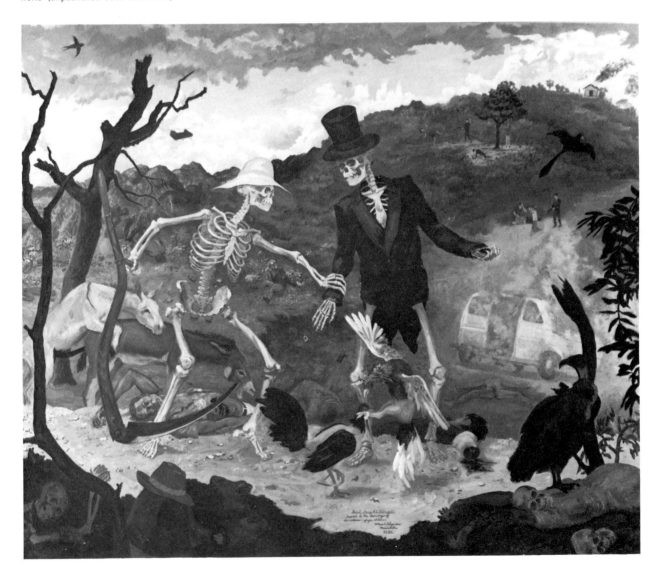

MIXING

▼▼

If you're in a coalition and you're comfortable, then it is not a broad enough coalition.—Bernice Johnson Reagon[1]

Every group arriving in this country has had at some point or another to grapple with the fact that they were a part of the whole, to figure out the exact nature of their liaison with that whole, and to deal with the very real fact that the whole would resist their participation on a par with the other members of the body politic.—Lowery Stokes Sims[2]

How can we determine what is true artistic synthesis versus an incongruous mumbo jumbo? What is the difference between biculturality and cultural schizophrenia?—Guillermo Gómez-Peña[3]

A great many contemporary artists from hugely diverse backgrounds are currently approaching the prospect of cultural mixing on a grander, if more carefully scrutinized scale than ever before. As a result, a magnificent tangle of contradictions arises. To mix means both to mate and to battle. Mixing is the central metaphor, the active social component of the intercultural process. It incorporates the interethnic violence that characterizes the history of this hemisphere, as well as the possibility of a "rainbow future," when everyone is of "mixed race" and the barriers of race-as-class are destroyed. The term applies here not only to "racial" blending, but to cultural and even esthetic mixtures and collaborations, introducing a full spectrum of contradictory decisions about identity and change.

Faced with the facts of nomadism and displacement, many artists are trying to form a new hybrid cultural identity and to locate themselves therein. Those involved in this enterprise include white North Americans who, like many

▼▼▼▼▼▼▼▼

It was an amazingly complicated process trying to get the "racial" breakdown of the U.S. population. Newspaper reports and library sources (all purporting to be based on data from the U.S. Census Bureau) proved wildly contradictory. University professors were vague. Requests sent to the Bureau itself were met with packets of irrelevant data. I finally telephoned around the government bureaucracy and got a woman in charge of "racial statistics," who said the most recent figures she had were from 1988 and they did not specifically include Asians or Native Americans. Based on a population of 241,155,000, her information was: "Whites 84.5%, Blacks 12.1%, 'Hispanic origins' 8.1%, and Other 3.3%." The Native American population has been cited at 1% for years in an improbable stasis. An article in the *San Francisco Chronicle* (February 6, 1990) said there were 6.5 million Asians in the United States (but their other figures were not the same as the above).

immigrants and exiles, are also alienated from the forced and false homogeneity that corporate multinationalism has brought to the United States—those who don't love "America" unconditionally, but would rather change it than leave it. Recognizing the failure of the melting pot and the stubborn survival of cultural heterogeneity, these artists are considering anew the prospect of a society that is cooperative rather than co-optive, syncretic rather than synthetic, multicultural rather than melted-down. As James Baldwin said, "This world is white no longer, and it will never be white again."[4]

Latin America offers models and cautionary tales for this country's accelerating *mestizaje*, or mixing.[5] As it painfully kicks over the last traces of colonialism, Latin America (including Mexico, Central America, and the Spanish-speaking Caribbean) is haunted by the question of how to build constructively on its often socially inequitable mixture of indigenous, African, and European roots. Latin Americans are far more sophisticated about the mixing process than most North Americans. They have lived several centuries of it with more liberal (if not less cruel) attitudes toward "racial purity" than those imposed by Anglo-Saxons on the northern continent. Like the French in the seventeenth and eighteenth centuries in North America, the Spanish in Latin America eventually saw miscegenation as a means of assimilation (first into, then over and above the Indian populations),[6] while the English tended to enforce rigid segregation, resulting in U.S. laws that forbade even voluntary unions. The outcome was the many dissimilar—if equally disastrous—experiences of indigenous peoples in North and Latin America. Each Latin American country has dealt differently with the double-edged sword of mixture, and each has a differently mixed population, from almost wholly European in Argentina and Uruguay, to mostly mestizo in Chile and Venezuela, up to nearly half Indian in Bolivia, Ecuador, Peru, and Guatemala, to a large black and mulatto population in the Caribbean, to a black majority in Brazil, to a more equal distribution of white, mestizo, Indian, and African in Colombia, to the almost fifty percent Asian population of Surinam and Guyana.[7]

So here we all are in North America. Some estimates state that by the year 2000 there will be no white majority in many parts of this country. "We are the next chapter in the story of the Americas," declared Henry Cisneros, then mayor of San Antonio, at the Hispanic Annual Salute in Denver in 1988. There are California and southwestern cities today where Caucasians are already in the minority. The process will no doubt accelerate, and in the next decade artists will be exposed to a vast range of cultural attitudes and images that today are still invisible to closed minds and closed eyes.

It cannot be taken for granted that mixing will resolve the potentially permanent tension between "races." There are other models. One is apartheid (appropriately pronounced "apart-hate" and not confined to South Africa), characterized by continued racism, ignorance, and brutal repression—and genocide, as in Guatemala. Another is voluntary separation stemming from cultural pride and resistance to assimilation, although this is relatively rare in the

Fig. 2: Maria Brito, *Altar*, 1987, mixed media, 42″ x 40″ x 21½″. Collection Mr. and Mrs. Jay Braus, Boca Raton, Florida. (Photo: Rafael Salazar.) Brito was born in Cuba and came to live in Miami at age thirteen. Her earlier work was in clay, but she moved into mixed media and also executed a large public sculpture in steel and aluminum for the Korean Olympics. There is usually a dreamlike quality to her work, in which furniture often figures, giving the pieces a sense of domestic theater. Here the central image is "the eye-deity (or Christ), but at the human level, demystified," a concept further explored by the bucket to catch the tears. "It's almost as if it were humanity crucified, without the Christ aspect" (letter to the author, 1990).

disjunctive climate of the twentieth century, when most people have moved out of traditional societies and are unsure where they belong, where the boundaries are drawn.

The problem of emphasizing cultural identity, which can encourage rigidity rather than openness and flexibility in self-definition, is accompanied by that of intertribal racism. Tribal stereotypes, says Peter Marris (using the word "tribal" in a general sociological sense, rather than as a synonym for "primitivism"), can "express, crudely, the diversity of cultures: but in defining the distinctiveness of one's own group, they tend to become moral categories, classing others as inferior."[8] When disparate groups are thrust together and treated by outsiders as though they were "all the same," they may draw together defensively and/or emphasize their uniqueness to exploit disparities, replacing geographical distance with social distance. Tribalism in this sense is a perverted, embattled form of community.

▼▼▼▼▼▼▼▼

A few days later, other Indians came with the news that these two strange men with hair on their faces had met a hunting party near what is known as the Forty Mile Desert. The Paiute braves, knowing it was not right for men to be so different from themselves, stoned them to death.
—Lalla Scott, *Karnee: A Paiute Narrative* (Reno: University of Nevada Press, 1966, p. 24)

The least frequent of all non-Nez Perce blood quanta units, however, are found in the *Negro* category. Although this low frequency may be explained by the paucity of Negroes in the surrounding Euro-American population, it is also the result of the Nez Perces' severe disapproval of unions with Negroes . . . as undesirable for most Nez Perces as would be a union with a [Native] traditional enemy.
—Deward E. Walker, "Measures of Nez Perce Outbreeding and the Analysis of Cultural Change," *Southwestern Journal of Anthropology* (v. 23, Summer 1967, p. 144)

Fig. 3: Domingo Cisneros (Tepehuane), *Chichimeca Resurrection* from "Zone of Silence Project," 1984, animal bones on site near Durango, Mexico. Cisneros was born in a funeral home near Monterrey, Mexico, studied architecture and cinematography, traveled widely, and in the early '70s went to Canada, where he taught for a while at Manitou College and settled in the little town of La Macaza, Quebec (in part because it means "my house" in Spanish). His work is made primarily from the hides and bones of animals he hunts to live on and from scavenging in the woods. From these materials he creates new, mythical hybrids, a "Laurentian bestiary," for which he has also written humorous accompanying texts. (*The Lazy One*, for instance, looks like a furry turtle with wings but is made of beaver skull, moose and deer bones, goat and sheep skins.) Cisneros rejects the "primitive" "ethnic" connotations usually attached to such work and to Indian art: "The origins of all of us, physical and artistic, lie in nature. I think a bear or a bird is as contemporary and as cross-cultural as an automobile," he says (*New Work by a New Generation*, p. 23). *Chichimeca Resurrection* was an installation of natural materials made in a Mexican desert as part of a vast, ambitious collaborative project he initiated between Canadian and Mexican artists. Cisneros described his site: "A sandy mound, surrounded by mesquite and huizache trees, near the watering hole in the ruins of Mohovano. . . . A cemetery of sand and wind. Skulls and skeletons of cattle dead of hunger, thirst, or disease. . . . Fossilized inferno. Sometimes Funeral of a Chichimeca Shaman or Mesquite Christmas Tree" (*La Zona del Silencio* [Montreal: Les Editions Intervention, 1985], n.p.).

Although an idealized form of *mestizaje* has long been offered as the socialist solution to the inequities and racism operating in Latin America, Marxists on both continents have actually had uneasy relationships to indigenous peoples. On one hand, it was (is) agreed that the "primitive" or "spiritual" relationship of Native peoples to their land—in the modern political context of holistic ecological sensitivity—is what makes them Indian, and that the "Indianness" of idealized indigenous communal economics can be a model for social change

Fig. 4: David Diao, *Seal/Zeal*, 1987, acrylic on canvas, 84″ × 84″. (Photo courtesy Postmasters Gallery, New York.) Diao, born in China, came to the United States at twelve, and since the '60s has participated in the mainstream of New York abstraction. In the early '80s he stopped painting for a while, frustrated with the notion of art for art's sake. The new work appropriates and recontextualizes the language of early modernism (especially Russian Suprematism) and the "abstract" signs of the Cyrillic alphabet as well as Asian ideographs and chops. Diao's concern is to reinstate geometry with meaning by looking at the historical notions of progress and rationality associated with it. This painting was part of an exhibition titled "Let A Hundred Flowers Bloom" (after Mao Zedong's unfulfilled proposal for the Cultural Revolution). Here Diao's red chop, or seal, on a white ground is overlaid with an unused Russian design for a bookcover spelling Constructivism in such elongated black print that it reads as form first and text only secondarily. The superimposition of Russian on Chinese (and the title reference to "zeal") has political as well as esthetic implications in regard to the history of abstraction. Diao returned to China for a family visit in 1980 and since then has found it "easier to refer to things Chinese because for me it's become less identified with my autobiography. . . . Maybe it's not by accident that I chose to be stuck in a geometrical mode of production, since one can see geometry as a keynote of Western culture. Maybe it's about my desire to be the Other. The Other for me is this culture, even having been here all this time" (interview with Michael Jenkins, *Art Papers*, May–June 1988, p. 33).

in the future.[9] On the other hand, it is precisely those qualities that are seen as impeding economic progress and, ultimately, as necessary sacrifices to modernization.

These intertwined positions are challenged by Arif Dirlik, who along with some other Third World–oriented theoreticians (of color, or white), insists that culture is not a thing, but an activity, a relationship, "that expresses contradiction as much as it does cohesion." Dirlik defines "culturism" as "that ideology which reduces everything to questions of culture, but has a reductionist conception of the latter as well," and blames it for a "preoccupation with the cultural gap . . . in the study of thought in Third World societies." Culturism, like historicism, is a reaffirmation, "in the midst of global history, of the separateness of the society we study."[10] The basic truth of Dirlik's analysis seems self-evident, but it poses its own dilemmas. Granted, notions of culture are often ideologically charged, the product of specific social relations. This does not alter the fact that cultures can realize and name themselves, and that traditions do exist, often providing the channel through which change flows. At the same time, memory is a tool with which to make connections, but it

▼▼▼▼▼▼▼

A national culture is not a folklore, nor an abstract populism that believes it can discover the people's true nature. A national culture is the whole body of efforts made by a people in the sphere of thought to describe, justify and praise the action through which the people has created itself and keeps itself in existence. A national culture in under-developed countries should therefore take its place at the very heart of the struggle for freedom which these countries are carrying on.
—Frantz Fanon, *The Wretched of the Earth* (p. 188)

National culture is defined by its content, not by the origin of its elements. Alive, it changes incessantly, it challenges itself, it contradicts itself, and it receives external influences that at times increase it, and that are wont to operate simultaneously as a threat and a stimulus.
—Eduardo Galeano, "The Revolution as Revelation," *Socialist Review* (Sept.–Oct. 1982, p. 14)

▼▼▼▼▼▼▼

When I was in Colombia in the fall of 1987 to jury a national exhibition, I took its organizers (or its artists) to task for omitting virtually any work that reflected Colombian life, even Colombian landscape, not to mention Colombian politics, with its chaos of guerrilla warfare, repressive government and drug crimes. I was in turn taken to task for being a typical gringo and demanding that Latin American art look the

can be swamped in nostalgia. At what point does dependence on the past preclude transition into an independent view of the present and future?[11] And, as Uruguayan writer Eduardo Galeano has asked, "Can a national culture really be achieved in countries where the material foundations of power are not national, or depend on foreign centres?"[12]

Few, if any, nations can claim a "pure" national culture. The assimilated, if still somewhat "dangerous" multiculturalism (or "pluralism") once touted as unique to the United States, is now familiar to European and Asian nations as well. And in Latin America, cultural pluralism has meant that artistic responses to internationalism and modernism or postmodernism are as diverse as the countries themselves. In some changing societies, artists are clinging to the worst of unrooted internationalism, while in others they are forging a new art conscious of all the operating sociocultural factors. Where traditional or indigenous culture is still strong, international styles or approaches can be positive ingredients in an inevitable new blend. Where traditional cultures have been weakened, suppressed, or destroyed, the negative effects of imported modernism (such as denial of social content or scorn for local concerns) often outweigh the positive. When rebellion against the loss of national identity occurs, the challengers sometimes refuse to maintain any aspect of cultural colonialisms, in effect throwing the baby out with the bathwater and returning to vestiges or to an undeveloped and overliteral premodernism. There is a fine line between erasing differences in the name of a homogenous "universal" (usually defined and imposed by a dominant culture) and protesting the "universal" as dismissive of differences (which can promote provincialism).

As the volatile relationship between Latin America and North America evolves, new elements or vantage points are revealed along each freshly visible fault-line. Part of the crippling bias of ethnocentrism in this country comes from the fact that we learn geography mostly from imperialism, discovering other nations when our government chooses to interfere in their sovereignty. We learn from the same sources that "there's no art down there; they're too poor, or too influenced by us, or too isolated. High art just isn't part of their culture." In fact, many Latin American exiles are the products of a sophisticated European-oriented education and find North American art, like North American arrogance, based in an extraordinary ignorance of history and politics. The ambivalence of many Latin Americans living in the United States is rooted in anger about the ways they are treated as second-class citizens, as beggars outside the mainstream.

Some of our national imperviousness can be blamed on the manic pace at which we absorb culture; on the inadequate, biased information we receive from the trade media; and on the invisible processes of hegemony itself, which blinds us to the unfamiliar by conflating all "otherness." On the other hand, from the viewpoint of a cultural democrat, I worry about Latino artists leaning too far over the brim of the melting pot, falling in, and depriving us of their unique voices. But who am I, after all, to imply that any artist who wants to

shouldn't have a chance at "making it" in the mainstream? Doesn't the dominant culture already impose just such limitations? Is my wish to maintain a diverse practice just another sort of matronizing ethnocentrism?

Susana Torruella Leval rejects the notion—popular in the United States—that Latin American artists are only preoccupied with "the search for individual identity" and offers a more complex explanation. They are, she says, searching not for an identity "but rather for the means of analyzing a powerfully felt sense of historical identity that has long fascinated Latin Americans in general and artists in particular."[13]

Many artists arriving in the United States from Third World countries bring with them a concept of internationalism that does not fit the ethnocentric view of the U.S. artworld. Leval says that the Latin American sense of reality is revealed through "a natural affinity to fantasy," dreams, mystical experiences, at the same time that it is "profoundly tied to the idea that art has social as well as esthetic meaning. . . . It is always relative, comfortable with contradictions and surprises, a dialogue of many levels, real and imagined." Its deeply held and unabashed humanism, grounded in figuration—Cubist or Surrealist—has been devalued in the United States, where it is considered "romantic, idealistic, and sentimental."[14]

The notion that those on "the margins" or in the Third World have something to teach us is not easy for Eurocentrically oriented art scholars to swallow. The Cuban art critic Gerardo Mosquera points out that for Third World nations and artists being drawn into modernization/Westernization, "it is not a matter of resuscitating precapitalist solutions. . . . It is a matter of making western culture on our own terms and at our own convenience . . . of bringing the ancestral to the modern, rather than the reverse." He rec-

way I thought it should—"primitive," or fantastic, à la García Márquez. In a lively discussion with an artists' group I argued that Colombia was not like the United States, that it would be unnatural and inconsiderate to expect the art to be the same. I wasn't asking for any particular Colombian style, but I was asking for a certain kind of content. I was told that until quite recently Colombian art had been uniformly "political," that the "Mexican influence" had been so strong, it had to be resisted in its turn. I still wondered where the Colombian art was; one of the few works in the salon that seemed different and noninternationalist turned out to be by a North American woman who had lived in Colombia for fourteen years.

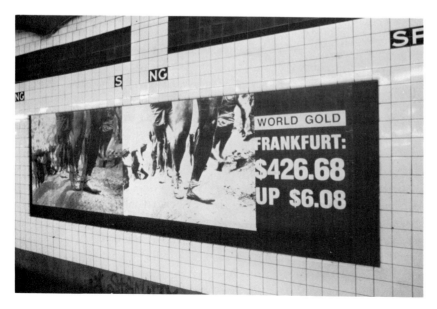

Fig. 5: Alfredo Jaar, *Rushes*, 1986, photographic posters filling the entire advertising space of the Spring Street subway station, New York. Jaar, who was raised in Chile and Martinique, is best known for his photographic light-box installations and his interest in site-specific political art that often focuses on the technological and ideological gaps between powers, and between the powerful and the powerless, especially in regard to the Third World. His eighty photos of Brazilian Indians mining for gold in a backbreaking, dehumanizing primitive process, juxtaposed with gold prices on the world market, brought to the subway-riding New Yorker a Third World reality. The title is a pun on the rush hour and the gold rush. Jaar's photographs uncomfortably closed the gap between those who produce and those who control the production—not only the corporations, but we who consume the products.

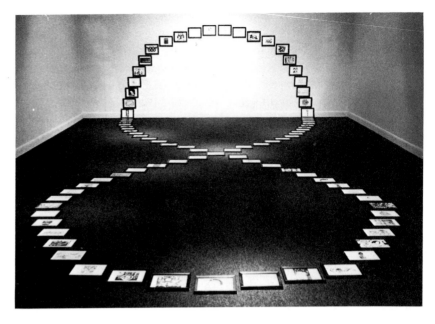

Fig. 6: Regina Vater, *Snake Nest*, 1988, installation at Laguna Gloria Museum, Austin, Texas. Vater, a Brazilian multimedia artist who has lived in the United States for many years, settling in Austin, continues to work with mythological themes related to indigenous and Yoruba Brazil, especially in regard to notions of time. She did a series of works on Yauti, the cosmological turtle of the Amazon, but chose snakes for Texas, which boasts a great variety of them. The snake is also a global symbol of spring and rebirth because it renews its skin. Here the infinity form (also an 8, and '88 was "the year of the dragon which is also a snake") was formed by 88 mythological symbols from different cultures utilizing images of snakes as images of time, fertility, and wisdom. A poster on the wall invited spectators to make their own snakes on the long strips of paper provided and during a May 1 spring celebration they were all placed within the "nest."

ommends "activating the Third World's values" so that Africans, Asians, and Latin Americans "make occidental culture, just as the 'barbarians' made Christianity."[15] Mosquera's suggestion that the Third World become an international catalyst is not just the pipe dream of an intellectual from a tiny island that has miraculously assumed geopolitical power. He is not implying that the features of hitherto "peripheral" cultures will disappear into some new Third World center, but that they will reappear, looking different in relation to other disregarded parts of the whole.

The resemblance between contemporary graffiti and ancient petroglyphs suggests a metaphor of continuing sign language, of communication across the centuries, across cultural borders, and inside the enemy lines. Some of the most visible Latino art in the urban centers today is anonymous to outsiders, but it has received more attention than much officially attributable art. Graffiti is an act of communal creative will in which the whole is vivid beyond the sum of its parts. It ranges from the "master" works on the outsides of entire subway cars—big, bold, and brilliant, executed at risk, momentarily sparking dismal stations into life as the cars flash by—to the ugly, dark, but exuberantly stylized signatures or "tags" that mar the cars' interiors and virtually all urban surfaces, defiantly recalling the uncalled for. Writing on the walls of the nation's land-and-over-lords gives voice to the pain and to the small victories in class warfare—hitting a wall with a spray can is called "bombing."

Graffiti was a twice-temporary phenomenon, "discovered" in the early '70s, almost forgotten as art, and almost immediately rediscovered at the end of the

decade, this time to survive most of the '80s. According to graffiti-supporter and promoter Hugo Martinez, there had been spray-paint and marker writing since the late '50s, but the new graffiti was marked by "its sense of purpose, the particular importance it placed on 'getting around.' " Surfaces were "property," and the goal was to "own" the city. Worried that the graffiti movement's "vast potential as a means of communication and alternative to alienation" would go the way of all fads, in October 1972 Martinez brought a group of graffiti masters to the art department at City College. This was the beginning, for better or worse, of the "gallerization" of graffiti art, as well as an attempt to encourage collaborative graffiti pieces.

A 1975 exhibition of the "United Graffiti Artists" at Artists Space in New York documented the history of the group founded in 1972 by Martinez to get the graffiti writers off the streets and into the galleries. When he was at City College in 1972, Martinez met a student whose father was a night watchman at the subway yards, who told him the graffitists were mostly Puerto Ricans in their early teens sneaking in at night. Martinez approached a Washington Heights gang called the Young Galaxies and was shown various "landmarks," including "Writers Corner 188" at 188th Street and Audubon Avenue, home base for one of the many graffiti cliques in the city, among them Brooklyn's Ex-Vandals (Ex for Experienced). There were already an evolved history, complex moral codes, and widely varying styles in different neighborhoods in Manhattan, the Bronx, and Brooklyn: "Everyone knew that Topcat 126 brought Platform Lettering to New York from Philadelphia." Martinez also found that the "masters" were consistently "working-class offspring from working-class neighborhoods," while the hard-core poor neighborhoods— "where neither parent works—did not create ambitious graffiti."[16]

In the '70s, although press coverage was abundant and work was sold, the white artworld for the most part reacted with condescension and a certain disdain to "studio graffiti": this stuff belonged in the street; it "lost something" when it came indoors, and was unable to compete with "high art" on its own turf. Little was heard of the Martinez group after their initial splash. There was some discussion of whether graffiti on canvas was "popular" or "folk" art. In a sympathetic essay in the Artists Space catalog, Peter Schjeldahl acknowledged the prevailing ironies:

> The gratuitous egoism of graffiti art, quite aside from its appeal to the eye, gives it a certain purity that no popular art can claim. The forms developed by the best graffiti artists urge us gradually away from a consciousness of their common sources, toward contemplating the mysteries of personality. As for the cultural significance of graffiti art, consider this paradox: in a time of reflex "anti-elitism" we are here presented with a thoroughly elitist and egocentric new form of expression from a decidedly unlikely source. . . . This elitism of the streets is almost Darwinian, being grounded in a survival code of personal courage, self-sufficiency and style.[17]

Graffiti images pay backhanded homage to a plastic populism, to the TV cartoons, comic books, and ads that are teenage graffitists' "art history." Many of the artists unconsciously parallel the reclamation of such imagery by Pop artists in the early '60s, although the difference not only in time but also in class background and even age makes the older work look staid and institutional compared with that of the teenagers, which looks fresh and raw. ("Fresh!" was once the highest term of praise among B-Boys.) These qualities were first reappreciated and reappropriated in 1978–79 by the young white neo-punks, a second "generation" of punk-rock and punk-art aficionados, although the two groups had little else in common, particularly since some of the more extreme punks played with a neo-Nazi racism.

Not so long ago, only white artists dipped into other cultures to make them their own. Now, following the lead of graffiti, a whole new hybrid is being developed by young culture-crossers who work from both sides, combining barrio life and culture, ubiquitous mass culture icons, and memories—direct and indirect—of *America Latina* with its African ingredients. This time the "discovery" was initiated by young white "New Wave" artists who were helping invent the new downtown club scene and revivify the cultural life of the Lower East Side. Disillusioned with the commercialism and elitism of the artworld, they began to make rebellious alliances across classes and cultures, often through graffiti and murals and a new marvelously sleazy public art exemplified by the anarchic artists' collective CoLab (Collaborative Projects). The creative inner-city "hip-hop" scene gave form to the resilient urban spirit of the early '80s with rap music, break dancing, and the innovative "wild style" graffiti. These exuberant oases of art-as-resistance were forming as Reaganism began

Fig. 7: Lady Pink/Jenny Holzer, *Tear Ducts*, 1983, acrylic on canvas, 92½″ × 156¼″. (Photo courtesy Barbara Gladstone Gallery, New York.) This collaboration was one of stylistic opposites. Lady Pink (Sandra Fabara) was the only woman well known for participating in the hard-core subway graffiti. Like her male colleagues, she turned to canvas when she was in her twenties and painted lush flowers, women's faces, bar scenes. She wrote at the time: "My paintings are usually about the dying culture of the underground teenage art movement. They are executed in their original medium: spray paint on canvas. It can no longer be called graffiti but art, and is accepted as such." Holzer, on the other hand, is known for her spare, disturbing, purely textual/material works (first made as printed posters and plaques and then in LED computer signs and carved granite), which reflect contemporary life with a threatening edge of dark humor. Holzer's text here reads "Tear Ducts Seem to Be a Grief Provision." The superimposition of this deadpan text on Pink's lugubrious sea of skulls is an exemplary cultural cross, or cultural clash.

to undermine support for the poor, and high-art institutions became enmired in retrograde neoclassicism, postexpressionism, and other warmed-over modernist relics.

In 1978 Austrian emigré Stefan Eins founded Fashion Moda in a devastated South Bronx storefront—not as an "alternative space," he insisted, but as "an international cultural concept." There the local graffiti artists began to hang out and transform the notion of street art indoors. In the next two years Group Material and ABC No Rio opened storefronts on the Lower East Side, CUD (Contemporary Urbicultural Documentation) began its public projects of recent urban archeology, and the political artists' group PADD (Political Art Documentation/Distribution) was formed; all of these groups welcomed and solicited multicultural participation.[18] CoLab became the best known by organizing "parasite" shows in non-art spaces all over town, most notorious of which was "The Times Square Show" in a former massage parlor. Young street artists and so-called urban folk artists were always included in these shows, and alliances among so many, and such various young artists made the difference between the graffiti fad in the '70s and '80s.

As the white artists began to attract grant support, collectors, and galleries, so did some of the graffiti artists. The media paid attention, somewhat condescendingly at first, then with increased respect for the broad, and soon commercialized, popularity of hip-hop. Articles, even books, were written about the movement; films were shot.[19] Often, no distinction was made between the trained and untrained work, the graffiti artists who were attending art school and those who had taught themselves the rudiments of "making it." Critic Jeffrey Deitch, who coined the short-lived upscaling term "Calligraffiti," recalls meeting Fab Five Freddie poring over art books, studying the sociology as well as the esthetics of the artworld.[20]

When it resurfaced in the commercial galleries in the '80s, graffiti became one of the major influences on "high art" (visible in the work of innumerable "East Village" artists as well as in that of Julian Schnabel and, of course, the former graffiti writer Jean Michel Basquiat)—one more example of cultural vitality surging up from the underclass, dusted off and ironed up for the art galleries, where it came in for more than the usual amount of market manipulation. A social scene was created that accommodated both college graduates and ghetto kids. Since most graffiti art was made by young black and Latino men, their entrance into the wealthy gallery scene was perceived, in a reversal of white "slumming" in the heyday of Harlem, to have a titillating aura of danger and sexual excitement. In some parts of the artworld, however, as in the '70s, the intruders were reminded that their real place was the streets. They were still often seen as "primitives" taken out of their element to play for a while in the "civilized" artworld. The very real danger and extralegality of graffiti made in the subway and the streets (not to mention the drug connections that were as prevalent in the artworld as in the ghetto) were considered "natural" for young artists of color. God forbid they be allowed too comfortable

▼▼▼▼▼▼▼

From 1975 to 1979 when the world seemed so different to me, I felt that my most important painting took place and rolled in its own private subterranean stage [the subway]. Which consisted of one of the world's largest audiences, but who never even noticed its life. It was a time when someone's identity depended on the determination of that someone's search for it. . . . So now with the hopefully slower relaxing pace of painting, I can show the other people the rooted physical look of Silent Thunderism. . . . People who were confronted with my work could take a closer and understanding look at it and respect me as an artist.

—Lee Quinones (statement for Fun Gallery exhibition, New York, 1982)

circumstances within which to work, sell their art, and learn the ways of these new contexts so their work could continue to grow. It was more acceptable for "honkies" to borrow some flash from the "homeboys."

The great parties, trips to Europe, and cross-class flirtations were short-lived. Most of the gifted, powerful artists "discovered" during that brief heyday were ushered out when the party was over. A gap also remained between the graffiti artists and most of the more conventional, Latino and black artists who were already pushing at the artworld's margins. Because few graffiti artists treat racism or any other directly political subject matter, mistrusting the white Left, they tend to be peripheral to the progressive art community as well, even when they are much admired therein. By 1983 the Sidney Janis Gallery was showing "Post-Graffiti" artists at the ripe old ages of eighteen to twenty-three, declaring the intention to document "their transition from subway surfaces to canvas, an extension in scope and concept of their spontaneous imagery."[21]

A few graffiti artists have survived the faddism, but those still exhibiting today are all from the "second wave." Harsher laws and exaggerated punishment for subway graffiti make it impractical for nonminors. As they grow older, graffiti artists are thrown back into the indoor art context, but their art is dismissed in the gallery scene unless its scope continues to grow. Those showing in recent years make art increasingly similar to the earlier Pop Art in a formal sense, although with a harsher edge appropriate to the callous Reagan era and hardly kinder and gentler Bush reign. For instance, Crash (John Matos), in his December 1988 show at the Sidney Janis Gallery, included huge paintings incorporating Roy Lichtenstein's Benday dots, Picabia-via-David Salle mechanical outlining, Rauschenbergian chunks of found walls and other materials, and particularly Jim Rosenquist's luscious transparencies and blown-out-of-scale fragments. These are combined with the virtuoso star-bursts and highlights of subway style and the ubiquitous one-on-one fistfights and "sexy girls." The results reflect a street-bred iconoclasm and a violence that is not derived solely from the mythical South Bronx but also from current artworld styles that have themselves borrowed from graffiti's high-energy recycling of mass culture. Crash's plywood murals have been commissioned around New York by institutions ranging from CitiCorp to the Albert Einstein Medical Center. Crash, twenty-seven at the time of this show, is a veteran of both the street scene and the equally dangerous art scene, which has chewed up and spit out a number of young black and Latino "discoveries."

Musicians have fared better, although in the early '80s artists and musicians seemed to be mixing tracks. The interdisciplinary precedents are many: the Beatles, the Rolling Stones, the Who, and later the Talking Heads were all led by art-school dropouts or graduates. More recently, "World Beat" has rolled around—often featuring white musicians playing Third World music in the venerable tradition sardonically described as "black roots, white fruits." The debate over acceptable degrees of appropriation centered for a while on Paul

Fig. 8: Crash (John Matos), *Arcadia Revisited*, 1988, spray paint on canvas, 96¼″ × 68″. (Photo: Allan Finkelman, courtesy Sidney Janis Gallery, New York.) This complex overlay of various graffiti and Pop Art motifs—brand name lettering, fragmented close-up faces, starry highlights, all rendered with a certain violence and in huge scale—is almost a parody of Crash's sources.

Simon's *Graceland*, recorded partly in South Africa and principally performed by South African musicians who were firmly based in "township jive," or *umbaqanga*. Another example of avant-garde/African musical syncretism is the Talking Heads' 1979 "I Zimbra," on their *Fear of Music* album, which combines a 1916 Dada cabaret chant, or sound poem, by Hugo Ball with the Afro-pop record "17 Mabone." "World Music" offers a break with Western harmonics and introduces a gutsy sound and earthy, indefatigible rhythms within the very African fusion of art, cosmology, and social action. It was therefore attractive

Fig. 9: Sophie Rivera, *Woman and Daughter in Subway*, c. 1982, silver gelatin print, 16" x 20". Rivera is a New York–based photographer, well known in the Americas, who has documented Puerto Rican life in New York for many years. Her work ranges from documentary to abstract to conceptual (a series of daily toilet bowl photos). The subway series was intended to record "the minorities who are unnoticed and underrepresented in our consciousness unless a crime occurs" (letter to the author, 1989). In this poignant image, a mother protects her child with a wary glance at the encroacher as they hurtle precariously beneath the city. The slightly blurred focus augments a sense of emergency, the necessity for constant vigilance that is both maternal and urban.

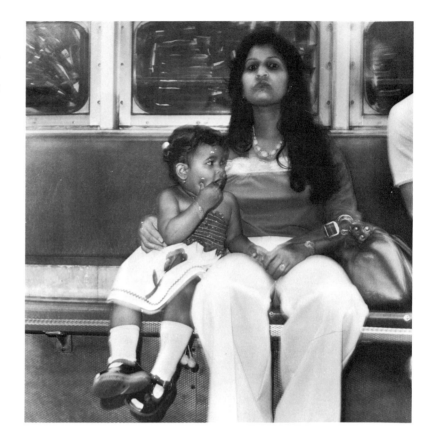

▼▼▼▼▼▼▼

Calypso is an art form that developed in colonial days to make fun of Massa; to plan slave escapes; to bring consolation to the oppressed. Before the coming of newspapers and television, the calypsonian was the town crier . . . the only game in town. It is still bringing messages today, although not in its strict traditional form.
—Mighty Sparrow (Francisco Slinger)
(quoted in *The Guardian*, Oct. 22, 1986)

Rap has also invaded poetry's territory, where it has influenced avant-garde poets and performers of all races with its relentless barrage of rhythm-rhymes. Rap's medium is words, above all. "Hip-hop lives in

to the avant-garde, which is dependent on change and constantly needs plasma from elsewhere.

Cultural mixing in the '80s has been epitomized by graffiti, rap music, and sampling—the digital collage technique of lifting pieces of other music track by track or wholesale. Originated by black DJs, sampling has since been used by white musicians as well, but like rapping, it remains black territory. Rap originated in calypso "toasting" and was spread in the United States in the late '70s by an influential Bronx-Jamaican DJ named Kool Herc. Calypso itself has roots in the African griot tradition of message carrying and political commentary. The polyphony of the Caribbean extends from language to music and images; its mixture of races prods the North American imagination as we witness the acceleration of our own hybridization. The Caribbean influence on graffiti is far less obvious than it is in the paintings and sculptures discussed in chapter 2, but it ranges from the pronounced effect of West Indian syntax on hip-hop music and style (with its roots in West African languages like Mande-kan, which also influenced quiltmakers) to the Yoruba drumming that is the core of salsa music.

There have been politicized (or just plain alienated) graffiti writers too,

including Samo,[22] whose cryptic poetry ("Pay for soup / build a fort / set it on fire") was eventually exposed as a collaboration between Al Diaz and Jean Michel Basquiat, although Basquiat eventually took most of the credit. An African American loner, who never worked with a graffiti crew or wrote on trains, Basquiat (plate 26) rarely used spray paint, Day-Glo, or the graffiti clichés—the ubiquitous smashing fists, screaming mouths, voluptuous women, anguished or fearful faces, comic book characters, lurid color, and incoherent fields of smoky lettering. However, he first exhibited with other white and black graffiti artists; his *Flats Fixed* was in a 1980 show at New York's downtown Mudd Club with works by Crash, Daze, Keith Haring, Kenny Scharf, and others. Basquiat's brilliant, rapid-fire style turned out to be particularly adaptable to the artworld's needs. He was the most successful and also the most tragic figure among the young artists of color who made a great deal of money and were exhausted—or wasted—by fame and fortune. He died of an overdose in 1988 at the age of twenty-seven. Artist Fab Five Freddie (Freddie Braithwaite) said, "Jean Michel lived his life like a fire—really hot and really bright; the fire went out but the coals are still hot."[23]

Born and raised in Brooklyn ("I grew up in an American vacuum"),[24] the son of a Puerto Rican mother and Haitian father, Basquiat was well read and well informed about art history (one of his paintings is punningly called *Leonardo's Greatest Hits*); he studied anatomy on his own. Once he began to exhibit, he became a "celebrity" and even collaborated with Andy Warhol on a rather negligible series of paintings shown in 1985. (A poster for an opening party at the Palladium showed the young black artist being knocked out in a boxing match by the older white artist.) His own work, which has become the classic example of "creolization" and graffiti-inspired vitality, was far more impressive. Basquiat left a huge body of work, one large canvas after another demonstrating not only bravado and virtuosity, but sheer painterly passion, dominated by straight-from-the-gut imagery, symbols of power and inscribed phrases (sometimes deliberately misspelled and crossed out) about race, death, religion, and economic injustice. ("There's a long list of leeches on this planet.") A self-assured expressionist, far less heavy-handed than most of his better-known European or American colleagues, he dealt with the canvas like a wall, not composing so much as covering it with fragments, suggesting the overall fields of some of his New York School predecessors while never neglecting the masks and figures that carried his messages.

Basquiat refused to "exploit [his] ethnic background." When a patronizing interviewer asked him if the teeth and bones in his work related to Caribbean culture, Basquiat looked exaggeratedly incredulous and said, "What's that?" The interviewer suggested he must "know a lot of people—from the graffiti side." Basquiat replied, "And from the academic side too." Undeterred, the interviewer remarked that there is a lot of "crudity to your heads. Would you like them to be more refined?" "I never met that many refined people," said the artist. Asked about "primal passion," he fired back, "Like an ape?"

the world of sound, not the world of music, and that's why it's so revolutionary," says drummer Max Roach. "What we as Black people have always done is show that the world of sound is bigger than white people think." Hip-hop's . . . appropriations pay homage to other musicians by "cut 'n' scratch." Call it a form of ancestor worship. The scratch is incantatory.
—Harry Allen, "Invisible Band," *Village Voice Electromag* (Oct. 1988 supplement, p. 10)

▼▼▼▼▼▼▼

No area of modern intellectual life has been more resistant to recognizing and authorizing people of color than the world of the "serious" visual arts. To this day it remains a bastion of white supremacy. . . . If you're Black and historically informed there's no way you can look at Basquiat's work and not get beat up by his obsession with the Black male body's history as property, pulverized meat, and popular entertainment. . . . Much has been made of Basquiat's ruder street-connections, but his links with hip-hop are high-handed deployment of scratchnoise, sampling, freestyle coloring, and bombing the canvas. . . . Basquiat's paintings read as hieroglyphic ensembles that glow with the touch of his hands and the unmistakable sign language that evolved out of his free-floating psyche.
—Greg Tate, "Nobody Loves a Genius Child," *Village Voice* (Nov. 14, 1989)

The role played by racism in Basquiat's art and life was clear to his friends. The late Keith Haring, artist and former (white) graffitist, said that Basquiat's extravagant lifestyle was his "way of sticking his nose up at people who were looking down on you. Being Black and a kid and having dreadlocks, he couldn't even get a taxi. But he could spend $10,000 in his pocket."[25] His work was described commercially as "primitive" and "frenzied voodoo-like magic"[26] and constantly compared to graffiti "scrawls," although had he been a white artist it would have been assumed that these electric stick figures and poetic commentaries were sedately *borrowed* from African American sources. (Basquiat's former dealer Annina Nosei has said that there "should be a morphological study of his work," in which his agglomeration of sophisticated information "is decoded.")[27] Robert Hughes called him the artworld's answer to Eddie Murphy.[28] Peter Schjeldahl defined his achievement as "not one of innovation, but one of revival," and later (having characterized "most work by non-whites in the New York mainstream of styles" as " 'wannabe': a diffident emulation of established modes") expressed surprise that a black artist could achieve such a "grasp of New York big-painting esthetics."[29]

In the early '80s, collaboration itself became a political statement, an effective way of attacking the conventional notion of rugged individual genius and of breaking down barriers between "downtown" and "uptown" artists. John Ahearn began working at Fashion Moda as soon as it opened, making his distinctive painted plaster casts of local residents, which became a hit in the neighborhood. Influenced by the Latino religious plasters he saw in the Bronx, Ahearn trained Rigoberto Torres, then a teenager, who worked nearby at a devotional sculpture factory, to make life casts. The two became partners and continue to show together occasionally, although Ahearn's name is usually featured—in part due to others' ethnocentrism, which he has been unable to change, and in part because his painted casts were well known before he worked with Torres. They have since made several public sculptures in the South Bronx. Another such collaboration, although it was only undertaken for one series of paintings in 1983, was between well-known downtown artist Jenny Holzer and Colombian-born Lady Pink (Sandra Fabara), the only well-known and respected woman underground graffitist. The combination of Holzer's dry, acerbic texts with Pink's lush, conscious Latinisms was particularly startling. Among other past collaborations were those between Don Leicht and John Fekner and Keith Haring and LA 2.

In 1986 Fashion Moda devoted an entire show to collaborations between white downtown artists and uptown graffiti artists. The announcement, perhaps inadvertently, pointed up some ironies (and injustices) of the situation in the 10 x 20-foot canvas it reproduced: hands on a piano keyboard "Crash" out a pictorial melody of easily distinguishable white artists' styles (Mark Kostabi, Rick Prol, Ronnie Cutrone, James Poppitz); in the lower corners are the inscriptions, "Where's Daze?" "Who is Daze?"

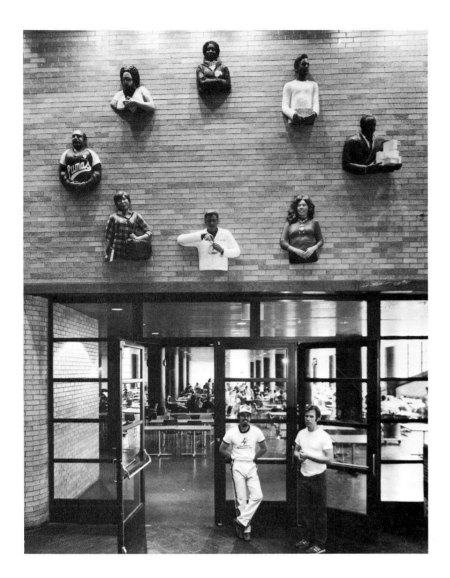

Fig. 10: John Ahearn and **Rigoberto Torres**, *The CCNY Series*, 1985, painted plaster, life-size. (Photo: Ivan Dalla Tana, courtesy Brooke Alexander, Inc.) Ahearn and Torres met in the late '70s when Ahearn was working out of Fashion Moda in the South Bronx, making brilliantly colored plaster life casts of neighborhood people. Torres, working nearby at a religious statuettes factory, became Ahearn's apprentice and then his partner. For the last decade the two have maintained a studio in the South Bronx. The subjects of their cast and painted individuals, couples, and groups—some just heads or busts, others full-length—have been kids playing, parents, lovers, workers, animals, and storekeepers, even Jesse Jackson. While their works are often shown in galleries and museums, as well as in public contexts, the two often give the casts to the people who posed for them. Their three-dimensional murals are on walls of buildings and playgrounds in the South Bronx. Here they are shown below a circle of eight collaboratively executed portrait busts at the City College of New York. All the casting work was done inside the cafeteria on lunch tables, during eating hours, for full public participation.

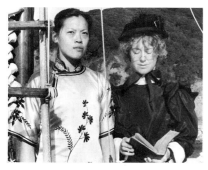

Fig. 11: Suzanne Lacy and **Kathleen Chang**,
The Life and Times of Donaldina Cameron,
October 29, 1977, performance on Angel Is-
land, San Francisco Bay. (Photo: Robert Bla-
lack.) For more than a decade Lacy, who is
white, has made works in collaboration with
women of other races, ages, and classes, as
a way of "experiencing other lives and un-
derstanding my own identification with
them." Her unique fusion of feminist organiz-
ing, oral history, social gatherings, and per-
formance art have resulted in such diverse
works as *Evelina and I: Crime, Quilts, and
Art* (with Evelina Newman, a black quilter
living in Watts), *Dark Madonna* (a living
"sculpture park" and ritual/discussion on
race and racism), and "The Whisper Project"
(two performances in La Jolla, California, and
Minneapolis with elderly women of all cul-
tures). This piece, created with actress Kath-
leen Chang, emerged from an interest in
"making public in an esthetic form the poli-
tics of oppression which created the Immi-
gration Station at Angel Island," where Asian
immigrants were held on arrival. Dressed in
nineteenth-century costume, the two women
sailed out to Angel Island on an old boat,
landed to meet their audience, and proceeded
to act out the relationship between the
Chinese revolutionary immigrant Leung Ken-
sun (a composite figure created by Chang to
represent the Chinese female community) and
missionary Donaldina Cameron (known either
as "the White Devil" or "the Mother" by San
Francisco Chinatown residents). The piece
ended with a public discussion between Lacy
and Chang about the collaboration process,
which had not been easy.

The most interesting and enduring collaboration that emerged from the late '70s cross-cultural alliances was between Tim Rollins and KOS (Kids of Survival) (plate 27). Rollins is a white artist from a small working-class town in Maine who, in the '70s, studied at the School of Visual Arts, where he was drawn to Conceptual Art, but found it lacking in social contact and context. As a founding member of the young progressive artists' collective Group Material, Rollins helped organize a landmark show called "Arroz con Mangos" in 1980 at the group's storefront gallery on East 13th Street in Manhattan. The exhibits were solicited from every dwelling on the block; residents were asked for the favorite "artwork" in their home, and the results were a lively collection of objects ranging from record covers to family pho- tographs to oil paintings to children's schoolwork to trophies. This populist mixture set the tone for Group Material's evolving notions of exhibitions as composite artworks in themselves, innocently combining so-called high and low arts, well-known and unknown, trained and untrained artists, "originals" and mass-reproduced images.

In 1980 Rollins began teaching in "Learning to Read Through the Arts" programs in the South Bronx, Brooklyn, and Harlem. In 1982 he became an artist-teacher at I.S. 52 in the South Bronx, where he founded KOS and, later, the Art and Knowledge Workshop, a special program for learning- disabled, emotionally handicapped teens with art talent. (The group is now raising money for the Bronx Academy of Fine Art, an ambitious "free private school" based on an arts curriculum.) Rollins developed a method of making collaborative artworks that linked the lives and environments of the students with readings from the daily newspapers to T. S. Eliot's *The Wasteland*, from comics to *Frankenstein*, *The Autobiography of Malcolm X*, *Alice in Wonderland*, *Moby Dick*, and so forth. The students became as au courant as any New Yorker about the latest art. Soon they too were showing in downtown galleries, in national, then international exhibitions. Today a large painting by KOS— typically executed on a surface made of all the pages of the book that inspired it—sells for five figures. They have been on the cover of *Artforum*, exhibited in the Museum of Modern Art, and represented in the Venice Biennale and Documenta.

KOS is not tied to any one style, and some of their work is abstract; one of their favorite painters is the "Black Monk" Ad Reinhardt, whose mono- chrome paintings are considered conceptually "difficult" in the highest ivory towers. They joke about Rimbaud and Rambo. They copy and take off from Grünewald's crucifixion and Marvel Comics. They paint about AIDS, which has claimed friends and family, on the pages of Daniel Defoe's *A Journal of the Plague Year*. They paint about women's liberation, in the apparently abstract monochrome canvases called *Red Alice*, *Black Alice*, a series begun when twelve- year-old Annette Rosado began to identify with and obsess about a Lewis Carroll drawing of an Alice grown too big for her confining space, scrunched uncomfortably into a boxlike room:

The Red Alice means to me both anger and blood. This is funny, because red is also the color of love—like valentines. The Red Alice is a young girl who is so angry and in pain that she has had it and might jump out of the painting and fight back. The Red Alice is angry because of all the girls who are raped and hurt and killed because they are girls.[30]

While Rollins is cannily aware that KOS's focus on European literature is simultaneously a "postmodern strategy" that confounds outsiders' limited expectations of inner-city children and a subversive means of "redoing European high culture and making it our own," he has been attacked by the black art community for exploiting his colleagues and imposing white culture on them. Michele Wallace has pointed out that the element left out of this triumphant crossover is some *internal knowledge*, such as the novels of Toni Morrison.[31] Kellie Jones has complained justifiably that the names of the fifty children who have passed through the program (or even those currently in it) are not featured with Rollins's name, are in fact barely mentioned in the vast literature about KOS's work. "We never know anything about KOS except that they're from the South Bronx," she writes, going on to say that "while the artist's work with KOS may smack of careerism in some respects, his dedication to reaching kids shut out by the educational system (and eventually by society) is not something to be taken lightly."[32]

The Kids of Survival have empowered themselves even though society had already decided to leave them out—as poor people, as young people, as black and Latino people, as artists. They are learning to understand history through empathy, by making their marks on it, painting the wounds in *Red Badge of Courage*, for instance, to represent "the bad stuff that has happened in our lives—like scars on our memory," says Richie Cruz. They would not have painted their sixth in a series of paintings based on Kafka's *Amerika* the same way if the widely publicized racial assault at Howard Beach hadn't happened. They rename and represent themselves to reverse the media image of their home as "Fort Apache." "I guess our art is one of the only ways we can show our point of view, about how we see the world. We don't own a TV station, but we can get a painting together," says Richie Cruz. "We have a chance to make a statement, and for people our age, this is a big chance," explains George Garces. "We paint about what is, but we also paint about what should be. Some day we'll be an inspiration for somebody in the future, somebody who'll look back at us because we'll be a part of history ourselves, and maybe we'll be the inspiration for that person to keep on."[33]

The unmarked borders between cultures in the inner cities are a microcosm of the marked *fronteras* between the United States and Mexico, where the border culture that has flourished for years has recently been noticed outside the Southwest. As Alan Weisman writes:

The border is not a line, but a full circle. Centuries ago, with the encouragement of Rome, Spain expelled the Moors who had already changed its life and language. Together, Rome and the southern European nations of Iberia forged a religious imperialism that contradicted the growing reformation in northern Europe. The descendants of these two adversaries confront each other today along another frontier. Enriched by the hues of native Americans, resilient Africans, and venturesome Asians, they meet at a border established by two countries, the United States and Mexico, and pull the world along behind them.[34]

Judy Baca, muralist, activist, spokesperson for the Chicano community, and professor at the University of California at Irvine, is best known as the director and instigator of *The Great Wall of Los Angeles*, which covers half a mile of flood channel in the San Fernando Valley and may well be the longest mural in the world (plate 28). Its subject is the history of *Califas* (California) from the viewpoint of those usually written out of the histories. Baca recalls that at the beginning of the Chicano *movimiento*, artists were searching for a language that would express their own experience. They looked to Los Tres Grandes—the Mexican muralists Diego Rivera, José Clemente Orozco, and especially David Alfaro Siqueiros; to the all-important family structures of their communities; to the *rasquache* (underdog) worldview; to *corridos*, the popular arts, *milagros*, *monitos*, home altars, low-riders, and decorated cars, and they began to see them all as subjects for art, as works of art in themselves. Baca explains:

> For me the process of making art is the transforming of pain. First there's rage, below that rage is indignation, below that indignation is shame, below that hope, and at its corniest base, love. After I got through all of that I could love myself, my art, my people, who I really was. That's how the Great Wall got done. The art process takes pain to its furthest transformation.[35]

Baca was involved in the *movimiento* and teaching in a city art program when she began to spend time in the Los Angeles city parks, hanging out with teenagers and learning about their visual subcultures—tattooing and graffiti:

> Kids with tattooed tears on their cheeks! What does that say about how the kids feel about themselves? . . . Visual symbols, calligraphy basically, were a focal point in their life on the street. You could read a wall and learn everything you needed to know about that community . . . all in what they call *placayasos*. . . . In the sixties, it was more political slogans; now, it's about territory. It has to do with people saying "Listen, I own nothing here. So I own your wall. Here's who I am."[36]

These experiences led Baca first to form a mural team, then the Citywide Mural Project, which completed 250 murals, about 150 of which she directed in person. And the rest is history, or rewriting history. Baca has been called

▼▼▼▼▼▼▼

Our people are internal exiles. To affirm that as a valid experience, when all other things are working against it, is a political act. That's the time we stop being Mexican-Americans and start being Chicanos. . . . If you deny the presence of another people and their culture and you deny them their traditions, you are basically committing cultural genocide.
—Judy Baca, in *Cultures in Contention*, edited by Douglas Kahn and Diane Neumaier (p. 63)

a "cultural diviner" for the cross-cultural educational work she has done in the process of executing the Great Wall. For its site she chose not the graffiti-rich barrios of "East Los," but the San Fernando Valley, a suburban area settled by white flight from those expanding barrios. The muralists were young people from various ethnic communities in LA, some of whom were recruited through the juvenile justice system and given the choice between reform school and mural painting. Subcultures have been described as "being different in packs," and Baca is an expert at navigating the labyrinthine channels through the various cultures and subcultures of southern California, guaranteeing her muralists safe passage through the turf of rival gangs, working with their various communities, and enlisting the aid of the city government and the Army Corps of Engineers. The Great Wall was created through an extraordinary educational process in which Baca brought in ethnic historians to teach and correct as images were being created. One of her strategies has been "overlapping legends"—the similar images and traditions discovered in different communities during the process of research. She devised games with the kids to expose the stereotypes they had of each other. She developed a protective surface for her murals (ironically against graffiti), which she arranged to have manufactured by a cottage industry in the neighborhood so no one else would profit from it.

Baca's works are as much organizing structures as mural paintings. She tries to integrate her art into the social as well as the physical space of a community: "That's changing everything and not just the facade. . . . The thing about muralism," she says, "is that collaboration is a requirement. . . . The [Great Wall's] focus is cooperation in the process underlying its creation."[37]

Baca is now planning a *World Wall*, inspired by the peace initiatives of Hopi elders. It is a portable mural that offers the kind of balance of representation for the world that the Great Wall offers for California. Sections will be produced in various countries, and she recently traveled to the Soviet Union to recruit a collaborator there. In addition, she is working in Guadalupe, a farmworkers' community in central California that is virtually a labor camp for agribusiness. Its people are Portuguese, Chinese, Japanese, and Basque, as well as Chicano. She spends a lot of time in the fields, gathering firsthand testimonies from which to design a historical colonnade in a public park. Baca has also worked with homeless and street people, making a mural on Skid Row in Los Angeles that maps local social services, laying out the lifelines. A recent collaborative billboard warns the community: "Be Skeptical of the Spectacle. Respect Your Own Perspective." Baca does not, however, advocate separatism so much as strength in a home base from which to move outward. She has devoted herself to "the reinvention of the American experience through the immigrant eyes of the Pacific Rim—not a dual culture between Anglo and Other, but the struggles and connections between the groups themselves so artists will have the whole global palette to work with."[38]

The oral narrative tradition and the cooperative structures that are embedded in Latino culture surface continually in contemporary art, especially in

Fig. 12: John Valadez, *Getting Them Out of the Car*, 1984, pastel on paper, 38″ × 100″. Valadez's work stands out from conventional figurative art not only because of his striking color and compositions, but also because he works from real, active, daily life, if often from the darker side. "I paint something that's not attractive, very attractively," he says. "I'm interested in how people blend in or clash with the urban landscape, . . . in depicting social issues such as ethnicity, classism. . . . I came from drawing dead Mexicans because I figured that's how people wanted to see us, either ejected or dead." Valadez has made many murals within the Chicano community and he monitors L.A. street life, working from his own photos and those in the news: "In downtown L.A., death is environmental and economic" (quotations from *Artweek*, November 9, 1989, p. 24). Sexual and racial tensions are often his subjects, as in this impressive work on the self-destructive aspects of Latino culture, with its equation of the dead *vato* and the crucifixion, the night and day juxtaposition of dying humans and slaughtered fish on the beach.

the large number of Latino popular theater troupes around the country that were inspired by Luis Valdez and his Teatro Campesino. These troupes in turn inspired the many *colectivas* that emerged from the Chicano movement on the model of Mexican organizations and thrived on the "family" process engrained in Chicano culture. Other now legendary art *grupos* begun in the late '60s and early '70s were the Royal Chicano Airforce in Sacramento; Self-Help Graphics, the East Los Streetscapers, and Los Four (Beto de la Rocha, Gilbert Lujan, Frank Romero, and Carlos Almaraz) in Los Angeles; the Mexican American Liberation Art Front in San Diego; and the Galeria de la Raza in San Francisco. "We see art as a vehicle for making society, for creating the future, for activating people," says San Diegan David Avalos, a co-founder of the Border Art Workshop who has often worked collaboratively in and outside the Chicano community. He called his 1989 New York exhibition "Cafe Mestizo." Its logo is two pots simultaneously pouring black coffee and white milk into a steaming cup of *café con leche*, its slogan is "a grind so fine . . . you give in to the pleasure," and its management "refuses to serve the half-baked notion that combining two races produces something less than a whole."[39]

In the late '60s the Chicano Movement was fueled by *indigenismo*—local awareness and reclamation of ancient Indian culture, especially the Mayan, Aztec, and Toltec civilizations. In 1969, at a huge national Chicano Youth Conference organized by the Crusade for Justice in Denver, the poet Alurista, the playwright Luis Valdez, and others resurrected the concept of Aztlán— the ancient Nahuatl word for the mythical home of the gods, the land that is now northern Mexico and southwestern United States. They wrote a position paper, "El Plan Espiritual de Aztlán," which called for the active participation of Chicano artists in the movement, which had its roots in the farmworkers' strikes organized by Cesar Chavez in the mid-'60s.[40] A year later, the second

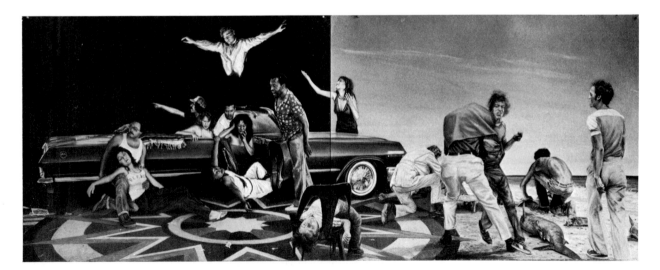

conference, attended by more than three thousand people, focused on how to implement *El Plan*. The artists attending made a commitment to accessibility and to the resurrection of the ancient culture: "Raza art must reflect our heart and our ancient heart has its own symbols, which are rich, colorful, and inexhaustible, therefore sufficient."[41]

In 1972, continuing this concerted effort to reclaim the indigenous heritage and to make common cause with the North American Native communities, the San Diego group Los Toltecas en Aztlán joined other Chicanos in attending Native American gatherings, committing themselves to treaty rights and national sovereignty by supporting the Alcatraz occupation and going on caravans to Indian reservations. Made easier by some common bloodlines and harder by the history of Mexican invasion and enslavement of Native peoples, these coalitions eventually diffused. Yet Chicanos and Native Americans remain the two peoples who are the most closely interwoven in the United States. Today, much of the *indigenismo* that characterized the early days of the Chicano movement has been absorbed into less specific historical references, but efforts are being renewed to unite in struggles for land, water rights, and cultural self-determination. The indigenous concept of simultaneous duality and unity, of internal and external worlds, remains extremely attractive to Latino artists working out a viable synthesis of politics and spirituality.

In San Diego, which lies only fifteen miles north of the border, the cultural intersection of many of these ideas and politics was Chicano Park, arising, like so many major populist monuments, from resistance to social disaster. In the mid-1960s, despite long-standing requests for a park in the Logan Heights barrio, an eight-lane interstate highway was shoved through its center, displacing some five thousand families who were lifelong residents and bisecting the community. In 1970 the land around a "jungle of pillars" beneath the Coronado Bridge was occupied by students and activists and claimed as Chicano Park, replacing the Highway Patrol parking lot that had been planned for the site. Women and children made human chains around the bulldozers and stopped construction, took over the bulldozers for their own use, and began to plant nopals, magueys, and flowers. After an agreement was finally made with the state, muralists began to paint the massive columns beneath the bridge, and a city building acquired by the local artists became the Centro Cultural de la Raza, still a major rallying point for the Chicano community today and increasingly a seedbed for some of the most inventive Latino art in the country (plate 29).

Rupert Garcia (plate 30), born and raised in northern California, works from a fusion of modernism, politics, and Latin folk culture that is a Chicano counterpart to the work of Juan Sánchez. Raised by his mother and grandmother, in Stockton, California, in high school Garcia ran with a crowd that was representative of "The Third World and poor whites—a group of Orientals, Negroes, Okies, and Mexicans."[42] His influences were the movie magazines his mother collected and the Hollywood dreams themselves, as well as the

▼▼▼▼▼▼▼

My parents are from Mexico. But I have Native American blood. To me there are sacred mountains, spiritual values. I do a lot of meditating in the land and stuff like that. My grandmother on my mother's side is an Indian from Canones Pueblo. My great-great-grandmother was a Spaniard woman. She had blue eyes. And my great-grandfather was a little Indian man. I have pictures of them. We're a mixture.
—Moises Morales, New Mexican land rights activist (interviewed by the author, June 1988)

A "border consciousness" necessarily implies the knowledge of two sets of reference codes operating simultaneously. The challenge is to fully assume this biculturality, develop it and promote it. . . . The "artistic border" is artificial. It shouldn't be there, and it is up to us to erase it.
—Guillermo Gómez-Peña, in *Made in Aztlán*, edited by Philip Brookman and Gómez-Peña (p. 93)

▼▼▼▼▼▼▼

No Human Being Is Illegal. / Who's the Alien, Pilgrim? / Buenas Dias. Chinga el Inglés Oficial.
—Recent slogans from the Chicano movement

▼▼▼▼▼▼▼

When I write it feels like I'm carving bone. It feels like I'm creating my own face, my own heart—a Nahuatl concept. . . . It is this learning to live with *la Coatlicue* that transforms living in the Borderlands from a nightmare into a numinous experience. It is always a path/state to something else.
—Gloria Anzaldúa, *Borderlands/La Frontera* (p. 73)

Fig. 13: David Avalos, *Wilderness*, 1989, version of installation piece, INTAR, original dimensions 1' × 8'. Avalos's "Café Mestizo" exhibition at INTAR, in New York, examined and commented on the historical and contemporary notions of wilderness and frontier, as seen from the Mexican American viewpoint. Among other cultural signposts, he focused on James Fenimore Cooper's novel *The Last of the Mohicans* as a key to the national mythology, as well as to hemispheric interventionism. Making the point that the wilderness was as much people as place, and to underscore his own indigenous heritage, Avalos has superimposed the letters of the word across a series of portraits of Native Americans. Included are dictionary definitions of *wilderness*, the first being "a tract or region uncultivated and uninhabited by human beings."

tissue paper figures made by one grandmother and the *folklorico* costumes made by the other. Although he was financially unable to go to Mexico until 1973, when he studied the murals at Teotihuacán, Garcia was raised to identify himself as a Mexicano living in the United States. After working as a dishwasher, a factory worker, and a soldier in Indochina during the Vietnam War, he returned to college under the GI Bill and became a militant in the Chicano movement, making striking posters influenced by Pop Art (particularly the fragmented, layered disjunctions of Jim Rosenquist) and by hard-edge abstraction. These protested in particular the disproportionate numbers of people of color who served and were killed in Vietnam. He and Frank Romero both made powerful works about the police killing of Chicano journalist Rubén Salazar after he had covered the first major Chicano march against the war. The same year—1970—Garcia wrote in his unpublished Master's thesis:

> **My art is committed to the paradox that in using mass-media I am using a source which I despise and with which I am at war . . . an art form whose motives are debased, exploitative, and indifferent to human welfare, and setting it into a totally new moral context. I am, so to speak, reversing the process by which mass-media betray the masses, and betraying the images of mass-media to moral purposes for which they were not designed; the art of social protest.**[43]

Despite his devotion to the work of Manet and other European masters, Garcia sees the world through the lens of his Chicanismo, and his overtly political images often transcend their immediate subject matter, belying the notion that social commitment, cultural tradition, and sophisticated art are incompatible. Having freelanced as a journalist and illustrator for bilingual Latino publications, he has brought to his painting the photojournalistic techniques of cropping and a cinematographic closeup. Unexpected viewing angles often interrupt his monumentally serene paintings with a sudden drama.

Garcia's later work in brilliant, velvety pastels continues his use of symbolic color, but introduces other elements, especially ominous landscape settings

▼▼▼▼▼▼▼

I've avoided calling myself "Indian" most of my life, even when I have felt that identification most strongly, even when people have called me an "Indian." Unlike my grandfather, I have never seen that name as an insult, but there is another term I like to use. I heard it first in Lakota and it refers to a person of mixed blood, a métis. In English it becomes "Translator's Son." It is not an insult, like half-breed. It means that you are able to understand the language of both sides, to help them understand each other.

—Joseph Bruchac, in *I Tell You Now*, edited by Brian Swann and Arnold Krupat (p. 203)

appropriate to the subjects of war in Vietnam and Central America, assassinations, and the ongoing oppression of radicals and workers. In the '80s Garcia has preferred the diptych form, which allows him further complexity and manipulation of scale and distance for his sliced compositions and double meanings. In all of these works he calls attention to the varying representations of Mexico: from the media, and real life unreported in the media, to the exotic images of tourist brochures, which can represent in turn objects of genuine cultural meaning, such as the popular masks from the Mexican state of Guerrero that Garcia often depicts. The lush, saturated colors and textural density of his pastels almost subvert the harshness of the original images and daily experiences that are juxtaposed.

One of the most successful works of activist public art to date was made in San Diego by David Avalos, Louis Hock, and Liz Sisco in 1987, to call attention to the status of undocumented Latino workers. Their photo-text posters on the back of 100 city buses were seen by some 80 percent of the population plus a good portion of the 80,000 visitors that came that month to the Superbowl in "America's Finest City" (the San Diego city slogan). The black-and-white photomontage centered on an image of a handcuffed worker being taken off a bus by *la migra* (the Immigration and Naturalization Service), flanked by images of brown hands scraping dishes and offering hotel maid service. The text reads "Welcome to America's Finest . . . Tourist Plantation." The posters' appearance was followed by an amazing flood of newspaper and TV coverage, letters to the editor, and public response. These ranged from demands to get rid of the posters immediately because they "gave the city a bad name" to an award from the Mexican American Business and Professional Association "in gratitude for the work which raised the San Diego community's consciousness of the plight of the undocumented worker." In the local newspaper letters columns, racist statements were made and parried: "Let us face it, Mexico will never change. They will always be the takers; we will always be givers," wrote Mary M. Gustafson of Poway. Jesus R. Cabezuela of Chula

Fig. 14: Robert Buitrón, *Popo en la Cocina*, from "The Legend of Ixtacihuatl y Popocatepetl," 1989, gelatin silver print, 10" × 12". Buitrón is a photographer in Phoenix, Arizona, where he was a cofounder of the alternate space MARS (Movimiento Artístico del Río Salado). This is one of twelve images (published as a calendar) in which Buitrón places the legendary figures in contemporary, even ordinary, life. *Popo en la Cocina* (with Ixta at the computer) deals with several issues: "role reversals in the Chicano community; the economic and emotional necessity to discard old values that contribute to the disintegration and impede cultural development and affirmation; the role of the Chicana in the work force; traditions and technology can mix and flourish (high tech tortilla on computer screen); and the Aztecs have landed at Plymouth Rock to help the 'Puritans' survive another tough spiritual winter" (letter to the author, 1990).

Vista replied, "The people you call 'uninvited' are, in reality, returning to the homeland of their ancestors which was stolen from them. In this case, the anglos were both takers and givers. They took the land, then gave the Mexicans the shaft."

Most San Diegans would privately concede the hotel and restaurant industry's debt to undocumented "wage slaves," not to mention California agribusiness' reliance on undocumented farmworkers. There was also an irony in the posters' placement since undocumented workers are often dragged off public buses and deported in official buses by the INS. "We're symbolically putting the people who've been taken off back on the bus," said Sisco. And Avalos asked, "Is it negative to yell 'fire' in a burning building? . . . We're pleased and amazed that three artists and a hundred posters have made this kind of impact."[44] Like so much border art, the project is appropriately a hybrid, spanning art, advertising, and political postering. When its term of display was up, the poster moved into the private sphere as a gallery installation, framed by the media it had provoked, which in turn expanded its meaning.

An important issue for many artists of color is that there is no recognition of the complexity of their heritage, for the ongoing process of "creolization," within which artists, says the white scholar Judith McWillie, "elaborate, enhance, invent and improvise according to codes perceived and understood within multicultural communities."[45] There is no single term in English for "mixed-blood," which covers most of us.[46] (The term "half-breed" has been

ruled out by its historically racist uses, the implication that a person so defined is somehow "not whole.") Yet white people, no matter how "exotic" their heritage (e.g., Polish, Swedish, Armenian) are perceived as occupying a center that moves with them wherever they go. For that reason, in part, white artists tend to be far less aware than artists of color of the historical extent to which genes are mixed and shared. For people of color, the implications of mixing are different.

Those people with any significant amount of African blood at all are identified in the United States as black. Some black people call themselves mulatto, but this is usually perceived as a kind of middle-class snobbism. Lorraine O'Grady (whose background is New England and West Indian, or

Fig. 15: David Avalos, Louis Hock, and Liz Sisco, *Welcome to America's Finest Tourist Plantation*, 1988, San Diego bus poster, silkscreen, 21″ x 72″. (Photo: Liz Sisco.)

Fig. 16: Bert Long, *Creativity*, 1989, 20,000 pounds of colored ice, 15′ x 40′ x 4′, installation at Eighth Abilene (Texas) Outdoor Sculpture Exhibition. (Photo: Gerald Ewing, *Abilene Reporter News*.) Long, an African American painter and sculptor from Shepherd, Texas, poses with his chain saw in front of his monumental ice sculpture executed on site—a skill learned from some twenty years working as a chef. He quotes a dictionary definition of creation: "the act of bringing the world into existence from nothing," although in this case the process was rapidly reversed. This artwork is as brief and ephemeral as life. Long saw it as a way of "bringing people together to observe the magic of art not imprisoned in the studio, but given life (created) in public so that one may understand that artists and creativity are not separate from society." As he worked against time, and the strange, murky dark colors and forms began to make sense, he hoped the audience would feel "the elation of bringing this seed to full maturation, solving the problems, knowing that it will not last, but knowing that it will exist forever in those that observe it" (Catalog).

▼▼▼▼▼▼▼
There is a tradition in black (and white) history of the "tragic mulatta," product of rape, caught between two races, "a metaphor for the crossover dream," as mixed-blood artist Lisa Jones put it in her 1986 performance *Combination Skin*: "a hot item these days. From the slave quarters to the Big House, from Convent Avenue to Hollywood . . . our paperback martyr." In another Jones performance—*Carmella and King Kong*—a character says, "Can you help? I'm having identity problems. Can't seem to decide whether I'm Lady Day or Doris Day."

Enrique Fernandez points out that when he was growing up in the North American South in the '50s, he and his friends called each other mulatto "regardless of race, something Cubans still do today. . . . [The black-white polarization is] so foreign to the Latin temperament's sensitivity to nuance. . . . We are all, Latinos and *americanos*, a mix of ruthless imperialists and—sometimes equally ruthless and imperialistic—pre-Columbian cultures, political and religious refugees, hungry immigrants, adventurous rogues, and mixes of mixes of mixes. My sons have Amerindian blood coursing through their veins, but it came from their *americana* mom, not their Latino dad."
—Enrique Fernandez, "What's in a Nombre, Hombre?" *Village Voice* (June 21, 1988)

Fig. 17: **Lorraine O'Grady**, *Sisters #2: Nefertiti's Daughter Merytaten/ Devonia's Daughter Candace*, 1988, Cibachromes, 26⅞" × 38⅜". *Sisters* is a four-part piece in which O'Grady pairs portraits of ancient Egyptian women with women from her own family who physically resemble them, drawing, as she put it, "on the deep historic black substratum that bridges the mulatto cultures of ancient Egypt and contemporary America" (*Art as a Verb*, n.p.). She began to work with this theme in the early '80s, with her performance *Nefertiti/Devonia Evangeline*, which dealt with the lives of the Egyptian queen and her own dead sister. O'Grady recalls studying history in school and wondering why the Egyptians looked like her and her friends if they were from "the Middle East," facing Europe. The inclusion of Egypt in African history offers a still more varied cultural ground for African Americans to look back to, and one that is, for better or worse, more respected in Western terms than that of the rest of the continent. O'Grady, then, is not augmenting her own family but the African American family as a whole.

what Michelle Cliff has called "Afro-Saxon"), with some irony, represents the mulatto as a proud representative of both cultures, the product not of rape but of resistance to racism, of modern marriage. In regard to her work *Sisters*—which consists of photographs of herself and her immediate family paired with ancient Egyptian portrait sculptures that closely resemble them—O'Grady recalls being outraged as a school child when she realized how much of her heritage had been denied her by the racial and cultural separation of Egypt from the rest of the African continent. Cornell professor Martin Bernal, in his ground-breaking book *Black Athena*, heals that wound by tracing the Afro-Asiatic roots of classical Greek civilization. He establishes Egyptians as "Negro" rather than "Caucasoid," and thus exposes the debt owed by Western civilization to early colonization by Africans. Citing anti-Semitism as a factor in the rewriting of classical history that began as late as the mid-nineteenth

century, he makes a connection between the dismissal of the Egyptians and the explosion of Northern European racism in the 19th century.[47]

The nuances of racial mixture in the United States have been buried in memory and history over the last century. Indians have noted with some indignation the "Cherokee Princess syndrome" among white people who have just discovered an Indian great-great-grandmother. (Significantly, they note, it is rarely a great-great-grandfather.)[48] Skeptical about those claiming distant Indian ancestry who are unwilling to act on the political ramifications of their romanticism, Edgar Heap of Birds says:

> Today the criterion of Indianness is suffering the pain of our culture, which is experienced in our traditional way "together." A true Indian cannot claim to be native one day and not native the next. [And yet] the mark of being of the native experience cannot be measured by a blood fraction.[49]

Relations between African Americans and Native Americans have differed depending on the location and specific historical conditions. For example, I was unaware that Africans were among the first non-Native settlers of the territory that is now the United States,[50] and of how early the mixing of freed slaves (most of them with some white blood) and Native peoples began in the Northeast, where my own ancestors come from. Black people have explored this side of their ancestry only minimally, partly because of the overwhelming interest in Africa and partly because of ambivalence about the lost history of these relations. "I used to enjoy thinking about my Indian ancestry," wrote Emma Amos, who was raised in Atlanta, and whose ancestry includes Cherokee, African, and Norwegian.

> I imagined how the families might have mixed. Maybe blacks helped Indians escape during the time of the forced Cherokee "Death March" to the West, and maybe blacks were helped by Indians to escape slavery. Or, I thought there were even marriages by choice between Indians and free blacks.[51]

The reality, she goes on to say, is that "Indians bought, sold, and kept slaves. They wrote tribal laws to prohibit intermarriage between blacks and Indians." However, there were Indian tribes who protected and rescued escaped slaves, those who claimed to keep slaves in order to allow black people to continue to live with them in freedom, and there were breakoffs of "pure" Indians from those who had intermarried. Today the Shinnecock Indians in Long Island, the Lumbee in North Carolina, the Seminole in Florida, and many other eastern tribes, are quite thoroughly Afro-Indians.[52] Whatever the lost history of these interactions might reveal, it is true that many black people have Indian blood, among them writer Alice Walker, artists Howardena Pindell, Betye Saar, and Alison Saar, and performer Robbie McCauley, whose major work of the late '80s is called *Indian Blood*, a phenomenon she explores with

▼▼▼▼▼▼▼

75% of the staff here is Black. I am considered white by them. It is so strange. I am used to being last and ridiculed, but it is funny to be considered white.
—Share Ouart, "Letter from Prison," *Sinister Wisdom: A Gathering of Spirit* (North American Indian Women's issue, no. 22–23, 1983, p. 64)

I boast that I am the only Negro in the United States whose grandfather on the mother's side was *not* an Indian chief. Neither did I descend from George Washington, Thomas Jefferson, or any Governor of a Southern state. I see no need to manufacture me a legend to beat the facts. I do not coyly admit to a touch of the tarbrush to my Indian and white ancestry. You can consider me old Tar-Brush in person if you want to. I am a mixed-blood, it is true. But I differ from the party line in that I neither consider it an honor nor a shame.
—Zora Neale Hurston, *Dust Tracks on a Road* (New York: Lippincott, 1942, p. 243)

Fig. 18: Christian Walker, from the "Miscegenation" series, 1985–88, silverprints with raw pigments, 16" x 20". Walker is an African American artist who was raised in Massachusetts and now lives in Atlanta, where he studies the subtleties of racism in the "New South." These lyrical and nonpolemic black-and-white photographs are subtly tinted with occasional browns. White and black hands, arms, feet, mouths, and other unidentifiable but suggestive body parts (all men's) touch or are juxtaposed in intimate, but slightly blurred, close-ups. The tensions are both visual and social. Metamorphosis and homoeroticism are among his subjects, but Walker sees fragile racial histories as the larger issue. He deconstructs myths of sexuality and, in the process, reacts to Robert Mapplethorpe's "patriarchal and idealized views of black men, the objectification of powerful individuals," which do not convey "the realities of African American gay men" (conversation with the author, 1990).

▼▼▼▼▼▼▼

I embody the racist's nightmare, the obscenity of miscegenation, the reminder that segregation has never been a fully functional concept, that sexual desire penetrates social and racial barriers, and reproduces itself. I am the interloper, the alien spy in the perfect disguise, who slipped through the barricades by mistake. . . . I represent the loathsome possibility that all of you are "tainted" by black ancestry. If someone can look and sound like me and still be black, who is safely white?
—Adrian Piper, *Women's Art News* (June 1987)

After reading about the anti-miscegenation law that had remained on the books [in California] until 1958, I suddenly saw my two-year-old self with my mother and father outside of one of downtown Oakland's leading department stores

some irony through her family's lives. In addition, black Americans have mixed African heritages. As Henry Louis Gates, Jr., points out:

> Slavery in the New World, a veritable seething cauldron of cross-cultural contact, however, did serve to create a dynamic of exchange and revision among numerous previously isolated Black African cultures on a scale unprecedented in African history. Inadvertently, African slavery in the New World satisfied the preconditions for the emergence of a new "African" culture, a truly "Pan-African" culture fashioned as a colorful weave of linguistic, institutional, metaphysical, and formal threads.[53]

There is a growing body of literary and visual works by African Americans about variations of skin color and hair and their ramifications within communities and even within families. Ironically, or perhaps predictably, several of the best-known contemporary black artists have been very pale skinned. Adrian Piper's ferocious photo-text *A Tale of Avarice* names names in narrating how part of her family became white and cut ties with those who did not. Like Piper, the late Romare Bearden felt his identity crisis was personified by his pale skin, "dramatized," as Ralph Ellison put it, by "facial structure, and the texture of Negro skin and hair."[54] Bearden was always being taken for a Russian. Christian Walker made a photographic "miscegenation series," and in Daniel Tisdale's "Post Plantation Pop," a series of paired portraits, each black face is transformed into its ghost—a "whitened/lightened" and neutralized image. David Hammons has also tried this strategy, making a 16-foot-high head of Jesse Jackson with pink skin, blond hair, and blue eyes inscribed (after a popular rap song) "How Ya Like Me Now?" (Because it could be read both as Hammons intended it, that if Jackson had been white he might be

Fig. 19: Daniel Tisdale, *Paul Robeson*, from the "Post Plantation Pop" series, 1988, graphite over photocopy, 10″ × 17″. These double photographic portraits of African American leaders—the one on the right touched up to "whiten" the subject, who becomes pale-eyed and straight-nosed—are about the pressure to assimilate and be absorbed into a mainstream culture that disdains blackness. Tisdale uses a photocopying technique to symbolize the pragmatic pressures to "fit in" and a photographic metaphor, negative and positive, to compare the altered and unaltered faces. He uses "pop art" and a somewhat Warholian style to emphasize the power of image in this media-manipulated society. Tisdale's work consistently addresses race, power, and fragmentation in daily life. A recent series called "Sign of the Times" is in part a media critique, questioning multicultural identities from a global perspective, with cultural types from around the world "dressed for success."

at Christmastime. It was 1954 and my parents were taking me to see Santa Claus for the first time. As my mother and I stood watching my father feed coins into a curbside parking meter, the air was split by the screams of an elderly white woman who came teetering towards us. Two decades later, I remembered only two of her words . . . "citizen's arrest!"

My parents remained rigid and silent until she was within a few feet of my father, who then turned his head and rumbled something terse, inaudible to me, that instantly halted the old woman's shrieks. Life seemed to stir again, but the wind had been knocked out of us—so much so that there was no hesitation or protest when my father beckoned toward the car and we rode home without bothering about my interview with Santa.

I could not stop crying at the library reading table and I was frightened by the violence of my own emotion. . . . A long distance call to my mother that evening confirmed my suspicion. Yes, she said, it had all happened just as I remembered. And my hunch was correct: the old woman had wanted to arrest my mother and father for miscegenation, until my father informed her that whatever miscegenation there'd been had taken place several generations ago!

—Judith Wilson, in *Autobiography: In Her Own Image* (p. 12)

president, and as an insult, that Jackson is trying to be white, the piece was vandalized when it was installed outdoors in Washington, D.C., in 1989.)

A cross-cultural process (often at cross-purposes) also exists within the various Native American nations, which are as diverse in terms of history, present, and symbolic codes as the tribal Central European societies incorporated into the Soviet Union or the "ethnic minorities" living under Han rule in China. As Jolene Rickard states,

> I'm not an American and neither will my children be. I'm a Tuscarora. I'm not a generic Indian either. We have separate political identities and separate relationships to our own tribes and specific understandings of our rituals. I'm not an advocate of taking a little bit of the pipe ceremony of the Lakotas and mixing it with a little bit of sandpainting from the Navajos. I have my own religion.[55]

When such groups are thrown together by a brutal, insensitive, or ignorant ruler, forced to share land despite dissimilar religions and lifestyles, schisms are bound to occur. Poverty and psychic oppression have made many Indian

people ill-equipped to deal with the double complexity of difference from the dominant culture and difference within Native coalitions and their own communities—between "reservation Indians" and "urban Indians," between generations, between traditionalists and reformists, men and women, the educated and the uneducated.

Art should be a healing force in this situation, but among Native artists the problem has been aggravated by the scramble for pieces of a relatively small pie. New legal restrictions instigated by some Native Americans permit only artists who are registered on the tribal rolls to show in certified "Indian" contexts—both markets and exhibitions. This has engendered agonizing divisions in the Indian art community. A premium has been set on the fact of enrollment with the tribe or the Bureau of Indian Affairs, reservation background, and family ties. Even those who have the required blood percentages and family trees may have internalized an insecurity that is all too often projected on those who are excluded. The results are painful and divisive, threatening individual self-esteem and the communal maintenance of history, stories, and images. Constant doubt is cast on the "Indianness" of even those who have done much for their peoples in the world.

On one hand these laws protect Indian markets from invasion by whites claiming some vague Indian background in order to cash in on the popularity of Indian arts. On the other hand, more is lost than gained. It becomes a terrible psychological hardship for those who cannot validate their heritage either through white or tribal records. Artists whose parents or grandparents left the reservation, lost family records, or passed as white for economic reasons are now cast into a no-man's land that denies them their Indian identity no

Fig. 20: Karita Coffey (Comanche), untitled ceramic masks, (a) 1980, red earthenware clay, 13″ x 7″ x 1½″; (b) 1987, earthenware clay, 12½″ x 6½″ x 1″; (c) 1989, earthenware clay, 10″ x 5″ x 1″. Coffey lives near Albuquerque and teaches at the Institute for the American Indian Arts (where she also studied) in Santa Fe. She traces her artmaking to her mother's allowing her to spend hours drawing on the walls of her room. Her masks may appear "traditional" to an outsider, but they are inventions based on art from many cultures. "I look for things that aren't symmetrical, balanced, or overworked. I like seeing fingerprints and irregular lines left by the artist" (quoted in *Women of Sweetgrass, Cedar and Sage*, n.p.).

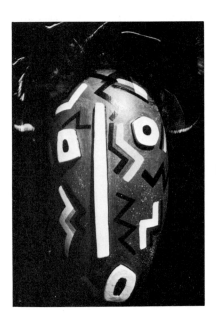
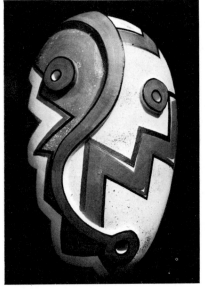
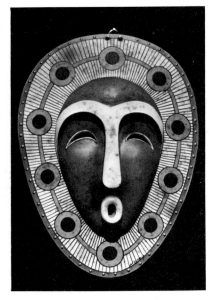

matter how strongly felt and inherited it may be. At the same time, the Indian art context is denied some of its most rebellious and original creators.

The Southwest—the great mixing bowl for Native, Latino, and Anglo peoples, with its history of immigration and invasion going back before European contact—has become the center of such controversies because since World War II Native Americans from other parts of the country have moved there, attracted to the area that has become for tourists the quintessential "Indian Country" and for Native peoples the heart of the Pan-Indian movement. This movement has produced composites such as eastern tribes wearing Plains headdresses in powwows, Navajos doing sweat lodges, and so forth. It has also provided an emotional and political strategy for intertribal communication, illustrated by a collaboration between photographers Jolene Rickard (a Tuscarora) and Jesse Cooday (a Tlingit) in which they collaged their similar facial features and titled the result *One Spirit*. Although some composites preceded contact, there are Native Americans who oppose the mixing of tribal customs. There is always the historical example of the Navajos, however—adapters par excellence ever since they arrived in the Southwest and acquired pottery, weaving, and major parts of their religion from the Pueblo peoples, and then horses and sheep from the Europeans. Far from being absorbed, they have grown to a reservation population of 200,000 and occasionally their adaptability has not stopped short of the kind of economic exploitation of their resources usually practiced by plundering whites.

> It's a very Indian activity [says Jimmie Durham] to take new ideas that are useful. Everything brought in from Europe was transformed with great energy. A rifle in the hands of a soldier was not the same as a rifle that had undergone Duchampian changes in the hands of a defender . . . by the employment of feathers, leather and beadwork. . . . We took glass beads, horses, wool blankets, wheat flour for fry bread, etc., very early, and immediately made them identifiably "Indian" things. We are able to do that because of our cultural integrity and because our societies are dynamic and able to take in new ideas.[56]

Contemporary Native American art occupies, for better or worse, a unique site not only between different Native traditions, but between the artworld and the traditional-turned-tourist arts. Nelson Graburn has written about "art as a mediating influence in acculturation processes" (the title of a 1969 paper). His 1976 book, *Ethnic and Tourist Arts*, offers a detailed analysis of the ways in which Fourth World arts—no longer isolated and automonous—are rarely produced for the group's own consumption. Therefore they must "take into account more than one symbolic and esthetic system," in a manner more conscious and more regulated than contemporary artists working in the artworld.[57] Conventional professional career choices are often closed to Native peoples, due to lack of educational opportunities, and the arts have become one of the few ways for Indian people to survive. By 1970 craft production was the primary industry in more than fifty percent of the pueblos.[58] If one is

▼▼▼▼▼▼▼
The fashion for collecting various forms of native, indigenous, and folk artifacts has contributed to more than a simple co-optation of their values. In subsuming the specificity of peripheral indigenous cultural value into the generality of central artistic culture (under the judgemental aesthetic of absolute stylistic formalism) a clear process of the redevelopment of peripheral culture is initiated.
—Kenneth Coutts-Smith, "The Power Lecture" (Sydney, Australia, 1980)

Fig. 21: Imogene Goodshot (Sioux), *Beaded Trucker's Cap*, 1984, beads and cloth, c. 10" diameter. (Photo: Richard Wickstrom.) Goodshot is a champion Indian market traditional beadworker who has become an avant-garde artist almost in spite of herself by beading unexpected objects. Raised on the Pine Ridge reservation in South Dakota, daughter of two well-known traditional artists and married to a Cochiti Pueblo artist from New Mexico, Goodshot admits that balancing between the pull of tradition and the need to create originally is difficult. On one hand, she spent fifteen years completing a traditional Sioux dance dress, and on the other hand, she beads sneakers, fedoras, and baseball caps. "I know I'm changing," she says. "There are changes all around me, but I can't lose the tradition. . . . Some people call these [traditional beaded] clothes 'costumes.' They're not costumes. A costume is something you'd wear on Halloween. My dress, and the outfits on the dolls, are traditional Sioux dance attire. Every part must be made a certain way, every part has a function and a meaning." (*Indian Market*, Santa Fe, 1982, p. 5). So, in a way, does her trucker's cap—standard apparel for those who often discriminate against Indians—here totally transformed, or turned around, by the addition of beads and a feather. There is an Indian saying that Goodshot has taken to heart: "If it doesn't move, bead it."

making art primarily to support one's family, experimentation is less likely to occur, and traditional techniques are replaced by faster methods. When those remaining traditional arts get out on the market, through fair means or foul, consumers manipulate their artistic development with the tools of economic acceptance and rejection. If objects are made too skillfully by hand, collectors think they are machine-made and reject them.[59] (On the other hand, crudely wrought objects can also look machine-made; it is a delicate balance.) Since the mid-'70s, there has been a trend toward highly skilled, clean, stylized objects and colors that meet the demand for the new "Salsa Southwest" designer look.[60]

Graburn also observes wryly that tourists like souvenirs to match the skin color of the makers, so in some countries dye and shoe polish are used on light woods. But when traditional objects are watered down or tarted up, they can harbor an element of anger, meaning "you're making us do this." Sometimes the difference between tourist and "authentic" arts is purely conceptual. The *santeros* of Cordova, New Mexico, make wooden *santos* for religious worship, then make the same or similar items for sale, but call the latter *monos* ("mere dolls, models"); the Hopi similarly distinguish between their sacred and commercial kachinas. Such acculturation, via double-coded objects, is not synonymous with assimilation. In a witty reversal, Graburn also points out that as Fourth World people decorate their now drab lives with manufactured items, magazine reproductions, and plastic flowers, "they might say that we are the makers of their 'folk' or 'primitive' arts!"[61]

Two other factors in the "acculturation" process: as agents try to get traditional artists to sign their objects so they can be sold for higher prices as "art," competition and individual success are introduced into small-scale societies, further skewing the relationship between object and tradition; also, tourist trades engender trends toward archaism and fake antiquity, exaggerated grotesquerie and exoticism, and an "obvious visual cross-cultural code, rather like pidgin languages."[62] Thus art is gradually separated from life—from belief and function. Artists and leaders are separated from the people, a hierarchy replaces egalitarian cooperative activities, and art—respected by the First World even when the artists are not—becomes a significant interface between Fourth and First Worlds.

An ongoing, often bitter debate is taking place in the Indian community about what constitutes "Indian Art," with the modernists (now including some "postmodernists") occasionally being excommunicated when they treat Indian subjects in what is perceived as white styles. While this is a valid internal dialogue, it is regrettably manipulated and exploited from the outside. As Edwin Wade has remarked, the traditionalists themselves are often working in white-inspired, even white-dictated, styles that have simply been proclaimed as "Indian" within the last century.[63] However well-meaning some of the early patrons of Native American art may have been, they did a lot of damage as

Plate 25: César A. Martinez, *Mestizo*, 1987, charcoal and pastel on paper, 29″ x 41″. Courtesy Ralph Mendez/Locus Gallery, San Antonio, Texas. This drawing was inspired by a detail from Francisco Eppens's mural *Allegory of Mexico* at the university in Mexico City, which shows a three-faced head with stylized Aztec and Spanish faces flanking a mestizo—a standard feature of Chicano murals. When Martinez began his own "Mestizo Series," he used the jaguar, native to the Americas, and the Spanish bull, representing Europe, to flank his own self-portrait. Martinez is an eminent Chicano artist best known for his "Pachuco Series" of composite portraits of Mexican American "types" isolated on brilliant monochrome color fields. In the late '80s he began a complex series of figures and architectural landscapes on Europe's confrontation with the Americas, in which bull, jaguar, pyramid, and serpent play the major roles.

Plate 26: Jean-Michel Basquiat, *Per Capita*, 1982, acrylic, oil stick, and collage on canvas, 80″ x 150″. Courtesy Robert Miller Gallery, New York. This painting is an ironic glance at the American dream and the ongoing black struggle for survival. "E Pluribus" is written over the haloed head of a black figure in "Everlast" boxer shorts who holds a burning torch. It is flanked by a list of per capita incomes from Alabama (the lowest) to Connecticut (the highest). Black people as skulls, masks, and moving figures populate Basquiat's paintings along with the neo-scientific fictions of his commentaries and a staccato rhythm of ragged patterns, brushstrokes, paint patches, and words that Robert Farris Thompson has traced to Haitian and African iconography. "The Black person is the protagonist in most of my paintings," said the artist. "I realized I didn't see many paintings with Black people in them." When asked if anger was an element in his art, Basquiat replied "It's about 80 percent anger" (quoted by Judith Wilson in *Black Arts Annual 1987/88* [New York: Garland Publishing, 1989], p. 48).

Plate 27: Tim Rollins and KOS (Angel Abreu, Nelson Montes, Howard Britton, Pablo Ortiz, Brenda Carlo, Carlos Rivera, Richard Cruz, Annette Rosado, George Garces, and Nelson Savinson), *Amerika—For the People of Bathgate*, 1988, mural, 55′ × 36′, Central Elementary School 4, South Bronx. (A project of the Public Art Fund, New York; photo: the Public Art Fund.) The twenty-eight golden horns, created by students and staff of the South Bronx school with KOS, are inspired by a section called "The Nature Theatre of Oklahoma" from Franz Kafka's unfinished novel *Amerika*. Each horn is an individual vision, collaboratively joined into the mural design by KOS, representing "not only the beauty, but also the challenge of democracy" (statement for press). The school staff and student participants were Anna Boutelle, Eddie Milian, Isalene Goldman, Jose Colón, Luis Medina, Stan Kaminsky, Eliana Fernandez, Roberto Ortiz, Steven Macias, Armando Figueroa, Eddy Ramirez, Melissa Marquez, Luis Figueroa, Kareen Simmonds, Shamel Simmons, Saladin Smith, Bruce Franco, Daniel Torres, and Kenneth Washington.

Plate 28: Judy Baca, *The Great Wall of Los Angeles* (detail: *Division of the Barrios*), 1983, 13′ high (whole mural c. 2500′ long), Tujunga Wash. (Photo courtesy SPARC, Venice.) Beginning with the original Pre-Columbian inhabitants, *The Great Wall*, directed by Baca, progresses decade by decade toward the present, covering such events as the deportation of Mexican American citizens in the '30s, the internment of Japanese American citizens during World War II, the Zoot Suit Riots in the '40s, as well as local strikes and gentrification struggles. This section of the wall shows the division of a tight-knit Los Angeles Chicano community by the addition of a freeway that split it in two. A historical, if futile, battle ensued and gang activities increased as the community was weakened. The mural is factual, but often witty, as when Rosie the Riveter is vacuumed into a TV to become a housewife after the men return from World War II or when the swooping bodies of Japanese American soldiers from the heroic 442d Battalion emerge from—or merge with—the stripes in the American flag. As a bicultural artist raised in California, Baca operates in what Guillermo Gómez-Peña has called "a Third Landscape" that encompasses both cultures.

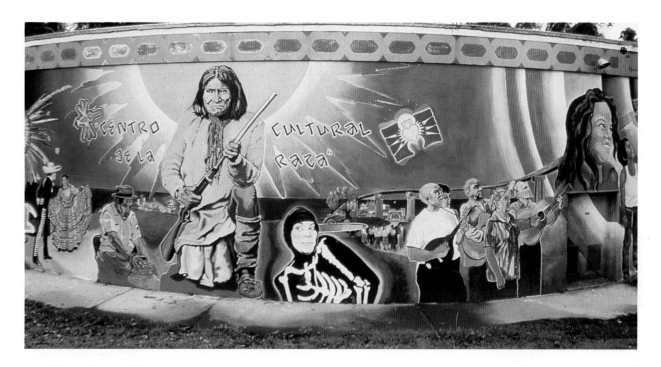

Plate 29: Victor Orozco Ochoa, *Geronimo*, 1981, mural at Centro Cultural de la Raza, San Diego. The murals on the outside of the Centro's round building—an abandoned water tank—were among the most striking of the *movimiento*. One section has a significant history. In 1974 Ernesto Paul painted a powerful image of a cross and a looming hooded skeleton wearing dark glasses, holding a hypodermic needle patterned in stars and stripes, and stirring a cauldron (the melting pot, from which a prisoner stares out through a barred window). It was seen by some as a "desecration" and "death symbols against the Christ." Eventually criticism and vandalism took their toll and the mural was removed, its seventy feet remaining blank until 1980–81, when Ochoa replaced it with a huge figure of the Apache warrior Geronimo, kneeling with his rifle ready. "Geronimo was born right in the border region," Ochoa explained. "I identified with him because my father's mother is Yaqui, and very closely related to the Apaches. Another factor is that it took 5,000 soldiers to apprehend him and thirty-eight of his camaradas. To me these are the kind of odds that the Chicano has had to survive" (unpublished interview with Philip Brookman, June 13, 1985). Geronimo is surrounded by images of contemporary Chicano cultural life. For instance, the hooded figure in a black costume with a skeleton painted on it is from a performance by the Teatro Campesino.

Plate 30: Rupert Garcia, *Nose to Nose*, 1985, pastel on paper (diptych), 60" × 96". (Photo: Ben Blackwell.) A black bomber against a handsome turquoise sky attacks a Mexican mask from the popular Moors and Christians dance imported from Spain, in which the blond blue-eyed Christians are the victors—a historical precedent, or metaphor, for the Conquest of the Americas. Both images are streaked with a multicolored confetti-like overlay, which serves to unite the two sides. (The confetti pattern, representing life's energy, stems from Garcia's childhood "Jamaicas," fiestas celebrating secular and holy events; children broke confetti-filled vessels over each other's heads and the "specks of color would burst forth like fireworks or sparkling stars.") The mask under attack refers to popular heroes shot by the police, perhaps a direct reference to the 1968 massacre of dissident students at Tlatelolco or to the murder of thousands of Indians in Guatemala, where such masks are also common; indigenous culture in Central America is constantly attacked by high-tech invaders. The mask stands for magic, imagination, and fantasy. It is "a symbol of popular cultural resistance and life's basic vitality," says Garcia, "an emblem of the power of the human spirit's ability to survive adverse conditions. . . . Folk art is a symbol of endurance . . . it is an important symbol for me—a symbol of hope" (quotations from letter to author, 1990, and Lori Baker, "Outrage," *Metro Phoenix*, v. 22, no. 12, December 1987, p. 75).

Plate 31: Ramona Sakiestewa, *Katsina/2*, 1987, wool Swedish yarn, 50″ × 70″. Collection Mobil Corporation. (Photo: Herb Lotz.) In Hopi, weaving is traditionally done by men, so even Sakieste-wa's vocation is a product of her mixed cultures. (Her father was Hopi, but she was raised with her white mother and a white stepfather, who was a connoisseur and collector of Indian arts. As an adult she has reestablished close contacts with the Hopi.) The kachinas are supernatural beings who represent the spirits of living animals, plants, and aspects of life. In the colors and designs of her tapestries, Sakiestewa analyzes and abstracts the kachina forms from traditional ceremonial masks, costumes, and representations, while maintaining the original symbolism. Many of the forms she uses are found in the petroglyphs of the Southwest, where the Hopi's ancestors, the so-called Anasazi, flourished in the seventh to fifteenth centuries. (Sakiestewa paid homage to this past when she reconstructed two Anasazi feather blankets for the Bandelier National Monument.) She also incorporates in her modernist work the influences of the great Navajo weavings, which were an offshoot of Pueblo art. Sakiestewa often dreams her patterns, which are syncretic fusions of nature, memory, and history. At times she works from Western models, as she did in 1987, when she was commissioned to make her own woven versions of a series of Frank Lloyd Wright's drawings.

Plate 32: Martin Wong, *Attorney Street: Handball Court With Autobiographical Poem by Piñero*, 1982–84, oil on canvas, 35½" × 48". Collection the Metropolitan Museum of Art, New York, Edith C. Blum Fund. (Photo courtesy the Metropolitan Museum of Art.) Wong collaborated on this painting with the late NuYorican poet and playwright Miguel Piñero. "Even though I did all the painting," Wong says, "it was Mikey who chose the site, told me what to include in my picture, and later composed the poem for it" (letter to the author, 1990). Like most of Wong's work, the painting is a loving tribute to the complex and not always lovable neighborhood where he lives on the Lower East Side. The deaf sign alphabet at the bottom translates the burnt wood plaque below ("It's the real deal Neal / I'm going to rock your world / make your planets twirl / aint no wack attack"). Piñero's poem reads in part: "I was born in a barrel of butcher knives / raised between two 45's / On a Saturday night when the jungle was bright and the hustlers were stalking their prey. . . . where even god was corrupt / and few go down crying as go down trying cause life in the ghetto is a bitter cup."

they wielded the big stick of economic support, changing the form and the content of Indian art as well as holding it back in the past, all in the name of "preservation." Within the traditionalist camp, the decorative, lively, opaque watercolors developed in the Sante Fe Indian school in the '30s have since been replaced for the most part by melodramatic figures in an illusionistic deep space, a style that has been tracked from Quincy Tahoma to Blackbear Bosin to Rance Hood, who sees his highly romanticized work as a cultural vision of what it was to be a Comanche. This style is often augmented by a Surrealistic tendency toward double images or visual puns which comes from deep within many Native American cultures and is not necessarily effaced by the almost calendar-art styles in which it often appears today. At worst, this sort of romantic traditionalism is saccharine and sentimental, at best, mysteriously adaptable.

The puns and double meanings, or double codings, that characterize much bicultural literature are visible in bicultural art as well, as in Inuit (not "Eskimo") sculptor Larry Beck's *Punk Walrus Inua*, which combines traditional carving and traditional humor to produce a very modern artifact that replaces traditional materials with those from a junkyard. The binary image is predictably frequent in the art of those who are straddling cultures. "I do not know why the little storm of words falls upon me," writes Cherokee poet Diane Glancy. "But I hear voices in the grass: Two Dresses, they say with the wind. And truly, I have the feeling of being split between two cultures, not fully belonging to either one."[64] Margo Machida calls herself "a permanent tourist in my life"[65] and makes art as a "split self"—reflected literally in her double-paneled paintings, a device also used by Ewao Kagashima, Kay Miller, and by Kay Walkingstick, whose two-canvas works juxtapose symbolic abstraction and casually realistic landscape. When asked about her "cross-cultural consciousness," Walkingstick wrote:

> I think of myself as a bi-racial woman raised in a white culture, but, throughout my childhood, constantly impressed with the idea of my Indianness. My Cherokee father was never around, and all my ideas of what it meant to be an Indian came from my white mother and my siblings. My mother was very positive, very pro-Indian, and she thought her children were blessed to be part Indian.
>
> The Cherokees were originally from the South but were "removed" to Oklahoma in the 1840s on the Trail of Tears. Because of their closeness to white culture since the 1500s and then their separation from their own beautiful Smokies, much of their old culture has been lost. Most Cherokee families have been Christians for centuries, for instance. A huge part of a culture is lost when a religion is lost. The language has been actively maintained, and, since Sequoia, a written language is taught as well. It's interesting that today the Cherokees of Oklahoma hold Pow-wows, even though it was never part of the culture to do so! . . . Anyway, as you can see, even if I'd been raised

▼▼▼▼▼▼▼

Pictogram forms from Europe, the Amur, the Americas; color from beadwork, parfleches, the landscape; paint application from Cobra art, New York expressionism, primitive art; composition from Kandinsky, Klee or Byzantine art provide some of the sources [of my art] In our work we connect our past with our knowledge of New York expressionism, minimalism, color field paintings and modernist markmaking which we have absorbed through education and travel. There is a particular richness to speaking two languages and finding a vision that's common to both.
—Jaune Quick-To-See Smith, in *Women of Sweetgrass, Cedar and Sage* (n.p.); 1985 statement for exhibition at Bernice Steinbaum Gallery, New York

Fig. 22: Robert Haozous (Chiricahua Apache/Navajo), *Portable Pueblo*, 1988, steel, 94" × 78" × 57". (Photo courtesy Rettig y Martinez Gallery, Santa Fe.) Haozous's witty and often angry views of Indian and white culture include such recent sculptures as *Homage to Our European Heritage* (a hefty blonde nude flexing her muscle), *Apache Pull-Toy* (a very white cowboy in a white hat, six-guns in hand . . . peppered with bullet holes), *Santa Fe Table* (coyotes, cactus, and bird on a coffee table chained down by dollar signs), and *Portable Pueblo*. The latter two are digs at those who come to the Southwest primarily to shop and "take it home." The pueblo is adorned with planes and cars rather than traditional symbols, and the wheel spokes are Indian women, who make the whole process move. On the other hand, Haozous's lovely *Apache Soul House* (in his own collection) utilizes the same quirky style to render profound homage to the land in which it stands.

in Tallequah, Oklahoma, like my father, I may still not have had the kind of "Indian experience" that a Hopi would.

But genetically I'm an Indian. I identify very strongly with that, and it has shaped my life and my art-making. Ideas are powerful. Are there genetic tracings that make me somehow "different"? Damned if I know. I somehow doubt it, but I do have a particularly proprietary view of the American landscape. . . . No doubt the diptych form is interesting to me because I am biracial. Two sides singing in concert, each very different from the other yet united as a whole. I like that.[66]

In recent years, the complexities of the internal debate around "Indianness" and the Indian Market's commercially motivated purism have spread and affected those Indians who have one foot in the national art scene. At the same time, the work of acculturated but nonassimilated modernists is changing minds on both sides of the fence about what an Indian art is or can be. "Authenticity" is valued, if differently defined, by Native American artists as well as by white collectors. Ironically, if the artist goes out into the cities or to art school, distortions decried by the traditionalists may be perceived as interesting, even skilled, by white mentors, a situation that can be confusing for young Native artists. There is the additional problem of the "invented Indian," the danger of discrediting one's own native culture because whites have meddled in it. And some have a vested interest in that invented image. Innovation is discouraged by nostalgic romanticists inside and outside of the Indian communities. Chiricahua Apache/Navajo sculptor Bob Haozous, son of well-known realist sculptor Allan Houser, has made clear his objections to the "not Indian enough" argument:

The objections come from the people who make money off of Indian art. . . . If you come up with something different, it's too threatening. . . . The kind of innovators that are promoted are innovators who take slow steps. They paint an off-white sunset instead of an orange one. The Indian art that is really innovative doesn't take slow steps, and consequently that kind of art doesn't sell.

Indian art is a bundle of safe, decorative ideas and motifs that have been repeated so doggedly they have lost all ability to communicate or awaken our esthetic senses. It's become a prop for the interior decorator. . . . I've lived in many different situations, with Indian families, my own included; with white people; in the city and in the country. . . . With this background have come a lot of different feelings and experiences. So I don't see why I only have to do Indian art. Yet that's where the paradox comes in; I'm still doing Indian art.[67]

Perhaps the most sensible approach to the problem, at least from the viewpoint of Native artists, is offered by Osage/Cherokee scholar Rennard Strickland, who suggests that the creation of a "new" past from the indigenous viewpoint is actually an old idea. Where Western historians see Indian art in

Fig. 23: **Larry Beck** (Chnagmiut Yup'ik), *Punk Walrus Inua (Poonk Aiverk Inua)*, 1986, mixed media, 16″ × 12″ × 12″. (Photo: Don Wheeler, Inc., courtesy Chicago Department of Cultural Affairs.) Beck, whose Indian name is Aklak, or Powerful Brown Bear, is a quarter Yup'ik (Inuit) living in Seattle. He rediscovered his Alaskan heritage and Native arts in depth only after receiving an MFA. Having spent much time studying mask collections in Washington, California, and the British Museum, he was in a junkyard looking for "some parts for my dog sled (my Toyota)" when he noticed a car mirror's resemblance to a mask form and decided to use a witty array of nontraditional materials from his own environment to make his own "traditional Eskimo" masks. They are inspired by traditional art, but unlike many artists working in this mode who emphasize age and decay, Beck creates pristine, neo-industrial artifacts. "I am an Eskimo, but I'm also a twentieth-century American," he says. "I live in a modern city where my found materials come from junkyards, trash cans, and industrial waste facilities, since the ancient beaches where my ancestors found driftwood and washed-up debris from shipwrecks are no longer available to me. But my visions are mine and even though I use Baby Moon hubcaps, pop rivets, snow tires, Teflon spatulas, dental pick mirrors and stuff to make my spirits [the walrus's tusks are car door handles], this is a process to which the old artists could relate. Because below these relics of your world, reside the old forces familiar to the Inua" (*The Eloquent Object*, p. 206).

▼▼▼▼▼▼▼

By making society the concrete and the individual the abstraction . . . [vernacular arts from the Third World can] reverse a pattern we in the West have taken for granted for centuries. But if this is the real novelty of such images, their newness is paradoxically mixed with the old-fashioned, even the ancient, in ways which underline the complexities of cultural interactions in the world today. The Third-World challenge of a narrow eurocentric view of art has sharpened the critique that these very different and apparently "older" forms can make of the status quo.
—Guy Brett, *Through Our Own Eyes* (p. 25)

There is more fine abstract design in one of my Navaho rugs than in all these modern paintings.
—Teddy Roosevelt on the 1913 Armory Show (quoted in Edwin Wade and Rennard Strickland, *Magic Images*, p. 107)

Is cowboy art ethnic?
—Jim Covarrubias (paper read at Cultural Apartheid panel, National Association of Artists' Organizations, Houston, 1985)

It is true, and now I can admit it openly, that when I was younger I was a cowboy for a while. But I don't believe I really had or have now cowboy tendencies. I did not really enjoy it, and I only did it for the money. This other cowboy I knew said, "You're an Indian and a cowboy? Be careful you don't kill yourself."
—Jimmie Durham, in *We the People* (p. 16)

Fig. 24: **Shigeko Kubota**, *Three Mountains*, 1976–79, plywood construction with mirrors, two 5-inch TV sets, five 13-inch TV sets, 59″, 60″, and 100″ at bases, 38″ and 67″ high. (Photo: © Peter Moore.) Kubota was born in a mountain village in Japan and her grandfather was a *sumi* artist who painted only mountains. "My mountains exist in fractured and distended time and space. My vanishing point is reversed, located behind your brain," she says. She is not making mountains to climb, because they "are there—a colonialist/imperialist notion—but to *perceive: to see*" (*Shigeko Kubota*, daadgalerie, Berlin, Museum Folkwang, Essen, Kunsthaus Zurich, 1982, p. 37). *Three Mountains* (with its four-channel images of the landscape, including the Grand Canyon, the Rocky Mountains, and a Taos sunset, set into three angular plywood "mountains") is a typically innovative video sculpture that pays homage to time Kubota spent in the West and Southwest with a Navajo friend and her family on the reservation in 1973. "I think I got inspired by this quite spiritual landscape. . . . I am from Japan but Indian. . . . We are the same race. Same faith. . . . They said hello, hello in Navajo pronounced 'Ya-tu-hey, ya-tu-hey.' It means I love you, I love you in Japanese. . . . They said Shigeko is something like daughter in Indian. . . . when I live at the Navajo reservation, with the Navajo family, I have kind of a smooth feeling" (*Profile*, November, 1983, p. 12).

terms of an evolution from traditional to modernist abstraction, he observes, "the primitive and the modern are part of the same artistic tradition . . . the process comes full circle."[68]

There is an infinite number of possible combinations for such an art of mixing executed with a clear awareness of its cross-cultural components. Much of it is surfacing in relation to the work of other transplanted Third World peoples. Shigeko Kubota, born in Japan, came to the United States at the age of twenty-six, inspired by John Cage and George Maciunas of the Fluxus group. She cites Buckminster Fuller, who said that people leaving Asia for America came with the wind. (To go to Europe would have been against the wind.) She has been a video artist from the beginning: "I always thought video is organic, like brown rice. You eat, like bean curd, very oriental, like seaweed, made in Japan."[69] Kubota is perhaps joined in this sentiment by the Korean American video pioneer Nam June Paik, with whom she has collaborated.

We tend to forget how deeply the art of Isamu Noguchi—who had Japanese, Anglo, and Native American blood—affected the North American mainstream. Perhaps this is because it was abstract and fit so well our preconceptions of the nature of "Oriental" art, while it also fit seamlessly, powerfully, and innovatively, into American and international art from the '50s on. There it paradoxically shared space with the second-generation Abstract Expressionist heirs to a secondhand Zen influence. Despite Noguchi's lifelong double alliance to Japan and the Americas (he spent time in Mexico), to his consciously bicultural identity, in the public view he became simply another "American" artist—the democratic ideal.

Many of the "Asian" artists in the United States are, like Noguchi, Asian American in "race" (Eurasian) as well as in citizenship. Yet even if they are half-Anglo, they will be categorized "Asian" and be forced to live Asian whether or not they choose to, until that much-heralded multicultural society finally takes its place. The ambivalence with which so many bicultural artists view their homelands or ethnic backgrounds is the result of this social contextualization. It is a constant theme in Asian American art. Japanese American artists in particular must deal with the fact that many parents did not tell their children about their internment during World War II; some recall their parents and grandparents burying precious, but possibly incriminating, objects of cultural heritage to avoid persecution during the internment period.

When political consciousness about cultural identity rose in the '60s, Asian American artists began to look more closely at the nature of their acceptance. As one artist said on a panel in the early '80s: "We are expected to be artists, so it's not hard to get into the mainstream. But the stereotypes are very limited and we've accepted and regenerated them. Our art doesn't reflect our social realities." Another artist interpreted the message from the mainstream to Asians: "We'll take your culture, but not you."[70] There is also an ongoing

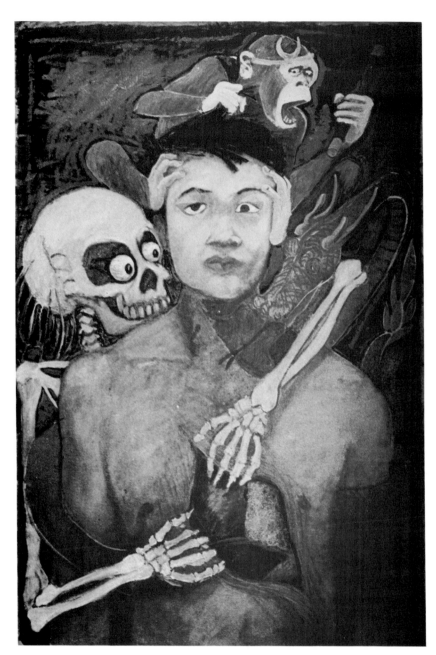

Fig. 25: William Jung, *Pardon My Heart, Amore*, 1987, oil on canvas, 36″ × 24″. Collection Asian Arts Centre, New York. Jung's "autobiography" reads in part: "William Jung was reincarnated for the oomteenth time in '55 and escaped the crown colony of Hong Kong on the back of a dolphin headed for the good ol' U.S. of A. Arriving at the tender age of six months, he was raised by a pack of wolves on the Lower East Side, where he soon learned the ways of the big city" (*A Place in Art/History*, p. 10). In this self-portrait, Jung studied "the effects of cross-cultural images that are literally tearing me apart. The tell-tale serpent is a Chinese dragon. The 'monkey on my back' is none other than Sun Wukong, the Monkey King, a mythological character from a Ming dynasty novel. The skull image is female, my Muse who is tearing away at my very heart and soul" (letter to the author, 1990). Jung appears here, masked, as a sacrifice to the cross-cultural process, the white muse tearing him open, the Chinese Monkey King dismayed at the loss, the serpent ready to embrace him. In other related works a naked Asian man tries to tear off a grinning Chinese New Year's mask, which happens to be white, or the artist strips himself of his skin (and thereby his Asian appearance), or places an oversized grinning and obsequious Asian face/mask on a frail body, a blurred image of the artist sandwiched between the two, in a triple escape from conventional portraiture.

internal debate on whether both sides of one's heritage should be equally balanced and recognized. In the catalog of a one-man show by Taiwan-born painter Chihung Yang, for instance, Robert Lee warns that "writers who categorize him as eastern, western or a mixture of the two, do not serve . . . to illuminate the intention of his work or the art of our time." Then on the

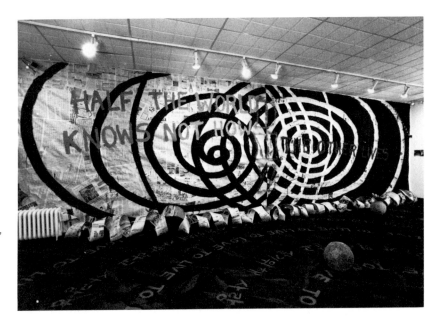

Fig. 26: Yong Soon Min, *Whirl War*, 1987, mixed media, 10′ x 29′ (this wall), installation at the Jamaica Art Center, New York. A Korean American who came to the United States at an early age (becoming part of the "1.5 generation"—betwixt and between two nationalities), Yong Soon Min was first a Minimalist. As she became increasingly aware politically and more alienated by her own identity crisis, her installations became increasingly layered and detailed. *Whirl War* was her first full environment. This wall was a collage of black and white painted newspapers, Korean on one side and English on the other, "a wall of oppositions, of conflict," the "whirls" readable as destructive or lifegiving. Painted over the spirals was: "Half the World Knows Not How the Other Lives," a phrase she got in a fortune cookie that expressed her frustration with narrowmindedness. The letters DMZ (Demilitarized Zone)—the epitome of the senseless divisions imposed by the cold war, and home of "unrequited spirits in search of a resting place"—ran in red vertically down the middle. On the floor another spiral was formed of a mantra: "To live, to love, to live, to love . . ." Four global vessels contained dirt, rice, and water. On the end walls a painted woman hurtled from the ceiling and a lifesize image of the artist held a globe on her back, Atlas-like—"a tongue-in-cheek way to symbolize empowerment." (Quotations from interview by Penny Fujiko Willgerodt, *Ikon*, no. 9, 1988, pp. 78–85, and letter to the author, 1989.)

next page, critic John Yau writes: "Born in Taiwan and living in New York, [Yang] has been both blessed and cursed with living in two, vastly different yet subtly linked worlds. If they are to survive and maintain their identity, the ancient and modern must be made to co-exist."[71]

As for "melting in" to North American society, even sansei like Tomie Arai are bitter about its impossibility: "I am a third-generation Japanese American and I still feel like people think I should go back home." There is often no "back home." Poet Fay Chiang, director of New York Chinatown's Basement Workshop, did go to China, where she experienced some of the same exhilaration and malaise reported by African Americans in Africa and found her identity problems intensified: "Everywhere I went, I fit in. I looked like them and could understand the dialect, but people were *so* polite and had a grasp of the ancient culture I didn't know. I thought, I'm an American, I have to go back to New York."[72]

There is a myth in this country that Asian Americans are easily assimilated because they're smart and thrifty and hardworking and well behaved and melt right into the American potluck. At the same time this "model minority" is also "the Yellow Peril"—too smart and hardworking for their own, and our, good. Often in the process of internalizing these facts of life, Asian American artists have decided they would rather "stand out" and have paved the way for more esthetic resistance to the ways their Asian heritage has been adapted to modernism by mostly Western artists. "To find a place for yourself in this culture is a political act," says Yong Soon Min. "To understand 'I have a right to be here and to be who I am.' "[73]

Fig. 27: Wen-ti Tsen, *Portrait of Peter Kiang, Version No. 1* (detail), 1988, acrylic on silk and paper, 54" x 300". In his determination to reach a broad Asian community, Tsen has painted murals, drawn comic strips, and worked with organizations as well as making studio art. This is the first in a series of six cross-cultural portrait installations, based on lengthy oral histories. Kiang, who is half Chinese and from Massachusetts, went to Harvard and became a leading activist on Asian American issues in Boston's Chinatown. The pictorial banners below his portrait show Asian American historical events and are labeled "Violence, Exclusion, Internment, Yellow." The portrait was installed in a Boston public space over the sculptural components of the complex installation.

Some of the dilemmas and choices inherent in this situation are demonstrated in the lives and work of two first-generation Chinese American artists whose backgrounds are intellectually, culturally, and politically complex. May Sun (plate 23), who was born in China and raised in Hong Kong, came to the United States at sixteen for college. When she went back to visit family in China in 1985, she became fascinated with the lives of her two revolutionary aunts, one of whom had been ambassador to Ireland, while the other was a close friend of Zhou Enlai (and of Paul Robeson). Since then, Sun's art has addressed the issues of having been born in a communist society and raised in a capitalist society, the dualities of her ethnic identity (involving two different Chinese experiences as well as the American one), and the dichotomous views of China from the Right and the Left in the United States. In a 1986 performance *The Great Wall, or, How Red Is My China?* she examined with slides, narrative, and dramatic episodes Robeson's life and his visit to China, and her aunts' lives, concluding: "Long live my communist aunts. They had their revolution *and* their tea party."

Wen-ti Tsen is a painter and muralist now living in Boston. His parents' families had been revolutionaries in the uprising that overthrew the Manchu dynasty in China; they were then educated in Paris, returned to China in the '30s, and became involved in "the progressive ferments of art and culture of the time." "She painted, first Western, then more Chinese. He politicked and was killed. When the Revolution came, it was natural for my mother to pick up the family and move to Europe." Tsen was educated in London and spent time in Paris (where he saw a lot of Hollywood movies and "absorbed well

▼▼▼▼▼▼▼

America doesn't allow itself to be influenced profoundly by outside culture. America's fascination with African culture today is like its fascination with Indian culture in the '60s and '70s. It's a faddist consumption mentality, and in a country that gobbles up the new and spits it out after making a few million, one wonders how long it will last.
—Wole Soyinka (quoted in *New York Times*, March 6, 1987)

the visual storytelling idiom of American filmic styles"), arriving in the United States in the late '50s:

> The directions of my work and life from the late '60s–early '70s on were determined largely by the realizations from the Vietnam War, the ideas from afar of the [Chinese] Cultural Revolution, feminism, and living for three years in pre–civil war Beirut. New babies and Maoist thinking channeled me into blue-collar livelihood and union membership—first as a billboard painter, then, for some 15 years, as a movie projectionist. . . . All the while, possibly for fear of being locked into a stereotyped career, I did not have much contact with the Asian American community or cultural activities. It was in 1986, through a community mural, that Chinatown, in full living complexity, became real and comfortable; now, it is the focus of most of my social and community art commitments.[74]

How clear, how blurred, then, should the boundaries of a culture be? What might be the model for a genuinely and respectfully mixed society? There is no rule that would be appropriate for every culture, or even for every microcosmic interaction within any one culture. In the arts and in social life, debates continue about the virtue of "separatism"—a much-misunderstood concept. It is somehow assumed by the dominant culture, or by most Caucasians, that pride in one's origins—if they are not Western—constitutes an automatic enmity to the society we all share; or else it is a form of childlike play that has little to do with the "real world." When black artists and women artists in the '60s chose to reserve private spaces of their own in which to grow, while coping with the larger social space on an everyday basis, they were accused of separating themselves out, and they/we were warned that such voluntary "ghettoization" put us literally beyond the pale. (White or white male organizations and groupings are, of course, exempt from such a process,

Fig. 28: Michiko Itatani, *Untitled*, from "Wave Guide," 1985, oil and acrylic on canvas, 134″ × 233″. Itatani was born in Osaka, Japan, and moved to the United States in 1970 to study art, having previously majored in philosophy and literature. She made the intellectual decision to go into visual art because she found it challenging for both mind and body. She brought to it her early training in *shodoh*, or calligraphy, applying the paint with a hypodermic syringe for a fleeting, vibrant line. Around 1984 she began to introduce the human figure into her "painted diagram of cosmology . . . incomplete, fragmented, and under inquiry." Despite the breadth of her subject matter and the vast spaces she depicts, Itatani says her painting "is about condensation and focus. I learned that from Japanese esthetics of simplification and symbolization. For example, Noh theater and the stone gardens of Zen temples present the reality of human existence in the context of a larger universe." The bodies in her paintings are "symbolic containers of human minds" and in a traditionally Eastern manner, they bear an "equal relationship" to all other elements, including the linear space in which they float and whirl in unpredictable vortices. "I am portraying the personal/social/political human struggle toward harmony with passion and optimism" (letter to the author, 1989).

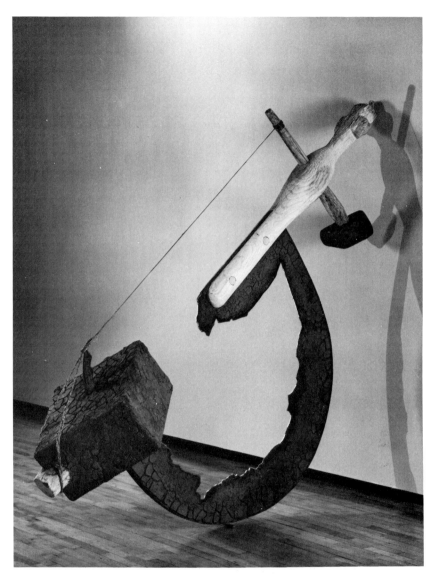

Fig. 29: Mel Chin, *The Sigh of the True Cross*, 1988, pine, olive ash, mud, steel, dirt, Rhoplex, bull gut treated with garlic, teff grass, 125″ x 87″ x 26″. (Photo: Adam Reich, courtesy Frumkin/Adams Gallery, New York.) Chin is a first-generation Chinese American raised in Texas, whose "weapons" or "tools" combine instruments of torture and musical instruments. This complex and evocative formal exploration of the swords-into-ploughshares concept is based on studies of both Eastern and Western alchemy. Chin is interested in the transformational aspects not only of specific materials, but of cross-cultural experience. He incorporates references to myths, cosmologies, science and politics, pleasure and pain. *The Sigh of the True Cross* was constructed as a response to the expulsion of the International Red Cross from Ethiopia, cutting off aid to drought and famine victims, and coinciding with a multi-million-dollar official Socialist celebration as well as the Festival of the True Cross, where the masingo, a stringed instrument on which this sculpture is based, is played. Its sickle-like bow is incorporated, caked in parched earth, as though resurrected from the past.

since they *are* society and need not worry about losing touch with the centers.) It is always difficult to know whether such assumptions are engendered by fear that marginal groups may draw strength from their own company, or whether they stem from pure paternalism and condescension: "separate yourself from me, and you're nowhere."

Even those artists who refuse to tolerate cultural and social boundaries often insist on their privacy. Yet if they incorporate subject matter that is relevant to their origins, they may be automatically excluded from "universality." The other side of the "not Indian enough" argument is Robbie McCauley's complaint that she gets asked, "Is your art *just* Black?" If an artist tries too hard to refute such an oversimplification, however, s/he may get called

Fig. 30: David Chung, *Seoul House (Korean Outpost)*, 1988, performance at the Washington Project for the Arts. Designed for "Cut/Across," an important cross-cultural exhibition at the WPA, *Seoul House* was a collaborative electronic rap opera in seven tableaux by artist David Chung, ethnomusicologist Pooh Johnston, and composer Charles Tobermann; it starred singer/songwriter "Black Elvis" (Clearance Giddons). A tragicomedy about interracial and intergenerational relations in D.C.—in particular the problems of Korean store owners in black neighborhoods—it featured video, music, and performance components (with elements of rhythm and blues, classical opera, and Korean mask theater), as well as a striking thirty-foot mural (charcoal drawings of a store's stockroom and D.C. street life) by Chung, who based the piece on the experiences of his own family. In a panel discussion Chung said that, for a Korean, simply living in the United States is already a political act that "expands the identity of American culture." He "recalled his ambivalence over whether to assimilate or retain his Korean culture. (Should he dye his hair blond or join a Korean cultural club whose members ate Korean food and spoke Korean, but resisted mounting an exhibition Chung suggested on Koreans in America?)" (as reported by Kristine Stiles, *High Performance*, Fall 1988, p. 35).

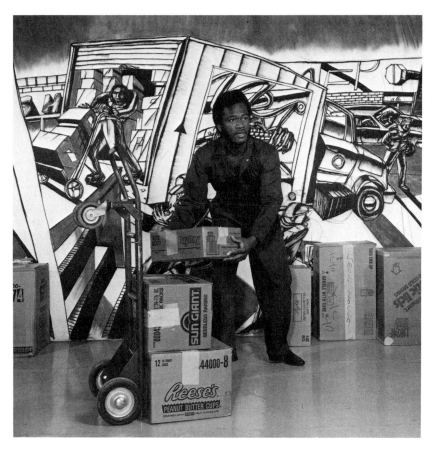

an Uncle Tom or Tomahawk, an Oreo, Apple, Banana, or Coconut (black, red, yellow, or brown on the outside, white on the inside). The divisiveness inherent in all of these internal insults is yet another result of pervasive bias.

The components of bias for or against a "traditionalist" stance include ignorance and deep misunderstanding. Differences in the most basic cultural values regarding objects are responsible for some of the incomprehension. For example, views of antiquity vary considerably among cultures. The old or "vintage" object is revered in many places for its wisdom or for the spirit it incorporates. In the West it is also respected for its financial value. Elsewhere it may be valued for the very process of its creation, rather than for its physical presence. J. V. S. McGaw cites Inuit carvers "to whom only the act of giving tangible form was important, after which the objects themselves tended to be discarded."[75] Nigerian writer Chinua Achebe has written, "Visitors to Igboland are shocked to see that artifacts are rarely accorded any particular value on the basis of age alone. . . . When the product is preserved or venerated, the impulse to repeat the process is compromised."[76]

Igbo scholar Chike Aniakor dispels the illusion that there is no change or invention in traditional art as social change takes place: "it is unproductive to lament changes that reflect current realities. Continuity with earlier forms will always be found."[77] Jaune Quick-To-See Smith points out that a vanishing culture does not make art and that a culture that changes is surviving. Thus, change happens, and always has, but it has the most positive effects when its process is conscious, if not voluntary.

How, then, can development of a consciously intercultural esthetic be reconciled with cultural grounding and modernism/postmodernism be achieved without either total assimilation or the polarization of cultural groups? Ideally, the goal would be a gradual meeting of cultures, in which they are neither subsumed nor forgotten but are instead respectfully and equally recognized in their various degrees of autonomy. Groups working for cultural change and new cultural policies have suggested strategies that will unite people rather than separate them in a process that Arlene Goldbard and Don Adams of the Institute for Cultural Democracy have called awakening a social imagination. "Racism Is a Lack of Imagination; Is Anyone Really White?" queried a graffito in the Black Artists/White Artists (BAWA) installation in Washington, D.C. BAWA is a multiracial discussion group working out of Washington that sometimes performs and makes art together. Actor Rebecca Rice, who is black, says the group "means coming together to surround an issue. It's a tidepool . . . [to] reduce issues like racism to more manageable levels. We hold a mirror to our deformities, and plan for a future without blindness—or at least where blindness is 'seeable.' "[78]

Jolene Rickard is more wary about the possibilities of coalitions with white people: "When I think of us coming together—well, it's about time, but we'll be last on the list. I hate to see it as them against us. So who's 'them'? All the people who aren't willing to share."[79]

Raymond Williams pointed out that most of what we call communication is in fact one-way, or transmission. Risk is made much of in the artworld, but the real risk, real originality, is not just another twist of the picture plane or the creation of something unfamiliar. It lies in venturing outside of the imposed art context—both as a viewer and as an artist, in and out of one's work—to make contact with people both like and unlike oneself. Perhaps the best that can come of postmodernism's shattering of modernism's mirror is the subsequent reevaluation of the artist's role in the reconstruction of a more multifaceted, just, and satisfying society. Here again, cultures excluded from the centers will have a potential advantage; much coalition work is being done between the various excluded cultures, and they know more about those occupying the center than is known about them.

These tentative coalitions being forged between the various so-called minority cultural communities are not only providing a respite from the confrontational aspect of white/other relationships, but are providing tremendous

▼▼▼▼▼▼▼

Together, we can collaborate in surprising cultural projects but without forgetting that *both should retain control of the product*, from the planning stages up through to distribution. If this doesn't occur, then intercultural collaboration isn't authentic. We shouldn't confuse true collaboration with political paternalism, cultural vampirism, voyeurism, economic opportunism and demagogic multiculturalism.
—Guillermo Gómez-Peña, in *The Graywolf Annual Five: Multicultural Literacy*, edited by Rick Simonson and Scott Walker (p. 133)

We have a responsibility to use each other as sources. Because the sources of artmaking in particular have been commandeered into the service of the dominant culture, we end up paying homage to that culture. . . . We are forging a new way, reasserting our voices, redefining language, to make ourselves present. We have to use other sources—and we are those sources. If my first references in the classroom are not a Black artist, a Cambodian artist, a Native American artist, then I am not educated.
—Judy Baca, "Mixing It Up II" (on radio station KGNU, Boulder, Colorado, April 7, 1989)

Fig. 31: Elizam Escobar, *Perfiles en un Álbum (Profiles in an Album)*, 1983, acrylic on canvas, 12″ × 16″. (Photo courtesy Friends of Elizam Escobar, Chicago.) Escobar came to New York from Puerto Rico in the '60s, studied art, taught in the public schools, and worked at El Museo del Barrio. An active member of both the art community and the Puerto Rican independence movement, he was convicted in 1980 of seditious conspiracy and is currently serving a sixty-eight-year prison sentence in El Reno, Oklahoma, where he continues to paint and exhibit nationally despite hostile jailers and difficult conditions. "Our century has proved that reality is much more fantastic than our imagination," he has written, "that the imagination is also a political weapon. And that the struggle is also between one fiction and another fiction." This image was intended to make "visible the experience lovers go through when one of them is in prison. The structure alludes somewhat to a photo album, because in prison an album is a sort of microcosm that substitutes for the real thing. Prisoners literally fall in love with photographs or only have photos of their loved ones." Escobar cites Rabindranath Tagore: "The world and the personal man [woman] are face to face, like friends who question one another and exchange their inner secrets." The spine of the album separates the two like prison bars. Using gesso over acrylic, Escobar made a subterranean map of the faces as though nerves and ligaments (and emotions) could be seen beneath a transparent skin. He points out that just as European art at certain moments in its history was nurtured by non-Western art, today "Latin American art is being nourished by these European digestions and other elements . . . through the lens of specific conditions in Latin America" (quotations from letter to the author, 1989, and extensive catalog: *Elizam Escobar: Art as an Act of Liberation* [New York/Chicago/San Francisco: Friends of Elizam Escobar, 1986]).

emotional support and a broader, kinder buffer zone within which to ally and act. As Amalia Mesa-Bains said of a moment when women artists of color were discussing these issues: "When each woman told her stories, the room filled up with sadness and absolute beauty. We were all the same person."[80] Although that moment—in which what is shared overcomes real differences— cannot last in a world like this one, there is a common ground on which to hope for more such moments. That hope is articulated in the delicate balance between maintaining a cultural identity and participating in the mainstream culture, changing both in the process. The mixing that is happening today in the United States can restore a dignity to the arts that has been denied them for most of the twentieth century.

Fig. 1: James Luna (Luiseño/Dieguéño), *The Artifact Piece*, 1986, installation in the Museum of Man, San Diego, sponsored by Sushi, Inc. In this classic example of art as intervention, Luna, in a leather breech clout, lay sedated in a display case in the section devoted to the Kumeyaay Indians, who once occupied San Diego County; labels unsentimentally explained his scars, resulting from drunkenness and fights. In three glass cases were Luna's personal effects—the accoutrements of a '60s American (albums by the Rolling Stones and Jimi Hendrix, buttons for SDS and the United Farmworkers Union), a significant collection of shoes, and the "medicine objects" used in rituals on the La Jolla reservation where he has lived since 1975—shown with no explanation. By his presence, Luna countered the "vanishing Indian" tone of the rest of the museum with its large collection of Edward Curtis's photographs of Indians dressed up and posed to document their own "disappearance." Luna calls himself a "contemporary traditionalist." He is in fact a healer, working as a counselor on alcoholism at Palomar College and making his art for Native audiences as well as outside, using dependency on alcohol as a metaphor for dependency on the dominant culture. "The art audience perceives my work differently than the Indian audience," he says. "Yet there is an affinity between these worlds, and I try to strengthen it." He sees a direct relationship between purification rites performed in the Sweat Lodge and Alcoholics Anonymous. "I feel like my art is strong as long as I stay working as a counselor. We Indians have survived as long as we have because of our ability to adapt. We still have our healers, leaders, and warriors. It's just that the new warriors are armed with legal, political, and artistic weapons. I am one of the warriors" (quoted in *James Luna: Two Worlds/Two Rooms* [New York: INTAR Gallery, 1989]).

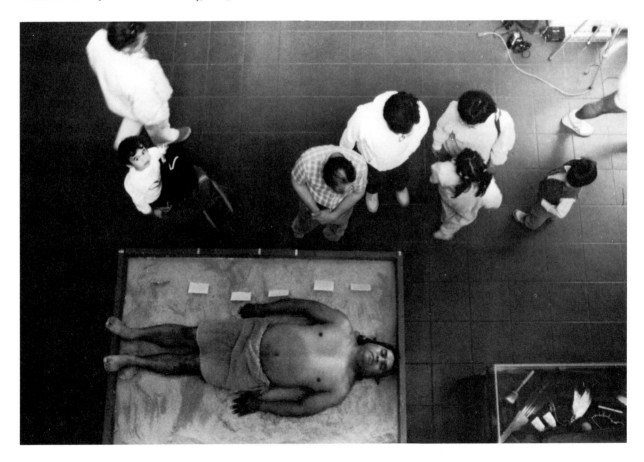

TURNING AROUND

▼▼

As an authorized savage it is my custom and my job to attack.—Jimmie Durham[1]

Those of us on the cultural margin face a couple of extra challenges to give our lives drama and excitement. First, there is the challenge of getting those of you, there, near the center, in the mainstream, to acknowledge our existence, so we can peaceably obtain resources and get on with our lives in this world we share. (*Who, me? Are you talking to me?!*) The moment when we stop being invisible to you is a highly rewarding one. (*I don't know what you mean. I've always liked black people. And anyway, I'm not in the mainstream either. I am an outsider too. No one understands me.*) We may exult briefly in our ability to disturb your epistemic complacency, to shock or rattle you, merely by being who we are. . . . [But] our exultation in your fear can't last. . . . Often it makes you get ugly, and attempt to protect yourself by attacking us with all the resources at your command. . . . We react with shock and dismay: we knew we unsettled you, and thought that noteworthy; but we didn't think we thereby inspired you to blow us off the map.—Adrian Piper[2]

Irony, humor, and subversion are the most common guises and disguises of those artists leaping out of the melting pot into the fire. They hold mirrors up to the dominant culture, slyly infiltrating mainstream art with alternative experiences—inverse, reverse, perverse. These strategies are forms of tricksterism, or "Ni Go Tlunh A Doh Ka"—Cherokee for "We Are Always Turning Around . . . On Purpose"—the title of a 1986 traveling exhibition of Native American artists organized by Jimmie Durham and Jean Fisher. Those who are "always turning around on purpose" are deliberately moving targets, subverting and "making light of" the ponderous mechanisms set up to "keep them in

▼▼▼▼▼▼▼

1. Act like a crazy dog. Wear sashes and other fine clothes, carry a rattle, and dance along the roads singing crazy dog songs after everybody else has gone to bed.

2. Talk crosswise: say the opposite of what you mean and make others say the opposite of what they mean in return.

3. Fight like a fool by rushing up to an enemy and offering to be killed. Dig a hole near an enemy, and when the enemy surrounds it, leap out at them and drive them back.

4. Paint yourself white, mount a white horse, cover its eyes and make it jump down a steep and rocky bank, until both of you are crushed.

—Crow (in Jerome Rothenberg, *Shaking the Pumpkin*, p. 160)

Fig. 2: Ester Hernández, *Sun Mad*, color serigraph, 1981, 22″ x 17″. Hernández is an ex-farmworker of Yaqui-Mexican ancestry who has worked as a muralist and painter, but primarily considers herself a printmaker. "My images are always those of *la mujer Chicana*," she says. "I made the print *Sun Mad* as a very personal reaction to my shock when I discovered that the water in my hometown, Dinuba, California, which is the center of the raisin-raising territory, had been contaminated by pesticides for 25 to 30 years. I realized I had drunk and bathed in this water" (*Chicana Voices & Visions*, n.p.). This popular image, based on the Mexican *calavera*, colored just like the "Sun-Maid" raisin box, has been put on postcards and T-shirts. Hernández has also depicted the Statue of Liberty being carved anew into a Mayan stele, the Virgin of Guadalupe as a karate fighter, and a Pre-Columbian textile with corpses and helicopters. She also makes loving portraits of the women in her farmworkers' community, which are simultaneously complex explorations of the Latina feminine.

their place." In the '80s an increasing number of artists picked up on the black humor that was at the heart of much '60s resistance and on the "decentering" that was projected as the core of antiracist cultural tactics in '70s activist art. Irony and subversion are used strategically to connect past, present, and future without limiting art or audience to one time or place.

Turning around is sometimes just that: the simple (and not so simple) reversal of an accepted image. Something or somebody is stood on its head. Sacred cows are milked. Magic phrases are written backwards and dances are reversed in the tradition of the Sioux *heyoka* (shamans) or the Cheyenne

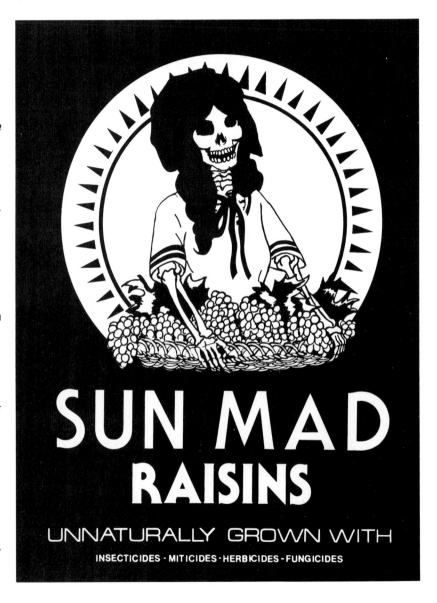

Contraries—warriors who rode backwards, said "hello" for "goodbye," washed in mud. Among the Navajos, witchery is effected by reversing the order and sequence of "beauty"-producing rites. The Latino concept of *rasquachismo* (from a Nahuatl word), or intentional bad taste, is a secular celebration of the breaking of taboos, of extreme disregard for "good taste" and its cultural origins. Robert Farris Thompson identifies another parallel, derived from the metaphoric characteristics of the Mande-kan, in "the style of rap boasts, and the way in which badness is turned inside out," with "stupid" meaning "great"; "def" (terrific) is "derived from death, like the '40s boppers would say: you kill me. You send me to heaven."[3] There are European parallels, as when men in a Spanish *semana santa* procession make obscene declarations of love to the Virgin of Macarena, and there are historical parallels, such as the Roman Saturnalia, in which servants were masters for a day, and contemporary ones like the Brazilian and Trinidadian Carnivals and Mardi Gras, which feature, among other things, a vast display of cross-dressing. These traditions can be seen in part as social valves, a temporary lifting of repression to avoid revolution, to maintain the prevailing social norms. They can also be seen as the seeds of social change, a "gap between ordered worlds" in which "almost anything can happen."[4]

Since their roots lie in the tribal or pagan past, such temporary inversions are not taken seriously today. But they have found a haven in art, where the extent of their devious powers is not always recognized. "Turnarounds" can

Fig. 3: Felix Gonzalez-Torres, *1987*, 1987, type on acetate, 8½" × 11". (Photo courtesy Andrea Rosen Gallery, New York.) Gonzalez-Torres, originally Cuban, a cultural activist, member of ACTUP and the artists' collaborative Group Material, throws out a far-from-random series of names, dates, phrases, and events (international and pop cultural) . . . and waits. It is up to the viewer to draw the connecting lines, which are both political and emotional, despite the spare presentation. We look back from 1987, with hindsight, and understand the net that catches the murders of black children during the Civil Rights Movement, the murders of Vietnamese children, the murders by neglect and homophobia of people with AIDS, the bread and circuses syndrome, and the fact that we reap what we sow (Collect On Delivery). If Gonzalez-Torres's collapsed history recalls the mass media's breathless substitution of headlines for memory, the unexpected juxtapositions are flexible and ironically fertile. These carefully constructed passages examine the social construction of meaning, from the viewpoint of a gay man of color. Gonzalez-Torres, who has also made public art pieces in the same style, has described his work as "a comment on the passage of time and on the possibility of erasure and disappearance. . . . It is about life and its most radical definition or demarcation: death" (statement for exhibition at Andrea Rosen Gallery, New York, January 1990).

▼▼▼▼▼▼▼

The "fool" was originally a human sac-
rifice (also the basis of the Catholic mass).
It was a noble, rather than a punitive role,
since in some primal societies it seems to
have been considered a privilege to be
chosen to give one's own life to prolong
the life of the community. Similarly, the
trickster, the fool, or the clown play a pro-
found role in acting out the communal sub-
conscious. The Eastern Cherokee, for
instance, tried the Booger Dance—their
traditional response to natural disaster, by
homeopathic rituals expressing their own
experience and neutralizing the threat—as
a way to deal with the white invasion. As
Jamake Highwater has written, they "did
not feel sufficiently powerful politically and
pragmatically to cope with white people—
[but they] felt completely competent to
cope with the same whites when trans-
formed by ritual into mythical animals and
grotesquely obscene creatures that invade
the Indian settlement in ritual perfor-
mances." After the dance a "cultural vic-
tory" was celebrated over those who had
defeated them by military means. (Source:
Jamake Highwater, *The Primal Mind* [pp.
145–47.])

be powerful forms of social criticism and psychic change, especially when they
are not institutionalized. ("Turnaround" is a literal synonym for "revolution.")
In modern societies it is most often artists who play the role of the fool, who
are expected to do the unexpected. Sometimes they do succeed in using surprise
and equilibrium to provoke the same sort of unwelcome insights and social
comment that were once the domain of sacred clowns. By reversing stereotypes
of submission, the artists discussed in this chapter are invalidating the external
naming processes that make them outsiders and rediscovering the wicked power
of humor as an equalizer. Their task is not just demystification, but reclamation.

In the religious context, backwards means extraordinary, blasphemous, or
sacred—even, sometimes, when it is the conventionally sacred itself that is
turned around. According to Mischa Titiev, the Hopi regard clowns "as per-
sonages who say and do things that are the opposite of normal expectancy:
this inevitably links them with the realm of the dead, where conditions are
frequently thought to be the opposite of those that prevail in the world of the
living."[5] The clown's profundity often escapes his targets, as in 1881, when
the Zuni parodied the amateur anthropologist and missionary John G. Bourke
as a Spanish Catholic priest and did a urine dance in his honor, during which
they drank urine and ate excrement and dirt. His predictable response: "A
disgusting rite . . . revolting . . . abominable dance . . . vile ceremonial."[6]
Native festivals and dances have historically been attacked in the process of
cultural genocide, until they have finally been reduced to harmless entertain-
ment in the eyes of the dominant culture.

For African Americans, slavery was the school in which lessons in turning
around were learned. African shamanic and trickster traditions were honed to
a high degree of ironic subtlety and double meaning in the face of prohibitions
on speech and religious expression. Some contemporary artists have inherited
the skills of Br'er Rabbit, another Trickster figure. While one side of Houston
Conwill's "Humanifesto" project (see chapter 2) is about home and landing,
about "taking place" in hostile territory, its reverse, or ironic, side was antic-
ipated in his *Cakewalk* installation (1983).

The cakewalk was a dance performed by slaves in competition for a cake.
It has been speculated that it began as a shuffle and gradually evolved into a
strutting, prancing step as slaves began to parody European dance styles.[7] But
this colonized version was rooted in the more ancient and sacred African ring
shout, and with this hidden foundation the cakewalk, presumably invented to
entertain "the masters," became a classic form of cultural resistance, of de-
tachment from and inversion of imposed indignities. Later the cakewalk was
adapted for minstrel shows and performed in blackface, and in the late nine-
teenth century, ironically, it became a popular dance among middle-class
whites.

Today white popular culture continues to skim off the surface of African
American arts for "entertainment" and the subcultures continue to invest them
with subversive meaning. For Conwill, the cakewalk is the embodiment of

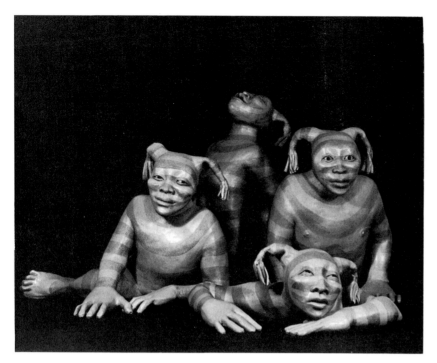

Fig. 4: Roxanne Swentzell (Santa Clara Pueblo), *The Emergence of the Clowns*, 1988, clay with iron oxide and paint, each figure c. 20″ x 12″, Heard Museum, Phoenix. (Photo courtesy Heard Museum.) The clowns, or Kosa, leading the people, are clambering from the Third to the Fourth world. According to the Tewa emergence myth, each one will go off in one of the four directions leading their group of people home. Swentzell grew up around many of the Southwest pueblos and has always been inspired by the clowns. Like all such figures, they make fun of people, but "the difference is the deep seriousness of the pueblo clowns," who play an important role in the balance of creation, reminding people of the path when they stray (quotations from letter to the author, 1990).

the spirit of survival—"high funk," a deliberate contradiction in terms. High means both aloof and flying; funk means getting high by getting *down*—"feeling, working, sweating." It is this type of reversal that allows the dancer to transcend even the "lowest" positions. By elevating the "silly" (an old English word that also has religious roots) and by resurrecting the sound (through color) and smells (through dust) of the past, Conwill's *Cakewalk* installation mapped out a lot of places for the black psyche to rest, and it insisted on acting *out* to other audiences as well—eating its cake and having it too. At the end of the performance that accompanied the installation one night, the audience was invited to join in, to hop, to repeat, like a heartbeat asserting life. Hopping is contagious, and Conwill urged us (the audience) to see its humor, and then challenged us to see the serious side too, to "make a fool of ourselves" by trying it. He called upon the Yoruba trickster figure Eshu, god of the crossroads, known for his mischievous behavior (and like Hermes, the Roman god of the crossroads, also a messenger, bearer of secrets).

Hopscotch, once endowed with ritual meaning (the "heaven and hell game"), is now a children's game, and the cakewalk was initially a trick performed by black "children" to get a treat. In Western culture, hopping up and down is seen as childish and even ridiculous, but this movement is a major element in much indigenous dance, which serves to further mystify it in a racist society. Play, often equated with creativity itself, is the elusive factor that brings all "disciplines" alive. Recently theorists have located play as the home of the outsider, the in-between (sometimes the go-between) "liminal"

▼▼▼▼▼▼▼

It has always been a great disappointment to Indian people that the humorous side of Indian life has not been mentioned by professed experts on Indian Affairs. Rather the image of the granite-faced grunting redskin has been perpetuated by American mythology.

People have little sympathy with stolid groups. Dick Gregory did much more than is believed when he introduced humor into the Civil Rights struggle. He enabled non-blacks to enter into the thought world of the black community and experience the hurt it suffered.

—Vine Deloria, Jr., *Custer Died for Your Sins* (p. 148)

Almost anything can happen in the fictional world of joking, and thus it happens that members of Western Apache communities sometimes step back from the less malleable realm of everyday life and transform themselves into Anglo-Americans through the performance of carefully drafted imitations. . . . If attending to joking imitations of Anglo-Americans can increase our understanding of aspects of Western Apache culture, it can also increase our understanding of aspects of our own. . . . To be sure, Whitemen have stolen land, violated treaties, and on numerous other fronts treated Indians with a brutal lack of awareness and concern. But these are not the messages communicated by Western Apache jokers. Their sights are trained on something more basic, and that is making sense of how Anglo-Americans conduct themselves in the presence of Indian people. . . . Commentaries in caricature about perceived deficiencies in an alien form of human guidedness, imitations of Anglo-Americans are also statements about what can happen to dignity and self-respect when two systems of sharply discrepant cultural norms collide in social encounters.

—Keith Basso, *Portraits of "the Whiteman"* (pp. 3, 6, 81–82)

mortar linking art, politics, and religion. According to Huizinga, all play is either a contest or becomes a contest for the best representation of something, and old rituals are revitalized in this process of "ludic recombination."[8] Play is chance and change, satire and mischievous insurrection, operating in every culture, but perhaps the hardest element to understand in anyone else's culture.

In Native American art, degrees of oppression are often indexed by degrees of subversive hermeticism, a natural strategy for a people whose secrets have been so grossly abused. Over the last century, Native societies have developed some elegant—if far from foolproof—means of dealing with the incursions of change and opposing value systems. The extent to which Indian art has long been snickering behind the backs of whites has rarely been acknowledged, either by the targets or the perpetrators. One side prefers to think of Native American people as wafting around in a permanent state of spiritual uplift—despite the realities of genocide, cultural racism, the thefts of identity as well as land and water rights, alcoholism, and domestic violence—while the other side may have considered hermeticism both strategic and convenient.

I have to admit to surprise when I realized that Native American art offered many of the most subtle and complex models of subversion. Why? Had I swallowed the crippling romanticism that is encouraged even by some Indian groups? Given the miraculous, if painful, survival of this once-doomed one percent of the population, the current revival of Native-based spiritual politics and the disproportionate influence (for better and worse) it is beginning to have on the alienated Euro-American population should be no surprise. As Jimmie Durham says:

To be an American Indian artist is quite possibly to be more sophisticated and universal than many white artists can manage, for what should be obvious reasons. . . . It would be impossible, and I think immoral, to attempt to discuss American Indian art sensibly without making political realities central.[9]

Certain messages are just becoming apparent to outside observers. A deceptively gentle sarcasm is revealed as a weapon for the long haul. It allows apparently decorative elements to pass as such, even when they shelter more profound meanings. (For example, Jolene Rickard's apparently conventional photo portraits of Indian people, when scrutinized, reveal tiny, red painted symbols that have specific meanings to her Tuscarora audience.) Jaune Quick-To-See Smith cites beauty and humor as the Indian person's most effective political tools:

In the most oppressive times in our history, we have produced some of our most illustrious work. When all else in our lives has failed, our ability to produce beautiful work has been the sustenance that carries us through. That process takes us to an inner world, uplifts our spirit and nurtures our soul.

Humor is a tie that binds tribe to tribe. Humor has been a panacea for what ails. The women tend to express their humor in a more subtle way than the men (who are often more blatant and slapstick). . . . Indian humor is known to be sardonic, sometimes sinister, and it always appears in unlikely places. . . . Humor is considered to have a role alongside the art forms, the landscape, storytelling and religion. Humor is a mainstay of Indian life.[10]

In the native legends of many nations, play or "turning around" is the function and domain of the Trickster—caught and skinned many times by scholars who have both claimed him as the epitome of Native religion and rejected him as yet another white invention. He eludes them with unattractive wiles, and is perceived with fascination and disgust by a puritanical and some-times prurient academia. Raffaele Pettazzoni, working with the Pawnee in the '40s, pointed out with some satisfaction that the Coyote stories were not true myths, but false ones, consisting as they do of "frauds, practical jokes, intrigues, lies, traps, swindles, deceits, thefts, lovemakings, fornications, and vulgarities of every kind."[11]

Hare or Coyote, or any other Trickster figure, is not yet a stuffed animal. Anne Doueihi has offered some insights into the reasons why Trickster is such an embarrassment to Western scholars. She says the main problem seems to be "the fact that a figure apparently so secular and at times almost evil should constitute part of a sacred mythological tradition." In one theory after another, she says, Trickster is "bounced back and forth, stretched and twisted so as to fit within the framework staked out by the discourse of domination by means of which the Western world, scholars included, distorts and suppresses its Other." Yet revenge is at hand. Trickster is not to be trapped in the Western context, which itself ultimately becomes "the victim of a not untricksterlike joke . . . set up by the undecidable coexistence of story and discourse in every trickster narrative. . . . For what is the story but a trick played by the discourse of Trickster?" The text that conquering scholars seek to decipher is in fact already being unraveled from within. "Trickster, in his story-cycles, embodies the power of language to make meaning possible . . . the power of signification." Deploring the naively reductive ways in which the Trickster narratives have been approached, Doueihi points out that

> quite in accord with deconstructionist criticism, interpretation of stories among American Indians is an endless activity: Divergent readings coexist without being perceived as mutually exclusive or contradictory, since interpretation is always local, specific, and personal, and does not pretend to present, explain, or solve the problem of the text's final, single meaning.[12]

Trickster is the model for Indian artists who seem only to be chuckling, if sarcastically, but intend the most drastic subversion. He (or sometimes she) appears in the guise of the conquered savage, the down-and-out drunkard who

▼▼▼▼▼▼▼
Some take up the tribal invention to survive, but not me, never. For me, sepa-rated from the sacred, but skeptical about tribal fundamentalism, terminal creeds, and political spiritualism, personal power lurks in secrets and trickeries. Secrets become my mythic connections to dreams; tricker-ies my balance between absurdities.
—Gerald Vizenor, *Earthdivers* (p. 108)

▼▼▼▼▼▼▼

Comic irony sets all cultures side by side in a multiple exposure, causing valuation to spring out of a recital of facts alone, in contrast to the hidden editorializing of tongue-in-cheek ideologists.
—Alfonso Ortiz

The comic frame should enable people to be *observers of themselves, while acting.* Its ultimate would not be *passiveness,* but *maximum consciousness.*
—Julian H. Steward

Irony is the element which turns criticism into myth.
—Octavio Paz (all three quotes from Barbara A. Babcock, "Arrange Me into Disorder: Fragments and Reflections on Ritual Clowning," in *Rite, Drama, Festival, Spectacle: Rehearsals toward a Theory of Cultural Performance,* ed. John J. MacAloon [Philadelphia: Institute for the Study of Human Issues, 1984, pp. 115, 123])

"can't adjust" as the object of murderous charity, as well as in the guise of the successful professor or businessman who seems to have learned the trick of adjusting; both may resort to a bag of tricks at any moment. Coyote—the best known Trickster avatar—is the Indian who isn't good because he won't stay dead. Sometimes he's even red.

In the paintings of Harry Fonseca (who is Maidu, Portuguese, and Hawaiian), Coyote comes in disguises that expose the new clothes of both Indian and Anglo emperors. He's a street kid in a flashy, bestudded leather jacket ("Coyote likes anything that shines"),[13] the star of the opera *Aida,* of the ballet *Swan Lake,* a honky-tonk hero, a Hollywood/cigar store "Indian Chief" in Plains headdress and black hightop sneakers, and a booth holder at the Indian Market, featuring the work of fellow Native artists Gail Bird, Yazzie Johnson, and Jody Folwell. In *Snapshot, or Wish You Were Here, Coyote,* the Trickster in tropical shirt and sandals poses in Taos or some other pueblo, complete with ladders and domed adobe ovens. "He has played a mirror joke, for we are laughing at ourselves."[14] Such mirror jokes are played more often than we realize. Sometimes Coyote is a woman. She might be the hip contemporary Indians in Jean LaMarr's prints, with their mirrored sunglasses that reflect toxic dumps, or a missile and a bomber, as well as reflecting those looking in, looking for their representational object, while the hidden subject looks out, protected. As Allan Rodway has written about such double vision, irony is "not merely a matter of seeing a 'true' meaning beneath a 'false'; but of seeing *a double* exposure on one plate."[15]

Few Caucasian artists, not even Marcel Duchamp or Joseph Beuys, have risen to the challenge offered by the Trickster strategy. It is an uncomfortable seat, a rough ride reserved for the Other. The Trickster is the undefeated skeptic, not a cynic. His or her humor is at once arrogant and self-deprecatory, or at least defensive-fast-becoming-offensive. It suggests that to laugh at others one has to know how to laugh at oneself, or that the laugh can be a double-edged blade in its reckless irony. Nothing is sacred, nothing is safe from the invasion of death-dealing laughter wielded by artists who have so little to lose they're ready to change the world.

If there were other deities who balanced Trickster's sharp edges, they are dimmed now by the brutal suppression of indigenous religions. Trickster has survived as the god for our time—a "seemingly polymorphous and uncentered persona" who does not own the world, "but inhabits it creatively," as Jean Fisher puts it:

[He is] as adaptable to change and adversity as the classical Western hero is fixed in his tragic search for the Absolute. . . . Trickster presents a life model that speaks not with an "imperative" voice bounded by the either/or logic, but with a polyphonic voice characterized by ambiguity and paradox. Instead of attempting to resolve the contradictions of life into idealized abstractions, it speaks from within contradiction and is thus closer to lived experience.[16]

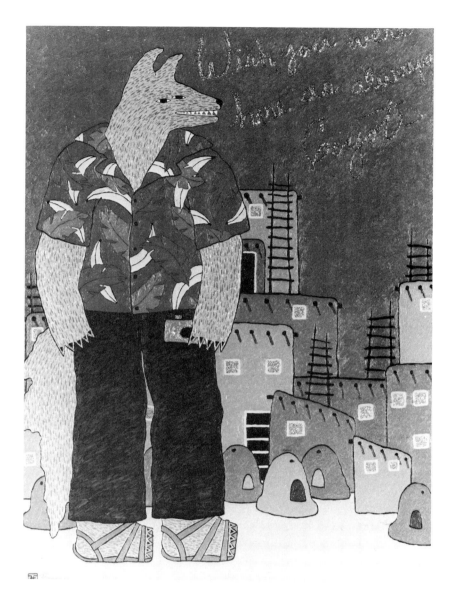

Fig. 5: Harry Fonseca, *Snapshot*, or *Wish You Were Here, Coyote*, 1979, acrylic and glitter,
48″ × 36″. Collection Mr. and Mrs. Thomas B. Coleman, New Orleans. (Photo Courtesy Philbrook
Museum of Art, Tulsa.) Fonseca, who is of Maidu, Portuguese, and Hawaiian descent, has spe-
cialized in bringing Coyote and friends into modern life. These works developed from traditional
Maidu spirit impersonator dances. Then Coyote "symbolically left his rural reservation to become
an important representation of the urban Indian" (Margaret Archuleta, *Coyote, a Myth in the
Making*, National History Museum Foundation, 1986, n.p.). "For me," says Fonseca, "Coyote is a
survivor and is indeed the spice of life." Here the often funky Coyote is disguised as a straight,
white tourist in Taos, complete with sandals, Hawaiian shirt, camera, and awkward snapshot
pose. Written across the sky in glittering letters is "Wish you were here, as always, Coyote."

What could be more "postmodern"? Not in the strictly deconstructive sense, nor in the reconstructive sense, but in the spirit of process, toward radical change. Coyote's humor is a strategy that the Dadas entertained with great success in the artworld, although it never helped to dry their tears for the rest of the world. Similar tactics were, less entertainingly, tried out by the working-class punk movement in England and by its middle-class U.S. progeny in the early '80s. The capacity for recognizing and enjoying paradox is curiously underdeveloped in contemporary North American Euro-American culture, which is not to deny its own rich humorous tradition. Our fundamental puritanism, our far from universal affluence, and our media cushion shield many of us from the contradictions the rest of the world is better acquainted with. The mainstream is further hampered by ignorance, by a false assumption of naiveté and innocence in work by the "Other." Frustration results when "We" don't know where we are around "Them," because they are always turning around on purpose.

Cherokee sculptor Jimmie Durham (plate 33) epitomizes the irony and ferocious humor of "turning around" in contemporary art.

Coyote, who invented death and singing, was the spirit who gave me my name. . . . This is what he gave me as a namegift: that I would always see whatever was dead if it were within my field of vision. For more than 30 years, I have seen every dead bird and animal every day wherever I am. So it became necessary to see if that was a usable gift or just a dirty trick that would drive me crazy.[17]

A little of both, as it turned out. Durham considers art "a matter of life and death and singing"—the title of a 1985 one-man show. Like Coyote, who gave him his name, he wears many hats. He is "not just" an artist, having been a founder of the American Indian Treaty Council, member of the executive committee of the American Indian Movement, a water rights activist, a poet, an essayist, a cowboy, a mechanic, an arts administrator, a performer, a polemicist, a rabble-rouser. Durham is currently living in self-imposed exile in Mexico, and distance has not improved his view of El Norte.

We are often asked the question, "What did the Indians eat?" as though we had quit the habit a hundred years ago. In fact, we are not part of your "rich cultural heritage." You did not inherit us or our history.[18]

Durham's work—which he wryly categorizes as "neo-primitive neo-conceptualism"—worries those who like wrap-ups, or closure. Just as Trinh T. Minh-ha deconstructs traditional ethnographic methodologies in her film *Reassemblage*, Durham constructs his sculptures of familiar materials reassembled in unfamiliar ways, parts related to the whole very particularly. In his poem about Sequoyah, the Cherokee leader who created a written alphabet, who was "so smart [they said] his father must have been some white guy," who

was murdered and then had a tree named after him, Durham wrote: "Sequoyah explained arrows: An arrow cannot be said to have parts because the parts are all something else until purpose connects them."[19]

Durham's sculptures are usually made of wood—natural or barbarized by usage (like a police barrier)—and of something dead, an animal's skull or bones, a human skull, some stones and shells and fur and feathers, a little paint. He uses materials that have become clichés in contemporary art, materials that are used to make good art and bad art, poetic art and dumb art. But when he puts these parts together they don't become lyrical or nostalgic for an ecological or spiritual connection to the past. Instead, they bite. Those bared teeth are not just for shows. The sum of the parts is an unconsummated union. The artist has cast a spell on them, denying rest to the bones and fur and shells, condemning them to more life, in anger and pain and action.

Nevertheless, those open jaws are laughing too. The laugh and the bite are a single grimace. The police barrier in *Tlunh Datsi* is surmounted by a shaman's panther skull and stenciled with flowers—perhaps a reminder of the counterculture's failure to get beyond the surfaces, and the fear instilled by panthers, black or gray. *Nigal'sti'stungh* is topped by a laughing coyote skull, a horned steer's skull between its wooden legs for virility, deceptively "kneeling." In a 1987 performance Durham solemnly told Coyote stories. When a white man in the audience began to heckle with racist comments, some horrified audience members were about to kick him out of the room when Durham wryly revealed that he was part of the performance. (Durham associates Bertolt Brecht with Coyote.)

One of Durham's most ironic and effective pieces was a 1985 performance called *Giveaway*, in which he told stories against a slide backdrop that began with "Trends in Indian Land Ownership"—a series of maps charting the white invasion of the North American continent. The piece was, therefore, more about loss than about gain. Having symbolically lost his communal shirt, Durham then proceeded to give everyone in the audience a gift—a handsome traditional ribbon shirt, a woven vest, stones, feathers, and postcard announcements of his shows—saying these were things he had gathered in his life, emphasizing the still-integral role of the "giveback" in Native culture. The uneasy feeling of guilt in the mostly white audience, as we participated in yet another takeaway, was tangible.[20]

As his reputation has risen in the last few years, Durham has been exhibiting two main bodies of work. The first are the sculptures described above—conventional art objects that seemed to resist the conventions surrounding them. However, they are now endangered by their beauty, and Durham is tempted to halt this series because it is too easily assimilated into the dominant culture's image of Indian art. The second—almost caricatures of the art he so clearly respects—are sometimes scrawled, messy, deliberately incomplete, interrupted, and almost-childish because a "savage" can't (or won't) make "fine" art. Begun in the mid-'80s, the ongoing series "On Loan from The Museum of the Amer-

▼▼▼▼▼▼▼
I do not want to deprive you of decent amusement or occasional feast days, but you should not do evil or foolish things or take so much time for these occasions. No good comes from your "giveaway" custom and dances, and it should be stopped. It is not right to torture your bodies or handle poisonous snakes in your ceremonies. All such extreme things are wrong and should be put aside and forgotten.
—Charles Burke, Commissioner of Indian Affairs, "A Message to All Indians" (National Archives, Feb. 24, 1923)

Fig. 6: Ron Noganosh (Ojibway), *Lubicon*, 1988, mixed media, 12' x 8'. (Photo: Roland Blassnig.) Noganosh is a Canadian living in Ottawa, a member of the Om niiak group. This installation refers to the Lubicon Cree of Northern Alberta, whose lands have been appropriated by oil companies amid a bitter land dispute that has lasted fifty years. It might also refer directly to the words of the Lubicon leader, Bernard Omniak, who has said, "Our culture is being glorified by the same people who are doing the damage to the Native people in our area. . . . I think a lot of times our people would be far better off if someone came up to them and got rid of them instantly. Anything so we wouldn't be dying a slow death" (quoted by Guy Brett in *Third Text*, spring 1989, p. 90). The word "Lubicon" is spelled out in liquor bottles against a hugely enlarged fragment of the Canadian flag, while a traditional Woodland beaded garment with a plastic skull lies before it on a burial platform made of branches. Liquid flows from bottle to bottle and into the skull through an intravenous tube, "but this is no medicinal cure. Instead it merely drains through. . . . The strangely soothing sound of the 'waterfall' is interrupted by a taped soundtrack of laughter, which stops suddenly and becomes the sound of crying, stops again, and so repeats itself like the history to which it refers" (Karen Duffek, in *Beyond History*, p. 37).

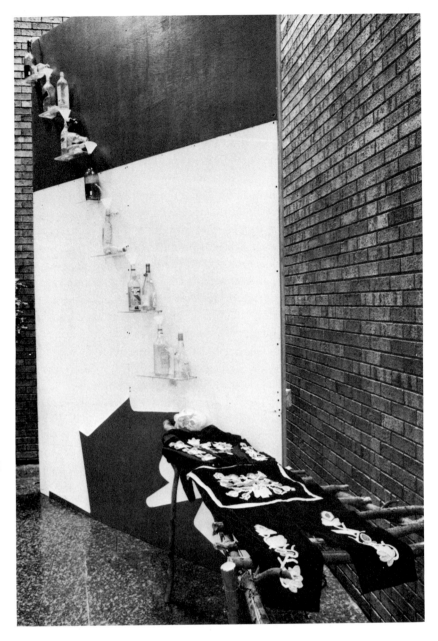

ican Indian" casually parodies the didactic forms of presentation characteristic of small museums. Satirical "sociofacts and scientifacts" about Indians expose the underlying misinterpretation and the distorting power of the didactic caption. Fragments and fake artifacts of a modern Indian's daily life are laid out with pompous labels ("An Indian's Toothbrush . . . Pocahontas' Underwear . . . This exhibit sponsored in part by the Sir Walter Raleigh Tobacco & Firearms Corp. and the John Jacob Astor Animal Skinning Co.").

Durham's "irreverence" (which is in fact reverence for a different set of values) mirrors that which is revered by a strictly materialist society. Even as he mocks official styles, he mocks himself and his production. This mixture of ferocious self-doubt with an impetus to self-determination gives a unique edge to his 1986 *Self-Portrait*—a flayed, full-body nude, a red "skin" (a hide, or hiding), hung on the wall like a hunting trophy, or a crucifix. A red star is branded on his forehead, fish are stenciled on his thighs, and he has "large and colorful" genitals, seashells for ears, bits of animal fur for hair, one turquoise eye ("just to show a little Indianness"). An open chest cavity reveals some feathers, which imply a certain "light-heartedness."

Whatever he does, Durham feels he is pursued by the voracious appetites of the dominant culture, which wants not only his land, his art, and his culture, but his soul. As prey and as artist, he has decided to set an erratic course, to double and redouble, engage and separate. He sees the struggle to maintain culture as a revolutionary effort. His use of discarded objects reflects on a dysfunctional society in which large sectors of the population live in a permanent state of denial, while others live in permanent poverty.

Two of Durham's works from 1984–85, *Bedia's Muffler* and *Bedia's Stirring Wheel*, employ remains of automobiles in a complex science-fictional archeology that does not mourn the passing of the Plane White People. Old vehicles have acquired a special aura in contemporary Indian art. When Jolene Rickard made a photo series of abandoned pickups beside houses on the Tuscarora reservation, she explained that they had the status of a retired but honored old horse or wagon, respected for a lifetime's work. In 1984 Ron Anderson, a Chickasaw/Choctaw from Anadarko, Oklahoma, wrapped a funerary blanket around his retired 1969 Mercury Cougar and elevated it on a traditional Plains burial scaffold. Dwight Billideaux, a university-educated Blackfeet sculptor living on the Flathead reservation in Montana, made a 16-foot Indian figure from the parts of a '56 Malibu he had bought from the telephone company, from whom he then liberated some telephone cable to complete the piece (now in the courtyard of Salish Kootenai College).

The role of activists and artists is to reveal such off-center views of the world. In 1986 Luiseño/Digueño James Luna performed his "Artifact Piece" at the San Diego Museum of Man, including himself as part of a display on "the contemporary Indian." Outrageous as this may appear, it was not without precedent. On August 29, 1911, a Yahi Indian named Ishi, who had been living in total isolation, the last of his tribe, was captured near Oroville, California, and brought to live at the Museum of Anthropology at the University of California, Berkeley, where, until his death in 1916, he demonstrated crafts and taught his language and customs to anthropologists.[21]

In 1987 Durham and Fisher curated a second exhibition of Indian art, "We the People," at Artists Space in New York. The title pointedly referred to the Iroquois Confederacy's constitution, borrowed in time by the United States, and the show commemorated the peoples whose rights did not survive that

▼▼▼▼▼▼▼▼

Don't worry—I'm a good Indian. I'm from the West, love nature, and have a special, intimate connection with the environment. . . . I can speak with my animal cousins, and believe it or not I'm appropriately spiritual. (Even smoke the Pipe.) . . . I hope I am authentic enough to have been worth your time, and yet educated enough that you feel your conversation with me has been intelligent. I've been careful not to reveal too much: understanding is a consumer product in your society; you can buy some for the price of a magazine. . . . Once you've bought some understanding, it's only natural to you to turn it around and make a profit from it—psychological, economic, or both. Then you'd get even fatter, more powerful. And where would I be?
—Jimmie Durham, in *Artforum* (Summer 1988, p. 101)

▼▼▼▼▼▼▼▼

We, I believe, are a very gifted society, but it takes objective and constant thought to rise above the mundane, the coarse, and thereby sense the special and meaningful aspects of our heritage. The songs, the children, the humor, the ritual, the straightforward commonsense approach—these are what I like.
—Peter Jemison (Seneca), in *Ni Go Tlunh A Doh Ka* (p. 22)

Fig. 7: Ron Anderson (Chickasaw/Choctaw), *The Killing of a '69 XR-7*, 1984, Mercury Cougar with wood, cloth, glass, rawhide, feathers, mixed media, c. 30′ high, near Varden, Oklahoma. (Photo: Bob Albright, *The Daily Oklahoman*.) The car was wrapped in a funerary blanket, placed on a traditional Plains burial scaffold, and left to decay in nature. The piece is actually a protest. The car was Anderson's transportation, and his child was born in it. When it was totaled by a drunk driver, the insurance company refused to replace it. As Rennart Strickland has written, "this was tantamount to stealing a man's horse and leaving him footbound out on the prairie. [The burial] makes a poignant statement about the necessity for mobility in both Indian and contemporary white society" (*The Arts of the North American Indian*, p. 302).

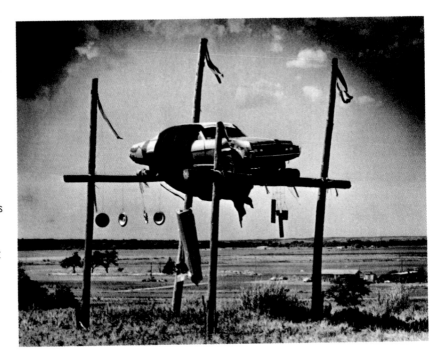

loan. The title added another level by referring to the fact that the real names of many of the two thousand Indian tribes then living in North America were words in their own languages meaning "the People." Fisher stated the aim of the exhibition:

> not to provide white audiences with revelations about who the people "really" are; Native Americans are wise to the fact that whatever is given to white culture is either consumed by it or used as ammunition against them. Not surprisingly, we find that they have withdrawn to a firm and sometimes none too polite distance, and that what they present of their circumstances tends to reveal more about our own attitudes. Either implicitly or explicitly, the work in the exhibition addresses how white culture perceives, and is perceived by, "Indians." And as we look at them gazing at us looking at them we might be just a little uncomfortable that our gaze, so long concealed behind a dissembling rhetoric or a monocular lens, is capable of being turned back on us.[22]

The dominant culture may not have paid much attention, but that gaze has been returned for some time, as in an often-reproduced 1946 watercolor by Creek/Potowatomi artist Woodrow Crumbo titled *Land of Enchantment*, which turns around the New Mexico state slogan. A Navajo mother and daughter stand by the roadside selling a rug and pots, confronted by a grotesque and oversized white tourist family, all of whom wear glasses (one a lorgnette) with which to scrutinize the natives. A less overt, but no less ferocious indictment is Navajo Grey Cohoe's *Tall Visitor at Tocito* (1981), which takes

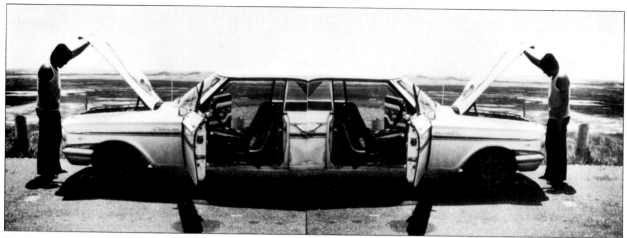

Fig. 8: Pena Bonita (Apache/Oklahoma Seminole), *Stalled . . . Again!*, 1988, color photograph with oil paint, 30″ x 40″. Bonita, who studied at Hunter College, is a printmaker, art therapist, and theater designer in New York. She has used this striking image in many different ways, repeated twice or a hundred and one times, reversed, turned into a ten-dollar bill, or rendered political-religious by the addition of a large wooden cross next to the standing man. It was inspired by "long years of experiencing the struggles of coping with indigenous properties. Universally when people find money hard to come by they share the common fate of old cars. Cheap, they are bought with such high hopes. They are constantly tinkered with, repaired, coached, begged, coaxed, kicked, petted, cussed and finally abandoned to start again with another model." Reminiscent of the film *Powwow Highway*, these journeys "can later be great yarns to tell over and over for amusing all warriors." Repetition of the image is a reflection of the frustration, humor, and unexpectedness of "these experiences which the years don't dim." "I've noticed when people view the work they talk, laugh and share. They seem to understand immediately," the artist says (letter to the author, 1990). One mysterious detail: as though drawn on the ground by the man's foot there is a six-circled glyph—the plastic top of a six-pack.

▼▼▼▼▼▼▼

One of the monuments of turning around in contemporary art is a little-known narrative film by Richard Weise and Gerald Vizenor called *Harold of Orange*. Harold (played by the consummately witty and highly educated Oneida comedian Charlie Hill) and his Warriors of Orange beguilingly con the more or less well-meaning asses on a foundation board with their economic development schemes (miniature oranges harvested "in a secret sacred place," which can't be revealed and doesn't exist; a fantasy pinch-bean coffee plantation and a string of coffee houses to wean Indians from alcohol). With his "school of social acupuncture," Harold is the fully up-dated, if not futurist, trickster. The script is full of cross-cultural jabs, subplots, and reversed clichés. "How many Indians were here when Columbus discovered America?" asks an innocent board member. "None," replies a warrior. At a softball game, the Warriors of Orange wear "Anglo" team shirts; the Anglo board wears "Indian" shirts. Harold wears both shirts, so even after letting the "Indians" win, he can't lose. Although there has been some criticism of the film's view of Indians as con-men, the protagonists' triumphant wit and wits would seem to allay such fears.

aim at the white "Lady Bountifuls" from the Mission Board or Arts and Craft Commission. An almost androgynous figure with curls, masses of Indian jewelry, and a squash-blossom belt around her wide girth, she towers over a Navajo woman, who looks up at her either beseechingly or, more likely, critically. Kiowa/Caddo T.C. Cannon's *The Collector (or Osage with Van Gogh)* is another classic reversal, depicting a confident, traditionally costumed elder in an arm-chair, showing off his Western masterpiece.

George Longfish plays games with the titles of country-and-western songs in his mostly abstract paintings, such as *Mama, Don't Let Your Sons Grow Up to Be Cowboys*, or *You Can't Rollerskate in a Buffalo Herd Even If You Have All the Medicine*. Randy Lee White has restaged the fall of Custer with vintage Chevrolets in a parking lot, in the style of the nineteenth-century "ledgerbook" drawings (in which the narrative paintings of Sioux tepees were adapted to the notebooks given imprisoned warriors). A play, in turn, on "ledgerbook"

art is Rick Glazer Danay's *Indians Are My Favorite Hobby*, an oil painting that simply reproduces a looseleaf notebook page with an actual third-grade writing assignment in a child's precarious printing:

> My favorite hobby is Indians. I like to read about them very much. I collect books about them and also plastic ones that I play with. Last summer my parents took me to where they live. It's called a reservation. We saw many Indians there. They danced and sang songs. My mom bought me a painting from a real Indian for thirteen dollars. It is haning [sic] in my room. Indians are a fun hobby.

Native American writer and activist Paul Smith has commented from the front lines on this syndrome with observations all the more devastating for their apparently casual tone:

> Here's what I can't figure out: Why can't Americans hate us? Here we are, a constant reminder that this country is profoundly evil, born in unspeakable crimes, we're often drunk, still refusing to assimilate, poorly educated and not worth a damn when it comes to forestry, and most Americans still like us. A lifetime of being Comanche and years of being a political activist and this still leaves me baffled. . . . I don't remember seeing too many Israelis grooving out on Arab culture. In fact, it probably would have seemed, well, a little inappropriate. Or look at South Africa. Do white South Africans take their families on vacation to black homelands? Teach them Zulu legends? . . . Maybe a new aesthetic requires a certain amount of flat-out hatred to develop.[23]

Mirror-writing, in the spirit of the contrary warriors, is a prime device with which to "get back." (A Native American art campaign to "decelebrate" Columbus's quincentennial in 1992 is called "Submuloc.") It is a feature of the searing conceptual art of Cheyenne-Arapaho Edgar Heap of Birds, who works out of Geary, Oklahoma. Having studied, traveled, and lived in continental Europe, London, and Philadelphia, Heap of Birds returned to his reservation in the '80s to acquire a concrete experience of his culture. He moved into "a little bitty cabin on a ridge" and began to hunt quail (which he had never done as a child) and to learn the traditional ceremonies, including Sundance, "so I could be an Indian artist" (implying that this was impossible otherwise). To emphasize this willed continuity, he is often photographed with members of his family, with his son Hoestevha (Fire Standing Up) or his grandmother, Lightning Woman. He is a member of the traditional Elk Warrior Society, and his textual art coexists with abstract paintings that reflect the overlapping and colliding rhythms of daily life and landscape.

Combining historical and geographical detail with quizzical, admonitory messages, Heap of Birds' unembellished texts leave gaps that refer to and bounce off social gaps and outrages. In the 1984 *Don't Want Indians*, for instance, the word NATURAL is literally turned around at the top of the broadside; centered

▼▼▼▼▼▼▼

They from the beginning announced that they wanted to maintain their way of life. . . . And we set up these reservations so they could, and have a Bureau of Indian Affairs to help take care of them. . . . Maybe we made a mistake. Maybe we should not have humored them in wanting to stay in their kind of primitive life-style. Maybe we should have said, "No, come join us. Be citizens along with the rest of us." . . . You'd be surprised. Some of them became very wealthy, because some of those reservations were overlaying great pools of oil. And you can get very rich pumping oil. And so I don't know what their complaint might be.
—Ronald Reagan, at Moscow University (quoted in *Time*, June 13, 1988)

below is an unenigmatic sentence: "We don't want Indians / Just their names / mascots / cities / products / buildings / LIVING PEOPLE." *Native Is Pain and You're Part?* is the title of a work calling attention to economic injustice. To commemorate the 1868 Washita River Massacre, he created a cinematic glimpse: "Death From the Top / Forget / Forgot / Sleeping Children / Running Children / Murdered in the Water."

Heap of Birds contends that the Native American art accepted in the mainstream is "that which fulfills the comfortable fantasy held by the non-Indian." Focusing on the differences in whites' and Native peoples' relationships with all other living things, including the earth itself, Heap of Birds has developed a subversive language from the vocabulary and the art styles of European traditions. He subtly (and sometimes literally) turns them around to refer to another kind of abstraction, giving them a concreteness that reflects the natural forces and places that define Indian identity. By comparing "he said," "she said," and "it was said," for example, he questions the validity of histories written from secondhand or nonexistent contact, and takes into account the dynamism of relationships to the land which cannot be pinned down into the romanticized stereotypes of Indian art and life so popular in white culture.

In his 1985 exhibition "Sharp Rocks," Heap of Birds used the metaphor of the arrowhead to confront the ongoing aggression of whites against Indians, pointing out that the original "sharp rocks" were used "for defense and as tools of preservation through hunting game animals." Today, Native peoples must defend themselves against hostile educational institutions and the electronic and print media, requiring the "modernization" of their expressive and communicative weapons to ensure survival.

The distinction between Heap of Birds' language art and that of most mainstream conceptual artists is precisely that the insurgent messages, rather than existing primarily as isolated linguistic references or mixed signals of alienation and anger, have a specific social and communal purpose. Heap of Birds feels that the most serious problem facing Native peoples today is "misrepresentation and the lack of opportunities . . . to comment on their own condition themselves." So in his art, he uses the language in which he has been forced to think to force people in turn to think about how that language has been used as a social weapon. At times he uses his own language to remind the dominant culture that there are thoughts it cannot manipulate.

He points out the irony of the word "Cheyenne," which is a mistaken form of a Lakota word meaning "unintelligible speech." Having taken upon himself the task of rendering a newly intelligible speech, he also enjoys renaming the white man Vehoe, or spider. (His own name was originally translated as "Many Magpies.") He has confronted issues as wide-ranging as nuclear and toxic waste dumping (*What About War?* [1985]) and the sexual ambiguities of modern life (*What Makes a Man?* [1988]). In his 1987 show at New York's

Fig. 9: Rick Glazer Danay (Caughnawaga Mohawk), *Missionary Headrest*, 1978, oil and enamel on wood, 12″ x 9″ x 9″. Danay takes on white patriotism and taboos in the light of a relaxed Indian sexuality. Here a couple is locked in intercourse on the "underside" both of his arched form and of hypocritical religions. Superheroes and Asian maidens overlaid with lipstick kisses and surmounted by a sexually adorned preaching platform suggest the erotic values that the Puritans had to confront in their attempt to convert the Third World. Danay is an urban Indian, born in Coney Island, a former high-steel construction worker who often paints on hard hats (an update of the nineteenth-century Iroquois beaded cap) and other found objects. In bright colors, exuberant patterns, pop cultural imagery, and a conglomeration of cultural symbols, he uses politics and eroticism to make humorous and ironic points about centuries of repression. Danay is now chairman of the American Indian Studies Department at California State University at Long Beach.

Fig. 10: Richard Ray Whitman (Yuchi/Pawnee), photograph from the "Street Chiefs Series," 1988. Whitman is from Oklahoma. He attended the Institute of American Indian Arts and the California Institute of the Arts. He began this series on homeless urban Indians to combat the romantic image of the Edward Curtis/Hollywood Indian. "The contemporary Indian in the isolation of city canyons and rural reservations is avoided," he writes. "The boredom, pain, frustration, poverty of the reality-counterbalance of our lives is harsh, unattractive, and unmarketable." He cites the way Indians have been placed and displaced over and over for the sake of "progress" and profit. "The United States is built on displacement. . . . We Indians have always been subject matter, ethnomaterial. By being behind the camera, I reveal something of my own identity as well as the identity of the subjects: the street chiefs, the tribes, the Indian nations." By taking the camera into his own hands, Whitman also empowers himself to act, aware at the same time that taking photographs has always been controversial for Indians "because the mass media has been used against us as a means of control, oppression, subjugation. . . . Of course the photographic convention, no matter who is behind the camera, has limitations: the split-second image, the time/space continuum, the illusion of capturing the moment, the illusion of control . . . but life is not static." Finally, however, the "Street Chiefs Series" is about "the ultimate paradox of the host people Native Americans being homeless, landless in our own homeland." (Quotations from letter to the author, 1989, and *Edgar A. Heap of Birds, Richard Ray Whitman*, Nave Museum, Victoria, Texas, 1989, n.p.)

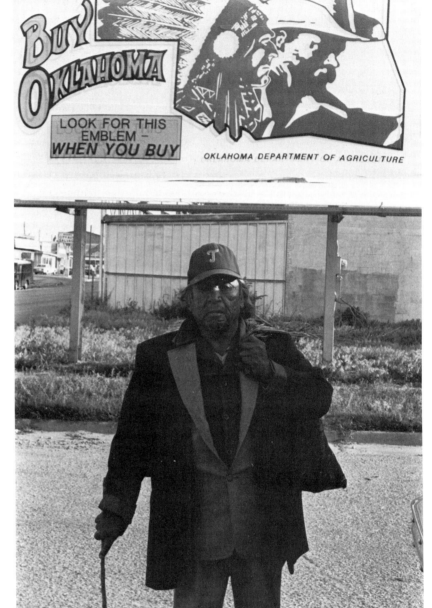

American Indian Community House Gallery—"Heh No Wah Maun Stun He Dun / What Makes a Man?"—Heap of Birds related language to an examination of the personal politics of manhood within the context of his tribal and cultural roles and responsibilities and in regard to the personal and sexual realities of modern life. The show consisted of a series of phrases written in jagged colored handprinting, among them "Milk the Offering, Hunting in the Sky, Nurture Submit, Drunk Pair, Lick Melt, Majestic Kneel Feed." He has also attacked

Plate 33: Jimmie Durham, *Karankawa*, 1983, mixed media, c. 20″ high. (Photo: Maria Thereza Alves.) Karankawa is the name of an Indian tribe that once lived near the beach in Texas where Durham found this skull. There might be an ironic reference here to the way Indian bones are disinterred and displayed in white museums. Durham has restored this ancestor to dignity and beauty. He has re-endowed him or her with a nose etched with empowering symbols, wrapped the neck in feathers, and adorned the forehead with a pattern of inlaid turquoise. One eye (a protruding shell) looks outward to the sea; the other, an empty socket, looks darkly inward.

Plate 34: Guillermo Gómez-Peña and **Emily Hicks** of the Border Art Workshop/Taller de Arte Frontizero, *Tijuana-Niagara*, 1988, site-specific performance at the United States/Canadian border. (Photo: BAW/TAF Archives.) In this piece, the Border Brujo bridges two borders, the physical boundary between the United States and Canada and the cultural boundary between Anglo and Latino arts. Mexico—the "other" border—is present in the form of the more or less traditional altar. Hicks, as a "social wrestler," wears a wrestler's mask like that made famous by the Mexican community activist Superbarrio (with whom the BAW/TAF has collaborated). She sits on a map of the world seen by the audience as upside down, the southern continents assuming the dominant position. As Gómez-Peña told Alan Weisman (in *La Frontera*), "We are creating artistic, political, and anthropological cartography." The BAW/TAF does not see borders as the "clash" of two cultures: "We don't see culture as a reflection of society, but as a vehicle for *making* society. . . . The border is one cultural entity, not two."

Plate 35: Andres Serrano, *Blood Cross*, 1985, Cibachrome, 30″ x 40″. (Photo courtesy Stux Gallery, New York.) The tableau from which this photograph was taken centers on a small plexiglass cross filled with animal blood; the looming scale and the dramatic sky were achieved by lighting. *Blood Cross* was made on Good Friday to symbolize the sacrifice at the heart of the crucifixion and Christianity. It can also be interpreted in the light of the healing power of the cross (pagan and Christian) or of the brutal history of Catholicism in this hemisphere. Its companion, *Milk Cross*, refers to the beneficent, maternal side of the Church, or to the contained and lily-white "purity" of Western religious institutions as they condemn or reject the contributions from other cultures.

Plate 36: Roger Shimomura, *Untitled*, 1985, acrylic on canvas, 60″ × 72″. If Shimomura's imagery is initially amusing—a cacophony of Disneyland and samurai, Superman and geishas, chopsticks and surfboards—there is a hidden agenda: a brown hand sprays Snow White with an aerosol can; a chain breaks across the face of a Kabuki player; a brushstroke of brown paint attacks the very pale pink skin of a "typical American teenager." The multiple scenes in this untitled work are overseen by a silhouetted "FBI man" at the upper right, while on the lower left, sitting glumly in a "cell" made of traditional Japanese screens, a perhaps revolutionary Pinocchio isn't using his camera or his rifle. (Outside, a war plane moves by and his alter ego runs past.) Donald Duck has entangled a samurai in a phallic garden hose and Wonder Woman appears interested in a Japanese woman, ignoring the glaring male at the front of the painting. Shimomura's imagery is intentionally ambiguous, but the meeting of East and West in full stereotype, in spite of themselves, seems to be his theme. His intricate compositions also have their sources of viewpoint and stylization in both cultures.

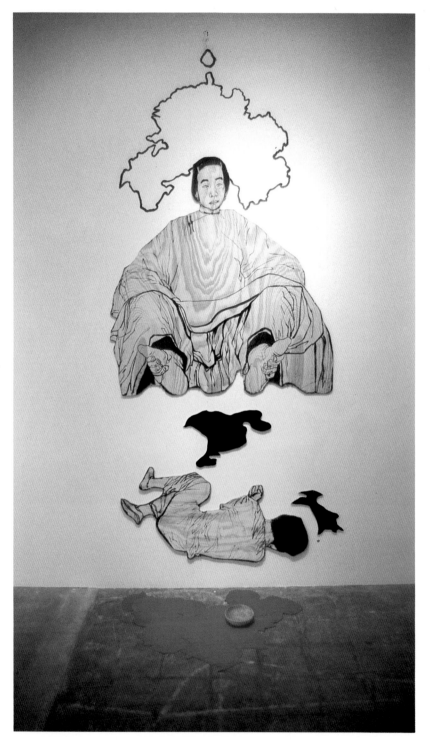

Plate 37: Hung Liu, *Trauma*, 1989, ink on plywood cutouts, acrylic on wall, felt cutout, and wooden bowl, 108″ × 52″ × 26″. (Photo: Jeff Kelley.) The woman showing her bound feet (an erotic and/or shameful act) has become the symbol in Liu's work for the suffering of old China. Here she is hovering like the Madonna in a pietà over the symbol of China in trauma again: a dead student from Tiananmen Square in June 1989. The woman has the map of China as a halo; the student's halo is a pool of his own blood. A felt cutout of Mao Zedong's head is the intermediary, the base for the ritual bowl. This ensemble was the centerpiece of a room-sized installation.

Plate 38: Robert Colescott, *Knowledge of the Past Is the Key to the Future (Love Makes the World Go Round)*, 1985, acrylic on canvas, 84″ × 72″. (Photo: Guy Orcutt, courtesy the Phyllis Kind Gallery.) A black man and a white woman, naked, are shackled together, slaves to passion, as well as to historical precedent and taboo. The huge pair of lips in the sky may refer to Man Ray's famous Surrealist painting, and the two heads at the left, reversing the central interracial couple, are Cleopatra and one of her powerful white lovers. The bust standing for history is half white, half black, resting with books, open and closed, beside an allegorical river of time, or of nourishment. The painting is a paean to miscegenation—not only to sexual mixing, but to the hybridization and expansion of knowledge as the inevitable occurs.

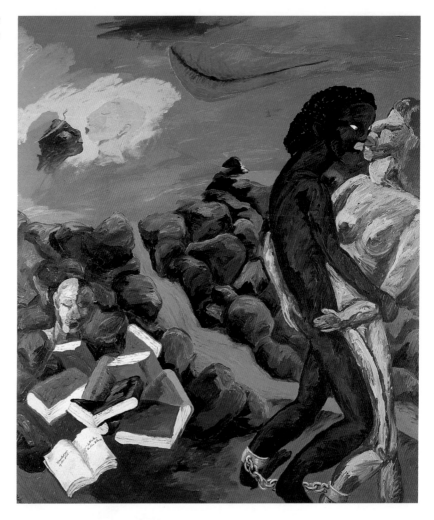

Plate 39: Candace Hill, *Meeting of the Minds*, 1989, color photographs, 40″ × 30″ each. "How I usually begin is with the camera's eye view; a poem, my own, juxtaposed with the media's view. Then I add the reactions, the mark of performance. The mark of an always imperfect performance. . . . Usually doodling for inspiration while thinking about things in the world. . . . Can I make a point about splinters without showing who makes the 'would' split into 'wood'? Everything illustrated is a political centerpiece, a model tabled to stand for something grand. Everything political has a spiritual quality" (interview with Tamie Jackson, *The Power to Provoke: Sue Coe, Candace Hill-Montgomery, Erika Rothenberg* [Old Westbury, N.Y.-Amelie A. Wallace Gallery, SUNY, 1984, n.p.). Hill is an African American New Yorker, a slippery purveyor of images (also a poet, a performer, a site sculptor, an activist, a teacher). Like her words, her images slide by each other. Martin Luther King and Brazilian figurines, *New Yorker* cartoons and her own funky line drawings are juxtaposed, subjected to an unfamiliar light and color space. A worn wooden hand smooths King's brow; brown people line up behind a screen of brushstrokes. These are truly double exposures, commenting simultaneously on reality, on pictures, and on art.

Plate 40: Jolene Rickard (Tuscarora), *Two Canoes*, 1988, chrome print, 11″ × 17″. The juxtaposition of nature and culture, and Anglo and Indian cultures, is made on two levels in this photograph. The title comes from Rickard's grandfather, "who always said the Indian canoe is too swift for white culture. You had to decide which way you were going to go." The two tall old trees symbolize, like Iroquois two-row wampum, the coexistence of cultures, parallel paths that do not cross. The lower section was taken at the wedding of a white woman ("who is very into her colonial background") and an Indian man ("who is also very into his past"). She is dressed nostalgically, like a nineteenth-century woman, Rickard points out, but he is dressed for the present (conversation with the author, 1990). The "natural" (a comfortable, traditional, and still common, moccasin) is contrasted with the "artificial" (a pointed fashionable shoe) in another pair of parallel lines.

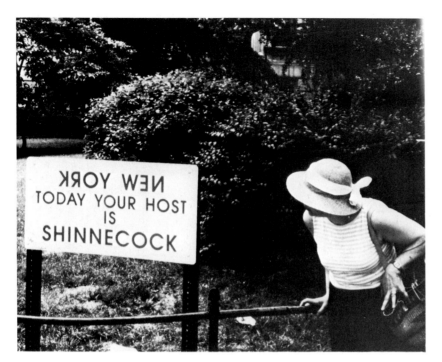

Fig. 11: Edgar Heap of Birds (Cheyenne/ Arapaho), *Native Hosts*, 1988, six aluminum signs in New York City parks, 18″ × 24″ each. (A project of the Public Art Fund.) These signs reminded New York's current inhabitants whose land they occupy: Shinnecock, Seneca, Tuscarora, Mohawk, Werpoe, and Manhattan. New York, written backwards, reversed the post-Columbian claims and forced viewers to face back into the past. Layered and effective, accessible to a fast reading, yet signifying more than most passersby would immediately comprehend, *Native Hosts* serves as a companion piece to an earlier textual work (from 1986) titled *Oh! / Those South African / Homelands / You Impose / U.S. Indian Reservations*, with its accompanying text telling the history of the twenty-nine Indian tribes relocated in 1866 to "Indian Territory" (Oklahoma) from as far away as New York and Florida. Heap of Birds recommends to everyone that they be "familiar with the Native tribal communities which are hosting the city in which one lives," and with the treaties that once covered every inch of North America (*American Policy*, n.p.). In 1984 Heap of Birds organized an exhibition of Native art called "No Beads No Trinkets" in conjunction with the United Nations "Four Directions Council"; in 1986 he made murals with Cheyenne and Arapaho youth from four Oklahoma towns, which were then installed at the Indian Hospital in Clinton. As the precedent for his public art, Heap of Birds points to the great Medicine Wheel, the innumerable effigy mounds, ritual sites, and petroglyphs of Native peoples.

head-on, in a series of public billboards planned in support of a protest march, the land-runs made by the "Sooners" (those who got there soonest) on more than thirty Oklahoma Indian reservations in 1889: "SOONERS [backwards] RUN OVER INDIAN NATIONS APARTHEID OKLAHOMA."

The monumental watercolors of Japanese-born Masami Teraoka are curious and impressive, examples of a mixing and turning-around esthetic that combines politics and eroticism. Like Heap of Birds' works, they derive their power from traditional sources, in this case from visual style, so that at first glance they resemble traditional Japanese prints. Their scale and content soon dispel this illusion, but it lingers in the calligraphy and cartouches, the images of samurai, waves, and ghosts that are mixed with jabs at Western mass media and more acid comments on AIDS and the destruction of the environment by Western culture. Teraoka's extraordinarily delicate and complex paintings often present dozens of figures, themes, and subthemes as Kabuki theater, complete with "posters" that double as explanatory captions in Japanese. They are at once beautiful and exquisite stylistic anachronisms and cutting contemporary social commentary.

Influenced by the earthy parody, eroticism, and campy theatricality of popular *ukiyo-e* ("Floating World") woodcuts and by the nineteenth-century masters Utagawa Kunisada and Katsushika Hokusai, as well as by U.S. Pop Art, Teraoka draws attention to the "overripe" condition of Japan today and the dangers therein. In the early '70s he made a series called "McDonald's

Fig. 12: Masami Teraoka, *AIDS Series: Geisha in Bath*, 1988, watercolor on canvas, 108″ × 81″. The geisha (identified by her coiffure as a high-ranking lady of the demi-monde) is Teraoka's symbol for traditional Japan. In her bath she is tearing open a condom package with her teeth because it is so difficult to open, according to the black text, which reads in part: "I cannot open this at all . . . I hate to go and borrow scissors from next door. . . . This could be spermicide; it's also slimy. . . . Oh no, this is an export model; my boyfriend won't be able to use it" (translated in Howard Link, *Waves and Plagues: The Art of Masami Teraoka* [Honolulu: The Contemporary Museum, 1988], p. 64.) Aside from parodies on Japanese erotic literature, Teraoka includes several textual and visual cross-cultural erotic puns: the exquisite drawing and delicate coloring combined with overt propaganda for safe sex, the implications about "opening up" and oral sex, the incompatability of East and West.

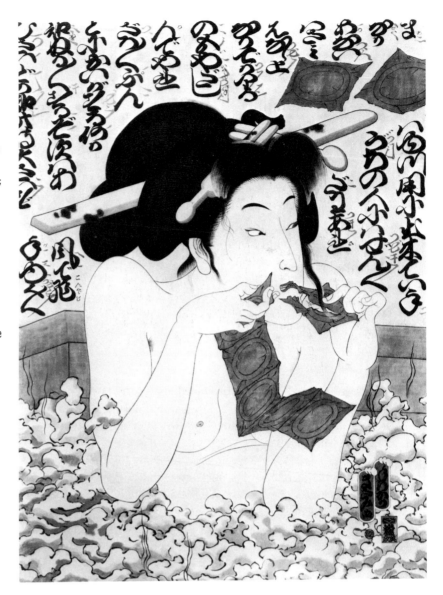

Hamburgers Invading Japan," where the lowly quarterpounder finds itself lying as trash beneath a flowering cherry tree or about to be trampled by a graceful herd of sandals or about to be swept away by a leafy bamboo broom. His "Wave Series" featured a heavily tattooed woman being seduced by an octopus within a roiling sea. Another hilarious series depicts Japanese tourists in Hawaii on guided tours so speedy that they barely have a moment to stop and videotape their surroundings.

Teraoka has lived in the United States for more than twenty years. He now spends most of his time in Hawaii, where his art was mellowing somewhat within the spectacular natural environment until a friend's baby contracted

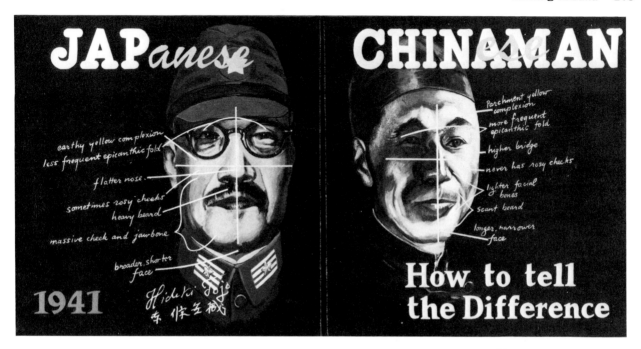

AIDS through a transfusion. Then he embarked on a chilling, but also humorous, series of paintings starring the condom, geishas, samurai, Western women, a gigantic serpent representing the disease, and an even uglier toad (the traditional symbol of evil)—with worse to come if safer sex practices are not adopted immediately. AIDS is seen as yet another form of imported pollution. The serpent is conquered only when it is trapped in a gigantic condom, and packages of condoms float through the pictures like butterflies. Surgeon General Koop appears in oval insets as an Asian saint or stern patriarch; "condom trade wars" take place between Japanese and American businessmen on board old sailing ships. Geishas tear open packets of condoms with their teeth. Perversely imitating in watercolor the woodcut styles of yore, Teraoka balances wittily between the "handmade" and the mass-reproduceable, low and high arts, lust and caution.

The broad humor and raunchy subjects of Teraoka's panoramas give way on scrutiny to a host of visual puns, sexual innuendos, and hidden nuances, many of which are made accessible (to those who read Japanese) in the calligraphic captions, which read in English translation like comics or *fotonovelas*. "The message and the beauty go hand in hand. The balance of the two is of the utmost importance. . . . Teraoka's iconography suggests that an even fiercer virus than AIDS awaits us—the ecological nightmares caused by man have come full circle, and nature now revolts against man himself."[24]

Ben Sakoguchi's satire is rougher and angrier. Interned as a child with his Japanese American family during World War II, he became permanently disaffected with the American Dream. In the '70s, in small, taut paintings,

Fig. 13: Ben Sakoguchi, *How to Tell the Difference*, mid-1980s, acrylic on canvas, 10″ x 20″, private collection. Sakoguchi's source was a propaganda layout from a 1941 *Life* magazine. The beneficent Chinese, with twinkling eyes and old-fashioned headwear, is juxtaposed against the evilly glaring and uniformed Prime Minister Tojo, "Jap" against "Chinaman." Prejudice is evident even in the language: Japanese features, such as "earthy yellow complexion, flatter nose, sometimes rosy cheeks, heavy beard, and broader shorter face" are contrasted with Chinese features: "parchment yellow complexion, higher [nose] bridge, never has rosy cheeks, lighter facial bones, and longer narrower face." Today the ironies and the profound double prejudice are clear, but the image is still as shocking as Sakoguchi found it. In his "Bananas" series, Sakoguchi reviews stereotypical Asians from American movies: Mr. Moto, Fu Manchu, and Charlie Chan, who, like most Asian characters, were played by white actors.

▼▼▼▼▼▼▼

... the disavowal of the Other always exacerbates the "edge" of identification, reveals that dangerous place where identity and aggressivity are twinned. For denial is always a retroactive process; a *half-*acknowledgement of that Otherness that has left its traumatic mark. In that uncertainty lurks the white masked black man; and from such ambivalent identification—black skin, white masks—it is possible, I believe, to redeem the pathos of cultural confusion into a strategy of political subversion. ... It is a mode of negation that seeks not to unveil the fullness of Man but to manipulate his representation. It is a form of power that is exercised at the very limits of identity and authority, in the mocking spirit of mask and image.

—Homi K. Bhabha, in *Remaking History*, edited by Barbara Kruger and Phil Mariani (pp. 144, 145)

Sakoguchi mercilessly lampooned patriotism in series on the atom bomb, the Vietnam war, and racism in America, using jolly orange crate labels and brand names as the incongruous vehicle for his brutal commentary. (In *World Upside Down*, for instance, a white teenager in overalls is hanging from a tree while a group of black people stare up at him.) Later he extended his attention to the collision of class needs (in *Less Is More*, named after the Minimalist credo, Ellsworth Kelly's monochrome panels hang behind a group of poor, depressed, elderly women) and to the commodification of the art object, naming the names of specific museums and collectors, and pointing out the often questionable symbiosis between corporations and art institutions. In the "Banana" series of the mid-'80s, he burlesqued the "they-all-look-alike" syndrome, using various Asian stereotypes to confuse the issue. (This subject is also taken on by Valerie Soe in her recent video *All Orientals Look the Same*, which celebrates "difference" by dissolving face into face of different Asian nationalities.)

An ambivalent attitude toward alienation marks much "turning-around" work. Alienation is a source, but also a byproduct of the ironic project. The mirrors held up in much contemporary art by visual ironists reflect and reverse not only the images of the oppressor or the unworthy idol, but those of the artist's own self and/or community. Artists of color in a white world looking for new means of empowerment must confront the double edges of self-mockery, and the possibility that their work will be co-opted by those who mocked them in the first place. Lorraine O'Grady's 1980 guerrilla performance of *Mlle. Bourgeoise Noire 1955*, for instance, enhanced the event it protested, even as her message came across. She intervened at the opening of an all-white "Persona" exhibition at New York's New Museum turned out in a tiara and debutante's gown made entirely of long white gloves, flagellating herself with a white-glove cat-o'-nine-tails, and protesting, "That's Enough! No more boot-licking, No more ass-kissing, No more buttering-up. ... BLACK ART MUST TAKE MORE RISKS!"

On the other hand, O'Grady's piece also demonstrated that alienation can be viewed as a positive force that resists the melting pot and offers a motive for differentiating between diverse cultural experiences, presenting what Jamake Highwater describes as the

> paradox that the real humanity of people is understood through cultural differences rather than cultural similarities. ... Children of the dominant culture are rarely given the opportunity to know the world as others know it. Therefore they come to believe that there is only one world, one reality, one truth—the one they personally know; and they are inclined to dismiss all other worlds as illusions.[25]

An existential alienation is the basis of one of the most unusual bodies of work, even within a realm in which novelty is valued both esthetically and commercially—the uncategorizable (unsalable, usually unshowable, and cur-

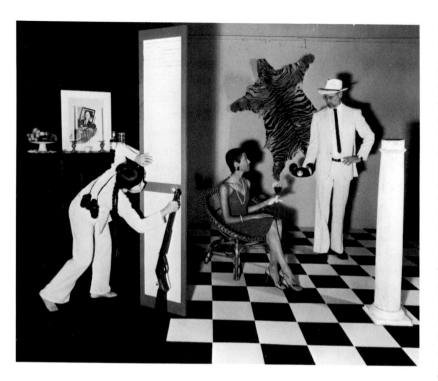

Fig. 14: **Hanh Thi Pham** and **Richard Turner**, *Reconnaissance/Cái nhà này nhà cũa ta*, 1985, color photograph, 20″ × 24″. Hanh Thi Pham is a Vietnamese refugee who settled in California in 1975, and Richard Turner is a white California artist who spent part of his childhood in Vietnam. This is one of a collaborative series called "Along the Street of Knives," which they made to confront their memories of, and fears for, Vietnam. Combining a "disorienting" collection of Eastern and Western symbols and artifacts, creating disturbing tableaux of cross-cultural anxiety, here the artists represent their double viewpoint: "[Turner's] as an American, an outsider being spied on, and mine as a Vietnamese youth—a witness with unfriendly purpose." The Vietnamese title translates as "This House Is My Own House" to connote Han Thi Pham's "sense of territory and fierce claim to ownership of a dwelling occupied by colonists." Her side of the house, which is dark, has an altar to her grandfather; a Western column and tiger skin adorn Turner's well-lit side, which stands for her childhood memories of diplomats' houses. As a child, she was curious about the foreigners, deeply resented their intrusion, and shot at their windows with a BB gun. "As an adult, here in the U.S., I try to voice the same disapproval. Anger grows larger into fierce rage. The memories of the Vietnam War continue to inflict internal pains in the guts of a Vietnamese person." (Quotations from letter to the author, 1990.)

rently unreproduceable) work of Chinese immigrant Tehching Hsieh. One of a small group of artists who have made the radical choice to actually live their lives as art, Tehching has to his credit a series of durational "performances" or "actions" that began in 1978–79, when for one full year he lived in a cage and never left it. In 1980–81 he punched a time clock every hour on the hour, twenty-four hours a day, for one year; in 1981–82 he remained outdoors on the streets of New York for one year; in 1983–84 he collaborated with another "life artist"—Linda Montano—to whom he was tied, without touching, by an eight-foot rope for one year; in 1985–86 his work was not to look at, make, read about, or talk about art, or enter a museum or gallery. On his thirty-sixth birthday, December 31, 1986, Tehching embarked on a "13-year plan" during which he will make art but not show it publicly. The black poster on which this was announced listed the years from 1986 to 1999 below a blank white rectangle; at the bottom is mysteriously inscribed the word EARTH.

Tehching was for several years an "illegal alien," an outsider who has fortified that condition, or position, through his art until it has become "larger than life." In a rare statement, he has mentioned "Sisyphus; everyone moves a stone, a symbol of doing everything over and over . . . it's about choice, to do this as art. . . . When I lived in the street, I wasn't a bum, when I lived in the cage I wasn't a prisoner."[26] His work is an absurdly extended pun on time. As Marcia Tucker has written, "The work constantly turns back on us, the public, changing in an unsettling way the usual distance between art, the

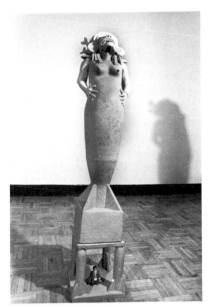

Fig. 15: Pedro Romero, *False Idol,* 1986, fired clay, 40″ × 8″ × 8″. (Photo: Eileen Little.) Romero is a Chicano muralist, ceramicist, and political activist from Colorado, living in Santa Fe. His bloated gray goddess of war, half woman, half bomb, has nuclear symbols on her earrings, graffiti and a target etched into her belly. Her grimacing face is based on fearsome Aztec gods but her form transfers the tradition of bloody sacrifice to the contemporary United States. At her feet worships a tiny general.

▼▼▼▼▼▼▼

Latins are not afraid of the absurd. Europeans had to invent the absurd, but we live in it.
—Ruben Blades (quoted in *Time,* July 11, 1988)

artist and the audience."[27] At the same time, it also expresses alienation in a manner that is perhaps more literary than visual, operating in the more metaphorical realm of reversal in which the self becomes prison and a cage becomes an escape from daily life. The artist is then free to sustain himself by pure contemplation.

I am tempted not only to draw parallels with the "crazy wisdom" of Zen Buddhist monks who relied on almost slapstick humor to make their points, but also to see Tehching's work in the context of ideas about freedom. "Freedom" is a word much bandied about in the United States; it is the ideal toward which immigrants are drawn, although many of them are surprised by what they find. Tehching is not a political person, so I doubt if he is making a direct comment on the shortcomings of democracy. Yet his outdoor piece predicted the dramatic rise in the homeless population living on New York streets (now in the hundreds of thousands); his clock-punching piece commented on the trap that a certain kind of wage work offers those who can get a job; his cage piece has to be read in terms of imprisonment, perhaps of "illegal aliens," of the disproportionate number of people of color who occupy North American prisons. The piece with Montano was "cross-cultural" in the most drastic sense, as well as gender-blending in the extreme. Tehching points out that it was

about independent individuals. We were woman/man, American/Oriental, different ages. I heard people use the word couple, but in many ways it was the opposite. . . . It's more than art—you have to be a human being *and* an artist. It's like Rashomon in that everyone's point of view and understanding of the same thing will be different.[28]

The *Rashomon* reference might relate not only to the film by Kurosawa, but also to the Chinese practice of painting a landscape as seen from multiple viewpoints all in one picture, in contrast to the Western use of one-point perspective. Tehching strikes me as the epitome of the "homeless" person, a stand-in for the world's refugee populations, although without any nostalgia. He reverses the expectations of immigrants who come to this country to "make a new life" and acquire material goods. His reserve, his silence, his refusal to participate in the art market even as he comments on it, do not add up to humble submission, but to a virtually heroic abstinence from belonging anywhere. The inscription of the word Earth on his latest project seems to imply that he is a citizen of nowhere, that the earth is his home; by extension it might also be a warning about what will happen to the earth in the crucial thirteen years during which Tehching will keep his art secret.

For Chicanos, the border between the United States and Mexico is the great "turning-around point": Home Base and Capture the Castle. Stanford anthropologist Renato Rosaldo has identified a Chicano literary "politics of

laughter" with its "peculiar double vision and sense of incongruity." He cites Americo Paredes's 1958 *With His Pistol in His Hand: A Border Ballad and Its Hero* as a major precedent, which "embodies a sophisticated conception of culture where conflict, domination and resistance, rather than coherence and consensus, are the central subjects of analysis." Rosaldo notes that "scholar-activist" Ernesto Galarza's autobiography, *Barrio Boy,* is not an "innocent narrative" either, its mockery of Mexican patriarchs provides "a critical idiom for resisting Anglo-American figures of authority."[29]

Laughter is an instinctive response when we are surprised, when "our heads are turned" or our minds are blown unexpectedly. Humor—real cut-to-the-bone humor—is at the heart of this reversal. Yet the humor of the powerless acting powerful often escapes those whose position is obscurely threatened by such "play." When Rosaldo read his paper at an academic conference, it "stimulated discussions of Kafka, Baudelaire's writings on humor, and other reflections on distant times and places. Perhaps the topic comes too close to home, for the 1980 Los Angeles population was over 27% of 'Spanish origin' " (and of course the percentage is much larger today). Certainly the (qualified) success of English Only campaigns in the late '80s proves Rosaldo right when he remarks on the Anglo-American fear of bilingualism and of "the playful heteroglossia of borderculture" as "the dark side" of mixing: "a manufactured anxiety about the Latinization of the United States, a vision which informs Miami Vice, the [Simpson-Rodino] Immigration Bill, and Ronald Reagan's rhetoric."[30]

If the United States–Canada border is viewed (at least from this side) as a rather comfortable two-way street for culture, acid rain, and big business, the moment of truth about borders comes in the South. This, our own territory of deterritorialization, is brought to intricate, steaming life by Guillermo Gómez-Peña, a self-baptized "Border Brujo" (witch), post-punk prophet of the perforated Mexico–United States border, upfront heir to Paredes and Galarza.

> **The word "border" is a multiple metaphor of death, encounter, fortune, insanity, and transmutation. At times it is an abyss, a wall, or a spiderweb. Other times it is an infected wound, or a membrane. Some days it's more like a hole, even a tunnel; and suddenly, it becomes a mirror, a bear hug, or a sudden flash.**[31]

A Mexican performance artist, poet, journalist, and activist, Gómez-Peña lived in San Diego during the '80s and became the most nationally visible practitioner of the balancing act that is the border sensibility. His work differs from that of his Chicano colleagues in its full-blown and confident *Mexicanismo,* which offers a welcome antidote to the media images of downtrodden peasants and directly confronts the art establishment on its own postmodern turf. The Border Brujo in performance (plate 34) appears in black—pan-historical drag—wearing a necklace of full-size plastic bananas, bracelets of bones, a chandelier of an earring, a seedy Panama hat, a genuine Border Patrol vest covered with

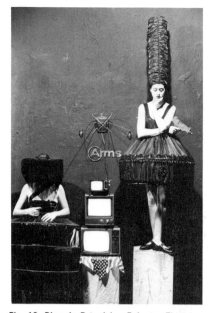

Fig. 16: Ricardo Estanislao Zulueta, *Therapy IV*, from the "Basement Therapy" series, 1988, photo/performance/installation, 60" × 48". Collection the Brooklyn Museum. Zulueta was born in Cuba, raised in Miami, and lives in New York. His tableau photographs have, like much postmodernism, a curiously (and deliberately) dated look. He conceives of them as vignettes of specific (but unidentified) historical situations, choosing the models, creating the costumes and props for a temporary "still performance," as though cinematically directing his own dreams and desires. At the same time they are oddly impersonal, recalling the Surrealist use of mannequins. Zulueta's stage at the time was a cramped basement apartment in the East Village, an ideal, if uncomfortable, site for exploring the subconscious. This piece suggests the phallic need to stockpile arms and the accoutrements of power (gun, grenades, piled TV sets, towering hat); it might also refer to the Cuban missile crisis.

political and cultural buttons, and a menacing black fright wig, which is doffed when he dons a superhero mask. Sitting behind a table of votive candles and Day of the Dead paraphernalia, speaking first in Nahuatl, then Spanish, then English, he harangues the audience with a punning poetic polemic. He revels in and reverses stereotypes, creating ornately intertwined cultural bastardizations in several mediums, celebrating, even as he decries, the

> massive "deterritorialization" of large human sectors . . . as cultures and languages mutually invade one another. . . . When an artist has been "deterritorialized," he or she is more disposed to transgress borders, whether they be aesthetic, cultural, political or sexual. . . . Interdisciplinarity and multi-ethnicity are two key signs for understanding contemporary art.[32]

Those who do not participate, he warns, "will not form part of the next great debates of the continent." Gómez-Peña and his colleagues in San Diego and Tijuana—Mexicanos and North Americans—are following up on the promise of the Chicano movement by facilitating that participation. Their vehicle is a "visual-linguistic object" or a "magazine/texto multicultural/travelling border art exhibit/propuesta bilingual experimental" called *La Linea Quebrada / The Broken Line*, emerging from the Border Art Workshop/Taller de Arte Fronterizo. Its model is cities like Tijuana, which, according to Gómez-Peña, are becoming "models of a new hybrid culture, full of uncertainty and life, and border youth, [where] *los* 'cholopunks' *terribles*, children of the mysterious crack that opens between the First and Third World, become the heirs of the new mestizaje."[33]

Specializing in a "binational perspective" and "border consciousness," BAW/TAF produces interdisciplinary projects that blur the lines between street events, performances, murals, videos, public sculptures, exhibitions, cabarets, and publications. They aim to transform the media-defined "war-zone," to redefine the concept of the "discovery of America," and offer new multicultural models for the future in their "process of negotiation toward Utopia." One way they plan to execute this ambitious reconstruction is through their "Alternative News Media Network by Artists," another line-breaking enterprise that emerges from their "sense of urgency about breaking out of the art circuit and enlarging the definition of the artist to embrace communicator/disseminator of ideas/images."[34]

The turning road is crooked, seductive, illusory, and finally dangerous. Art, which demands leeway, even within culturally restrictive contexts, twists and turns in ways that sometimes seem less like reversal and more like avoidance and denial. But it can also be the sly twist of a knife in the gut of the dominant culture. "In a complex way, Latin American history secretes the history of Europe and in turn renders it ironic."[35] In his 1982 Nobel Prize lecture, Gabriel García Márquez pointed out that "the statue of General Francisco Morazan erected in the main square of [the Honduran capital of] Tegucigalpa is actually one of Marshal Ney, purchased at a Paris warehouse of second-hand sculp-

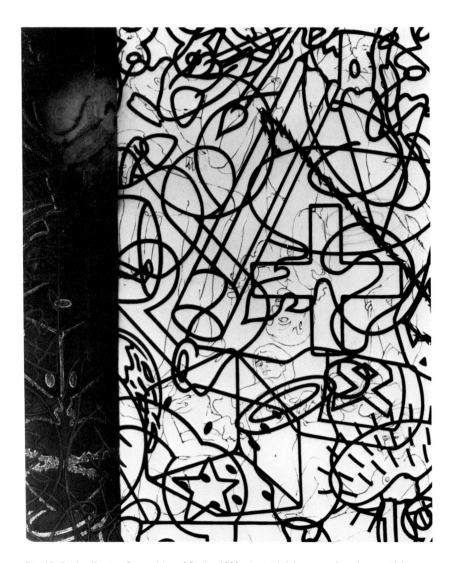

Fig. 17: Benito Huerta, *Premonition of Desire*, 1988, charcoal, ink, watercolor, glass particles, pastel, pencil shavings, oil pastel, ink wash, gouache, and spray paint on paper, 50" × 44". (Photo: Frank Martin.) Huerta is a Chicano artist and influential freelance curator from Houston. For several years he was best known for his modernist classificatory paintings—rows of cultural artifacts and similar cartoonlike abstract forms—on black velvet, a deliberate challenge to mainstream taste. Since then his quest for a style that would reconcile the humor and political perversity of *rasquachismo* with the formalist framework of Jasper Johns or Al Held has led to paintings like *Premonition of Desire*, which also incorporates the vocabulary of bleeding and flaming hearts, barbed wire crown, fuzzy dice and flowers, placed like black ironwork screens over finer-lined, red erotic nudes. In the upper left corner is a plumb bob, a phallic symbol, as Carey Rote has pointed out, that "represents the concept of finding a balance between primal desires and the constraints of society" (*Benito Huerta* [Corpus Christi-Weil Gallery, Corpus Christi University, 1989], p. 6). Without abandoning the baroque intensity of Chicano culture, Huerta's images are evolving into a kind of linear language hidden within textures and behind other images.

Fig. 18: Larry Fuente, *Derby Racer*, 1975, beads, buttons, rhinestones, costume jewelry, guitars, tennis rackets, ceramics, mirrors, feathers, spark plugs, .22 cartridges, etc., set in epoxy resins over a fiberglass base on a 1960 Berkeley (British sports car), 48″ × 48″ × 120″. (Photo: Eliza Hicks.) The ultimate in *rasquachismo*, this is one of several transformed cars Fuente has created to protest, and simultaneously celebrate, a materialist society. *Mad Cad* has a mass of pink flamingos rising from its rear, and *Derby Racer II* is a winged bug with trophy figures marching along its spine; a 1984 installation featured a car painted in leopard skin. *Derby Racer* was made for the Downhill Racer Derby held by the San Francisco Museum of Modern Art, where it won the prize for "most beautiful car." It sports two guitars on its rear fenders, flanking carousel horses' heads, swans rising from the trunk, eye-or-breast-like front fenders—opulence over the edge. Fuente, who lives in Northern California, plays this secular madness against intimations of religiosity, suggesting the cult of consumerism in which machines become gods or kidding the Latino baroque sensibility (or superkitsch) as it appears in altars and lowriders. He says that "the transformation of cars into works of art is a manifestation of my belief that art should be more accessible to the general public than is permitted by gallery and museum showings, and that the street provides a perfect format" (letter to the author, 1990).

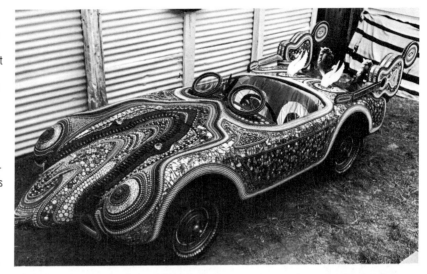

Fig. 19: Gilbert "Magu" Lujan, *Our Family Car*, 1985–86. (Photo courtesy of Saxon-Lee Gallery, Los Angeles.) Lujan, the son of migrant workers who settled in Los Angeles, served in the Air Force and has an MFA from the University of California at Irvine. He has made social and community murals with the East Los Streetscapers and (with Beto de la Rocha, Carlos Almaraz, and Frank Romero) was a member of "Los Four." His preoccupation with the culture of the automobile and customized cars began early; he drew them in school. This brilliantly painted car (a 1957

tures."[36] In art, too, what appears to be historicism can often turn (inside) out to be a slier kind of appropriation, a triumph over poverty and a reversal of the poverty of representation.

The Latino strategy sometimes involves an art based in the vernacular that is exuberant, cluttered, labyrinthine, turning the blindfolded viewer around and around before s/he is pointed at the piñata. *Rasquachismo* is one secret weapon. Tomás Ybarra-Frausto defines *rasquache* as an

outsider viewpoint [which] stems from a funky, irreverent stance that debunks convention and spoofs protocol . . . a bawdy, spunky consciousness seeking to subvert and turn ruling paradigms upside down—a witty, irreverent and impertinent posture that recodes and moves outside established boundaries. . . . To be rasquache is to be down but not out—*fregado pero no jodido*.[37]

Rasquachismo is a kind of Chicano camp, the triumph of wit and high spirits over prejudice, and bad taste over good. Ybarra-Frausto lists as *medio* (defined as "low") *rasquache*: shopping at K-Mart, pretending you're "Spanish," and *tortillas de harina* made with vegetable oil; while *muy* (high) *rasquache* is: shopping at J. C. Penney, being bilingual and speaking with an accent in both languages, and tortillas made with lard. In a "Rasquachismo" show in Denver in 1989, Tony Ortega created a low-rider altar, an automotive extravaganza in which people could pose for photographs wearing shades and red bandana, complete with every imaginable bit of paraphernalia, including fuzzy dice, rosaries, dashboard Virgin, shiny fringe, and red velvet and serape seat covers. Some of the ultimate *rasquachismos* have been committed in California by sculptor and installation artist Larry Fuente, whose horror vacui reaches epic proportions, and, most notably, by the group Asco in East Los Angeles.

Asco was born in 1971 and named "Disgust" (or "Nausea," or "Loathing") for the response its work seemed to inspire in almost everybody. The *colectiva* consisted of Gronk (Glugio Gronk Nicandro), Harry Gamboa, Willie Herron, and Patssi Valdez. Valdez had been typically, backhandedly, inspired to achieverdom by a homemaking teacher at Garfield High who taught gravy making thus: "I know you little Mexicans have never eaten this kind of food before, but you'd better listen because someday you'll be a cook or maid in someone's house."[38]

Figuring that if things were going to be that bad they might as well make them worse, the four specialized in iconoclastic gestures and "social surrealism": Gronk as Pontius Pilate patrolled a Marine recruiting station in the barrio during the Vietnam War, blessing pedestrians with holy popcorn; he also taped two people to the wall of a liquor store for an "instant mural" about those trapped in their environments by a lot of red tape. In 1972 Asco offered Christmas shopping crowds an apparition of the Virgin of Guadalupe dressed in black, followed by a walking tree ornament in green crinolines and blinking red lights. Herron, in a costume of painted Masonite, played a mural component that had gotten fed up with the constrictions of conventional Chicano wall art and walked off. Told by a Los Angeles County Museum curator that "Chicanos don't make real art," Asco spray-painted the museum's entrances and exits and signed it as an art "piece," which years later was exhibited in photographic form inside the same museum. Until its demise in 1987, Asco attracted a number of other members, notably Diane Gamboa and Daniel Martinez, but the original four hung in more or less till the last event.

"Asco started out very collaborative," recalls Harry Gamboa. "We were all on the same life raft, going down a precarious rapid. Everyone experimented with swimming in their own ways. . . . People who were doing traditional art forms really disliked us. . . . We weren't Chicano enough for some, too Mexican for others." His sister Diane (known for her paper fashions) remembers Garfield High in the early '70s as "extremely violent. . . . The focus wasn't on 'Where

Chevy two-door sedan) is a chariot to Aztlan, related to Lujan's 1984 silkscreen showing the Aztecs (here pictured on the side) driving their own extraordinary vehicle out of the pre-Columbian past.

▼▼▼▼▼▼▼
The LA city schools were designed in that era [the '60s] to create failures out of the Mexican population. [The Asco founders attended the school romanticized in the film *Stand and Deliver*.] Racism and political expediency and the need for a cheap labor force made it in their interest not to have people succeed or compete. The use of Spanish was totally punished. It was drummed out of us. If you spoke Spanish you were dumb. I made it a point that I was going to speak English better than they did. I was going to turn it against them.
—Harry Gamboa (in Linda Frye Burnham, "Asco," *LA Style*, Feb. 1987, p. 57)

Fig. 20: Asco, *Walking Mural*. (Photo: © 1990, Harry Gamboa, Jr.) Patssi Valdez was the "Virgen de Guadalupe-in-black," Willie Herron was "the mural that walked against the ugliness of urban street life," and Gronk was "the inverted Xmas tree in three green chiffon dresses" on Whittier Boulevard in East Los Angeles, in one of Asco's first street performances in 1972. "Our look was incredibly stylized," Gamboa recalls. "Our credo was 'If you can walk, wear it.'" Asco's "No-movies" were scenes created to resemble stills from a movie ("projecting the real while rejecting the reel," said Gamboa). Their goal was to confront people with Chicano life and its importance to the city, and to give a public voice to Chicano artists in unexpected ways. (Quotations from *High Performance*, no. 35, 1986, p. 51.)

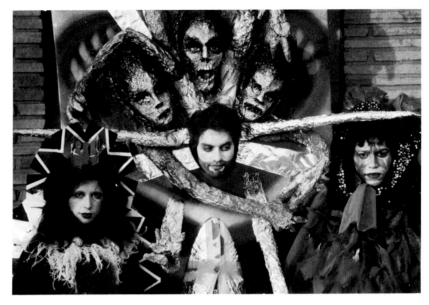

am I going to college.' It was more like 'Am I going to make it home?'" She is amazed "that I was able to pick myself up after being knocked down so far. It's the anger I feel and the need to express myself that's been my lifesaver in this hell I've lived through. . . . East L.A. is my home. But there will always be a dark cloud over my home. As much as I love it, I hate it." Much younger than Harry, she recalls having been exposed to art as a perfectly natural activity—via Asco rather than Picasso. Patssi Valdez says, "Making art was the only way to survive. . . . Asco is really a concept. [Like Dada] Asco will never die."[39]

Gronk's name means "to fly" in a Brazilian Indian dialect—his mother found it in a *National Geographic* while she was in labor—and he has since noted that he was one of "the flier generation," that is, he passed out political leaflets as a high school militant. A co-founder of Asco when he was only seventeen, Gronk learned to "sabotage seriousness" from the "Jetters," members of the Chicano youth movement in the late '60s who, by tuning up their language and fashion to a high screech, refused the role of victim. Use of glamour and high-society images has been criticized as soap-opera idolization of the rich and famous. But this ignores the critical and humorous capacity of *rasquachismo* to lampoon high fashion without being taken in by it, and to celebrate simultaneously the street styles of the Chicano and African American communities. Gronk's own style has ranged from a vernacular camp that out-cholos any cholo to ultra-civilized European decadence.

Gronk recalls that in 1974, when Chris Burden was lying under a tarp on the freeway in a now-famous performance piece, he was lying on an East LA street as a "Decoy Gangwar Victim" in an equally realistic, if less heralded

piece done with Harry Gamboa. His first performance was called *Cockroaches Have No Friends* (*la cucaracha* being an uncomplimentary nickname for a Chicano); it included a tableau of a huge mouth and tongue constructed of human bodies. Its star was named Cyclona, predecessor of Tormenta, the glamorous evening-gowned, barebacked woman who appears in many of Gronk's paintings as a metaphor for turning away from the so-called centers. As Shifra Goldman has commented, Tormenta, like her creator, is a survivor.[40] For instance, Gronk put her on board the *Titanic* when it sank, but she was not among the victims.

A voyeur and activist, Gronk considers his work political, although not in the expected ways. Acknowledging graffiti as a symbol and as an influence on his work, he has evolved a secret graffiti-like language of hieroglyphic script to express, along with his images, his favorite themes: "sex, hate, love." In his art the oral narrative tradition goes out to meet the enigmatic modernist tradition but still keeps a foot on the community hearth. Although wary of being categorized, Gronk welcomes the term "community artist" and says that it is the "true avant-garde," unrecognized for the ways it changes the environment: "In my work I am commenting on the human condition and on people in general—people crossing borders, crossing cultures and being part of a community." At the same time he and Asco rebelled against the historical imagery prevalent in *movimiento* art at the time, which they saw as perpetuating stereotypes. "We wanted to stay in the present and find our imagery as urban artists and produce a body of work out of our sense of displacement. Latin imagery had a strong input, but we also had Albert Camus, Daffy Duck, and B movies like *Devil Girls from Mars*."[41]

Fig. 21: Gronk (Glugio Gronk Nicandro), *Untitled*, 1986, pastel on paper, 29½" x 37". Collection Jane Livingston, Washington, D.C. (Photo: William Nettles, courtesy Saxon-Lee Gallery, Los Angeles.) Tormenta, the heroine of Gronk's ongoing melodrama (and perhaps his alter ego) is often assumed to be a "society lady," but it's more likely she is a high-fashion Latina out on the town, or both. As Gronk once said, "Borders don't apply now. East L.A. is everywhere" (*Los Angeles Times Magazine*, March 27, 1988, p. 18). Here Tormenta appears as a combination of Samson bringing down the columns of the temple (or classical civilization) and Moses parting the waves of the Red Sea, moving toward confrontation with the volcano itself.

FOOL HEAVEN SAIL SEA

"We did not–repeat–did not
trade weapons or anything else
for hostages–nor will we."

Fig. 22: Epoxy Art Group, "Fool Heaven Sail Sea," from *Thirty-Six Tactics*, 1987, photocopy, 7″ × 9″. (Photo: Ming Fay/Epoxy.) This is a page from an artist's book in which ancient Chinese stratagems for survival and defense are related to contemporary events. The thirty-six tactics appear frequently in Chinese political and historical writings. In this case, "Heaven" implies the law or morality; "Sail Sea" means to cross. "Fool Heaven Sail Sea" indicates a situation where confrontation is present and denial is offered. Another page of the book, "Pointing at Mulberry and Revile the Locust Tree," is a photograph of Chinese watching the trials of the Gang of Four on television, while a huge poster of Mao overlooks the scene. The proverb means "using a lesser subject to reflect a higher issue." Jiang Ching is in court, but Mao's Cultural Revolution is really on trial. "The people are watching Jiang Ching, and Mao is watching them, unstained" (letter to the author, 1989).

▼▼▼▼▼▼▼

Suddenly I saw the relationship between the merchandise I used to covet and draw from old Sears catalogues and the bizarre collection of objects that now fills my house. So did I see the relationship be-

A similar response to a kaleidoscope of disparate and often colliding influences has been created by six young New York artists, formerly of Hong Kong. In 1982 they formed a group called Epoxy to emphasize the inextricable quality of cross-cultural bonding and to demonstrate that "the twain" had met in the here and now:

> We grew up in a fermented, multicultural environment. The myths we were brought up with were not really traditions. Donald Duck, Superman, King Kong and all the pop heroes and monsters were there, plus things from way back in Chinese history.[42]

In unexpected ways, although still following culturally recognizable tracks, Epoxy is inventing, as Fred Ho has suggested, art that is truly Asian American, with one foot in each culture. In 1985 Epoxy put together a show called "Myths" at New York's pioneering Asian American art space, Basement Workshop. It broke the stereotype of the laid-back, lyrical, ascetic Asian art with Bing Lee's bold black red and white "temple" fusing East Village expressionism and the emblematic solemnity of traditional sources; Kwok Mang Ho's ode to Asian kitsch including tinsel, Day-Glo, glitter scarves, and Chinese campaign buttons; Jerry Kwan's "slave of time," a painted prisoner chained to a real incense burner; and Ming Fay's *Legend of Wu Loo* with its symbols of life (a gourd), birth (a red egg), longevity (a pine cone), and death (a vegetable crate full of blackened skulls). Epoxy continues to work together on installations, slide shows, and performances, although the artists' styles and individual works are highly diverse.

In his brassy acrylic paintings, Roger Shimomura (plate 36) mixes Pop Art and *ukiyo-e* prints. His strategy is to depict bicultural imagery in a purely "American" painting style. Shimomura is a sansei who, as a child during World War II, was interned with his parents and grandparents in a concentration camp in Minidoka, Idaho, while his uncle served in combat with the heroic 442nd division of Japanese Americans. Shimomura is bitterly aware of statements made by whites about Japanese Americans during this period—such as those by the governor of Wyoming, who said that if Japanese Americans were not interned, "there would be a Jap hanging from every pine tree," and by Idaho's attorney general: "We want to keep this a white man's country."[43]

Shimomura lives with "a lifetime accumulation of images." He has long collected Japanese pop songs and pop culture, appropriating them with the same exuberance and insouciance as he does American pop culture, although the latter is likely to suffer more in the exchange: "It just seemed so logical that Superman appear in the paintings. Superman plays an important role in the paintings as representative of the white American male dominant society," a stand-in for imperialism.[44] As Don Desmett points out, Shimomura knows "there is no harm in laughing at something and suddenly realizing it's really not funny. The damage is done when the delayed reaction is not acted on, and corrections made."[45]

The border between East and West is transgressed increasingly often in the arts, as masks are traded off at a bewildering pace. Anthropologist Dorinne Kondo, writing about David Henry Hwang's "creatively subversive" play *M. Butterfly*, offers some alternatives to the deconstruct-and-discard theories of identity construction. In a way that also illuminates the strategies of visual artists, she analyzes Hwang's intertwining of "geography and gender, where East/West and male/female become mobile positions in a field of power relations."[46] The shifting ground of Hwang's play—a profound reversal of the Puccini opera with its blatant stereotypes and "topography of closure"—concerns a French diplomat in Japan during the period of the French Vietnam War and the Chinese Cultural Revolution who falls in love with a Japanese woman who is in fact a Chinese man and a spy for the People's Republic. In the end it is the Western man who becomes the submissive Asian "woman," but he still refuses to allow the Asian "woman" to become the powerful man s/he actually is, and thereby replays the conventional East-West tragedy.

Borrowing the metaphor of the "borderlands" from Gloria Anzaldúa, Kondo perceives a model for identity construction that is "far from bounded, coherent, and easily apprehended," a model that "views gender and racial identities not as universal, ahistorical essences or as incidental features of a more encompassing, abstract 'concept of self.'" Her conclusion is that "gender and race are mutually constitutive in the play of identities; neither gender nor race can be accorded some a priori primacy over the other." The "power plays" on the personal, racial, sexual, and geopolitical levels, she says, suggest a future where "'White Western man' may become 'Japanese woman' as power relations in the world shift and as 'the West' continues to perceive 'the East' in terms of narrative conventions of fixity and essentialist identity."[47]

A number of Asian artists have commented in their work on the ambiguous stature of the Asian man in a macho society where homophobia is common, and where height, weight, and hairiness, among other attributes, are associated with masculinity. Art Nomura's 1987 film *Wok Like a Man* takes up this theme, as do the satirical painting/constructions of Ken Chu and the paintings of Gordon Wong. After he left the *Butterfly* cast, B. D. Wong remarked on aspects of racism in the play's reception. A *New York Times* review bemoaned "the sexist and racist roles that burden white men"; Wong said:

> I understand that even though they don't realize it, the fact that I'm not white makes it easier for many people to accept the premise that I'm not human. . . . I have to be able to use my androgyny without it being seen as an expression of my ethnicity, and vice versa.[48]

The role of the mask in both gender and racial politics has been a staple of feminist and bicultural art. In art, as in society, there is a subtle and ceaseless donning and doffing of masks. Disguise has been employed as weapon and as shield, allowing the artist a chance to "make her/himself up." Ritual masks

tween misleading reproductions in art history books and my mom's old issues of *Woman's Day* . . . between a meal of steamed black cod and the Colonel's Wingdinger, between vintage Kurosawa and Johnny Socko . . . between an Oreo Cookie and a Chiquita Banana and between Minnie Mouse and one of Utamaro's beauties.

It seems that at some point I no longer felt compelled to project my own point of view toward the things that concerned me. I found myself more interested in creating a visual forum that expressed ironic and contradictory attitudes toward these concerns. This direction . . . led me to practicing a form of self-legalized visual larceny. Using images from my past and immediate environments, from earlier and current work and using them as cultural metaphors, I became a dispassionate viewer of my own layering system.
—Roger Shimomura, *Roger Shimomura* (Cleveland: Cleveland State University Art Gallery, 1988, p. 5)

▼▼▼▼▼▼▼
Now our considerations of race and sex intersect the issue of imperialism. For this formula—good natives serve Whites, bad natives rebel—is consistent with the mentality of colonialism.
—David Henry Hwang, "Afterword," *M. Butterfly* (New York: New American Library, 1989, p. 99)

▼▼▼▼▼▼▼
Hwang's play was promoted on television with what amounts to an intriguing miniature performance artwork. It began with a shot of B. D. Wong, dressed as the demure Butterfly, fan in hand. She turns around to reveal a laughing, confident B. D. Wong, now in masculine guise, in suit and tie. He laughs, puts his face in his hands, and turns again. As the hands open, the sorrowful face of John Lithgow is revealed, painted in lurid Japanese whiteface and Kabuki-like makeup, dressed as Butterfly.

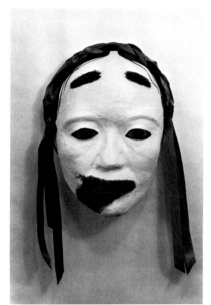

Fig. 23: Betty Kano, *Noh-thing Mask*, 1989, acrylic and ribbon on ceramic (cast by Suzan Kaplan), 12″ × 7″ × 3½″. (Photo: Marion Gray.) Kano is a Japanese American artist, primarily a painter, from Berkeley, who is also a political and cultural activist. This mask, with its double image of formal entertainment and messy tragedy, was made for the "1000 Faces" project, a multicultural public artwork organized by Sas Colby at Oakland's Festival at the Lake. It was modeled on the traditional Noh woman's mask. "The magic of a Noh mask," writes Kano, "is that it can appear either smiling or sad, based on the power of the actor behind the mask. (Noh stage has only actors, no actresses.) Some famous actors have supposedly caused the illusion that tears fell down the mask's face" (letter to the author, 1990). The lower part, however, breaks the mask's illusion. The mouth is burnt or decayed, or smeared with dirt, blood, or makeup, violated and soiled by racism.

from traditional cultures often have their eyes closed, presumably so they can see inside, where it matters. But the mask has its negative aspects. "To pass" is also to die. The mask makes the subject wearing it into an object—of curiosity, disdain, amusement, or fear. The element of self-mockery is often present in mask art. And a false or foreign mask imposed or adopted from outside the self but grown into the skin can be torture.

The blackface/whiteface convention, from minstrelsy on, is seduced and abandoned in works like Adrian Piper's posters and performance art (see chapter 1) and Howardena Pindell's now-classic 1980 video *Free, White, and 21*. Using a deadpan "talking-head" format, the artist tells horrific stories of the racial prejudice she and her mother have personally experienced, and the ways her life has been diverted by them. A founder of the woman's co-op gallery AIR, Pindell declares: "I'm not going to remain silent. I have been punished for being in the Women's Movement and for having brown skin, so I figure—shoot! It couldn't be any worse."[49] But the "documentary" form and content are subverted and made more dangerous by the minimal gestures with which the black artist, appearing in two forms of whiteface, tells her cautionary tales.

First Pindell appears as and speaks in the voice of a brassy white woman in blonde wig and shades who harps on two themes: "You must be paranoid" ("All that never happened to me, but then after all, I'm Free, White, and 21"), and the ungrateful Other ("After all we've done for you!"). She informs the black artist that if her work is not "political" it won't be validated by the white artworld. "Don't worry, we'll find other tokens!" Then, in the silent passages, Pindell wraps and then unwraps her head in a long "bandage" of white gauze, which can be read as either shroud or swaddling. "Made up" as a white woman, Pindell can give vent to what might be perceived both as rage and as self-hatred, an exorcism that functions through "becoming the other" in order to shed and unravel the traits of the hated Other found in oneself. "One can look at it psychologically," she has said in regard to her paintings. "Being black in this country, you have to cover up your identity. You have to whitewash everything in order to make it palatable."[50]

A *stereo*type implies that the message is coming from two directions. Some artists succeed in presenting one face to the world and another to their own communities; the first is sometimes an ironic play on the second. A certain double vision results. From the white perspective: now you see your friend (as you have known her, in white contexts), and now you don't (because "at home" she is no longer the person you thought you knew). Like "shape-shifting" Northwest Coast Indian masks, two faces are included in one. When Henry Louis Gates, Jr., puns, "The future of theory, in the remainder of this century, is black, indeed," he leaves the choice of meaning up to the reader.[51]

While one oppositional strategy favored in white theory is the use of the elements of a structure against the structure that they support (as suggested by Victor Burgin and exemplified by the work of Hans Haacke), Audre Lorde has cautioned against the attempt to dismantle the master's house with the

master's tools. Wole Soyinka combines the two: "And when we borrow an alien language to sculpt or paint in, we must begin by co-opting the entire properties of that language as correspondences to properties in our matrix of thought and expression."[52] "The words are their words, but the song is ours," says African writer Théodore Obenga.[53]

However, turning "their words" around into "our song" can be risky business, and it doesn't always work. Lowery Stokes Sims has remarked on the limited options open to "ethnic artists" trying to reclaim their own representations:

> Often these artists tread a thin line between genuine cultural expression—which may have become rusty with disuse—and repetition of the stereotypical interpretations of themselves fed them by the media. The results can be replete with irony, as I am fully aware, being a collector of "black memorabilia"—representations of black people created by a white marketplace whose motivations did not preclude the intent to ridicule and denigrate. Does the acceptance of these images, and even the collecting of them, mean that one has capitulated to self-hatred or a low self image? Or is it a strategy for absorbing rejection? Or worse, is it complicity in the economic oppression of one's own race?[54]

Betye Saar also found herself collecting these images, and in the late '60s she began her homeopathic use of stereotypes as weapons to attack the racism that produced them. She juxtaposed the images from old postcards, sheet

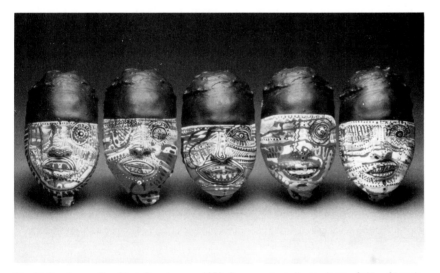

Fig. 24 Ben Jones, *Five Black Face Images*, 1970, fluorescent acrylic on plaster, 8½″ x 6″ each. Collection Steven Jones. Jones is an African American artist from New York. These sculptures were made during the height of the Black Art movement. They appear to give magical status to the faces they mask with brilliant color and symbolism. Each face has one eye wide open and the other closed, as though to look in and out simultaneously.

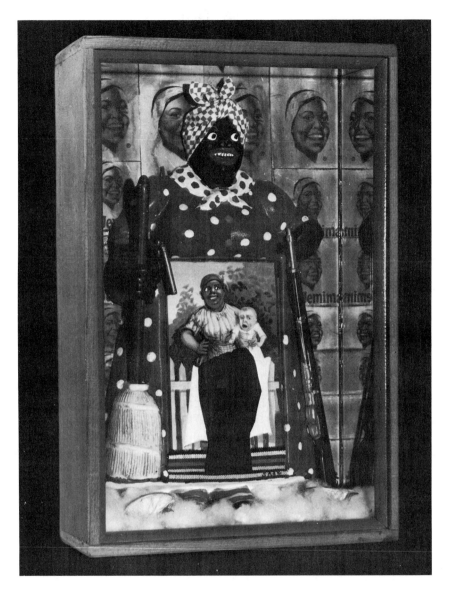

Fig. 25: Betye Saar, *The Liberation of Aunt Jemima*, 1972, mixed media, 11¾″ × 8″ × 2¾″.
(Photo courtesy The University Art Museum, University of California, Berkeley.) There are three
levels of imagery and Aunt Jemimas here. The wallpaper is a Warhol-like grid of the "modern"
Jemima; the front plane is an antique stereotype in which a grinning woman holds an equally
unattractive fat white baby casually under one arm; and in the middle, between past and pres-
ent, stands a black, no-nonsense Jemima with a broom in one hand and a rifle in the other.
Saar has used the overall format of an altarpiece as a continued reference to the spirituality
necessary to maintain the life force. Since she painted this, Aunt Jemima has undergone yet
another "modernization," and has finally taken off her turban/headband. Quaker Oats an-
nounced in 1989 that it wanted to "present Aunt Jemima in a more contemporary light, while
preserving the important attributes of warmth, quality, good taste, heritage and reliability"
(Cathy Campbell, "A Battered Woman Rises," *Village Voice*, Nov. 7, 1989).

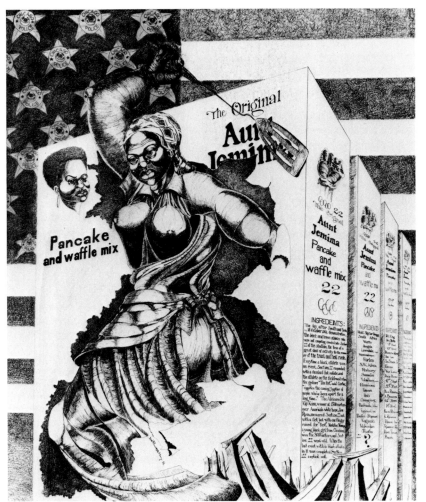

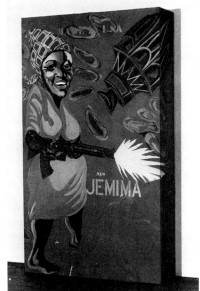

Fig. 27: Joe Overstreet, *The New Jemima*, 1964, acrylic on fabric over plywood construction, mixed media, 102½″ × 61″ × 17″. The Menil Collection, Houston. (Photo: Janet Woodard.) Pancakes flying, syrup bottle transformed into a grenade, the new Jemima is a revolutionary. Overstreet, an African American painter best known for his abstractions inspired by jazz, is director and founder (with Corinne Jennings) of the nonprofit art gallery Kenkeleba House in New York.

Fig. 26: Murray DePillars, *Aunt Jemima, Section 22*, 1968, pen and ink, 38″ × 32¾″. (Photo: George Nan.) DePillars is Dean of the School of Arts at Virginia Commonwealth University in Richmond. In the heyday of the Black Power movement, he depicted Aunt Jemina against a background of the American flag (the stars are Chicago police badges). She is bursting from her box, ready to do some damage with raised flyswatter, under the gaze of an angry contemporary black woman. The boxes arranged like books at the right are each topped by a clenched fist, and texts about African American history are found under the "Ingredients" of "The Original Aunt Jemima Pancake and Waffle Mix."

music, and advertisements against harsh realism. *Let Me Entertain You*, for instance, had a "dancing darky" with a banjo in one panel of a window, a lynching scene in another, and a rifle in another, moving, as she put it, from two "white entertainments to their reversal by means of a different 'instrument.' " Some of the stereotypes she found were violent in themselves, like a watermelon exploding to reveal a black person's head inside it. In *National Washboard* Saar juxtaposed the insulting caricatures with lovely old photo-

graphs of real black families; "the washboard itself was a symbol of the black woman—her Aunt Jemima role." On the back (or front) of the suspended washboard there is a black hand and a clenched red fist—"the other side of the coin." Saar has refused to ignore the continuing pain such images give:

> It's like if it happened in your father's time or your grandfather's time, those hurts are still passed down to you, and it's just kind of one way of explaining why the anger is still within the black man—it's because of all that other stuff that happened before and those images are part of that.[55]

The Aunt Jemima image, which originated a century ago, was a favorite target and vehicle for reversal by black artists in the '60s. Superficially harmless, even benign, as it evolved over the years, it consistently transmitted the image of black women not only as inevitable domestic servants, but as cheerful, old-fashioned, overweight neo-slaves. The manufacturers eventually figured this out and changed "Auntie's" face to make her younger, slimmer, lighter-skinned, and more "modern," though still garbed in a headcloth and still an "aunt," recalling slaveowners' paternalistic habit of calling black people "uncle," "aunt," and "mammy," as though the real relationship were not one of forced oppression. (These days, the use of "aunt" ironically implies a blood relationship.) Revised representations of Aunt Jemima from the '60s, by Murray DePillars, Joe Overstreet, Betye Saar, and others, flattened this cozy picture like a pancake. Similarly, Joyce Scott's slender beaded "mammy" holding a rather hydrocephalic white baby is titled *Nanny Now, Nigger Later*. Scott has also made a number of pieces playing with the word and image of watermelons, as in *Aunt Jemelon, Melon Medusa*, and *Venus de Melon*.

A more maleficent reversal of advertising imagery is Adrian Piper's ongoing series called "Vanilla Nightmares." Relatively conventional charcoal drawings of strong, handsome black people—usually naked, with exaggerated genitalia, often hairless and sometimes eyeless, like vodun zombies returning from the dead with vengeance on their minds—invade full pages of the *New York Times* that contain either an article about race or South Africa, or a particularly gruesome sexist advertisement. The impassive intruders infiltrate and overlay the marching columns of print, emerging from the shadows like slaves whispering behind the plantation house. Their uninvited presence on these staid pages is ominous and exemplifies the insecurities of any ruling class in any revolution. They are shocking not only because of their scale, their unexpected presence, but because they represent common social nightmares. Piper trades wickedly on the myths of black sexual superiority, fears of rape and rebellion, at the same time that she angrily prods the bruises of xenophobia.

More than any other contemporary artist, Piper has consciously explored the genre of social transformation through the self, fusing rage with extraordinary cool. Her most daring inversion is the small brown *My Calling (Card) #1*, copyrighted on the back as "Angry Art" (see sidebar), which she describes

▼▼▼▼▼▼▼▼
Dear Friend,
I am black.
I am sure you did not realize this when you made/laughed at/agreed with that racist remark. In the past, I have attempted to alert white people to my racial identity in advance. Unfortunately, this invariably causes them to react to me as pushy, manipulative, or socially inappropriate. Therefore, my policy is to assume that white people do not make these remarks, even when they believe there are no black people present, and to distribute this card when they do.
I regret any discomfort my presence is causing you, just as I am sure you regret the discomfort your racism is causing me.
Sincerely yours,
Adrian Margaret Smith Piper
My Calling (Card) #1, 1986

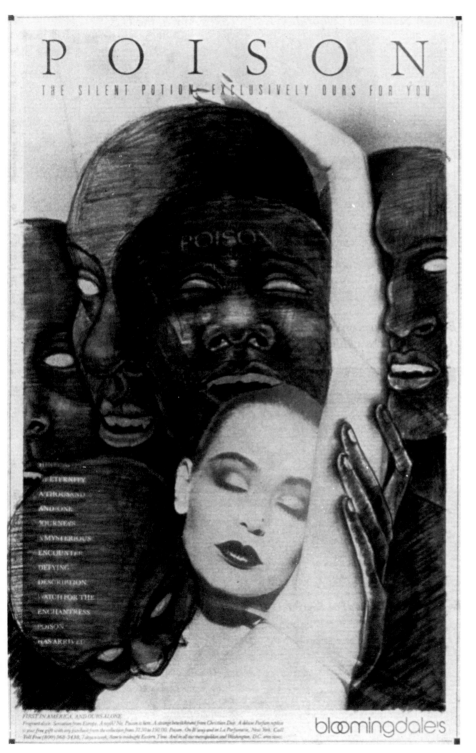

Fig. 28: Adrian Piper, *Vanilla Nightmares #8*, 1986, charcoal on newspaper, 14″ × 22″. (Photo courtesy John Weber Gallery, New York.) Piper has taken a Bloomingdale's ad for Poison perfume—"the silent potion exclusively ours for you"—and turned it around so that it applies to the black invaders of the white erotic domain. Here the white model is the slave. The printed word "poison" is repeated on the forehead of the central drawn figure, and a list of words (also in white print in the ad) march across the skull of the figure at the left, whose teeth are buried in the model's shoulder. They read: "Hinting at Eternity, a Thousand and One Journeys, A Mysterious Encounter Defying Description, Watch for the Enchantress, Poison Has Arrived." This text, idiotic in the advertising context, takes on another meaning in the context of Piper's alterations. It also turns upon the stereotypes of and white fascination with "black magic" and "white slavery."

Two grotesques, swinging lariats and singing, come in on the west side of the court and, seeing the woman, drop on their hands and knees and crawl toward her, each loosening his breechclout and displaying a false penis made of a gourd neck. When she finishes washing an old fringe of rags, she washes her legs, displaying a great false vulva so that all the spectators can see it and laugh at her. The grotesques and the two clowns—all whitened with clay—finally converge on her, and as she sits on the sacred shrine they propose copulation with her. She points to the presence of her boy as an obstacle. The clowns send the boy to get a jar of water and then proceed upon the shrine either to copulate or to imitate copulation with the utmost grossness.
—Alexander M. Stephen, *Hopi Journal of Alexander M. Stephen* (New York: Columbia University Press, 1936, p. 331)

as a "reactive guerrilla performance (for dinners and cocktail parties)." She states calmly that her cards "attack and subvert institutionalized rules of etiquette that I find oppressive" and are aimed at self-awareness and questioning of the implicit assumptions behind common racist practices.[56]

With this deceptively weightless artwork, Piper confronts the sinner with evidence of the sin, her antidote to "the pernicious protective mechanisms of ideology," which she defines as "the inability to change the mind and grow, one-way communication." The calling card format is subversively polite, genteel, businesslike, a parody of "civilized" communication that protests the barbaric behavior of precisely those so-called civilized people whom Piper is trying to educate.

There has been little said about cross-cultural views of sexual activity and language in visual art, aside from occasional feminist work. Yet if there is any place cultural difference is deeply felt, it is at the site of sexuality. Joan Nestle, discussing "the impact of Native American sexual systems on the Protestant view of the world," says that Cherokee and Hopi artifacts "depict a comfort with oral and anal sex that directly challenged the colonialists' world view of how the body should be used."[57] When I attended a relatively iconoclastic university course on "Native American Religions and the Tradition of Play" in 1987, the only time I saw the students blanch was in a discussion of Hopi Don Talayesva's autobiography, *Sun Chief*, notable for its sexual frankness especially in relation to his childhood. I have seen strong Anglo tourist men blush when describing the raunchy clowning at some Indian dances, and I saw firsthand at a Zuni Shalako ceremony the Indian mothers giggle and cover their children's eyes and ears when the Mudheads (supposedly products of, and warnings against, incest) displayed their hilarious obscenities. Trickster himself is frequently priapic, specializing, like some avant-garde artists, like Native clowns, in "sanctioned disrespect"—what Nietzsche called "gay science," combining wisdom with laughter.

Such purposeful fusion of sexual and ironic powers is salient in the work of Robert Colescott (plate 38). Beginning in the mid-'70s, one series inserted "golliwogs," or caricatured black figures, into white "masterpieces," taking, for instance, Aunt Jemima off the box and into one of Willem de Kooning's "Woman" paintings (which are themselves, not incidentally, emblematic for feminists of the misogyny of male artists). Colescott has transformed many of art history's "sacred cows" with a broad humor that veils rage. The pregnant wife in Jan Van Eyck's Arnulfini wedding portrait becomes a black woman. George Washington crossing the Delaware is replaced by his namesake Mr. Carver and a boatload of grinning black stereotypes, including Aunt Jemima again. In the 1976 *Homage to Delacroix: Liberty Leading the People*, liberty herself is led by a black drummer boy. Van Gogh's *Potato Eaters* is transported to a southern milieu in *Eat Dem Taters*, and where Van Gogh's Dutch peasants look miserably resigned, the black sharecroppers are grinning their heads off,

as required. In a classic reversal, Colescott offers *Shirley Temple Black and Bill Robinson White*, in which Shirley Temple and Bojangles switch races and expose the "incongruity" of the black, or white, role.

Among the ironies surrounding Colescott's work is that his shows have been protested by the NAACP and local black leaders. He acknowledges that he is "pushing the standards of taste. I'm exploiting stereotypes, questioning the heroic in art. I use humor as bait, pulling you in to confront the social comment. The visual joke alone is a sidetrack. There's another layer."[58] That other layer is what has surfaced in the '80s. The paintings have become less cartoonlike (although his painterly style has always pulled them over to the art side), more fragmented, with different times and spaces piled on one another, less like a collage than a vision. His various earlier concerns—racial violence, consumerism, sexual identity, miscegenation, and art—are now crowded together in one composition: vernacular "barrelhouse" subject and classical Cubist structure coexist as uneasily as black and white.

Eroticism and race, never segregated in Colescott's work, are now fully entwined. In his 1985 *Knowledge of the Past Is the Key to the Future (Love Makes the World Go Round)*, a mixed couple are linked not only by their embrace but by manacles on their ankles. In another painting from the same series, subtitled *Saint Sebastian*, a figure that is half black male and half white female is tied to a classical column and pierced by arrows. A pile of skulls at the left, beside the ubiquitous river, have met a similar fate. In the sky, on either side of the central scene, are busts of a white man in a necktie and a black woman, connected by a rope that forms nooses around each neck. An interpretive field day can be had by all, including racists. Another Colescott painting of this period is titled, significantly, *The Power of Desire; the Desire for Power*.

There is a disturbing element of torment in these paintings that goes beyond ambivalence. Teasing women (usually white) are consistently the vehicles for much of Colescott's rage and sexual temptation. He transforms, for instance, the titillating sixteenth-century Fontainebleau painting of two aristocratic women in the bath, one touching the other's nipple, into a love scene between a black cowgirl and a white cowgirl, one of whom wears a gun that has been perceived as a "phallic surrogate" and a symbol of male dysfunction.[59] Colescott's rather jealous view of lesbianism is quite explicit in *Tin Gal*, which pictures a "fearless," topless black cowgirl inscribed: "Her only weakness is coming unscrewed."

Beauty Is in the Eye of the Beholder is the title of another painting in which the artist, as Matisse in the process of applying red-brown color to white dancers in *The Dance*, is distracted by a plump disrobing white model. Perhaps in the spirit of (or in spite of) recent deconstructionist theories of representation, the gaze of the beholder of these women functions as expected and is not subverted. Colescott's women are be-held in stereotypical slavery that is finally a queasy device, which seems less liberating than complicit.

Fig. 29: Jud Hart II, *Ideological Hostage Experiencing Two Myths of Freedom (Origins of Wisdom and Ignorance)*, 1984, mixed media with mirror, 16½″ x 24″. Collection (and photo by) Gary Emrich, Denver. Jud Hart II is an African American photocopy, poster, and mail artist as well as a painter. He is based in Denver and San Francisco, where he makes his living constructing floats for parades. Hart's irreverent, sardonic collage images often include repellent black stereotypes and relatively positive images of "Jabbo"; he calls himself "Ultra Urban Aborigine," works out of "Studio Mondo Condo," propagates BUBBA Information Theory (BIT), and is a generally irrepressible neo-shaman. The mirror on which this piece is painted raises the question of whose flesh and blood is the hostage and which myth of freedom is under discussion. Chinese and Arabic scripts, Caucasian and African profiles, and the identity of the decaying angel further compound the satire. The sacrificial figure has a bag ("ideological bag/gage") over its head, another recurrent theme in Hart's art. "The bag comes off in the '90s," he says. "It's already started. The figure with the bag could be anyone" (letter to the author, 1989).

Interracial sex is another of Colescott's prime subjects, and one that is usually avoided in writings about him. Interracial marriage, which he knows firsthand, has clearly provided him with some enduring fantasies and nightmares that fuel a painful wit. Presumably he knows what he risks by "pushing good taste" in the two most sensitive areas—race and sex. Yet as Thomasine Bradford has pointed out:

> That a painter so intelligent, so severe an observer, would resort to persistent and recurring stereotypes of other human beings because of sex, while the stated purpose of his work is to rout out racial stereotypes, underscores in darkest ink the unconscious power of the ideology of difference.[60]

A passage from a 1987 statement by Colescott suggests a broader base for some of these misogynous and miscegenous scenes:

> One of the great unlearned lessons of history, standing out in ten-foot-high neon letters, is about the historical chain of interrelationships and interdependencies between Black and White . . . it winds back into dim prehistory touching familiar sign posts along the way—the dark-skinned Europeans that live closer to Africa; the white-appearing slaves who worked for and were owned by their fathers; King Solomon and the Queen of Sheba; the Nubian Kings and Queens of Egypt, and our common African ancestor "Eve." . . . However, even the most powerful seem unable and unwilling to put the meaning of history to work for themselves and us. . . .
>
> The matching of contemporary problems and historical allusion inflates the subject to such proportion that I'm not sure paintings can be made that adequately address it. Since no one learns from history anyway, is there a point to historical paintings except to talk about that contradiction? The seemingly

irrational distortions of fact, fiction, and form ultimately call into question this kind of "preachers' expressionism" anyway. The paintings end up devouring themselves in the final irony, which is to question the idiom itself.[61]

So what does it take to turn a stereotype around, to undermine a commonly assumed "realism"? The options for breaking patterns, reversing stigmas, and conceiving a new and more just world-picture are many and multifaceted. They range from opening wounds, to seeking revenge through representation, to reversing destructive developments so the healing processes can begin. To turn a stereotype around, it is necessary to be extreme, to depart from, rather than merely engage with, accepted norms and romanticized aspirations. Stereotypes have the borrowed power of the real, even when they are turned around in the form of positive images by those trying to regain their pasts. It is necessary to depart from stereotype in two senses—to take off from it and finally to leave it behind. The effective turnaround is a doubling back rather than a collusion or a dispersion. It can be an unexpectedly vicious dig in the ribs indicating that the joke's on you, or a double vision that allows different cultures to understand each other even as they speak in different ways. Transformation of self and society is finally the aim of all this mobile work that spins the status quo around. While irony, with its tinge of bitterness as well as humor, is the prevalent instrument, another is healing, in which the artist, as neo-shaman, heals her or himself, as a microcosm of the society.

Fig. 1: Albert Chong, *Anointing the Eggs*, from the "I-Trait Series," silverprint, 30" × 30", 1985. Chong, an African Chinese originally from Jamaica, writes that as a "Black man living under the pressures of Western Civilization, I have tried to penetrate a deeper understanding of man, his origins in Africa and his mystic heritage—the heritage of the King, the sage, the warrior and the slave, the musician, the artist, the tiller of the soil, the wielder of fire and the magical healer. . . . These are the traits of the African that I call I-Traits" (quoted in *Contemporary Afro-American Photography*, p. 12). The "I-Traits" are self-portraits made from 1980 to 1985 in which Chong acted out the parts just cited as the camera recorded his actions on time exposure, transforming him into a blurred ghost of himself. The blur of his moving figure and the concreteness of the ritual objects offer a synchronous double time that evokes the attempts to remember a dream right after waking. This image is from a subseries titled "Anointing the Eggs," as though healing the future. Chong's later work also concerns religion, nature, and cultural identification, but it uses still lifes influenced by the Santería ritual, as well as installations about the meaning of the cross in relation to slavery.

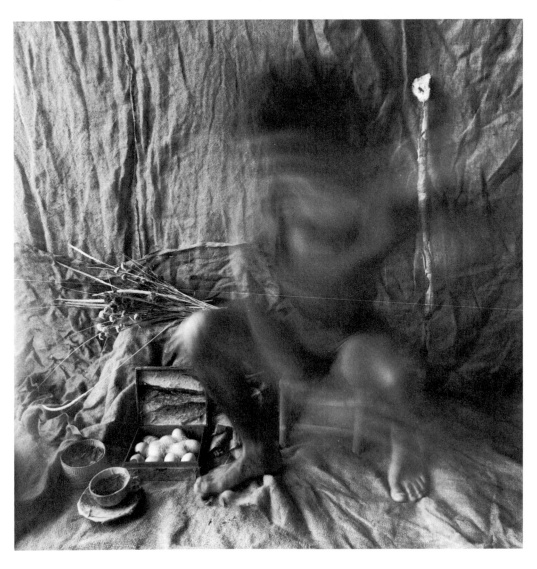

DREAMING

▼▼▼

> I would like to suggest that a group of us malcontents get together and perform the sacred ritual of the Dadaists for the origin of a new name. We will choose a new language that nobody can identify with and we will purchase a dictionary for it. We will shoot an arrow at this dictionary and the word upon which the tip of the arrow touches will be our new name. This will give us the freedom that we need, because nobody will know what to expect. —Edward Poitras, (Canadian Métis)[1]

I complete this book, on the first day of the century's last decade, with an overwhelming sense of humility. Had I realized at the beginning how complex the subject was, I would never have attempted it. The journey has often been hallucinatory, as I dreamed myself into the lives of others and in the process re-viewed my own life. The unfamiliar images and symbols buried in cultures not our own, or coming mysteriously to us in dreams and flashbacks, offer fresh ways of seeing the world, and art. They support Émile Durkheim's contention that society itself is a creative power, and that only the intensity of collective life can awaken individuals to new achievements. On the other hand, only the individual can effect the collective dream. The artists in this book (and outside of it) are piling up stones in their glass houses to be used as weapons in the image wars. They offer convincing evidence that art is open—to interpretation and to *use* by those from other neighborhoods. They evoke places to land, new addresses, new ways to affect mass reality, new forms and issues to be addressed within the relational network. The illusion of unity in the dominant culture and the American myth is threatened by such envisioning.

My own ambivalence about the alienation and exclusivity of contemporary visual art is sometimes countered by an image's or an action's sheer unex-

Fig. 2: Kaylynn Sullivan Two Trees, . . . *and he had six sisters* (Part I of *Nighttrippers*), 1984, performance at New York Public Baths. (Photo: Robin Holland.) Sullivan is an African American (and Native American) multimedia performance artist now living in New Mexico, whose art has been extraordinarily varied and original. For many years, beginning in the mid-1970s, her theme was domestic violence. (Her mother was murdered by her stepfather when she was six; the same fate later befell her cousin; Sullivan herself was an incest victim.) In her work she moved through ca-tharsis to self-healing, with broader cultural issues the vehicle. In a piece called *Halfway to Jesus*, based on a hospital experience, she dealt with age and natural death, which pre-pared the way for her work as a professional healer. Sullivan calls herself "Seer Nueva"; her task is "to find and clarify a voice of wholeness and jubilation at being alive which is not self-congratulatory or boring." This piece was dedicated to Zora Neale Hurston. Like Hurston, Sullivan collected "old wives' tales" in the South, which were then "sung and snarled by the wise, isolated sisters whose lore will not be tamed . . . I was at-tempting to weave a tapestry of voice and sound which could evoke the deep primordial bond which women share both in support of each other and also as a line of passing on certain destructive myths regarding our power and our roles." (Quotations from letter to the author 1990, and Arlene Raven, "Feminist Rituals of Re-Membered History.

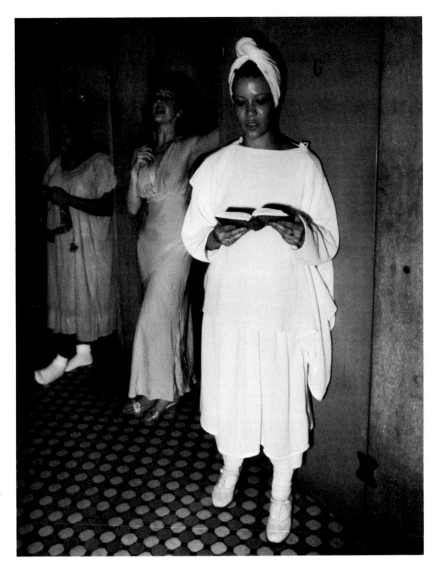

pectedness, the potential for visionary communication that is unlike any other form. Joseph Campbell remarked that art is the only ritual medium we have left today, but that not many artists realize what they're handling. Exposure to and understanding of difference must be allowed to expand and help re-habilitate the role of the communal imagination. We dream, we see, and only then do we think and act. We see things in other traditions that have gone unnoticed in our own. If we are now in a somewhat absurd moment of naming, still anchored to our hyphens, our politically correct and awkward terms and lists, perhaps we can see this process as the laying of a groundwork, or the construction of a network, a safety net to catch the fragments as our precon-ceptions explode. While the United States confronts the reality of a truly

multicultural society in which all cultures are equally respected, conservatives are digging in their heels with immigration laws, English Only laws, and censorship laws. We can choose instead to learn to read the unfamiliar symbols and images buried in the experiences of others, to share the development of a fresh outlook—or an *inlook*, a vision.

If naming and renaming inevitably set up boundaries, crossings and mixings are echoes from the future, headed out of bounds. Reality and the probable can be enhanced and expanded by the possible—in this case, the possibility of reconciliation between cultures, the alternative to which is the apparently endless civil wars that plague the world today. The works of art in this book are among the many signposts out there, and the connections between them form the maps for a series of cross-cultural journeys. As in dreams, the symbols they use are familiar but often refuse to yield dogmatically specific meanings. The very density (sometimes opacity) of this art, its layering and fragmentation, suggest the necessity to rethink the assumptions that have led us to this precarious point. An increasing number of people are turning their backs on the fading "center," motivated not just by anger, but also by a profound disinterest in the value systems it promulgates. The vertiginous collage that is contemporary life is illuminated through the cracks of difference. Edges and boundaries shift, revealing new views just coming into focus.

Kay Miller (cover plate) takes, or has been given, one of the most complex positions in the panoply of difference. She sees herself as "the transformer, the Joker, the Blending Edge of Opposites . . . all self-identities resulting from stories my mother told me when I was six or seven years old." Part Comanche and Métis (but without "papers" and unable to trace her ancestry), a mixed-blood raised very poor in an urban ghetto in Houston, Texas, Miller is wary of becoming a public or one-dimensional Indian, although her heritage is a significant part of her life and her art. She insists on keeping her double identity and on the possibility of a spiritual union between "urban and tribal views, ghetto and ecological attitudes, white and Indian cultures, orthodox religion and personally intuited insights."[2]

Miller's paintings often present unpredictably paired images united on uniform grounds, heavily laden with thick, brilliant pigment and glowing color. Opposites (in imagery as well as in the virtually transcendental sense of color/light and an earthly formal weight) spark each other and offer a way of seeing that is fundamentally unfamiliar to Western thought. While the images themselves are compelling, it is the energy *between* them that gives her paintings their force. Sometimes Miller's sparring pairs are dissimilar, and sometimes they collaborate on different forms of the same message. In *Shoreless River* the tip of a dark feather is brushing the "ground," overwhelming the cross with which it shares a steely gray field; the implication is that on an achronological religious field of combat, the Native American symbol has held its own. In *Natural History* a volcano shrinks to meet an enlarged beadwork pendant, both female symbols, one natural, one cultural.

▼▼▼▼▼▼▼

When depicting reality, Northwest coast artists often showed two beings simultaneously occupying a single space by sharing various parts. Such visual puns did more than express complexity: they depicted transformation. Before one's eyes Bear became Wolf, then Bear again. The image didn't change, of course. What changed was the observer's organization of its parts. But the effect was one of transformation.
—Edmund Carpenter, "Introduction: Collecting Northwest Coast Art," *Form and Freedom* (Houston: Institute for the Arts, Rice University, 1975, p. 9)

Fig. 3: Norval Morrisseau (Ojibway), *Shaman and Disciples*, 1979, acrylic on canvas, 51″ × 82½″. Collection (and photo courtesy of) McMichael Canadian Art Collection, Kleinburg, Ontario. Morrisseau, who is considered the founder of the Canadian "Ojibway-Cree-Odawa" school of legend painting, learned Ojibway tales and psychic ritual practices from his grandfather, the "mythman," as a child in Thunder Bay, Ontario, before he was sent away to a Jesuit boarding school. He began to make his images in sand, then in the traditional shaman's birchbark, and then in paint, after having a vision in which he was told that the Copper Thunderbird would protect him in his "wanderings through the lattices" of a parallel universe, where he receives his imagery. He now considers himself a spiritual conduit from another world: "It seems as if I had pictures to bring back from another plane," he has said. "I have as much interest in the history and lore of my people as any anthropologist. . . . I do not wish my work to be exploited in any commercial way but to be properly used as an art form in its proper place for the generations of Ojibway people to see in the future" (unpublished statement for exhibition at the Bayard Gallery, New York, 1980).

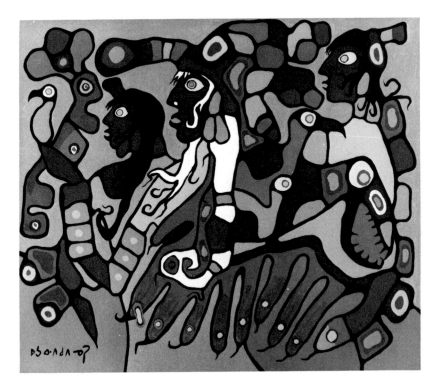

The central puzzle for the viewer of Miller's work is to see what the two unlike images really "have to do with" each other, and what that says about their "offspring"—the meaning they produce. A crystal and a medicine wheel, a tongue and a waterfall, a helicopter and a dragonfly, a shell and a joker card, a sun rattle and an eagle claw, a pistol and an ear of corn, a multicolored knife and a swaddled corpse, a headless figure and a tantric knot, a hand in a mudra and an upside-down flaming match, an awesome whirling, burning sun and a multicolored cloud of porcupine quills: the logic of these juxtapositions emerges from a spiritual tradition that incorporates chance, a "new" tradition that Miller, a student of the I Ching, weaves from Asian and Native American belief systems.

Even when Miller paints a single image—a black bear of tremendous density and stillness (which she has called a self-portrait) moving across a red ground, or a multicolored branch of elk antlers spreading like tree branches across a profound blue ground in which turquoise chips are embedded—the mystery remains. Painting for her is a "timeless and multidimensional field" that "bypasses non-essentials" and is "inseparable from the observer mixing into the sacredness that allows humor to flow freely."[3] The concept of synchronicity provides her work with a place in which the social tensions of intercultural life are not denied, but transcended. She does not, however, deny fundamental historical problems. International war is the subject of several pieces, and other

Fig. 4: Kay Miller, *Scouting*, 1985, oil on canvas, 48″ × 60″. Collection Dorothy Schramm. The figure on the right is a Tantric image, rising from the ground as its solar plexis is transformed into coils of light that are capable of scouting metaphysical realms. The leaf at the left is from a Kirlian photograph recording the energy or aura of an object (from Robert Hobbs, *Kay Miller*, Foxley/Leach Gallery, Washington, D.C., 1987). The two seem to be dancing together on the dark green ground that is partly patterned in heavy paint to convey wind and flowers.

works contemplate warring ideologies or warring emotional needs between couples and friends.

Miller is a visionary whose "global" political/spiritual view springs from the earthy and ethereal sources of her own class and cultural background. She has discovered within herself a female trickster figure whose humor is healing. For all their profundity, and their imag(in)ing the existence of wholeness, her images sparkle with disjunctive laughter about the irony of living in a world that is unable to put the pieces together. Miller's "two-word world" is where everyone not wholly incorporated into the dominant culture lives. On one hand, there is the prevailing truism that "under the skin, we're all alike," which expresses the natural need to belong to the larger society one inhabits. On the other hand, those whose backgrounds have been denigrated, who in order to survive must pretend to be other than they are (and this includes many artists), one word may be shouted unheard, muffled beneath the other word that must be spoken more loudly for survival.

These paradoxes are our future. If they are acknowledged and perused with

Fig. 5: Lonnie Holley, *The music lives after the instrument is destroyed*, 1987, musical instruments, wire, artificial flowers, 7" × 32" × 36". Collection William Arnett, Atlanta. (Photo: Kathryn Kolb.) At forty, Holley is one of the younger artists known for working in a vernacular mode, and one of the most inventive. He lives in Birmingham, Alabama, where his home has been described as "a monumental site-specific work" and "a visionary landscape" (Judith McWillie). "One of the main currents in Holley's philosophy is that the material world encodes ideas through time. He sees his role as an artist and as a black person to be a discoverer of new uses and new beauty in things others have discarded and overlooked. He not only finds this process an appropriate metaphor for the historical and economic roles of the black in America, but also sees in such found objects symbols for himself and the race: considered trash, yet still useful and meaningful" (letter from Paul Arnett, 1990). The broken saxophone and burned guitar are connected by the wire-outlined profiles of their musical spirits or former players, and the horn is resurrected by green leaves and colored flowers. "Their inner formal music is a medicine, designed to protect us from becoming idolatrously attached to brand new things," writes Robert Farris Thompson. Holley himself explains: "It's the music opening and growing, like a vine. The music made a flower open up in somebody's mind. It causes love to be" (*Another Face of the Diamond*, pp. 63, 41).

a certain delight, if they are not made to fit molds they have already outgrown, they will provide the raw material for a multifaceted sense of identity where difference can live and breathe. Culture can be the realm of wishful thinking. It can also be prophetic.

Without a vision, without a big dream, without the anger and humor that keeps our feet on the earth even when our heads are in the clouds, we won't see the multicultural society that these artists in their diverse ways are trying to show us. N. Scott Momaday has said that "We are what we imagine. Our very existence consists in our imagination of ourselves. . . . The greatest tragedy that can befall us is to go unimagined."[4]

Notes

Full citations are not given for references included in the bibliography.

Introduction: Mapping

1. Kumkum Sangari, "The Politics of the Possible," *Cultural Critique* no. 7 (Fall 1987), p. 176.

2. James Clifford, *Predicament of Culture*, p. 146.

3. Henry Louis Gates, Jr., *"Race," Writing and Difference*, p. 5.

4. I like these terms better than the Canadian "mosaic," which sounds frozen into place.

5. Carlos Fuentes, *Latin America: At War with the Past* (Toronto: CBC Enterprises, 1985).

6. Adrian Piper, "Ways of Averting One's Gaze," 1987 (unpublished).

7. Bruce Chatwin, *The Songlines* (New York: Viking, 1987).

8. Tony Fry and Anne-Marie Willis, "Aboriginal Art: Symptom or Success?" *Art in America* (July 1989), pp. 114–15.

9. Caren Kaplan, "Deterritorializations: The Rewriting of Home and Exile in Western Feminist Discourse," *Cultural Critique* no. 6 (Spring 1987), pp. 188–89, 191.

10. Emily Hicks, "What Is Border Semiotics?" *BAW/TAF* (San Diego: Border Art Workshop/Taller de Arte Fronterizo, 1988), p. 50.

11. Maria Lugones and Elizabeth Spelman, "Have We Got a Theory for You!" pp. 580, 576.

12. Barbara Christian, "The Race for Theory," *Cultural Critique* no. 6 (Spring 1987), p. 61.

13. Sangari, "Politics of the Possible," p. 184.

14. Cornel West, interview by Stephanson, p. 51; my notes from "Show the Right Thing" conference at New York University (Fall 1989), as published in *Z* (Nov. 1989), p. 80.

15. Nancy Hartsock, "Rethinking Modernism: Minority vs. Majority Theories" from "The Nature and Context of Minority Discourse" ed. A. JanMohammed and D. Llloyd (New York, Oxford University Press, 1990), p. 26.

16. Claude Lévi-Strauss, *Tristes Tropiques* (New York: Atheneum, 1975), p. 436.

17. See for instance, the dialog between German American art historian Benjamin Buchloh and curator Jean-Hubert Martin of the Pompidou Center in Paris, in regard to the "Magiciens de la terre" exhibition at the Pompidou in 1989 (*Art in America* [May 1989], pp. 150–59, 211, 213).

18. Chela Sandoval, quoted in Kaplan, "Deterritorializations," p. 187.

19. Bell Hooks, *Feminist Theory*, p. 27.

20. Maxine Hong Kingston, *The Woman Warrior* (New York: Vintage Books, 1977), p. 35.

21. Two artists' books titled *Colored People* demonstrate some differences. The first, published in 1972 by white Californian Ed Ruscha, consists of many colored photographs of cactuses that resemble figures. The second, by African American Adrian Piper, consists of photo-booth portraits of white and black people, men and women, trying to express emotions dictated by the artist: green with envy, white with fear, blue, red with rage, etc.

22. Trinh T. Minh-ha, introduction, *Discourse* no. 8 (1986).

23. Paul Kagawa, in *Other Sources*, ed. Villa, p. 9; somewhat similarly, anthropologist Sally Price goes so far as to define "Westerners" as "people with a substantial set of European-derived cultural assumptions," no matter where they are from (letter to the author, 1988).

24. Sangari, "Politics of the Possible," p. 158.

25. Sylvia Wynters, "On Disenchanting Discourse: 'Mi-

nority' Literary Criticism and Beyond" from "The Nature and Context of Minority Discourse" ed. A. JanMohammed and D. Llloyd (New York, Oxford University Press, 1990), p. 459.

26. The bicultural connotation is that used in Jeff Jones's and Russell T. Cramer's influential 1989 report on "Institutionalized Discrimination in San Francisco's Funding Patterns."

Chapter One: Naming

1. James Baldwin, "A Talk to Teachers," originally delivered in 1963; published in *Graywolf Annual Five: Multicultural Literacy*, ed. Simonson and Walker, p. 8.

2. See "Many Who Are Black Favor New Term for Who They Are," *New York Times* (Jan. 31, 1989). In Britain, "black" is applied to Africans, Asians, and all other people of color by racists as well as by people of color taking a political stance to emphasize a shared colonial history and experience of oppression.

3. In the nineteenth century, both here and in England and continental Europe, "Red Indian" was used as a semantic distinction from East Indian. "Squaw" is another insulting term, rumored to have originated because "we squawked when we were raped," according to Jaune Quick-To-See Smith.

4. Judith Wilson, "Stereotypes, or, A Picture Is Worth A Thousand Lies," in *Prisoners of Image*, p. 21.

5. The *New York Times* (Sept. 9, 1989) reported that today, as in Dr. Kenneth Clark's famous "black doll" experiment two generations ago, black children asked to select the "prettier, cleaner, smarter" image, chose the white over the black.

6. Elaine Kim, "Defining Asian American Realities Through Literature," *Cultural Critique* no. 6 (Spring 1987), p. 109.

7. Vine Deloria, Jr., quoted in Jamake Highwater, *The Primal Mind*, p. 173.

8. William King and Saul Bellow, *New York Times* (Jan. 18, 1988). Ironically, as Judith Wilson pointed out to me, there *was* a "Tolstoy of the Zulus"—Thomas Mofolo, whose novel *Chaka* was written in the Sotho language around 1908, published in 1925, and has since been translated into English, German, and Italian.

9. Susan Hiller, "Sacred Circles: 2,000 Years of North American Indian Art," *Studio International* no. 1 (1977), p. 56.

10. See James Clifford's bemused account of the Portland (Oregon) Museum of Art's negotiations with Tlingit elders about the reinstallation of a major collection of Northwest Coast art. The totally unexpected process, which focused on songs and stories rather than specific data about specific objects, yielded insights into the marginal role of objects in certain cultures, reinforcing Clifford's determination to find a museological way to "represent that discrepancy between object and context prominently in the exhibits" (in "The Global Issue: A Symposium," *Art in America* [July 1989], pp. 152–53). See also Canadian art historian Charlotte Townsend, in her provocative article "Kwakiutl Ready-mades?" (*Vanguard* [Nov. 1988], pp. 28–33). She similarly demonstrates that food vessels "can be identified as emblematic of a complex of ideas and practices. In Native terms they are not reducible to either a use-factor or cosmological references. They can be seen as shifting back and forth between functional objects and spiritual representations, culturally meaningful as both. They are physically, and conceptually, ambiguous." In addition, see Edward Chappell, "Museums," *The Nation* (Nov. 27, 1989), on current display techniques, and reports on the ICME Conference, "Presentation of Culture," Leiden, Holland, 1987.

11. James Clifford, "Histories of the Tribal and the Modern," *Art in America* (April 1985), pp. 164–77. See also Lucy R. Lippard, "Give and Takeout," in *The Eloquent Object*, ed. Manhart and Manhart, pp. 202–27.

12. See John Berger, "Primitive Experience," *Seven Days* (March 13, 1977), pp. 50–51.

13. Jerome Rothenberg, "Pre-Face," *Technicians of the Sacred*, p. xix ff. Rothenberg suggests the term "archaic" as "a cover-all term for 'primitive,' 'early high,' and 'remnant,' " which also encompasses "mixed" cultural situations and a vast variety of cultures.

14. Lowery Stokes Sims, "Race, Representation, and Appropriation," in *Race and Representation*, p. 17.

15. Gerardo Mosquera, *Contracandela* [collected essays] (Havana: Editorial José Martí, forthcoming).

16. Judith McWillie, in *Another Face of the Diamond*, p. 7.

17. Michele Wallace, "The Global Issue," *Art in America* (July 1989), p. 89. However, as Judith Wilson pointed out to me, black artists were buying African art in the '20s, as advised by Alain Locke in his important 1925 essay, "The Legacy of the Ancestral Arts." By the '50s, many black artists based their forms directly on these objects and traveled to Africa.

18. Jaune Quick-To-See Smith, in conversation with the author, Santa Fe, Jan. 1985.

19. See Barbara Braun, "Cowboys and Indians: The History and Fate of the Museum of the American Indian," *Village Voice* (April 8, 1986), pp. 31–40.

20. Peter Jemison, "Out of Sight, Out of Mind I," *Upfront* no. 6–7 (Summer 1983), p. 20.

21. Quick-To-See Smith, conversation, Jan. 1985.

22. The U.S. representation in "Magiciens de la terre" was all Euro-American, except for Navajo artist Joe Ben. Nam June Paik, a Korean living part-time in New York, and Alfredo Jaar, a Chilean living in New York, were also included. Two Native Canadians were represented.

23. See "Report from Havana: Cuba Conversation," *Art in America* (March 1987), pp. 21–29. Extensive catalogs

exist for the 1986 and 1989 Third World Bienals in Havana.

24. Rasheed Araeen, "Our Bauhaus, Others' Mudhouse," *Third Text* no. 6 (1989), pp. 4, 6, 12, 8.

25. Tony Fry and Anne-Marie Willis, "Aboriginal Art: Symptom or Success?" *Art in America* (July 1989), pp. 114–15.

26. Jean-Hubert Martin, "The Whole Earth Show: An Interview with Jean-Hubert Martin," by Benjamin H. D. Buchloh, *Art in America* (May 1989), p. 156.

27. Rasheed Araeen, "From Primitivism to Ethnic Arts," *Third Text* no. 1 (Autumn 1987), p. 10.

28. Gronk, in conversation with the author, Dec. 8, 1988.

29. Araeen, "From Primitivism," p. 10.

30. Barbara Christian, "The Race for Theory," *Cultural Critique* no. 6 (Spring 1987), p. 61.

31. Coors sponsors many Native American powwows, and in the dance competitions each participant must wear a number that also advertises Coors; some fold the brand name under so that only the number shows, erasing Coors as Coors for so long tried to erase minorities from its labor force.

32. At another time, visiting Puerto Rico for a conference, Reagan announced how glad he was to be in Costa Rica.

33. See Edward Said, *Orientalism*.

34. A recent film by Christine Choy and Renee Tajima—*Who Killed Vincent Chin?*—reveals the complexity of this situation.

35. Fawaz Turki, "Victims of the Literature of Power," in *Prisoners of Image*, p. 11.

36. Thanks to Margo Machida for much of this information.

37. An interesting aspect of the "Nigger Drawings" controversy was this white artist's appropriation of "outsider" status through a pejorative term. As a Caucasian, he had not "earned" that name, but he sensed its inverse power. In the throes of self-pity, he reached out and took its shock value as his own. (I owe this insight to Anne Twitty.) In the late '70s there was such a furor about the use of the word "nigger" that many African Americans decided it was best to forgo the use of the word even among themselves; comedian Richard Pryor, famous for his familiar and usually ironic use of the term, also promised to stop using it.

38. See the catalog *Ethnic Images in the Comics*.

39. At the core of the Alternative Museum's important "Prisoners of Image" show in 1989 was the Janette Faulkner Collection of Stereotypes and Caricatures of Afro-Americans (from San Francisco). As Robbin Legere Henderson says in the catalog, "Viewed within the context of racial violence . . . it becomes painfully apparent why manufacturers assumed that there was a market for ashtrays and games which allowed whites to symbolically attack blacks, or golf tees which evoked images of 'playful' sadism" (p. 6).

40. David Goldberg, "Images of the Other: Cinema and Stereotypes," in *Race and Representation*, p. 30.

41. Howardena Pindell, quoted in Richard Lorber, "Women Artists on Women in Art," *Portfolio* (Feb./March 1980), p. 71; Pindell lecture at Mills College, Oakland, Cal., March 1988.

42. Pindell's report "Statistics, Testimony and Supporting Documentation" was first delivered at the "Agenda for Survival Conference," Hunter College, New York, June 1987. It was published as "Art (World) & Racism," in *Third Text* no. 3–4 (Spring/Summer 1988), pp. 157–190, and in the *New Art Examiner* (March 1989).

43. Yolanda López, in conversation with the author, Oct. 1988. Her 28-minute videotape *When You Think of Mexico: Commercial Images of Mexicans* is distributed by Piñata Productions in Oakland, Cal.

44. Victor Turner, *Dramas, Fields, and Metaphors* (Ithaca: Cornell University Press, 1974), pp. 152–53.

45. Judith Wilson, in *Autobiography: In Her Own Image*, p. 15.

46. See the exchange between Barbara Barr and Adrian Piper, *Woman Artists News* (June 1987), p. 6; the debate continued with letters from readers in subsequent issues.

47. Adrian Piper, "Flying," in *Adrian Piper* (New York: Alternative Museum, 1987), pp. 23–24.

48. Homi Bhabha, "Remembering Fanon," in *Remaking History*, ed. Kruger and Mariani, p. 146.

49. Michael M. J. Fischer, in *Writing Culture*, ed. Clifford and Marcus, pp. 195, 196.

50. David C. Driskell, quoted by Clement Alexander Price, in *The Afro-American Artist in the Age of Cultural Pluralism*, p. 7.

51. Lois Mailou Jones, in *New Directions for Women* (March/April 1985), p. 19.

52. Robert Lee, "Introduction: A Feather's Eye," in *The Mind's I: Part I*, p. 4.

53. Margo Machida, quoted on National Public Radio, Jan. 28, 1988, about the "Cut-Across" exhibition in Washington, D.C.

54. All quotations from Margo Machida here and below are drawn from a series of unpublished statements on her work, a published statement in *Cultural Currents* (San Diego: San Diego Museum of Art, 1988), and answers to a questionnaire from Arlene Raven (1989).

55. Dominique Nahas, in *Orientalism: Exhibition of Paintings by Margo Machida and Charles Yuen* (New York: Asian Arts Institute, 1986), n.p.

56. Robert Reinhold, *New York Times* (Dec. 13, 1987).

57. Jimmie Durham, *Columbus Day* (Minneapolis: West End Press, 1983), p. 7 (his emphasis).

58. Roy Wagner, *The Invention of Culture* (Chicago: University of Chicago Press, 1981), p. 107.

59. N. Scott Momaday on National Public Radio, Nov. 25, 1989.

60. Jaune Quick-To-See Smith, curatorial statement for "24 Native American Photographers" (New York: American Indian Community House, 1984).

61. Henry Louis Gates, Jr., "Authority, (White) Power and the (Black) Critic; Or, It's All Greek to Me," from *Cultural Critique*, No. 7 (Fall 1987), pp. 33, 37.

62. Christian, "Race for Theory," p. 52.

63. Cornel West, "Black Culture and Postmodernism," in *Remaking History*, ed. Kruger and Mariani, pp. 88, 92.

64. Paul Gilroy, "Cruciality and the Frog's Perspective," *Third Text* no. 5 (Winter 1988–89), p. 37.

65. Lorna Simpson, unpublished interview with Moira Roth, 1989.

66. Ibid.

67. Kellie Jones, in *Lorna Simpson* (New York: Josh Baer Gallery, Oct. 1989).

68. Edited by Gloria T. Hull, Patricia Bell Scott, and Barbara Smith.

69. See two issues of *Heresies*: "Third World Women" (no. 8, 1979) and "Racism Is the Issue" (no. 15, 1982). The collective editorials tell the story.

70. Bell Hooks, *Ain't I a Woman?* p. 138; see also Angela Davis, *Women, Race, and Class.*

71. Maria Lugones and Elizabeth Spelman, "Have We Got a Theory For You!" p. 575.

72. Judith Wilson, correspondence with the author, Fall 1989.

73. Trinh T. Minh-ha, speaking at the Chatham Square Public Library, New York, Nov. 14, 1989.

74. Ibid.

75. Mosquera, *Contracandela.*

76. James Clifford, *Predicament of Culture*, p. 12.

Chapter Two: Telling

1. Trinh T. Minh-ha, *Woman, Native, Other*, p. 2.

2. C. L. R. James, "C. L. R. James on the Origins," *Radical America* v. 2, no. 4 (July/Aug. 1968). (Excerpted in *Radical America* v. 16, no. 3, 1988, p. 51.)

3. James Clifford, in "Of Other Peoples: Beyond the 'Salvage' Paradigm," in *Discussions in Contemporary Culture Number One*, ed. Foster, p. 126.

4. Amalia Mesa-Bains, taped discussion, "Mixing It Up I" symposium, University of Colorado, April 1988.

5. Rosalind Jeffries, in *Black Artists on Art* v. 2, ed. Samella Lewis and Ruth Waddy, p. 30. It may be, of course, that we are all Africa reincarnated. *Newsweek* of January 11, 1988, showed on its cover a handsome (and incongruously "bright;" or light-colored) African couple as Adam and Eve. The ac-

companying article proposing Africa (or maybe Asia) as the cradle of the human race was a source of pride for the black and progressive communities. "Eve"—not the first woman, but our common ancestor—was preceded by "Lucy," the African semi-hominid named whimsically, and Eurocentrically, after the Beatles' song, "Lucy in the Sky with Diamonds"—naming being at the disposition of the "discoverers," as in "Indians" and "America."

6. Claude Ardrey, unpublished letter to *Arts* magazine concerning the Gerrit Henry review of Sam Gilliam's work in *Arts* (Feb. 1985).

7. Mary Schmidt Campbell, in *Tradition and Conflict*, p. 60.

8. See also the work of Tyrone Mitchell in his catalog *Plumes for Dark Victories* (New York: Cyrus Gallery, 1988; text by Stephen Westfall).

9. In New York the Caribbean Art Center often presents exhibitions that balance somewhere between art and history and religion.

10. Ishmael Reed, "America, The Multinational Society," in *Graywolf Annual Five: Multicultural Literacy*, ed. Simonson and Walker, p. 156.

11. David Hammons, interviewed by Guy Trebay, *Village Voice* (April 29, 1981).

12. See Robert Farris Thompson, *Flash of the Spirit*, p. 142 ff.

13. David Hammons, interviewed by Kellie Jones, *Real Life* no. 16 (Autumn 1986); Trebay interview.

14. Hammons, in Jones interview.

15. Benjamin Buchloh, interview with Jean-Hubert Martin, *Art in America* (May 1989), p. 155.

16. Alison Saar, in *Soul Service Station* (Roswell, N.M.: Roswell Museum and Art Center, 1986), n.p.

17. Bessie Harvey, quoted in Shari Cavin Morris, "Bessie Harvey: The Spirit in the Wood," *The Clarion* (Spring/Summer 1987), p. 45.

18. Houston Conwill, quotations in this section are from a public dialog with the author at the Studio Museum in Harlem, 1987.

19. Irene Borger, "Funk Lessons: A Guerrilla Performance," *LA Weekly* (March 28, 1984), p. 63.

20. Judith Wilson, in correspondence with the author, 1989.

21. Dave Matheny, "Lesson in Funk isn't just dancing; it's an artistic leap," *Minneapolis Star and Tribune* (Nov. 1, 1983).

22. Trinh T. Minh-ha, "Grandma's Story," *Blasted Allegories*, ed. Wallis, pp. 11, 13.

23. Sonia Boyce, interviewed by John Robert (who was citing Homi Bhabha in his question), *Third Text* no. 1 (Autumn 1987), p. 63.

24. Faith Ringgold, in *Heresies* no. 4 ("Women's Traditional Arts: The Politics of Aesthetics") (Winter 1978), p. 84.

25. Michele Wallace, "Reading 1968: The Great American Whitewash," *Z* (Dec. 1988), pp. 47–48.

26. See Charlotte Robinson, ed., *The Artist and the Quilt* (New York: Alfred Knopf, 1983)—a project in which contemporary artists and traditional quilters collaborated.

27. Thompson, *Flash of the Spirit*, pp. 207–10.

28. Robert Farris Thompson, "From the First to the Final Thunder: African-American Quilts, Monuments of Cultural Assertion," in *Who'd a Thought It?*, ed. Leon, p. 15.

29. Ibid., p. 21.

30. Navajo artist Emmi Whitehorse, in conversation with Jaune Quick-To-See Smith, 1989 (letter to the author).

31. Frank Cushing and Ruth Bunzel, quoted by Nancy J. Parezo, Kelley A. Hays, and Barbara F. Slivac, "The Mind's Road: Southwestern Indian Women's Art," in *The Desert Is No Lady*, ed. Norwood and Monk, p. 168. Collectors sometimes refuse to buy rugs lacking this trademark. Noel Bennett writes, similarly, that the "spirit trail" was a pathway, smaller than a trail—neither a "devil line," as some would have it, nor a way to let the negative forces out, but a pathway to liberation, for the personal growth of the weaver. Fearing that the imposed border might entrap her "spirit, mind, energies, and design," and jeopardize her future experiences at the loom, the Navajo woman made the path "as a moment of liberation, of peace, of security—and a wish for the future: may the next weaving be even better" (*The Weaver's Pathway* [Flagstaff, Ariz.: Northland Press, 1974], p. 35).

32. Joyce Scott, in *The Paul and Joyce Show* (Baltimore: Maryland Art Place, 1987), n.p.

33. Joyce Scott, in *En Masse/Fiber* (St. Louis: St. Louis Gallery of Contemporary Art, 1988), n.p.

34. Joyce Scott, quoted by Horace Freeland Judson, in *The Eloquent Object*, ed. Manhart and Manhart, p. 129.

35. Sherry Byrd, quoted by Leon, *Who'd a Thought It?* p. 22.

36. See *Another Face of the Diamond*; Jane Livingston and John Beardsley, *Black Folk Art in America 1930–1980* (Jackson: University Press of Mississippi, 1982); and Randall Morris, *American Mysteries* (forthcoming book on self-taught artists).

37. Jean Dubuffet, quoted by Michel Thévoz, *Art Brut*, pp. 9, 11.

38. See Lucy R. Lippard, "The Pink Glass Swan," *Heresies* no. 1 (1977); "Something from Nothing," *Heresies* no. 4 (1978); "Up, Down, and Across: A New Frame for New Quilts," in *Artist and the Quilt*, ed. Robinson, pp. 32–43.

39. Donald Kuspit, "Aycock's Dream House," *Art in America* (Sept. 1980), p. 87.

40. Eugene W. Metcalf, Jr., "From the Mundane to the Miraculous," *The Clarion* (Winter 1987), p. 56.

41. Susan Havens Caldwell, "The Place of Folk Art in the Art of an Industrialized Society," in *Folk Art in Oklahoma* (Oklahoma City: Oklahoma Museums Association, 1981), p. 22.

42. Anonymous mental patient quoted in Natasha Mayers, *Inside/Outside: Private Art* (Portland: University of Southern Maine, 1987).

43. Roland Rochette, quoted by Lucy R. Lippard in "Amazing G.R.A.C.E.," *Ten Years of G.R.A.C.E.* (St. Johnsbury, Vt.: Catamount and the Grass Roots Art and Community Efforts Program, 1987), p. 9.

44. Guy Brett, *Through Our Own Eyes*, p. 11.

45. Betye Saar, in *Betye Saar* (Los Angeles: Museum of Contemporary Art, 1984), n.p.

46. Betye Saar, in *Rituals: The Art of Betye Saar* (New York: Studio Museum in Harlem, 1980), n.p.

47. Betye Saar, interviewed by Ishmael Reed, *Shrovetide in Old New Orleans* (Garden City, N.Y.: Doubleday, 1978), p. 148.

48. Mary Schmidt Campbell, quoting William Seitz and Arnold Rubin in *Rituals* (Saar catalog), p. 9. Cornell himself was inspired in turn by "tribal" art.

49. Betye Saar, 1977 statement quoted in Houston Conwill, "Interview with Betye Saar," *Black Art* v. 3, no. 1 (1978), p. 4.

50. See Kay Turner and Pat Jasper, in *Day of the Dead*. The Alternative Museum in New York began annual Day of the Dead shows and processions through the streets in 1988. Amalia Mesa-Bains wrote a text for the first catalog.

51. Kay Turner, in *Lady-Unique-Inclination-of-the-Night*, Cycle 6 (Autumn 1983), pp. 11–12. (See also Tomás Ybarra-Frausto, in *Ceremony of Memory*, p. 9.)

52. Turner, ibid.

53. Amalia Mesa-Bains, in *Offerings: The Altar Show* (Venice, Cal.: Social and Public Art Resources Center, 1985), p. 5.

54. Ibid.

55. Tomás Ybarra-Frausto, "Sanctums of the Spirit—The Altars of Amalia Mesa-Bains," in *The Grottoes of the Virgin: Amalia Mesa-Bains* (New York: INTAR Gallery, 1987), pp. 2–9.

56. Kathy Vargas, letters to the author, 1988–90.

57. Ana Mendieta, unpublished interview on death and ritual with Linda Montano, 1983–84; letter to the author, undated (c. 1985).

58. Mendieta, Montano interview.

59. Serrano, along with photographer Robert Mapplethorpe, became the center of a storm around censorship when the American Family Association, Senator Jesse Helms, and others decried the exhibition of his *Piss Christ* (partially funded by the NEA). As a result, Congress imposed restrictions on the art that can be funded by the NEA; the restrictive language, despite the First Amendment and the art community's outrage, remains in place at this writing.

60. Andres Serrano, quoted by William Honan, *New York Times* (Aug. 16, 1989).

61. Michael Tracy, *Terminal Privileges* (New York: P.S.1, 1988), p. 45.

62. Victor Zamudio-Taylor, in *Ceremony of Memory*, pp. 16, 17, 18.

63. Regina Vater, in *The Flue* v. 3, no. 2 (Spring 1983), p. 5.

64. See Victor Turner, ed., *Celebration: Studies in Festivity and Ritual* (Washington, D.C.: Smithsonian Institution Press, 1982).

65. Robbie McCauley, "Mixing It Up II," radio station KGNU, Boulder, Col., April 7, 1989.

66. For instance, David Hammons, Houston Conwill, Senga Nengudi, Maren Hassinger, Jessica Hagedorn, Ntozake Shange, and especially Adrian Piper were all doing varieties of performance art in the '70s.

67. Lowery Stokes Sims, "Aspects of Performance by Black American Women Artists," in *Feminist Art Criticism*, ed. Raven, Langer, and Frueh, p. 208.

68. Ibid.

69. Quotation from *High Performance*, in publicity information sent to the author, c. 1988.

70. From publicity information sent to the author, 1989.

71. Jacki Apple, "Angels of Swedenborg," *High Performance* no. 45 (Spring 1989), pp. 51–52.

72. *Custom and Ritual: Native American Powwow* (Arvada, Col.: Arvada Center Folk Arts Series, 1988).

73. Jaune Quick-To-See Smith, correspondence with the author, Nov. 1989. Other Native American performers include musician Jim Pepper, playwright/director Hanay Geigomah, Danse Lab Pildowi (which bases its experimental work on ethnological data, memory transmission, and secret interpretations of Indian masks), and the American Indian Dance Theater (whose company members are sacred and powwow dancers living on reservations and in Indian communities all over the country).

74. *White Cloud Bulletin* (San Francisco: Hatley Martin Cultural Forum) v. 2, no. 4 (June/July 1987).

75. Undated flyer for Spiderwoman performance, from Just Above Midtown, New York (early 1980s); *American Indian Community House Newsletter* (June 1988).

76. Jolene Rickard, "Mixing It Up II," on radio station KGNU, Boulder, Col., April 7, 1989.

77. Susana Torruella Leval, correspondence with the author, Fall 1989.

78. Trinh, in *Blasted Allegories*, p. 11.

79. Zora Neale Hurston, *I love myself when I am laughing and then again when I am looking mean and impressive: A Zora Neale Hurston Reader*, ed. Alice Walker (Old Westbury, N.Y.: Feminist Press, 1979), pp. 85, 93.

80. Maxine Hong Kingston, *The Woman Warrior* (New York: Vintage Books, 1977), pp. 22–24.

81. Trinh, in *Blasted Allegories*, p. 20.

82. Margo Machida, conversation with the author, Fall 1989.

83. Robert Lee, "Ancient Precepts in a New Context," in *Door Gods & Other Household Deities* (New York: Asian Arts Institute, 1984); see also texts by Anne Goodrich and Maxine Miska on Chinese folk religion.

84. Program notes by Fred Wei-han Ho, "A Chinaman's Chance," Brooklyn Academy of Music, 1989.

85. Theresa Hak Kyung Cha, *Dictée* (New York: Tanam Press, 1982), p. 133.

Chapter Three: Landing

1. *Black Elk Speaks: being the life story of a holy man of the Oglala Sioux, as told through John Neihardt* (New York: Pocket Books, 1972), p. 36.

2. N. Scott Momaday, *The Names*, p. 142.

3. The possibility has also been raised that the Bering Strait crossing originally went the other direction and that the Americas were settled long before the crossings.

4. Momaday, *The Names*, p. 25.

5. Vine Deloria, Jr., quoted in Nelson Graburn, *Ethnic and Tourist Arts*, p. 1.

6. Nancy J. Parezo, Kelley A. Hays, and Barbara F. Slivac, "The Mind's Road: Southwestern Indian Women's Art," in *The Desert Is No Lady*, ed. Norwood and Monk, p. 164.

7. George Longfish and Joan Randall, "Landscape, Landbase and Environment," 1984 typescript; see also their similar text "Contradictions in Indian Territory," *Contemporary Native American Art* (Stillwater: Gardiner Art Gallery, Oklahoma State University, 1983).

8. Romanticism, although including the "sublime" (which was intended to put humans in their place in a vast and awe-inspiring nature), remains a kind of containment, separating people from nature and permitting exploitation even as it pays homage.

9. Jaune Quick-To-See Smith, interview with the author, Jan. 1985.

10. Jaune Quick-To-See Smith, quoted in Gerald Vizenor, *Earthdivers*, p. xxii.

11. Jaune Quick-To-See Smith, statement for her 1985 exhibition at Bernice Steinbaum Gallery, New York, and letter to the author, April 13, 1983.

12. Ronnie Lupe, quoted by Susan Rasky in *New York Times* (Aug. 4, 1988). The anthropologist involved is Keith Basso and the project is already a decade old.

13. Robert Gay, in *The Chronicle of Higher Education* (April 6, 1988).

14. See *NARF Legal Review*, v. 13, no. 1 (Winter 1988). The Native American Rights Fund, based in Boulder, Colorado, filed amicus curiae briefs in this case.

15. Anonymous, quoted in letter to the author from Jaune Quick-To-See Smith, Nov. 1989.

16. This is particularly obvious in Sam Gill's book *Mother Earth*, when he discusses Charles Eastman, a Santee Sioux who graduated from Dartmouth in 1887 and from the Boston University School of Medicine in 1890. Eastman returned to his people, practicing medicine at Pine Ridge, and was there at the time of the Wounded Knee massacre, treating some of the survivors. As Gill puts it, "Eastman spent the balance of his long life making his way along the narrow path that bridged his two cultures."

Eastman himself wrote in his book *The Soul of the Indian* (1911): "The Indian no more worshipped the Sun than the Christian adores the Cross. The Sun and the Earth, by an obvious parallel, holding scarcely more of poetic metaphor than of scientific truth, were in his view the parents of all organic life. . . . Therefore our reverence and love for them was really an imaginative extension of our love for our immediate parents, and with this sentiment of filial piety was joined a willingness to appeal to them, as to a father, for such good gifts as we may desire. This is the material of physical prayer" (quoted in Gill, p. 134).

Gill claims this statement from the horse's mouth as proof of his own interpretation, as evidence that since "these prayer references are the extension of poetic metaphor, there is no reason to conclude that they are spiritual or theological to any degree more than all other aspects of reality so designated" (p. 152). Yet he ignores the subtle distinction Eastman makes between a belief system that responds to and is not separated from life, and religious institutions as imposed on Native activities by the West. See also "The Earth Mother Figure of Native North America," by Professor Nancy C. Zak (who is of Inuit descent), *ReVision*, v. 10, no. 3 (Winter 1988), pp. 27–36.

17. Russell Means, in *The Bloomsbury Review* (Sept./Oct. 1988), p. 26; group of articles around Gill's book edited by Annette Jaimes.

18. As quoted by James Mooney in 1890; cited in Gill, *Mother Earth*.

19. Vine Deloria, Jr., quoted in *Bloomsbury Review*, p. 23.

20. Pam Colorado, quoted by Ward Churchill, "A Little Matter of Genocide," *Bloomsbury Review*, pp. 23, 24.

21. For example, the struggle around Big Mountain in Arizona, involving Navajo, Hopi, the U.S. government, and multinational corporations.

22. These nineteenth-century colonizers paid no attention to the fact that at the beginning of this country's history, common lands were also recognized in New England.

23. Victor Zamudio-Taylor pointed this out in a lecture at the Museum of Contemporary Hispanic Art, New York, Dec. 2, 1989.

24. Luis Jimenez, statement for *Awards in the Visual Arts* (Winston Salem, N.C.: SECCA, 1985), p. 86.

25. Dave Hickey, in *Luis Jimenez* (Laguna Gloria, Tex.: Laguna Gloria Museum, 1983), p. 6.

26. Luis Jimenez, in *Jimenez*, p. 14.

27. Annette DiMeo Carlozzi, in *Jimenez*, p. 26.

28. Clifford Geertz, quoted in *Art Among Us*, p. 10.

29. Ricardo Pau-Llosa, in *Expatriates*, p. 5.

30. Clifford Jackson, quoted by Leonard Malone, in *An Ocean Apart: American Artists Abroad* (New York: Studio Museum in Harlem, 1983), p. 12.

31. Beauford Delaney, quoted in James Lewis, "Afro-American Artists Abroad," unpublished paper given to the College Art Association, 1970.

32. Gilles Deleuze and Félix Guattari, "What Is a Minor Literature?," p. 17.

33. Caren Kaplan, "Deterritorializations: The Rewriting of Home and Exile in Western Feminist Discourse," *Cultural Critique* no. 6 (Spring 1987), p. 189.

34. Susana Torruella Leval, in *Luis Cruz Azaceta: Tough Ride Around the City* (New York: Museum of Contemporary Hispanic Art, 1986), n.p.

35. Josely Carvalho, panel at Marymount College, New York, Sept. 19, 1988.

36. Angel Kalenberg, in *Luis Camnitzer* (Montevideo: Museo Nacional de Artes Plasticas, 1986), n.p.

37. Leandro Katz, "The 21 Columns of Language: Column I—Angualasto," unpublished statement, 1971; see also *Dislocation and Relocation of Monuments* (self-published booklet: "This work is an unsolicited contribution to Documenta 1972").

38. Zydnia Navario, letter to the author, 1988.

39. Rafael Montañez Ortiz, in *Taller Alma Boricua*.

40. Walter Benjamin, *Illuminations* (New York: Schocken Books, 1973), p. 233. In the same collection, see also "The Storyteller" (pp. 83–109), in which Benjamin discusses the relationship of storytelling to history and historiography, which constitutes the "common ground of all forms of the epic."

41. John Yau, in *Martin Wong* (New York: Exit Art, 1988), p. 9.

42. Hung Liu, unpublished statement on her Capp Street projects, San Francisco, 1988.

43. Ibid.

44. Tomie Arai, wall panel introducing the series when shown at the Chinatown History Project, New York, June 1989.

45. Fred Wei-han Ho (formerly Houn), "Tradition and Change, Inheritance and Innovation, Not Imitation!" *East Wind* (Spring/Summer 1986), pp. 5–8. (Speech presented at the Kearny Street Workshop, San Francisco, March 21, 1985.)

46. Ibid., p. 6.

47. Ibid., p. 7.

48. Ming Fay, quoted in *New York Times* (Jan. 4, 1985).

49. Hung Liu, statement on Capp Street projects.

50. Virginia R. Dominguez, "Of Other Peoples: Beyond the 'Salvage Paradigm,' " in *Discussions in Contemporary Culture Number One*, ed. Foster, p. 136.

51. Arlene Goldbard and Don Adams, "Cultural Democracy," *Cultural Correspondence* no. 5 (1985), n.p. See also Charles Frederick, "Culture and Community Development," *Cultural Correspondence* no. 6 (1986); and ongoing issues of the Alliance for Cultural Democracy's magazine, *Cultural Democracy*.

52. Ralph Hils and Deborah Clifton Hils, "Some Comments on the Arts and Rural Development," unpublished paper distributed at Alliance for Cultural Democracy conference, Atlanta, 1985.

Chapter Four: Mixing

1. Bernice Johnson Reagon, "Coalition Politics: Turning the Century," in *Home Girls*, ed. Barbara Smith (New York: Kitchen Table Press, 1983), p. 358.

2. Lowery Stokes Sims, "The Art of Benny Andrews, Raphael Soyer, Chiu Ya-Tsai, and Martin Wong," in *The Mind's I: Part I*, p. 15.

3. Guillermo Gómez-Peña, in *Made in Aztlán*, ed. Brookman and Gómez-Peña, p. 93.

4. James Baldwin, *Notes of a Native Son* (Boston: Beacon Press, 1984).

5. It was in the arts—albeit the hopelessly romanticized "indigenist" arts beginning with the *Comentarios Reales* (1609) by Garcilazo de la Vega, who was half Inca, half Spanish—that *mestizaje* emerged as a fact of life in Spanish-speaking America, and the dream of a unified Latin America began.

6. However, blood quantums were an object of fascination in eighteenth-century Mexico; there were more than twenty different varieties and degrees of *mestizaje*, ranging from the mestizo, product of Spaniard and Indian, to the now-unheard terms *castizo, morisco, torna atras, lobo, zambaigo, cambujo, albarazado, barcino, chamiso*, and *coyote* (which is still used in New Mexican communities to denote half white).

7. *Peoples of the Earth*, v. 4 (Danbury, Conn.: Danbury Press, 1972), p. 131.

8. Peter Marris, *Loss and Change* (Garden City, N. Y.: Anchor Doubleday, 1975), p. 74.

9. Not only in the future; Marx and Engels studied American Indian societies and governmental forms, and the Iroquois "became in Marxist theory the ideal to which industrial communism would return once the workers smashed private property, classes, and the state . . . but the image quickly lost any connection with the Iroquois or any other Indian group" (Jack Weatherford, *Indian Givers*, p. 162).

10. Arif Dirlik, "Culturalism as Hegemonic Ideology and Liberating Practice," *Cultural Critique* no. 6 (Spring 1987), p. 15.

11. The relation of culture to national liberation can't be treated here, but this book was originally inspired by the cultural activities in Cuba and Nicaragua, and within the liberated zones of El Salvador.

12. Eduardo Galeano, quoted in *Third Text* no. 1 (Autumn 1987), p. 4.

13. Susana Torruella Leval, "Latin American Art and the Search for Identity," *Latin American Art* no. 1 (Spring 1989), p. 41.

14. Ibid.

15. Gerardo Mosquera, *Contracandela* (Havana: Editorial José Martí, forthcoming).

16. Hugo Martinez, "A Brief Background of Graffiti," in *United Graffiti Artists 1975* (New York: Artists Space, 1975), n.p.

17. Peter Schjeldahl, "Notes on Studio Graffiti," in *United Graffiti Artists*.

18. For a lively record of this period, see Alan Moore and Marc Miller, eds., *ABC No Rio Dinero: The Story of a Lower East Side Art Gallery* (New York: ABC No Rio with Collaborative Projects, 1985); see also Lucy R. Lippard, *Get the Message?*

19. See Norman Mailer, *The Faith of Graffiti* (New York: Praeger, 1974); Cesaretti Gusmano, *Street Writing: A Guided Tour of Chicano Graffiti* (Los Angeles: Acrobat Books, 1975); Craig Castelman, *Getting Up: Subway Graffiti in New York* (Cambridge, Mass.: MIT Press, 1982); Martha Cooper and Henry Chalfant, *Subway Art* (New York: Holt, Rinehart & Winston, 1984); Steven Hagen, *Hiphop: The Illustrated History of Break Dancing, Rap Music and Graffiti* (New York: St. Martin's Press, 1984). Castelman's book has a good bibliography.

20. Jeffrey Deitch, *Calligraffiti* (New York: Leila Tagghinia-Milani, 1984), n.p.

21. *Post-Graffiti* (New York: Sidney Janis Gallery, 1983).

22. Basquiat said SAMO stood for "same old shit"; Peter Schjeldahl suggests it was a play on "Sambo" and notes that it is an anagram for "Amos" as in "Amos and Andy" ("Paint the Right Thing," *Elle*, Nov. 1989).

23. Freddie Braithwaite, in a videotape on Basquiat produced by Paul Tschinkel for Art/New York, 1987.

24. Quotations from Basquiat from the Art/New York videotape.

25. Keith Haring, quoted in *New York Times* (Aug. 27, 1988).

26. Press releases for Basquiat exhibitions, 1989.

27. Annina Nosei, Art/New York videotape.

28. Quoted by Greg Tate, "Nobody Loves a Genius Child," *Village Voice* (Nov. 14, 1989), p. 33.

29. Schjeldahl in Art/New York videotape and in "Paint the Right Thing," p. 214.

30. Annette Rosado, quoted in *Parkett* no. 20 (1989; special issue devoted to KOS).

31. Michele Wallace, in *Amerika: Tim Rollins + K.O.S.* (New York: Dia Art Foundation, 1989), p. 45. See also *Tim Rollins + K.O.S.* (London: Riverside Studios, 1988).

32. Kellie Jones, statement on KOS, *Parkett* no. 20 (1989), p. 100.

33. Kids of Survival, quoted in Michele Sola, "Just Take It Step by Step," *Radical Teacher Magazine* no. 33 (1988).

34. Alan Weisman, *La Frontera.*

35. Judy Baca, "Mixing It Up II," radio station KGNU, Boulder, Col., April 7, 1989.

36. Judy Baca, "Our People Are the Internal Exiles," in *Cultures in Contention*, ed. Doug Kahn and Diane Neumaier, p. 66.

37. Ibid., p. 75.

38. Baca, "Mixing It Up II."

39. David Avalos, in a meeting on cultural participation in the artworld sponsored by Group Material in New York, June 1988; and Philip Brookman, in *David Avalos Presents Cafe Mestizo* (New York: INTAR Gallery, June 1989).

40. See Philip Brookman, in *Made in Aztlán*, for an excellent coverage of the movement in southern California.

41. "Que Pasó en Denver?" *La Verdad* (San Diego) (April 1970), p. 6.

42. Rupert Garcia, in Ramon Favela, *The Art of Rupert Garcia* (San Francisco: Chronicle Books/Mexican Museum, 1986), p. 16.

43. Rupert Garcia, unpublished master's thesis, quoted in Favela, p. 18.

44. From scrapbook of media coverage provided by the artists. The bus poster, a moving target, was not censored, though not for lack of trying. David Avalos had worse luck with a previous individual work of public art. In 1984 his sculpture was removed from the U.S. Courthouse Plaza in San Diego; it depicted an undocumented worker being frisked by an Immigration agent riding a Tijuana tourist burro, and it was deemed "a security risk."

45. Judith McWillie, "The Migrations of Meaning," *Visions* (Fall 1989), p. 9.

46. In Canada the term *métis* is used very specifically for a mixture of French and Native alone; *hapa* is mixed-blood in Hawaii. *Mestizo, ladino, cholo, pocho,* and *criollo* mean a variety of things in Latin America and in U.S. subcultures. *Moreno* is used among Latin black people to denote a degree of darkness. The "mestizo" Adam and Eve featured on the *Newsweek* cover were perhaps made lighter in color and more Caucasian in feature than most Africans to make the prospect of common ancestry more palatable to the magazine's white readers.

47. Martin Bernal, *Black Athena.*

48. By the time Cherokees were forced west, they were already a tribe of mestizos, mixed white Scots/Irish, black, and Native.

49. Edgar Heap of Birds, in *Ni' Go Tlunh A Koh Da,* p. 14.

50. In 1526, when they accompanied Spaniards in the colonization of San Miguel de Guadalupe; the Spaniards left and the Africans remained to intermarry with the Native peoples (Herbert Aptheker, *American Negro Slave Revolts* [New York: International Publishers, 1969], p. 62).

51. Emma Amos, unpublished statement, 1988.

52. *The New Pequot*, a fascinating film made for PBS in 1988 by Ken Simon, explores racial issues on a Connecticut reservation today. See also William Loren Katz, *Black Indians: A Hidden Heritage* (New York: Atheneum, 1986).

53. Henry Louis Gates, Jr., *The Signifying Monkey*; excerpt published in *Art Papers* (Nov./Dec. 1985), p. 32.

54. Ralph Ellison, in *Romare Bearden* (Albany: Art Gallery, SUNY, 1968), n.p.

55. Jolene Rickard, "Mixing It Up II," on radio station KGNU, Boulder, Col., April 7, 1989.

56. Jimmie Durham, *American Indian Culture.*

57. Nelson Graburn, *Ethnic and Tourist Arts,* p. 2.

58. Edwin Wade, *Magic Images,* p. 10.

59. Graburn, *Ethnic and Tourist Arts,* p. 16.

60. Jaune Quick-To-See Smith, letter to the author, Nov. 1989.

61. Graburn, *Ethnic and Tourist Arts,* pp. 15, 12.

62. Ibid., pp. 22, 17.

63. Wade, *Magic Images,* p. 13.

64. Diane Glancy, in *I Tell You Now*, ed. Swann and Krupat, p. 171.

65. Margo Machida, quoted by Susana Torruella Leval, in *The Mind's I: Part II*, p. 13.

66. Kay Walkingstick, letter to the author, Sept. 22, 1985.

67. Robert Haouzous, quoted by Wade in *Magic Images,* pp. 14, 16–17.

68. Rennard Strickland, *Magic Images,* p. 108; see also Lucy R. Lippard, *Overlay.*

69. Shigeko Kubota, *Profile* v. 3, no. 6 (Nov. 1983), p. 2.

70. Author's notes on a panel on Asian American art at the Institute for Asian American Arts, New York, June 1983.

71. John Yau, *Chihung Yang* (New York: Asian Arts Institute, 1984), n.p.

72. Fay Chiang, "Asian American Cultural Identity: Two Voices," *Upfront* no. 14–15 (Winter/Spring 1987–88), p. 54.

73. Yong Soon Min, "Mixing It Up I" symposium, University of Colorado, Boulder, April 1988.

74. Wen-ti Tsen, letter to the author, Jan. 14, 1989.

75. J. V. S. McGaw, "Western Desert Acrylic Painting—Artefacts or Art?" *Art History* (June 1982), p. 214.

76. Chinua Achebe, "Foreword," in Herbert Cole and Chike Aniakor, eds., *Igbo Arts: Community and Cosmos* (Los Angeles: Museum of Cultural History, UCLA, 1984), p. ix.

77. Chike Aniakor, in *Igbo Arts*, p. 14.

78. "Black Artists/White Artists," in *Cut/Across*, p. 5.

79. Rickard, "Mixing It Up II."

80. Amalia Mesa-Bains, at the "Autobiography" conference at Mills College, Oakland, Cal., March 1989, referring to the "Mixing It Up" symposium in Boulder, Colorado.

Chapter Five: Turning

1. Jimmie Durham, broadside published on the occasion of one-man exhibition at the Orchard Gallery, Derry, Northern Ireland, 1988.

2. Adrian Piper, "Ways of Averting One's Gaze," unpublished essay, 1987.

3. Robert Farris Thompson, quoted in Glenn Collins, "Rap Music, Brash and Swaggering, Enters Mainstream," *New York Times* (Aug. 29, 1988).

4. Victor Turner, *Dramas, Fields, and Metaphors*, p. 13.

5. Mischa Titiev, "Some Aspects of Clowning Among the Hopi Indians," in Mario Zamora, J. Michael Mahar, and Henry Orenstein, eds., *Themes in Culture* (Quezon City, Philippines: Kayumanggi, 1971), pp. 326–36. In 1989 Hopi video artist Victor Masayesva, Jr., made a vivid, and complex animated tape about Hopi ceremonies called *Ritual Clowns* (IS Productions).

6. John G. Bourke, *The Urine Dance of the Zuni Indians of New Mexico* (privately published, 1920), p. 5.

7. Lynn Fauley Emery, *Black Dance from 1619 to Today* (Princeton: Princeton Book Co., 1988).

8. Huizinga, *Homo Ludens* (Boston: Beacon Press, 1955), p. 13; Victor Turner, *Celebration: Studies in Festivity and Ritual* (Washington, D.C.: Smithsonian Institution Press, 1982), p. 212.

9. Jimmie Durham, in *Ni' Go Tlunh A Doh Ka*, p. 1.

10. Jaune Quick-To-See Smith, in *Women of Sweetgrass, Cedar and Sage*, n.p.

11. Raffaele Pettazzoni, *Studies in the History of Religions: Essays on the History of Religions*, v. 1 (Leiden: Brill, 1954), p. 21.

12. Anne Doueihi, "Trickster: On Inhabiting the Space Between Discourse and Story," *Soundings: An Interdisciplinary Journal* (Fall 1984), pp. 293, 298, 297.

13. Harry Fonseca, quoted in Margaret Archuleta, *Coyote, a Myth in the Making* (Washington, D.C.: National History Museum, 1986), n.p.

14. Edwin Wade, *Magic Images*, p. 95.

15. Allan Rodway, "Terms for Comedy," *Renaissance and Modern Studies* no. 6 (1963), p. 113.

16. Jean Fisher, in *Ni' Go Tlunh A Doh Ka*, p. v.

17. Jimmie Durham, "A Matter of Life and Death and Singing," *Alternative Museum Newsletter* (Dec. 1984/Jan. 1985), n.p.

18. Jimmie Durham, in *We the People*, p. 16. "You think you own us. You think our history is American history," he wrote on another occasion (*Artforum* [Summer 1988], p. 104).

19. Jimmie Durham, "Sequoyah's Silver Spurs," in *Ni' Go Tlunh A Koh Da*, p. 6.

20. For an account of the performance, see Charles Frederick, "To Compare Apples and Oranges, Start by Calling Them Both Fruit," *Upfront* no. 10 (Fall 1985), p. 29.

21. Theodora Kroeber, *Ishi in Two Worlds* (Berkeley: University of California Press, 1961).

22. Jean Fisher, "Guidelines," in *We the People*, p. 9.

23. Paul Smith, "Anadarko Calling," in *We the People*, p. 25.

24. Howard A. Link, *Waves and Plagues* (Honolulu: Contemporary Museum, 1988), p. 76.

25. Jamake Highwater, *The Primal Mind*, p. 6.

26. Tehching Hsieh, quoted by Marcia Tucker, in *Choices: Making Art of Everyday Life* (New York: New Museum of Contemporary Art, 1986), p. 86.

27. Marcia Tucker, *Choices*.

28. Tehching Hsieh, *Choices*.

29. Renato Rosaldo, "Politics, Patriarchs, and Laughter," *Cultural Critique* no. 6 (Spring 1987), pp. 69, 79–80.

30. Ibid., p. 86.

31. Guillermo Gómez-Peña, "Border Culture and Deterritorialization," *La Linea Quebrada/The Broken Line* no. 2 (1987), n.p.

32. Ibid.

33. Ibid.

34. Information on BAW/TAF Capp Street Exhibition, San Francisco, Summer 1989.

35. Kumkum Sangari, in *Cultural Critique* no. 7 (Fall 1987), p. 159.

36. Gabriel García Márquez, "Latin America's Solitude" [1982 Nobel Lecture], *Le Nouvel Observateur* (Jan. 8, 1983), p. 60.

37. Tomás Ybarra-Frausto, brochure for "Chicano Aesthetics: Rasquachismo," MARS (Movimiento Artistico del Rio Salado), Phoenix, Jan. 1989.

38. Patssi Valdez, quoted in Alan Weisman, "Born in East LA," *Los Angeles Times Magazine* (March 27, 1988).

39. All quotes from Linda Burnham, "Asco: Camus, Daffy Duck, and Devil Girls from East L.A.," *LA Style* (Feb. 1987), pp. 56–58.

40. Shifra Goldman, "Painting as Theatre," 1986 type-

script; later published in *La Opinion* as "In the Middle of Gronk's Torment."

41. Gronk, quoted in Burnham, "Asco," p. 58. See also a lengthy interview with Gronk by Julia Brown and Jacqueline Crist, in *Summer 1985* (Los Angeles: Museum of Contemporary Art, 1985), n.p.

42. Epoxy, statement for "Myths" exhibition at Basement Workshop, New York, 1985.

43. Idaho attorney general, quoted in *Roger Shimomura* (Cleveland: Cleveland State University, 1988), p. 9.

44. Roger Shimomura, in *Shimomura*, p. 7.

45. Don Desmett, in *Shimomura*, p. 14.

46. Dorinne Kondo, " 'M. Butterfly,' Gender Identity, and a Critique of the Interiorized 'Self,' " *Cultural Critique* (forthcoming).

47. Ibid.

48. B. D. Wong, quoted in *Village Voice* (Nov. 21, 1989), p. 45.

49. Howardena Pindell, quoted by Judith Wilson in "Howardena Pindell Makes Art That Winks at You," *Ms.* (May 1980), p. 67.

50. Ibid.

51. Henry Louis Gates, Jr., "Authority, (White) Power and the (Black) Critic; Or, It's All Greek to Me," *Cultural Critique* no. 7 (Fall 1987), p. 46.

52. Wole Soyinka, quoted in *New York Post* (Feb. 11, 1987).

53. Theodore Obenga, quoted by unidentified participant in roundtable at the Habana Bienal, 1986.

54. Lowery Stokes Sims, in *Race and Representation*, p. 18.

55. All quotes by Betye Saar from interview with Ishmael Reed, in *Shrovetide in Old New Orleans* (Garden City, N.Y.: Doubleday, 1978), pp. 146, 148, 154.

56. Adrian Piper, *Adrian Piper: Reflections 1967–1987* (New York: Alternative Museum, 1987), p. 33, and unpublished statement.

57. Joan Nestle [book review of *Intimate Matters* by John D'Emilio and Estelle Freedman], *Z* (Oct. 1988), p. 84.

58. Robert Colescott, interview on National Public Radio, March 23, 1989.

59. Lowery Stokes Sims, in *Robert Colescott: A Retrospective, 1975–1986* (San Jose: San Jose Museum of Art, 1987), p. 6.

60. Thomasine Bradford, in *Art Papers* (Jan./Feb. 1989), p. 55.

61. Robert Colescott, statement for show at Semaphore Gallery, New York, March 1987.

Postface: Dreaming

1. Edward Poitras, in *New Work by a New Generation* (Regina: Norman Mackenzie Art Gallery, University of Regina, 1982), p. 63.

2. Kay Miller, in *Women of Sweetgrass, Cedar and Sage*, n.p.

3. Kay Miller, in David Floria, *Revelations: The Transformative Impulse in Recent Art* (Aspen, Col.: Aspen Art Museum, 1989), p. 18.

4. N. Scott Momaday, quoted in Jamake Highwater, *The Primal Mind*, p. 168.

Bibliography

This is an eccentric (and eclectic) bibliography, reflecting the range of sources that informed this book—although space allows for inclusion of only a fraction of the references. Because there are no books specifically on this subject, my secondary sources were usually either articles and catalogs or outside the art field. (Primary sources were contact with or statements by the artists themselves.) With some exceptions, I have not duplicated the references cited in footnotes, sidebars, and captions. I have also had to omit individual artists' references, since even two citations for each artist would have doubled the length of this bibliography.

Books and articles are listed alphabetically by author; special issues are listed alphabetically by the name of the periodical, and catalogs are listed alphabetically by the exhibition title. —L.R.L.

I. Books and Articles

Allen, Paula Gunn. *The Sacred Hoop: Recovering the Feminine in American Indian Traditions.* Boston: Beacon Press, 1986.

Anzaldúa, Gloria. *Borderlands/La Frontera: The New Mestiza.* San Francisco: Spinsters/Aunt Lute, 1987.

Araeen, Rasheed. "From Primitivism to Ethnic Arts." *Third Text* no. 1 (Autumn 1987), pp. 6–24.

———. *Making Myself Visible.* London: Kala Press, 1984.

Arrom, José Juan. *Mitología y artes prehispanicas de las Antillas.* Mexico City: Siglo veintiuno editores, 1975.

Aufderheide, Pat. "A Map Upside Down (Third World Artists Explore Their Territory)." *The Progressive* (March 1987), pp. 36–37.

Babcock, Barbara, ed. *The Reversible World: Essays in Symbolic Inversion.* Ithaca: Cornell University Press, 1978.

Basso, Keith. *Portraits of "The White Man": Linguistic Play and Cultural Symbols among the Western Apache.* New York: Cambridge University Press, 1979.

Beardsley, John, and Livingston, Jane. *Black Folk Art in America: 1930–1980.* Jackson: University Press of Mississippi, 1982.

Bernal, Martin. *Black Athena: The Afroasiatic Roots of Classical Civilization.* Vol. 1, *The Fabrication of Ancient Greece 1785–1985.* New Brunswick, N.J.: Rutgers University Press, 1987.

Bhabha, Homi. "Of Mimicry and Man: The Ambivalence of Colonial Discourse." *October* (Spring 1984), pp. 125–33.

———. "The Other Question—The Stereotype and Colonial Discourse." *Screen* (Nov./Dec. 1983), pp. 18–86.

Bowling, Frank. "Formalist Art and the Black Experience." *Third Text* no. 5 (Winter 1988–89), pp. 78–82.

Brett, David. "From the Local to the Global: The Place of Place in Art." *Circa* no. 29 (Summer 1986), pp. 17–21.

Brett, Guy. *Through Our Own Eyes: Popular Art and Modern History.* Philadelphia: New Society, 1987.

Brookman, Philip. "California Assemblage: The Mixed Message." In *Forty Years of California Assemblage.* Los Angeles: Wight Art Gallery, UCLA, 1989, pp. 72–88.

——— and Gómez-Peña, Guillermo, eds. *Made in Aztlán: Centro Cultural de la Raza, Fifteen Years.* San Diego: Centro Cultural de la Raza, 1986.

Buhle, Paul; Cortez, Jayne; Lamantia, Philip; Peters, Nancy Joyce; Rosemont, Franklin; and Rosemont, Penelope, eds. *Free Spirits: Annals of the Insurgent Imagination.* San Francisco: City Lights Books, 1982.

Cabral, Amilcar. "Identity and Dignity." In *Return to the Source.* New York: Monthly Review Press, 1973, pp. 57–69.

Camnitzer, Luis. "Access to the Mainstream." *New Art Examiner* (June 1987), pp. 20–23.

———. "La Segunda Bienal de la Habana." *Arte en Colombia* (May 1987), pp. 79–85.

Candelaria, Cordelia, ed. *Multiethnic Literature of the United States: Critical Introductions and Classroom Resources.* Boulder: University of Colorado, 1989.

Cardinal-Shubert, Joane. "In the Red." *Fuse* (Fall 1989), pp. 20–28.

Chernoff, John M. *African Rhythm and African Sensibility.* Chicago: University of Chicago Press, 1979.

Chin, Daryl. "Some Remarks about Racism in the American Arts." *M/E/A/N/I/N/G* no. 3 (May 1988), pp. 18–25.

———. "Interculturalism, Postmodernism, Pluralism." *Performing Arts Journal* no. 11–12 (1989), pp. 163–75.

Claerhout, G. A. "The Concept of Primitive Applied to Art." *Current Anthropology* vol. 6 (1965), pp. 432–38.

Cliff, Michelle. *Claiming an Identity They Taught Me to Despise.* Watertown, Mass.: Persephone Press, 1980.

Clifford, James. *The Predicament of Culture: Twentieth-Century Ethnography, Literature, and Art.* Cambridge: Harvard University Press, 1988.

——— and Marcus, George E., eds. *Writing Culture: The Poetics and Politics of Ethnography.* Berkeley: University of California Press, 1986.

Coe, Ralph T. *Lost and Found Traditions: Native American Art 1965–1985.* Seattle: University of Washington Press with American Federation of Arts, 1986.

Coutts-Smith, Kenneth. "The Myth of the Artist as Rebel and Hero." *Black Phoenix* no. 3 (Spring 1979).

Crahan, Margaret E., and Wright, Franklin, eds. *Africa and the Caribbean: The Legacies of a Link.* Baltimore: Johns Hopkins University Press, 1979.

[Crawford, John.] "Editorial: Defining People's Culture." *People's Culture* vol. 1, no. 1 (Winter 1988), p. 3.

Creighton-Kelly, Chris. "Still Dreaming of a Multicultural Canada." *Border/Lines* no. 15 (Summer 1989), pp. 4–5.

Davis, Angela. *Women, Race, and Class.* New York: Vintage Books, 1983.

Davis, Douglas. "What Is Black Art?" *Newsweek* (June 22, 1970), pp. 87–88.

Davis, Wade. *The Serpent and the Rainbow.* New York: Warner Books, 1985.

Deleuze, Gilles, and Guattari, Félix. "What Is a Minor Literature?" In *Kafka: Towards a Minor Literature.* Minneapolis: University of Minnesota Press, 1986, pp. 16–27.

Deloria, Vine, Jr. *Custer Died for Your Sins: An Indian Manifesto.* New York: Avon Books, 1969.

Dockstadter, Frederick J. *The Song of the Loom: New Traditions in Navaho Weaving.* New York: Hudson Hills Press/Montclair Art Museum, 1987.

Donelly, Margarita; Lim, Shirley; and Tsutakawa, Mayumi, eds. *The Forbidden Stitch: An Asian American Women's Anthology.* Corvallis, Ore.: Calyx Books, 1989.

Doueihi, Anne. "Trickster: On Inhabiting the Space Between Discourse and Story." *Soundings: An Interdisciplinary Journal* (Fall 1984), pp. 283–311.

Dower, John W. "Yellow, Red, and Black Men." In *War Without Mercy: Race and Power in the Pacific War.* New York: Pantheon Books, 1986, pp. 147–81.

Drinnon, Richard. *Facing West: The Metaphysics of Indian Hating and Empire-Building.* New York: Meridian Books, New American Library, 1980.

Durham, Jimmie. *American Indian Culture: Traditionalism and Spiritualism in a Revolutionary Struggle.* (Photocopied booklet, Chicago, n.d.; originally written in 1974.)

———. "Here at the Centre of the World." *Third Text* no. 5 (Winter 1988–89), pp. 21–32. (Includes an "interview" with the late Francisco Elso Padilla.)

——— and Fisher, Jean. "The ground has been covered." *Artforum* (Summer 1989), pp. 99–105.

Escobar, Elizam, "Havana Biennial and Art in Latin America." *Panic* (Aug. 1988), pp. 25–38. (A reply to "Report from Havana, Cuba Conversation," *Art in America*, March 1987.)

Fabian, Johannes. *Time and the Other: How Anthropology Makes Its Object.* New York: Columbia University Press, 1983.

Failing, Patricia. "Black Artists Today: A Case of Exclusion." *ARTnews* (March 1989), pp. 124–31.

Fanon, Frantz. *Black Skin, White Masks.* New York: Grove Press, 1964.

———. *The Wretched of the Earth.* New York: Grove Press, 1968.

Fax, Elton C. *Black Artists of the New Generation.* New York: Dodd Mead, 1977.

Ferguson, Russell; Gever, Martha; Trinh T. Minh-ha; and West, Cornel, eds. *Out There: Marginalization and Contemporary Cultures.* New York: New Museum of Contemporary Art/ Cambridge, Mass.: MIT Press, 1990.

Ferrero, Pat; Hedges, Elaine; and Silber, Julie. *Hearts and Hands: The Influence of Women and Quilts on American Society.* San Francisco: Quilt Digest Press, 1987.

Ferris, William, ed. *Afro-American Folk Art and Crafts.* Boston: G. K. Hall & Co., 1983.

———. *Local Color: A Sense of Place in Folk Art.* New York: McGraw-Hill, 1982.

Fine, Elsa Honig. *The Afro-American Artist: A Search for Identity.* New York: Hacker Art Books, 1982.

Fisher, Jean. "The Health of the People Is the Highest Law." *Third Text* no. 2 (Winter 1987–88), pp. 63–75. (On "ReVisions," an exhibition of Native American and Canadian art at the Banff Center, 1988.)

Foster, Hal, ed. *Discussions in Contemporary Culture Number One.* Seattle: Bay Press, 1987.

———. *Recodings: Art, Spectacle, Cultural Politics.* Port Townsend, Wash.: Bay Press, 1985.

Freire, Paulo. *Pedagogy of the Oppressed.* New York: Seabury Press, 1973.

French, Laurence. "Multicultural Synthesis." In *Psycho-cultural Change and the American Indian: An Ethnohistorical Analysis*. New York: Garland, 1987.

Fusco, Coco. "Fantasies of Oppositionality." *Afterimage* (Dec. 1988), pp. 6–9.

Gates, Henry Louis, Jr., ed. *"Race," Writing and Difference*. Chicago: University of Chicago Press, 1986. (Essays originally published under the same title as a special issue of *Critical Inquiry*, vol. 12, no. 1, 1985.)

————. *The Signifying Monkey: A Theory of Criticism*. New York: Oxford University Press, 1988.

Geertz, Clifford. *Local Knowledge: Further Essays in Interpretive Anthropology*. New York: Basic Books, 1983.

Gill, Sam. *Mother Earth: An American Story*. Chicago: University of Chicago Press, 1987.

Goldbard, Arlene, and Adams, Don. *Crossroads: Reflections on the Politics of Culture*. Ukiah, Cal.: Institute for Cultural Democracy, 1990.

Goldberg, David. "Raking the Field of the Discourse of Racism." *Journal of Black Studies* (Sept. 1987), pp. 58–71.

Goldman, Shifra. "Latin Visions and Revisions." *Art in America* (May 1988), pp. 138–47.

———— and Ybarra-Frausto, Tomás. *Arte Chicano: A Comprehensive Annotated Bibliography of Chicano Art 1965–1981*. Berkeley: Chicano Studies Library Publication Unit, University of California, 1985. Includes essays by authors.

Goldwater, Robert. *Primitivism in Modern Art*. Cambridge, Mass.: Belknap Press of Harvard University, 1986.

Gómez-Peña, Guillermo. "The Multicultural Paradigm: An Open Letter to the National Arts Community." *High Performance* (Sept. 1989), pp. 18–27.

———— and Kelley, Jeff, eds. *The Border Art Workshop: A Documentation of Five Years of Interdisciplinary Art Projects Dealing with U.S.–Mexico Border Issues, 1984–1989*. New York: Artists Space/La Jolla: Museum of Contemporary Art, 1989.

Goode-Bryant, Linda, and Phillips, Marcie S. *Contextures*. New York: Just Above Midtown, 1978.

Graburn, Nelson. *Ethnic and Tourist Arts*. Berkeley: University of California Press, 1976.

Gradente, Bill. "Art among the Low Riders." In *Folk Art in Texas*, ed. Francis E. Abernethy. Dallas: Southern Methodist University Press, 1985.

Green, Rayna, ed. *That's What She Said: Contemporary Poetry and Fiction by Native American Women*. Bloomington: Indiana University Press, 1984.

Harris, Marie, and Aguero, Kathleen, eds. *A Gift of Tongues: Critical Challenges in Contemporary American Poetry*. Athens: University of Georgia Press, 1987.

Harris, Wilson. *The Womb of Space: The Cross-Cultural Imagination*. Westport, Conn.: Greenwood Press, 1983.

Highwater, Jamake. *The Primal Mind: Vision and Reality in Indian America*. New York: New American Library, 1981.

————. *The Sweet Grass Lives On: Fifty Contemporary Native American Indian Artists*. New York: Lippincott & Crowell, 1980.

Hiller, Susan. "Anthropology into Art" (an interview). In *Women's Images of Men*, by Sarah Kent and Jacqueline Morreau. London: Writers & Readers, 1985.

Hooks, Bell. *Ain't I a Woman? Black Women and Feminism*. Boston: South End Press, 1981.

————. *Feminist Theory: From Margin to Center*. Boston: South End Press, 1984.

Hull, Gloria T.; Scott, Patricia Bell; and Smith, Barbara, eds. *All the Women Are White, All the Blacks Are Men, But Some of Us Are Brave*. New York: Feminist Press, 1982.

Igoe, Lynn Moody. *250 Years of Afro-American Art: An Annotated Bibliography*. New York: R. R. Bowker, 1981.

Jojola, Ted. " 'Corn, or What We Indians Call Maize.' " *Village Voice* (Dec. 5, 1989), p. 110.

Joselit, David. "Living on the Border." *Art in America* (Dec. 1989), pp. 120–29.

Joseph, Gloria I., and Lewis, Jill. *Common Differences: Conflicts in Black and White Feminist Perspectives*. Boston: South End Press, 1981.

Kahn, Douglas, and Neumaier, Diane, eds. *Cultures in Contention*. Seattle: Real Comet Press, 1985.

Korean-American Women Artists and Writers Association. *Symposium '89: Works by Korean-American Women Artists*. Oakland: Mills College, 1989. (Text by Moira Roth.)

Kramer, Hilton. "Black Art and Expedient Politics." *New York Times* (June 7, 1970).

Kruger, Barbara, and Mariani, Phil, eds. *Remaking History: Discussions in Contemporary Culture No. 4*. Seattle: Bay Press, 1989.

Leon, Eli, ed. *Who'd a Thought It: Improvisation in African-American Quiltmaking*. San Francisco: San Francisco Craft and Folk Art Museum, 1987. (Texts by Leon, J. Weldon Smith, and Robert Farris Thompson.)

Lewis, Samella. *Art: African American*. New York: Harcourt Brace Jovanovich, 1978.

————. *Black Artists on Art*, 2 vols. Los Angeles: Contemporary Crafts, 1969–71.

Lippard, Lucy R. "Captive Spirits." *Village Voice* (March 20, 1984).

————. "Ethnic Images in the Comics." *Z* (April 1988), pp. 70–71.

————. "Ethnocentrifugalism: Latin Art in Exile." *Village Voice* (July 12, 1983).

————. *Get the Message? A Decade of Art for Social Change*. New York: E.P. Dutton, 1984.

————. "Mestizaje." *Z* (March 1988), pp. 58–59.

————. "Native American Art Holding Up a Mirror to America." *The Guardian (New York)* (Dec. 16, 1987).

———. "Native Intelligence." *Village Voice* (Dec. 27, 1983).

———. "Not So Far from South Africa." *Village Voice* (Nov. 13, 1984).

———. *Overlay: Contemporary Art and the Art of Prehistory.* New York: Pantheon Books, 1983.

———. "Primitivism: Cultural Transfusions Enlivening Western Art." *In These Times* (March 12–18, 1986).

———. "Re-Orienting Perspectives by Asian American Artists." *In These Times* (July 10–23, 1985).

———. "See Colorful Colorado." *In These Times* (April 23–29, 1986).

———. "Showing the Right Thing for a Change." *Z* (Nov. 1989), pp. 79–81.

Lipsitz, George. "Mardi-Gras Indians: Carnival and Counter-Narrative in Black New Orleans." *Cultural Critique* no. 10 (Fall 1988), pp. 99–121.

Lugones, Maria C., and Spelman, Elizabeth V. "Have We Got a Theory for You! Feminist Theory, Cultural Imperialism and the Demand for 'The Woman's Voice.' " *Women's Studies International Forum* vol. 6, no. 6 (1983), pp. 573–81.

Machida, Margo. *Cultural Identity in Transition: Contemporary Asian American Visual Arts as a Vehicle for the Representation of Self and Community.* New York: Asian American Center at Queens College, forthcoming 1990–91.

Manhart, Marcia, and Manhart, Tom, eds. *The Eloquent Object: The Evolution of American Art in Craft Media Since 1945.* Tulsa: Philbrook Museum of Art, 1987.

Martí, José. *Our America.* New York: Monthly Review Press, 1977.

Mayer, Monica. *Translations: An International Dialogue of Women Artists.* Los Angeles: Monica Mayer, Jo Goodwin, and Denise Arfitz, 1980. (The account of an exchange between U.S. and Mexican women artists.)

Mesa-Bains, Amalia. "Meeting the Challenge of Cultural Transformation." *FYI* vol. 5, no. 3 (Fall 1989), p. 1.

———. "Contemporary Chicano and Latino Art." *Visions* (Fall 1988), pp. 14–19.

Metcalf, Eugene. "Black Art, Folk Art, and Social Control." *Winterthur Portfolio* (Winter 1983), pp. 271–89.

Momaday, N. Scott. *The Names: A Memoir.* Tucson: University of Arizona Press, 1976.

Moraga, Cherríe, and Anzaldúa, Gloria, eds. *This Bridge Called My Back: Writings by Radical Women of Color.* New York: Kitchen Table: Women of Color Press, 1981.

Mosquera, Gerardo. "Bad Taste in Good Form." *Social Text* no. 15 (Fall 1986), pp. 54–63.

Muñoz, Braulio. *Sons of the Wind: The Search for Identity in Spanish American Indian Literature.* New Brunswick, N.J.: Rutgers University Press, 1982.

Murray, Pauli. *Song in a Weary Throat.* New York: Harper & Row, 1987.

Neumann, Marc. "Wandering Through the Museum: Experience and Identity in a Spectator Culture." *Border/Lines* no. 12 (Summer 1988), pp. 19–27.

Norwood, Vera, and Monk, Janice, eds. *The Desert Is No Lady: Southwestern Landscapes in Women's Writing and Art.* New Haven: Yale University Press, 1987.

O'Brien, Mark, and Little, Craig. *Reimaging America: The Arts of Social Change.* Philadelphia: New Society, 1990.

P.A.D.D. (Political Art Documentation/Distribution). "Out of Sight Out of Mind I: Black and Native American Art." *Upfront* no. 6–7 (Summer 1983), pp. 18–22.

———. "Out of Sight Out of Mind II: Asian and Hispanic Art." *Upfront* no. 9 (Fall 1984), pp. 17–21.

Pau-Llosa, Ricardo. "Art in Exile." *Americas* (Aug. 1980), pp. 3–8.

———. "Landscape and Temporality in Central American and Caribbean Painting." *Art International* (Jan./March 1984), pp. 28–33.

Pincus, Robert L. "The Spirit of Place: Border Art in San Diego." *Visions* (Summer 1989), pp. 4–7.

Pindell, Howardena. "Art (World) & Racism: Testimony, Documentation, and Statistics." *Third Text* no. 3–4 (Spring/Summer 1988), pp. 157–90.

Pinkel, Sheila. "Interview with Sheila Pinkel, Project Director of 'Multicultural Focus: A Photography Exhibition for the Los Angeles Bicentenial.' " *Obscura* vol. 1, no. 4 (1981), pp. 2–11.

Price, Sally. *Primitive Art in Civilized Places.* Chicago: University of Chicago Press, 1989.

Qoyawayma, Polingaysi (Elizabeth Q. White). *No Turning Back.* Albuquerque: University of New Mexico Press, 1964.

Quirarte, Jacinto. *A History and Appreciation of Chicano Art.* San Antonio: Research Center for the Arts and Humanities, 1984.

———, ed. *Chicano Art History: Selected Readings.* San Antonio: Research Center for the Arts and Humanities, 1984.

Raven, Arlene, ed. *Art in the Public Interest.* Ann Arbor: UMI Research Press, 1989.

———. "Colored." *Village Voice* (May 31, 1988).

———. "Feminist Rituals of Re-Membered History: Lisa Jones, Kaylynn Sullivan, Joyce Scott." *Women and Performance* no. 7 (1988–89), pp. 23–41.

———; Langer, Sandra; and Frueh, Joanna, eds. *Feminist Art Criticism: An Anthology.* Ann Arbor: UMI Research Press, 1988.

Richard, Nelly. "Postmodernism and Periphery." *Third Text* no. 2 (Winter 1987–88), pp. 5–12.

Rivera, Tomás. *Into the Labyrinth: The Chicano in Literature.* Edinburg, Tex.: Pan American University, 1971.

Roth, Moira, ed. *Connecting Conversations: Interviews with 28 Bay Area Women Artists.* Oakland: Eucalyptus Press, 1979.

Rothenberg, Jerome. *Shaking the Pumpkin*. Garden City, N.Y.: Doubleday, 1972.

Rubin, Arnold. "Accumulation: Power and Display in African Sculpture." *Artforum* (May 1975), pp. 35–47.

Rubin, William, ed. *"Primitivism" in 20th-Century Art: Affinity of the Tribal and the Modern*, 2 vols. New York: Museum of Modern Art, 1984. (See also *Artforum* April and May 1985 for an exchange of letters between Rubin and Thomas McEvilley.)

Rushing, W. Jackson. "Another Look at Contemporary Native American Art." *New Art Examiner* (Feb. 1990), pp. 35–37. (In reply to Clare Wolf Krantz's "Bridging Two Worlds," in Nov. 1989 issue, pp. 36–38; see also letters column, May 1990, p. 3.)

Saakana, Amon Saba. "Mythology and History: An Afrocentric Perspective of the World." *Third Text* no. 3–4 (Spring/Summer 1988), pp. 143–49.

Said, Edward W. *Orientalism*. New York: Vintage Books, 1979.

———. *The World, the Text, and the Critic*. Cambridge, Mass.: Harvard University Press, 1983.

Sanchez-Tranquilino, Marcos, ed. "Art and Histories Reconsidered." *Journal* (Winter 1987). (A special section including Harry Gamboa, Jr., "The Chicano/a Artist Inside and Outside the Mainstream [pp. 20–29] and Tranquilino's "Mano a Mano: An Essay on the Representation of the Zoot Suit and Its Misrepresentation by Octavio Paz" [pp. 34–42].)

Schechner, Richard. "Intercultural Themes." *Performing Arts Journal* no. 33–34 (1989), pp. 151–62.

Scully, Vincent. *Pueblo: Mountain, Village, Dance*. New York: Viking Press, 1975.

Simonson, Rick, and Walker, Scott, eds. *The Graywolf Annual Five: Multicultural Literacy*. Saint Paul: Graywolf Press, 1988.

Sims, Lowery Stokes. "*Heat* and Other Climatic Manifestations: Urban Bush Women, Thought Music, and Craig Harris with the Dirty Tones Band." *High Performance* no. 45 (Spring 1989), pp. 22–27.

———. The Mirror/The Other: The Politics of Esthetics." *Artforum* (March 1990), pp. 111–115.

———. "The New Exclusionism." *Art Papers* (July/Aug. 1988), pp. 37–38.

Sollors, Werner, ed. *The Invention of Ethnicity*. New York: Oxford University Press, 1989.

Soyinka, Wole. "The Fourth Dimension." *Semiotext(e)* vol. 4, no. 3 (1984), pp. 69–72.

Spivak, Gayatri Chakravorty. *In Other Worlds: Essays in Cultural Politics*. New York: Routledge, 1988.

Stewart, Kathryn. *Portfolio II: Eleven American Indian Artists*. San Francisco: American Indian Contemporary Arts, 1988.

Sullivan, Michael. *The Meeting of Eastern and Western Art*. Berkeley: University of California Press, 1989.

Swann, Brian, and Krupat, Arnold, eds. *I Tell You Now: Autobiographical Essays by Native American Writers*. Lincoln: University of Nebraska Press, 1987.

Tate, Gregory. "Cult-Nats Meet Freaky-Deke." *Village Voice Literary Supplement* (Dec. 9, 1986), p. 5.

Thévoz, Michel. *Art Brut*. New York: Rizzoli, 1976.

Thompson, Robert Farris. *Flash of the Spirit: African and Afro-American Art and Philosophy*. New York: Vintage Books, 1984.

Traba, Marta. *Propuesta Polemica sobre Arte Puertoriqueño*. San Juan: Libreria Internacional, 1971.

Trinh T. Minh-ha. *Woman, Native, Other: Writing Postcoloniality and Feminism*. Bloomington: Indiana University Press, 1989.

Tuan Yi-Fu. *Space and Place: The Perspective of Experience*. Minneapolis: University of Minnesota Press, 1977.

Tupahache, Asiba. *Taking Another Look*. Great Neck, N.Y.: Spirit of January Publications, 1988.

Turner, Victor. *Dramas, Fields, and Metaphors: Symbolic Action in Human Society*. Ithaca: Cornell University Press, 1974.

———. *Process, Performance, and Pilgrimage: A Study in Comparative Symbology*. New Delhi: Concept Publishing, 1979.

Villa, Carlos, ed. *Other Sources: An American Essay*. San Francisco: San Francisco Art Institute, 1976.

Vizenor, Gerald. *Earthdivers: Tribal Narratives on Mixed Descent*. Minneapolis: University of Minnesota Press, 1981.

Vlach, John Michael. *Afro-American Tradition in the Decorative Arts*. Cleveland: Cleveland Museum of Art, 1978.

Wade, Edwin, ed. *The Arts of the North American Indian: Native Traditions in Evolution*. New York: Hudson Hills Press/ Tulsa: Philbrook Art Center, 1986.

——— and Strickland, Rennard. *Magic Images: Contemporary Native American Art*. Norman: University of Oklahoma Press, 1981.

Walker, Sheila. "Candomblé: A Spiritual Microcosm of Africa." *Black Art: An International Quarterly* vol. 5, no. 4 (1984), pp. 10–22.

Wallace, Michele. " 'I Don't Know Nothin' 'bout Birthin' No Babies.' " *Village Voice* (Dec. 5, 1989), p. 112.

———. "Michael Jackson, Black Modernisms, and 'The Ecstasy of Communication.' " *Third Text* no. 7 (Summer 1989), pp. 11–22.

———. "Multicultural Blues: An Interview with Michele Wallace" by Jim Drobnick. *Attitude* (Spring 1990), pp. 2–6.

Wallis, Brian, ed. *Blasted Allegories*. New York: New Museum of Contemporary Art/Cambridge, Mass.: MIT Press, 1987. (Anthology of artists' writings, including a number of artists of color.)

Weatherford, Jack. *Indian Givers: How the Indians of the Americas Transformed the World*. New York: Crown, 1988.

Weisman, Alan, "Born in East L.A." *Los Angeles Times Magazine* (March 27, 1988), pp. 10–25.

———. *La Frontera: The United States Border with Mexico.* New York: Harcourt Brace Jovanovich, 1986.

West, Cornel. "The Dilemma of the Black Intellectual." *Cultural Critique* no. 1 (Fall 1985), pp. 109–24.

———. [Interview by Anders Stephanson.] *Flash Art* (April 1987), pp. 51–55.

———. "Postmodernism and Black America." *Z* (June 1988), pp. 27–29.

Williams, Raymond. *Culture and Society, 1780–1950.* New York: Columbia University Press, 1983.

Williams, Reese, ed. *Fire Over Water.* New York: Tanam Press, 1986. (Anthology including texts by Theresa Hak Kyung Cha and Cecilia Vicuña.)

Willis-Thomas, Deborah. "Photography." In *Black Arts Annual 1987/88,* ed. Donald Bogle. New York: Garland Publishing, 1989.

Wilson, Judith. "Art." In *Black Arts Annual 1987/88,* ed. Donald Bogle. New York: Garland Publishing, 1989.

Yau, John. "Official Policy." *Arts* (Sept. 1989), pp. 50–54.

Ybarra-Frausto, Tomás. "The Chicano Movement and the Emergence of a Chicano Poetic Consciousness." *New Scholar: VI* (1977), pp. 81–108.

II. Special Issues of Periodicals

Art in America. "The Global Issue" (July 1989). (Articles around the issues raised by the "Magiciens de la terre" exhibition at the Centre Pompidou in Paris.)

Art Papers. "The Black Aesthetic Issue" (Nov./Dec. 1985); [Multicultural issue] (July/Aug. 1990).

Artes Visuales. [Special issue on Chicano Art] (June 1981).

Bridge. "Asian American Women" (Winter 1978–79; Spring 1979).

Broken Line/La Linea Quebrada. Border Art Workshop/ Taller de Arte Fronteriza, San Diego. (Each issue focuses on border issues and is "special" in format; no. 3 is a boxed exhibition; no. 4 is "The Latino Boom . . . BOOM!!")

Les Cahiers du musée national d'art moderne. "Magiciens de la terre" (Summer 1989). (Almost the entire issue was translated into English in the Spring 1989 issue of *Third Text.*)

Cultural Critique. "The Nature and Context of Minority Discourse." Nos. 6 & 7 (Spring and Fall 1987).

Cultural Democracy. "Campaign for a Post-Columbian World." No. 37 (Fall 1989).

Discourse. "She, The Inappropriate(d) Other." No. 8 (Winter 1986–87).

———. [On ethnography and the politics of representation.] No. 11 (Spring 1988).

Feminist Review. "Difference: A Special Third World Women Issue." No. 25 (Spring 1987).

Flue. [Special issue as catalog for the exhibition "Multiples by Latin American Artists" at the Franklin Furnace, New York.] Vol. 3, no. 2 (Spring 1983).

Frontiers. "Chicanas in the National Landscape" (Summer 1980).

Heresies. "Racism Is the Issue." No. 15 (1982).

———. "Third World Women: The Politics of Being Other." No. 8 (1979).

Ikon. "Art Against Apartheid." Second Series, no. 5–6 (Winter/Summer 1986).

———. "Without Ceremony." [Asian American Women.] Second series, no. 9 (1988).

International Review of African American Art. "Art in Public Places." Vol. 7, no. 2 (1987).

Sage: A Scholarly Journal on Black Women. "Artists and Artisans." Vol. 4, no. 1 (Spring 1987).

Screen. "The Last 'Special Issue' on Race." Vol. 29, no. 4 (Autumn 1988).

Visions. "Acculturation and Assimilation" (Fall 1989).

III. Exhibition Catalogs

Acts of Faith: Politics and the Spirit. Cleveland: Cleveland State University, 1988. Curated, with text, by Lucy R. Lippard.

¡Adivina! Latino Chicago Expressions. Chicago: Mexican Fine Arts Center, 1988. Bilingual text by Felipe Ehrenberg.

The Afro-American Artist in the Age of Cultural Pluralism. Montclair, N.J.: Montclair Art Museum, 1987. Curated by Wendy McNeil; text by Clement Alexander Price.

American Policy: Edgar Heap of Birds, Alfredo Jaar, Aminah Robinson, Nancy Spero. Cleveland: Art Gallery, Cleveland State University, 1987. Curated, with text, by Don Desmett.

American Resources: Selected Works of African American Artists. New York: Bernice Steinbaum Gallery, 1989. Curated, with text by Bernice Steinbaum.

Americanos: Contemporary Allegories. Easthampton, N.Y.: Easthampton Center for Contemporary Art, 1988. Curated by Jennifer Cross.

Another Face of the Diamond: Pathways Through the Black Atlantic South. New York: INTAR/Atlanta: New Visions Gallery of Contemporary Art, 1989. Curated by Judith McWillie; essays by McWillie, Robert Farris Thompson, and John Mason.

Another Reality. Houston: Hooks-Epstein Galleries, 1989. Curated by Suprik Angelini and Bert Long; texts by Angelini, Long, Geri and Charles Hooks, and Thomas McEvilley.

Aquí: 27 Latin American Artists Living and Working in the U.S. Los Angeles: Fisher Gallery, UCLA, 1984. Texts by John Stringer, Donald Goodall, and Carla Stellweg.

Art Among Us/Arte Entre Nosotros: Mexican American Folk Art of San Antonio. San Antonio: San Antonio Museum of Art, 1986. Curated by Pat Jasper and Kay Turner; texts by Turner and Jasper, Suzanne Seriff, José Limon, and Ricardo Romo; bibliography.

Art as a Verb: The Evolving Continuum. Baltimore: Maryland Institute College of Art, 1988–89. Curated, with texts, by Leslie King-Hammond and Lowery Stokes Sims.

Art in Washington and Its Afro-American Presence: 1940–1970. Washington, D.C.: Washington Project for the Arts, 1985. Curated by Keith Morrison.

Artists from Latin America in Washington, D.C. Washington, D.C.: Martin Luther King Memorial Library, 1989. Curated by Mercedes Naveiro; introductory essay by Luis Camnitzer.

Autobiography: In Her Own Image. New York: INTAR, 1988. Curated by Howardena Pindell; essays by Judith Wilson and Moira Roth.

Baking in the Sun: Visionary Images from the South. Lafayette: Art Museum, University of Southwestern Louisiana, 1987–88. The Collection of Sylvia and Warren Lowe.

Beyond History. Vancouver: Vancouver Art Gallery, 1989. Texts by Tom Hill and Karen Duffek. (Native American and Canadian art.)

Black Art: Ancestral Legacy (The African Impulse in African American Art). Dallas: Dallas Museum of Fine Arts, 1989. Curated and edited, with text, by Alvia J. Wardlaw; essays by Richard Brettell, David Driskell, Edmund Barry Gaither, Regenia Perry, William Ferris, Uta Stebich, and Robert Farris Thompson.

The Blues Aesthetic: Black Culture and Modernism. Washington: Washington Project for the Arts, 1989. Curated by Richard Powell; essays by Powell, Dwight P. Andrews, Eleanor W. Traylor, E. Ethelbert Miller, John Michael Vlach, Kellie Jones, Sherill Berryman-Miller, Jeffrey Stewart, Joseph A. Brown.

Bridge between Islands: Retrospective Works by Six Puerto Rican Artists in New York. New York: Henry Street Settlement, Bronx Museum, and El Museo del Barrio, 1979. Curated by Renata Karlin, Luis Cancel, and Jack Agueros.

California Black Artists. New York: Studio Museum in Harlem, 1978. Preface by Leonard Simon.

California Chicano Murals. Venice, Cal.: Social and Public Art Resources Center, 1987. (A calendar.)

Caribbean Art/African Currents. New York: Museum of Contemporary Hispanic Art, 1986. Curated, with text, by Susana Torruella Leval.

Celebration: Eight Afro-American Artists Selected by Romare Bearden. New York: Henry Street Settlement, 1984.

Ceremony of Memory: New Expressions in Spirituality among Contemporary Hispanic Artists. Santa Fe: Center for Contemporary Arts, 1988. Curated by Amalia Mesa-Bains; texts by Mesa-Bains, Tomás Ybarra-Frausto, and Victor Zamudio-Taylor.

Chicana Voices and Visions. Venice, Cal.: Social and Public Art Resources Center, 1983. Curated, with text, by Shifra Goldman.

Chicanarte. Los Angeles: Municipal Art Gallery, 1976. Curated by the Comité Chicanarte.

Chicano Expressions: A New View in American Art. New York: INTAR, 1986. Curated, with texts, by Inverna Lockpez, Tomás Ybarra-Frausto, Judy Baca, and Kay Turner.

Chicano and Latino Artists in the Pacific Northwest. Olympia, Wash.: Evergreen State College, 1984.

Chulas Fronteras: An Exhibition of Texas Hispanic Art. Houston: Midtown Art Center, 1986. Curated, with essay, by Benito Huerta.

Collision. Houston: Lawndale Alternative, University of Houston, 1984. Curated by Anne Harithas; texts by James Harithas, John Yau, and Edward Lucie-Smith.

Common Heritage: Contemporary Iroquois Artists. New York: Queens Museum, 1984. Curated by Peter Jemison and Irving Kligfield; texts by Jemison, Kligfield, and Robert Venables.

Constructed Images: New Photography. New York: Schomburg Center for Research in Black Culture, 1989. Traveling exhibition curated, with text, by Deborah Willis; essay by Kellie Jones.

Contemporary Afro-American Photography. Oberlin: Allen Memorial Art Museum, Oberlin College, 1983. Curated, with texts, by William Olander and Deba P. Patnaik; bibliography.

Contemporary Art by Women of Color. San Antonio: Guadalupe Cultural Arts Center and the Instituto Cultural Mexicano, 1990. Organized by Kathy Vargas; texts by Lucy R. Lippard and by jurors Amalia Mesa-Bains, Yong Soon Min, Rina Swentzell, and Judith Wilson.

Contemporary Native American Art. Stillwater: Oklahoma State University, 1983. Texts by Erin Younger and George Longfish and Joan Randall.

Contemporary Native American Photography. Traveling exhibition sponsored by the U.S. Dept. of the Interior, Indian Arts and Crafts Board, Southern Plains Indian Museum and Crafts Center, 1984. Curated by Jaune Quick-To-See Smith.

Crossed Cultures. Seattle: Seattle Art Museum, 1989. Curated, with text, by Patterson Sims. (Native American art.)

Crossings in New York: Works by Four Expatriate Chinese Artists (Ming Fay, Jerry Kwan, Bing Lee, Wucius Wong). Hong Kong: Chingying Institute of Visual Arts Exhibition Hall, 1988. Text by Hong Bing-wah; discussion among the artists.

Cultural Imprints. Banff: Banff Centre, 1987. Curated by Daina Augaitis, Linda Casbon, Dagmar Dahle, and Christina Horeau.

Cut/Across. Washington, D.C.: Washington Project for the Arts, 1988. Curated by Mel Watkin; essays by Watkin, Judith Wilson, Olivia Cadoval, Margo Machida, and Maurice Berger.

(Exhibition included performances and workshops; see also Kristine Stiles's article on the show in *High Performance* [Fall 1988], pp. 34–38.)

Dále Gas: Chicano Art of Texas. Houston: Museum of Contemporary Art, 1977.

Day of the Dead—The Tex/Mex Tradition. San Antonio: Guadalupe Cultural Arts Center, 1989. Text by Kay Turner and Pat Jasper; photographs by Kathy Vargas.

The Decade Show. New York: New Museum of Contemporary Art, Museum of Contemporary Hispanic Art, Studio Museum in Harlem, 1990. Texts by Eunice Lipton, C. Carr, Judith Wilson, Lowery Stokes Sims, Margo Machida, Susana Torruella Leval, Guillermo Gómez-Peña, David Deitcher, Jimmie Durham, Micky McGee, Gary Sangster and Laura Trippi, Sharon Patton, and Julia Hertzberg. Bibliography.

Deceleration. Ottawa: Saw Gallery, 1989. Presented by the Om niiak Native Arts Group, with essays by Brian Maracle and Jacqueline Fry.

Dia de los Muertos. New York: Alternative Museum, 1988. Texts by Amalia Mesa-Bains, Gobi Stromberg Pellizzi, Carla Stellweg, Enrique Chagoya, and Geno Rodriguez.

Dialectics of Isolation (An Exhibition of Third World Women Artists of the United States). New York: AIR Gallery, 1980. Curated by Kazuko, Ana Mendieta, and Zarina.

Dreams and Fantasies: Exhibition of Works by Helen Oji, Ming Fay, and Paul Wong. New York: Asian Art Institute, 1985. Curated, with text, by Robert Lee.

Ethnic Images in Advertising. Philadelphia: Balch Institute for Ethnic Studies, 1990. Edited by Gail Stern; essays by Stern, M. Mark Stolarik, John J. Appel, and Amy Rashap.

Ethnic Images in the Comics. Philadelphia: Balch Institute for Ethnic Studies, 1986. Edited by Charles Hardy and Gail Stern; essays by Hardy, Stern, Pamela Nelson, John J. Appel, Steven Loring Jones, Amy Rashap, Carla B. Zimmerman, and Gerald Kolpan.

Ethnic Notions: Black Images in the White Mind. Berkeley: Berkeley Art Center, 1982. The Janette Faulkner collection of stereotyped images.

Events: La Gran Pasión, En Foco. New York: New Museum of Contemporary Art, 1983. Curated, with texts, by Charles Biasiny-Rivera and Frank Gimpaya for the En Foco photographers' group.

An Exhibition of Black Women Artists. Santa Barbara: Committee for Black Culture and the Center for Black Studies, 1975.

Exhibition: Hispanic Artists in New York. New York: Association of Hispanic Arts, 1982. Curated by Inverna Lockpez.

Expatriates: Paintings by 15 Young Latin American Artists. Gainesville, Fla.: Thomas Center Gallery, 1986–87. Text by Ricardo Pau-Llosa.

Expresiones Hispanas: The 1988/89 Coors National Hispanic Art Exhibit and Tour. Traveling exhibition out of Golden, Colorado, 1989. Essays by Giulio Blanc, Miguel Dominguez, and Felix Angel.

The Extension of Tradition: Contemporary Northern California Native American Art in Cultural Perspective. Sacramento: Crocker Art Museum, 1985.

Films with a Purpose: A Puerto Rican Experiment in Social Films. New York: Exit Art, 1987. Introduction by Jay Leyda.

Four Artists Working in Texas: James Bettison, Bert Long, Jesse Lott, Floyd Newsum. Plano, Tex.: Didactic Gallery, 1989. Introduction by James Surls. (An exhibition celebrating the birthday of Martin Luther King, Jr. and Black History Month.)

The Fourth Biennial Native American Fine Arts Invitational. Phoenix: Heard Museum, 1989–90. Curated, with text, by Margaret Archuleta.

Fragments of Myself/The Women: An Exhibition of Black Women Artists. New Brunswick, N.J.: Douglass College Art Gallery, 1979. Curated, with foreword, by Joan Marter.

Hidden Heritage: Afro-American Art, 1800–1950. San Francisco: Art Museum Association of America, 1985. Curated, with text, by David C. Driskell.

Hispanic American Art in Chicago. Chicago: Chicago State University Gallery, 1980. Essay by Victor Sorell.

Hispanic Art in the United States. Houston: Museum of Fine Arts, 1987. Curated, with texts, by John Beardsley and Jane Livingston; essay by Octavio Paz.

Hispanic Artists in New York. New York: City Gallery, 1981. Introduction by Ana Hernandez-Porto.

Hispanics USA. Bethlehem, Pa.: Ralph Wilson Gallery Lehigh University, 1982.

Huellas (Avanzada Estetica por la Liberacion Nacional). New York: La Galeria en el Bohio, 1988. Curated, with introduction, by Juan Sánchez.

Imagenes: A Survey of Contemporary Chicano Artists from Colorado. Arvada, Col.: Arvada Center, 1985.

Imagenes Guadalupanas de Artistas Chicanas. San Antonio: Mexican Cultural Institute Museum, 1985. Curated by Santa Barraza.

Influence: An Exhibition of Works by Contemporary Hispanic Artists Living in San Antonio, Texas. San Antonio: Guadalupe Cultural Arts Center, 1987. Bilingual texts by Pedro Rodriguez, Kathy Vargas, and the artists.

Jus' Jass: Correlations of Painting and Afro-American Classical Music. New York: Kenkeleba Gallery, 1983. Curated by Joe Overstreet.

Latin American Art: A Woman's View. Miami: Frances Wolfson Art Gallery, Miami-Dade Community College, 1981. Text by Roberta Griffin.

Latin American Artists in New York Since 1970. Austin: Archer M. Huntington Art Gallery, University of Texas, 1987. Curated by Jacqueline Barnitz with texts by Janis Bergman-Carton and Florencia Bazzano Nelson.

The Latin American Spirit: Art and Artists in the United

States, 1920–1970. New York: Bronx Museum of the Arts in association with Harry N. Abrams, 1988. Essays by Luis Cancel, Jacinto Quirarte, Marimar Benitez, Nelly Perazzo, Lowery S. Sims, Eva Cockcroft, Felix Angel, and Carla Stellweg.

Lo del Corazon: Heartbeat of a Culture. San Francisco: Mexican Museum, 1986. Text by Tomás Ybarra-Frausto.

Loaded. San Antonio: Blue Star Art Space, 1989. Curated by Glenna Park; artists' statements.

Magiciens de la terre. Paris: Centre Georges Pompidou National d'Art Moderne, 1989. Curated, with text, by Jean-Hubert Martin; essays by Aline Luque, Mark Francis, André Magnin, Pierre Gaudibert, Thomas McEvilley, Homi Bhabha, Jacques Souillou, and Bernard Marcade.

Mano a Mano, Abstraction/Figuration: 16 Mexican-American and Latin American Painters from the San Francisco Bay Area. Santa Cruz: Art Museum of Santa Cruz County and University of California, 1988. Curated, wtih bilingual text, by Rolando Castellon.

The Mind's I. New York: Asian Arts Institute, 1987. A four-part, four-catalog exhibition curated by Robert Lee. Part I: Benny Andrews, Raphael Soyer, Chiu Ya-Tsai, and Martin Wong (texts by Robert Lee, Lowery Sims, and Chang Tsongzung). Part II: Luis Cruz Azaceta, Robert Colescott, and Margo Machida (texts by Robert Lee and Susana Torruella Leval). Part III ("On the Concept of Self in Transition"): William Jung, Charles Parness, and Jorge Tacla (texts by Robert Lee and Grace Stanislaus). Part IV: Albert Chong, Linda Peer, Alison Saar, and Patti Warashina (texts by Robert Lee and Russell Leong).

¡Mira! The Canadian Club Hispanic Art Tour 1984. New York: El Museo del Barrio; San Antonio: San Antonio Museum of Art; Los Angeles: Plaza de la Raza, 1984. Text by Nancy L. Kelker.

¡Mira! The Canadian Club Hispanic Art Tour 1988–89. Los Angeles: Los Angeles Municipal Art Gallery, and elsewhere, 1988–89. Curated, with texts, by Susana Torruella Leval, Ricardo Pau-Llosa, and Inverna Lockpez.

¡Mira! The Tradition Continues. New York and Chicago: Association of Hispanic Arts and MI Raza Arts Consortium, 1985–87. Text by Jacinto Quirarte.

Modern Native American Abstraction. Philadelphia: Philadelphia Art Alliance, 1983. Curated by Edgar Heap of Birds.

Multicultural Focus: A Photography Exhibition for the Los Angeles Bicentennial. Los Angeles: Municipal Art Gallery, 1981. Juried show directed, with text, by Sheila Pinkel.

New Work by a New Generation. Regina: Norman Mackenzie Art Gallery, 1982. Texts by Carol Phillips and Robert Houle. (Native Canadian and American art.)

Ni' Go Tlunh A Doh Ka. Old Westbury, N.Y.: Amalie A. Wallace Gallery, State University of New York College at Old Westbury/Boston: North Hall Gallery, Massachusetts College

of Art, 1986. Curated, with texts, by Jean Fisher and Jimmie Durham; artists' statements.

Nine Uptown. New York: Harlem School of the Arts, 1988. Curated, with text, by Kellie Jones.

1989 Annual Exhibition (Guadalupe Garcia, Reiko Goto, Mildred Howard, Hilda Shum). San Francisco: Walter/McBean Gallery, San Francisco Art Institute, 1989. Curated, with texts, by Jamie Brunson and Amalia Mesa-Bains.

Offerings: The Altar Show. Venice, Cal.: Social and Public Arts Resource Center, 1985. Curated, with text, by Linda Kaun; essays by Amalia Mesa-Bains and Judith Baca; artists' statements.

Offrendas. Sacramento: La Raza Bookstore/Galeria Posada, 1984.

Orientalism: Exhibition of Paintings by Margo Machida and Charles Yuen. New York: Asian Arts Institute, 1986. Curated, with text, by Robert Lee.

Other Gods: Containers of Belief. Syracuse: Everson Museum of Art; Washington, D.C.: Fondo del Sol Visual Arts Center, Wallace Wentworth Gallery, Art Caprice; New Orleans: Contemporary Art Center; Los Angeles: Municipal Art Gallery, 1986. Curated by Rebecca Crumlish, Marc Zuver, and Josine Ianco-Starrels; texts by Crumlish, Zuver, Ronald Kuchta, David Driskell, Houston Conwill; artists' statements.

Personal Odysseys: The Photography of Celia Alvarez Muñoz, Clarissa T. Sligh, and Maria Martinez-Canas. New York: INTAR Gallery, and elsewhere, 1990. Curated by Inverna Lockpez; bilingual essay by Moira Roth.

A Place in Art/History: Six Contemporary Asian American Artists. New York: Henry Street Settlement, 1988. Texts by Fay Chiang and Margo Machida; artists' statements.

Power Struggle. Cleveland: SPACES, 1989. Curated, with text, by Don Desmett.

Price of Power. Cleveland: Cleveland Center for Contemporary Art, 1990. Curated, with text, by Don Desmett.

Prisoners of Image: Ethnic and Gender Stereotypes. New York: Alternative Museum, 1989. Texts by Alice Walker, Robbin Legere Henderson, E. San Juan, Jr., Jerry Robinson, and Judith Wilson.

Puerto Rican Painting: Between Past and Present. New York: El Museo del Barrio, and elsewhere, 1987. Curated, with text, by Mari Carmen Ramírez.

Race and Representation: Art/Film/Video. New York: Hunter College Art Gallery, 1987. Texts by Johnnetta B. Cole, Maurice Berger, Lowery S. Sims, Tilden J. LeMelle and Margaret G. LeMelle, and David Goldberg.

Raices Antiguas/Visiones Nuevas (Ancient Roots/New Visions). Tucson: Tucson Museum of Art, 1977. Bilingual text by Santo Martinez, Jr.

Raices y Visiones. Washington, D.C.: National Collection of Fine Arts, 1977.

Receptacles of Spirit: On the Sacred in Art. Brooklyn: Rotunda Gallery, 1989. Text by Nadine Delawrence.

Revelations: The Transformative Impulse in Recent Art. Aspen: Aspen Art Museum, 1989. Curated, with text, by David Floria.

Ritual and Myth: A Survey of African American Art. New York: Studio Museum in Harlem, 1982. Texts by Mary Schmidt Campbell, David Driskell, and Leslie King Hammond; bibliography.

Ritual and Rhythm: Visual Forces for Survival. New York: Kenkeleba House Gallery, 1982. Curated by Juan Sánchez; artists' statements.

Rooted Visions: Mexican Art Today. New York: Museum of Contemporary Hispanic Art, 1988. Curated by Carla Stellweg.

Search for Identity: Contemporary Third World Architecture. New York: Pratt Institute, 1983. Curated by Theoharis David; essays by David, Louise Noelle, Salah Zaki Said, Michael G. Colocassides, Udo Kultermann, and Ted Jojola.

17 Artists: Hispanic, Mexican-American, Chicano. San Antonio: Witte Memorial Museum, 1976. Text by Jacinto Quirarte.

Signs of Transition: 80's Art from Cuba. New York: Museum of Contemporary Hispanic Art, 1988. Curated by Coco Fusco; texts by Fusco and Luis Camnitzer.

Southern Expressions: A Sense of Self. Atlanta: High Museum of Art, 1988. Curated, with text, by Susan Krane.

Southwest Artists Invitational: An Exhibition of Contemporary Art by Seven Texas Artists of Hispanic-American Descent. Corpus Christi: Weil Gallery, State University Center for the Arts, 1980. Text by Roberto Tomás Espaza.

A Spirit Shared: Twentieth-Century Art in Mexico and New Mexico. Santa Fe: Museum of New Mexico, 1984.

Staying Visible, The Importance of Archives: Art and "Saved Stuff" of Eleven 20th-Century California Artists. Cupertino, Cal.: Deanza College, 1981. Curated, with text, by Jan Rindfleisch.

Stitching Memories: African-American Story Quilts. Williamstown: Williams College Museum of Art, and elsewhere, 1989. Curated, with text, by Eva Grudin.

Taller Alma Boricua 1969–1989: Reflections on Twenty Years of the Puerto Rican Workshop. New York: El Museo del Barrio, 1989. Curated by Petra Barreras del Rio. Texts by Borreras, Marcos Dimas, Rafael Montañez Ortiz, Lucy R. Lippard, and Fernando Salicrup.

Ten Latin American Artists Working in New York. New York: International House, 1984. Preface by Barbara Duncan.

Three Women Three Islands: Sophie Rivera, NYC; Lilia Fontana, Cuba; Frieda Medin Ojeda, Puerto Rico. New York: El Museo del Barrio, 1983. Curated by Evelyn Collazo.

The Ties That Bind: Folk Art in Contemporary American Culture. Cincinnati: Contemporary Arts Center, 1986–87. Curated, with texts, by Eugene Metcalf and Michael Hall.

Timeless Aspects of Modern Art. New York: Museum of Modern Art, 1948–49. Text anonymous (prehistoric, vernacular, and contemporary global art is compared with regard to "affinity and resemblance").

Tradition and Conflict: Images of a Turbulent Decade, 1963–1973. New York: Studio Museum in Harlem, 1985. Curated by Mary Schmidt Campbell; texts by Campbell, Lerone Bennett, Jr., Benny Andrews, Vincent Harding, and Lucy R. Lippard.

Traditions Transformed: Contemporary Works by Asian-American Artists in California. Oakland: Oakland Museum, 1985. Curated, with text, by Terrie Sultan.

Trans-fers: Uptown, Downtown. New York: "Morivivi y su Zambumbia" at Henry Street Settlement, and "Melting Pot: Work on Paper from Henry Street" at El Grupo Morivivi, 1983. Curated, with texts, by Elaine Rosner-Jeria and William Jung.

Uhuru: African and American Art Against Apartheid. Newark: City Without Walls Gallery, 1988. Curated by Victoria Scott and Victor Dauson.

Unity: A Collaborative Process. New York: Goddard-Riverside Community Center, 1988. Curated, with texts, by Tomie Arai and Deirdre Scott.

"Up South": An Exhibition on Racism and Discrimination. Brooklyn: Baca Downtown, 1987. Curated, with text, by Bill Batson.

UP Tiempo! Performing and Visual Artists of the Americas. New York: El Museo del Barrio, 1988. (A six-week performance and visual art series curated by Rafael Colon-Morales for Creative Time and El Museo del Barrio.)

Vive tu recuerdo: Living Traditions in the Mexican Day of the Dead. Los Angeles: Museum of Cultural History, UCLA, 1982. Curated by Robert V. Childs and Patricia Altman.

Yesterday: Reflections on Childhood. New York: Asian American Arts Centre, 1988. Curated by Robert Lee; texts by Lee and Kimiko Hahn; artists' statements.

We the People. New York: Artists Space, 1987. Curated by Jimmie Durham and Jean Fisher; texts by Durham, Fisher, Susan Wyatt, and Paul Smith. (Contemporary Native American art and video.)

What It Is: Black American Folk Art from the Collection of Regenia Perry. Richmond: Anderson Gallery, Virginia Commonwealth University, 1982.

Why Do You Call Us Indians? Joane Cardinal Schubert, Robert Houle, Gerald R. McMaster Gettysburg, Pa.: Gettysburg College Art Gallery, 1989. Curated, with text, by Amelia Trevelyan; artists' statements.

The Wisconsin Connection: Black Artists Past and Present. Madison: Memorial Union Galleries, University of Wisconsin, 1987. Text by Frieda High Tesfagiorgis; artists' statements.

Women Artists from Puerto Rico. New York: Cayman Gallery, 1983.

Women of Sweetgrass, Cedar and Sage: An Exhibition of Thirty

Indian Women Artists. New York: Gallery of the American Indian Community House, and elsewhere, 1985. Curated by Jaune Quick-To-See Smith and Harmony Hammond; texts by Quick-To-See Smith, Erin Younger, Lucy R. Lippard; artists' statements.

IV. Periodicals

This is by no means a complete list of periodicals specializing in specific or cross-cultural arts; some are defunct but back issues are relevant.

Afro-American Art History Newsletter. Edited by Judith Wilson. New York.

Bridge: Asian American Perspectives. New York: Basement Workshop. (No longer publishing.)

Callaloo: A Black South Journal of Arts and Letters. Lexington: Department of English, University of Kentucky.

Community Murals. Edited by Tim Drescher. San Francisco. (No longer publishing.)

Contact: A Poetry Review. Edited by Maurice Kenny. Bowling Green, N.Y.

Cultural Democracy. Minneapolis: Alliance for Cultural Democracy.

East Wind: Politics and Culture of Asians in the U.S. San Francisco: Getting Together Publications.

The International Review of African American Art. Jamaica, N.Y.

Journal of Ethnic Studies. Bellingham: Western Washington University.

The Spirit of January. Edited by Asiba Tupahache. Great Neck, N.Y.

Third Text (Third World Perspectives on Contemporary Art and Culture). Edited by Rasheed Araeen. London: Kala Press.

Upfront. New York: P.A.D.D. (Political Art Documentation/Distribution). (No longer publishing.)

Index

NB: *Bold type refers to illustrations; when not in bold type, plate (pl.) refers to captions; references to foot-notes follow the roman numeral chapter designation.*

Permissions Acknowledgments

Grateful acknowledgment is made to the following for permission to reprint from previously published material:

Asian American Arts Centre: Excerpt from exhibition catalog, "Yesterday: Reflections on Childhood," curated by Robert Lee, text by Robert Lee and Kimiko Hahn. Reprinted by permission of the Asian American Arts Centre.

Aunt Lute Books: Excerpt from "Tilli, Tlapalli: The Path of the Red and Black Ink" from *Borderlands/La Frontera* by Gloria Anzaldua. Copyright © 1987 by Gloria Anzaldua. Reprinted by permission.

Bay Press: Excerpt from "Black Culture and Postmodernism" by Cornel West from *Remaking History: Discussions in Contemporary Culture* no. 4, 1989, edited by Barbara Kruger and Phil Mariani. Reprinted by permission of Bay Press.

Robert Colescott: Robert Colescott, Statement from show at Semaphore Gallery, New York, March 1987. Reprinted by permission.

East Wind: Excerpt from Fred Wei-han Ho, "Tradition and Change, Inheritance and Innovation, Not Imitation" from *East Wind*, Spring/Summer 1986. Reprinted by permission of *East Wind*.

KGNU FM, Boulder, Colorado: Excerpts from Judy Baca, Jolene Richard, and Robbie McCauley, "Mixing It Up." Used by permission.

Museum of American Folk Art: Bessie Harvey, quoted in Shari Cavin Morris, "Bessie Harvey: The Spirit in the Wood" from *The Clarion*, Spring/Summer 1987, published by the Museum of American Folk Art, New York City. Reprinted by permission.

New York Chinatown History Project: Excerpts appearing in "Memory in Progress: A Mother/Daugher Project, Silk Screen Prints of Asian American Women by Tomie Arai." Produced by the New York Chinatown History Project (May 21, 1989–June 30, 1989). Reprinted by permission.

Oxford University Press: Nancy Hartsock, "Rethinking Modernism: Minority vs. Majority Theories" from "The Nature and Context of Minority Discourse" p. 26. Copyright © 1987 Oxford University Press. Article originally appeared in *Cultural Critique*, No. 7, Fall 1987. Used with permission.
 Sylvia Wynter, "On Disenchanting Discourse: 'Minority' Literary Criticism and Beyond" from "The Nature and Context of Minority Discourse" p. 459. Copyright © 1990 Oxford University Press. Article originally appeared in *Cultural Critique*, No. 7, Fall 1987. Used with permission.
 Henry Louis Gates, Jr., "Authority, (White) Power and the (Black) Critic: Or, It's All Greek to Me" from *Cultural Critique*, No. 7, Fall 1987, pp. 33, 37. Copyright 1987, Oxford University Press. Used with permission.

San Antonio Museum Association: Excerpts from *Art Among Us:*

Mexican Folk Art of San Antonio, curated by Pat Jasper and Kay Turner, texts by Pat Jasper, Kay Turner, Suzanne Seriff, Jose Limon, and Richardo Rico. Reprinted by permission of the San Antonio-Museum Association.

Southern Exposure: Quotation from Caroline Senter, "The Healing Art, An Interview With Louise Anderson" from *Southern Exposure*, Vol. 14, nos. 3–4, p. 22. Reprinted by permission of *Southern Exposure*, P.O. Box 531, Durham, NC 27702.

UMI Research Press: Excerpts from Lowery Sims's, "Aspects of Performance by Black American Women Artists" in *Feminist Art Criticism: An Anthology*, edited by Arlene Raven, Cassandra Langer, and Joanna Frueh. Copyright by Arlene Raven, Cassandra Langer, and Joanna Frueh. Reprinted by permission of UMI Research Press.

Village Voice: David Hammons, interviewed by Guy Trebay from the April 29, 1981 issue of the *Village Voice*; Greg Tate, "Nobody Loves a Genius Child" from the November 14, 1988 issue of the *Village Voice*; and Enrique Fernandez, "What's in a Nombre, Hombre?" from the June 21, 1988 issue of the *Village Voice*. All material is reprinted by permission of the *Village Voice* and the authors.

Mitsuye Yamada: From *Camp Notes and Other Poems* by Mitsuye Yamada, published by Shameless Hussy Press, 1976. Reprinted by permission of the author.

▼▼▼

Harry Allen, "Invisible Band," *Village Voice Electromag* (October 1988 supplement, p. 10).

Rasheed Araeen, "Our Bauhaus, Others' Mudhouse," *Third Text*, no. 6 (1989), pp. 4, 6, 8, 12.

Sonia Boyce, interviewed by John Robert, *Third Text*, no. 1 (Autumn 1987), p. 63.

Lorna Dee Cervantes, "Visions of Mexico While at a Writing Symposium in Port Townsend, Washington," in Marge Piercy, ed., *Early Ripening* (New York/London: Pandora, 1987) p. 23.

Mel Edwards, *Mel Edwards*. New York: The Studio Museum in Harlem, 1978.

Harry Gamboa (in Linda Frye Burnham, "Asco," *LA Style*, Feb. 1987, p. 57).

Guillermo Gómez-Peña, "Border Culture and Deterritorialization," *La Linea Quebrada/The Broken Line* no. 2 (1987), n.p.

David Hammons, interviewed by Kellie Jones, *Real Life* no. 16 (Autumn 1986).

Ralph Hils and Deborah Clifton Hils, "Some Comments on the Arts and Rural Development," (unpublished, c. 1986).

Cornel West, interview by Stephanson, p. 51; author's notes from "Show the Right Thing" conference at New York University (Fall 1989), as published in *Z* (Nov. 1989), p. 80.